THE ROMAN AMPHITHEATRE

FROM ITS ORIGINS TO
THE COLOSSEUM

Katherine E. Welch

Institute of Fine Arts, New York University

CAMBRIDGE
UNIVERSITY PRESS

CAMBRIDGE UNIVERSITY PRESS
Cambridge, New York, Melbourne, Madrid, Cape Town, Singapore, São Paulo, Delhi

Cambridge University Press
32 Avenue of the Americas, New York, NY 10013-2473, USA

www.cambridge.org
Information on this title: www.cambridge.org/9780521744355

First published 2007
First paperback edition 2009

Printed in the United States of America

A catalog record for this publication is available from the British Library.

Library of Congress Cataloging in Publication Data

Welch, Katherine E.
The Roman amphitheatre : from its origins to the Colosseum / Katherine E. Welch.
 p. cm.
Includes bibliographical references and index.
ISBN 0-521-80944-4 (HB)
1. Amphitheaters – Rome. 2. Architecture and society – Rome. I. Title.
NA3 13.W45 2003
736'.68'0937 – dc21 2003043503

ISBN 978-0-521-80944-3 hardback
ISBN 978-0-521-74435-5 paperback

 Publication of this book has been aided by a grant from the
Millard Meiss Publication Fund of the College Art Association and by the
Graham Foundation.

10062159 7 X

CONTENTS

ACKNOWLEDGMENTS

I would like to thank the following people who helped me with various aspects of the manuscript, either in the research or in the manuscript stages: Malcolm Bell, Lionel Bier, Bob Bridges, Lisa Buboltz, Sharon Chickanzeff, Amanda Claridge, Cinzia Conti, Joseph Connors, Lanfranco Cordischi, John H. D'Arms, Stefano de Caro, Sheila Dillon, Karin Einaudi, Marian Feldman, Elizabeth Fentress, Alison Futrell, Giovanna Gangemi, Patricia Gargiullo, Gabriella Gasparetti, Pier Giovanni Guzzo, Christopher H. Hallett, Evelyn B. Harrison, Keely Heuer, Ashley Hill, Nicholas Horsfall, Anne Hrychuk, Mark Wilson Jones, Laurie Kilker, Laura Klar Phillips, Lynne Lancaster, Marina Lella, Michelle Lowry, Mary di Lucia, Susann S. Lusnia, Sarah Madole, James R. McCredie, Maggie Meitzler, Emi Maia Nam, Clare Hills Nova, James Packer, Mary Paden, Nigel Pollard, First Lt. Gianluca Pasquilini, Gabriella Colucci Pescatori, Xavier Dupré Raventós, Beatrice Rehl, Jenni Rodda, David Romano, Rosella Rea, Charles Brian Rose, Christina Salowey, Valeria Sampaolo, William V. Slater, Danica Stitz, David Stone, Jennifer Udell, Roger Ulrich, Giuseppe Vecchio, Alessandra Villone, Nikos Varoudis, John D. Welch, Charles K. Williams II, Paul Zanker, and especially James C. Anderson jr., Jennifer Chi, Kathleen M. Coleman, J. Clayton Fant, William V. Harris, Laura Hebert, Julia Lenaghan, Floriana Miele, R. R. R. Smith, Philip Stinson, and Rose Trentinella. My special thanks go to Myles McDonnell.

Much of the research for this book was undertaken while I was a Fellow at the American Academy in Rome and at the American School of Classical Studies at Athens. I am especially grateful to the staff of both these institutions. This book profited greatly from grants from the Millard Meiss Publication Fund of the College Art Association and from the Alexander Graham Foundation.

The translations from Greek and Latin in this book are adopted or adapted from the Loeb Classical Library. For those texts not in the Loeb

series, the translations are my own except where noted. I would like to thank Felipe Rojas and Ian Lockey for checking the Greek and Latin translations.

Thank you also, Kim Gordon and Lee Ranaldo, for "I dreamed I dream."

This book is dedicated to Brian Welch, MD, who inspired my interest in ancient Greece and Rome.

ILLUSTRATIONS

Color Plates (*appear following page 186*)

Figures

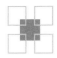

ABBREVIATIONS

AE = L'Année Epigraphique.

Atti = Atti del Convegno di studi sulla Magna Grecia

BdA = Bollettino di Archeologia

Beloch, *Campanien* = J. Beloch, *Campanien, Geschichte und Topographie des antiken Neapel und seiner Umgebung* (Leipzig, 1880 [repr. Rome, 1964]).

CIL = Corpus Inscriptionum Latinarum.

Coarelli 1985 = F. Coarelli, *Il Foro romano nel età repubblicano e augusteo* (Rome, 1985).

D.A.I. = Deutsches Archäologisches Institut.

DS = Ch. Daremberg & E. Saglio, *Dictionnaire des antiquités grecques et romaines,* eds. (Paris, 1873–1919).

De Caro & Greco 1981 = S. De Caro & A. Greco, *Guide archeologiche Laterza* 10: *Campania* (Rome/Bari, 1981).

EAA = Enciclopedia dell' arte antica (Rome, 1958–).

Frederiksen, *Campania* = M. Frederiksen, *Campania* (London, 1984).

Friedländer = L. Friedländer, *Darstellungen aus der Sittengeschichte Roms in der Zeit von Augustus bis zum Ausgang der Antonine,* 6th ed., 4 vols. (Leipzig, 1919).

Futrell 1997 = A. Futrell, *Blood in the Arena. The Spectacle of Roman Power* (Austin, 1997).

Golvin 1988 = J.-C. Golvin, *L'Amphithéâtre romain: Essai sur la théorisation de sa forme et de ses fonctions* (Paris, 1988).

Golvin & Landes 1990 = J.-C. Golvin & C. Landes, *Amphithéâtres et gladiateurs* (Paris, 1990).

Hopkins 1983 = K. Hopkins, "Murderous games" in idem, *Death and Renewal* (Cambridge, 1983) 1–30.

IG = Inscriptiones Graecae.

ILLRP = Inscriptiones Latinae Liberae Rei Publicae (ed. A. DeGrassi).

ILS = Inscriptiones Latinae Selectae (ed. H. Dessau).

Keppie 1983 = L. Keppie, *Colonisation and Veteran Settlement in Italy 47–14 B.C.* (London, 1983).

LTUR = E. M. Steinby, ed., *Lexicon Topographicum Urbis Romae* Vols. I–VI (Rome, 1992–2000).

MRR = T. R. S. Broughton, *The Magistrates of the Roman Republic* I–II (New York, 1951–2).

PIR = *Prosopographia Imperii Romani.*

Platner-Ashby = S. B. Platner & T. Ashby, *A Topographical Dictionary of Ancient Rome* (London, 1929).

Richardson 1992 = L. Richardson jr., *A New Topographical Dictionary of Ancient Rome* (Baltimore and London, 1992).

RE = *Real-Encyclopädie der classischen Altertumswissenschaft.*

Rend. Acc. Nap. = *Rendiconti dell' Accademia di Archeologia, Lettere, e Belle Arti di Napoli.*

Robert 1940 = L. Robert, *Les gladiateurs dans orient grec* (Paris, 1940).

Salmon 1982 = E. T. Salmon, *The Making of Roman Italy* (London, 1982).

TLL = *Theasaurus Linguae Latinae.*

Ville 1981 = G. Ville, *La gladiature en occident des origines à la mort de Domitien* (Rome, 1981).

Wiedemann 1992 = T. Wiedemann, *Emperors and Gladiators* (London and New York, 1992).

PREFACE

I would like to call readers' attention to the republican amphitheatre at Nola (recently excavated and as yet unpublished), which I had the opportunity to study firsthand in summer 2004. The excavators, Dott. Giuseppe Vecchio and Dott. ssa Valeria Sampaolo, were kind enough to give me permission to visit and photograph the building (as yet closed to the public). Dott. Vecchio provided me with an updated plan and some slides taken during the dig, and discussed the excavation with me in detail. Unusually for republican amphitheatres, the building is quite well preserved and has important implications for some of the arguments in this book. For example, it is strikingly similar in architectural respects to the amphitheatre at Pompeii (both cities were Sullan colonies). Because this information on Nola became available to me only after this book had been submitted for final proofs, I could not integrate much discussion of it into the main text. I would therefore recommend that interested readers consult Cat. 13 on Nola along with their reading of Chapter Three, which concerns the earliest amphitheatres constructed in stone.

Please also note that the sequential arrangement of republican amphitheatres discussed here in the Appendix basically follows that of Golvin 1988, with some additional buildings included. Although Golvin attempted to put the amphitheatres into some kind of chronological order, be aware that the sequential arrangement in this book should not necessarily be taken to reflect the true chronology of the buildings, since they are in many cases difficult to date with any great precision. I have given my opinion on the dates in each catalogue entry.

Note also that not all of the bibliographical citations in the Appendix appear in the main bibliography.

Finally, I would like to emphasize that the term "arena" can refer to the amphitheatre as a cultural institution, but in architectural terms it denotes

the performance floor of an amphitheatre, bounded by a podium separating the audience from the combatants. Moreover, in my discussion of republican amphitheatres it is the dimensions of the arena that are critical, less so those of the *cavea* (auditorium, with its seating), which could vary considerably in size.

August, 2006.

INTRODUCTION

The amphitheatre was one of the ancient Romans' most emblematic constructions. Yet it is such a familiar building in the Roman landscape and such a familiar fact of Roman culture that for much of the early and middle twentieth century it was either neglected by scholars or explained in general terms as a manifestation of "Roman cruelty," as either an aspect of "bread and circuses" or a mark of cultural *ennui* in the Rome of the Caesars. Most, if not all, of these interpretations drew on the fundamental and encyclopedic work of L. Friedländer, *Darstellungen aus der Sittengeschichte Roms in der Zeit von Augustus bis zum Ausgang der Antonine* 4 vols. (Leipzig, 1888–90) II, which usefully assembled (together with other aspects of ancient Roman social life) many important details of arena games in the city of Rome. Friedländer, although comprehensive in his discussion of the ancient evidence, framed his analysis of the games in moralizing terms, which expressed modern western Christian values as well as class and gender biases, for example (pp. 16–17: English translation, Routledge & Kegan Paul Ltd., [London, 1908]):

> But these spectacles did not just occupy the masses, for whom they were intended . . . [they] fascinated all, infected the intellect of Rome, even the highest and most cultured circles, and especially the women. How the games pervaded every man's thought, the proverbs show. When they drew breath, they breathed in the passion for the circus, the stage, and the arena, "an original evil begotten in the womb." But, certain as are the evil moral effects of the games even on the upper classes, the demonstration of it in detail is impossible.

Friedländer's work, in both its collection and interpretation of the evidence, dominated the interpretation of the amphitheatre and its games for nearly a century.[1] Much of what was written about the amphitheatre repeated and/or reflected Friedländer's views; for example, "[the Roman arena] was one of the most appalling manifestations of evil that the world has ever

known. Nearly all the spectators wallowed unrestrainedly in blood-lust"
(M. Grant, *Gladiators* [1967] 104).

This situation began to change with the publication of R. Auguet's *Cru-
auté et civilisation: les jeux romains* (1970) – a short, provocative essay that
attempted to analyze Roman spectacles in ancient Roman terms, avoiding
modern value judgments and offering the view that the arena was in fact a
useful institution in Roman society. Similar in approach but more scholarly
was P. Veyne's *Le pain et le cirque: sociologie historique d'un pluralisme politique*
(1976), the first work to evaluate the Roman arena using a sociological
method. Veyne reacted against the older view that grain distributions and
public shows had been a necessary evil that helped to placate the Roman
plebs. In Veyne's view, the arena was socially useful, even necessary, not only
for ordinary Romans but also for those in positions of power.[2]

Less theoretical but very comprehensive in terms of gladiatorial spec-
tacles was G. Ville's monumental *La gladiature en occident des origines à la
mort de Domitien* (1981), which updated Friedländer's work by assembling
a great deal of new information. It remains today the essential reference
work on arena spectacles in the Roman West. Although much evidence
is presented, the material remains undigested, and Ville does not offer a
compelling explanation for the significance of arena spectacles in Roman
culture.[3]

It was K. Hopkins who galvanized the field of arena studies in the 1980s
with the first chapter of his book *Death and Renewal* (1983, 1–30) entitled
"Murderous games." Making use of an interdisciplinary historical method,
this short but penetrating essay argued that arena spectacles both reflected
the traditional bellicose spirit of ancient Rome and served as a substitute for
warfare and as a venue for political expression during the imperial period,
when the *pax Romana* had distanced most Romans from battle and when
the Roman people lost their right to vote. Since its publication, this essay
has been the most influential work on the significance of the amphitheatre
and its spectacles.

Since Hopkins' essay, many useful publications on the subject of the arena
and its spectacles have appeared, most employing an interdisciplinary, his-
torical method to good advantage. The interaction between the emperor
and the people, for example, is central to T. Wiedemann's *Emperors and
Gladiators* (1992). Wiedemann also argues that the amphitheatre was a sym-
bol of the ordered world – a place where civilization confronted lawless
nature. Other analytical works on the Roman arena include B. Bergmann
and C. Kondoleon's *The Art of Ancient Spectacle* (1999) and C. Donerque,
Ch. Landes, and J.-M. Pailler's *Spectacula I: gladiateurs et amphithéâtres*
(1990), both of which contain articles by different scholars on subjects

ranging across architecture and art to religion and social history; A. Futrell's *Blood in the Arena. The Spectacle of Roman Power* (1997), which explores the religious context and the connections between the arena and the imperial cult, particularly in the northern provinces of the Empire; and D. Kyle's *Spectacles of Death in Ancient Rome* (1998), which is particularly good on both the social status of gladiators and the mechanics of dealing with the bodies of dead arena combatants. Another author who has made significant contributions to our understanding of arena games is K. M. Coleman in seminal articles on the historicity, nature, and cultural significance of two particularly elaborate events forming part of the arena repertoire under the Empire: mythological executions (on which, see Chapter Five) and *naumachiae* (mock sea battles).[4] A straight-forward, common sensical book, K. Hopkins & M. Beard, *The Colosseum* (2005), debunks many modern myths about the arena.

Two books are noteworthy for their relatively daring approaches to the subject. The first is that of A. Futrell, just mentioned, which in interpreting the violent nature of Roman spectacles employs an overall anthropological approach.[5] Using cross-cultural analogies of ritual violence (for example, in Meso-America), the author suggests that the significance of gladiatorial games in Roman culture is to be explained in part by the fact that they originated in practices of human sacrifice. The analogy of human sacrifice is rather problematic, however, because in the historical period, from which our evidence for the nature of gladiatorial spectacles comes, it is plain that the Romans did not conceive of gladiatorial events in this way.[6] An anthropological approach that analyzes the violence of the Roman arena in diachronic terms does not do so well in capturing what is unique about the amphitheatre – namely, its combination of cultural institutionalization, efficiency of organization, and lavishness of production.[7] Explanations for the importance of the arena in the Roman world are best sought, in my opinion, not in cross-cultural analogies but within the peculiar social and political aspects of Roman culture itself.

C. Barton's *The Sorrows of the Ancient Romans: The Gladiator and the Monster* (1993), on the other hand, uses a psychoanalytic method to try to explain the significance of the Roman arena.[8] It attempts to elucidate the gladiatorial phenomenon in terms of a collective Roman anguish and *ennui* that was characteristic of the early imperial period (Barton's Rome is very much the Rome of Nero, as described by Tacitus and Seneca) and manifested itself in displays of cruelty in the amphitheatre.[9] The popularity of gladiatorial combat is also connected with a political disillusionment and loss of *dignitas* as Rome moved from a republican to a monarchical form of government. For those who lived in a world in which everything outside the arena was a loathsome and bitter burlesque, the gladiator came to be a symbol of

self-vindication and redemption. In their obsession with arena spectacles,
Barton rightly deems the Romans "surpassing strange." But, in imposing
a late-twentieth-century attitude onto the Roman arena phenomenon, this
book comes no closer to explaining Roman gladiatorial spectacles than did
the earlier moralizing commentators such as Friedländer.

Ironically, in psychological terms Romans seem to have been consid-
erably more foreign to our way of thinking than Barton makes them out
to be. There is actually little evidence that they thought of arena activ-
ities as cruel.[10] Romans apparently cared little about most of the people
who fought and died in the arena; their sympathy for another's suffering
was proportional to the sufferer's social status, and most arena combatants
had none.[11] Romans went to the arena not so much because they enjoyed
watching people suffer, but because of the excitement of an uncertain and
dramatic outcome. They also went to watch the display of aggressive man-
liness and fighting skills, as this book will demonstrate. The world in which
the ancient Romans lived was one where violence was ordinary, both in-
side and outside of an arena context, and it is doubtful that viewing death
in an amphitheatre held an overarching redemptive value for the Roman
populace.[12] It is a guiding principle of this book that we may get closer to
an understanding of the "strange" Romans if we think of violent death in
Roman culture as something that was not unusual, and if we try to put aside
modern notions of the inherent worth of individuals.

Although arena spectacles *per se* have been the focus of considerable
scholarly interest for a long time, it was only in the late 1980s that the
amphitheatre building type (in which they were held) finally received a
comprehensive treatment with J.-C. Golvin's magisterial *L'amphithéâtre
romain. Essai sur la théorisation de sa forme et de ses fonctions* (1988). This
book contains both a catalogue of amphitheatres (with plans and extensive
bibliography) and a comprehensive discussion of the building type in its for-
mal and functional aspects.[13] Since the publication of Golvin's book, several
other useful works have been published on the architecture and function
of Roman amphitheatres and those of other spectator buildings.[14] There
is still, however, no satisfying analysis of the amphitheatre's development
framed in both architectural and historical terms (such terms are inextrica-
ble). In addition, no satisfying explanation for the importance of the arena
in the Roman world, which takes into account the critical period for the
institution's development, has yet been given. The explanations put for-
ward by K. Hopkins, particularly, are especially compelling, but they have
largely to do with the imperial period and they pay only scant attention to
the middle and late Republic – the period of the amphitheatre's origin and
initial dissemination by the Romans. This is a major gap that the present
work intends to fill.

The 'Imperial' Interpretation of Arena Games

Like many scholars, and most who have followed him, Hopkins locates the significance of the arena primarily in the social and political changes that occurred with the advent of the principate. Hopkins's thesis rests on two propositions: (1) that gladiatorial games provided the Roman people with a venue for political expression after they lost the right to vote in the assembly under Tiberius and (2) that, once cut off from regular participation in battle by the *pax Romana*, the traditionally militaristic and bellicose Roman people needed to experience violence vicariously. These points are valid, but on their own they are inadequate explanations for the importance of the arena in Roman culture, as is seen in the following.

Hopkins's idea that the emperor made use of the amphitheatre and its games to demonstrate his own power and legitimize his position is surely correct,[15] but the amphitheatre was not the only venue for political dialogue between emperor and people; it also took place in both the circus and the theatre. In addition, like so much else about the early Empire, the political dimension of gladiatorial spectacles actually had its origin in the Republic, when magistrates and dynasts who competed for power staged ever more elaborate combats. It can be argued that senators under the Republic had a more immediate political stake than did emperors in how well the plebs liked their gladiatorial shows, because election to the praetorship often depended on the success of a politician's aedilician games.[16]

In fact, there is little about the imperial gladiatorial spectacles that did not originate in the Republic. The elaborate forms of entertainment associated with the games staged by the emperors, for example, cannot be fully explained in terms of the needs of the pacified population of imperial Rome,[17] because free public banquets had regularly been given in conjunction with gladiatorial games since at least the second century BC. Livy tells us: "on the occasion of the funeral of Publius Licinius [in 183 BC], there was a public distribution of meats and one hundred and twenty gladiators fought, and funeral games were given for three days and after the games a public banquet. During this, when the banqueting tables had been arranged through the whole Forum, a storm coming up with great gusts of wind drove most people to set up tents in the Forum."[18] The manner in which Livy describes the association of the banquet and the distribution of food with gladiatorial games suggests that it was not unusual. (The incident is only mentioned because of its anecdotal value.) Thus, imperial largesse is not on its own an adequate explanation for the importance of the arena to the ancient Romans.

Similarly, the social and political function of the amphitheatre as a place where the populace could voice their likes and dislikes to the emperor[19]

cannot be directly dependent on the Roman people's loss of the right to pass legislation and elect magistrates, since the former too has republican precedents. In the *Pro Sestio* (125–7), Cicero describes the lively political dialogue that took place between people and the ruling elite at a gladiatorial show. Cicero describes Appius Claudius Pulcher (praetor 57 BC), yelling out to the crowd at a gladiatorial show: "Do you want Cicero to return [from exile]?" and the crowd shouting back, "No!" (126). Cicero objects that the people who shouted were "*Graeculi*" planted in the crowd by his enemy A. Claudius. Cicero comments, "I for my part think that there has never been a greater crowd than at that gladiatorial shows, neither at any *contio* (political meeting) nor indeed any *comitium*."[20] He calls the crowd at a gladiatorial show "this countless throng of men, this unanimous expression of the whole Roman people" and exults that those who can tyrannize over the *contio* could be indicted by the Roman people at the gladiatorial shows.[21] It can even be argued that the political dimension of gladiatorial spectacles was greater under the Republic than under the Empire, because of imperial legislation – the so-called *lex Julia Theatralis*,[22] for example – that hierarchically segregated the audience according to social and political status, and that surely inhibited the type of anonymous expression of political points of view that was possible under the Republic, when most of the audience were seated *promiscue*, that is, mixed together.[23]

Nor is it clear that the frequency of gladiatorial games dramatically increased in the city of Rome during the early Empire. It was in the competitive climate of the late Republic that gladiatorial combat had become more and more lavish in scale. For example, during Caesar's aedilician games in 65 BC, he exhibited so many pairs of gladiators that it aroused anxiety among his opponents, and the senate passed a decree declaring a maximum number of gladiators that any man might own.[24] It was to restrain that kind of aristocratic competition that legislation limiting the frequency of gladiatorial games and the number of pairs of gladiators that could be shown was enacted under the Julio-Claudian emperors.[25] Augustus restricted gladiatorial games to two per year with never more than 120 combatants, and he forbade praetors from putting on shows without the senate's approval.[26] The particularly bloody *munus sine missione* (a type of combat with no reprieve for the fallen gladiator) was banned under Augustus.[27] Tiberius was even more stingy with public spectacles than was Augustus: after his death, the people threatened to burn his body in the amphitheatre, presumably to ensure that he at last provided some public entertainment.[28] Tiberius limited the number of pairs of gladiators in private exhibitions, Augustus having previously done so for public shows, and he tried to banish *venationes* (wild beast shows) from the city of Rome.[29] Similar prohibitions occurred under Nero who decreed that no provincial official could hold gladiatorial shows without imperial permission.[30] Gladiatorial games in Rome under

the Empire were generally on a more extravagant scale, but they were subject to the censorial power of the emperor. What is new and significant in the imperial period in Rome is not the popularity of arena games, but their increased scope (as is argued in Chapter One), which is a function of imperial expenditure. Any explanation for the popularity of gladiatorial games that relies on the assumption of their exponential growth in Rome during the early imperial period, therefore, is likely to be unsatisfying.

The most intriguing aspect of Hopkins' explanation for the significance and popularity of gladiatorial contests – that they were a function of a bellicose Roman populace having been deprived of the experience of battle[31] – is also the most vulnerable. It is in one sense contradicted by the numerous legionary amphitheatres, many in Roman outposts along the northern frontiers of the Empire,[32] that were built by and for soldiers, who can hardly have had the need to experience violence vicariously. But the explanatory value of Hopkins' thesis is obviated by the plain fact that the growth in the popularity and scale of gladiatorial spectacles, and the development of the amphitheatre as a building type occurred, not under the Empire but under the Republic, precisely during the period when Rome was undergoing its greatest imperial expansion and when more Romans were going to war than at any period before or after.

Hopkins' essay successfully demonstrates that gladiatorial games "suffused Roman life"[33] in imperial times, and many of the explanations he cites for the importance of the Roman arena are trenchant. The amphitheatre did perform a number of useful functions in the imperial period: it facilitated social ordering and interaction; it was a place where the emperor could display his power and munificence to the Roman populace; it recreated battlefield conditions for the amusement of the urban population. These are all fortuitous symptoms of the amphitheatre in Roman culture, however, not its determining causes.

It is the lack of detailed consideration of the social significance of gladiatorial games and of the buildings in which they were held during the republican period that has, in my view, kept us from a full understanding of the amphitheatre and the gladiatorial phenomenon. The neglect of the third to first centuries BC (roughly the middle and late republican periods) has partly to do with the fact that the historical sources for this time are scanty and lacunose, but it is also connected with a widespread but mistaken assumption that the amphitheatre as a building type was not particularly important before the imperial period. This book demonstrates that such an assumption is unfounded and that the Republic gives important insight for understanding the amphitheatre and its games. It is the cultural circumstances of the genesis of the Roman amphitheatre building, more than anything else, that holds the key to understanding why the arena assumed such an important place in Roman culture, as will be argued in the first three chapters. It is the

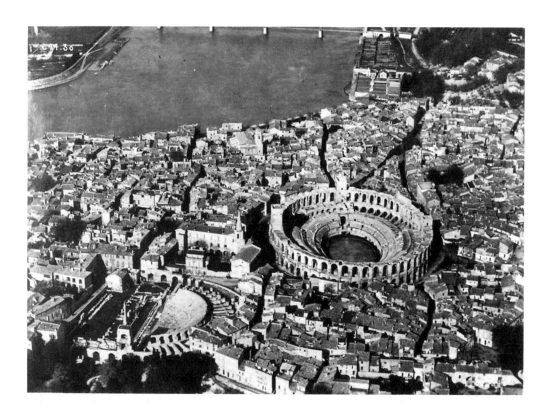

1. Amphitheatre at Arles (*D.A.I. Rome neg. 58.2794*).

very deep-rooted nature of the amphitheatre in Italy, and the pervasiveness of its bloody spectacles throughout the Empire, that – I believe – make it critical to gaining fresh insights into the distinctive character of Roman culture and Rome's spectacular amassing of empire.

* * *

The approach I take in this book is to consider the amphitheatre building at three critical stages of its architectural history: its origins, its monumentalization as an architectural form, and its canonization as a building type, exploring in detail the social and political contexts of each of these phases. This book does not contain a comprehensive survey of amphitheatre architecture[34]; rather, it is an interpretive essay on the development of the amphitheatre building type and an exploration of how the cultural circumstances of this development can help us to understand the architectural iconography and the importance of the arena to ancient Romans.

The book begins with an examination of a neglected but critical aspect of arena studies – the genesis and early development of the amphitheatre building, both in Rome itself and in Italy (Chapters Two and Three). The most imposing surviving amphitheatres, such as the Colosseum, and those at Nîmes and Arles (Figure 1), are of the imperial period. Consequently,

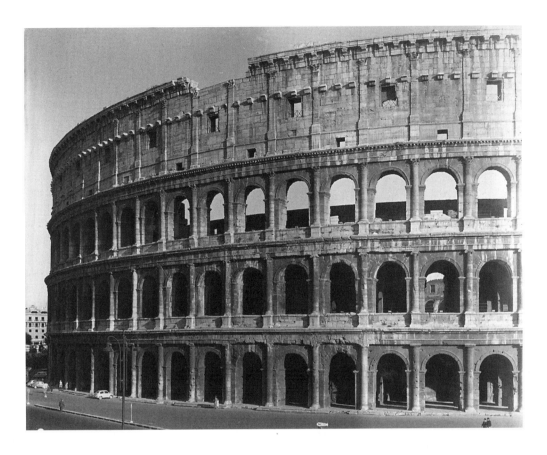

2. Colosseum: façade (American Academy in Rome, Fototeca Unione 6162).

they have received the most attention.[35] But many amphitheatres of a less monumental nature were built beforehand, in republican times. By examining these little-known republican amphitheatres (see Appendix), most of which I had the opportunity to study firsthand, and by placing them in their social and historical settings, it is demonstrated that the Republic is in fact a critical period for understanding the amphitheatre building.

Architecturally, the amphitheatre was more than a purely functional building type. Gladiatorial games could be and (as we know from literature and inscriptions) often were held in venues other than the amphitheatre. Any place that could accommodate crowds – a circus, a theatre, or even a public square – could and did serve as a place for men to fight and kill each other as public entertainment.[36] Buildings of intricate construction with façades sheathed in columnar orders and filled with statues, such as the Colosseum of AD 80 (Figure 2 and Plate 1), were not necessary for the staging of gladiatorial games. This suggests that the significance of the amphitheatre went beyond simply providing a place to hold gladiatorial shows – that by the first century AD the building had become, in some way, a

representational architectural form. The representational aspects of the building type are explored in Chapters Four and Five, whereas the reception of this building type in the Greek world is examined in Chapter Six.

In the brief survey of the scholarly literature here, it has been shown that the institution of the arena is often explained in terms of social and political conditions specific to the Empire. A consideration of a wide range of evidence, however, will indicate that the significance of the amphitheatre in Roman culture cannot adequately be explained in such a way. Ancient texts show that arena games were popular in Italy not only during the relatively peaceful period of the early Empire but also during the Republic, Rome's most active period of military expansion; and archaeology informs us that it was the Republic, not the Empire, that witnessed the appearance and initial proliferation of the amphitheatre as a building type in Italy over the course of the first century BC. Our investigation begins with an examination of the evidence for the origins of arena spectacles, and for their frequency in Rome during the middle and late republican periods.

CHAPTER ONE

ARENA GAMES DURING THE REPUBLIC

Origins of Gladiatorial Combat

The origins of gladiatorial combat are obscure. Various theories, none based on a great deal of evidence, have been proposed. The two main arguments are (1) that gladiatorial games were Etruscan in origin and (2) that they originated in the Osco-Samnite cultures of South Italy. An Osco-Samnite origin for these games, which was first proposed in the early twentieth century, has been championed by G. Ville, who argues that gladiatorial games were originally held in both South Italy and Campania in the fourth century BC and then exported to Rome via the Etruscans.[1] An Etruscan origin for gladiatorial games was first proposed in the mid-nineteenth century, and the idea is still favored by some Etruscologists.[2] The evidence may be summarized as follows.

The Osco-Samnite Hypothesis

Literary Evidence. In an account of how the Romans and their Campanian allies celebrated a victory over the Samnites in 308 BC, Livy contrasts the Romans, who piously hung up captured shields in the Forum, with the Campanians, who celebrated by banqueting: "...the Campanians on account of their arrogance and their hatred of the Samnites armed their gladiators, who performed during banquets, in the fashion [of the captured men] and addressed them as 'Samnites.'"[3] Strabo adds: "As for the Campanians, it was their lot, because of the fertility of their country, to enjoy in equal degree both evil things and good. For they were so extravagant that they would invite gladiators, in pairs, to dinner, regulating the number by the importance of the dinners."[4] Silius Italicus mentions the same practice: "It was their ancient custom to enliven their banquets with bloodshed, and

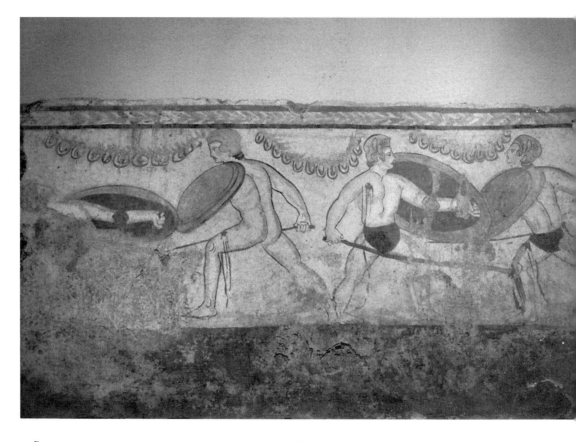

3. Paestum, Tomb 53, Andriuolo necropolis (photo, S. Lusnia).

to combine with their feasting the horrid sight of armed men fighting; often the combatants fell dead above the very cups of the revelers, and their tables were stained with streams of blood."[5] In all of these passages, the treacherous and decadent Campanians (Capua had defected to Hannibal in the Second Punic War) are censured for giving gladiatorial games in a secular context (banquets) and are implicitly contrasted with Romans who hold gladiatorial games in a religious, funerary setting (the *ludi funebres*).[6] None of these authors actually say that the practice of gladiatorial combat originated in Campania, but the passage from Livy suggests that this type of entertainment was popular in South Italy, at least in the late fourth century BC. This supposition accords with the archaeological evidence.

Archaeological Evidence. The material evidence for gladiatorial shows in South Italy before the Social War (early 1st c. BC) consists of representations of single combat in Osco-Samnite tombs and on South Italian vase paintings, all dating to the second half of the fourth century BC.[7] For example, scenes painted on the walls of tombs discovered in the necropoleis at

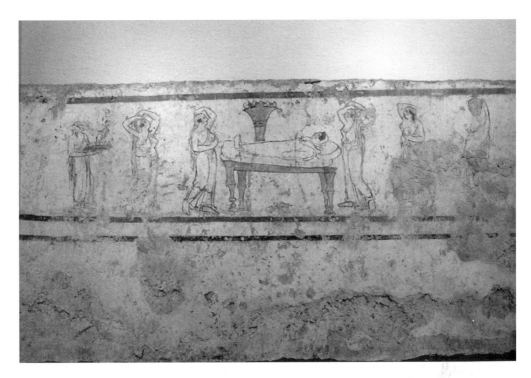

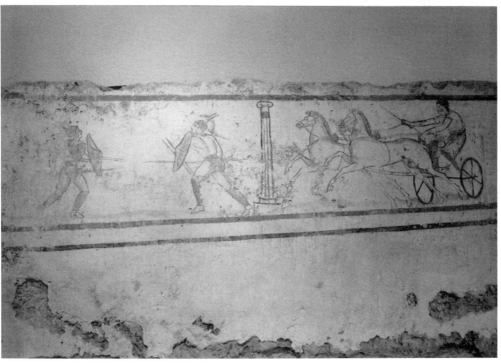

4. Paestum, Tomb X, Laghetto necropolis (photo, S. Lusnia).

Paestum depict men, both bearded and unbearded, fighting each other with spears and bleeding (Figure 3). Several factors indicate that these scenes show single combat as public entertainment rather than as great deeds from the life of the deceased person, or as mythological scenes (as the episodes from the Trojan war in Etruscan tombs such as the François Tomb at Vulci). The scenes of single combat in the Osco-Samnite tombs are juxtaposed with scenes of chariot racing, mourning, and corpses laid out on biers. This, and the fact that the combat scenes are embellished with representations of pomegranates (symbols of the underworld), indicates that the fighting is intended to be seen in a funerary context. In one tomb (Figures 4a and 4b) a scene of single combat appears in the tomb of a woman (her corpse is shown laid out on a funeral couch), making it clear that in this case the scene of fighting was not related to the life of the deceased person, but perhaps to funerary ritual involving her family.[8] These tomb paintings are convincing representations of single combat as public entertainment in the fourth century BC. The archaeological sources are silent, however, about Osco-Samnite gladiators after this period.

The Etruscan Hypothesis

Literary Evidence. Nicolaus of Damascus, writing in the late first century BC, made reference to gladiatorial combat and said that the Roman practice of showing gladiators was inherited from the Etruscans: "The Romans staged spectacles of fighting gladiators not merely at their festivals and in their theatres, borrowing the custom from the Etruscans, but also at their banquets."[9] This passage does not actually say that the Etruscans invented the practice of showing gladiators; it simply says that the Romans borrowed the practice from the Etruscans. It is not surprising that the Romans would advance an Etruscan origin for gladiatorial games, because many other venerated Roman institutions (such as augury and the triumph) had Etruscan roots. One ancient tradition held that gladiatorial combat was introduced to Rome by the Etruscan kings: a fragment attributed to Suetonius states that: "Earlier Tarquinius Priscus exhibited to the Romans two pairs of gladiators which he had matched together for a period of twenty-seven years."[10] That gladiatorial games were being staged at Rome as early as the sixth century BC is perhaps unlikely, but the association of the Tarquins with gladiatorial games was a natural one to make, because Tarquinius Priscus was credited with other civilizing innovations, such as the draining of the Roman Forum, the building of the Capitoline temple, and the introduction of circus games.[11]

Some aspects of gladiatorial shows may have been Etruscan: for example, the word *lanista* (owner of a gladiatorial troop) may come from the Etruscan language (as do many Latin proper names of masculine gender that belong in the first declension), though this is by no means certain.[12] There was also the arena attendant, called *Iovis Frater* by Tertullian,[13] who removed corpses of gladiators from the arena; this figure carried the attribute of a mallet and has been associated with the Etruscan god Charun.[14] Whether this character was a relic from a time when the Etruscans practiced gladiatorial games or he was introduced by the Romans, because they believed that gladiatorial games came to them from the Etruscans, is not clear.

Archaeological Evidence. Wall paintings from Etruscan tombs of the sixth century BC have been adduced as evidence that the Etruscans invented gladiatorial combat.[15] Several tomb paintings show a peculiar character labeled "Phersu," who is bearded and dressed in a conical hat and a mask. In the Tomba degli Auguri, he stands holding the leash of a dog, which is attacking a man dressed in a loincloth who holds a club and has a sack over his head (Figure 5). This scene has been interpreted in different ways: as an example of early gladiatorial combat, as a prototype for the *venatio* (beast shows) or *damnatio ad bestias* (execution by wild beasts), as a mythological scene of uncertain nature (such as Herakles in Hades attempting to capture the dog Kerberos), as an athletic event, or even as a propitiatory human sacrifice in Etruscan funeral ritual.[16] The last of these interpretations is the least problematic one, as there is little about this scene that in any obvious way resembles depictions of gladiatorial games, *venationes*, or *damnatio ad bestias* in later, Roman art.[17]

Aside from the Tomba degli Auguri, there are scenes in some Etruscan tombs, such as the Tomba delle Bighe and the Tomba della Pulcinella, that show men armed with helmet, shield, and sometimes a cuirass and sword. These figures are static, however, and are not engaged in fighting. The Tomba delle Bighe shows spectators seated on what seem to be wooden stands, watching a boxing match above what appears to be a podium (Figure 6). This painting indicates only that the Etruscans watched athletic games while seated on wooden stands, not that they invented gladiatorial combat. In Etruscan tombs, one never sees a scene of veritable single combat, that is, a scene of two opposing armed men. The material evidence for the Etruscan origin of gladiatorial combat is, then, not terribly convincing.[18]

In summary, the material evidence for gladiators before the first century BC consists of representations in South Italian tombs and on vases, all dating to the fourth century BC. Several written sources mention gladiatorial

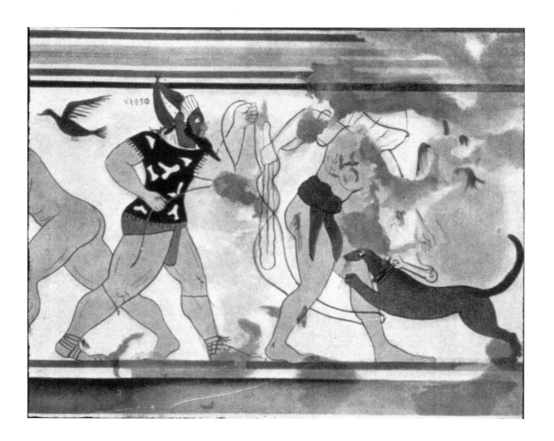

5. Tarquinia, Tomba degli Auguri, Phersu Scene (M. Pallottino, *Etruscologia* [Milan, 1973] tav. LXIX).

combat as a part of Campanian banquets during the republican period. There is no clear archaeological evidence for Etruscan gladiatorial combat. Literary sources, however, indicate that some Romans (at least by the Augustan period) believed that they had inherited from the Etruscans the practice of giving gladiatorial games. Ville argues that the Etruscans borrowed gladiatorial combat from South Italy at either the end of the fourth or the beginning of the third century BC. It is perhaps not necessary, though, to insist that gladiatorial games went to Etruria before they arrived at Rome. Indeed, by at least the mid-third century BC, gladiatorial games were not restricted to Campania but were already taking place in Rome.[19]

It is worth looking more closely at the passage, mentioned previously, from Athenaeus' *Deipnosophistae*. This passage is usually discussed or quoted only in terms of what is said about the Etruscan versus the Campanian origins of gladiatorial combat. However, these are not the only opinions offered in the text on the subject of where these games originated: "Some of the Campanians fight gladiatorial combats during their symposia. And Nicolas of Damascus, a peripatetic philosopher, records in the 110th

6. Tarquinia, Tomba delle Bighe (F. Poulsen, *Etruscan Tomb Paintings* trans. I. Anderson, [Oxford, 1922]).

book of his *Histories* that the Romans held gladiatorial fights during their banquets. He writes as follows: 'the Romans staged spectacles of fighting gladiators not merely at their festivals and in their theatres, borrowing the custom from the Etruscans, but also at their banquets.'"[20] The text goes on: "In the twenty-third book of his *Histories*, Poseidonius says: 'The Celts sometimes have gladiatorial contests during dinner. Having assembled under arms, they indulge in sham fights and practice feints with one another, and sometimes they proceed even to the point of wounding each other, and then, exasperated by this, if the company does not intervene, they go as far as to kill.'"[21] A further explanation is then offered: "Hermippus in Book One of his work *On Lawgivers* says that the Mantineans were inventors of gladiatorial combat, having been counseled thereto by Demonax, one of their citizens."[22]

It is clear from the previously cited passages in Athenaeus that there was a debate even in ancient times about where gladiatorial games had originated. In other words, even the Romans themselves did not have the answer. Considering this, it is interesting that so much effort has been made trying to determine what culture was really responsible for gladiators. It has been

suggested that the issue has never been entirely free of political agendas, especially in the nineteenth century, when the view of the Romans as a civilized people was perhaps invested in demonstrating that the uncivilized practice of slaughter for recreational purposes had originated outside Roman culture (in an "oriental," Etruscan milieu).[23] And anyway, the subject of origins hardly explains either the continuing success or the increasing scale of the gladiatorial phenomenon.

Gladiatorial Games during the Republican Period

Although the specific origin of gladiatorial combat may never be resolved, it is clear from literary evidence that at least in Rome gladiatorial games were popular and frequent as early as c. 200 BC. Part of the difficulty in understanding the integral role that these games played in Roman society before the first century BC rests in the fact that they are mentioned only occasionally in the literary sources for this period; thus, it is often assumed that they were not held regularly before the early to mid-first century BC, at which point they increased dramatically in frequency.[24] It is true that there are relatively few citations of gladiatorial games in the literature that deal with the period before Pompey and Caesar. (It is no coincidence, though, that in the time of Pompey and Caesar we begin to have exponentially more evidence for all aspects of Roman life – because of the voluminous writings of Cicero, which have survived in large part.) The received view is that gladiatorial shows became more popular in the early to mid-first century BC, because at this time they began to be separated from a funerary context and came to be used more and more for political ends.[25] However, this solution puts the cart before the horse, in a sense, because the popularity of gladiatorial combat surely preceded the awareness that it could be used for political ends. When the evidence is sensitively analyzed, a very different picture emerges: gladiatorial games were popular and frequent in the early second century BC, as were the other events that eventually became part of the arena repertoire – *venationes* (wild beast shows), *damnatio ad bestias* (execution by beasts), crucifixion, and *naumachiae* (mock sea battles) – that seem to have originated during the middle republican period in a military context. The evidence considered in this work suggests a more complex picture for the social significance of gladiatorial games in Roman republican society than the one that is usually offered (namely, that it had to do mainly with funeral customs and political competition) and, by extension, a very different reading of the Roman arena in general. We may begin with an examination of Livy, our main source for gladiatorial games before the first century BC.

Livy tells us that the earliest gladiatorial game at Rome was given by Marcus and Decimus Brutus for their father Decimus Junius Brutus Pera in 264 BC: "Decimus Iunius Brutus was the first to give a gladiatorial show in honor of his deceased father."[26] Valerius Maximus adds: "the first gladiatorial show at Rome was given in the *Forum Boarium* in the consulship of Ap. Claudius and Q. Fulvius [264 BC]; the donors were Marcus and Decimus, sons of Brutus Pera, honoring their father's ashes with a funerary memorial."[27] Ausonius adds, "the three first combats [of gladiators] of the Thracian type were matched in three pairs – these were the offering made by the sons of Iunius at their father's tomb."[28] Servius tells us that the combatants were war captives: "Even among the ancients, men used to be killed, but when Iunius Brutus died and many families had sent captives to his funeral, a relative of his was paired to the men who had been sent with one another and so they fought, and since they had been sent as a gift, from that time they called the battle a *munus*."[29] Note that combatants were war captives (quite possibly taken from Volsinii, an important Etruscan city, which fell to Rome in 264 BC). From their earliest attestation in Rome, then, gladiatorial games were connected not only with funerals but also with warfare.[30] There is actually more information about this gladiatorial show than about any other show mentioned in the surviving sections of Livy (on which, see following). This is because it was popularly thought of as the first such show. (Whether because it really was, or because it took place in an important year that saw the beginning of the First Punic War, is uncertain.)

We know considerably less about other gladiatorial shows in the late third and second centuries BC. The next combat mentioned by Livy took place in 216 BC: "and in honor of M. Aemilius Lepidus, who had been consul twice and augur, his three sons, Lucius, Marcus, and Quintus, gave funeral games for three days and showed twenty-two pairs of gladiators in the Forum."[31] Note that in this instance the combat took place in the *Forum Romanum*, the usual location for gladiatorial combat throughout the remainder of the republican period (Plate 2). Next we hear of Scipio's funeral games for his deceased father and uncle at New Carthage in 206 BC: "Scipio returned to [New] Carthage to pay his vows to the gods and to hold a gladiatorial show which he had arranged in honor of his deceased father and uncle."[32] Livy adds that the participants were not gladiators of either the slave or the freedman classes; they were volunteers who were not paid to fight. (They may have been Scipio's soldiers.) After this citation, Livy mentions gladiatorial games in 201 BC (in honor of M. Valerius Laevinus), in 183 BC (in honor of Publius Licinius Crassus), and in 174 BC (in honor of Titus Flamininus).[33] This is the sum total of the gladiatorial games at Rome recorded by Livy. But this should not be taken as an indication that gladiatorial events were infrequent during the middle republican period.

It should be noted that Livy's surviving text, which is our major source for the republican period, lacks his narrative of the years from 292 to 218 BC, and from 167 BC on. As Ville rightly noted, we would have a good deal more information about gladiatorial combat if we had the narrative of those missing years.[34] It should be added, though, that even in the fully preserved books, Livy is selective with gladiatorial material. Indeed, Livy seems to have singled out these particular games not because they were unusual but because the individuals concerned were famous, because their *gentes* (families) were well known in Livy's own day, and because these shows were on a much grander scale than was usual during the period. Consider the following statement of Livy: "Many gladiatorial games were given in that year [174 BC], some unimportant, one noteworthy beyond the rest – that of Titus Flamininus [conqueror of Philip V] which he gave to commemorate the death of his father, which lasted four days, and was accompanied by a distribution of meats, a banquet, and scenic performances. The climax of the show which was big for the time was that in four days seventy-four gladiators fought."[35] It is clear from this passage that the other gladiatorial shows that took place at Rome in 174 BC were not deemed important or large enough for Livy to mention. This is also indicated by a parenthetical remark in Polybius' discussion concerning a particularly expensive gladiatorial show to be given on the occasion of the funeral of Aemilius Paullus: "The total expense of such a show amounts to not less than thirty talents if someone does it in a sumptuous manner."[36] This passage implies that some gladiatorial shows in the mid-second century were not given on a particularly generous scale – in other words, there were shows more ordinary in nature than those given in commemoration of the famed Aemilius Paullus, conqueror of Macedon.

Other sources indicate that gladiatorial games were regular events in second-century BC Rome. Inscriptions from Delos show that gladiatorial combats were held on that island in the second century BC in the Agora of the Italians.[37] In addition, there are schematic paintings of gladiators in Delian houses of the late second and early first century BC.[38] The Agora of the Italians was evidently the venue for gladiatorial games on Delos, which would mean that it was used the same way as an Italian forum would have been employed (on the gladiatorial uses of the latter, see Chapter Two).[39] Gladiatorial activity was evidently important enough to Romans that by the later second century BC they brought gladiators (with freedman names such as "Μ. Καικίλιος Ἐπάγαθος"[40] [M. Caecilius Epagathos]) along with them when they lived abroad.

Further evidence of the early popularity of gladiatorial games at Rome can be gathered from Pliny the Elder. Writing in the Flavian period, in a discussion of paintings of gladiators, Pliny explicitly states that the practice

of painting the portraits of gladiators had been popular for centuries:

> When a freedman of Nero was giving a gladiatorial show at Antium [Anzio], the public porticoes were filled with paintings, so we are told, containing life-like portraits of all the gladiators and assistants. This portraiture of gladiators has been the highest interest in art for many centuries now; but it was Gaius Terentius Lucanus[41] who began the practice of having pictures made of gladiatorial shows and exhibited in public; in honor of his grandfather who had adopted him he provided thirty pairs of gladiators in the Forum for three consecutive days, and exhibited a painting of the teams in the Grove of Diana.[42]

These paintings were exhibited in the Sanctuary of Diana on the Aventine hill, the plebeian haven *par excellence* in the city of Rome,[43] indicating that as early as the second century BC gladiatorial games were rooted in popular support as well as in upper-class political interests. This is also revealed in the preface to the *Hecyra* of Terence: "The first act [of the play] met with approval, but on a cry that there was to be a gladiatorial show, in flocked the people with uproar and clamor and a struggle for seats with the result that in the meanwhile I could not change my place."[44] In addition, we hear of a *ludus Aemilius* in Rome, probably the private gladiatorial school of the *Aemilii Lepidi*, one of the most important families in Rome during the early second century BC.[45]

Also worth considering in the context of second-century *munera* is the unusual interest of the Greek king Antiochus IV Epiphanes in gladiatorial combat: "In his shows too, [Antiochus IV] surpassed earlier kings in splendor of every sort. Most [shows he gave] were in their own proper manner and with an abundance of Greek performers, but he also gave a gladiatorial show after the Roman fashion."[46] Polybius adds that in putting on gladiatorial entertainment Antiochus had wanted to upstage Aemilius Paullus, who had given Greek athletic shows as part of his triumphal games in Macedonia in 168 BC.[47] This passage in Polybius indicates that gladiatorial games were already being used for political purposes as early as the mid-second century BC.[48] The passage in Livy concerning the gladiatorial shows of Antiochus IV suggests that gladiatorial games were a pervasive feature of Roman culture in the early second century BC: Antiochus' interest in gladiators is best explained as part of a larger Romanizing strand in his cultural politics, influenced by his stay in Rome (as hostage after the peace of Apamea) between 188 and 176/5 BC.[49]

The evidence indicates that gladiatorial games "suffused Roman life"[50] long before the Roman people lost the right to vote and pass legislation and long before the *pax Romana* – at the very time, in fact, when active Roman imperialism was at its height and when the Roman military self-image was taking shape. An early indication of the self-consciousness of this image

is found in a line of Ennius (early second century BC): "Brave are the Romans as the sky is deep."[51] In a well-known passage, Sallust gives a more specific account of this self-conception:

> But it is incredible to remember how much the state grew within a brief period, once freedom had been gained; so great was the desire for glory that affected men. As soon as the young were old enough for war, they learned the business of soldiering by toiling in an armed camp, and they took their pleasure more in fine arms and cavalry horses than in whores and partying. Therefore to these kinds of men work was a common objective, no place seemed rough or steep, no enemy under arms seemed frightening: courage had gained complete control. But there was intense competition among them for glory; each of them hastened to strike down an enemy, to climb the rampart, and to be seen doing such a deed.[52]

In fact, the beginning of regular gladiatorial combat at Rome (probably mid- to later third century BC) coincides with the beginning of Rome's most active military expansion. And the institution of limitations on gladiatorial games in the city of Rome coincides with both the end of Rome's major military expansion and the beginning of the *pax Romana*, as discussed in the Introduction. This does not seem to be a coincidence, and it certainly casts serious doubt on theories that would explain the importance of arena games either as a substitute for warfare or as a function of imperial-period *ennui*.

In short, gladiatorial games were more frequent in republican Rome than scholars have supposed. Part of the misconception stems from the fact that ancient writers themselves did not emphasize gladiatorial games. To the writers of the republican period these games were usual. They were simply taken for granted by ancient authors, who mention them only in passing and rarely for their own sake, unless they are either innovative, particularly spectacular, or because something went wrong. Spectacles were thought to be irrelevant and even inappropriate to annalistic and forensic writing,[53] and they are mentioned by a geographer such as Strabo only in the context of a footnote designed to "flesh out" an otherwise dry narrative.[54] Roman writers did not begin to take a self-conscious interest in arena games until the early imperial period, with authors such as Calpurnius Siculus, Martial, Statius (discussed in Chapter Five), and Suetonius (whose *de Ludis* was a three-volume work on the history of games: two devoted to Roman spectacles and one to Greek spectacles).[55]

The *Venatio* and *Damnatio ad Bestias* in the Republican Period

Just as gladiatorial shows can be shown to have become popular in the middle Republic, the other events that joined the arena repertoire under

the Empire also had their roots in this early period. In the early imperial period, gladiatorial combats were often combined with *venationes* and *ludi meridiani* to become the so called *munus legitimum*. A standard amphitheatre program of the imperial period might have consisted of a wild beast show in the morning, with gladiatorial shows following in the afternoon. In between the two main events, there were sometimes mock gladiatorial fights (by *paegniarii*) and public executions by various means, including those by wild beasts (*damnatio ad bestias*) and/or crucifixion.[56]

Venationes. The *venatio*, which included combats between animals and fights between animals and trained beast fighters (Figures 7 and 8) was an integral part of amphitheatre activities under the Empire. Before the mid-first century AD, however, wild beast displays took place, not as part of gladiatorial games but as part of the public festivals (*ludi*) that occurred in the *Circus Maximus*.[57] In the first century BC displays of this sort were famous for the political use to which they were put by dynasts such as Pompey and Caesar. For example, Pliny tells us: "A fight with several lions at once was first bestowed on Rome by Q. Scaevola [cos. 95 BC] when he was consular aedile, son of Publius, when consular aedile, but the first of all who exhibited a combat of one hundred lions with manes was L. Sulla, later dictator, in his praetorship [93 BC]. After Sulla, Pompey the Great showed six hundred lions in the Circus, including three hundred fifteen with manes, and Caesar when he was dictator showed four hundred."[58]

This use of the *venatio* by powerful generals extended much further back in time, though, to the period of the introduction of exotic beasts into Italy. During the middle republican period, Roman military successes made available many areas populated with unusual animals, and they began to be displayed in military triumphal contexts as early as the third century BC.[59] Elephants first came to Rome in 275 BC, having been taken from Pyrrhus in the south of Italy, and were displayed in the triumph of M. Curius Dentatus, as recorded by both Seneca[60] and Eutropius.[61] Next, Pliny the Elder says that L. Caecilius Metellus brought 140 (or 142) elephants to Rome in 252 BC and exhibited them in the *Circus Maximus*. He notes that there is disagreement in the sources concerning whether they were merely hunted or killed. (Presumably they were also displayed in the general's triumph.)[62]

The first recorded staged animal hunt on a large scale was sponsored by M. Fulvius Nobilior in 186 BC, as Livy tells us: "Then for the first time an athletic contest was put on at Rome, and a hunt was staged in which lions and panthers were the quarry, and the games were especially honored with all types of resources and abundance that a nation at that time had."[63] Nobilior had vowed this event at the capture of Ambracia in western Greece as part of the *ludi magni* in honor of Jupiter Optimus Maximus. By 170 BC,

7. Molding from the podium of the amphitheatre at Lupiae (Lecce), showing scene of a *venatio* (American Academy in Rome, Fototeca Unione 12816).

the Senate considered it necessary to prohibit the importation of African beasts into Italy (in order to discourage generals from currying political favor by putting on spectacular *venationes*), a measure that was countered by a *plebiscitum* sponsored by Cn. Aufidius. As Pliny describes: "There was a *senatus consultum* prohibiting the importation of African beasts into Italy. In disagreement with this, Cn. Aufidius, tribune of the plebs, took the measure to the people, and permitted the importation of these animals for the purpose of circus games."[64] As early as 169 BC, however, more animal displays of such lavish proportions are recorded. Livy tells us that: "With luxury already growing, it is recorded in memory at those games paid for by the curule aediles Publius Cornelius Scipio Nasica and Publius Lentulus, sixty-three leopards and forty bears and elephants participated."[65] Although the *venatio* was not being performed in conjunction with gladiatorial shows at this time, it is noteworthy that animal combats – which became such an integral part of the arena repertoire in the imperial period – seem

to have had their origin in the military conquests and public displays of the middle Republic.

8. Scene of a *venatio* from a Roman tomb (Rieti, *Museo Civico*) (*D.A.I.* Rome neg. 73.702).

Damnatio ad Bestias. Execution of condemned criminals and prisoners of war by means of wild beasts was to become a basic ingredient of amphitheatre entertainment (Plate 3). This is often assumed to have been

an invention of the 'decadent' capital at the end of the Republic and un-
der the Empire,[66] but similar activities are attested as early as the second
century BC. Deserters from the Roman army were being thrown to wild
beasts as early as the time of Aemilius Paullus in 167 BC as part of the great
ludi given by him in Greece after the Battle of Pydna. Valerius Maximus,
in a section on military discipline, says: "And L. Paullus after defeating
king Perseus laid persons of like nationality and guilt in front of elephants
to be trampled.... For military discipline requires a harsh, brusque sort of
punishment...."[67]

Scipio Aemilianus then threw deserters to beasts in 146 BC. Valerius
Maximus, in the same discussion of military discipline, tells us that Scipio
"threw deserters of other than Roman nationality to wild beasts in the shows
he exhibited for the people."[68] Livy explains that in doing this Scipio had
taken his cue from his father: "Scipio in imitation of his father Aemilius
Paullus, who had conquered Macedon, put on games and threw the prison-
ers of war and deserters to wild beasts."[69] As early as 146 BC, then, people
were being transported to Rome to be thrown to beasts during public *ludi*. At
the conclusion of the Sicilian Slave War in 101/100 BC, the Roman general
M. Aquillius had the defeated troops of his opponent Satyrus (1,000 men)
freed from immediate punishment, so they could be taken to Rome to do
combat with wild beasts. (They committed suicide to avoid it.)[70] What is
important to note here is that all of these early executions by beasts were
staged in a military context, just as were the early instances of the *venatio*.

Other Forms of the Death Penalty

Other types of spectacular public violence seem also to have had their ori-
gins in a military context. In the early imperial period, *naumachiae* (mock sea
battles), involving condemned criminals who fought to the death, became
an integral part of the arena repertoire.[71] Julius Caesar gave the first known
public *naumachia* in a basin in the *Campus Martius* in 46 BC.[72] A few years
later in 40 BC, Sextus Pompey, for the benefit of his troops, gave a mock sea
battle involving a fight to the death of prisoners of war.[73] The *naumachia* was
not new in the military sphere, however. Mock sea battles (*navales pugnae*)
are known to have occurred in the late third century BC, under Scipio
Africanus in the context of military display and training.[74] In this instance,
though, the combatants were Scipio's soldiers, and of course they did not
fight to the death.

In Pompeii, on the Via delle Tombe outside the Porta Nocera, a gladia-
torial advertisement was found that reads: "Twenty pairs of gladiators and
their substitutes will fight at Cumae on the first, fifth, and sixth of October:

there will be crucifixions, a beast show, and awnings."[75] This inscription dates to the first century AD, but crucifixion occurred under the Republic before it entered the arena repertoire under the early Empire. Crucifixion was routinely employed for recalcitrant slaves and soldiers during the republican period. The first recorded instance was in 217 BC when twenty-five slaves were publicly crucified on the *Campus Martius* at Rome, and this practice was fodder for many a joke in the plays of Plautus.[76] Scipio Africanus crucified Roman army deserters after Carthage was defeated in 202 BC,[77] and in 70 BC, after their army fell to Crassus, 6,000 followers of Spartacus were crucified along the Via Appia for all to view.[78] *Damnatio ad flammas* was another type of punishment that was deployed in arena contexts under the Empire. A well-known example is the burning alive of the Christian bishop Polycarp in the stadium at Smyrna during the second century AD.[79] But something similar occurred earlier, in 43 BC, when a soldier was burned alive in a gladiatorial school at Gades in Spain by order of Balbus the Younger.[80] The incident is mentioned by Cicero only because the soldier was a Roman citizen (citizens were exempt from such punishments) and suggests that the penalty may not have been unusal for non-citizens in public contexts.

The Arena and the Roman Army

All of this evidence suggests that an important key to understanding the Roman arena lies with the Roman army, as Hopkins recognized.[81] These were the two most violent institutions in Roman society, and as we have seen, they were linked at an early date. That they are related is also shown by the facts that military amphitheatres were often built in legionary camps, and that both gladiators and soldiers were forced to take an oath (the former an oath of servitude, the latter an oath of loyalty), on pain of death.[82]

The Roman Empire was realized by means of controlled violence and obsessive military discipline.[83] One way in which commanders chose to discipline their armies was through decimation: if soldiers either misbehaved or were cowardly, one soldier in ten could be arbitrarily selected and cudgeled to death by his fellow soldiers.[84] It is important for our purposes to recognize the distinctly 'amphitheatric' quality to disciplinary actions in the Roman army. For example, when a mutiny had taken place among Scipio Africanus' legions in Spain (late third century BC), ironhanded action was taken in front of a throng of soldiers assembled all around as spectators.

> [Scipio] ordered the lictors to divide the crowd into two parts, and when they did so, the senators dragged the guilty leaders into the middle of the assembly. When they cried out and called their comrades to their aid, everyone who

uttered a word was killed by the tribunes. The rest of the crowd, seeing that the assembly was surrounded by armed men, remained in sullen silence. Then Scipio caused the wretches to be dragged into the middle of the crowd, to be beaten with rods, those who had cried out for help being beaten hardest, after which he ordered that their necks should be pegged to the ground and their heads cut off. He gave pardons to the rest among this number. In this way the mutiny in Scipio's camp was put down.[85]

This very Roman conflation of discipline and popular spectacle in a theatrical setting is also encountered in Tacitus, in his account of a mutiny of Germanicus' troops in Germany during the Augustan period. When this happened, Germanicus did what a good general was expected to do according to Roman tradition: he authorized the public execution of a certain number of the instigators in order to teach the soldiers a lesson. Again, the soldiers acted as an audience and were encouraged to take part in the executions. The mutinous soldiers were paraded on a platform in front of their comrades. If their fellow soldiers shouted "guilty!" they were thrown down and butchered.[86] Tacitus adds: "The troops reveled in the butchery, as though they were absolving themselves of guilt."[87] This type of audience participation is similar to that of the spectators in the amphitheatre, who, from a safe distance, decided the fate of a fallen gladiator. If they liked the way he fought, they might shout "missus!" (set him free); if not "jugula!" (cut his throat).[88] A final striking example of a perceived link between war and gladiatorial spectacles comes from Tactitus' narration of the siege of Rome in the war between Vespasian and Vitellius (AD 69): "The people stood by like spectators watching the combatants; as if at a contest in the games they cheered and clapped for this side and then the other."[89] This connection between army and arena activities is an important but often neglected one, which is explored in detail in subsequent chapters.

Conclusion

This chapter has shown that an "amphitheatre mentality" reigned as strongly under the Republic as under the Empire. We have seen that the popularization of arena games had as much or more to do with the social conditions of the middle and late Roman Republic (the period of Rome's most active military expansion) as it did with social conditions specific to the Empire. Just as the literary evidence suggests that the phenomena associated with the amphitheatre – gladiatorial combat, wild beast shows, *damnatio ad bestias*, and *naumachiae* – developed in the middle republican period,

specifically in a military context, so too the amphitheatre building has its roots in both the middle-late republican period and in a military milieu. Therefore, if we wish to understand better what the amphitheatre building and its games meant to the Romans, we must also look to the Republic, the period of the amphitheatre building's origin and early development.

ORIGINS OF AMPHITHEATRE ARCHITECTURE

This chapter explores the physical setting of gladiatorial games during the middle and late republican periods. It focuses specifically on the evidence for temporary wooden seating arrangements in the *Forum Romanum* and proposes a series of reconstructions of such structures during different periods of the Forum's use for gladiatorial spectacles. These temporary wooden seating arrangements, it is proposed, were pivotal in the genesis of later stone amphitheatre architecture. The chapter concludes with a short discussion of the known evidence for some other wooden spectator buildings, both Roman ones and some later examples, which can serve as comparanda for the wooden structures in the Roman Forum.

The Setting of Gladiatorial Games at Rome during the Republic: The *Forum Boarium* and the *Forum Romanum*

As we have seen, in middle and late-republican Rome, arena games were a deeply ingrained phenomenon. During this period, gladiatorial games were held in the religious context of aristocratic funeral ritual. As far as we know, the first gladiatorial game at Rome took place in 264 BC at the funeral of Iunius Brutus Pera.[1] The location of this early *munus* is said by Valerius Maximus to have been the *Forum Boarium*, and Ausonius locates this show at the tomb of the deceased, in which case it is likely that it took place in an extra-pomerial context (outside of the sacred boundary of the city, or *pomerium*) – perhaps just outside the *Porta Trigemina*, close to the *Forum Boarium*.[2] The arena in this case may have been formed either by wooden benches or simply by the people watching the show.[3] As mentioned in Chapter 1, this practice of holding funeral games near tombs may have been inherited from Osco-Samnite or Etruscan funerary practices, in which the *manes* (spirits) of the deceased had to be placated through combat.[4]

Tertullian suggests that early gladiatorial games were held next to tombs: "for formerly, in the belief that the souls of the dead were appeased by human blood, they used to sacrifice during their funeral rites captives or slaves of poor quality whom they had brought... and so, those whom they had procured and trained in such arms as they had and as best they could only that they might learn to die, on the appointed day of the funeral were then killed amidst the tombs."[5] Servius says much the same thing: "clearly it used to be the custom that captives would be killed at the tombs of powerful men: because afterwards this was seen as cruel, it was later resolved that gladiators would fight before the tomb."[6]

The next gladiatorial show at Rome mentioned by Livy took place in 216 BC and occurred in the *Forum Romanum*.[7] In fact, the great majority of the references to republican gladiatorial games after 264 BC for which the venue is mentioned record the location as the *Forum Romanum*, which was evidently the usual place for them until the Augustan period (Plate 2). The latest explicit reference to gladiators in the *Forum Romanum* is Tiberius' *munus* in honor of his father in the mid-20s BC.[8] This indicates that the Forum continued to be used for games until at least that date and probably down to the time it was damaged by fire in 14 and 9 BC and then re-paved c. 7 BC.[9]

Evidence for Spectator Arrangements in the *Forum Romanum* in the Republican Period

Citations of games in the Forum are often anecdotal and give little or no information about physical setting, as for example, in Propertius, where the poet chides Cynthia as follows: "You are not to dress up and walk abroad in Pompey's colonnade, or when the sand is strewn for games in the Forum."[10] There is, however, a small number of texts, which – when taken together – provide enough information to gain a picture of the type of structure that accommodated spectators at gladiatorial shows when they were held in the Forum. A starting point is Vitruvius' statement:

> The Greeks lay out their town squares in the form of a square with wide double porticoes... But in the cities of Italy the same method cannot be followed for the reason that it is a custom handed down from our ancestors that gladiatorial shows should be given in the forum. Therefore, let the intercolumniations around the show place (*circum spectacula*) be rather wide; round about in the colonnades put the bankers' offices; and have balconies on the upper floor (*maeniana superiora*) properly arranged so as to be convenient and so as to bring in some revenue. The dimensions of the forum ought to be adjusted to the audience lest the space be cramped for use, or else, owing to a scanty

attendance, the forum should seem too large. The proportion of the forum should be 3:2, length to width. Its shape will then be oblong and its ground plan conveniently suited to the conditions of shows."[11]

Vitruvius' explanation for the fact that Italian *fora* are oblong is that gladiatorial games had traditionally been held inside them, suggesting that the oblong space of a forum was considered a natural one for displaying and watching gladiators.[12] Vitruvius also tells us that the space inside *fora*, in which gladiatorial combat took place, was called a "*spectacula*" (that is, "show place," or "looking place"). We may now turn to a detailed examination of the evidence for the provisions for spectators during gladiatorial shows in the *Forum Romanum* at Rome, which were wooden and of a temporary nature.

The Middle Republic

Maeniana. Vitruvius (in the passage cited) says that *maeniana superiora*, or balconies, should be present in a forum so that spectators may utilize them during gladiatorial shows so as to "bring in some revenue (i.e. tickets were charged)."[13] Vitruvius' use of the term *maeniana* is important for our purposes, because this was the word regularly used in literary and epigraphical sources for the tiers of seats in monumental stone amphitheatres.[14] The origin of the term is explained by the ancient authors in two different ways. Two scholiasts of late antique date tell us that the name comes from a certain Maenius who lived in the early second-century BC. We hear from Pseudo-Asconius (an anonymous scholiast on Cicero) of one Maenius, who sold his house in the Forum to both M. Porcius Cato and L. Valerius Flaccus,[15] the censors, so that a basilica might be built there (the *Basilica Porcia* of 184 BC, located in the northwest sector of the Forum; see Figure 9): "Maenius took the right for himself of a single column, above which he extended a roof out of sliding planks [probably a cantilevered balcony] from where he himself and his descendants could watch gladiatorial games, which even then were given in the Forum."[16] Similarly, Porphyrius, a scholiast on Horace, says "It is told that, having sold his house which faced the Forum, he reserved a single column from which he could watch the gladiators, and from this the column of Maenius was named."[17]

Another, different origin for the name is indicated by three encyclopedic authors of late antique date. Festus, a fourth-century writer who composed a Summary of Roman History that drew extensively on earlier authors, especially Livy, tells us that the word *maeniana*, meaning tiers of seating in amphitheatres, was originally derived from the name of Maenius the censor.

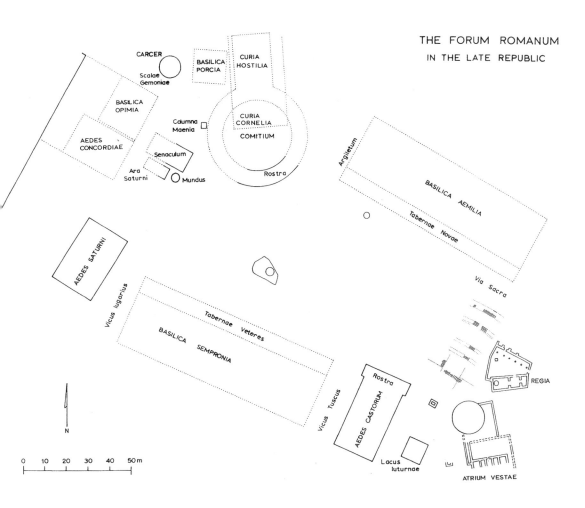

THE FORUM ROMANUM
IN THE LATE REPUBLIC

He means the famous C. Maenius who was consul in 338 BC, censor in 318 BC, conqueror of the Volsci at the Battle of Antium, and who – in his capacity as censor – was responsible for a major transformation of the northwest sector of the Forum, comprising monuments that commemorated his military victory: the Rostra decorated with the beaks of the ships captured at Antium, an equestrian statue of himself, and the *Columna Maenia*, or Maenian column, atop which stood another statue of the same conqueror.[18] Festus's exact words are "They are called *maeniana* for Maenius the censor who was the first to extend wooden beams in the Forum beyond the columns so that the upper *spectacula* could be enlarged."[19] This statement suggests again that the wooden seating arrangement in the Forum was known as "*spectacula*" (meaning "the show place") and that it extended relatively high up (he refers to "upper spectacula"). Note that this name emphasizes not the form of the structure but its function, as a place for people to

9. The *Forum Romanum* as it might have appeared in the time of Sulla (adapted from H. Broise, M. David, *Architecture et société* [*MEFRA*, 1983] 244.) (Note: depiction of *Comitium* area, based on Coarelli 1983, *Foro Romano*, fig. 39, is controversial; compare Carafa.)

watch the games. Another author, Isidore, whose encyclopedic work *Origines* drew extensively on earlier works, attributes the invention of *maeniana* to the same C. Maenius: "Maenius, colleague of Crassus, projected timbers in the Forum, so that there would be places where the spectators could stand, and from his name they came to be called *maeniana*."[20] Notice that the author specifies that the spectators would stand, as opposed to sit, on these balconies (a point that will be discussed later). A final author, Marcellus Nonius, says much the same thing: "*Maeniana* are named after their inventor Maenius; from the same man comes the name *Columna Maenia*."[21]

These passages, which have been extensively debated by scholars, indicate that confusion existed in antiquity about the exact derivation of the term *maeniana*. As we have seen, the confusion springs from the fact that the creation of these balconies for viewing gladiatorial games in the Forum is either attributed to C. Maenius the consul of 338 BC (according to the three antiquarian sources) or (according to the two scholiasts) to his descendant, the Maenius, who sold his house to M. Porcius Cato so that the latter could build the *Basilica Porcia* (184 BC) on the spot.[22] It should be noted that the antiquarian sources that ascribe the *maeniana* to C. Maenius, consul in 338 BC, are generally more reliable than the scholiastic sources that accredit them to the Maenius who lived in the second century BC. This fact led Ch. Hülsen and others to attempt to solve the confusion by dismissing the scholiastic tradition as false altogether.[23] Others have accepted the scholiastic tradition and have proposed that there were two Maenian columns: the first being the one erected by Maenius in the late fourth century BC, and the second being the one associated with the *Basilica Porcia* of 184 BC and reserved for the *Maenii* as their spot for viewing gladiatorial games in the Forum from a balcony, cantilevered from the upper story of that Basilica.[24]

If we accept the testimony of Festus, Isidore, and Marcellus Nonius (that *maeniana* were invented by C. Maenius, consul in 338 BC) this might suggest that gladiatorial games were taking place in the *Forum Romanum* as early as the fourth century BC. Although not impossible, this scenario does contradict the testimony of Livy and other authors (see Chapter One) that gladiatorial games were first sponsored at Rome in 264 BC. Can we resolve this contradiction? Probably not. One possibility is that at this early date the balconies were used for watching the triumphal procession, which passed through the Forum (see Plutarch *Vit. Aem.* 32.1). But perhaps the question of whether *maeniana* existed already in the fourth century BC or whether they were invented in the early second century BC is not so very pressing. What is significant for us is the following. First, *maeniana*, or viewing balconies, existed in the *Forum Romanum* at least as early as 184 BC, the year that Cato the Elder purchased the ancestral *domus* of the *gens Maenia* so that he could use the plot of land to build his *Basilica Porcia*. Second, gladiatorial games in the Forum had become sufficiently important by 184 BC

(or even earlier) for provisions to be taken to provide extra viewing space for spectators, in the form of wooden balconies on which people could stand.

In the second century BC, then, in the context of gladiatorial spectacles, *maeniana* were cantilevered out over the columns of the upper floors of the basilicas that lined the *Forum Romanum* (the *Porcia* of 184 BC, and presumably the *Basilica Aemilia et Fulvia* of 179 BC, and the *Basilica Sempronia* of 170 BC), and certainly also of the second stories of the *tabernae* that flanked the facades of the basilicas (see Fig. 9). We have evidence that the *Tabernae Veteres*, in front of the *Basilica Sempronia*, were outfitted with *maeniana*, as were the *Tabernae Novae*, in front of the *Basilica Aemilia et Fulvia*.[25] These practices in Rome explain Vitruvius' recommendation (5.1.1, see previously) that Italian *fora* be equipped with "*maeniana superiora*" for gladiatorial spectacles. And indeed, in the second century BC, following innovations in Rome, colonies such as Cosa began not only to surround their *fora* with colonnades but also to build basilicas adjoining them.[26] And as epigraphical evidence indicates, *maeniana* were cantilevered above such colonnades in imitation of practices in the mother city. An inscription of republican date, probably from Aeclanum in Campania, describes the erection of "*maeniana in foro*": *M. Palius M. f. IIII vir i(ure) d(icundo) d(e) s(enatus) s(ententia) porticum quom maenianei(s) in foro et fornic[em] qua in foro eitu[r] f(aciendum) c(uravit) i(dem)q(ue) p(robavit)*.[27] "Marcus Palius, son of Marcus, IIII vir, for administering the law, had constructed by vote of the senate a portico with *maeniana* in the forum and an arch through which one went into the forum, and he also approved the work."

· A final point about *maeniana* may be made. As we have seen, the first gladiatorial game that we hear of in the Roman Forum is that associated with the funeral of M. Aemilius Lepidus in 216 BC.[28] At this early date, the great basilicas that lined the Forum did not yet exist; they were built in 179 (*Aemilia*) and in 170 (*Sempronia*). The *Forum Romanum* was at that time surrounded by elite atrium houses, probably with *tabernae* integrated into the façades of the *domus*, looking much like the houses in Osco-Samnite Pompeii and second-century BC Cosa and Fregellae.[29] Any *maeniana* used for gladiatorial shows during this period would presumably have been balconies cantilevered from the upper parts of the facades of the houses above the *tabernae*. Such *maeniana* in this period would presumably have served as privileged "balcony seats" for the owners of the houses (and their friends and clients) at the time of the gladiatorial games or could have been rented out to the sponsors of the games to use as they saw fit.[30] Beyond the existence of *maeniana*, we can only guess as to what other physical arrangements were made in the Forum for gladiatorial spectacles during the middle-republican period. For the late Republic, however, we have considerably more evidence.

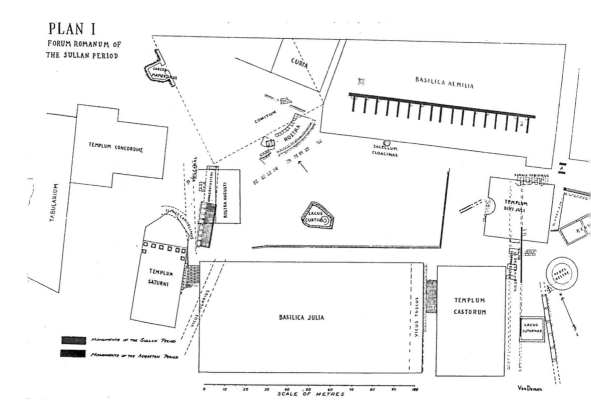

PLAN I
FORUM ROMANUM OF
THE SULLAN PERIOD

10. Plan of
Forum Romanum
showing location
of pozzetti in
front of
Republican *Rostra*
(E. B. Van
Deman, "The
Sullan Forum"
JRS 12 [1922]
fig. 1).

The "Pozzetti" in the *Forum Romanum*. Before moving on to a discussion of the evidence for spectator seating in the *Forum Romanum* in the late republican period, we shall discuss a feature that some have connected with spectator seating for gladiatorial games in the Roman Forum, but which now is thought to pertain to something very different: the "pozzetti," or pits, that line the Forum square. Dating to the second century BC, they measure c. 1 m² and 1 m deep and are equipped with travertine curbs.[31] Rows of pozzetti have been found in the following locations: (1) in front of the facade of the Republican *Rostra* (Figure 10), (2) under the paved street just north of the *Basilica Julia*, and (3) at the edge of the republican structure under the temple of *Divus Iulius*.[32] The north side of the Forum, which is still unexplored, probably had a row of them as well.

It was once thought that they might have been employed to support either the wooden seating or the *vela* (awnings) used during gladiatorial games. They have been more plausibly explained by F. Coarelli and others, however, as being connected with a *templum*, or temporary voting enclosure, that was used during the voting of the *comitia tributa*, at the point when this body had been moved from the actual *Comitium* into the central part of the

Forum.[33] Cicero and Varro attribute this change to C. Licinius Crassus, tribune of the plebs in 145 BC,[34] whereas Plutarch gives the responsibility to Gaius Gracchus.[35] As Coarelli interprets it, the *comitia tributa* (legislative assembly of the *tribus*, which involved voting) was transferred here in 145 BC by C. Licinius Crassus, which would explain Varro's statement that Crassus moved the meetings of the *comitia tributa* out of the *Comitium* and into the *"saepta iugera forensia."*[36] The transformation of most of the area of the Forum into a political space explains the presence of "pozzetti," because these held the posts that marked out the *templum* (sacred space) in which the popular assembly met and voted. A series of the same kind of pits exists in the forum at Fregellae (Roman colony of 123 BC), where Coarelli has apparently found evidence that they supported rows of screen walls that segregated the voters into different groups during the election process. Other examples of such pits have been found at Cosa, where a row of

11. Plan of forum at Cosa, second century BC (F. Brown, *Cosa: The Making of a Roman Town* [Ann Arbor, MI, 1980] fig. 37).

pozzetti follows the perimeter of the southern half of the Forum (Figure 11).[37] Thus, the "pozzetti" in the *Forum Romanum* should not be seen as directly relevant to gladiatorial games. They do illustrate, however, what an important role the Forum played in the lives of not only the elite but also ordinary Romans during the republican period. For, in addition to being the place where the people watched gladiatorial games during the *ludi funebres*, the Forum was a politically charged place where the duties and privileges of Roman citizenship were enacted.[38]

The Late Republic

Cicero in his *Pro Sestio* provides some information about the physical provisions for gladiatorial games in the *Forum Romanum* during the late republican period, when he describes the entrance of his defendant into the Forum during a gladiatorial spectacle that took place in 54 BC:

> It was the kind of show which is attended by crowds of all classes in great numbers, and which has a special charm for the masses. Into that crowd of spectators came P. Sestius, tribune of the plebs, who was wholly devoted to my cause during his term of office. He came and showed himself to the people...he came, as you know, from the Maenian column [at the northwest corner of the *Forum Romanum*]. All at once from all the spectators' seats (*ex omnibus spectaculis*) right down from the Capitol and from all the barriers *(cancellis)* of the Forum there were heard such shouts of applause that it was said that the whole Roman people had never shown greater nor more manifest unanimity in any cause... But that praetor [Ap. Claudius Pulcher, praet. 57, cos. 54]...although he was present every day at the gladiatorial games, was never seen when he came. He used to creep up underneath the floorboards and appear all of a sudden (*emergebat subito, cum sub tabulas subrepserat...*). And so that hidden way by which Appius came to his seat began to be called the Appian Way.[39]

This passage indicates that the structure was made of wood, that it had seats, and that there was a way for an important Roman to get to his seat without being seen by the crowd, probably by means of substructures at ground level under the seating. When we move to the 40s BC and explore Julius Caesar's provisions for the gladiatorial games he put on in the context of his quadruple triumph of 46 BC, we are even better informed.

The *Hypogea* in the *Forum Romanum* and Caesar's "Cynegetic Theatre." An intricate network of subterranean galleries, or *hypogea* (also referred to as *cuniculi*) was constructed in the *Forum Romanum* sometime during the first century BC (Figure 12). These consisted of a central corridor

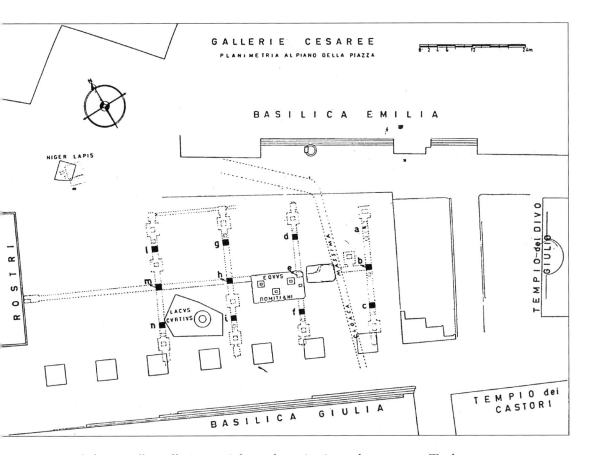

GALLERIE CESAREE
PLANIMETRIA AL PIANO DELLA PIAZZA

BASILICA EMILIA

NIGER LAPIS

ROSTRI

TEMPIO del DIVO GIULIO

g

d

a

b

h

m

EQVVS
DOMITIANI

n

LACVS
CVRTIVS

i

f

c

BASILICA GIULIA

TEMPIO dei CASTORI

with four smaller galleries, at right angles to it, situated 15 m apart. Twelve vertical shafts (whose curbs are still visible), each measuring 1.2 m², connect this underground passage with the ground level above. The shafts were covered over and put out of use when the Forum was re-paved under Augustus.[40] When this subterranean network was excavated between 1901 and 1904 by G. Boni, the wooden armature for a winch system at the bottom of the shafts was still visible (Figure 13). This winch system and the fact that the subterranean galleries are so extensive and deep (they extend 3.5 m below the pavement level) make it unlikely that it was used for drainage of the Roman Forum (which anyway had the benefit of the *Cloaca Maxima* running underneath it). Following an idea of Boni, G. Carettoni argued that the network of shafts and tunnels functioned as an "elevator" system for combatants to be propelled up into the Forum via the substructures from below when gladiatorial games were taking place there (Figure 14). In other words, the *hypogea* functioned as a 'backstage' for arena personnel during gladiatorial shows.

12. Plan of *hypogea* in the *Forum Romanum*. Dark squares show position of winches. (G. Carettoni, "Le gallerie ipogee del Foro Romano e i ludi gladiatori forensi" *Bull. Com. Arch.* 76 [1956–8], Tav. 1).

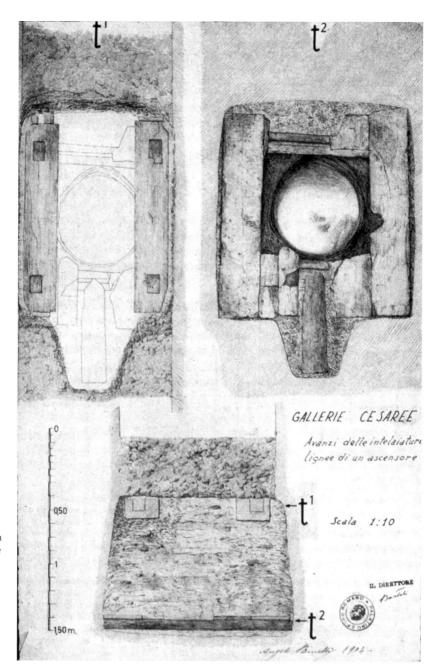

13. Wooden sockets for winch system of *hypogea* (G. Carettoni, "Le gallerie ipogee del Foro Romano e i ludi gladiatori forensi" *Bull. Com. Arch.* 76 1956–8).

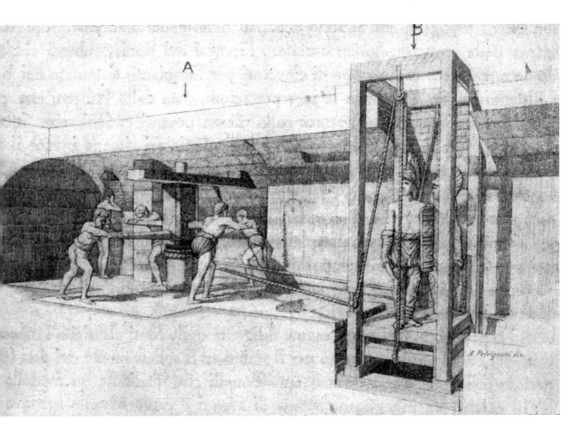

14. Workings of *hypogea* in the *Forum Romanum*, according to Carettoni (G. Carettoni, "Le gallerie ipogee del Foro Romano e i ludi gladiatori forensi" *Bull. Com. Arch.* [76] 1956–8).

Carettoni's interpretation, which has generally been accepted,[41] should be slightly revised. Rather than being for both gladiators and animal combatants, it is more likely that these "elevator" shafts were used only for the animals that took part in the *venatio* and the *damnatio ad bestias*. Indeed, this is precisely how the "elevators" encountered in the basements of imperial amphitheatres, e.g., the Colosseum and the imperial amphitheatre at Puteoli (Figures 15 and 16), were used. Gladiators typically entered the arena not from the basement structures but by means of *carceres* [starting gates] located at arena level at either side of the "Porta Triumphalis" at the major axis of an amphitheatre building.[42]

It is in Caesar's games that we first hear of animals being used during spectacles in the Forum. And it is likely that the *hypogea* were part of the provisions that Caesar made for his elaborate, "cynegetic," or hunting theatre, which he built, apparently in the Forum, in conjunction with his quadruple triumph of 46 BC, over Gaul, Egypt, Africa, and Pontus.[43] (This is the triumph during which a banner was carried with the famously laconic phrase *Veni vidi vici*. ["I came. I saw. I conquered."]). Cassius Dio describes Caesar's "cynegetic theater" as follows: "He built a kind of hunting-theatre

of wood, which was called an amphitheatre from the fact that it had seats all around without any stage. In honor of this and of his daughter [Julia, who had died eight years earlier, in 54 BC] he exhibited combats of wild beasts and gladiators . . . As for the men he not only pitted them one against another singly in the Forum, as was customary, but he also made them fight together in companies in the Circus, horseman against horsemen, men on foot against others on foot, and sometimes both kinds together in equal numbers."[44] We hear from Pliny that Caesar stretched awnings (*vela*) over the whole *Forum Romanum* when he gave a gladiatorial show there in 46 BC,[45] presumably the same show for which he built his "cynegetic theatre."

By the mid-first century BC, provisions for gladiatorial spectacles in the Roman Forum had evidently become quite elaborate. The mention of *vela*, in combination with the archaeological evidence for the *hypogea* (basement structures) in the *Forum Romanum*, and the passage in Cicero's *Pro Sestio* that describes a wooden construction equipped with seats and substructures indicate that by the time of Cicero and Caesar the seating arrangement in the Forum had assumed a degree of monumentality.[46] We may now move to an exploration of some further evidence for the shape and appearance of this seating construction.

15. Imperial amphitheatre at Puteoli, view of arena with basement structures (American Academy in Rome, Fototeca Unione 2630).

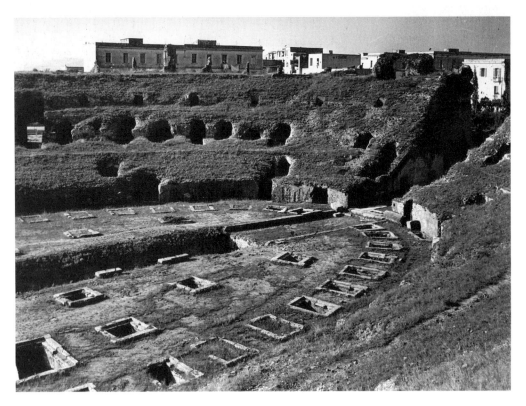

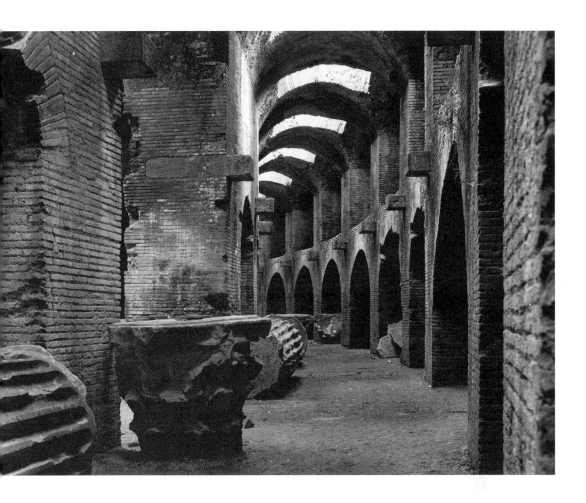

The Shape and Form of the Seating Construction ("*Spectacula*") in the *Forum Romanum*

16. Imperial amphitheatre at Puteoli, view of basement itself (American Academy in Rome, Fototeca Unione 2649).

It was first recognized by J.-C. Golvin (1988) that the oval shape of the monumental amphitheatre building may owe something to the oblong space of the *Forum Romanum*. Since these wooden structures in the *Forum Romanum* were erected and dismantled on a semiregular basis for gladiatorial shows, different seating arrangements may have been tried, until one was found that was best adapted in a formal sense to the irregular trapezoidal space between the two great basilicas (and previous structures) there. Golvin and the present author have attempted to reconstruct this seating arrangement.[47] The former reconstructs the wooden structure in the *Forum Romanum* as shown in Figure 17: straight runs of seats would have followed the line of

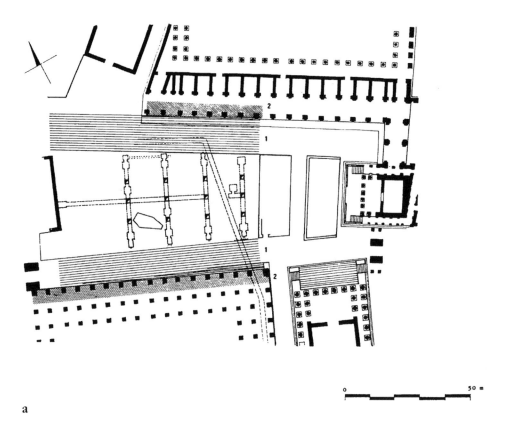

0 50 m

a

17a and 17b. Golvin's reconstructions of wooden seating arrangement in the *Forum Romanum* (Golvin 1988, fig. Vb; Golvin & Landes 1990 p. 59): a) with straight seats, and b) as a truncated stadium.

the basilicas (Figure 17a), perhaps ending in circular tribunes, rather like a truncated stadium (Figure 17b). But another shape may be preferable.

The arena (performance floor) of a wooden structure in the *Forum Romanum* such as that envisioned by Golvin (Figure 17) would have been quite long (c. 100 m in length as opposed to the arenas of most republican amphitheatres, which are considerably smaller; the arena at Pompeii, for example, is 67 m in length). It would also have been somewhat splayed (that is, wider at one end than at the other), a shape unattested in any known gladiatorial arena. In addition, there are practical problems with an arena of such a shape. The dimensions of an arena such as Golvin reconstructs would have resulted in a skewed viewpoint for spectators seated at the corners (not to mention an awkward performance space for a pair of gladiators).

Golvin's stadium-like reconstructions of the seating arrangement (Figure 17) are better suited to a space for the *venatio*, which Golvin says played a role in the evolution of the shape of the oval arena.[48] Now, the *venatio* was an essential ingredient of the arena repertoire under the Empire. But there is no evidence that beast shows ever took place in the *Forum Romanum* before the time of Caesar; indeed, the *Circus Maximus* was the

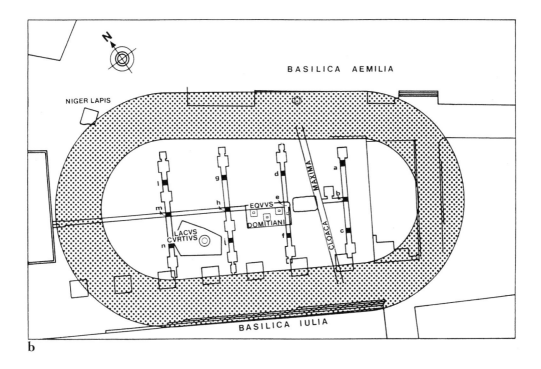

b

17b. (continued)

usual location for the *venatio* down to the reign of Nero.[49] The earliest recorded instance of animals performing in the *Forum Romanum* occurred during Caesar's quadruple triumph of 46 BC, as we have seen. A subsequent instance is recorded in a passage of Strabo describing an execution with wild beasts he himself witnessed in the *Forum Romanum* in the 30s BC.[50] Finally, Augustus himself records that he gave *venationes . . . in circo aut in foro aut in amphitheatris*.[51] This evidence suggests that the *Forum Romanum* was used for *venationes* only for a short time, beginning in 46 BC until the Forum was paved over (ca. 7 BC) and the *hypogea* covered and put out of use in the reign of Augustus. Gladiatorial games had been given in the Roman Forum at least as early as 216 BC, that is, for well over a century and a half before *venationes* began to be staged in the Forum. The wooden seating in the Forum should, then, have evolved to suit the requirements of gladiatorial combat *per se*, not the *venatio*.

Golvin suggests that the elongated space was well suited to a variety of gladiatorial combats taking place simultaneously. There is no evidence, however, that multiple pairs of gladiators fought at the same time in the Roman arena during the republican period.[52] They fought in individual pairs. Indeed, the passage in Cassius Dio, discussing Caesar's games of 46 BC, explicitly states that single combat had been the norm before the innovations of Caesar: "As for the men, he not only pitted them one against

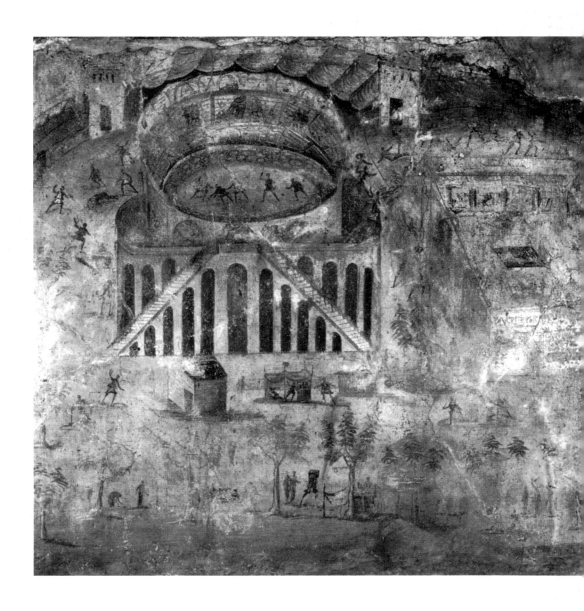

18. Painting of amphitheatre riot, Pompeii, House I iii 23 (H. Eschebach, *Pompeji* [Leipzig, 1978]). (See color Plate 4 in this text.)

another singly in the Forum, as was customary, but he also made them fight together in companies in the Circus."[53] The painting of the amphitheatre riot at Pompeii (Figure 18 and Plate 4) is sometimes said to show multiple pairs of gladiators. But in fact it shows spectators (Pompeians and Nucerians) running about both inside and outside the amphitheatre because a riot is taking place.[54] The shape of the wooden structure in the Forum cannot, therefore, be explained in terms of performance requirements involving multiple combatants – human or animal.

Golvin proposes that the shape of the Forum structure is reflected in the plan of the early first-century AD amphitheatre at Cherchel (Caesarea) in Mauretania, North Africa (Figure 19), built by the Roman client King Juba II (reigned 24 BC–AD 23).[55] The Cherchel amphitheatre has straight sides with curved ends and resembles a short stadium. However, the arena (that is, the performance floor), is c. 100 m in length and is too long for gladiatorial combat and too short for running laps in a stadium (the *dromos* of which was normally 600 ft long, or about 190 m). The Cherchel experiment was apparently not very successful, because it was never tried again as far as we know. It is unlikely that the shape of the arena at Cherchel was a reflection of the "*spectacula*" in the Forum, as Golvin suggests; if it had been, we would expect to see more amphitheatres with straight sides and curved ends that resemble the one at Cherchel.[56] We may suggest a better interpretation of the unusual structure at Cherchel: its odd shape seems to be an architectural compromise between the Greek stadium and the Roman amphitheatre, conceived by a Hellenized king with a Roman agenda.[57]

The most serious difficulty with Golvin's reconstruction is that it shows the *Forum Romanum* after it had been regularized with the building of the *Basilica Paulli* (also known as *Aemilia*) on the north side of the Forum by L. Aemilius Paullus, completed in 55–54 BC, the *Basilica Julia* on the south side by Julius Caesar, begun in 54 and dedicated in 46 BC, and the *Rostra Caesaris* on the west side, erected in 44 BC.[58] Archaeology indicates that

19. Cherchel: plan of amphitheatre (Golvin 1988 pl. XXIX, 1.)

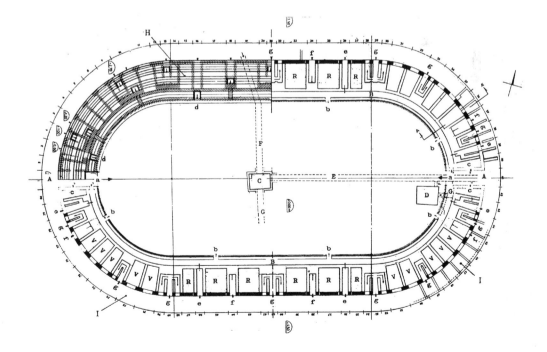

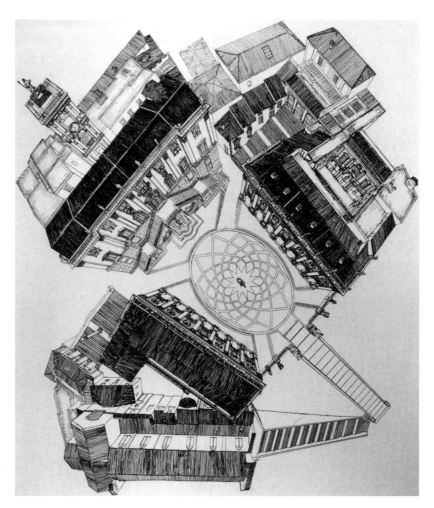

20.
Campidoglio,
Rome (from the
original etching
by J. H. Aronson,
courtesy of the
artist).

before this period the open space of the Forum was at least 10 m wider,
being flanked by the *Basilica Aemilia et Fulvia* built in 179 BC and the *Basilica
Sempronia* built in 170 BC (Figure 9).[59] That is, in the period when the ear-
liest securely dated stone amphitheatre appears (the one at Pompeii, which
dates to c. 70 BC; see Chapter Three), the Forum was a considerably more
open, irregular area, in which a building shaped like a truncated stadium
(Figure 17b), such as Golvin proposes, would make little sense. However,
even after the Forum space had been "tightened" during the age of Caesar,
Golvin's splayed structure would still have had a trapezoidally shaped arena,
which would have resulted in a skewed viewpoint for those seated in the cor-
ners. It would also have been a less than ideal solution for Roman architects,
who favored spaces symmetrical on at least two axes. Moreover, a truncated
stadium with straight, parallel sides (such as is found in the amphitheatre at
Cherchel) placed inside the trapezoidally shaped *Forum Romanum* would in

plan have resulted in awkward slivers of space at the edge of the structure. Clearly, alternative shapes need to be considered.

A circular structure, such as the Spanish *corrida*, would have been an ideal space in terms of all the spectators getting a good view of the show. But egalitarian seating arrangements were never a Roman concern (seating was hierarchically organized, with the senatorial and equestrian classes occupying the best seats).[60] Nor would a circular structure have maximized the available viewing space for gladiatorial spectacles inside the Forum. Another reason that a circular shape is unlikely to have been chosen is that the Romans evidently already had a circular building type – the *Comitium*.[61]

The only sensible shape for the temporary wooden structures erected inside the *Forum Romanum* for gladiatorial shows is an oval. Indeed, an oval is the only shape that can give the impression of a designed relationship in an irregular, trapezoidal space such as the *Forum Romanum*. As an analogy, we may point to Michelangelo's elliptical pavement in the trapezoidally shaped Campidoglio piazza in Rome (Figure 20 and Plate 5); here an oval shape was chosen instead of a circle, precisely to avoid formal conflict.[62] If one superimposes a plan of an oval amphitheatre with an arena (performance floor) of exactly the same dimensions as the arena at Pompeii of c. 70 BC (67 × 35 m) onto plans of the *Forum Romanum* in the second century (Figure 21),

21. Author's reconstruction of the shape of the wooden seating arrangement ("*spectacula*") in the *Forum Romanum* (drawing, P. Stinson). (Note: plan of *Comitium* area, based upon Coarelli, 1983, fig. 39, is controversial.)

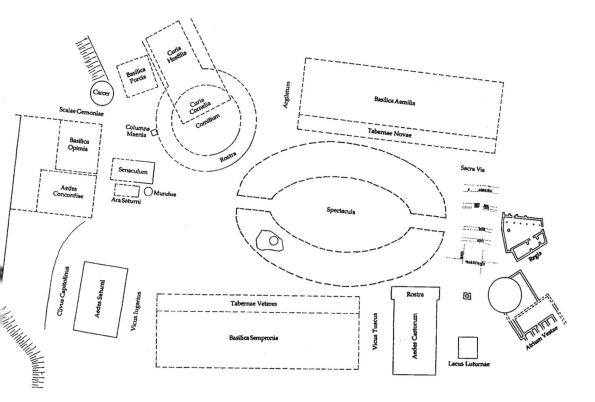

the result is not only proportionally more harmonious but also a space better suited to the performance requirements of single combat.[63] The visually dynamic shape of the elliptical arena would have encouraged a pair of fighters to keep to the center of the performance space, where they could be admired from all sides by spectators in all parts of the wooden structure. In an arena with seating arranged around it in an oval shape, the gladiatorial combat, steadily turning on itself, would have been continuously visible to the whole audience. Moreover, a seating arrangement in this shape would have provided the 'commanding' axes that the Roman elite required when they were seated in public. Spectators seated at the minor axis of such a structure would have a better view of the combat taking place in the center of the arena, and they themselves would become the natural visual focus of the entire audience when combats were not taking place (that is, before the spectacle began and in between the individual pairs of gladiators). This spot is precisely where the *tribunalia*, or seats for the most important people, including the emperor, were located in later, monumental amphitheatre buildings.

One critical text supports the idea that the shape of the temporary wooden arenas in the *Forum Romanum* was oval. Plutarch mentions an occasion in 123 BC when the people were going to enjoy "an exhibition of gladiators in the *Forum Romanum*" (μονομάχους ἐν ἀγορᾷ). On this occasion, Gaius Gracchus incurred the enmity of his fellow aristocrats in the following way. "The magistrates had constructed seats for the show in a circle, and were offering them for hire."[64] Gracchus had the seats pulled down so that the plebs could see the show without paying. This passage (which actually goes back to a source of the Gracchan period[65]) suggests that the wooden seating was arranged so that it formed a curvilinear enclosure, presumably – given the oblong shape of the Forum – of roughly oval shape. That the word κύκλος in Plutarch refers to an oval seating plan is supported by the fact that Cassius Dio uses the word κύκλος to describe the oval auditorium of the Flavian Amphitheatre (Colosseum).[66] Note also that this passage in Plutarch indicates that as early as 123 BC the wooden structure in the Roman Forum was already in certain cases substantial enough in size that one could not see the show unless one were sitting inside it.

The passage in Plutarch suggests that the *spectacula* in the Roman Forum had assumed an oval shape by 123 BC. It is, however, unclear whether the oval shape of the seating was mandated by the configuration of the two great basilicas, or whether these basilicas were laid out in the way they were because the wooden seating had already assumed a roughly oval form by the 180s–170s, when they were first built. Vitruvius's explanation for the oblong shape of the Italic forum – that it derived from the practice of staging gladiatorial games in *fora* – might support the latter interpretation.[67] (But of course, italic fora were themselves modelled on the *Forum Romanum*,

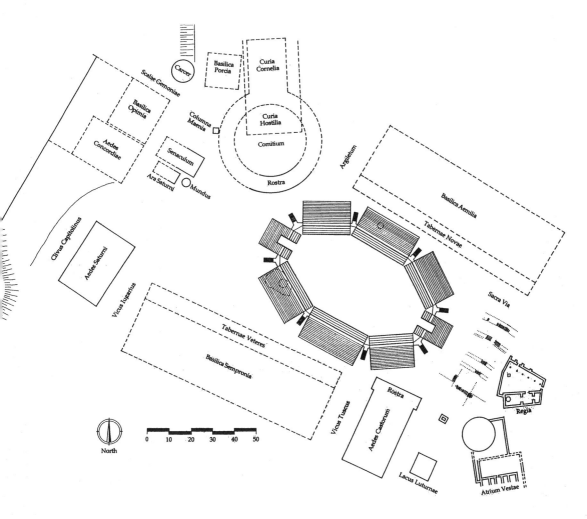

which because of natural geological features, was oblong and irregular in its contours.)

From the above evidence, it is possible to give some idea of the appearance of the temporary wooden *spectacula* in the *Forum Romanum*. Figures 22 to 30 illustrate a series of hypothetical wooden structures in the Forum, whose *caveae* differ in complexity but whose critical dimension, the size and shape of the oval arena, is the same (67 × 35 m, as at Pompeii). Figure 21 to 26 provide different possible reconstructions (with section and perspectival view) of wooden *spectacula* in the Forum as they existed before Caesar's additions, that is, for most of the period that the Forum was being used for gladiatorial games (third century to mid-first century BC). Figures 27 to 30 provide a similar set of drawings that give possible reconstructions, more or less elaborate, of amphitheatres in the Roman Forum after the additions of the mid-first century BC, that is, in the second architectural phase of its

22. Possible reconstruction of wooden seating arrangement in the *Forum Romanum* with seating built in straight sections, second century BC (drawing, P. Stinson).

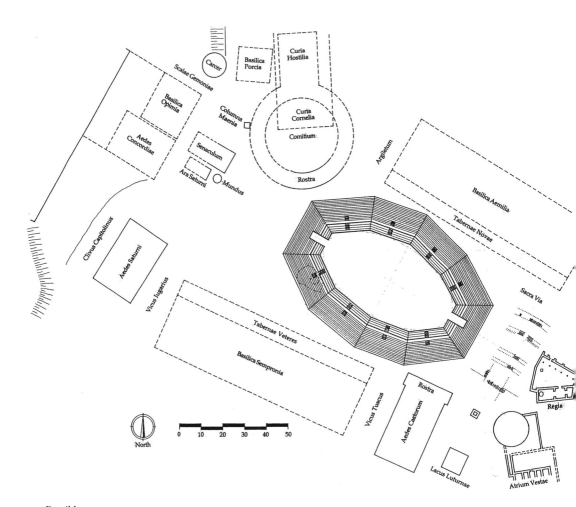

23. Possible reconstruction of wooden seating arrangement in the *Forum Romanum* with integrated seating blocks, second century BC (drawing, P. Stinson).

use for gladiatorial games (mid- to late-first century BC). In the later phase (Figure 27), note how the *hypogea* (basement structures with their curb stones discussed earlier) beneath the surface of the Forum fit nicely inside an arena of exactly the same size as that of the amphitheatre at Pompeii. The resulting plan is strikingly similar to the arrangement of basement structures in later monumental amphitheatres, such as the imperial amphitheatre at Puteoli (Figure 31). We may suggest that the plan of the *Ludus Magnus* (gladiatorial training school), which was built in conjunction with the Colosseum in the Flavian period and which has an oval arena inside a rectangular enclosure of several stories (Figures 32 and 33), is a later reflection (in concrete) of the plan of the original, oval *spectacula* in the *Forum Romanum*.[68]

In my reconstructions, the wooden armature supporting the seating would have been built over the *Lacus Curtius* (Figure 21).[69] It is worth asking: would the Romans have covered a sacred monument such as this,

even on a temporary basis? That this would not have been considered inappropriate is indicated, for example, by the *Niger Lapis* and its altar (probably an archaic shrine to Vulcan), which were paved over permanently (but still marked out as a place of veneration by a stone curb) probably in the Caesarian period.[70] In my reconstruction, the *Lacus Curtius* is at least protected by the seating of the *cavea* itself.[71] In Golvin's reconstructions (Figure 17), it lies inside the arena itself. It is difficult to imagine pairs of gladiators (*perditi homines*, as Cicero calls them[72]) being allowed to spill their blood anywhere near this hallowed monument.

The greater width of the Roman Forum in its pre-Caesarian phase would have allowed for a greater seating capacity during gladiatorial spectacles. Allowing for 0.40 m² of seating space per person (that is, 2.5 individual places per meter of seating), it may be estimated that the earlier structure in the Forum in its most elaborate form could have seated up to 15,000 spectators (the same seating capacity as that for the Theatre of Pompey), but the

24. Possible reconstruction of wooden seating arrangement in the *Forum Romanum* with most advanced arrangement of seating blocks, approximating a true oval, second century BC (drawing, P. Stinson).

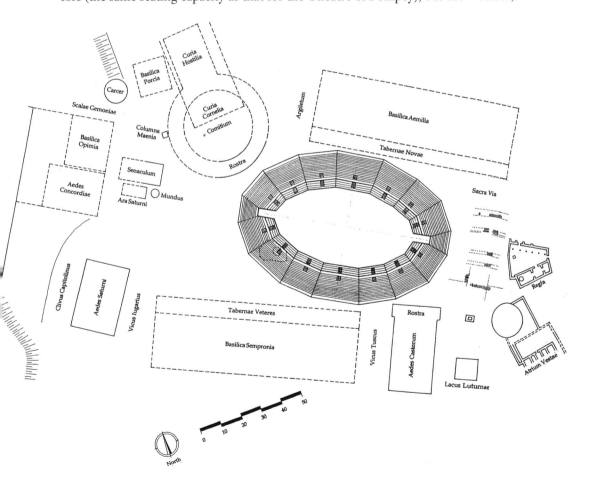

later structure could have held only about 10,000.[73] Only a small fraction, therefore, of the population of republican Rome could have attended gladiatorial games in the *Forum Romanum*,[74] suggesting that attendance was a rather exclusive affair. Cicero in fact tells us that wealthy Romans controlled access to the games given by others of their number by handing out passes to their clientele. These well-to-do Romans, in turn, received sections of seating from higher ranking Roman magistrates who gave them to family, friends, and close colleagues.[75] Romans who lacked connections could only have access to seating at gladiatorial games by paying a substantial amount of money.[76] A less expensive option than a seat may have been a standing position on one of the *maeniana* attached to the great basilicas surrounding the Forum square, where the spectators were high up and the view, therefore, was not as good.[77] The relatively small seating capacity of the *spectacula* in the Forum (which was perforce further reduced in the mid-first century BC) was surely one of the reasons that gladiatorial games ceased being given in the *Forum Romanum*, early in the reign of Augustus, who pursued a policy of entertainment on a grander and more popular scale.[78]

Why would the Romans have bothered building and dismantling such an elaborate structure in the *Forum Romanum* on a regular basis instead of constructing a permanent structure for gladiatorial games, such as was eventually built in 30 BC (namely, the Amphitheatre of Statilius Taurus, discussed in Chapter Four)? First, during the republican period there was an aristocratic prohibition against permanent spectator buildings in the city of Rome.[79] More important, however, was not only the location of the wooden structure in the *Forum Romanum*, the political heart of republican Rome, where the people voted and passed laws, but also the location of aristocratic funeral ceremonies of which gladiatorial combat had traditionally been a part.[80] The lack of a permanent amphitheatre in Rome until Augustus' reign is not connected with the kind of moral prohibitions that were applied to the theatre. Theatre spectacles were alleged to be enervating and corrupting, while the gladiatorial combat that took place in the Forum was thought to harden people to pain and death and to promote military

25. Possible section through wooden seating arrangement in the *Forum Romanum*, second century BC (drawing, P. Stinson).

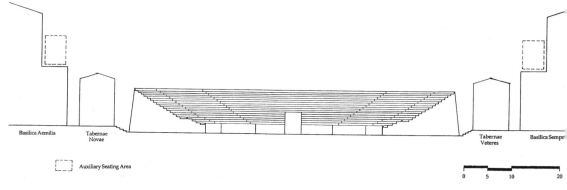

Basilica Aemilia Tabernae Novae Tabernae Veteres Basilica Sempr

☐ Auxiliary Seating Area

0 5 10 20

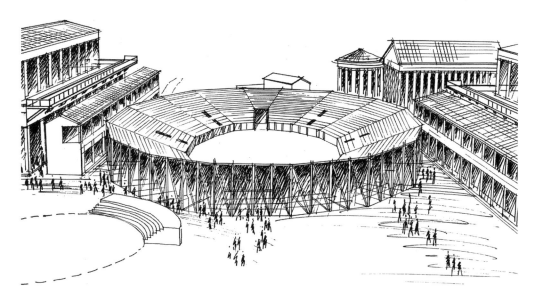

discipline.[81] No moral stigma was attached to gladiatorial entertainment.[82] The impermanence of the earliest arenas in the Forum is less the result of moral policing than of force of conservative habit. The conspicuous location of the *spectacula* in the center of the city in the *Forum Romanum* – and the willingness of the ruling class to disrupt the regular business in the Forum when the games took place, and beforehand when the *spectacula* was being constructed – speak for the important position of gladiatorial games in Roman society.[83] The situation is roughly comparable to the idea of football games being regularly held in the capital of the United States at Washington, D.C. on the Mall, between the Capitol Building and the Lincoln Memorial (and in addition gladiatorial combats had the further poignancy of being religious events as part of aristocratic funeral games).

26. Conjectural perspectival view of wooden seating arrangement in the *Forum Romanum*, second century BC with wooden balconies (*maeniana*). Note: numismatic evidence suggests that the circular Temple of Vesta was probably not yet a columnar tholos at this point but a more 'primitive' circular structure. (drawing, P. Stinson).

Constructional Aspects of the *Spectacula* in the *Forum Romanum*

We may suggest the following scenario for the construction of a wooden *spectacula* in the *Forum Romanum*. The *cavea* of such a temporary wooden structure could have been supported by a trusslike system of wooden beams (Figure 34). The essential building blocks of the amphitheatre would have been timber frames, which could have been assembled in straight sections with additional framing at the angles. The structure could have been more or less intricate depending on how much money and time were spent on its construction. For the most advanced structure as many as forty to fifty wooden frames would have been necessary. The joinery between the

wooden members could have consisted of simple mortise and tenon con-
nections. Lateral bracing would have been important, because it would have
held the frames steady during sudden movements of the crowd above. Such
lateral bracing between the frames could have been provided by logs, tied
into place.

The construction process of these frames could have taken place in the
Forum Romanum itself, but it may have been more convenient to assemble
the frames partially in another large, open space (such as either the *Forum
Boarium* or the *Circus Maximus*) so as to interrupt regular activities in the
Forum for as little a time as possible. A week or so before the scheduled glad-
iatorial events, the process of constructing the frames would have begun.
The Forum itself could also have been prepared at this time, with surveyors
and building contractors establishing the future placement of the frames
on its pavement. A few days before the show, work crews would have begun
the actual construction in the Forum, a detailed schedule having been pre-
viously arranged for the placement of the frames and their erection, so as
not to overwhelm the space with too much building activity and too many
workmen at once. The frames would be brought into the Forum on carts
and, one at a time, methodically, would have been tilted up into position. As
the frames were erected, the lateral bracing would have been put into place.

27. Possible
reconstruction of
wooden seating
arrangement in
the *Forum
Romanum*,
mid-first century
BC; dotted lines
indicate auxiliary
seating areas
(drawing, P.
Stinson). (Note:
Temple of Divus
Julius and Curia
Julia both begun
44 BC and
dedicated in
29 BC; plan of
Temple of
Concord
controversial for
this period)

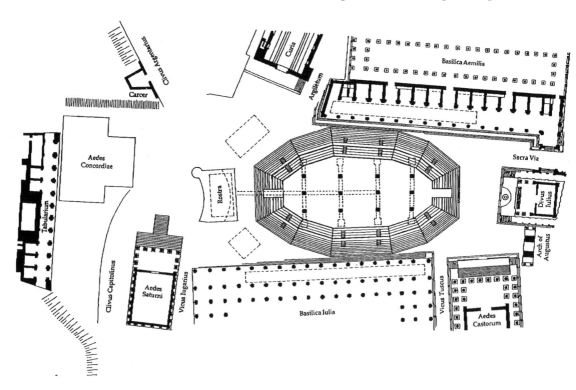

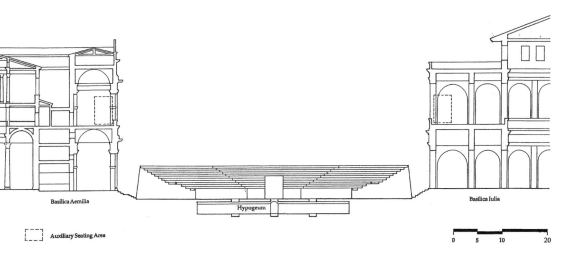

Basilica Aemilia

Hypogeum

Basilica Iulia

Auxiliary Seating Area

0 5 10 20

After the skeleton of wooden frames was completed, large work crews of carpenters (perhaps 500–1,000 men) would have descended on the Forum in order to put into place all the secondary framing necessary for seats, stairs for entrances and exits, railings, podium wall, safety barriers, nets, etc. The entire process would have taken from several days to one week depending on the number of frames used for a given gladiatorial show.[84]

On the day of the show, the spectators would have made their way to the Forum from the surrounding streets (Figure 35). They would then proceed into the wooden structure either by means of external staircases or (in particularly elaborate versions of the structure) via entrances in its substructures, which led to internal staircases issuing in *vomitoria* (points of egress to the *cavea*) from which people could find their seats in the stands. After several days of gladiatorial games, the wooden structure could have been dismantled relatively quickly, over the course of, perhaps, two to three days, and the political and business activities in the Forum would have resumed.

Some Later Comparanda. Temporary, wooden spectator buildings of later periods may serve to help visualize the architectural arrangements for gladiatorial games in the *Forum Romanum*. An idea of the section through the wooden cavea of one of these *spectacula* in the Forum may be gleaned by comparison with a theatre described and shown, in section, in Sebastiano Serlio's treatise on architecture (Figure 36).[85] This drawing was based on an actual theatre built in the "ancient style" by Serlio in Vicenza in 1539 and explained by him as follows:

> … the Proscenium is the part marked D. The part E, raised half a foot above ground level, represents the Orchestra. The seats for the most eminent nobles

28. Possible section through wooden seating arrangement in the *Forum Romanum*, mid-first century BC (basilica details highly controversial) (drawing, P. Stinson).

are where F can be seen. The first seating steps, marked G, should be for the noblest ladies; rising above these are the places for lesser noblewomen. The broader space at H and I is a walkway. The seating steps between these should be for noblemen. The large space marked K (which may be larger or smaller depending on the size of the place) should be for the common people. The theatre and stage which I built in Vicenza were more or less in this arrangement: from one horn of the theatre to the other was about eighty feet since it was built in a large courtyard where there was plenty of space, more in fact than there was in the place for the stage because the stage was constructed against a loggia. *The bracings and joints of the carpentry were done in the manner shown below, and since this theatre had no support of any kind, I decided for greater strength to build an escarpment in the outside circular wall.* [italics mine][86]

29. Conjectural perspectival view of wooden seating arrangement in the *Forum Romanum*, mid-first century BC with wooden balconies (*maeniana*) Note: numismatic evidence suggests that the circular Temple of Vesta was probably not yet a columnar tholos at this point but a more 'primitive' circular structure. (drawing, P. Stinson).

An example of an oval arena made of wood and situated in a rectangular space is provided by engravings of Jacques Callot that show two temporary, oval wooden arenas that were erected (at different times) in 1616 in Piazza Santa Croce in Florence (Figure 37) for the *Guerra d'Amore*, a performance staged as part of *Carnivale* by Cosimo II de' Medici for his wife.[87] This provides an evocative comparandum for both the shape and the appearance of the wooden structures erected for gladiatorial combat in the *Forum Romanum*.

Wooden Theatres. It is clear that the Romans had the technical skill to build a large and elaborate wooden structure in the Roman Forum during the republican period. Because of the aristocratic prohibition against building permanent spectator buildings in the republican period, mentioned

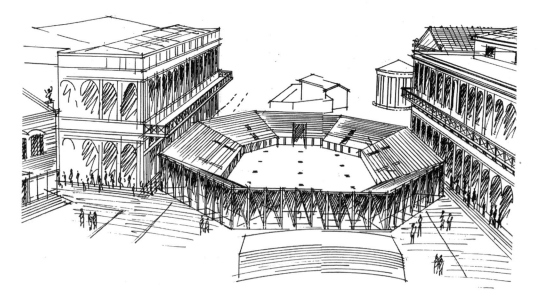

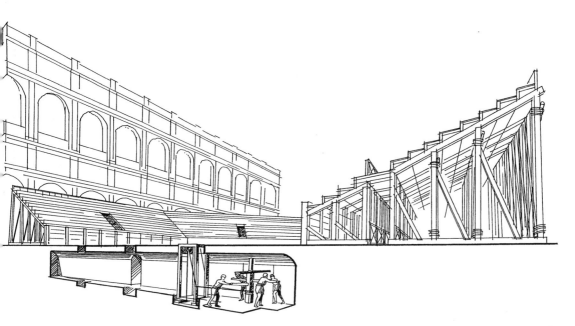

30. Conjectural perspectival view of wooden seating arrangement in the *Forum Romanum* showing *cavea* and basement structures (*hypogea* or "*cuniculi*"), mid-first century BC (drawing, P. Stinson).

earlier, Romans constructed temporary theatres every year for different festivals *(ludi)*, and as a result they became experts at wooden construction, as will be shown in the following.[88] Indeed, by the end of the republican period, Vitruvius could comment (in a typical tangential remark) that many wooden theatres are built every year in Rome and that the planning and building of these structures was one of the most significant activities of architects.[89] Some of the most innovative Greek-inspired aspects of design in Roman architecture (such as the use of colored marbles, broken pediments, stage buildings profligately outfitted with statuary [initially looted], etc.) were probably initially introduced in these theatres.

As early as 179 BC we hear that M. Aemilius Lepidus built a wooden *cavea* and stage near the Temple of Apollo in the approximate location where the Theatre of Marcellus was later erected.[90] In 174 BC the censors Q. Fulvius Flaccus and A. Postumius Albinus contracted for a *scaena* (stage) for the use of the aediles and the praetor, that is, the authorities in charge of the *ludi Romani, Plebeii, Megalenses,* and *Apollinares.*[91] With the multiplication of occasions for *ludi scaenici*, those responsible for putting on plays built ever finer and larger theatres. When the censors of 154 BC were nearly done building a permanent theatre on the Palatine for the *ludi Megalenses*, the Senate, at the insistence of P. Cornelius Scipio Nasica, decreed not only that the theatre should be demolished but also that the Roman people should henceforth watch their plays standing, lest they decline into Greek effeminacy.[92] It is doubtful that this stricture lasted very long, since we next hear of elaborate theatre construction when L. Licinius Crassus, the Orator,

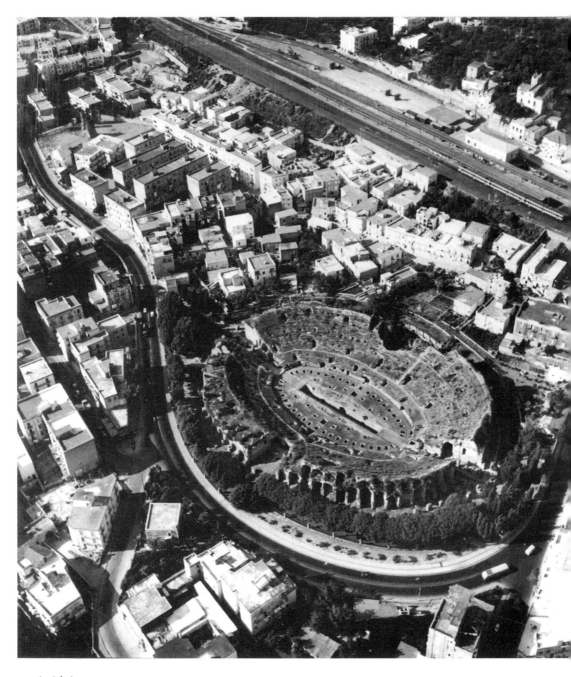

31. Aerial view
of the imperial
amphitheatre at
Puteoli
(American
Academy in
Rome, Fototeca
Unione 10535F).

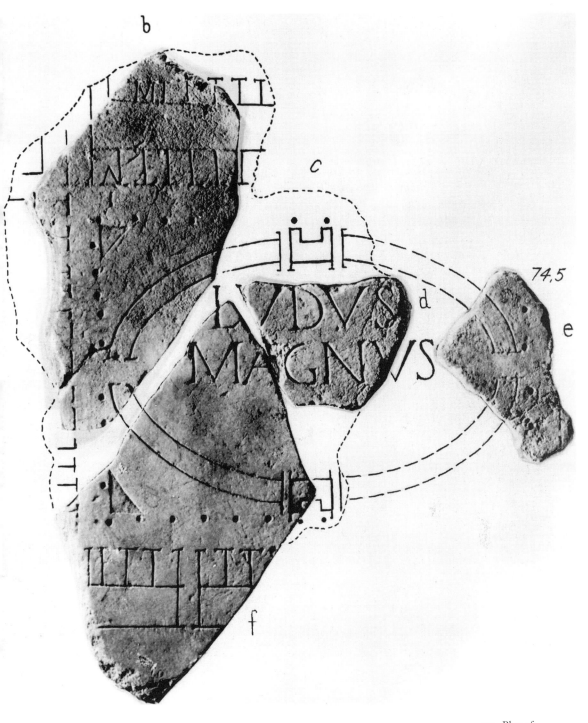

32. Plan of *Ludus Magnus*, Severan Marble Plan (American Academy in Rome, Fototeca Unione 5929).

as aedile between 105 and 100 BC, imported columns of Hymettian marble to adorn his temporary theatre.[93] According to Valerius Maximus, C. Claudius Pulcher (curule aedile in 99 BC) was the first to apply colors to the stage building, which had previously consisted of unpainted boards.[94] As praetor in 66 BC, C. Antonius lined the whole of his stage with silver, and in the 60s BC, Petreius outfitted a stage with gold; and Q. Catulus, with ivory.[95] In a passage describing the architectural marvels of the city of Rome, Pliny includes mention of a roofed wooden theatre built by an architect called Valerius of Ostia for the games of L. Scribonius Libo in 63 BC.[96]

It was not until 55 BC that Rome's first permanent theatre was constructed (the Theatre of Pompey in the *Campus Martius*).[97] Of this occasion, Tacitus says the following: "it had been a measure of economy when the theatre was housed in a permanent building instead of being erected and dismantled, year after year, at enormous expense."[98] Two of the temporary theatres that preceded the Theatre of Pompey were quite famous in antiquity, and the descriptions of them illustrate the high degree of technical virtuosity that had been reached in such wooden buildings during the late Republic.

33. Model of the *Ludus Magnus* in the Museo della Civiltà Romana (*D.A.I.* Rome neg. 73.999).

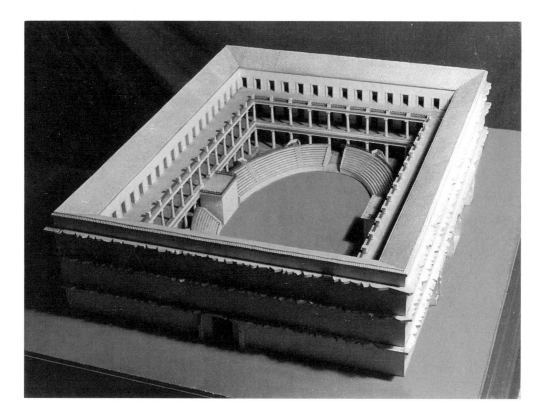

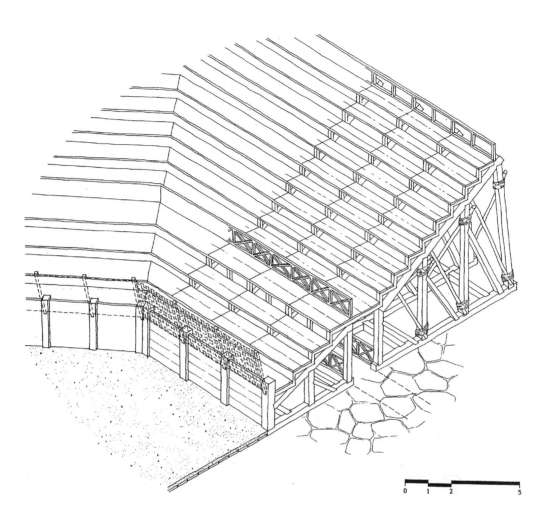

Pliny the Elder tells us of a (plausible) wooden theatre–amphitheatre built in 52 BC by C. Scribonius Curio (tribune, 50 BC) that consisted of two wooden halves that revolved on pivots. When separated they functioned as twin theatres. Pliny writes,

> He built close to each other two very large wooden theatres, each poised and balanced on a revolving pivot. During the morning, a performance of a play was given in both of them and they faced in opposite directions so that the two casts should not drown each other's words. Then all of a sudden the theatres revolved (and it is agreed that after the first few days they did so with some of the spectators actually remaining in their seats), their corners met, and thus Curio provided an amphitheatre in which he produced fights between gladiators.[99]

34. Conjectural isometric section through the wooden seating in the *Forum Romanum* showing *cavea* substructures, *balteus* (walkway, with fence in front), podium, and nets (drawing, P. Stinson).

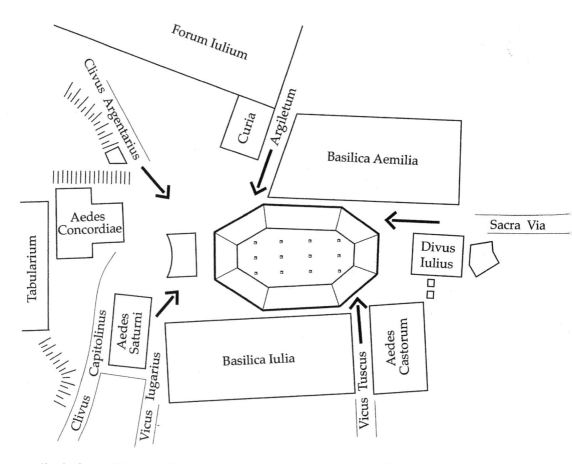

35. Sketch of access routes to the *spectacula* in the *Forum Romanum*, mid-first century BC (drawing, P. Stinson). (Note: Temple of Divus Julius and Curia Julia were both begun in 44 BC and dedicated in 29 BC.)

Pliny the Elder's evocative description of M. Aemilius Scaurus' theatre of 56 BC is as follows:

> As aedile he [M. Scaurus] constructed the greatest of all the works ever made by man, a work that surpassed not merely those erected for a limited period but even those intended to last forever. This was his theatre, which had a stage arranged in three stories with 360 columns; and this in a community that had not tolerated the presence of six columns of Hymettus marble without reviling a leading citizen [Crassus, the Orator]. The lowest storey of the stage was of marble, and the middle one of glass [presumably mosaic] (an extravagance unparalleled even in later times), while the top storey was made of gilded planks. The columns of the lowest story were, as I have stated, each 38 feet high. The bronze statues in the spaces between the columns numbered 3000, as I mentioned earlier. As for the auditorium, it accommodated 80,000; and yet that of Pompey's theatre amply meets all requirements with seats for 40,000 even though the city is so much more numerous than it was at that time. The rest of the equipment, with draperies of gold cloth, scene paintings and other properties was on so lavish a scale that when the surplus items that could be

put to ordinary use were taken to Scaurus' villa at Tusculum and the villa itself was set on fire and burnt down by the indignant servants, the loss was estimated at 30,000,000 sesterces.[100]

The seating capacity, and the number of statues are clearly exaggerated (from the size of its *cavea*, the seating capacity of Pompey's theatre is estimated to have been fifteen thousand), yet the masterly and extravagant design of the theatre is not to be doubted. Columns 38 feet high are actually plausible, given the comparable dimensions of the largest columns from the *scaenae frons* of the Theatre of Pompey of 55 BC. Notwithstanding its extravagance, the theatre of Scaurus was in use for barely a month.[101]

Wooden Amphitheatres. Although the Romans were skilled at wooden construction, not every architectural experiment in wood was a success. The wooden amphitheatre at Fidenae collapsed in AD 27 because it was flimsily constructed, and thousands of people lost their lives as a result. As Tacitus writes:

> A certain Atilius, of the freedman class, who had begun an amphitheatre at Fidenae, in order to give a gladiatorial show, failed both to lay the foundation in solid ground and to secure the fastenings of the wooden structure above; the reason being that he had embarked on the enterprise, not from a super-abundance of wealth nor to court the favors of his townsmen, but with an eye to sordid gain. The amateurs of such amusements, debarred from their pleasures under the reign of Tiberius, poured into the place, men and women, old and young, the stream swollen because the town lay near. This increased the gravity of the catastrophe, as the massive structure was packed when it collapsed, breaking inward or sagging outward, and precipitating and burying a vast crowd of human beings, intent on the spectacle or standing around ... Fifty thousand persons were maimed or crushed to death in the disaster; and for the future it was provided by a decree of the senate that no one with a fortune less than four hundred thousand sesterces [that is, no one below equestrian status] should present a gladiatorial display, and that no amphitheatre was to be built except on ground of proven solidity.[102]

36. Drawing by S. Serlio of section through the theatre constructed by him in Vicenza in 1539 (*Sebastiano Serlio on Architecture* Vol. I, Books I–V of "*Tutte l'opere di architettura et prospetiva*," by Sebastiano Serlio, trans. from the Italian with an introduction and commentary by V. Hart & P. Hicks [New Haven, CT, 1996]).

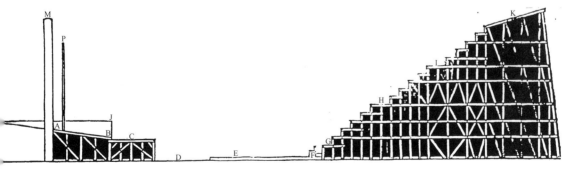

We know of other wooden amphitheatres from literary sources such as the famously large one at Placentia, modern Piacenza (evidently a source of jealousy in neighboring towns), constructed in large part with wood and burned down in AD 70 when Otho stormed that city:

37. Engraving of Jaques Callot showing wooden arena erected by Cosimo II de Medici in Piazza Santa Croce in Florence, 1616 (H. D. Russell et al., *Jacques Callot. Prints and Related Drawings* [Washington DC, 1975] p. 87).

During that struggle the beautiful amphitheatre, which was situated outside the walls, burned, being set on fire either by the besiegers as they threw fire-brands, hot bullets, and burning missiles, or by the besieged themselves as they directed their return fire. The common people of the town, being given to suspicion, believed that flammable material had been treacherously brought into the amphitheatre by some people from the neighboring colonies, who looked on it with envy and jealousy, since no other building in Italy was so large.[103]

Although there is no archaeological trace of the amphitheatre at Placentia, we do have important archaeological evidence of wooden amphitheatres

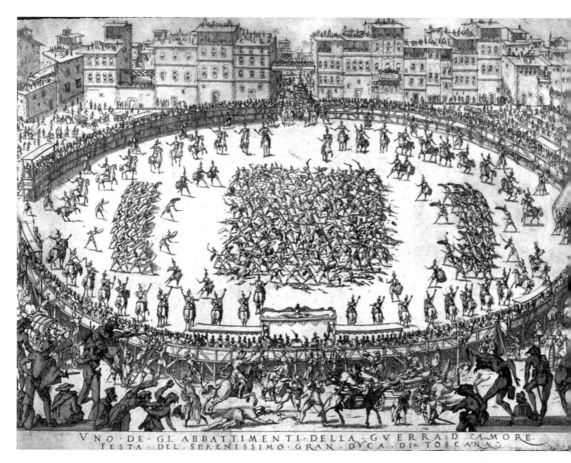

VNO · DE · GL ABBATTIMENTI · DELLA · GVERRA · D CAMORE.
FESTA · DEL · SERENISSIMO · GRAN · DVCA · DI · TOSCANA.

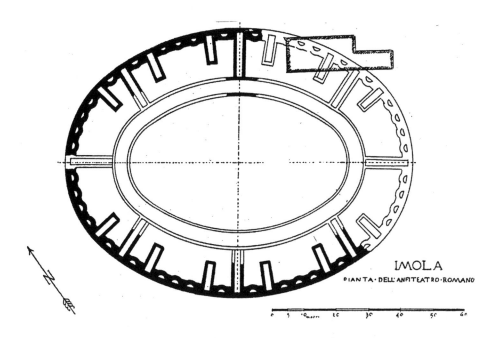

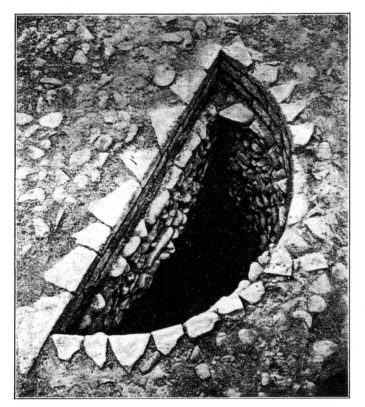

38. *Forum Cornelii*, plan of amphitheatre and socket for wooden post (S. Aurigemma, "Gli anfiteatri di Placentia, di Bononia, e *Forum Cornelii*" *Historia* 6 [1932] pp. 558–87, fig. 4).

in Italy, one at *Forum Cornelii* (modern Imola) near Bologna. The remains consisted of a concrete foundation with sockets for upright wooden beams along the external annular wall that evidently carried the principle weight of the superstructure (Figure 38).[104] Another example is an amphitheatre

39. Wooden amphitheatre on Trajan's column (S. Settis et al., *La Colonna Traiana* [Roma, 1988] pl. 181).

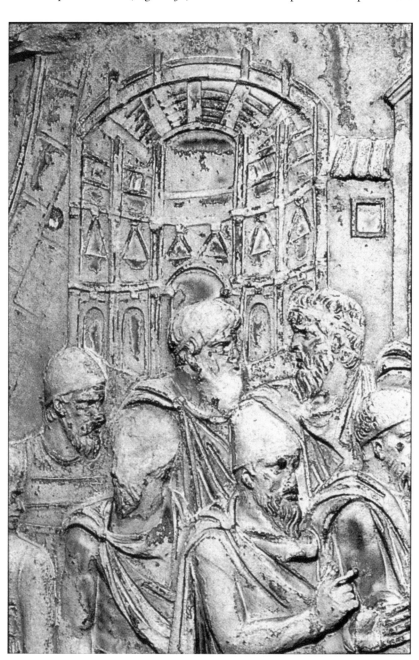

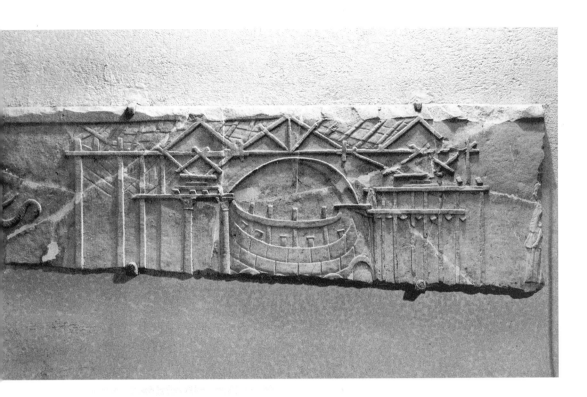

at *Forum Novum* in Lazio, a town that was located during a geophysical survey conducted by the British School in Rome in the late 1990s (and excavated in 2000).[105] The amphitheatre was built of a network of timbers laid horizontally, within which were set large vertical timbers that were tied into the seating above. This system was not freestanding, as it may have been that at *Forum Cornelii*, but was supported by means of an external retaining wall. The amphitheatre probably dates to the early imperial period and, as the excavator notes, is unlikely to have been discovered were it not for remote sensing methods that can detect ruins below modern ground level that are not obvious in the landscape.

We may envisage the appearance of such wooden amphitheatres by comparison to one that appears on Trajan's column (Figure 39). It occurs in a scene of the second Dacian War showing a group of barbarian ambassadors in a town on the Roman side of the Danube bridge (perhaps a veteran colony). The amphitheatre, which is outside the city walls, appears to have a façade of two stories, a stone first story with vaults and a second story of carpentry.[106] There is also a funerary relief that depicts what appears to be an amphitheatre with a truss roof and an armature of wooden beams supporting a *cavea* (Figure 40). The relief, which was discovered beneath

40. Funerary relief found beneath Palazzo della Cancelleria, Rome (photo courtesy of A. Claridge).

the Palazzo della Cancelleria in Rome,[107] had been cut down from its original, much larger, size and was reused as building material. The identity of this structure as an amphitheatre seems assured by the presence of an elephant trunk and tusks at the far left. At the top of the façade there appear to be a number of wooden uprights (masts for the *vela*), similar to those depicted on the Column of Trajan (Figure 39). It is not easy to understand, however, how the wooden armature that is shown relates to the view of what is apparently the façade of an amphitheatre with arched openings. Could it show the amphitheatre under construction with scaffolding at either side? It is perhaps more likely that it shows a cross section through a building rather than a building under construction. (Note the presence of roof tiles above the wooden armature, which indicate that the building may have been completed.) It could be that the *cavea* was supported by means of the wooden armature, and the exterior was decorated with a stone façade (or stuccoed? see Appendix, Cat. 13). It is not out of the question that it depicts the amphitheatre of Statilius Taurus (ca. 30 BC) (see Chapter Four p. 116, n.36). (The presence of animals on the relief would suggest a date in the Augustan period or later, when *venationes* became part of the amphitheatre repertoire – see Chapter One.) One may hypothesize that this relief decorated the tomb of a middle-class family that had worked as contractors in the erection of an amphitheatre built at least partially of wood.[108]

Some wooden amphitheatres consisted only of earthen banks enclosing an oval space and supplemented by timbering (Figure 41). This type of construction is typical of early imperial military amphitheatres in the northern provinces, for example, the early imperial phases of the amphitheatres at Colonia Ulpia Traiana, Rusellae, Segusium, Cemenelum, Carnuntum, Silchester, Noviomagus Batavorum, Vetera, Augusta Raurica, and Vindonissa.[109] All of these timber-and-fill military amphitheatres were rebuilt in stone in the second century; indeed, we know that they had wooden phases only because they were (unusually) carefully excavated and studied. Amphitheatres composed of earthen embankments enclosing an oval space and supplemented by timbering with little or no masonry were probably quite common and can easily go undetected. Such constructions will have left little or no archaeological trace above ground – as is the case not only at *Forum Novum* in Italy but also at the Roman colony of Antioch in Pisidia (Turkey), where we know from an inscription of the second century that one L. Calpurnius Paullus built a wooden amphitheatre in the space of two months: *[m]unus promisit [et] [in]tra duos men[ses] [a]mphitheatrum ligne[u]m fecit* ("he sponsored a gladiatorial show and built a wooden amphitheatre within two months.")[110] There surely existed many more wooden amphitheatres in the Roman world than we know about today.

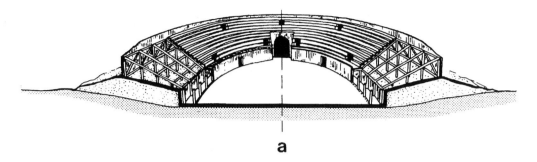

a

Conclusion

41. Timber-and-fill type amphitheatre (Golvin, 1988 pl. II, a).

It is probable, on the basis of the evidence cited in this chapter, that the temporary seating constructions in the *Forum Romanum* (called "*spectacula*") were made of wood, were oval in shape, and had assumed a degree of monumentality, at least by the later second century BC. It is also likely that these wooden structures in the Roman Forum constituted a canonical amphitheatre 'type' during the Republican period. As will be argued in Chapter Three, this type seems to have served as the model for the architecture of the earliest stone amphitheatres in the towns of Italy, where both the oval form and the functional appearance were loyally reproduced.

The wooden amphitheatre was born in the *Forum Romanum* during the second century BC at the height of Rome's most active military expansion. The many versions of it were surrounded by monuments that commemorated warfare: for example, the Maenian column, the *Rostra* with its beaks of captured ships, the *Curia Hostilia* whose façade was decorated with battle paintings, and the great basilicas with their *tabernae* hung with captured enemy shields.[111] Such monuments would have formed an inspiring backdrop for the audience during gladiatorial spectacles. It is here that we have the historical kernel behind the proverbial association between the Roman amphitheatre building and the Roman military machine, as manifested first in the stone amphitheatres of the Republic (Chapter Three) and ultimately in the canonical architectural iconography of the Colosseum (Chapter Five).

CHAPTER THREE

STONE AMPHITHEATRES IN THE REPUBLICAN PERIOD

In Chapter Two, it was suggested that the wooden structures built on a semiregular basis in the *Forum Romanum* during the middle and late Republic served as a model for the earliest stone amphitheatres in Italy, such as the one built at Pompeii in c. 70 BC. This chapter explores the evidence for such a connection and argues it in detail.

It is commonly believed that the amphitheatre as an architectural form was a Campanian invention.[1] Two main pieces of evidence are cited to support this position: (1) the earliest securely datable amphitheatre is in Campania, at Pompeii, built c. 70 BC (Figures 42 and 43); and (2) the earliest surviving depictions of gladiatorial combat occur in South Italian tomb paintings of the fourth century BC (Figures 3 and 4). These two pieces of evidence are three centuries apart, however. There is no relevant Campanian testimony between the South Italian tomb paintings and the Pompeian amphitheatre, yet it is alleged and usually accepted that there is a causal link between them.

If gladiatorial shows had been popular in Campania since the fourth century BC, one might have expected the amphitheatre to have made an earlier appearance. To help explain this discrepancy, scholars have hypothesized a keen and lingering appetite for gladiatorial combat on the part of Campanians in the third and second century BC (for which there is no clear evidence; see Chapter One). This is said to have led, in an unspecified way, to the invention of the oval amphitheatre building type. Although gladiatorial combat may well have originated in South Italy, this does not adequately explain the appearance of the amphitheatre several centuries later in Pompeii. Indeed, gladiatorial games had been held at Rome itself since at least the mid-third century BC, that is, for nearly 200 years before the erection of the stone amphitheatre at Pompeii.

Another way in which scholars have explained the appearance of the stone amphitheatre in Campania is to point to factors such as the cosmopolitanism and prosperity of late-Republican Campania as well as aristocratic

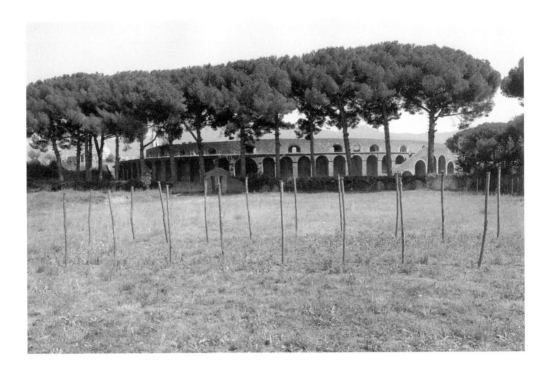

competition, which was channeled into building particularly monumental stone theatres, of which Campania has some early examples.[2] But although wealth, political demagoguery, and euergetism may explain how the first monumental amphitheatres were built, they do not explain why these particular buildings (as opposed to buildings with other functions) were constructed or where the architectural form of these oval structures originated. In short, there is something lacking in the hypothesis that the amphitheatre first appeared in Campania.

Republican amphitheatres are not so numerous nor as architecturally impressive as those built in the imperial period, but they are very important for the issue of the origin and initial dissemination of the amphitheatre as an architectural form. The earliest stone amphitheatres appeared in Italy around the beginning of the first century BC, over 100 years after gladiatorial games had assumed a prominent place in Roman culture. Why exactly did this building type come into being during this period, and what were the historical circumstances of its dissemination? It is this neglected but critical period of the amphitheatre's history to which we turn in the following.

This chapter begins with a detailed discussion and investigation of the social context of the best preserved and documented republican amphitheatre, that at Pompeii. It then explores the connection between the amphitheatre and army culture. The chapter ends with a new interpretation of the

42. View of the amphitheatre at Pompeii, looking southeast from the so-called *Vigna con triclini estivi* (photo, author).

so-called Palestra Grande, a building adjacent to the amphitheatre at Pompeii and – it is argued – closely associated with it, in terms of both patronage and chronology.

The Amphitheatre and Sullan Colony at Pompeii

Because it is exceptionally well preserved, more is known about the amphitheatre at Pompeii than about any other republican amphitheatre. It is closely dated (by epigraphical evidence) to c. 70 BC, and a fair amount is known both about its patrons and about the social and political circumstances of its construction. It therefore merits a detailed examination, both architectural and historical.

Architecture. Like most amphitheatres, the amphitheatre at Pompeii (see Figures 114a–116 in the Appendix) is located at the edge of town, at the easternmost point of the city just inside the city walls.[3] Its major axis is 140 m long, its minor axis is 105 m, and its arena measures 67 × 35 m. (As previously noted, the term arena refers to the performance floor, that is, the surface separated from the *cavea* by the podium.) Structurally, the amphitheatre is a large earthen bowl; earth was excavated to form the arena and was piled up outside to support the *cavea*. The façade wall is articulated and reinforced by a continuous blind arcade of concrete faced with "opus quasi reticulatum," which here is composed of irregularly cut pieces of broken lava with tufa and limestone quoins (see following p. 84, Figures 115 and 120b in the Appendix and Color Plates 6 and 7). During the games, the individual arcades were evidently used by vendors, with permission of the aediles (junior magistrates of the town council), as indicated by an inscription.[4]

At four places on the perimeter facing the town there are stairways, arranged in double flights from opposite directions, also supported on arcades. These stairways lead up to a broad walkway that formed the main access route for spectators to the seating of the *cavea*. In addition, there are two straight, barrel-vaulted corridors that run under the seating at either side of the major axis of the amphitheatre, which slope downward from the exterior of the building to the arena and which were for the entry and exit of arena combatants and personnel (see Figure 117, A and B on plan in the Appendix). This corridor in the northern sector of the amphitheatre, that is, the sector facing the city and the neighboring "Palestra Grande" (on which, see later) was presumably the "Porta Triumphalis," from which gladiators paraded into the arena at the beginning of a show. The opposite corridor to the south (which faces away from the civic center) was presumably the "*Porta Libitinensis*," where dead and wounded gladiators were carried out of the arena.[5]

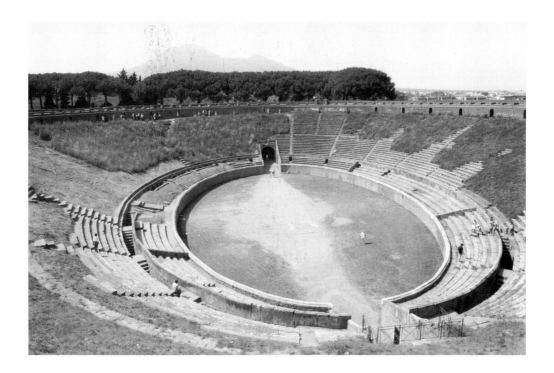

The *cavea* is divided into *cunei* (wedges of seats) by radial steps and into four seating sections by annular *baltei* (low walls providing a walkway that horizontally divides one part of the *cavea* from another) (see Figures 116 and 117 in the Appendix). The two lower *maeniana* (tiers of seats) are divided by a curving parapet (see Figure 118 in the Appendix). The seats of the *ima cavea* (lowest seating section) are larger than those of the rest of the auditorium, indicating that they were designed to accommodate *bisellia*, or portable wooden seats, used by the more important people in the town, who were entitled to the best view. Inscriptions on the parapet wall indicate that the stone steps of the individual *cunei* of the amphitheatre were completed piecemeal, by different magistrates at different times.[6] On the occasion of the eruption of Vesuvius (AD 79), less than half of the *cavea* had stone seats (of tufa). Throughout most of the amphitheatre's history, therefore, the majority of people sat on wooden benches, or perhaps simply on banks of earth.

The *ima cavea* was accessible directly from an annular barrel-vaulted passage, running the circumference of the arena under the *cavea* (see Figure 117, f on plan in the Appendix). This annular corridor was reached by means of two straight, barrel-vaulted corridors, situated parallel to each other, that led into the amphitheatre from the exterior of the building along its southwestern façade (labeled H and I on plan). The *media cavea* and *summa cavea* (middle and highest seating sections) were accessible by means of the double staircases located along the façade, an otherwise unknown feature

43. View of the *cavea* of the amphitheatre at Pompeii, looking northwest (photo, author).

in amphitheatre façades (see Figures 115 and 120a in the Appendix). The arena, which lacks basement structures, is bounded by a podium 2 m high on which were painted scenes of gladiatorial combat, which no longer survive (see Figure 119 in the Appendix).[7]

Above the façade was a superstructure (a later addition of the imperial period) of concrete faced with crude *opus incertum* of broken lava (see Figure 121 in the Appendix). Small vaulted openings in the superstructure (*vomitoria*) allowed access from the exterior walkway to the seating. The interior wall of this superstructure (that is the wall facing the arena) was equipped with tiers of wooden seating. It therefore functioned as the *maenianum summum in ligneis*: "the highest tier of seating, in wood," a designation known from an inscription relating to the Colosseum (see Chapter 5). Set into the exterior of this superstructure were sockets that held the masts for the *vela* (awnings), as are shown in the famous fresco of the riot of AD 59 from House I.iii.23 (Figure 18, Plate 4).

Historical Context. Fortunately for us, the eruption of Vesuvius has preserved this amphitheatre in a uniquely full archaeological context. The edifice was built soon after the planting of the Sullan colony at Pompeii in 80 BC.[8] The dedicatory inscription of this building survives (Figure 44): "C. Quinctius C.f. Valgus and M. Porcius M.f., *duoviri* and *quinquennales* of the colony, as a duty of office, with their own money, oversaw the building of the *spectacula* and for the colonists they donated the place forever."[9] A copy of the inscription was displayed above the west and the east spectator entrances, respectively. The amphitheatre here is referred to as "*spectacula*." The term *spectacula* emphasizes the functional aspect of the building as a place for spectators to congregate and watch. This was the general term for amphitheatre buildings in the republican period (the word *amphitheatrum* did not come into regular use until the early imperial period).[10]

The amphitheatre at Pompeii was built, then, by Quinctius Valgus and Marcus Porcius, *duumviri* (chief magistrates) and *quinquennales* (five yearly magistrates, responsible for taking a census for the central government in Rome) of the colony of Pompeii *causa honoris*, that is, as part of their duties as chief magistrates of the colony. Valgus and Porcius are the earliest known *duumviri* of the colony, and were probably appointed, together with the entire *ordo decurionum* (town council), by Faustus Cornelius Sulla (the colony's *deductor*, or founder, and the dictator Sulla's nephew), acting under orders from Rome. These two individuals also erected the *theatrum tectum*, a small covered theatre in the city's theatre quarter.[11] The dedicatory inscription of the latter reveals that at the time of the erection of the *theatrum tectum*, Valgus and Porcius had not yet become *quinquennales*. The *theatrum tectum* is therefore earlier than the amphitheatre and is normally dated to c. 75 BC.

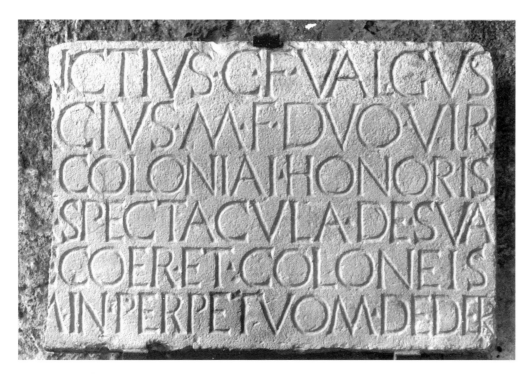

44. Cast of the dedicatory inscription of the amphitheatre at Pompeii (photo author).

Valgus and Porcius had already become *quinquennales* at the time of the amphitheatre's dedication. The first census of the colony of Pompeii is likely to have taken place in 70 BC (a date that coincides with a census year in Rome),[12] hence, the amphitheatre's conventional dating to c. 70 BC.

C. Quinctius Valgus was a magistrate in several other towns around Campania. He may also have been the Valgus who was father-in-law of the tribune P. Servilius Rullus and who figures as a target of Cicero in the *de lege Agraria*. (He is accused of impropriety in selling land and for fraudulent evictions of tenants around Casinum [Casino].) M. Porcius was a wine exporter who had probably acquired his vineyards in the Sullan proscriptions. In most military colonies, the *duumviri* were military tribunes and centurions of the colonizing legion; therefore, in all likelihood Valgus and Porcius were military men.[13]

That Valgus and Porcius erected this amphitheatre soon after the colony was founded suggests that the activity that took place inside it was important to them and to the colonists. Indeed, the veteran colonists seem to have regarded the building as their own structure. The dedicatory inscription explicitly states that the building was donated "to/for the Roman colonists" *(coloneis)*.[14]

A connection between amphitheatres and veteran colonization is supported by other evidence. The charter of the Caesarian colony of Urso

in Spain (44 BC) stipulates that, during his magistracy, each *duumvir* was required to spend 2,000 sesterces of his own money on a public show, either gladiatorial or *ludi scaenici*, in honor of the Roman state gods, Jupiter, Juno, and Minerva: *munus ludosve scaenicos Iovi Iunoni Minervae*.[15] The charter adds that the *ordo decurionum* as a body could choose whether *munera* (gladiatorial shows) or *ludi scaenici* (stage plays) would be put on, and that part of the cost (at most 2,000 sesterces) would be paid with public funds (*ex pecunia publica*).[16] It is often assumed that in the late Republic, gladiatorial games were given only in a private, funerary context, as offerings or *munera* owed to important men at their deaths, and that they were never publicly provided (although they might be given by men who happened to be holding a magistracy at the time).[17] But the Urso charter, which is the best preserved Roman municipal charter and the only extant colony charter, calls for gladiatorial games to be dedicated to the Roman state gods and specifies that the state was to contribute to their cost.[18]

The Urso charter of 44 BC is the earliest surviving evidence of governmental organization of gladiatorial games, but some evidence suggests that such policies existed as early as the time of Sulla. Between the time of Sulla and that of Caesar, a constitutional system was developing for Rome's colonies and municipalities, and it is likely that many of the measures we hear of in the Urso charter were already in place in Sullan times.[19] There is an inscription from Pompeii dating from the first years of the Sullan colony recording a benefaction by the *duumviri* from the money that they were required by law to spend on either the games or on a monument.[20] This text indicates that there was a Pompeian law stipulating that magistrates put on *ludi*. It is possible that *munera* were also included as an option in the Pompeian *lex* (as was the case with that of Urso), but they are not mentioned here because of the abbreviated and honorific nature of the inscription. An inscription of AD 55–56 from Pompeii records a gladiatorial show given by one of the *quinquennales* "*sine impensa publica*" ("without public financial burden") suggesting that the Pompeian charter called for public funds to be used for *munera*, at least in the imperial period.[21] Vitruvius takes it for granted that magistrates were required to put on gladiatorial shows (10. praef. 3): "So it is even with public spectacles which are given by magistrates, either of gladiators in the forum or of plays on the stage" *(sed etiam in muneribus, quae a magistratibus foro gladiatorum scaenicisque ludorum dantur)*.[22]

Another indication that gladiatorial games could have figured in the Pompeian charter (and, by extension, that the veteran colonists considered it a duty to sponsor them) comes from gladiatorial *tesserae* (tickets to arena games) found in Italy, which are stamped with the names of Roman consuls. The earliest surviving of these *tesserae* are from Rome and date to the time of Sulla, suggesting the possibility of official organization of the games during

this period.[23] A passage in Ennodius states that in 105 BC the consuls Rutilius Rufus and G. Manlius[24] were the first to put on a gladiatorial show in their capacity as magistrates, so that in times of peace the plebs would remain hardened to war.[25] (A similar sentiment is found in Polybius, where we hear that the Roman senate would make war so that the people would not become enervated by a lengthy peace.[26]) It has been argued that this event lies behind the official staging of gladiatorial games in Rome's colonies,[27] though this is by no means certain. We may conclude, in any case, that gladiatorial games were mandated by some colony charters in the time of Caesar, and may also have been prescribed earlier in the age of Sulla, the time of the amphitheatre at Pompeii.

Army Training and Gladiatorial Combat: 105 BC and After

Why was there special interest in games on the part of the Sullan colonists at Pompeii, and why was the decision taken to stage gladiatorial games in a monumental structure instead of in public squares (*fora*), where Vitruvius tells us they were normally held, and where even at Pompeii they continued to be held after the amphitheatre was built?[28] To answer these questions, a historical digression is helpful. As mentioned previously, the colonists for whom the amphitheatre was built were veterans of Sulla's army. Only a generation before they came to Pompeii, Rome had been in a state of military crisis. Roman armies had experienced difficulty with the forces of Jugurtha in North Africa, and German tribes (the greatest danger to Rome since Hannibal) had invaded the Roman province of Narbonensis and threatened Italy itself. This situation, and the great shortage of men in the army at this time, led to Marius' famous decision in 107 BC to forego property qualifications altogether in army recruitment. Shortly afterwards in 105 BC, when four legions were felled by German tribes at Arausio (modern Orange), Rome panicked, and more far-reaching measures were taken. For the first time, men with no military experience were recruited in unprecedented numbers from the landless classes. They needed efficient training, and the emergency situation demanded it at short notice.[29]

One of the measures taken to meet this crisis was that in 105 BC, during the consulship of P. Rutilius Rufus, gladiatorial methods were introduced into infantry training. Valerius Maximus tells us that: "Practice in handling arms was passed on to soldiers by the Consul P. Rutilius, Cn. Manlius' colleague. Following the example of no previous general, he called in gladiatorial instructors from the gladiatorial school of C. Aurelius Scaurus to plant in the legions a more sophisticated system of avoiding and giving a blow."[30] The army trained in this way by Rutilius Rufus was the one Marius later

commanded against the Cimbri (a German tribe).[31] It was with this new force that the Germans were defeated by Marius. Since Sulla had served under Marius as legate during the German war,[32] it is arguable that Sulla's soldiers, like those of Marius, were also trained by means of gladiatorial methods.

Several texts suggest that, once introduced to the army, gladiatorial methods continued to be employed. In the *Pro Caelio*, Cicero makes a connection between the training of young Roman soldiers and the gladiatorial practices by his use of the word *ludus* (the standard word for gladiatorial training school[33]): "When I was young, we usually spent a year ... in tunics undergoing army training in the *ludus* and on the *campus*, and, if we began our military service at once, the same practice was followed for our training in the *castrum* and in the field."[34] The connecting of *ludus* and *campus* is again found in a passage in Cicero's *De Oratore*: "But let them consider what they want, whether it be for sport or warfare that they wish to take arms. Indeed, one person may desire a pitched battle, and another may wish merely for our *ludus* and *campus*. For all that, the skill itself, that of exercising with arms, is valuable for gladiator and soldier alike."[35] Moreover, the military exercises of young Roman men, of the sort that Cicero had engaged in, could take the form of contests that were watched and even bet upon by spectators.[36] Here we have a strikingly significant parallel between gladiatorial games and military training.[37]

Further evidence for a close connection between military training and gladiatorial combat is to be found in a series of rhetorical passages that state that watching gladiatorial combat increased military preparedness. For example, Cicero wrote that there could be "no stronger discipline against pain and death for the eye than a gladiatorial show".[38] A similar sentiment is found in a famous passage from a letter by Seneca:

> Men will make greater demands upon themselves if they see that death can be despised by the most despised class of men ... I shall now prove to you that the virtue of which I speak is found as frequently in the gladiators' training school as among the leaders in a civil war. Recently, a gladiator who had been sent forth to the morning exhibition was being conveyed in a cart along with his guards; nodding as if he were heavy with sleep, he let his head fall over so far that it was caught in the spokes; then he kept his body in position long enough to break his neck by the revolution of the wheel.[39]

An analogous attitude is found in Pliny the Younger's Panegyric to Trajan: "And so spectacles were put on that were not weak and flabby, nor the sort of thing that softens and breaks men's spirits, but such as to incite them to glorious wounds and contempt of death, since love of glory and desire to win were apparent even in the bodies of slaves and criminals."[40]

Gladiatorial games may even have been purposefully staged for the benefit of soldiers before they went to war, as the following passage in the *Scriptores Historiae Augustae* suggests:

> Whence this custom arose, that emperors setting out to war gave an entertainment of gladiators and wild beasts, we must discuss briefly. Many say that among the ancients this was a solemn ritual performed against the enemy in order that the blood of citizens being thus offered in sacrifice under the guise of battle, Nemesis (this is the very same force of fortune) may be calmed. Others have related in books, and this I believe is nearer the truth, that when about to go to war the Romans felt it necessary to behold fighting and wounds and steel and naked men contending among themselves, so that in war they might not fear armed enemies or shudder at wounds and blood.[41]

The year 105 BC, which may have seen the introduction of gladiatorial methods into army training, could be the historical kernel behind statements such as these, which are frequent among Latin writers.[42] These passages invite further exploration of a connection between gladiatorial combat and army life during the Republic.

It is well known that, in the imperial period, amphitheatres were often built just outside of legionary fortresses. Inside these amphitheatres soldiers celebrated festivals and watched gladiatorial games for entertainment. Since they appreciated the combat as connoisseurs, soldiers would have been an exacting audience.[43] There is even evidence that army units under the principate included soldiers who doubled as arena combatants.[44] It is often said that legionary amphitheatres were constructed specifically for military training and exercises.[45] But the evidence suggests that this activity probably more often took place in the *campus*, or parade ground of the legionary camp.[46] The earliest archaeologically attested legionary amphitheatres are Augustan and Julio-Claudian in date. Located in the northern regions of the Empire, they were modest structures, of timber-and-fill type.[47] It is possible that such makeshift amphitheatres were also attached to legionary camps in Italy during the late republican period. One passage in Suetonius is suggestive. At the end of 50 BC when Caesar was about to invade Italy, he was stationed with his thirteenth legion at Ravenna. In order (apparently) to distract attention from his plan to cross the Rubicon, he engaged in a number of ordinary activities, among which was the inspection of the plan of a *ludus* he was about to build.[48] Ravenna was not an important civic center at this time, but it was a legionary encampment of 5,000 soldiers. Surely the *ludus* mentioned by Suetonius was an amphitheatre intended to be attached to Caesar's military camp.

Perhaps makeshift legionary amphitheatres came into being sometime after the Rutilian army reform of 105 BC. There is no sign of them earlier,

and they do not figure in Polybius' detailed description of the Roman army camp.[49] However, this does not necessarily mean that the amphitheatre at Pompeii was architecturally indebted to early and now lost legionary amphitheatres.[50] It is more likely that both the arena at Pompeii and the military amphitheatres had one model in common: the temporary wooden structures of the *Forum Romanum*, discussed in Chapter Two.

In summary, it is clear why ex-soldiers in the age of Sulla would have been particularly interested in gladiatorial games: not only were *munera* good military-style entertainment that they were familiar with from the capital, but the technique of the combat may also have been familiar to them from their army training. It is not surprising, then, that the earliest securely datable monumental amphitheatre (c. 70 BC) should appear at Pompeii, a city colonized by army veterans soon after gladiatorial training methods were introduced. As has been demonstrated, we are quite well informed about the date and historical context of the amphitheatre at Pompeii. We may now turn to what we know of the other extant amphitheatres dating to the republican period.

Geographical Distribution and Dating of Republican Amphitheatres

Although the amphitheatre at Pompeii of c. 70 BC is the only closely dated republican amphitheatre, there are at least twenty other known amphitheatres that can be dated to the late republican period from both historical evidence and comparison to the amphitheatre at Pompeii, to which they are similar both in form and in construction technique (Nola is especially close to Pompeii in its architectural configuration). The majority of these early amphitheatres were built in Campania. With few exceptions, they are unexcavated and not thoroughly published. It is not surprising, then, that their cumulative presence in Italy has never been appreciated. A detailed description and documentation (where this was possible) of all the known republican amphitheatres may be found in the Appendix.

Stone amphitheatres dating to the republican period appear at the following sites:

CAMPANIA
 Pompeii (Sullan colony 80 BC) = Cat. 1
 Capua (municipium since late fourth century BC, veteran settlement 59 BC, triumviral colony, Augustan colony) = Cat. 2
 Liternum (maritime colony 194 BC) = Cat. 3
 Cumae (*municipium optimo iure* since at least second century BC)=Cat. 4
 ?Abella (possible Sullan veteran settlement, colonial status certainly by Augustan period) = Cat. 5

Cales (Latin colony late fourth century BC, triumviral veteran settlement) = Cat. 6

Teanum (Latin colony late fourth century BC, triumviral colony) = Cat. 7

Puteoli (maritime colony 194 BC; possible Sullan veteran settlement, triumviral or Augustan colony) = Cat. 8.

Telesia (possible Sullan colony, colonial status certainly by Augustan period) = Cat. 9

Suessa Aurunca (Latin colony late fourth century BC) = Cat. 11

Nola (Sullan colony) = Cat. 13

Compsa (municipium, first attested in 70 BC [Cic., *Verr.* 5.158]); as yet unpublished; The amphitheatre is evidently late republican. I thank Dott.ssa G. Colucci Pescatori for this information, which she recently communicated to me.

Abellinum (Sullan colony) = Cat. 12

?Aeclanum (probable Sullan colony) = Cat. 14 (existence of amphitheatre likely but not certain)

LUCANIA

Paestum (Latin colony 273 BC, possible Sullan or Caesarian veteran settlement, colonial status certainly by the Augustan period) = Cat. 10

ETRURIA

Sutrium (Latin colony late fourth century BC, triumviral colony) = Cat. 15

Ferentium (municipium after Social War, Augustan colony) = Cat. 16

SPAIN

Carmo (municipium since late second century BC) = Cat. 17

GREECE

Corinth (colony Julius Caesar) = Cat. 18

SYRIA

Antioch (provincial capital of Syria; amphitheatre said by Malalas to have been built by Julius Caesar) = Cat. 19

Note that this list is hardly likely to contain the full number of amphitheatres built during the republican period. Because republican amphitheatres were not monumental structures, many will not have left obvious traces in the landscape. A good example is the small amphitheatre at Ferentium, which is practically invisible in the landscape until one is standing inside its

45.
Amphitheatre
with *cavea*
partially cut out
of terrain and
partially
sustained on
vaults (Golvin
1988 pl. 2c).

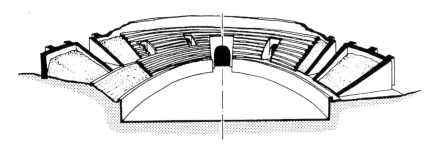

ruins (Figures 182 and 183). More significant, however, is the probability
that many wooden amphitheatres were constructed in republican times but
have either been built over or have left no obvious archaeological traces
(see Chapter Two).

The criteria with which I have dated the amphitheatres in the previ-
ous list to the republican period are as follows. Compared to securely
dated Italian amphitheatres of the imperial period, these structures are
simple in terms of their construction. They are small; they lack basement
facilities; they make extensive use of the natural terrain, being partially
embanked in the earth rather than built up by means of extensive vault-
ing. Like the amphitheatre at Pompeii, these buildings have a functional
appearance, lacking architectural orders on the façade and other decoration
(Figure 45). Architecturally, these buildings are all quite similar to Pompeii's
amphitheatre.

Importantly, brickwork (*opus testaceum*) is not used in the construction of
these amphitheatres, as it is in imperial amphitheatres such as the Flavian
amphitheatre at Puteoli (Figure 81). Instead, they are generally faced with
cut blocks of tufa or limestone, arranged in a pattern known as *opus incertum*,
opus reticulatum,[51] or in some cases "quasi-reticulatum" (a modern term sig-
nifying a facing technique that looks like a transition between *incertum* and
reticulatum). One may compare, for example, the quasi-reticulate technique
of the republican amphitheatre at Puteoli (Figure 46) to the nearly identical
technique used in the amphitheatre at Pompeii of c. 70 BC (Figures 47 and
120b in Appendix, Plate 7). This kind of wall facing is found in Rome at
the end of the second century BC (Figures 48 and 49) and at Pompeii only
following the installation of the Sullan colony in 80 BC, and so provides a
fairly good chronological indication, that is, a *terminus post quem* of c. 100
BC for these amphitheatres.[52]

Amphitheatres before Pompeii? Some have dated the amphitheatres at
Cumae, Liternum, and the republican arena at Capua to the late second
or early first century BC, identifying them as the very earliest Roman
amphitheatres.[53] In this dating, they follow W. Johannowsky.[54] There is ac-
tually no good evidence for so specific a date, however. The amphitheatre
at Cumae (see Figures 128–133 in Appendix) is relatively small, and its

46. Puteoli:
republican
amphitheatre,
detail of masonry
(photo, author).

cavea is embanked in earth, suggesting that it is pre-imperial. The wall
facing of its *summa cavea* is often described as *opus incertum*, a wall-facing
technique that in the city of Rome and its environs provides a good in-
dication of a second or early century BC date. There are two problems
with this dating. First, the use of *opus incertum* is not a viable chronological

indicator outside of Rome and Latium; one can point to examples of it in Campania as late as the first and second centuries AD. For example, the exterior wall of the *summa cavea* of the amphitheatre at Pompeii, a first-century addition, is faced in *opus incertum* (see Figures 47 and 121 in Appendix).[55]

47. Pompeii amphitheatre, detail of façade showing masonry (photo author).

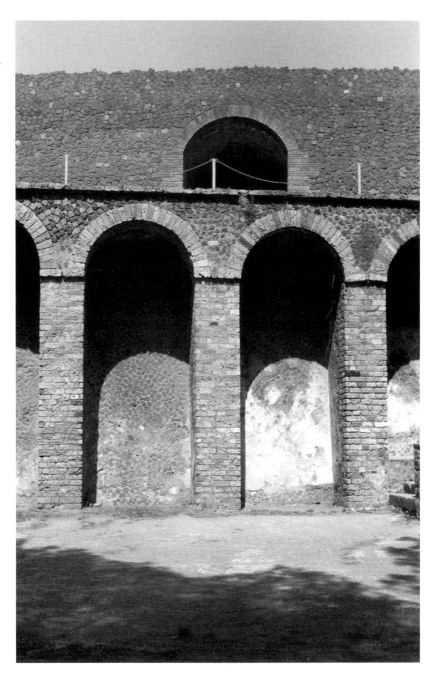

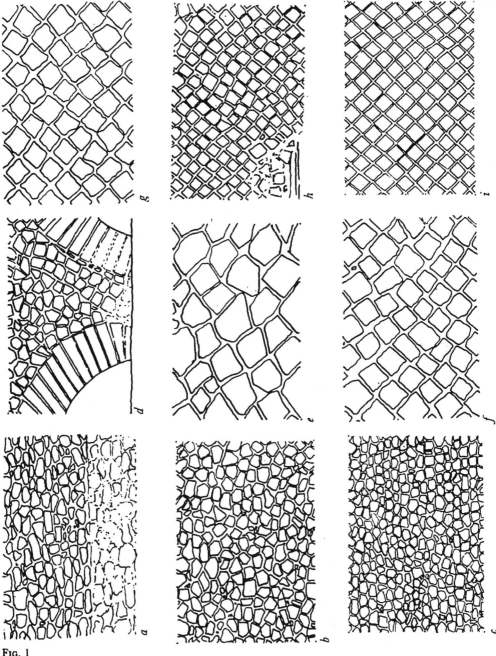

Fig. 1

a. Temple of Magna Mater, Phase 1, 204–191 b.c.
b. Foundations of Capitolium, 189 b.c.
c. Porticus Aemilia, 174 b.c.
d. Viaduct in Forum, 174 b.c.
e. Porticus Metelli, 146 b.c.

f. Lacus Iuturnae, 116 b.c.
g. Horrea Galbana, 110–100 b.c.
h. House of the Gryphons, c. 100 b.c.
i. Theatre of Pompeius, 60 b.c.
(The drawings are not to scale)

48. F. Coarelli's chart of different masonry styles in Rome in the second and first centuries bc (a–e = *opus incertum*; f–h = "opus quasi reticulatum"; i = *opus reticulatum*) (F. Coarelli, "Public building in Rome between the Second Punic War and Sulla" *PBSR* 45 [1977] fig. 1).

Second, the wall facing used for the amphitheatres at Cumae and Capua (see Figures 124 and 133 in Appendix)[56] does not at all resemble the 'canonical' *opus incertum* one associates with Rome (the so-called *Porticus Aemilia*) or Latium (Praeneste, Terracina). Instead, it consists of large chunks of stone set irregularly into thick mortar beds. Its rough construction thus conforms to no chronologically documented wall-facing system and is therefore difficult to date. It is not inconceivable that the amphitheatre at Cumae was built in the early first century BC, thus predating the one at Pompeii, but we cannot be sure.[57] One wonders if the amphitheatre at Cumae is popularly known as the "oldest Roman amphitheatre" because of its primitive appearance (it is less architecturally impressive, even, than Pompeii) and because of the general acceptance of the (circular) argument that Campania was the birthplace of the amphitheatre as a building type. In short, the amphitheatres at Cumae, Capua, and Liternum could be earlier than the amphitheatre at Pompeii, but there is no convincing evidence of this dating.

Republican Amphitheatres and Colonization. It has been suggested that there is a pattern in the location of republican amphitheatres: they appear in places where gladiatorial combat is attested early: Campania, Lucania, and Etruria.[58] A more reasonable explanation is that they appear in places that had particularly close ties with Rome. Two kinds of places may be distinguished: first, cities settled by army veterans, and second, old Latin and maritime colonies and municipia.[59] How are we to account for this distribution of sites?

One consequence of the Marian army reforms discussed previously was that in the age of Sulla and Caesar Rome had to find land on which to settle thousands of landless ex-soldiers. Southern Italy, where the Samnites had resisted Sulla to the very end, was most affected. Unfortunately, very few of Sulla's colonies can be named, probably because many were recolonized under the triumvirs and Augustus.[60] For their own security, the veterans had to be settled in fairly large groups (and for their collective morale, men from the same legion were often settled together), which meant expropriating land from the older inhabitants.[61] Sulla's settlements fostered cultural turmoil (the "bitterness of the Sullan period,"[62] as Cicero put it) and greatly contributed to the disappearance of local customs. Oscan, for example, declined quickly in Campania after the early-first century BC.

In Sullan colonies, there seem to have been two communities that coexisted in mutual hostility, at least at the beginning. In the first few years of the colony at Pompeii, for example, the names of the old Samnite aristocrats are absent from the epigraphic record of the town's magistrates.[63] Cicero describes this situation at Pompeii as "the great quarrel between the people of Pompeii and the colonists" that "grew chronic and continued for many years."[64] He adds that the natives and the new settlers argued over *suffragia*

et ambulationes – "elections and public walks [or spaces]" and that the privileged position of the new settlers clashed with the interests of the native inhabitants. This was the social atmosphere in which the amphitheatre at Pompeii was constructed and initially used.

A significant demographic change in southern Italy had also taken place. With Sulla's settlements after the Civil War in 82 and with Caesar's agrarian bill of 59 it is safe to estimate that at least 60,000 Roman veterans were settled in Campania during the first half of the first century BC. Sulla settled between 23 and 27 legions – 80,000–120,000 men – by means of colonization and land allotment ("viritane assignation") in and around Italian municipia.[65] The earliest amphitheatres appear in Campania at a time when veteran colonization was taking place there on an unprecedented scale (throughout the first century BC, beginning with Sulla and continuing under Caesar and the triumvirs),[66] and this is no coincidence.

It is possible that army veterans, such as those who colonized Pompeii, were among the first to give monumental form to the arena. Yet why do they seem to have done so more in Campania than in other places, such as Etruria and Latium, where large numbers of them were also settled?

Firstly, we cannot rule out that early amphitheatres existed in Etruria and Latium, which have not been detected or were subsequently built over. One possibility is at the Sullan colony of Arretium (Arezzo), which has a monumental amphitheatre dating to the first century AD. Another candidate is Tusculum, which had sided with the Marians during the Civil War and whose *ager* was reorganized by Sulla.[67] Epigraphical evidence reveals that the city walls at Tusculum were built during the Sullan period, and archaeology shows that the Forum and theatre were remodeled then too. The amphitheatre at Tusculum, located right outside the city wall, has never been investigated. It is conventionally dated to the mid-second century AD because of some visible masonry in *opus mixtum*. Yet many republican amphitheatres were rebuilt in brick during the high imperial period (Cales being a good example; see Figures 145 and 143).

Secondly, Etruria and Latium were considerably less wealthy and urbanized than Campania during this period and had proportionally fewer buildings of all kinds. Third, one may suggest that soldiers settled in cities like Pompeii had more of a reason to make an architectural statement of their presence than did those who were settled in Etruria. In Campania, the custom of competitive building programs (sponsored by lively local euergetism) was strong, and it may be surmised that Sulla's colonists would have felt a keen interest in participating in it. This is indicated by the following remarks of Cicero concerning Sulla's colonists:

> The third group [of Catilinarian conspirators] comprises men who are now getting on in years but whose active life has kept them physically fit. The

Manlius [a centurion under Sulla] whom [Catiline] has now joined is in this class. They are men from those colonies which Sulla founded, all of which, I believe, are as a whole composed of men of complete loyalty and outstanding bravery. Nevertheless they are the colonists who have used their sudden and unexpected wealth to which they were quite unaccustomed and which was beyond their means. Putting up buildings as men of wealth and enjoying their choice of farms, their large establishments, and their sumptuous banquets, they have run so deeply into debt that they would have to raise Sulla from the dead if they wanted to be in the clear.[68]

The veterans at Pompeii found themselves in a new environment, surrounded by large numbers of Oscan- and Greek-speaking people, who were presumably hostile to outside interference. By building such an imposing and novel structure as the amphitheatre, the colonists were making a statement of their power and of its distinctive character.[69]

On the basis of this evidence, it seems likely that army veterans were a critical force in the imposition of the amphitheatre building on Campanian cities, such as Pompeii and probably Telesia and Nola, where Sullan veteran settlements are attested. On the other hand, not all amphitheatres were built by veteran colonists. We may consider again the three amphitheatres conventionally said to be older than the amphitheatre at Pompeii: Cumae, Liternum, and Capua. Let us assume for the sake of argument that the amphitheatres in these cities were indeed built in the late second century BC (as is often suggested) and thus predate the amphitheatre at Pompeii (though bear in mind that there is no convincing evidence of this dating; see earlier). If the building of amphitheatres in such cities did indeed occur before the Social War (which ended in 89 BC), these new buildings could then be interpreted as symbols of "self-Romanization" of the sort that has been discussed in regard to other types of distinctively Roman buildings put up in Campania initially in the late-second century BC (such as basilicas and administrative edifices) in emulation of buildings in the capital. Such constructions may have conveyed signs of a community's allegiance with Rome and its wish to procure the Roman citizenship.

On the other hand, during the period after the Social War, Campanians for the first time had finally gained the Roman citizenship and access to public office in Rome.[70] What better way for nonveteran Campanians in the Latin colonies and the municipia to express connection with Rome than loyally to reproduce a building type that had close Roman associations. Campanians now had a good incentive to imitate Roman forms, especially those who inhabited the old Latin colonies such as Cales and Teanum, which both have amphitheatres built close to the time of that at Pompeii. (Their wall-facing technique is nearly identical with that of the latter.) They had the model of the citizen soldiers from Rome; they had the money; and – to

judge from the evidence of the famous gladiatorial schools of Capua – they had a ready supply of excellent gladiators.

The *Ludi* of Capua

The *ludi* (gladiatorial training schools) at Capua are sometimes invoked to support a Campanian origin for the Roman amphitheatre. The Capuan schools are first attested in the late-second century BC and are best known to us because they produced Spartacus. These schools were in fact owned by noble Roman families, not by members of the Capuan aristocracy (which, incidentally, had a large measure of independence before the Social War[71]). The sum total of the evidence for ownership of the *ludi* at Capua is as follows. An otherwise unattested individual called C. Aurelius Scaurus owned the gladiatorial school at Capua from which Rutilius Rufus drew his gladiatorial *doctores* (trainers) in 105 BC. The Aurelii Scauri constituted a small Roman *gens*, and the individual Valerius Maximus mentions is likely to have been a close relation (perhaps the brother) of M. Aurelius Scaurus, cos. suff. 108 BC.[72] The man who owned the school in which Spartacus' slave revolt took place was the noble Cn. Cornelius Lentulus Vatia.[73] And in 49 BC, none other than Julius Caesar was the owner of a *ludus* in Capua.[74] That elite Romans were in control of the economic resource of Campanian gladiators at the time that the first stone arenas appear further suggests that the amphitheatre phenomenon was disseminated not from Campania but from Rome itself.

The Transition from Wood to Stone

Interestingly, we do not see stages of development in early amphitheatres. The buildings appear suddenly, as if fully formed with *vela*, *vomitoria*, and oval arenas, suggesting that that these buildings were drawing upon a model in which these features had already been developed. The 'styleless' and functional-looking aesthetic of early amphitheatres, like that at Pompeii, could well derive from the wooden structures that were built for gladiatorial games in the Roman Forum. And there is another indication that the Forum structures and early amphitheatres are related. As discussed in Chapter Two, Festus tells us that the word *maeniana*, which means tiers of seating in amphitheatres, was originally named for Maenius, censor in 338 BC: "who was the first to extend wooden beams in the Forum beyond the columns ... so that the upper *spectacula* could be enlarged."[75] This statement indicates that the wooden seating arrangement in the *Forum Romanum* was called "*spectacula*" – the same name given to the amphitheatre at Pompeii in

its dedicatory inscription.[76] Finally, an arena of exactly the same dimension as the one in the amphitheatre at Pompeii fits neatly around the *hypogea* (basement structures) that were used for gladiatorial spectacles in the *Forum Romanum* in the time of Caesar and Augustus (see Chapter Two and Figures 27 and 29).

How could temporary wooden structures be so well known that they served as the collective model for the earliest monumental amphitheatres? Surely it was because of their prestigious location in the Forum in Rome. This was the location of the aristocracy's funeral ceremonies, of which gladiatorial combat had traditionally been a part. Such a model would have been familiar to and a natural choice for Roman colonists and soldiers, who wished to create a monumental building for gladiatorial shows in a civilian or military context.

If we accept that the temporary wooden amphitheatres in the *Forum Romanum* were oval, and that they functioned as the prototype for early oval arenas in the towns of Italy like Pompeii, how are we to explain the jump from a post-and-lintel timber structure (Figure 26) to a relatively sophisticated concrete one with barrel vaults (Figure 117)? Need we hypothesize either a local, Campanian architect who was practiced in concrete theatre construction or one who was suddenly inspired to build oval amphitheatres because of his familiarity with round "*ekklesiasteria*" of the sixth and fifth centuries BC, such as existed at Agrigento, Paestum, and Metapontum?[77] The latter hypothesis (suggested to me by some scholars, but never discussed in print) has a formalist appeal but lacks a basis in historical probability: all of these *ekklesiasteria* had been abandoned or built over by the fourth century BC; hence, they were invisible by the time that amphitheatres began to be built. The former hypothesis, that stone amphitheatres were somehow indebted to Campanian vaulted theatre architecture of the later second century BC is possible but not necessary.

It could be that the colonists at Pompeii supplied the conception of the oval building type, whereas local building traditions provided the construction technology. Indeed, the amphitheatre at Pompeii has some advanced architectural features, such as blind arcades on its façade, barrel-vaulted annular corridor beneath its *cavea*, and *vela*. But these are not features specific to Campanian architecture. Experimentation in concrete was by no means restricted to this region. One can point to innovations at terrace sanctuaries in Latium as well, such as that of Fortuna Primigenia at Praeneste of the later second century BC, which features blind arcades and the earliest known annular vaulting.[78] As mentioned in Chapter Two, *vela* had been used to cover spectators in the *Forum Romanum* from at least 69 BC.[79]

Despite these up-to-date architectural aspects, the early amphitheatres in Campania were in reality not so very sophisticated in their construction. In

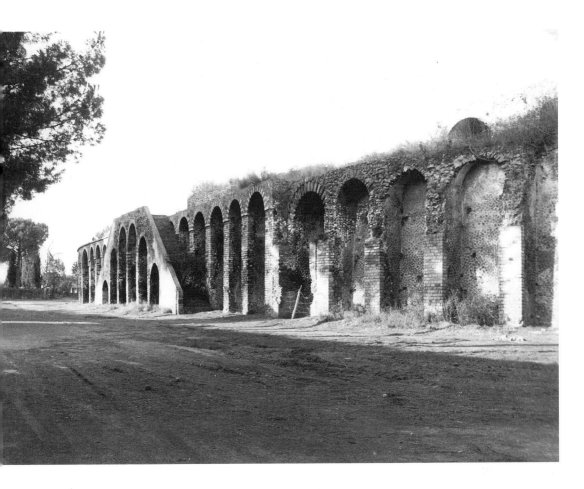

49. Façade of the amphitheatre at Pompeii, showing double staircases (*D.A.I.* Rome neg. 67.627).

plan, republican amphitheatres are relatively primitive, especially at Pompeii. There, for example, most of the spectators entered the *cavea* via external staircases (Figure 117). Others could enter by means of two barrel-vaulted corridors (labeled H and I on the plan) from where they could proceed to the annular vaulted passageway beneath the *cavea* where any number of staircases issued out into the seating. The difficulty was that the entryways for the gladiators, that is the two barrel-vaulted corridors leading to the arena along the major axis of the building (A and B), spatially intersect with the annular corridor (f) used for spectator circulation. (This would never have been the case in a monumental amphitheatre of the imperial period.) This aspect of the plan meant that there was a chance – however remote – that members of the audience could come into physical contact with the performers. In other architectural respects the amphitheatre at Pompeii lacks monumentality: it is built against the city's fortification walls; its façade is broken by steps and has different architectural plans on both the ground and

the upper levels (the upper level being an oval and the ground level having straight sides). And the main means of access to its seating is from the top of the structure rather than from the ground level. To a Pompeian observer, the new amphitheatre would have appeared to be exactly what it was: a great bowl hollowed out of the earth, with an unadorned concrete retaining wall around it (Figures 115 and 116). In the late republican period, most amphitheatres were conceived more as "architecturalized" terrain than as buildings in their own right (republican amphitheatres of later date, such as Paestum and Abella, have somewhat more sophisticated spectator access, but not by far (see Appendix). The oval amphitheatre had yet to be fully accepted as a monumental urban form.

Interestingly, the closest formal parallel for the façade of the amphitheatre at Pompeii with its double-staircased buttresses (an apparently unique feature) is in Roman fortification architecture; and, indeed, this amphitheatre effectively formed part of the inside of the city wall. The arrangement of its double staircases may owe something to the double *ascensus* sometimes found inside the walls of Roman military camps, positioned parallel to the ramparts (Figures 49 and 50).[80] The overall architectural iconography of the amphitheatre at Pompeii is rather similar to that of military amphitheatres, the earliest surviving examples of which are early imperial in date, for example, the military amphitheatre at Caerleon in Wales (Figure 51).[81] The legions played an important role in providing architectural expertise for civil engineering projects.[82] It is perhaps worth considering, then, that legionary construction techniques may have inspired the design of the façade of Pompeii's amphitheatre. This would make sense if some part was taken in the choice of their building's design and construction by Porcius and Valgus, *duumviri* and veterans of Sulla's army.[83] We may now turn to a structure connected with the amphitheatre for which the Sullan veteran colonists at Pompeii seem also to have been responsible.

50.
Reconstruction of Roman fortification wall at Rottweil in Upper Germany (A. Johnson, *Roman Forts of the 1st and 2nd Centuries A.D. in Britain and the German Provinces* [London, 1983] Fig. 57).

The Amphitheatre and *Campus* at Pompeii

Just west of and adjacent to the amphitheatre at Pompeii is a large rectangular open area surrounded on three sides by porticoes (Figures 52 and 114 in the Appendix). The extant structure, known as the "Palestra Grande," is the result of rebuilding after the earthquake of AD 62, but it is generally thought to have been erected originally in early imperial times as an athletic field (*campus*) for young men, in emulation of Augustus' promotion of sport in Rome.[84] The conventional date of the building is based upon the facts that: (1) graffiti were found scratched on the walls of the porticoes attesting to the fact that the *iuvenes* (youth) of Pompeii exercised here,[85] and (2) Augustus is said to have been the first to organize the *Iuvenalia*.[86] There are no convincing grounds, however, for such a dating, in part since the *iuventus* has republican precedents.[87]

51. R.E.M., Wheeler, "The Roman Amphitheatre at Caerleon, Monmouthshire," *Archaeologia* 78 (1928) pl. 18.

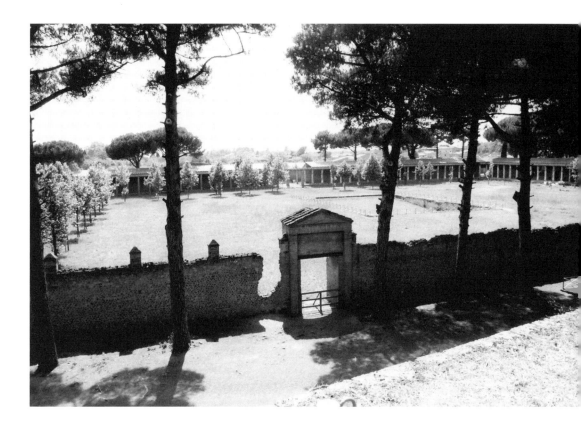

52. View of the "Palestra Grande" at Pompeii, looking northwest from the amphitheatre (photo, author).

Let us consider the possibility that the Palestra Grande dates to an earlier period. An analogy from Spain provides some support for this view. At Emporiae, a veteran colony of Julius Caesar,[88] there is an amphitheatre in the southwestern sector of the city just outside the city wall. Adjacent to and contemporary with it is a large rectangular enclosure (Figure 53) with which the following inscription has been associated: "Caecilius Macer, son of Lucius, of the Galerian tribe, aedile, duovir, oversaw the construction of the *campus* using his own money and likewise approved it."[89] The style of the lettering and the republican spelling of "curavit" indicate that the inscription is late republican or Caesarian/Augustan in date (and by extension that the *campus* is too).[90] The spatial configuration of the amphitheatre and the *campus* at Emporiae is comparable to that of the amphitheatre and Palestra Grande at Pompeii (see Figure 114 in Appendix). And the formula of the inscription is also strikingly similar to the dedicatory inscription of the amphitheatre at Pompeii. Moreover, the type of person who built it (veteran colonist) is analogous to those who built the amphitheatre at Pompeii.

On the basis of analogy with this late-republican veteran colony in Spain, we may suggest that the Palestra Grande at Pompeii was not a creation of

the early imperial period but was initially dedicated by the Sullan colonists, as an exercise ground (*campus*) for the young men of the city, where they might engage in sports and undergo training for military service. Indeed, in Rome, soldiers had traditionally undergone their training in the *Campus Martius* (hence, the association of this part of Rome with Mars), and the *campus* (parade ground) attached to a legionary fortress was where soldiers practiced fighting while on campaign.[91]

Further support comes from a republican inscription from Nola, which like Pompeii was a Sullan colony, that records the setting up of a *campus* and some other structures, dedicated "for the *genius* [collective spirit] of the colony and of the colonists" (see also Appendix, Cat. 13).[92] Just as the dedicatory inscription of the amphitheatre at Pompeii specifically associated this building with the colonists, at Nola the *campus* is associated with the colonists. On the basis of all of this evidence, we may propose that the Palestra Grande at Pompeii was laid out together with the amphitheatre,

53. Plan of Emporiae (Ampurias), Spain (E. Ripoll, *Ampurias*, Barcelona, 1977).

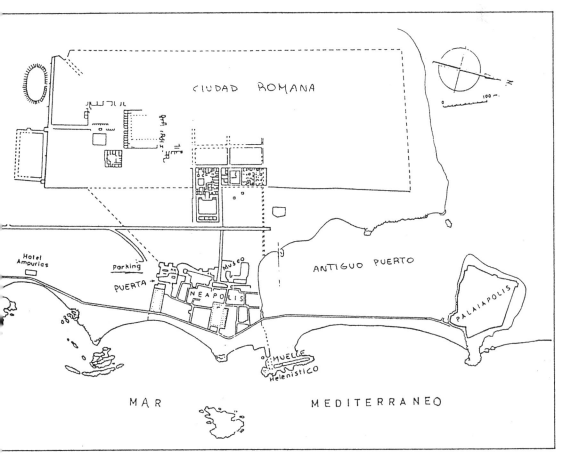

the two buildings serving the new colony as a kind of Roman and legionary cultural "package."

There are apparently traces beneath both the amphitheatre at Pompeii and the adjacent Palestra Grande of second century BC middle class housing, of the type one finds in the whole neighborhood around the amphitheatre.[93] This presents the possibility that the Sullan colonists purposely destroyed a large sector of local housing to accomodate their new buildings – an action that would not be out of keeping with what we know of how they operated in general (they seem to have done something similar at Nola: Appendix Cat. 13).

A close association between the amphitheatre and the *campus* is also supported by what we know of the activities of the *iuvenes*. First, high-ranking individuals in this organization are known to have built amphitheatres. Indeed, inscriptions reveal that the builder of the Tiberian amphitheatre at Lucus Feroniae in Latium was the *magister* (leader) of the *collegium Iuventutis* (association of the *iuvenes*) of that city.[94] Second, as part of their training, *iuvenes* practiced combats with animals, contests of swordsmanship, and gladiatorial games.[95] An epitaph from Carsulae in Italy records an individual who was a *pinnirapus iuvenum* (gladiator who fought with trident and net) "of the *iuvenes*."[96] This inscription and other evidence indicate that the *iuvenes* played in the arena at being gladiators and *bestiarii*.[97]

We know that the *campus* at Pompeii was used by the *iuvenes* (because of the graffiti found there; see earlier), and it is possible that the amphitheatre could also have been used for the public displays of the *iuvenes*, before the assembled populace of the city (whereas the *campus*, which lacks seating, would have been used for practice, with or without spectators). A supporting piece of evidence for this idea is an imperial epitaph recording a *iuvenis*, who in his hometown of Aquae Sextiae (Aix-en-Provence) performed publicly as a *venator* probably in the local amphitheatre (which is called *harena* in the inscription).[98]

All of this lends credence to the seemingly bizarre story that Domitian invited an ex-consul to his estates in Alba Longa to participate in a fight with a lion as part of the emperor's *iuvenalia*.[99] This event was noted by Cassius Dio not because it was unusual for beast fighting to take place as part of the *iuvenalia* festival but because it was considered inappropriate for an ex-consul to perform as a *bestiarius*. This disapproval had to do with the fact that, since AD 11, individuals of senatorial and equestrian status had been officially forbidden to perform publicly either on the stage or in the arena[100] (which is presumably why this event took place in Domitian's extra-urban villa, far from the public eye).

In spite of the prohibition, however, some elite members of Roman society continued to perform publicly as gladiators[101] (the emperor Commodus

being the most notorious example[102]), and the different possible motives for this have been the subject of much speculation. B. Levick (n. 100) suggests that severe financial problems, or the desire to escape a disgraceful situation, may have caused some members of the upper classes to take the gladiatorial oath (which meant the loss of freedom and citizenship status).[103] As she and other scholars note, however, it is probable that not all such people actually did take the oath; most probably performed on only one or a few occasions in the arena, returning to their regular lives when the spectacle was over, though henceforth they would be barred from sitting among the equestrians and senators when they attended public shows.[104] C. Barton (following G. Ville) assumes that elite volunteers were seeking morbid pleasures and had fallen victim to a fascination with debasement that characterized the early imperial period.[105]

Another possible explanation for the elite Roman desire to fight in the amphitheatre is not nearly so titillating, however. In republican Rome, young men of rank had publicly practiced riding and swordsmanship in the *Campus Martius*. That this could take the form of a public performance is suggested by the fact that betting was involved.[106] At a municipal level the same activities were performed in a *campus* laid out specifically for this purpose, as at Pompeii. During occasional festivals, young men in the cities of Italy may have performed publicly as gladiators in the local amphitheatre, as the evidence cited previously suggests. That this was going on not only in the towns of Italy but also in the capital is indicated by some passages that mention senators and equestrians fighting publicly in the arena as gladiators in the games of Julius Caesar[107] and even earlier in the second century BC.[108] In the Caesarian episodes, it is clear that the venue in which the high-ranking Romans fought was the *Forum Romanum*. In the earlier instances, no indication of venue is provided. The Roman Forum is a possibility, but one suspects that it was instead the *Campus Martius*, the traditional venue for such elite activities in the city of Rome. The staging of combats involving elite gladiators in the *Forum Romanum* under Caesar would, then, be an innovation not out of keeping with the time.

The eventual stigmatization of this type of activity beginning in the reign of Augustus may be connected with an agenda of promoting dignified behavior in the ranks of the elite, as is often assumed, but it may also have had a more political purpose in limiting the possibilities of aristocratic self-advertisement in the public sphere. In summary, the republican tradition of elite youths performing publicly as gladiators surely played a role in the desire on the part of some members of the elite to perform publicly in the amphitheatre during the early imperial period. Here again we see how a consideration of evidence from the Republic can shed important light on a phenomenon of the arena often thought to be specific to the Imperial period.

Conclusion

This chapter demonstrates a close connection between Roman coloniza-
tion and the inception of stone amphitheatres in late republican times.
The amphitheatre at Pompeii, which we used as a test case because it is
exceptionally well documented, was dedicated specifically to/for Sulla's
veteran colonists. It has been argued that army veterans had a particular
appetite for building amphitheatres because of their familiarity with glad-
iatorial techniques, which had become part of Roman army training after
105 BC, and which soldiers watched as recreation while on campaign. The
campus at Pompeii (Palestra Grande), it has also been suggested, was ini-
tially laid out together with the amphitheatre in the Sullan period to create
an architectural complex devoted to military-style entertainment and to
military training, both of which were important to veteran colonists.

When stone amphitheatres made their initial appearance in the late re-
publican period, they did so suddenly, as it were, fully formed with *vela*,
vomitoria, annular passages for circulation, and oval arenas. Where we can
judge, Pompeii was perhaps the most primitive in terms of its façade and
spectator access. Yet there are no evident major stages of development in
early amphitheatres, suggesting that their architects were relying on an au-
thoritative prototype. Aside from Pompeii, the other amphitheatres dating
to the republican period (most of which are located in Campania) were all
built in places with particularly close connections to Rome, suggesting that
their prototype is to be found in the capital.

It has been proposed that the model for early stone amphitheatres was
provided by the temporary wooden arenas for gladiatorial games, located
in the Forum in Rome, which had assumed an oval shape at least by the
later second century BC (see Chapter Two), not long before the stone am-
phitheatre made its initial appearance. The connection between Rome and
the earliest stone amphitheatres is made clear by the dedicatory inscription
of the amphitheatre at Pompeii, in which the building is referred to by the
name *spectacula*, the same term used for the wooden seating arrangements
in the *Forum Romanum*. The 'styleless,' functional appearance of republi-
can amphitheatres is a reflection of the structures in the Roman Forum,
which were wooden and temporary, presumably lacking any kind of elabo-
rate architectural iconography, at least on their façades. Finally, it is worth
emphasizing that of the eight amphitheatres where we can establish the
size of the oval arena, six of them (Pompeii, Puteoli, Telesia, Cales, Nola,
and probably Cumae) have arenas of quite similar dimension, between ca.
65 and 70 m in length.[109] This coincidence is surely due to the size of the
arenas of their common prototype, the *spectacula* in the *Forum Romanum*,

which we have reconstructed (Figures 21–30) using an arena of 67 × 35 m (the same size as the extant arena at Pompeii).

We may conclude that the *spectacula* in the Roman Forum served as the model for the architecture of the earliest stone amphitheatres in the towns of Italy, where the oval form and functional appearance were proudly reproduced. Building a permanent (stone) arena was a way of establishing a particularly Roman architectural presence, which explains why so many early amphitheatres appear in colonies and why the building type became popular after the Social War, in the climate of increasing romanization in the communities of Italy, who now all had the Roman citizenship. To continue to attribute the birth of the Roman amphitheatre to Campania, therefore, is to mistake a proliferation of symptoms for their origin and cause.

CHAPTER FOUR

THE AMPHITHEATRE BETWEEN REPUBLIC AND EMPIRE: MONUMENTALIZATION OF THE BUILDING TYPE

Having investigated the origins of the Roman amphitheatre, we now turn to the second key point in the evolution of arena architecture: the monumentalization of the amphitheatre as a building type. Stone amphitheatres of the republican period had an undecorated, functional appearance, as was described in Chapter Three. Their arenas were generally dug out of the earth, and their *caveae* were embanked, rather than free standing, making these buildings in formal terms little more than 'architecturalized' terrain. Façades were low and quite plain in appearance, consisting simply of concrete retaining walls, sometimes articulated with arches and external staircases as a means of access for spectators, and with minimal vaulting beneath the *cavea* for circulation (for example, at Pompeii). This 'styleless' aesthetic seems to have derived from the wooden prototype in the *Forum Romanum* (discussed in Chapter Two). This situation changed dramatically in the Augustan period when the amphitheatre first came to be monumentalized as a building type. This chapter explores this monumentalization from an architectural, topographical, and historical point of view.

Decoration of the Façades of Early-Imperial Amphitheatres: The Tuscan Order

During the Augustan period, amphitheatres with monumental façades and an applied architectural order suddenly appeared in Rome's colonies: for example, at Augusta Emerita (Mérida) in Spain (Figures 54–56, Plate 9), Luca (Lucca) in Umbria (Figure 57), and Lupiae (Lecce) in Apulia (Figures 58 and 59), all of which have façades decorated with rusticated Tuscan pilasters in a "fornix" motif. (A fornix is an arch framed by columns or pilasters and an entablature.)[1] Characterized not only by a new emphasis on decorated façades made of cut stone (ashlar) masonry rather than simple

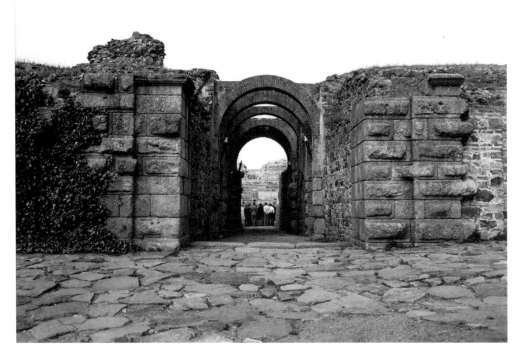

concrete, these Augustan structures also included more extensive vaulting for spectator circulation than had their republican predecessors, often with a regular rhythm of barrel-vaulted entryways running the whole circumference of the building. These are the first amphitheatres that exhibit a truly civic architectural character, as opposed to a military one (as exemplified by republican amphitheatres, such as that at Pompeii). The new importance placed upon spectator access may be connected with the Augustan *lex Julia Theatralis*, a law that rigidly segregated all the spectators (not only senators and equestrians, as previously) at public shows into different social groups, each with a predesignated seat accessible via a specific entryway to the building (as discussed in the Introduction and in Chapter Five). This type of elaborate hierarchical seating arrangement was adopted not only in Rome but also in Rome's colonies.[2]

54.
Amphitheatre at
Augusta Emerita
(Mérida), façade
(American
Academy in
Rome, Fototeca
Unione 15111).

Generally, when the façade of one of these Augustan amphitheatres is preserved, it is decorated with Tuscan elements, combined with rustication. Tuscan (which in Latin means "Etruscan")[3] is a simplified version of Doric, though differentiated from it by a plain frieze instead of by a triglyph and metope frieze. It has a simple molding of cyma recta or cyma reversa type for capitals and impost blocks, column bases of Attic type, and sometimes an astragal (necking ring) on the upper part of the column shaft. One of the finest examples of such Tuscan decoration in an Augustan amphitheatre

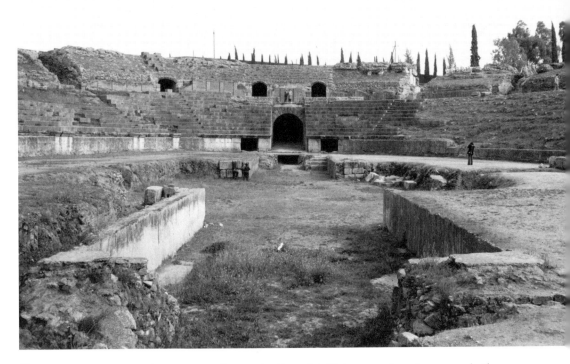

55.
Amphitheatre at
Mérida, *cavea*
(American
Academy in
Rome, Fototeca
Unione 15113).

is found at Augusta Praetoria (Aosta).[4] This was a frontier town, built as
one of Augustus' first veteran colonies in 25 BC after the subjugation of
the Salassi, a tribe that dwelt at the foot of the Alps.[5] Built as a bulwark
of Roman control in a dangerous area, Augusta Praetoria is laid out as a
castrum with sixteen main building blocks enclosed by a strong wall 10 m
high and provided with twenty towers (Figure 60). The amphitheatre was
positioned just inside the northeast corner of the ancient city walls, prob-
ably for security reasons. Part of it is now walled into the convent of
Santa Caterina. In the courtyard of this convent are the remains of the
amphitheatre's impressive Tuscan façade (Figures 61 and 62a, 62b). Here
applied half-columns are used instead of pilasters, though again together
with rustication.

Why was the Tuscan order favored (over Doric, Ionic, and Corinthian)
for Augustan amphitheatres? Aside from its functional appearance (which
was in keeping with the aesthetic of republican amphitheatres), it was
probably chosen because it had come to be seen in the early imperial period
as a distinctively Italian form of decoration. In earlier times the "Tuscan or-
der" had been used in Etruscan temples, such as the larger temple at Pyrgi,
the Ara della Regina in Tarquinia, the Portonaccio temple at Veii, and – most

notably – the Temple of Jupiter Optimus Maximus on the Capitoline Hill in Rome.[6] Tuscan had also been used for the Capitolia of Rome's colonies in the third and second centuries BC (e.g., at Cosa, Alba Fucens, Alatri, and Mons Albanus), where Tuscan columns were combined with wooden entablatures.[7] However, during the second and first centuries BC the Doric, Ionic, and especially the Corinthian orders supplanted the Tuscan order for temples and other prestigious public buildings at Rome: examples include the Doric used for the temples in the *Forum Holitorium*, the *Tabularium* and the *Basilica Aemilia*; the Ionic Temple of Portunus and the Corinthian round temple in the *Forum Boarium*; and the dynamic new kind of Corinthian temple that characterized Augustan Rome, exemplified by the Temple of Mars Ultor in Augustus' Forum and the Temple of the Dioscuri in the *Forum Romanum*.[8] The surviving evidence suggests that the relatively simple Tuscan order eased out of fashion during the late Republic, at least for prestigious civic and religious buildings. It was only during the early Empire, with the appearance of the monumental oval amphitheatre, that Tuscan again came into its own.[9]

As a newly monumentalized building type, the amphitheatre was as yet relatively low in the hierarchy of Roman building types and therefore less suited for decoration with the (privileged) Greek architectural orders. But the application of Tuscan to the façades of Augustan amphitheatres may also be connected with the new atmosphere of nostalgic patriotism that characterized the Augustan age (whose literary signposts were such works as Horace's *Carmina* and Virgil's *Aeneid*). During this period there was a great interest in Etruscan history and legend. For example, the Augustan writer Verrius Flaccus wrote a treatise called *res Etruscae*. Dionysius of Halicarnassus tells us that he was planning to devote a historical work

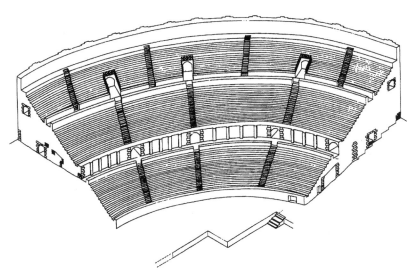

56.
Reconstruction drawing of the amphitheatre at Mérida, showing vaulting (M. Bendala Galán & R. Durán Cabello, "El anfiteatro de Augusta Emerita: rasgos arquitectónicos y problemática urbanística y cronologia" in *El anfiteatro en la Hispania Romana* [Mérida, 1994].

57.
Amphitheatre at
Luca (Lucca)
integrated into
modern housing.
(photo, J. C.
Fant).

to the Etruscans.[10] This period also witnessed a sentimental nostalgia
for the antique in religion.[11] For example, Vitruvius was pleased that the
Etruscan augural methods of inspecting livers had been revived.[12] There
were *elogia* set up at Tarquinii that celebrated Etruscan history at a time
when Tarquinii was already thoroughly romanized. There was also a cer-
tain elitism attached to Etruscan origins in Roman aristocratic circles, the
most conspicuous example being Augustus' friend and agent Maecenas.[13]
At this time it was popularly thought that gladiatorial combat was Etruscan

in origin and had been introduced to Rome by the Etruscan kings,[14] as discussed in Chapter One. The Tuscan ("Etruscan") order would, therefore, have been a natural choice at this time for decorating the newly monumentalized amphitheatre building type.[15]

The application of architectural orders to the façades of amphitheatres suggests that the status of the amphitheatre building had begun to change. A symptom of this change was the coining in Augustan times of the word *amphitheatrum* (a word derived from Greek roots, meaning a place "for looking from both sides"). The word *amphitheatrum* – a neologism with

58.
Amphitheatre at Lupiae (Lecce), façade (American Academy in Rome, Fototeca Unione 2884).

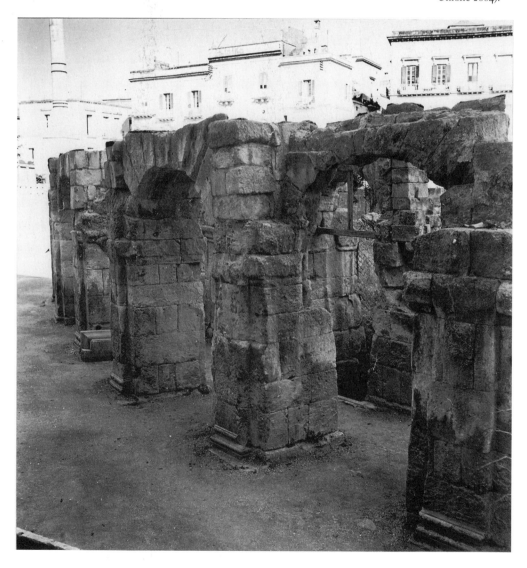

a refined, Greek ring to it – replaced the functional term *spectacula* that had been used for amphitheatres during the Republican period such as the one at Pompeii, as the word for triumphal arch – *fornix* – was replaced at this time by the more elegant word *arcus* (a Latin transcription of the Greek word for "bow").[16] Just as the stone amphitheatres of the republican period had drawn on a model from the city of Rome (the *spectacula* in the *Forum Romanum*), so these new Tuscan amphitheatres of the Augustan age seem to have drawn on an authoritative prototype in the capital: as will be argued in the following section on the amphitheatre of Statilius Taurus.

A Higher Order of Killing: Statilius Taurus and Rome's First Stone Amphitheatre

Rome's first permanent amphitheatre was erected in 30 BC in the *Campus Martius* by T. Statilius Taurus, one of the leading figures in the triumviral and Augustan periods. He paid for it with the proceeds from his spoils of war (*manubiae*), which he brought to Rome after his African campaign in 34 BC.[17] The Amphitheatre of Taurus has never excited scholarly interest and is assumed to have been relatively unimportant,[18] in large part because no trace of it survives today. But on the basis of evidence provided by the

59.
Amphitheatre at
Lupiae, (Lecce)
cavea (*D.A.I.*
Rome neg. 62.
1291).

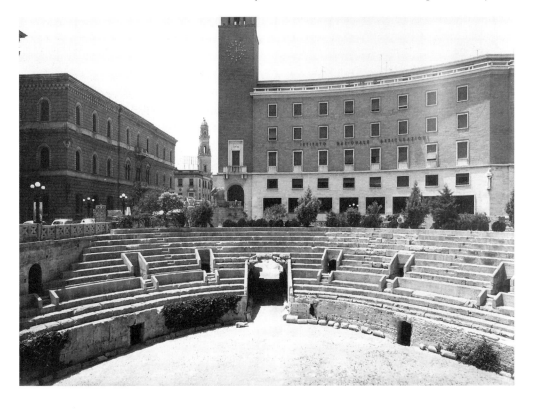

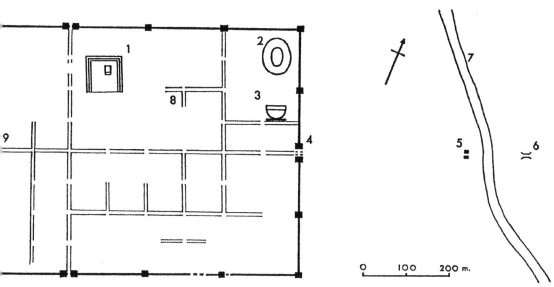

Aosta (after A. Boethius (*The Golden House of Nero*, 1960, 43, fig. 21), F. Castagnoli (*Ippodamo di Mileto e l'urbanistica ·ianta ortogonale*, 1956, 96, fig. 50) and others): 1. 'Forum'. 2. Amphitheatre. 3. Theatre. 4. 'Porta Praetoria'. 5. Arch of Augustus. 6. Roman Bridge. 7. R. Buthier. 8. Baths. 9. 'Porta Decumana'.

60. Augusta Praetoria (Aosta): plan of the city (I. Richmond, *Roman Archaeology and Art* [London, 1969] 252).

amphitheatres in Augustan colonies, by ancient literary sources, and by an eighteenth-century etching, it is possible to evoke this Amphitheatre's architectural appearance and situate it in its contemporary topographical and historical contexts. The result shows that Taurus' Amphitheatre was a very important and influential building in its time.

As discussed previously, the Tuscan order first appears in amphitheatres built in Augustan colonies, such as Augusta Praetoria, Lupiae, Luca, and Augusta Emerita. Since all of the major public buildings in these colonies were modeled on Roman prototypes, it is reasonable to suggest that the amphitheatres, with their new Tuscan façades, were also. The logical candidate for a prototype is the Amphitheatre of Statilius Taurus. Taurus' building was not only Rome's first stone amphitheatre; it was also probably the first monumental amphitheatre to have been built on level ground, since it was situated in the *Campus Martius*. Because it was built in a flat area, this amphitheatre would have had a great expanse of façade that called for decoration. By the end of the Republic, the Tuscan order had taken on an Italian significance through comparison to the Greek orders, which were now widespread in Roman architecture. Since, as we have seen, the Tuscan had a specifically Italian connotation, this order would have been a logical choice for the decoration of Rome's first permanent amphitheatre, a building that housed native forms of public entertainment: gladiatorial combat and wild animal shows.

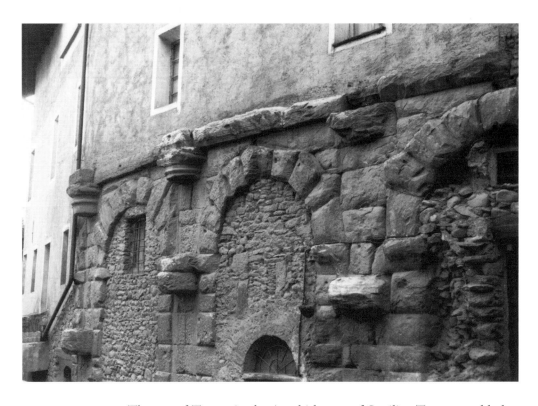

61.
Amphitheatre at Augusta Praetoria (Aosta), façade with arches walled up (photo, author).

The use of Tuscan in the Amphitheatre of Statilius Taurus would also have stood in poignant contrast to the contemporary theatre of Marcellus, begun in 23 BC and dedicated in 13 BC (Figure 63), and probably to the earlier Theater of Pompey (55 BC).[19] The Theatre of Marcellus, as a building which housed entertainment of imported mythological Greek subject matter – namely, the popular pantomime plays – was appropriately decorated in the lowest story of its façade with a Doric triglyph and metope frieze, whereas Taurus' amphitheatre, which housed Italic forms of entertainment, is likely to have displayed a suitably Italic form of decoration.

Contrary to general opinion,[20] the ancient sources make it clear that Taurus' Amphitheatre was an integral part of Augustus' great building program. Suetonius writes:

> [Augustus] also urged other prominent men to adorn the city with new monuments or to restore and embellish old ones, each according to his means. And many such works were built at that time by many men; for example the Temple of Hercules Musarum by Marcius Philippus, the Temple of Diana by Lucius Cornificius, the *Atrium Libertatis* by Asinius Pollio, the Temple of Saturn by Munatius Plancus, a Theatre by Cornelius Balbus, an Amphitheatre by Statilius Taurus; and by Marcus Agrippa in particular many magnificent structures.[21]

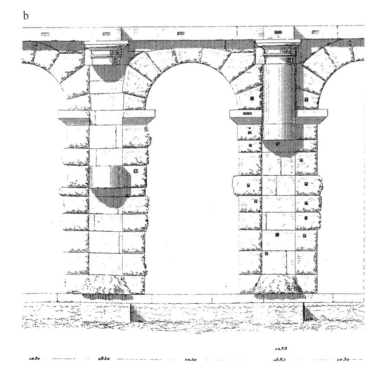

62.
(a) Amphitheatre
at Augusta
Praetoria (Aosta)
Restored section
of façade (b)
Restored
elevation of
façade (C.
Promis, *Le
antichità di Aosta*
[Torino, 1862]
tav. XI).

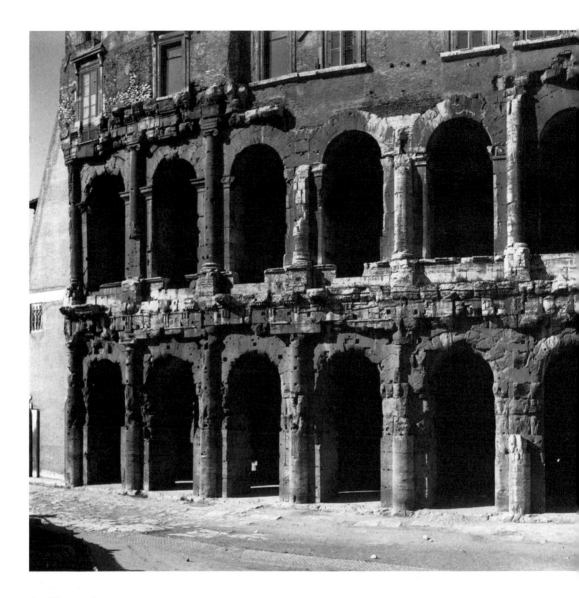

63. Theatre of Marcellus, façade (American Academy in Rome, Fototeca Unione 540).

In a passage describing M. Aemilius Lepidus' request to Tiberius for permission to restore the *Basilica Aemilia*, Tacitus adds the following acid comment: "Public munificence was a custom still. Nor had Augustus discouraged a Taurus, a Philippus, or a Balbus from devoting the trophies of his arms or the overflow of his wealth to the greater splendor of the capital and the glory of posterity."[22]

These excerpts from Suetonius and Tacitus show that Taurus' Amphitheatre was considered over one hundred years after its dedication to have been an important part of the cityscape of Augustan Rome. Why, then, do scholars assume it was not? This may be partly because the structure does not

survive, but also perhaps – as Cassius Dio mentions – because Caligula disliked the Amphitheatre of Taurus and used the *Saepta* for gladiatorial shows instead.[23] Yet Caligula did use the amphitheatre of Taurus, as we hear in Suetonius: "He gave several gladiatorial shows, some in the Amphitheatre of Taurus, some in the *Saepta*."[24] The reason for Caligula's dislike was probably that by Caligula's time (AD 37–41) the Amphitheatre of Taurus had begun to look small and old fashioned, compared to contemporary amphitheatres such as the Julio-Claudian arenas at Pola and Verona (Figures 64–66; Figure 78 in Chapter Five; Plate 10).[25] The latter amphitheatre anticipates the Colosseum in having three stories (earlier amphitheatres had had only two), in having an annular, barrel-vaulted circulation corridor behind the façade on all three levels, and in being considerably larger than earlier amphitheatres (its *cavea* is 152 m in length, as opposed to 126 m for Mérida).

Yet at the time when the Amphitheatre of Taurus was first constructed, it was an impressive building. It was the first monumental, free-standing amphitheatre with a cut stone façade and an applied architectural order. It

64. View of amphitheatre at Verona (American Academy in Rome, Fototeca Unione 13245).

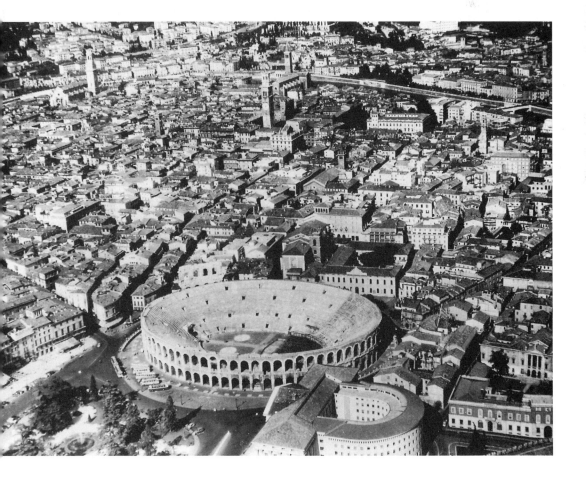

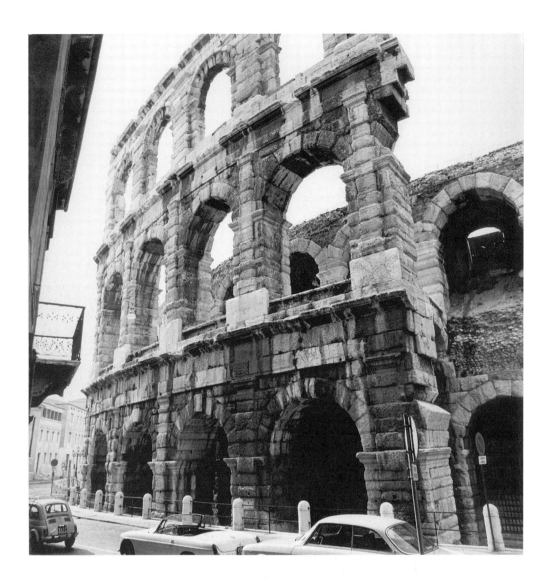

65.
Amphitheatre at
Verona, façade
(*D.A.I.* Rome
neg. 70.2282).

was, in addition, where Tiberius chose to hold funeral games in honor of
his grandfather in the 20s BC: "He gave a gladiatorial show in memory of
his father and another in memory of his grandfather, Drusus, at different
times and in different locations, the first in the Forum, and the second in
the Amphitheatre . . . "[26] Also, Augustus boasts of holding *venationes* both in
the Forum and in the Amphitheatre: "On twenty-six occasions I gave to the
people, in the Circus, in the Forum, or in the Amphitheatre, hunts of African
wild beasts, in which about three thousand five hundred beasts were slain."[27]

Cassius Dio provides us with the important chronological informa-
tion that Taurus both constructed and dedicated his Amphitheatre while

Octavian was still in his fourth consulship.[28] Octavian's fourth consul-
ship was in 30 BC; this makes the Amphitheatre of Taurus the first major
public building in Rome to be dedicated after his victory at Actium
(31 BC) and the beginning of his principate.[29] Why? I explain below. Dio
also mentions that the Amphitheatre of Taurus was made of stone. In a later
passage he tells us that the building was destroyed in the great fire of AD 64:
"The calamity which the city experienced has no parallel before or since,
except in the Gallic invasion. The whole Palatine hill, the Theatre [*sic*] of
Taurus, and nearly two thirds of the remainder of the city were burned,
and countless persons perished."[30] Dio is following a first-century source
for his description of the damage done by the great fire,[31] so the fact that

66.
Amphitheatre at
Verona, detail of
façade with
entryway "65"
(LXV) (*D.A.I.*
Rome neg.
70.2281).

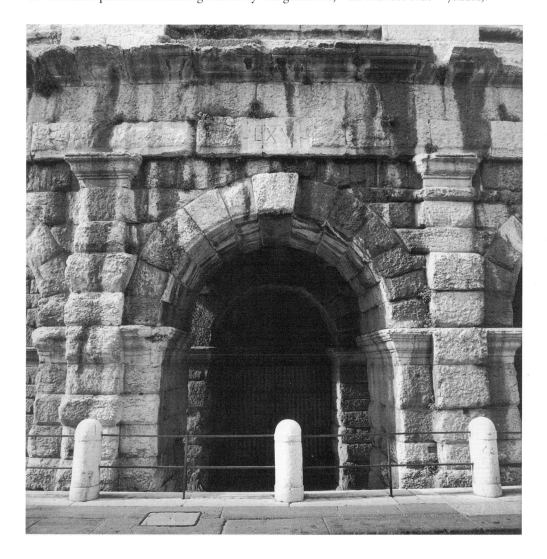

the Amphitheatre of Taurus is singled out here is another indication of its importance at the beginning of the imperial period. That it disappeared in the great fire and was not rebuilt suggests that much of the interior of the building may have been made of wood. The use of both stone and wood in amphitheatre construction was quite common in the late Republic and early Empire, as was discussed in Chapter Two. Examples include the amphitheatres at Carmo in Baetica and Corinth in Achaea; and military amphitheatres, such as those at Vindonissa in Germania Superior (Tiberian); Vetera in Germania Inferior (Claudian); Carnuntum in Pannonia Superior (Flavian). There is also a relief depicting an amphitheatre whose interior seems to have been made of wood and whose façade was executed in stone and wood (Figure 40 with discussion in Chapter Two).[32] It is not out of the question that this relief actually depicts the Amphitheatre of Taurus.

Epigraphy reveals that a large number of Taurus' freedmen and slaves were involved in his Amphitheatre's construction and maintenance. The tomb of the Statilii near the Porta Maggiore has yielded over 400 epitaphs of the family's freedmen and slaves.[33] Several inscriptions show that members of this *familia* were involved in the maintenance of Taurus' Amphitheatre.

1. *Charito / custos / de amphitheat(ro)*
2. *Menander l (ibertus) / ostiarius / ab amphitheatr(ro)*
3. *Evenus Chresti / Auctiani vicar(ius) / de amphitheatro / v(ixit) a(nnos) XXV.*[34]

Moreover, the tomb of the Statilii reveals that Taurus' *familia* was prominent in Rome's building trade. We hear of slaves and freedmen with the titles *faber*, *faber tignarius*, and *faber struc[tor] parietar[ius]* (craftsman, carpenter, and constructor of walls).[35] The family's freedmen were also prominent in the *collegium fabrum tigniarorum* (that is, the association of carpenters who work with wooden beams). Taurus also seems to have been involved in the importation of lumber to Rome from Dyrrachium, where he was *praefectus urbi* and *quinquennalis*.[36] This is another indication that the Amphitheatre of Taurus was probably made partly of stone and partly of wood (the latter perhaps comprising much of the interior; hence its destruction by fire).

That Taurus had slaves and freedmen involved in the building trade and that he had a share in the importation of lumber may explain why he constructed a large public building. However, why did he decide to build an amphitheatre instead of another type of structure? His career provides an answer to this question. Taurus was a *novus homo* of Lucanian origin. Velleius Paterculus mentions this status: "It is but rarely that men of eminence have failed to employ great men to aid them in directing their fortune, as the two Scipios employed the two Laelii, whom in all things they treated as equal to themselves, or as the deified Augustus employed M. Agrippa and after him Statilius Taurus. In the case of these men their lack of lineage

67. (*facing page*) Plan of *Campus Martius* in the Augustan period; some details controversial, particularly the shape of the Pantheon's plan (F. Coarelli, "Il Pantheon: L'apoteosi di Augusto e l'apoteosi di Romolo" *Analecta Romana Instituti Danici* 10 [1982] 43).

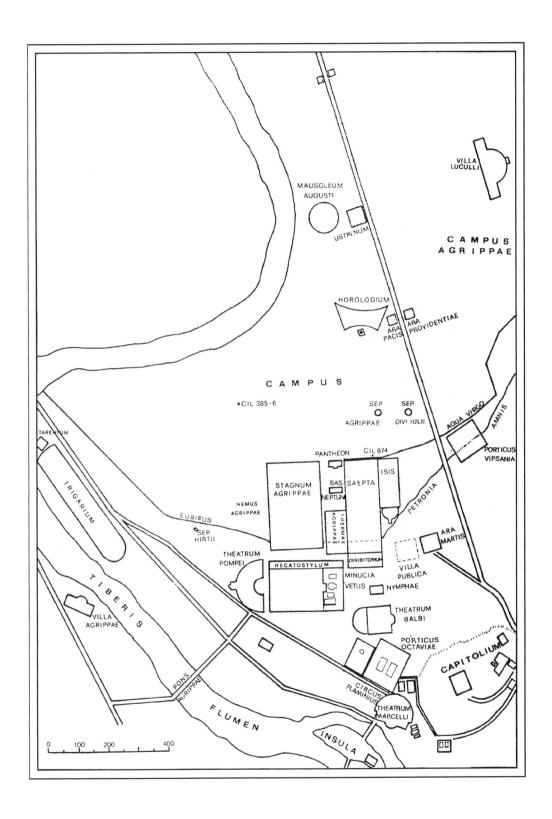

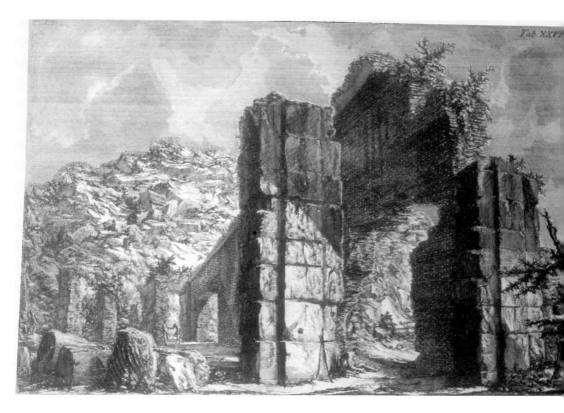

68. Etching by Piranesi showing ruin of a *cuneus* at Monte de' Cenci (*Campus Martius*, Roma 1767, pl. XXVIII).

was no obstacle to their elevation to successive consulships, triumphs, and numerous priesthoods."[37] Augustus built temples; Agrippa and Taurus built less elevated, more functional structures, the former baths, an aqueduct, and a warehouse (the Baths of Agrippa, the Aqua Virgo, and the Horrea Agrippiana), the latter an amphitheatre.[38] Just as buildings associated with water were appropriate to be sponsored by Agrippa, Augustus' great admiral at the battle of Actium, so Taurus – who had been the infantry commander in that same battle – was the right person to sponsor an amphitheatre, where gladiatorial combat took place.

In 36 BC Taurus was Octavian's general in the war against Sextus Pompey. In 34 and 33 BC he served Octavian in the Dalmatian war. After Actium (31 BC) Octavian concentrated on his eastern settlement, while Agrippa and Taurus remained in Rome and kept order. The praetorian guard, which was responsible for maintaining military security, did not yet exist, but Taurus' private troop of German soldiers may have helped to keep the peace.[39]

After his amphitheatre had been built, Taurus went back into the field; in 29 BC he defeated the Cantabri and other enemies in Spain. Having been acclaimed *imperator* three times, he retired to civilian life in the 20s.[40] He was *consul ordinarius* in 26 BC, and we last hear of him as *praefectus urbi* in 16 BC.[41]

Since their inception, monumental amphitheatres had been closely connected with Roman soldiers, who built amphitheatres in veteran colonies. As discussed in Chapter Three, the earliest closely dated stone amphitheatre, the one at Pompeii, was built for Sulla's veteran colonists. Archaeology reveals that by the imperial period, amphitheatres were a regular feature of army camps. Military men were especially interested in gladiatorial games – not only were they good military-style entertainment, but also the technique of the combat may also have been familiar to soldiers from their army training.[42] Since the monumental amphitheatre was closely connected with the Roman military ethos, it is not surprising that Rome's first stone amphitheatre was built by Statilius Taurus, the greatest military man of his time, after Agrippa, and Octavian's infantry commander par excellence. Indeed, other military men built amphitheatres in the same period, for example, at Alba Fucens and Falerii Novi.[43] Nor is it surprising that the Amphitheatre of Taurus was constructed in the *Campus Martius*, a traditional setting of army training, manubial building (that is, construction of monuments using moneys gained from the spoils of war) and aristocratic military display, as well as popular entertainment.[44]

69. Detail of R. Lanciani, *Forma Urbis* pl. XXVIII, showing radial walls at Monte de' Cenci near top, center.

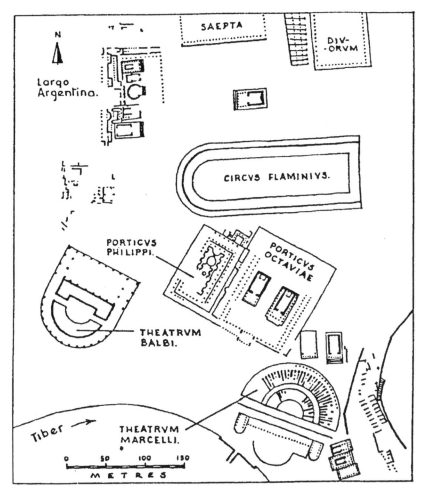

70. Location of *Circus Flaminius* before (left) and after (right) the new arrangement of the marble plan by G. Gatti (G. Lugli, *I monumenti antichi di Roma e suburbio* III [Roma, 1938]).

a

As for the location of Taurus' Amphitheatre, the Augustan geographer Strabo gives the most explicit reference. When describing the *Campus Martius*, Strabo mentions the splendor of the buildings of Pompey and Agrippa and then says: "Near the *Campus Martius* is another campus with colonnades round about it in great numbers and sacred precincts, as well as three theatres, and an amphitheatre, and very costly temples, all in close succession to one another, giving one the impression that they are trying, as it were, to declare the rest of the city a mere accessory."[45] By the words "another campus" Strabo can only mean the area of the *Circus Flaminius* in the southern *Campus Martius*, where three theatres are known to have been located: those of Pompey, Marcellus, and Balbus (Figure 67).[46]

In the eighteenth century, Piranesi etched the remains of a vaulted substructure that was part of a *cavea* with a rusticated Tuscan pilaster order on the façade (Figure 68). In his description of the etching, he named the

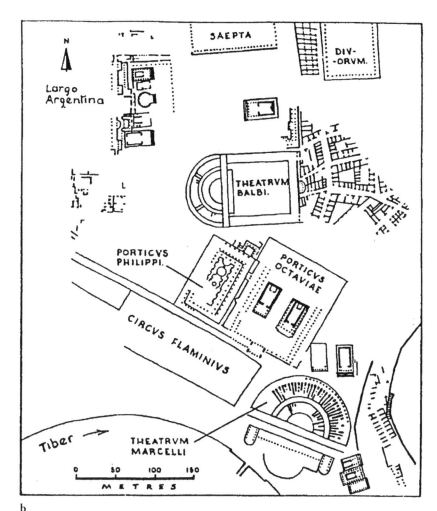

b

70. (*continued*)

location as the Monte de' Cenci (just east of the modern Via Arenula) and labeled the substructure "*Theatrum Balbi*" (Theatre of Balbus).[47] In his notes to the *Campo Marzio* volume, Piranesi describes these ruins as being located in the basement of a wine shop between the Palazzo Cenci and the bank of the Tiber river.[48] A half-century later Antonio Nibby[49] mentions this discovery of Piranesi, writing that the ruin still existed in his own day in a tannery under San Tommaso a' Cenci on the Via di San Bartolomeo de' Vaccinari opposite the bank of the Tiber.[50] In R. Lanciani's *Forma Urbis Romae*, these walls are plotted in the southwest corner of the Palazzo Cenci (Figure 69).[51] Although there is no trace today of these walls in this part of the Monte de' Cenci, we can be sure that the ruin that these men saw did exist, but – in fact – did not belong to the Theatre of Balbus.

Indeed, until 1960, the Theatre of Balbus was always assumed to have been located at Monte de' Cenci in the Jewish Ghetto area of Rome, and

71. Piranesi's walls reconstructed as part of the *Circus Flaminius* (G. Marchetti Longhi, "Nouvi aspetti della topografia dell'Campo Marzio di Roma" *MEFRA* 82 [1970]).

the *Circus Flaminius* was thought to be around 200 m to the northeast, just south of the Via delle Botteghe Oscure. By joining together previously unplaced fragments of the Severan marble plan, however, G. Gatti was able to demonstrate that the *Circus Flaminius* was actually located between the *Porticus Octaviae* and the Tiber. The ruins beneath the Via delle Botteghe Oscure were then identified as the site of "Crypta Balbi," and the remains of the *cavea* below Palazzo Mattei were shown to belong to the Theatre of Balbus (Figure 70).[52]

When it had been determined that the remains recorded by Piranesi at Monte de' Cenci could not have belonged to the Theatre of Balbus, Gatti in 1960 and later G. Marchetti Longhi in 1970 suggested that they might instead have been part of the curved end of the *Circus Flaminius* (Figure 71).[53] However, we now know from a fragment of the Severan marble plan (Figure 72) that in the imperial period the *Circus Flaminius* was not a circus in the proper sense of a racetrack with vaults supporting a *cavea*. It was in fact simply an open space bounded by the Theatre of Marcellus and colonnades and temples. Marchetti Longhi had suggested in a footnote that the

72. Fragment of Severan Marble Plan showing *Circus Flaminius* (G. Marchetti Longhi, "Nouvi aspetti della topografia dell'Campo Marzio di Roma" *MEFRA* 82 [1970]).

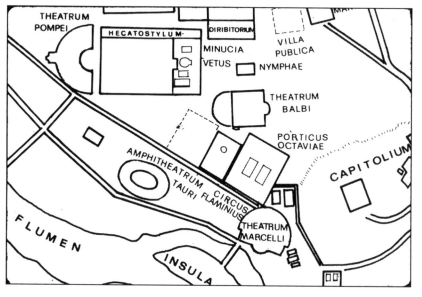

73. Location of Amphitheatre of Statilius Taurus, as first proposed by G. Marchetti Longhi (after F. Coarelli, "Il Pantheon: L'apoteosi di Augusto e l' apoteosi di Romolo" *Analecta Romana Instituti Danici* 10 [1983] 43 [detail]).

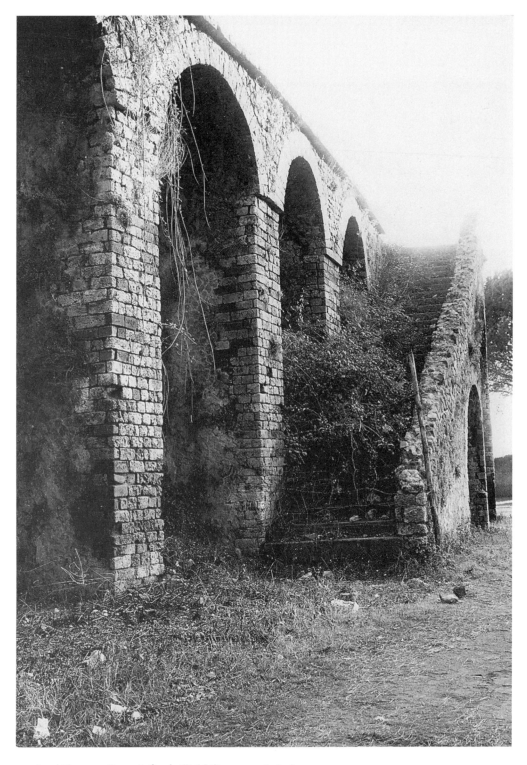

74. Amphitheatre at Pompeii, façade (*D.A.I.* Rome neg. 67.624).

radial walls seen by Piranesi could have been part of the Amphitheatre of Statilius Taurus, and several other scholars have since tacitly accepted this identification.[54]

Strabo's description (see earlier) indicates that Taurus' Amphitheatre must have stood quite close to the west end of the *Circus Flaminius* (that is, in the area of the modern Monte de' Cenci), because there is no space farther east for an amphitheatre, even a small one, in this crowded part of the southern *Campus Martius* (Figure 73).[55] The radial walls with a rusticated Tuscan pilaster order drawn by Piranesi (Figure 68) and identified by him as being beneath the Monte de' Cenci, then, can quite plausibly be identified as the remains of part of the façade of the Amphitheatre of Statilius Taurus. Here we have an amphitheatre that in its façade closely resembles the Augustan amphitheatres at Luca, Lupiae, and Augusta Emerita (Figures 54, 57, 58) and that, because of its location in the capital and its early date – 30 BC – was probably their prototype.

As mentioned previously, Taurus' Amphitheatre, the first stone one in Rome, was both constructed and dedicated while Octavian was still in his fourth consulship, that is, by the end of 30 BC.[56] That the Amphitheatre was

75.
Amphitheatre at Capua, façade (American Academy in Rome, Fototeca Unione 5320).

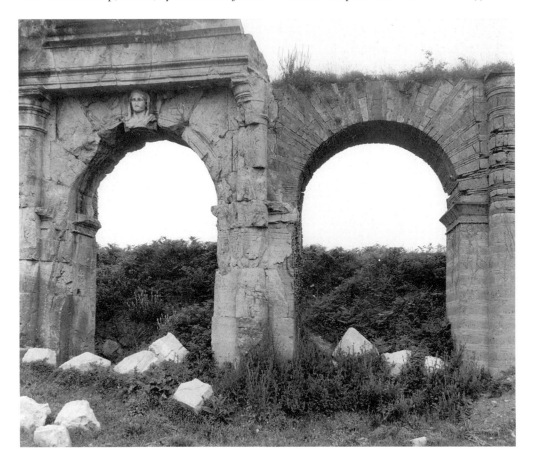

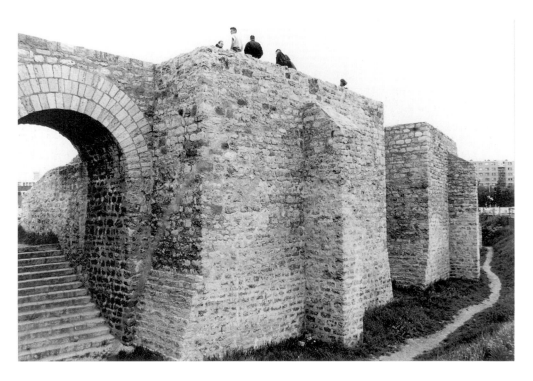

76.
Amphitheatre at
Aquincum
(Budapest),
façade (partial
modern
restoration)
(photo, author).

built so quickly, we may now suggest, was because it needed to be finished in time for the great Triple Triumph of Octavian, which celebrated the Dalmatian wars and the battle of Actium.[57] In both of these wars, Taurus had been an instrumental figure. On August 13, 29 BC, the first day of that triumph, therefore, we must imagine the proud soldiers of Octavian, Taurus, and Agrippa, and the other participants of the triumph being arranged into a procession in the *Circus Flaminius* (where the triumph generally mustered and where at that time the Theatre of Marcellus had not yet been built),[58] in the very shadow of Taurus' new, monumental Amphitheatre, decorated with the sturdy, newly revived Tuscan order (Figures 68 and 73). There was no better person than the great infantry commander Taurus for Augustus to allow to take credit for the monumentalization of a building type that was dear to soldiers and whose raison d'être was the sport of combat.

Conclusion

The Amphitheatre of Statilius Taurus is our missing architectural link between early amphitheatres such as Pompeii (Figure 74), with their unadorned concrete piers, and the great amphitheatres of the imperial period, such as the Colosseum and the amphitheatre at Capua (Figure 75, Plate 11), both of which use the Tuscan order on the façade in their first stories.

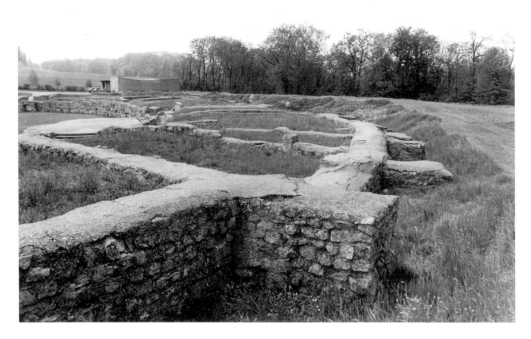

77.
Amphitheatre at
Carnuntum,
(near Vienna)
façade (photo,
author).

The new prominence and monumentalization of this building type in the city of Rome during the Augustan period explains the exponential proliferation of amphitheatres throughout Italy and the western provinces during the Augustan and Julio-Claudian periods (a notable and unusual example in the East being the amphitheatre built by Rome-friendly Herod the Great at Caesarea Maritima).[59] Taurus' Amphitheatre was their ultimate model.

It was the Augustan age, then, that witnessed the appearance of the amphitheatre as a monumental, civic building type. Vitruvius wrote too early to have witnessed this important architectural development,[60] which probably explains why there is no discussion of the amphitheatre as a building type in his *De Architectura* (just as there is no discussion of the newly canonized Augustan Corinthian order for temples).[61]

From the Augustan period on, one may discern two strands in amphitheatre architecture, a new civilian one exemplified by the Amphitheatre of Statilius Taurus and its followers, for example, the Julio-Claudian amphitheatres at Verona (Figures 65, 66, and 78) and at Pula in Istria (modern Pola in Croatia), and the continuation of the old military one, seen first at Pompeii and later during the High Empire in the many amphitheatres, both civilian and military, on the Roman frontiers, for example, at Aquincum (Budapest) and Carnuntum (near Vienna) in Pannonia (Figures 76 and 77).[62]

THE COLOSSEUM: CANONIZATION OF THE AMPHITHEATRE BUILDING TYPE

We have seen that the amphitheatre originated as a temporary wooden structure in the *Forum Romanum* during the republican period and was initially disseminated as a permanent stone building in Italy during the first century BC by Roman colonists. It then came to be monumentalized in Rome early in the reign of Augustus with the Amphitheatre of Statilius Taurus (30 BC). The period of the amphitheatre's origins and its initial monumentalization constitute the first and second important phases, respectively, in the architectural evolution of the amphitheatre. This chapter explores the third and final key point in this evolution: its canonization as a building type.

The Amphitheatre of Statilius Taurus was the prototype for the many monumental amphitheatres that were built in Italy and the western provinces, beginning in the Augustan age and continuing through Julio-Claudian times. By the later Julio-Claudian period, some of these amphitheatres had become quite large and sophisticated in terms of *cavea* substructures for spectator circulation, for example, the amphitheatres at Pola and Verona (Figure 78).[1] All of them (as far as the surviving evidence allows us to determine), however, continued the tradition of using Tuscan half-columns or pilasters on their façades (Figures 65 and 66, Plate 9), as, we have argued, the Amphitheatre of Statilius Taurus originally did. The robust Tuscan order was part of the native Italic architectural repertoire and was thus appropriate for a building type that housed autochthonous spectacles. It was also fitting for a building type that was relatively new and less elevated in the hierarchy of Roman building than, for example, temples (which in the Augustan period generally used the Corinthian order), or theatres (such as the Theatre of Marcellus [Figure 79], which used the Doric, Ionic, and [probably] Corinthian order on its façade).[2]

This situation changed with the construction of the Flavian Amphitheatre, or Colosseum, dedicated in AD 80 by the emperor Titus (Figure 80, Plate 1). This building's façade was embellished with Greek architectural

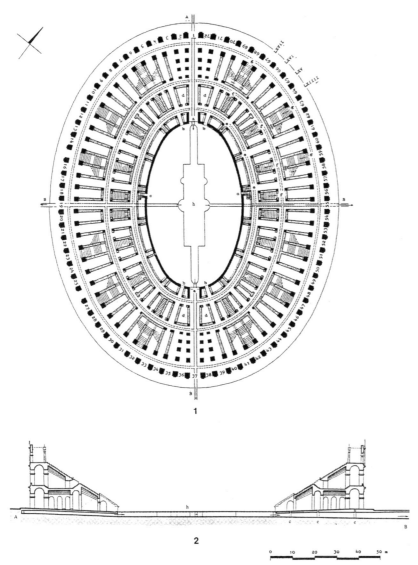

1

2

0 10 20 30 40 50 m

Amphithéâtre de *VERONA* (Vérone). — 1. Niveau inférieur : a) entrées axiales. b) portes de service. c) escaliers de liaison avec les loges. d) pièces de service. e) escaliers du *podium*. f) escaliers d'accès à l'*ima cavea*. g) escaliers d'accès à la *media cavea* et à la *summa cavea*. h) bassin central. A. aqueduc; B. égout d'évacuation du bassin central. — 2. Coupe longitudinale. A. arrivée de l'aqueduc; B. égout d'évacuation; C. branchement des égouts annulaires.

78.
Amphitheatre at
Verona, plan and
section (Golvin
1988). pl.
XXXIII).

orders, painted architectural sculpture in the *cavea*, and statuary on the façade. No earlier amphitheatre had looked like the Colosseum, and all securely dated amphitheatres built in important cities after the Colosseum self-consciously draw on it in certain aspects of construction and decoration.[3] Good examples are the Flavian amphitheatre at Puteoli and the Hadrianic amphitheatre at Capua (Figures 75 and 81).[4] The Colosseum canonized the architectural type of the monumental amphitheatre

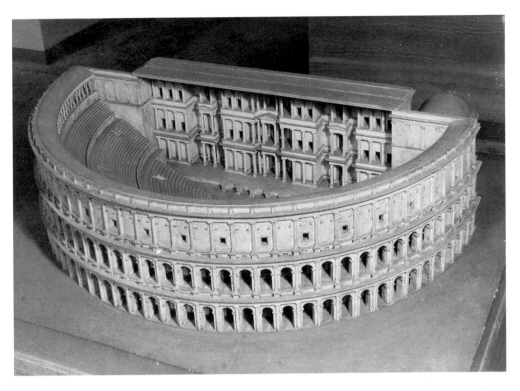

79. Theatre of Marcellus, model in the Museo della Civiltà Romana (*D.A.I.* Rome neg. 73.998).

throughout the Roman Empire. We may now examine this building in some detail, exploring its patronage and contemporary reception, as well as the social and political circumstances of its erection.

The Innovation of the Colosseum's Façade: Greek Architectural Orders and Sculptural Decoration

In AD 64 the Amphitheatre of Taurus was destroyed in the great fire, and Rome was left without a permanent stone amphitheatre. Some years earlier in AD 57 Nero had constructed an amphitheatre in the *Campus Martius*.[5] Nothing of Nero's amphitheatre survives, but we know from literary sources that it was large, made of wood, and was built on level ground. We know next to nothing of its appearance, however, except some details of the elaborate appearance of its interior.[6] The façade of the amphitheatre of Nero, however, is not very likely to have been elaborately decorated with applied architectural orders, because the building was evidently made entirely of wood. It is, moreover, not clear whether this amphitheatre was meant to be permanent. Indeed, we hear nothing more about it after AD 57.

Construction of a new stone amphitheatre was begun early in the reign of Nero's successor, Vespasian (AD 69–79), on the site of what had been

the artificial lake of Nero's *Domus Aurea* (Golden House). The Flavian Amphitheatre, or Colosseum as it later came to be called, was dedicated by Vespasian's son Titus in AD 80 and was inaugurated with a 100-day-long festival of gladiatorial games, wild beast shows, executions, and *naumachiae*.[7] The largest amphitheatre ever built in the Roman world (it measured 188 × 156 m and accommodated ca. 50,000 people), the Colosseum together with its annex buildings (the barracks for arena combatants – *Ludus Magnus* and *Ludus Matutinus*; the *Summum Choragium* [facility for the construction and storage of scenery]; a hospital; an armory; and barracks for the army of men who worked the awnings, etc.)[8] occupied a vast tract of choice real estate in the center of downtown Rome.[9] The new amphitheatre was located at a confluence of several major thoroughfares (the *Via Sacra*, the *Vicus Sandilarius*, the *Via Tusculana*, and the *Via Labicana*) between the *Forum Romanum* and the Oppian, Caelian, and Velian hills (Figure 82). One may

80. Colosseum, façade (American Academy in Rome, Fototeca Unione 6261).

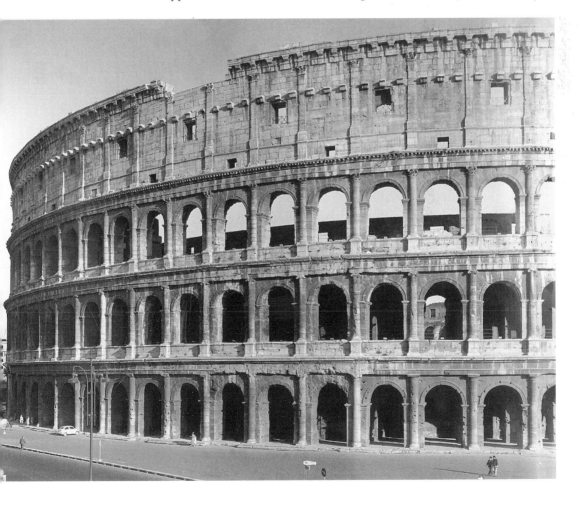

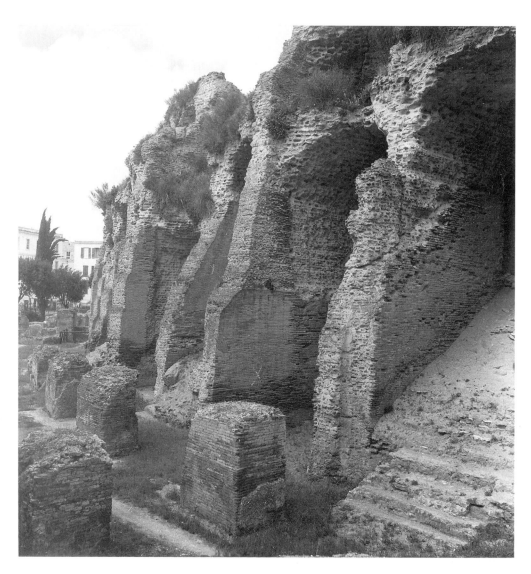

81. Imperial amphitheatre at Puteoli, *cavea* substructures (American Academy in Rome, Fototeca Unione 2640).

say that the Colosseum towered over the Roman cityscape (Figure 83), in much the way that cathedrals later towered over medieval towns.[10]

This was an unusual choice of site for an amphitheatre in the urban landscape, since amphitheatres were usually located at the edge of town. The Amphitheatre of Statilius Taurus had been located in the *Campus Martius*, outside the civic center of Rome and outside the *pomerium*. The central location of the Colosseum was suitable, however, for a number of practical reasons. The tract of land was already owned by the imperial family; the earth there, made of a compact clay, could sustain a great deal of weight; and the area had already been excavated and was equipped with a drainage

system (for Nero's lake, see following). In addition, the choice of location may have been influenced by an awareness on Vespasian's part that Augustus had once wanted to build an amphitheatre "in the middle of the city."[11] Finally and most importantly, there was the ideological convenience of the location of a major public entertainment building at the center of what had been the sprawling palace complex of Nero, with whom the emperor Vespasian seems to have made a concerted effort to contrast himself (see following). A further reason is surely that the location fit well with the

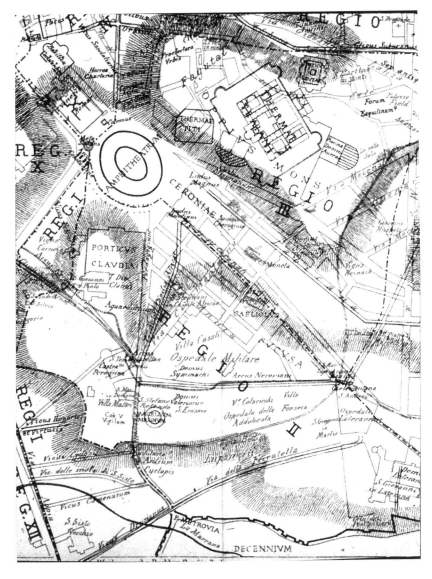

82. Plan of the Colosseum valley, Esquiline, and Caelian hills (H. Jordan & Ch. Hülsen, *Topographie der Stadt Rom im Altertum* I 3 [Berlin, 1907] pl. V).

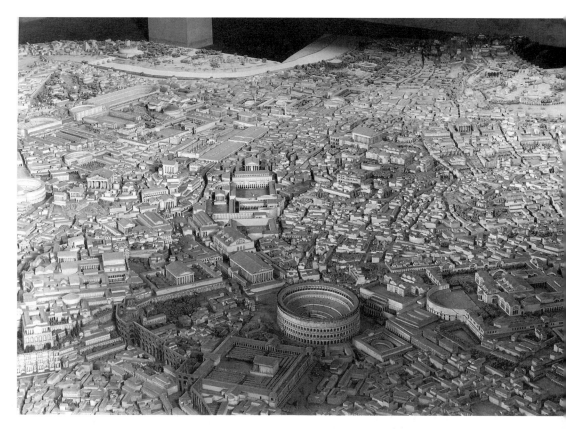

83. Model of
Rome, Museo
della Civiltà
Romana (*D.A.I.*
Rome neg.
68.1042).

traditional way in which Vespasian chose to represent himself to the Roman
people.[12] The Colosseum was close to (and, indeed, its façade was even
visible from) the *Forum Romanum* (Figure 84), the time-honored venue of
gladiatorial spectacles throughout the republican period (Plate 5).

The Flavian amphitheatre was a magnificent feat of design and engineer-
ing both in its *cavea* substructures and in its basement structures (Figures 85
and 86).[13] Its foundation consisted of a massive elliptical ring of concrete,
the lower part of which was encased in a great trench, whereas the upper
part was contained within a ring of brick-faced concrete, into which myriad
conduits drained water from the great bulk of the building above.[14] The
building was surrounded by a pavement in travertine that extended out
ca. 17.5 m from the façade. The amphitheatre itself consisted of a vast
framework of travertine piers, between which were inserted radial walls, in
the first and second stories made of squared tufa blocks and in the third story
and attic made of brick-faced concrete. On its first three levels, the building
had two annular peripheral galleries behind the façade for spectator circu-
lation (previous amphitheatres, such as the one at Verona [Figure 78] had
only single annular galleries). These galleries are all barrel vaulted, except

the inner gallery on the second story, which is groin vaulted[15] (an early instance of groin vaulting in Roman architecture). An intricate system of staircases on four levels led from these corridors to the *vomitoria* (entryways), which issued into the *cunei* (wedges) in the four different *maeniana*, or seating sections of the Colosseum (Figure 87).

The Colosseum's exterior consisted of four stories of travertine in *opus quadratum* (cut stone) that reach a height of about 50 m (Figure 80). The building was accessible by means of two steps that led up to it from ground level. (These are now partially obscured by the modern paving.) Each of the first three stories had 80 arches (each 2.70 m wide; 240 in all) flanked by half-columns in a "fornix" motif. At ground level the arches served as access points to the building for spectators. On the second and third stories, each arch had a parapet wall at its foot. On the ground floor, the arched openings are flanked by Tuscan half-columns on bases, on the second story by Ionic half-columns on pedestals, and on the third by Corinthian half-columns on pedestals. The attic story is formed by a wall articulated by Corinthian

84. Aerial view of the Colosseum, with *Forum Romanum* in background (American Academy in Rome, Fototeca Unione 4370F).

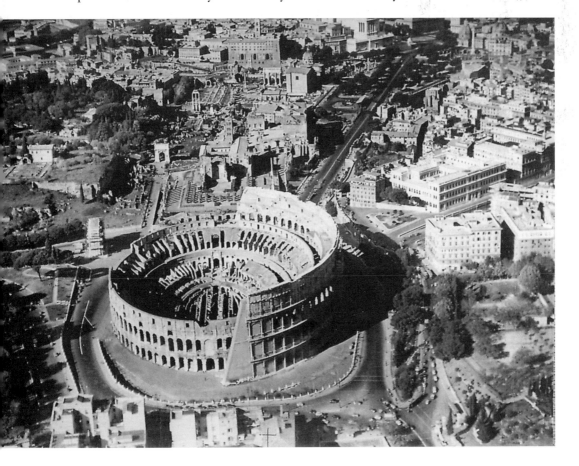

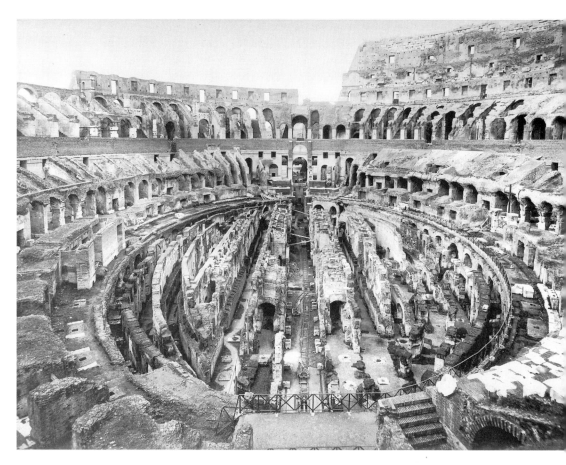

85. Colosseum, view of *cavea* and basement structures (*D.A.I.* Rome neg. 77.1435).

pilasters on high pedestals, the positioning of which corresponds to the columnar orders on the levels below. At attic level each bay has three projecting corbels (close to the cornice) into which were socketed the masts (240 in all) that held a large movable awning, extending over the amphitheatre and protecting spectators from the sun.[16] Every other bay at attic level contains a square opening. The bays in between were decorated with shields (presumably of gilded bronze), as we know from numismatic evidence (Figure 88).[17] Coins also show a triumphal arch in the first story, atop which is a *quadriga* (four-horse chariot), marking the entrance leading to the imperial box, located at the minor axis of the building in its western sector.

The coins show another feature of the façade that is significant to our theme. On the second and third stories, the *fornices* contained statues. The statues would have stood on high bases, one positioned in each *fornix* behind the parapet (Figure 88). The bases would have been visible over the parapet (Figure 88) as the parapet walls, which are a little over 2 m in height. The statues themselves were probably of uniform scale and size and

are likely to have been commissioned as a set, in gilded bronze, specifically for this monument. In order to be visible from below, they would have had to occupy about three quarters of the height of the *fornices*; that is, they had to reach the height of the impost blocks, which are located inside each arch where it begins to spring. (In the model that can be seen today in the Museo della Civiltà Romana [Figure 89], the statues appear too small.)[18] The statues were probably colossal in scale, each about 5 m in height.

A funerary relief of Trajanic date, now in the Lateran collection of the Vatican Museums, shows a series of buildings, including one that appears to be a freely depicted representation of the Colosseum's façade (Figure 90).[19] It shows the triumphal arch, and it also depicts statues in the *fornices*. The statues shown at the second level (from left to right) are: Hercules with his club and lion skin, Apollo leaning on the Delphic tripod, and a bearded Asclepius. The Hercules is in a famous statue format – the Farnese (or "weary") Hercules (a popular statue in the Roman world that was derived from an original statue of the late Classical period made by Lysippus). The Apollo is a version of the Hellenistic "Apollo Kitharoidos" or the so-called

86. Colosseum, reconstructed view and section of *cavea* and substructures (courtesy of G. C. Izenour Archive).

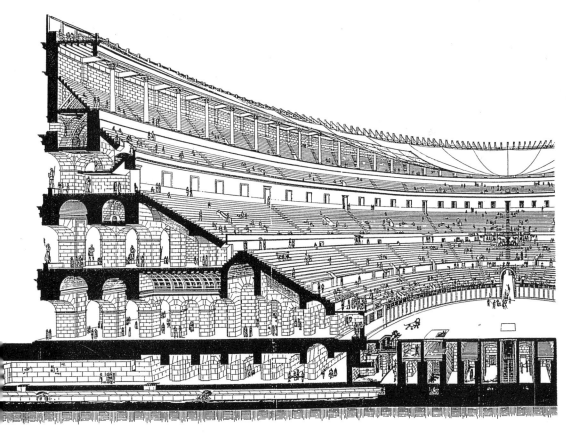

87. Colosseum,
section showing
different seating
areas (R. Rea,
"Le antiche
raffigurazione
dell'Anfiteatro"
in M. L.
Conforto et al.,
Anfiteatro Flavio
[Rome, 1988]
32–3).

Cyrene format, and the Asclepius is probably derived from a late Classical
Asclepius format.[20] This funerary relief suggests that the statues that deco-
rated the Colosseum's façade were of stock Greek types (gods and heroes).
If the statues occupied both the second and the third stories, as the coin
evidence suggests that they did, then there would have been 160 of them
present in the Colosseum's façade.[21]

The decoration of the Colosseum's façade, therefore, represents an im-
portant innovation in amphitheatre architecture.[22] Here we have an am-
phitheatre façade decorated with shields, a triumphal arch, articulated with
Greek architectural orders and filled with statues of Greek subject matter.
The Colosseum was the first amphitheatre that we know to have used Greek

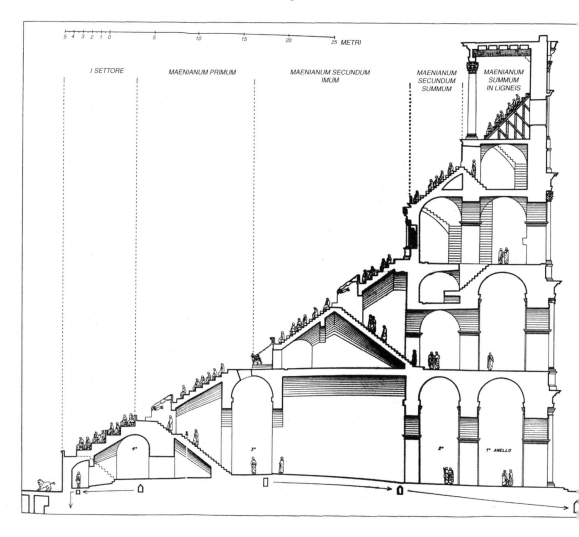

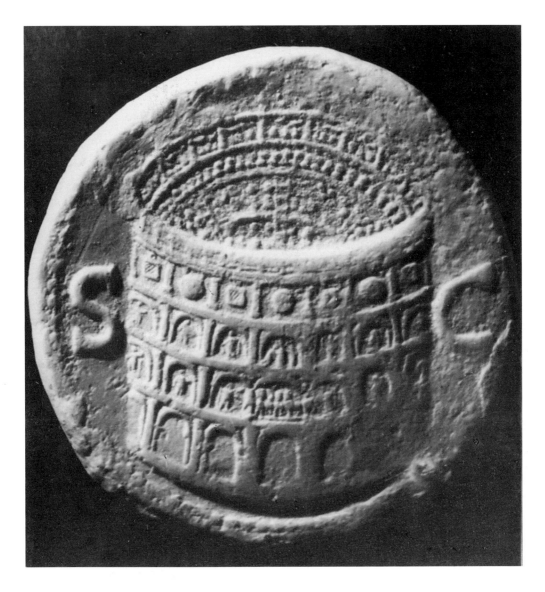

architectural orders for its façade. No earlier amphitheatre had looked like this, as far as the evidence allows us to judge. Indeed, the amphitheatre at Verona (Figures 64–66) gives a good idea of the kind of austere and rusticated Tuscan façade used for an amphitheatre in a wealthy and important Roman city in late Julio-Claudian times, shortly before the Colosseum was built.

In a general sense, the Colosseum's façade would have struck viewers as being similar to that of the Theatre of Marcellus (compare Figures 91

88. Coin of Titus (AD 80) showing Colosseum (American Academy in Rome, Fototeca Unione 4267).

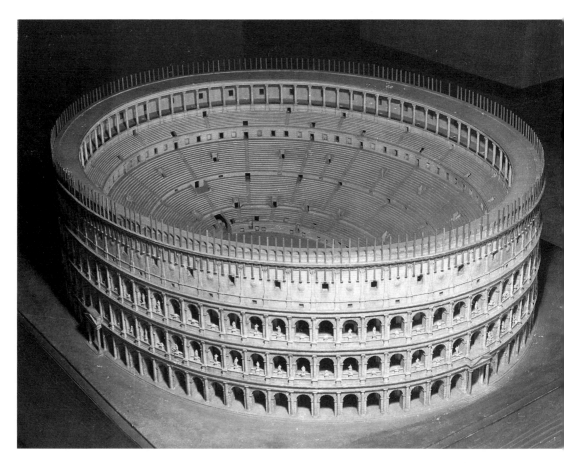

89. Colosseum, model in the Museo della Civiltà Romana (*D.A.I.* Rome neg. 73.1000).

and 92). Both have façades of several stories, incorporating arches flanked by half-columns. Like the Theatre of Marcellus, the Colosseum has an Ionic order on the second story and a Corinthian on the third story. But two important aspects were different from the Theatre of Marcellus. First, the Colosseum's façade was filled with Greek statues and decorated with shields and a triumphal arch, whereas that of the Theatre of Marcellus was evidently not. (It was decorated with theatrical masks on the keystones.[23]) The second feature of the Colosseum that would have formed a contrast with the Theatre of Marcellus was its lower order, which is Tuscan (Plate 12), not (Romanized) Doric (on which see 303 n. 19). Tuscan, as we have seen, was the native Italic order *par excellence*. It had been a feature of old republican temples, and it had become fashionable again in the Augustan and Julio-Claudian periods when it began to be used regularly in amphitheatre architecture (such as the Amphitheatre of Statilius Taurus; see Chapter Four). As patrons of the Colosseum, the Flavian emperors had taken a building type that had always had a plain façade, one that had always been relatively low in the Roman hierarchy of building types, one which Roman soldiers

had regularly built in their legionary camps and had wrapped it in a Greek architectural 'skin' for the first time, with the poignant substitution, however, of Tuscan for Doric in the lower story, the part of the façade closest to the public eye.[24]

The application of Greek architectural orders to the façade of the Colosseum suggests that the status of the amphitheatre building had changed. Further evidence for this change comes from the fact that in the late-Julio-Claudian and especially in the Flavian periods, the amphitheatre and its games came now to be deemed suitable subjects for eclogues and epigrammatic poetry. We may quote several examples. The first one is an

90. Colosseum as depicted on the Tomb of the Haterii, Vatican Museums (R. Rea, "Le antiche raffigurazione dell'Anfiteatro" in M. L. Conforto et al., *Anfiteatro Flavio* [Rome, 1988] fig. 3).

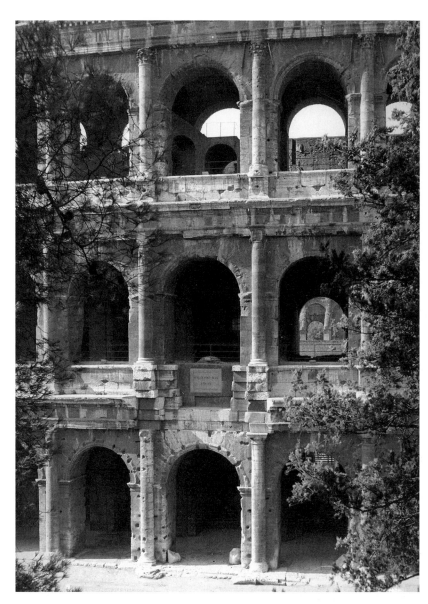

91. Colosseum, façade (American Academy in Rome, Fototeca Unione 6276).

excerpt from the Eclogues of Calpurnius Siculus, which has been connected by scholars with the wooden amphitheatre that Nero built on the *Campus Martius*. In this passage, one shepherd-poet tells another in awe what it was like to approach this amphitheatre, climb its access stairs to the top of the *cavea* where he took his seat and gazed down into the auditorium:

> We saw a *spectacula* that rose skyward on wooden, joined beams and almost looked down on the top of the *Tarpeium*. Passing up the steps and slopes of

gentle incline, we came to the seats, where in dingy garments the mob viewed the show close to the women's benches [the *summa cavea*]. For the uncovered parts [those not covered by *vela*], exposed beneath the open sky, were thronged by knights or white-robed tribunes [that is, the *ima cavea*, where personal 'umbrellas' were probably deployed by slaves]. Just as the valley here expands into a wide circuit, and winding at the side, with sloping forest background all around, stretches its concave curve amid the chain of unbroken hills, so there the sweep of the arena encircles the level ground, and the curve of the oval there in the middle is bound by twin piers... Oh how we quaked, whenever we saw the arena part asunder and its soil upturned and beasts plunge out from the chasm cleft in the earth; yet often from these same rifts the golden arbutes sprang amid a sudden fountain spray of saffron.[25]

92. Theatre of Marcellus, façade (American Academy in Rome, Fototeca Unione 540).

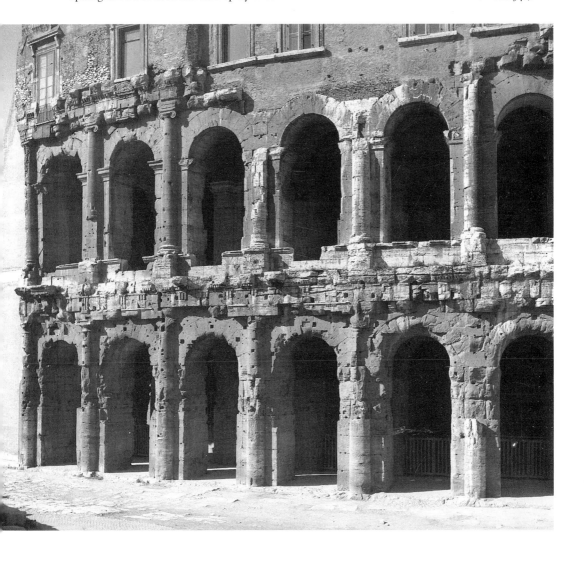

Important for our purposes also is a poem of Statius that describes games held inside the Colosseum lasting until nightime during the Saturnalia festival presided over by the emperor Domitian, which featured food, drink, fireworks and virtuoso combats between women and between dwarves. Here are some excerpts (from a rather antiquated, yet evocative translation):

Hence, Father Phoebus and stern Pallas! Away ye Muses, go, keep holiday; we will call you back at the New Year. But Saturn, slip your fetters and come hither/and December tipsy with much wine, and laughing mirth and wonton wit, while I recount the glad festival of our merry Caesar and the banquet's drunken revel. (1–8)

But lo! another multitude, handsome and well dressed, as numerous as that upon the benches, makes its way along all the rows. Some carry baskets of bread and white napkins and more luxurious fare; others serve languorous wine in abundant measure; so many cup bearers of Ida would you think them. Thou dost nourish alike the circle of the noble and the austere and the folk that wear the toga, and since, O generous lord, thou dost feed so many multitudes, haughty Annona knoweth naught of this festival. Come now, Antiquity, compare with ours the age of primeval Jove and the times of gold: less bounteously then did vintage flow, not thus did the harvest anticipate the tardy year. One table serves every class alike, children, women, people, knights, and senators: freedom has loosed the bonds of awe. Nay even thyself – what god could have such leisure, or vouchsafe as much? – thou didst come and share our banquet. And now everyone, be he rich or poor, boasts himself the emperor's guest.

Amid such excitements and strange luxuries the pleasure of the scene flies quickly by: women untrained to the sword take their stand, daring, how recklessly, men's battles! You would think Thermodon's bands were furiously fighting by Tanais or barbarous Phasis. Then comes a bold array of dwarfs, whose term of growth abruptly ended has bound them once for all into a knotted lump. They give and suffer wounds, and threaten death – with fists how tiny! Father Mars and Bloodstained Valour laugh, and cranes, waiting to swoop on the scattered booty, marvel at the fiercer pugilists. (25–64)

Scarce was dusky night shrouding the world, when through the dense gloom a ball of flame fell gleaming into the arena's midst, surpassing the brightness of the Gnosian crown. The sky was ablaze with fire, and suffered not the reign of darkness: sluggish Quiet fled, and lazy Sleep betook himself to other cities at the sight. Who can sing of the spectacle, the unrestrained mirth, the banqueting, the unbought feast, the lavish streams of wine? Ah! now I faint, and drunken with thy liquor drag myself at last to sleep. (85–96)[26]

The celebration of the amphitheatre and its games in poetry and the application of Greek architectural orders and statues to the façade of the Colosseum both reflect a shift in the amphitheatre's status during the mid- to later first century AD. This is nowhere better illustrated than in the *de Spectaculis* to which we now turn, a work written by another Flavian poet, Martial, for the occasion of the inauguration of the Colosseum itself in AD 80.

93. Terracotta lamp from the Athenian Agora with scene of a woman being raped by a donkey (A. Hönle and A. Henze, *Römische Amphitheater und Stadien* [Zürich, 1981] fig. 31).

Cultural Repertoire of Amphitheatre Games under the Empire: 'Fabulous' Executions

In order to read the visual signs of the Colosseum's façade still further, it is useful to know something of the building's function. Coinciding with its inauguration, a new type of entertainment was introduced into the amphitheatre program on a grand scale. Previously the standard arena repertoire had generally consisted of gladiatorial combat and wild beast shows. In the Colosseum, however, a whole series of elaborate executions were staged. These were presented in the guise of certain Greek dramas, whose subject matter entailed the deaths of the actors (actually condemned criminals, men and women) in a burlesque or grotesquely incongruous fashion. Martial's *de Spectaculis* features a poetic account of the many mythological deaths that took place in the Colosseum during its one 100-day-long inauguration festival in AD 80 under Titus. Examples of these deaths include Orpheus devoured by a bear, Hercules consumed by flames, and Daedalus mangled by a bear. These executions involved complicated stage sets, and collapsible

scaffolds placed above cages of wild beasts, and condemned criminals dressed up as characters from Greek mythology, who were forced to perform and, at the performance's climax, were put to death.[27] Martial describes the executions with light-hearted humor: "Daedalus, when you are being thus torn by a Lucanian bear, how you wish you now had your wings!"[28] "Earth through a sudden opening sent a she-bear to attack Orpheus. She came from Eurydice!"[29]

What these 'fabulous' executions seem to have done was to take Greek myths, which had formed the basis of Greek drama (and subsequent Roman theatre performances), and put them into a distinctively Roman setting. The difference between these mythological executions in the amphitheatre and Greek dramas in the theatre was commented upon by Martial as an improvement:

> Believe that Pasiphae was mated to the Dictaean bull; we have seen it, the old legend has won credence. And let not hoary antiquity plume itself, Caesar; whatever Fame sings of, the arena makes available for you.[30]

A similar type of execution is light-heartedly recounted in Apuleius' *Metamorphoses* in a passage describing extravagant plans for the execution of a female criminal at Corinth. She and Lucius the ass are expected to perform the sexual act, and a wild panther is to be let into the cage to savage the woman and the ass – *in mediis rebus*.[31] In the story, Lucius the ass escapes, but the reality of precisely this kind of execution is illustrated by a whole class of terracotta lamps that show donkeys raping women (Figure 93).[32] Such elaborate pornographic executions were difficult to stage and cannot have been frequent events, and we may hypothesize that lamps and other types of artifacts such as this one were manufactured specifically as souvenirs.

In the case of the female criminal ("Pasiphae") forced to copulate with a bull in the Colosseum, it is worth noting, by contrast, that the story of Pasiphae and the bull had been performed earlier as a (bloodless) pantomime performance in the theatre under Nero.[33] Similarly, the death of Laureolus, a legendary Sicilian brigand, which had previously been shown as a pantomime,[34] was now enacted in reality inside the Colosseum:

> As Prometheus, bound on Scythian crag, fed the tireless bird with his too abundant breast, so did Laureolus, hanging on no sham cross, give his naked flesh to a Caledonian bear. His lacerated limbs lived on, dripping gore, and in all his body, body there was none. Finally he met with the punishment he deserved; the guilty wretch had plunged a sword into his father's throat or his master's, or in his madness had robbed a temple of its secret gold, or laid a cruel torch to Rome. The criminal had outdone the deeds of the ancient story; in him, what had been a play became an execution."[35]

These executions, therefore, 'improved' upon the Greek stage both by leaving little to the spectator's imagination and by conveying a chastening reminder of civic values.

'Fabulous' executions together with the 'noble' architectural orders of the Colosseum's façade both reflect a new Roman concern that the amphitheatre be recognizably distinct from the Greek theatre by borrowing from and at the same time improving on it. Greek-style executions together with the Greek architectural orders, a *cavea* decorated with architectural sculpture, and the façade filled with Greek statues, all served to elevate the cultural status of the Colosseum in relation to that of the theatre. Theatre productions based upon Greek themes had always been popular in Rome, but they had been emphasized greatly by Vespasian's predecessor Nero, who as emperor had performed in them himself.[36] Moreover, Nero had come under criticism for not killing enough, that is, for sponsoring performances in the amphitheatre in which the protagonists did not die.[37] In staging such mythological executions, therefore, Flavian emperors were, in part, answering that criticism. They were also giving the people the Greek performances that they now demanded but adjusting them so that they went beyond being simply entertaining. They were now formulated as 'morally uplifting' events. Just as the mythological executions put a Roman spin on Greek drama, however, so the substitution of Italian Tuscan for Greek Doric in the lower story of the façade put a Roman spin on the traditional hierarchy of Greek architectural orders.

We have seen that the innovative decoration of the Colosseum can be read partly as a response to Nero's phil-Hellenic patronage of the theatre. The iconography and function of the Colosseum are in fact highly interdependent with that of the building program of Vespasian's predecessor, Nero. Indeed, the architecture of the Colosseum cannot be fully understood outside of the context of Nero's greatest architectural achievement, the "Golden House," atop which the Flavian amphitheatre was eventually built. Yet the connection between the Flavian Amphitheatre and Nero's building activities has never been explored in detail. We may now turn to a consideration of Nero's palace complex: the Golden House, or *Domus Aurea*.

The Colosseum and Nero's *Domus Aurea*

In the surviving literary sources, Nero is generally portrayed as a frivolous, immature matricide. He is said to have had none of the interests, skills, or experience needed by a Roman emperor. He is represented as a poor public speaker, and as an emperor who never campaigned in war. According to the sources, he eventually lost interest in ruling and dedicated the last nine years

of his reign to Greek frivolities: music, poetry, lyre playing, singing, acting, and chariot racing. He instituted the first named Greek festival in Rome (comprising stage plays, chariot racing, and Greek athetic competions) and increased controversy by naming the festival after himself (the "*Neronia*") rather than after a deity as was customary for Greek (and Roman) festivals.[38] On the occasion of the first *Neronia*, Nero was persuaded not to participate publicly as an actor and charioteer. But at the second festival in AD 65 he insisted on having his public debut and performed in front of the Roman people both in the Theatre of Pompey and in the *Circus Maximus*.[39] Nero's activities eventually provoked reaction. In AD 66 Nero returned from his concert tour in Greece to Rome to find the provincial armies in revolt. He committed suicide in AD 68, at the age of 31. A year of civil war followed, and order was eventually restored by Vespasian, who founded the Flavian dynasty. Unlike Nero, Vespasian and his son Titus, his co-ruler and then successor, were both soldiers and conquerors, and they purported to rule according to more traditional Roman values. The picture the literary sources represent is of the Roman people having been rescued by the Flavians from Nero, the last and most decadent of the Julio-Claudian emperors.

The *Domus Aurea*. Under Vespasian and Titus, Greek spectacles still took place, but they were no longer actively promoted and actually participated in by the emperor himself, as they had been under Nero. As we have seen, however, the native Roman arena spectacles held inside the Colosseum were a focus of much energetic planning in the Flavian period. As mentioned earlier, the Colosseum was erected on the site of the artificial lake that had been located at the center of Nero's sprawling palace complex: the *Domus Aurea*, or Golden House. Martial tells us that by erecting the Colosseum on the site of Nero's palace complex, the Flavian emperors were returning the center of Rome to the Roman people:

> Where the starry Colossus sees the constellations at close range and lofty scaffolding rises in the middle of the road, once gleamed the odious halls of a cruel monarch, and in all Rome there stood a single house. Where rises before our eyes the august pile of the Amphitheatre, was once Nero's lake. Where we admire the warm baths [Baths of Titus], a speedy gift, a haughty tract of land had robbed the poor of their dwellings. Where the Claudian colonnade [substructures on the Temple of Divine Claudius] unfolds its widespread shade, was the outermost part of the palace's end. Rome has been restored to herself, and under your rule, Caesar, the pleasances that belonged to a master now belong to the people.[40]

As this passage in Martial makes clear, Nero's *Domus Aurea* had provoked a strong negative reaction. We may now review some well-known passages that explain why. In the great fire of AD 64 Rome had burned for nine

days, and two thirds of the city was destroyed. The destruction gave Nero a building opportunity not to be missed. Tacitus, writing about fifty years after the event, tells us that "Nero took advantage of his country's disaster to build a palace, the marvels of which were not so much jewels and gold, the familiar commonplaces of luxury, as fields and lakes, a contrived solitude of woods and vistas and open pastures."[41] Writing somewhat later, under Hadrian, Suetonius gives us the most evocative account of the *Domus Aurea* in the following famous passage:

> Nero built a palace stretching from the Palatine to the Esquiline, which was at first called the *Domus Transitoria*, but after it had burnt in the fire it was restored and was called the *Domus Aurea*. The following facts will serve to give some idea of its size and luxury. In its vestibulum there was a colossal statue of Nero 120 feet high; and so spacious was it that it had a portico a mile long. There was an artificial lake to represent the sea, and on its shores were buildings laid out as cities; and there were stretches of countryside, with fields and vineyards, pastures and woodlands, and among them were herds of domestic animals and all sorts of beasts. In other parts it was overlaid with gold and jewels and mother of pearl. There were dining halls whose ivory ceilings were set with pipes to sprinkle the guests with flowers and perfume. The main dining hall was circular and it revolved constantly day and night like the universe. There were also sea water baths and baths of sulfur water. When Nero moved in, he only deigned to remark 'At last I can begin to live like a human being.'[42]

A contemporary source, Pliny the Elder, who wrote within a decade of Nero's fall, also comments on the vastness and luxuriousness of the *Domus Aurea*, which he says "encapsulated the whole city."[43]

The ancient sources are in agreement, then, that the *Domus Aurea* appropriated a large area of downtown Rome as Nero's luxury private villa and that later, after Nero's fall, the Flavian Colosseum returned the area to the Roman people. From the literary evidence we gather that the *Domus Aurea* extended from the Palatine to the Esquiline, including the Velian hill, the Colosseum Valley, and also at least part of the Caelian hill. The archaeological remains are in broad agreement with the literary sources, suggesting that the *Domus Aurea* consisted of a large park, at the center of which was an artificial lake. Surrounding the lake were a series of buildings and pavilions that seem to have been arranged in a loose, non-axial arrangement on the slopes of the surrounding hills (Figures 94 and 95, and Plate 13).[44]

The remains of the *Domus Aurea* survive in four areas of Rome: (1) the Palatine, where there was a large circular structure (only the concrete core of which survives today); (2) the Caelian, where there are the remains of a great aediculated nymphaeum (fountain) built against the northeast flank of hill; (3) the well-known suite of rooms on the Esquiline hill; and (4) around the Colosseum valley, where there are the remains of a great porticoed

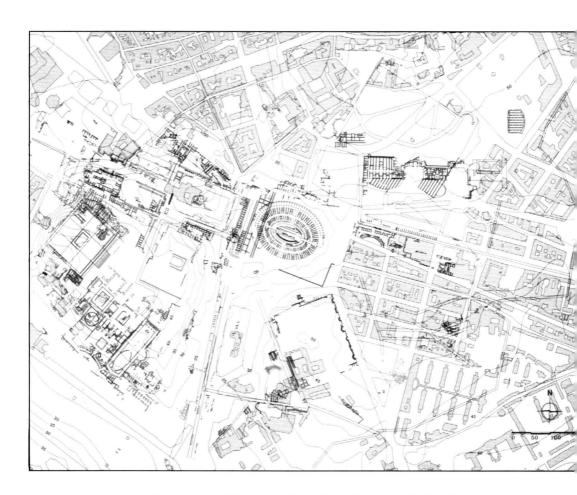

94. Area of the *Domus Aurea* (black lines; later structures in gray line) (*LTUR* II, Fig. 18). See Color Plate 13 in this text.

street (Nero's rebuilding of the *Sacra Via* and perhaps the "*vestibulum*" mentioned by Suetonius) running from the east end of the *Forum Romanum* toward a porticoed square (perhaps the "*atrium*" mentioned by Martial), containing a colossal, gilded statue of Nero, and beyond this the artificial lake (the "*Stagnum Neronis*"), upon which the Colosseum was later built (Figure 94).[45] The artificial lake and the nymphaeum on the flank of the Caelian hill should be seen together as part of a grandiose landscaping design, inspired by previous Roman villa architecture but achieved at a vast scale in the center of Rome. To gain an impression of the sort of effect at which the *Domus Aurea* was aiming, we would have to invoke Roman villas of a later age, such as either the Villa Borghese in Rome or the Villa d'Este in Tivoli.

Recent scholarship on the *Domus Aurea* complex has suggested that the true novelty of this complex was neither in the technical innovations lauded by some architectural historians nor in its luxurious

decorations – but rather in its scale and location. Traditionally, elite Romans had built such enormous estates, but only outside the city walls of Rome. These estates were called *horti*, from the Latin word *hortus* (garden). Unlike a wealthy Roman's *domus* in the center of Rome, a large part of which was open to the public, a *hortus* outside of Rome was fully private, perhaps being surrounded by low walls in much the same way that Italian villas are today along the roads leading into modern Rome, such as the Via Appia Antica. The grounds of Nero's *Domus Aurea* constituted the most spectacular set of *horti* of all time in that it transported to the center of Rome that which had previously been too large and ostentatiously luxurious to have been built inside the city proper.[46]

The ancient sources are unanimous in criticizing the *Domus Aurea* for its great size and its location in the center of Rome. We may now explore this ancient attitude toward Nero's palace in more detail. The sources claim that the *Domus Aurea* was built over some of the most crowded parts of

95. Area of *Domus Aurea*, plan showing streets (H. Jordan & Ch. Hülsen, *Topographie der Stadt Rom im Altertum* I 3 [Berlin, 1907] pl. VI).

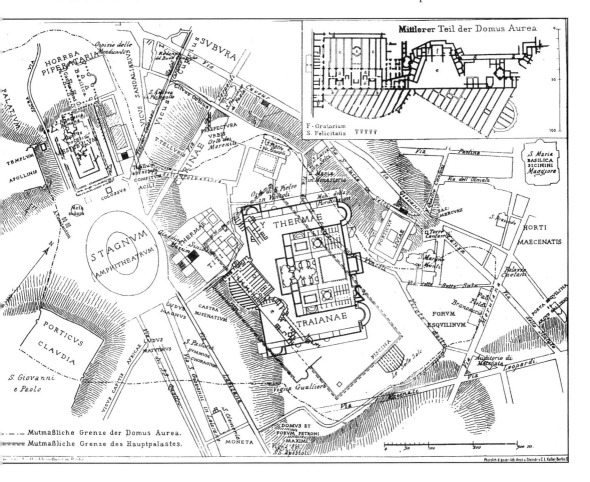

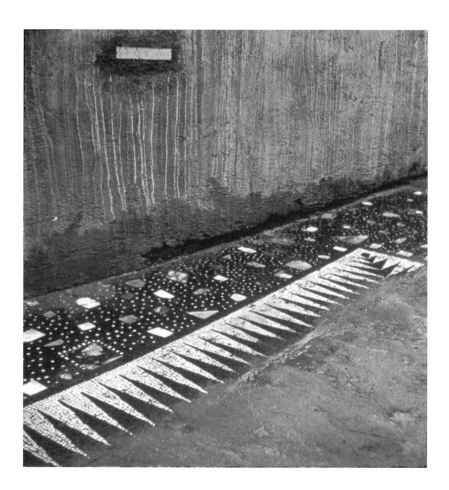

96. Pavement of a late-republican house under the arena of the *Ludus Magnus* (A. M. Colini & L. Colini, *Ludus Magnus* [Rome, 1962]).

Rome. In the passage quoted previously, Martial called it "a haughty tract of land that robbed the poor of their dwellings."[47] Yet, if we examine the archaeological evidence for the areas over which the *Domus Aurea* was built, we come to a very different conclusion.[48] The principal areas involved in the construction of the complex were the Palatine, the Velia, the Esquiline, the Colosseum Valley, and the *mons Caelius*. The Palatine had always been an elite district, so there is no question of common people having been displaced in that part of Rome. By Nero's time, much of the Esquiline was an imperially owned, public park (parts of the former estates of Maecenas). The other parts of the Esquiline were home not only to Romans of the middle classes but also to elite Romans such as Pliny the Younger.[49]

In the Colosseum valley, the ancient streets (Figure 95) were, according to Suetonius, lined with shops and warehouses, which Nero ordered to be pulled down after the great fire of 64.[50] This implies that the area of the Colosseum valley had been a commercial district before it became part of

Nero's *Domus Aurea*. In addition, farther east in the Colosseum valley under the arena of the later *Ludus Magnus* (which was adjacent to the Colosseum) an aristocratic mansion was discovered in the early 1930s, which has floors decorated in an early and fine type of opus sectile pavement that dates the building to the first century BC (Figure 96).[51] Contrary to what the ancient sources would have us believe, then, most of the area that the *Domus Aurea* came to occupy had not been a popular district at all. Much of it seems to have been occupied by mansions and warehouses, which were owned by the elite. This would explain in part why the elite literary sources are so hostile to the *Domus Aurea*.

Another reason why the Roman elite so hated the *Domus Aurea* was the use to which Nero put it. For literary and archaeological evidence suggest that Nero's palace complex, or at least a major part of it, was open to the Roman public some of the time.[52] The great porticoed street and the porticus with the colossal statue (the probable "*vestibulum*" and "*atrium*," respectively) were directly adjacent to the *Forum Romanum*. As M. Griffin points out, one can hardly assume that the Forum went out of use when the *Domus Aurea* was constructed (Figure 97). A fully private residential estate in the heart of city would have created enormous problems for the

97. Conjectural reconstruction of the center of the *Domus Aurea* (*Forum Romanum* in foreground; *Templum Pacis* under construction at left; n.b. lake is restored incorrectly as irregular in contour; it was in fact rectangular) (R. Luciani & L. Sperditi, *Foro Romano* [Rome, 1992] fig. 17).

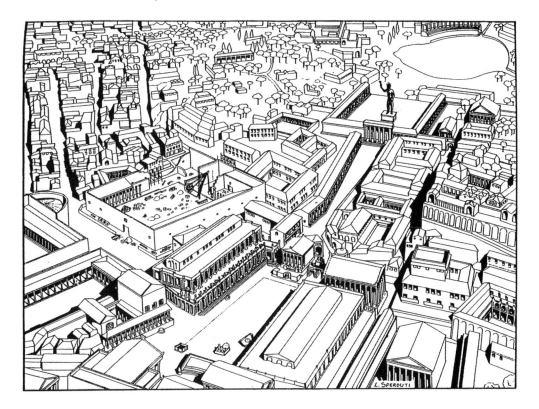

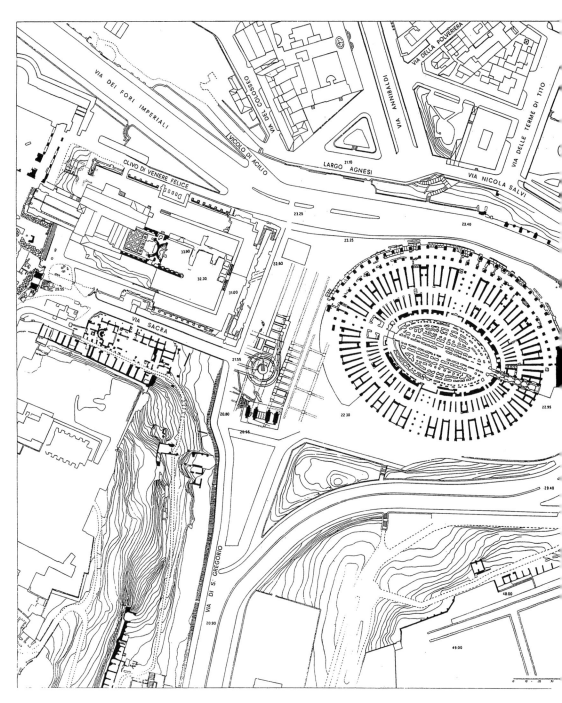

98. Plan of Colosseum Valley showing structures under the *Meta Sudans* (porticus surrounding the *Stagnum Neronis*) (C. Panella et al., *Meta Sudans I: un' area sacra in Palatio e la valle del Colosseo prima e dopo Nerone* [Rome, 1996]). (See Plate 13.)

movement of traffic. The roads from the Colosseum Valley to the Gardens of Maecenas, such as the Via Labicana, were major thoroughfares in ancient Rome (Figures 82 and 95), and there is no evidence that traffic on them was blocked during Nero's time. Despite the general hostility of the texts, they do not say either that the *Domus Aurea* prevented movement throughout the center of the city or that there were any walls around the complex (though guards could have been posted at major access points). Architectural evidence also provides some support for the idea that parts of the grounds of the *Domus Aurea* may have been open to the public. Excavations in the Colosseum Valley underneath the Domitianic *Meta Sudans* have shown that Nero's lake was surrounded by a great quadriporticus with porticoes, which contained rows of individual rooms that in their plan resemble *tabernae*, or shops, facing the exterior of the structure (and probably the interior as well) (Figures 98 and 99, Plate 13).[53] This hints at a public function for the very center of the *Domus Aurea* complex.

That the grounds of the *Domus Aurea* were occasionally open to the Roman people agrees with Nero's other public activities as outlined in the

99. Detail showing structures under the *Meta Sudans* (porticus surrounding the *Stagnum Neronis*) (C. Panella et al., *Meta Sudans I: un' area sacra in Palatio e la valle del Colosseo prima e dopo Nerone* [Rome, 1996] fig. 7).

literary sources. Before the great fire, Nero had opened up his private gardens across the Tiber river to the public.[54] Immediately after the great fire, Nero opened up his own gardens as a refuge to the populace (It was here that he had Christians burned alive as a public spectacle).[55] We may add to the passages collected by other scholars an excerpt from the writings of the Elder Pliny, in which he discusses a rare and valuable type of cup confiscated from a wealthy Roman by Nero. In this passage, Pliny parenthetically remarks that he himself had attended an art opening in Nero's theatre in his private, Vatican gardens:

> Lavish expenditure in [Nero's] day was increasing everyday ... an ex-consul, drank from a myrrhine cup [probably amber] for which he had paid 70,000 sesterces, although it held just three pints. He was so fond of it that he would gnaw its rim; and yet the damage he thus caused only enhanced its value, and there is no other piece of myrrhine ware even today that has a higher price set upon it. The amount of money squandered by this same man upon the other articles of this material in his possession can be gauged from their number, which was so great that when Nero took them away from the man's children and displayed them, they filled the "private theatre" [*theatrum peculiare*] in his gardens across the Tiber, a theatre which he filled with the people since at the time he was rehearsing for his appearance in Pompey's theatre. It was at this time that I saw the pieces of a single broken cup included in the exhibition. It was decided that these, like the body of Alexander, should be preserved in a kind of catafalque [a decorated framework in or upon which a body lies in state during a funeral] for display, presumably as a sign of the sorrows of the age and the ill-will of Fortune.[56]

This passage suggests that Nero was in the habit of staging extravagant exhibitions in his private gardens, to which he invited not only the elite (Pliny the Elder, who was of equestrian status, was in attendance) but also the people. Pliny explicitly says that Nero's private theatre was "filled with the people."

On the basis of all this evidence, then, we may suggest that the *Domus Aurea* had a distinctly public if periodic function, belonging not only to the emperor but also to the emperor's people. If it had actually been an exclusively private estate, one would perhaps expect its Latin name to say so. But the complex was called neither *horti Neroniani* nor *villa*; it was called a *domus*. The Roman *domus* had a distinctly public function – the *vestibulum*, *atrium*, and (occasionally) garden of an important person's *domus* were, according to Vitruvius, regularly open to the public, though always at the discretion of the *patronus*.[57]

This interpretation puts a new and interesting light on the famous episode recounted by Tacitus of a banquet given by Nero's praetorian prefect

Tigellinus and placed in Tacitus's narrative, proleptically, right before the great fire of AD 64:

> Nero now tried to make it appear that Rome was his favorite abode. He gave feasts in public places as if the whole city were his home. And the most prodigal and notorious banquet was given by Tigellinus…The entertainment took place on a barge constructed in Marcus Agrippa's lake. It was towed about by other vessels, with gold and ivory fittings. Their rowers were degenerates, assorted according to age and vice. Tigellinus had also collected birds and animals from remote countries, and even the products of the ocean. On the quays were brothels stocked with high-ranking ladies. Opposite them could be seen naked prostitutes, indecently posturing and gesturing.[58]

This banquet, which is described by our literary sources in a manner that is highly rhetorical and plainly exaggerated, was staged in the *Campus Martius* in the *Stagnum Agrippae*, the great pool in M. Agrippa's baths. By analogy with the banquet of Tigellinus on Agrippa's lake, it is probable that the *Stagnum Neronis* in the *Domus Aurea*, which also appears to have been surrounded by *tabernae*, was built to serve a similar purpose. This idea is supported by a passage in Cassius Dio, which records that Nero feasted the Roman people on boats in the *Naumachia Augusta* (an artificial lake normally used for mock sea battles, located in *Transtiberim*). That is, Nero's lake was not simply built to create the atmosphere of a seaside villa in downtown Rome. It was built as a place that could accommodate not only private recreational events on a lavish scale but also popular entertainment.[59]

In constructing the *Domus Aurea*, then, Nero did not drive the Roman people from their homes to build a private pleasure palace that completely excluded the plebs. To some extent, he seems to have been using coveted property in the heart of city as a public park that extended to the Roman people, at least some of the time, pleasures hitherto restricted to extra-urban *horti* and villas of the elite.[60] In doing so, the *Domus Aurea* had effectively erased the distinction between public and private spheres in the center of downtown Rome. I would argue that this is an important reason why the *Domus Aurea* aroused such anger in our elite sources and caused them to allege that Nero was trying to build a new city called "Neropolis."[61] Under Nero, it was no longer obvious who the heart of downtown Rome belonged to, the Roman elite, the emperor, or the Roman people themselves.

This interpretation sheds new light on the most celebrated of passages in the history of art, that of Pliny the Elder when he gives a long list of the great Greek artists and sculptors – a passage that has important implications for our analysis of the iconography of the Colosseum.[62] After mentioning the most famous works of some 200 artists (mostly sculptors), including Polycleitus, Myron, Praxiteles, Lysippus, and others, Pliny comments, "of

all the works I have enumerated the most famous are to be found in Rome today, dedicated by the emperor Vespasian in the Temple of Peace and his other buildings. They were brought to Rome by Nero as plunder and were displayed throughout the "sitting rooms" of the Golden House."[63] The reference to the works of art as plunder could refer to original Greek works taken from Greece by Nero, but it is more likely an allusion to Nero's proscriptions of the estates (and their artistic contents) of many elite families after the Pisonian conspiracy in AD 65. If Nero took the bulk of these statues from the villas of his proscribed colleagues, we may imagine the statues as being a motley group, of marble and bronze, of different sizes, probably including Roman replicas of original works of art as well as versions on Greek themes, and perhaps Greek originals inherited from the days of mass looting in the Republic.[64] We may suggest that, given the probable public nature of the center of the *Domus Aurea* complex, many of these statues had been displayed by Nero in the groves of the *Domus Aurea* where they could be admired at times by all of the different segments of the Roman people. This passage by Pliny is telling not only because it reflects the elite hostility toward Nero's *Domus Aurea* as a house of plunder but also because it describes how the Flavians reacted to the display of these confiscated art works in the *Domus Aurea*. The Flavians, unlike Nero, displayed these works of art to the Roman people in a venue that was traditional, that is, a temple combined with a porticus, in the vein of the traditional manubial temples of the republican period. For the *Templum Pacis* (Figure 97), in which Vespasian displayed the statues that had been confiscated by Nero, was in a very real sense the antithesis of the *Domus Aurea* in that it was a box-like space, axial in plan, architecturally leading to the spectator, and closed much of the time (a concept not out of keeping with the modern museum).[65]

Connections between the Colosseum and the *Domus Aurea*. After the accession of Vespasian in AD 69 most of the *Domus Aurea* complex was dismantled, and the *Stagnum Neronis* became the site of the Colosseum, which, as we have seen, was hailed by Martial as a building that returned this area of downtown Rome to the people. But Martial's statement and indeed the architectural iconography of the Colosseum itself can only be fully understood in terms of the relationship of the Colosseum to its topographical predecessor, Nero's *Domus Aurea*. Before the Colosseum, amphitheatres had almost always been located marginally at the edge of town in cities other than Rome and in Rome in the *Campus Martius* outside the sacred boundary of the city. In addition to the ideological convenience of its proximity to the *Forum Romanum*, where gladiatorial events had been traditionally held, the placing of the Colosseum in the very center of Rome may be read partially as a response to the central location of the *Domus Aurea* and perhaps even an 'improvement' upon it in functional terms. Indeed, Martial states that a

naval battle was staged as part of the 100-day inauguration festival and that this was an outdoing of such events that had been staged in Nero's *stagna* (presumably including the *Stagnum* in the *Domus Aurea*).

> Whatever is viewed in the Circus and Amphitheatre, that, Caesar, the wealth of your water has afforded you. So no more of Fucinus and the lake of direful Nero, let this be the only sea fight known to posterity.[66]

The replacement of a public park by a Roman spectator building such as the Colosseum also represents a marked and conscious contrast to Nero's *Domus Aurea*. Indeed, the Colosseum was a building in which by law the audience was rigidly segregated and divided at both a vertical and horizontal level (Figure 87). The building was surrounded by a series of bollards or posts made of travertine, and each post was equipped with a metal ring on top that held a chain or rope.[67] These, along with wooden barriers (attested to by cuttings in the vertical surfaces of the bollards) were used to categorize and funnel the spectators from the broad piazza outside the Colosseum toward the façade and into the appropriate arched entryway. Spectators were assigned to predesignated sections of the *cavea* – that is, to a specific *maenianum* (tier), *cuneus* (wedge of seats), *gradus* (row), *locus* (seat) – based on their degree of *dignitas* (that is, on the basis of rank and financial means), their profession, religious affiliation, and gender. Senators and Vestal Virgins got front-row seats (as did the emperor and his family). Wealthy equestrians sat above. Then came male Roman citizens of the middle classes and finally women and slaves at the top of the auditorium where the view was poorest. This hierarchical division was achieved not only at a vertical level but also at a horizontal level. The plebs were probably divided into seating sections by tribes and within their tribes by collegia, such as *Augustales, diffusores, macellarii, scholastici* (officials of the imperial cult, oil merchants, butchers, scholars).[68] Those seated in the wedges closest to the minor axis of the arena were the most important people and had the best view, and they sat closest to the emperor and his family (probably including the women). Upon entering the building, only the individuals of the highest social status (senators and knights) were allowed to penetrate very far into the labyrinthine vaults and passages beneath the *cavea* on the way to their seats. Others had to climb laboriously the seemingly endless staircases situated within the two outer annular corridors (One wonders how many women were regular visitors at the Colosseum.)

We may propose that the hierarchical segregation by social status in the Colosseum furnished a distinct counterpoint to the type of public gatherings that were possible in Nero's *Domus Aurea* where, as in a quasi-public park, the people could at times come and go freely, and the upper classes perforce had to rub shoulders with everyone else whether they wanted to or not. In the Colosseum, the Roman aristocracy had front-row seats where they could

be seen on their own terms. The Colosseum was a Roman panopticon *par excellence*, representing a return to traditional Roman social ordering.

Finally, we come to the most innovative aspect of the Colosseum: the decoration of its façade. In the Colosseum, Romans were now no longer able to admire Greek art works with the kind of freedom and personal entitlement as they had been able to do at times in the *Domus Aurea*. Greek statues were now presented inside the arched openings of a towering façade. That is, they were presented in a way that might make the average Roman viewer feel awed and small (as he or she might feel when gazing at the statue-filled *scaenae frons* [stage] of a Roman theatre).[69] In short, one may say that the Colosseum provided the Greek entertainment and Greek statues that the people especially now wanted but also pressed them into the service of the Roman state.

The deliberate and self-conscious contrast between the Colosseum and the *Domus Aurea* is nicely epitomized by a discovery – what is apparently the dedicatory inscription of the Colosseum reconstructed from the peg-holes visible under a fifth-century AD inscription re-dedicating the Colosseum in late Antiquity (Figure 100).[70] According to G. Alföldy, the original dedicatory inscription of the building, with Titus as dedicator, which formed the architrave over an entrance into the arena, reads as follows: *I[mp(erator)] T(itus) Caes(ar) Vespasi[anus Aug(ustus)] / amphitheatru[m novum (?)] / [ex] manubi(i)s (vac.) [fieri iussit (?)]*, "The emperor Titus Caesar Vespasian Augustus had the new amphitheatre built from the profits of war." The term *ex manubiis* refers to the *manubiae*, or proceeds from the booty taken in Titus' conquest and sack of Jerusalem in AD 70. (This lends some credence to the popular notion that a labor force of Jewish prisoners of war were involved in the construction of the building, although this would only have been possible with the less skilled aspects of the building works, such as the production and laying of concrete.) The inscription is ostentatiously stark in its language, and it uses a (by then) self-consciously antiquated republican formula (*ex manubiis*), in specifying that the amphitheatre was built from the spoils of war.[71] It loudly proclaimed that the Colosseum was a manubial monument (in the tradition of the amphitheatre of Statilius Taurus 100 years before [see Chapter Four]). The manubial nature of the Colosseum, we may suggest, explains the presence of shields and a triumphal arch on the Colosseum's façade at the main entrance.[72]

Nero, an emperor who had never campaigned in war, had confiscated the contents of the estates of his elite colleagues and had openly conducted a Greek-style private life in the quasi-public space of the *Domus Aurea*. He had exalted Greek culture by display and participation. The Colosseum and everything in it, on the other hand, was paid for in the old Roman way, by the defeat of foreign enemies. In the Colosseum, Greek cultural artifacts

**IMP·T·CAES·VESPASIANVS·AVG
AMPHITHEATRVM·NOVVM
EX·MANVBIS FIERI·IVSSIT**

100. Dedicatory inscription of the Flavian Amphitheatre (Colosseum) (G. Alföldy, "Eine Bauinschrift aus dem Colosseum" *ZPE* 109 [1995] fig. 4).

were now 'properly' labeled in the old-fashioned way – not as works of this or that Greek artist, but Greek statues, Greek decorative architectural orders, Greek entertainment – all were properly identified as the fruits of war booty, in service of the Roman state.

Thus, when the ancient sources speak of Titus returning downtown Rome to the people by building the Colosseum, they were perhaps not so much misrepresenting the situation. The reference to returning the area to the people needs to be understood in the traditional Roman sense of the *res publica*, as something that involved popular participation, but that was ultimately organized, segregated, and controlled by the elite. Similarly, when the sources criticize Nero for using the center of Rome as his own private estate, they may be alluding to the traditional Roman sense of private space: a venue where Greek cultural activities were pursued for the purpose of leisure. According to this view of the *Domus Aurea* and the Colosseum, the facts conveyed by the literary tradition hostile to Nero may be retained, but they are interpreted in a new way when placed alongside the architectural evidence.

Conclusion

From the time when the *Domus Aurea* was built under Nero (AD 64) to the time of the dedication of the Colosseum under Titus (AD 80), a series of choices were made that would have important repercussions for the future of Roman imperial architecture. The two major monuments discussed here (the Colosseum and the *Domus Aurea*) were highly distinctive, complex, and interdependent, and (respectively) they exerted a great influence, both 'positively' and 'negatively,' on subsequent Roman imperial architecture. Sprawling villas such as the *Domus Aurea* were never again built as official imperial residences. Future emperors built such complexes only in private contexts such a Hadrian's villa at Tivoli.[73] The imperial residence in

Rome that replaced Nero's, the Flavian palace on the Palatine, was entirely different from the *Domus Aurea*. Although it featured virtuoso vaulted architecture inside, it was enclosed, surrounded by rectilinear walls, axial in plan, and fortress-like in its privacy. Its form would become canonical for many future urban imperial palaces.[74] By contrast, the Colosseum, which in its decoration and function was such a poignant reply to that of Nero's *Domus Aurea*, became canonical for monumental amphitheatre architecture throughout the Roman Empire (for example, at Pozzuoli, Capua [Plate 11], Italica in Spain, Thysdrus [El Djem] in Africa).[75]

After the Colosseum was built, the amphitheatre ceased to evolve in a significant way as a building type. The period between c. 70 BC (Pompeii) and AD 80 (the Colosseum) saw the most important developments. By AD 80, the amphitheatre had come a long way indeed in terms of its architectural iconography since the days of the lean, wooden *spectacula* in the *Forum Romanum* and the ruthlessly functional-looking stone amphitheatres of the republican period. With the erection of the Colosseum, the amphitheatre was now a cultural building in its own right.

Finally, it is worth noting here that of all the different types of Roman spectator building – amphitheatre, theatre, circus, and stadium – the amphitheatre was the only one that the Romans could claim as their own true invention. Indeed, the Roman theatre was derived from the Greek theatre, the Roman stadium from the Greek stadium, and the Roman circus from the Greek hippodrome. The amphitheatre, on the other hand, had no obvious Greek architectural precedent. Similarly, Roman plays were in many ways derivative of Greek plays; Roman athletics were hardly different from Greek athletics, and Roman chariot racing had its roots in the Greek world.[76] But gladiatorial games had no Hellenic precedent. Just as arena spectacles were an original Roman cultural contribution, the amphitheatre was an original Roman architectural contribution, a fact of which the Romans seem to have at this point become aware and proud. The opening lines of Martial's *de Spectaculis* nicely make the point:

> Let barbarous Memphis speak no more of the wonder of its pyramids, nor Assyrian toil boast of Babylon; nor let the soft Ionians be extolled for Trivia's temple; let the altar of many horns say nothing of Delos; nor let the Carians exalt to the skies with extravagant praises the Mausoleum poised on empty air. All labor yields to Caesar's Amphitheatre. Fame shall tell of one work instead of all.[77]

RECEPTION OF THE AMPHITHEATRE IN THE GREEK WORLD IN THE EARLY IMPERIAL PERIOD

Previous chapters have shown that in the Roman West the amphitheatre building was closely associated with notions of Roman identity from the time of its origins until its monumentalization and canonization as a building type in the Augustan and Flavian periods, respectively. How were the architectural and cultural phenomena that comprised the Roman amphitheatre received in the Greek East? This chapter investigates the architectural reception of the amphitheatre building and gladiatorial spectacles in the Greek world under the early Empire. Although the epigraphical evidence for this subject has received considerable attention, the architectural evidence has not been fully considered. The monuments will be used here as primary documents for understanding Greek attitudes about Roman gladiatorial games. The architectural responses to Roman spectacles of two different types of cities will be used as case studies: Athens (an old Greek city) and Corinth (in its later existence as a new Roman colony and capital of the Roman province of Achaea). These two cities have been chosen both because they are well documented and because the evidence suggests that they established architectural trends that were later followed by most other Greek cities.

The Athenians held their gladiatorial games in a theatre, the Theatre of Dionysus, and the Corinthians held them in an amphitheatre. The Theatre of Dionysus at Athens is a well-known, well-preserved, and extensively published building, whereas the amphitheatre at Corinth is little known, poorly preserved, and little published. But for the purpose of reconstructing the cultural context of the reception of gladiatorial games in the Greek world, these buildings are equally important. This chapter offers a reassessment of the Roman phase of the Theatre of Dionysus and will then provide an archaeological discussion and a new interpretation of the amphitheatre at Corinth.

We may begin with the evidence for the onset of gladiatorial shows in the Greek world. Gladiatorial games were put on in the Greek world for the first time by the romanized Seleucid monarch Antiochus IV at Antioch, in 166 BC, as mentioned in Chapter Two. Polybius tells us that Antiochus put on these games for the purpose of outdoing the Roman general Aemilius Paullus, who had given his own games at Pydna in 168 BC. As a young man, Antiochus had been a hostage in Rome between 188 and 176/5 BC, and it is probable that his extended stay in Rome was responsible for his interest in gladiatorial games and his subsequent sponsorship of them in the Greek East.[1] Apart from this instance, all of the other known gladiatorial events in Hellenistic Greece were sponsored by Romans. Gladiatorial games were held by Romans on the island of Delos, probably in the Agora of the Italians, during the later second century BC.[2] L. Lucullus is also known to have put on gladiatorial games at Ephesus after his victory over Mithridates in 71/70 BC. And Cicero matter of factly mentions that he watched a gladiatorial show at Laodicea in Phrygia when he attended a *conventus* (assembly for provincial assizes) there in 50 BC while he was governor of Cilicia.[3]

This evidence suggests that gladiatorial shows were an infrequent occurrence in the Greek world, until the imperial cult was introduced in early imperial times and gladiatorial games began to be held as part of the imperial cult festival. In the imperial period, however, gladiatorial games in Greek cities were no longer being sponsored exclusively by visiting Roman generals, governors, and renegade Hellenistic Kings. Rather, they were generally sponsored by Greek aristocrats themselves. The substantial corpus of gladiatorial inscriptions published by Louis Robert in 1940 showed that Roman spectacles were staged regularly and energetically in the Greek world, as part of the imperial cult festival, and that most of the donors of the games were priests of the imperial cult.[4] On the basis of the epigraphic evidence alone, one would conclude that gladiatorial games underwent a smooth transition from being a purely Roman phenomenon to being an ingrained Greek–Roman institution.

These gladiatorial inscriptions provide only part of the story, however. First, they reflect only the attitudes of the Romanophile component of the elites in Greek cities. Second, because the great majority of the gladiatorial inscriptions date to the high imperial period, they tell us little about the initial reception of Roman spectacles, when gladiatorial combat was still something novel to most Greeks. The strangeness of gladiatorial games to people unaccustomed to them may be gleaned from a passage in Livy concerning the aforementioned games of Antiochus IV in Syria: "[When Antiochus] presented a gladiatorial game after the Roman fashion, it was at first received with greater terror than pleasure on the part of men who were unused to such sights, then by frequent repetitions, sometimes by allowing the fighters to go only so far as wounding one another and at othertimes

requiring them to fight without reprieve, he made the sight familiar and even pleasing, and he roused in many of the young men an enthusiasm for arms."[5] In order to appreciate the full complexity of the initial reception of Roman gladiatorial games in the Greek world, we must turn to the evidence provided by architecture of the early imperial period.

In the Roman West the adoption of gladiatorial games was straightforwardly accompanied by the building of amphitheatres. This is not surprising for the following reasons. The oval amphitheatre was an ideal shape for an audience to view gladiatorial spectacles from all sides. It was also an ideal compromise between the centric and linear requirements of Roman spectacles, which from the time of Caesar and Augustus involved both single combats and wild beast shows, requiring an elongated space for running and chasing. More important than its functional practicality, however, was the symbolic Roman significance of this oval building type, which has to do with the circumstances of its inception in the *Forum Romanum* and its initial dissemination in Italy, as we have seen in previous chapters.

Yet, although the architectural response to gladiatorial games in the West is fairly straightforward, in the Greek East the need to put on these games elicited an architectural response that was more varied and complex, requiring a detailed explanation. In order to create a venue for gladiatorial contests, some Greek cities modified existing Greek spectator buildings, such as theatres. Other Greek cities built Roman-style amphitheatres. Some cities did both. These different architectural responses to gladiatorial games in the Greek world are epitomized by the buildings of two major cities: Athens and Corinth.

Athens

In Athens gladiatorial games were held in the Theatre of Dionysus, the orchestra of which was converted specifically for that purpose (Figure 101). The distinguishing mark of this conversion was a parapet wall, slightly over 1 m high, that was made of thin upright slabs of marble and placed around the orchestra, enclosing it completely as far as the *paradoi* (Figure 102). It was pierced at the foot at regular intervals to allow for the escape of surface water into the drainage channel behind it. This channel was covered with large marble slabs (horizontally laid), with cuttings in a rosette pattern for the reception of rainwater. A series of small holes, at more or less regular intervals, were discovered in the pavement just in front of the parapet.[6] These holes were for the reception of wooden poles that suspended a system of nets, used to protect the audience during gladiatorial shows and/or beast fights.

The conversion of the orchestra of the Theatre of Dionysus for Roman spectacles is sometimes said to have taken place in the high imperial or

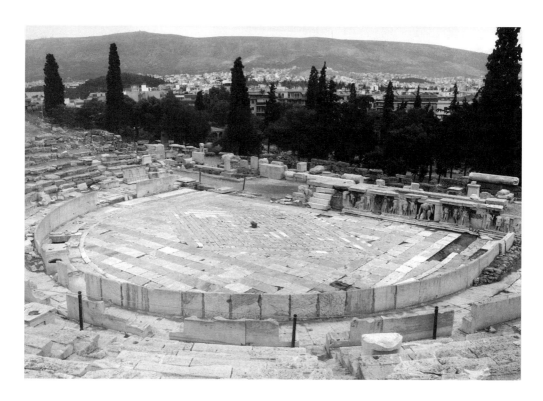

101. Theatre of Dionysus, view of orchestra (photo, author).

late antique period,[7] but it is more likely to have occurred in the mid-first century AD as part of a general renovation of the building that included an entirely new, Roman-style *scaenae frons* (stage building).[8] The *scaenae frons* is not well preserved, but large fragments of an architrave were discovered here and are known to have formed part of its central projecting *aedicula*, or porch (Figure 103). This architrave bears an inscription indicating that the new theatre was dedicated to Dionysus and Nero.[9] The combination of this Neronian inscription and a text of Dio Chrysostom (quoted later), which indicates that gladiators were performing in the Theatre of Dionysus during the 70s (the date of Dio's Rhodian oration), suggest that a large-scale renovation of the theatre took place during the Neronian period, which included not only the erection of the new stage but also the conversion of the orchestra for Roman gladiatorial games.

Theatre buildings came generally to be used for gladiatorial spectacles in the Greek world.[10] Athens, however, seems to have been the first Greek city to arrive at the idea of converting the orchestra of its theatre into a mini-arena for gladiatorial events. The other securely dated examples of such conversions cluster around the mid- to late-second century AD.[11] This conversion of an orchestra was achieved in one of two ways: either by erecting a parapet wall, usually of about 1.5 m in height (Figures 101, 102, and 104), or by removing the first few rows of seats so that the orchestra

could be faced with a podium, on top of which a post-and-net system was erected (Figure 105, Plate 14).

The distinguishing mark of this conversion in the Theatre of Dionysus – the marble barrier that runs around the orchestra and protects the audience – is considerably thinner and lower than most such parapet walls in other theatres (compare Figures 106 and 107). The point seems to have been to make it as visually unobtrusive as possible. Indeed, the Theatre of Dionysus seems to have been converted in the least architecturally conspicuous way, although still providing adequate protection for spectators. The new Roman *scaenae frons* of the Theatre of Dionysus is similarly restrained. It self-consciously retained some of the essential dimensions of its classical predecessor, the *skene* (stage) of the fourth century BC. Although the new, Neronian *scaenae frons* had the typically Roman features of a low *pulpitum* (platform, on which the acting took place) with decorative columnar orders as its backdrop, it was considerably smaller and shorter than most Roman *scaenarum frontes*. The *parodoi* (entrances to the orchestra) remained

102. Theatre of Dionysus, parapet wall encircling orchestra (photo, author).

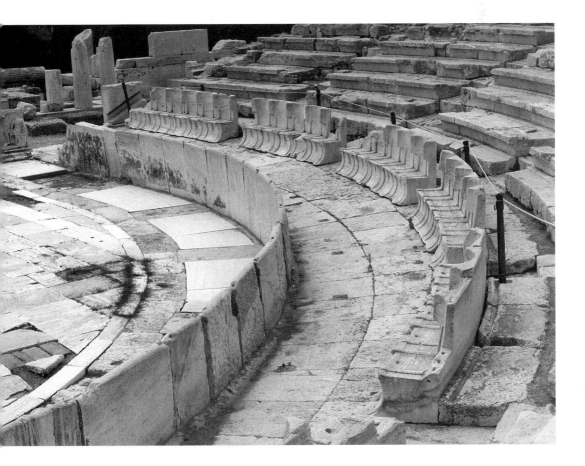

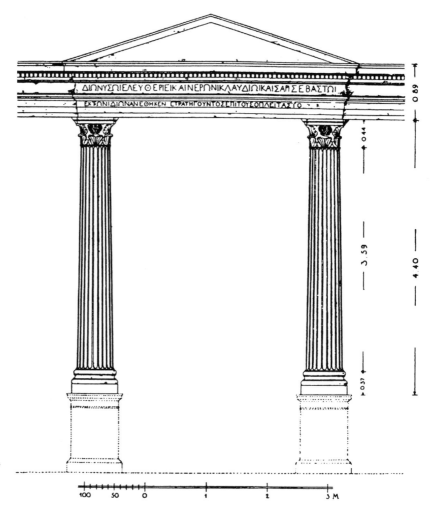

103.
Reconstructed
elevation, central
aedicula of
Neronian *scaenae
frons*, Theatre of
Dionysus (W.
Dörpfeld, *Das
griechische Theater*
[Athens, 1896]
fig. 28).

unvaulted, in good Greek fashion, and the stage building seems to have
preserved the general outline of the *paraskenia* (projecting wings) of the old
fourth-century Theatre of Dionysus (Figures 108 and 109).[12]

A theatre with such *paraskenia* would have appeared quite old-fashioned
in the imperial period, as Greek theatres of the *paraskenion* type had ceased
being built in Hellenistic times, when a new type of theatre with a flat stage
was introduced.[13] By Neronian times, there were very few surviving theatres
of the *paraskenion* type (the theatre at Epidaurus being a well-known exam-
ple). Compared to the architectural renovations of other Greek theatres
of the Roman period, such as Perge, the alterations made to the Theatre
of Dionysus, both in its *scaenae frons* and in its orchestra, were relatively
minimal. To understand why this was the case, one needs to consider the

social background of the theatre's conversion, for the architectural changes seem to have been controversial.

The architectural changes to the Theatre of Dionysus were carried out under the direction of an Athenian about whom we know a great deal: Ti. Claudius Novius, whose name as hoplite general (for the seventh time) probably appeared on the inscription on the stage building of the Theatre of Dionysus, dedicating the theatre to both Dionysus and Nero. Novius was one of the foremost men both in Athens and in the province of Achaea during the reigns of Claudius and Nero.[14] He held the post of hoplite general, which was closely connected with the administration of the imperial cult, eight times in the period between AD 41 and 61.[15] Novius' other titles show him to have been particularly close to Roman power. He was awarded the title *philokaisar* (loyal to the emperor) sometime during the reign of Claudius.[16] Also under Claudius he was high priest of Antonia Augusta (the daughter of Antony and mother of Claudius),[17] *agonothetes* (president of the contests) in honor of the games of Claudius,[18] and first "*agonothetes* of the games of the Augusti" (ἀγωνοθέτης πρῶτος τῶν Σεβαστῶν Ἀγώνων).[19]

The conversion of the Theatre of Dionysus was not the only architectural project in which Novius was involved. At the same time he also had a hand

104. Theatre at Perge, view of orchestra (photo, author).

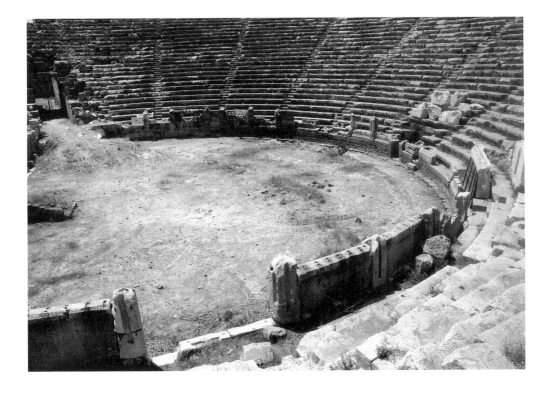

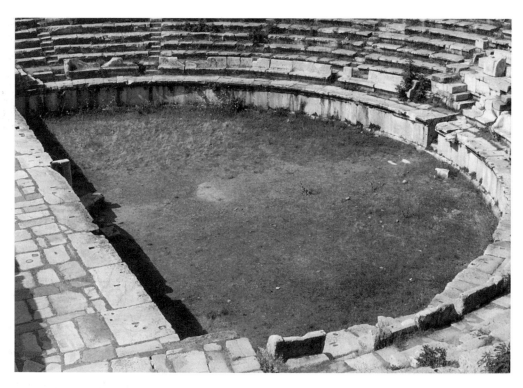

105. Theatre at Aphrodisias, podium encircling orchestra (photo, author).

in another, though related, architectural undertaking: an alteration of the Parthenon, close by (Figures 110 and 111, Plate 15). For many years during the nineteenth century, mysterious cuttings on the east architrave of the Parthenon posed a problem for archaeologists. It was clear that there had been an inscription there and that it had been monumental, but no one was able to make out what it had said. Nor could anyone guess why the large bronze letters had been removed so soon after they had been put up, as was evident from a distinct and peculiar absence of weathering. In 1896, Eugene Andrews, a young Fellow of the American School of Classical Studies in Athens, was persuaded by the prominent archaeologist W. Dörpfeld to help solve the enigma of the inscription, by climbing up the building (by means of a bosun's chair) and taking a series of laborious squeezes over the course of several weeks. Shortly after deciphering the inscription, Andrews wrote in a letter: "The inscription has proven to be a dedication to Nero, whereat I am much disgusted."[20] The inscription reads as follows:

> The council of the Areiopagus and the council of the six hundred and the Athenian people, to the emperor greatest Nero Caesar Claudius Augustus Germanicus, son of a god, Tiberius Claudius Novius, son of Phileinus, being hoplite general for the eighth time, and being overseer and lawgiver, when Pauline, daughter of Capito, was priestess [of Athena Polias].[21]

Novius' name appears prominently on the Parthenon inscription as hoplite general for the eighth time, just as it seems to have done in the inscription recording the dedication of the Theatre of Dionysus, during his seventh hoplite generalship. An ephebic text gives a date of AD 61/62 for Novius' eighth term as hoplite general and reveals that in this year Novius had become *epimelites* (curator) of the city of Athens for life, had been awarded the title "Best of the Hellenes," and was serving as high priest of Nero.[22] Novius seems to have been closely involved, then, in two building projects in honor of the emperor Nero: the remodeling of the Theatre of Dionysus and the alteration of the Parthenon by placement of an inscription on its east architrave. One should see the two projects in tandem, reflecting Novius' offices of *epimeletes* and hoplite general,[23] and particularly his priesthood of Nero.

Despite the prestigious offices that Novius held, he was not so typical of the Athenian political elite of his time. His praenomen and nomen reveal that he had received Roman citizenship under Claudius. His cognomen, Novius, is Campanian, and it has been suggested that he may have come from a family of Italians with a presence on the island of Delos.[24] Some support for this idea comes from the fact that he was *epimeletes* of the sacred island of Delos and priest of Delian Apollo for life.[25] Another possible

106. Theatre of Dionysus, detail of parapet wall encircling orchestra and *prohedria* (seats of honor), behind (photo, author).

107. Theatre at Perge, detail of parapet wall encircling orchestra (photo, author).

indication of his non-Athenian birth is his choice of wife, one Demostheneia of Marathon, who likewise was not a native Athenian. She came from an upper-class family from Sparta, the P. Memmii, who had enjoyed the patronage of P. Memmius Regulus, governor of Achaea between AD 35 and AD 40.[26] Evidently Novius was wealthy enough to carry out major building projects, but he was not part of the old Athenian nobility.

Not everyone in Athens seems to have approved of the architectural changes made to Athenian public buildings during the seventh and eighth hoplite generalships of Ti. Claudius Novius. Literary evidence suggests that the conversion of the Theatre of Dionysus for Roman games and the staging of gladiatorial games inside it were received negatively by some. Resistance was voiced by philosophers, for example, who championed traditional values, expressing outrage that gladiatorial games would be held at the foot of the Acropolis in the Theatre of Dionysus, a sacred place where the great tragedies had been performed and where the *demos* still assembled to vote. Philostratus tells us that Apollonius of Tyana, a neo-Pythagorean sage active in the mid- to late-first century AD, was on a certain occasion invited to attend a meeting of the *Ekklesia* (civic assembly) in Athens. He wrote a letter to the people of Athens, refusing to enter the Theatre of Dionysus where the *Ekklesia* was held:

The Athenians ran in crowds to the theatre beneath the Acropolis to witness human slaughter, and the passion for such sports was stronger there than it is in Corinth today; for they would buy for large sums adulterers and fornicators and burglars and cut-purses and kidnappers and such-like rabble, and then they took them and armed them and set them to fight with one another. Apollonius then attacked these practices, and when the Athenians invited him to attend their assembly, he refused to enter a place so impure and reeking with gore. And this he said in an epistle to them, that he was surprised "that the goddess had not already quitted the Acropolis when you shed such blood under her eyes..."[27]

108. Plan of Theatre of Dionysus, Roman period (W. Dörpfeld, *Das griechische Theater* [Athens, 1896] fig. 32).

A particularly dramatic protest against the use of the Theatre of Dionysus for gladiatorial shows is found in the writings of Lucian. The passage concerns Demonax, a cynic philosopher of the mid-second century AD, who made a career of criticizing Athenian public institutions. At one point

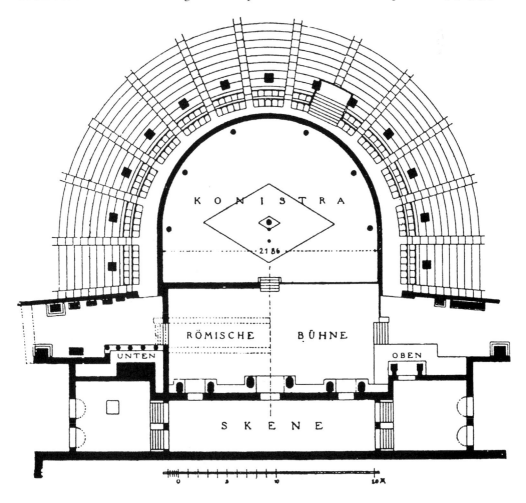

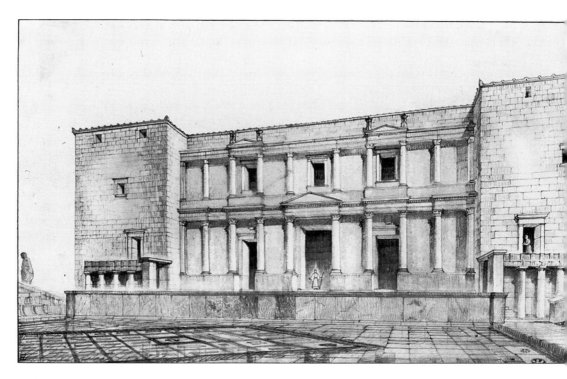

109. Theatre of Dionysus, Neronian *scaenae frons*, according to Fiechter (E. R. Fiechter, *Das Dionysos-Theater in Athen* [*Antike griechische Theaterbauten Heft 7*] Stuttgart, 1936 fig. 43).

Demonax appeared before the *Ekklesia* to try to dissuade the Athenians from instituting gladiatorial games: "When the Athenians out of rivalry with the Corinthians were thinking of holding a gladiatorial show, [Demonax] came before them and exclaimed, 'Don't pass this resolution, men of Athens, without first pulling down the Altar of Pity!'"[28] The Altar of Pity was a refuge of suppliants; the implication of this quip is that the Roman arena was, by contrast, devoid of any compassion.

The unease of Demonax about the threat that these games presented to Greek culture was also expressed by an earlier orator, Dio Chrysostom, active in the third quarter of the first century AD. In the passage mentioned previously in connection with the date of the conversion of the Theatre of Dionysus, Dio writes:

> As matters now stand, there is no practice current in Athens which would not cause any man to feel ashamed. For instance, in regard to gladiatorial shows the Athenians have so zealously emulated the Corinthians, or, rather, have so surpassed them and all others in their mad infatuation, that whereas the Corinthians watch these combats outside the city in a ravine (χαράδρη), a place that can hold a crowd but otherwise is filthy and such that no one would even bury a freeborn citizen there, the Athenians look on this fine spectacle in their theatre under the very walls of the Acropolis, in the place where they bring their Dionysus [the cult statue] into the orchestra and stand him up, so

that the very seats [the prohedria] in which the hierophant and other priests must sit are sometimes spattered with blood.[29]

Dio Chrysostom's objection to gladiators in the Theatre of Dionysus is that killing is unclean, and therefore it is inappropriate to hold gladiatorial games in a sacred precinct. His concern is specifically about the contamination of the building *per se*. People such as Dio had set themselves up as the guardians of Greek tradition, and it is likely that they were expressing opinions shared by their conservative Greek contemporaries.[30] In the first and early second centuries, then, there were some Greeks who had strong objections to bloody Roman games being staged in the Theatre of Dionysus and who perceived this practice as a threat to traditional Greek culture.

The opposition expressed by these philosophers is understandable, considering other evidence for opposition to Rome among the old nobilities in Greek cities in the early Imperial period. Athens, with a long tradition of democracy, seems to have preserved some hostility to Roman rule in early imperial times; the city had been sacked by Sulla in the not too distant past (88 BC). Some reflection of a lingering opposition in Athens is provided by an anecdote related in Cassius Dio: when Augustus was on his way to Athens in

110. Parthenon, east façade (photo: *D.A.I.* Athens neg. 1878).

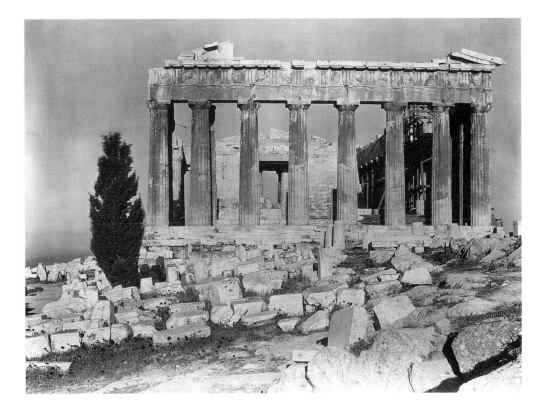

22/21 BC, a statue of Athena on the acropolis turned around and spat blood, as a result of which Augustus refused to enter the city.[31] There are also reports in several sources of a revolt (the leaders of which were executed) at Athens in AD 13 at the end of Augustus' life.[32] Greek resistance toward Rome is also suggested by an honorary decree of Mantinea-Antigoneia in which a local noble is extolled because he was "pleasant to the divine Senate since he praised the proconsuls and did not accuse them."[33] The passage suggests that it was not unusual for prominent Greeks to complain of Roman rule.[34] Unrest in Tiberius' reign is suggested by the emperor's transfer of the province of Achaea from senatorial control to his own direct control and by a speech that Cn. Calpurnius Piso is said to have made in AD 18, accusing the Athenians of continuous trouble making.[35] Also in the reign of Tiberius apocalyptic prophecies were circulating in Greece that predicted Rome's downfall.[36] Such sentiments would presumably have found a reception among the discontented segments of the Athenian government.[37]

That such hostility persisted into the later first century AD is suggested by a Greek literary text, probably of the second half of the first century AD, preserved in the correspondence of the Emperor Julian. The text discusses an Argive embassy that requested a hearing concerning a dispute with Corinth over Argive payments for the staging of *venationes* at Corinth. The anonymous author argues that Argos should not be made to pay "to toil as slaves for a foreign spectacle celebrated by others."[38] The objection is that payments were being used to support spectacles that were neither Greek nor ancient. The wording of the text makes no effort to disguise Argive dislike of the Roman arena events for which the disputed payments were intended.[39]

The objections on the part of Dio Chrysostom, Demonax, and Apollonius of Tyana to the use of the Theatre of Dionysus for gladiators can, thus, be situated in the larger context of politically conservative Greek opposition to Roman rule and cultural activities. We may suggest that not only philosophers but also some traditional Athenian noblemen may not have been pleased by the new use of the Theatre of Dionysus. The large (25-m-long), gilded inscription on the architrave of the Parthenon may have occasioned controversy as well: the fact that it was removed immediately upon Nero's fall – and not replaced with another – suggests that this was the case. The inscription not only compromised the classical integrity of one of the choicest architectural treasures of Greece but also occupied a position, on the entablature of the building, where at the time honorific inscriptions were normally placed on Roman temples, but not on Greek ones.[40] There are no known precedents for the conversion of the orchestra of a Greek theatre for Roman spectacles or for the placing of an honorific inscription on the architrave of a major Greek temple. These were architectural

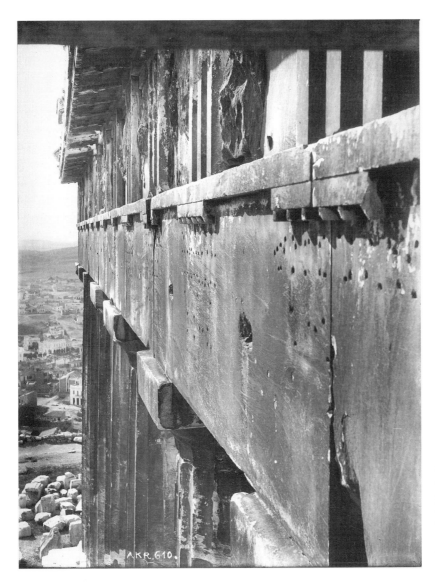

III. Parthenon, east façade, detail of architrave with cuttings for Neronian inscription (photo: *D.A.I.* Athens neg. Akr 610).

innovations, and the decision to change these antique buildings was bound to be controversial.

Architecturally speaking, the manner in which Novius and his colleagues chose to modify the two buildings in question is revealing. In formal terms, neither the Theatre of Dionysus nor the Parthenon was significantly altered. One can interpret this in two ways. On the one hand, the fact that both buildings were not much changed might have conciliated traditionalist Athenian opinion. On the other hand, the fact that two of Athens' most hallowed buildings had been left in near pristine Classical form would have

made them all the more valuable as gifts in honor of Nero, Rome's first openly philhellenic emperor.[41] Ti. Claudius Novius, it may be suggested, was one powerful Athenian who, at a felicitous moment, embraced the new realities of Roman power, and did so forcefully.

Corinth

If the alteration of traditional buildings in Athens occasioned opposition among certain sectors of the Athenian populace, it is of great interest to note how this opposition was expressed. Dio Chrysostom, Lucian, and Philostratus, when condemning the Athenians for putting on gladiatorial games in the Theatre of Dionysus, all make reference to the city of Corinth, stating that the reason that the Athenians began putting on gladiatorial shows in the Theatre of Dionysus was to emulate the Corinthians. Unlike Athens, Corinth held its gladiatorial games not only in a Greek theatre but also in a Roman-style oval amphitheatre. In fact, Corinth was one of a very few Greek cities that possessed such a Roman building type. This raises some interesting questions: first, why Athens felt the need to emulate Corinth in staging gladiatorial games; and, second, why Athens used only a theatre for this purpose, whereas Corinth used two different types of spectator building for gladiatorial games.

The amphitheatre at Corinth was built in an area approximately 1 km east of the Classical civic center, but still inside the Classical city walls (Figure 187).[42] Unfortunately, the building is not well preserved and has never been excavated.[43] The exact plan is still uncertain, but it is clear that the structure was relatively small, oval in shape, and rock-cut (Figures 112, 188 and 189 in the Appendix, Plate 16). The amphitheatre's crater-like *cavea* was quarried out of the surrounding bedrock; the irregular contour of the arena that can be seen today is the result of considerable erosion of this stone. The part of the rock-cut auditorium that is now visible is evidently the partially collapsed *media cavea* of the amphitheatre. Only a few tiers of seating are still visible (see Figure 190 in the Appendix). The *ima cavea*, podium, and arena floor are still buried. Bits of concrete survive in the earth above the *media cavea*, but not enough to suggest that the amphitheatre had a superstructure of stone or concrete. The line of the façade is invisible today. Since there are no remains of a monumental superstructure (*summa cavea*), it has been plausibly suggested that the amphitheatre had a superstructure of wood.[44]

Two plans of the amphitheatre at Corinth do, however, exist: the first (Figure 113, Plate 18) was executed in 1701 under the direction of Francesco Grimani, who was Provveditore Generale (General Purveyor) of the

112.
Amphitheatre at
Corinth. View
looking north
toward "*porta
libitinensis*."
Staircase in
foreground
(photo: courtesy
of the Corinth
Excavations,
American School
of Classical
Studies at
Athens).

Venetian army, which occupied Corinth from 1699 to 1715; the second (see Figure 193 in the Appendix) was published by the Expédition Scientifique de Morée in the 1830s.[45] The latter shows a *cavea* divided into twelve wedges. Both plans show a rock-cut passage leading out from the arena to the north. This feature, which is still visible (see Figure 194 in the Appendix), was presumably the "*porta libitinensis*," which was used as an exit for arena combatants and was normally positioned at one of the major axes of an amphitheatre, facing away from the civic center.[46] The southern sector of the building is completely buried, but it is likely to have had a corresponding rock-cut passage, which functioned as the "*Porta Triumphalis*," the entrance to the arena for gladiators and other performers, normally positioned opposite the "*Porta Libitinensis*."[47]

In previous discussions, the amphitheatre at Corinth has been dated to the high imperial period or later (second or third century AD). This dating is based on eighteenth century plan of the building itself as well as on two literary passages. We may examine each of these pieces of evidence in turn. The plan of Francesco Grimani (Figure 113; Plate 18) shows a network of rectangular chambers running along the outer circumference of the building; these have been interpreted as holding areas where wild beasts used in the performances were kept.[48] Facilities for storing caged animals are a known

feature of high imperial amphitheatres, such as those at Puteoli, Capua, and the Colosseum in Rome. At Corinth, however, there is no evidence that these kinds of rectangular chambers ever existed. Although there is a hollow, grotto-like area in the stone located beneath and behind the *media cavea* (see Figure 193 in the Appendix), this is evidently not an ancient feature of the building but one created by erosion.[49] Moreover, an interesting letter of Francesco Grimani addressed to the Senate in Venice reveals that his plan of the building was made in conjunction with a proposal to use the ruins of the amphitheatre as a fortified hospital and storage facility during an epidemic. According to the captions attached to the plan (see Figure 113; Plate 18), the great rock-cut entrance to the arena (the "*porta libitinensis*") was to be used to house sick people; the valuable goods were to be stored in the remains of the *cavea*; and a "Casa del Priore" (Warden's Quarters) was to be built in the southern sector of the building. Note that in the plan the rectangular chambers are labeled as follows: "Grotte, che devono ridursi in Camere 18 colle mura separate" (grottoes that should be changed into eighteen rooms with separate walls). This indicates that the storage rooms were meant, at some point in the future, to be built into the amphitheatre's "grottoes." It is clear both from Grimani's text and from the plan itself, where the existing remains of the building are rendered in black and the chambers are rendered in red, that the chambers did not exist in Grimani's time but were intended to be built into the remains of the amphitheatre to safeguard valuables.[50] There is no surviving response to Grimani's letter (to my knowledge), and there is no archaeological evidence that his plan was ever realized.[51] The idea that the amphitheatre at Corinth had cells beneath the *cavea* (used in ancient times for animal cages) should be abandoned.[52]

The literary evidence on which the high imperial dating of Corinth's amphitheatre is based is drawn first from Pausanias, who wrote in the mid-second century AD: this author does not mention an amphitheatre in his description of Corinth, whereas he does mention the theatre and the odeion, as well as monuments on the outskirts of the city, such as tombs.[53] This has been taken to mean that the amphitheatre that survives today was built sometime after Pausanias wrote.[54] In addition, while Dio Chrysostom in the 70s AD (see earlier) does mention a place for viewing gladiatorial games at Corinth, this is assumed to have been a structure other than the surviving amphitheatre, because Dio rather contemptuously locates his amphitheatre outside the city walls, whereas the surviving amphitheatre is actually inside the Classical city wall. Furthermore, he refers to the place as a χαράδρη (ravine), yet the surviving amphitheatre is assumed to have been an architecturally impressive building that would not warrant such a description.[55]

MITTHEILUNGEN DES ARCHAEOL. INSTITUTES 1877. Taf. XIX.

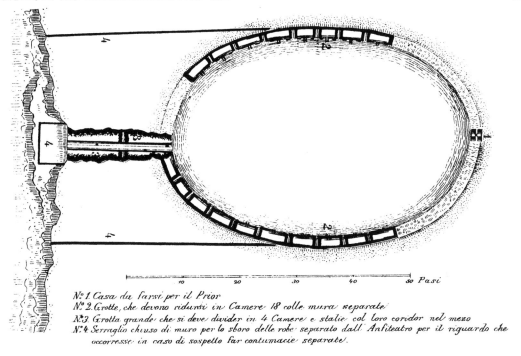

No. 1. Casa da farsi per il Prior
No. 2. Grotte, che devono ridursi in Camere 18 colle mura separate
No. 3. Grotta grande che si deve divider in 4 Camere e stalie col loro coridor nel mezo
No. 4. Serraglio chiuso di muro per lo sboro delle robe separato dall' Anfiteatro per il riguardo che
occorresse in caso di sospetto far contumacie separate.

ANFITEATRO ANTICO A CORINTO CON GROTTESCHI SERVE PER LAZARETTO.

Pausanias' silence about this building, however, would be perfectly consistent with a Greek intellectual's dismissive evaluation of gladiatorial games. There is no reason, furthermore, why the surviving amphitheatre at Corinth could not be the "ravine" to which Dio Chrysostom referred. First, the building is not a monumental freestanding structure but is cut out of the living rock. Second, although the building is still inside the Classical city walls, it is far enough away from the civic center to have warranted Dio's scornful description of it as being outside the city. Third, the tone in which Dio mentions the structure is typical of conservative Greek writing on the subject of Roman spectacles.[56] The author would not have wished to emphasize any civic importance that the structure may have had. As we have seen, the amphitheatre – unlike a theatre, odeion, or stadium – was a type of spectator building that lacked a Greek cultural pedigree. We may conclude, then, that the amphitheatre whose ruins we see today was the one mentioned by Dio Chrysostom in his Rhodian oration, written not long after AD 70.

That the building was considerably earlier than the time of Dio Chrysostom is suggested by its construction technique. Like the amphitheatre

113.
Amphitheatre at Corinth, plan of 1701 by Grimani (S. P. Lampros, "Ueber das korinthische Amphiteater" *Ath. Mitt.* 2 [1877] pl. 19. (see Color Plate 18.)

at Pompeii, the amphitheatre at Corinth was relatively small, functional looking, and – as was demonstrated earlier – lacked any substructures for spectator circulation or basement structures for animal cages, such as in amphitheatres of the imperial period. Indeed, the closest formal parallels for the Corinth amphitheatre are found in amphitheatres of the first century BC: two well-documented examples are the rock-cut amphitheatre at Sutrium in Etruria (see Figure 179 in the Appendix) and the amphitheatre at Carmo in Baetica (Figure 186), both probably built in the triumviral period.[57] Furthermore, as has been established by D. G. Romano, the Corinth amphitheatre is located just at the northeastern corner of the centuriated grid plan of the Roman colony (Figure 194 [the amphitheatre does not appear on the plan]).[58] Its location in the plan of Roman Corinth is comparable to that of amphitheatres in other Roman colonies, which are normally located at the edge of town. This suggests that the amphitheatre at Corinth was built, or at least planned, at the time of the colonization of Corinth, which was organized by Julius Caesar in 44 BC.[59]

It may be argued, then, that Corinth's reputation in Athens as precocious in its staging of gladiatorial games, as stated by Dio Chrysostom, Lucian, and Philostratos, can be explained by its status as a Roman colony settled by Julius Caesar, the first such colony in the Greek world. Corinth had a substantial population of Roman citizens for whom, it may also be suggested, building an amphitheatre was an important way of establishing a Roman architectural presence. There are additional reasons, though, why Corinthian colonists would have required an amphitheatre. In colonies established by Julius Caesar, gladiatorial combat may actually have been mandated by law, as discussed in Chapter Three. Roman colonial magistrates were expected to put on gladiatorial shows as a public duty. And finally, as we have seen, amphitheatres were especially common in colonies settled by army veterans, a well-documented example being Pompeii, and there is evidence that the colony at Corinth was settled in 44 BC by a contingent of Romans consisting not only of freedmen but also of army veterans.[60] The establishment of a Roman colony at Corinth as early as 44 BC suggests that the Corinthian amphitheatre was an original feature of the colony, making it one of the earliest, most likely the very earliest, amphitheatre built in the Greek world.

Other than at Corinth, very few amphitheatres were constructed in the Greek world, but most of the cities in which they were built were, like Corinth, Roman colonies, or provincial capitals, or Greek *poleis* with a substantial Roman presence. Other Greek examples include Knossos (a veteran colony of Augustus) and Gortyn (provincial capital of Crete and Cyrene).[61] In Asia Minor there are amphitheatres at Antioch (capital of Syria province), Pergamon (which had a substantial Roman presence), and Pisidian Antioch,

a Roman colony.[62] Thus, it is not surprising that an amphitheatre should have been built in a Roman colony such as Corinth, because constructing an amphitheatre was a way for overseas colonists to demonstrate their Roman identity, as suggested by the circumstances of the erection of stone amphitheatres in republican Italy (see Chapter Three). In a colony such as Corinth, an amphitheatre served as an architectural indication that the dominant element of the population was now Roman.[63]

The subsequent adoption of gladiatorial spectacles in Athens and other Greek cities can be seen, then, as a response to the earlier institution of such games in colonies like Corinth. Here is the explanation for the trope found in the ancient sources that the Athenians adopted gladiatorial games "out of rivalry with Corinth." Corinth provided a model to which other Greek cities could look in searching for ways to accommodate the new contingencies of Roman power.[64] The staging of gladiatorial games in the Theatre of Dionysus in Athens can be seen as a direct response to this assertion of status. The adaptation of the Theatre's orchestra, however, was a way of accommodating Roman spectacles without actually adopting Roman architectural forms, thus keeping Greek cultural identity relatively intact.

Conclusion

This chapter has explored two different architectural responses to the Roman amphitheatre and its spectacles in the Greek world in the late Hellenistic and early imperial periods. In the time of Julius Caesar, Corinth had become a Roman colony. Like their counterparts in Italy, the colonists at Corinth constructed an amphitheatre in which to stage their Roman spectacles. Athens, traditionally a cultural model, seems to have been the first city to have arrived at the idea of converting the orchestra of its theatre for Roman gladiatorial games, thereby providing a venue for Roman spectacles without compromising the integrity of Greek architectural forms. The success of the Athenian architectural response can be gauged by the fact that most Greek cities chose to imitate Athens by converting their theatres instead of by building amphitheatres.

The Athenian solution did, however, have considerable practical disadvantages for both viewer and combatant. The semicircular orchestra of most Greek theatres is less than one third the size of an amphitheatre's arena. The smaller space would have limited the scale and ferocity of the events (particularly in the case of wild-beast hunts) that could be accommodated there.[65] Even with the parapet and net system in place, there was still the possibility of contact between combatants (that is, gladiators) and

spectators in the first row. As we have seen, Dio Chrysostom complained that the front-row seats were sometimes spattered with blood. Another factor was that theatres were designed for stylized and controlled dramas that were meant to be viewed principally from the front of the stage building, with the actors facing the audience. In a theatre, actors did not turn their backs to the audience except for a dramatic purpose. Gladiatorial games were very different. While the fighting could be orchestrated to some extent, the combatants were less concerned about giving the audience the best view than they were with matters of life and death. When gladiatorial combat took place in the semicircular orchestra of a theatre, there was always the possibility that one of the pair of combatants would be driven into a corner, and that the climactic moment, when one gladiator gained the advantage and the loser asked for his life, would be obscured from the view of the greater part of the audience.

By contrast, the oval shape of the amphitheatre provided an ideal space for viewing both gladiators and wild-beast shows. It had a relatively spacious arena, usually at least 70 m in length, and a high podium, usually at least 2 m in height, to protect the spectators. Moreover, the oval arena encouraged a pair of fighters to keep to the center of the performance space, where they could be admired from all sides by spectators in all parts of the *cavea*. The Greek practice of holding gladiatorial combat in theatres was considerably less convenient from the perspective of both the audience's view and the mechanics of the spectacle itself. Why, then, considering the scale and expense of the imperial cult festival, were not more amphitheatres built in the Greek world?

Converting a preexisting theatre was less expensive than building an amphitheatre, and this is certainly one reason why amphitheatres were not commonly built in the Greek world. Yet considering the fact that wealthy Greek cities readily adopted another Roman recreational building type – the imperial bath – the rarity of amphitheatres remains surprising.[66] One could argue that amphitheatres were not needed, because gladiatorial games were held only on a limited number of days a year during the imperial cult festival. This does not seem to be an adequate explanation, however, because western cities, many of which built amphitheatres, also held gladiatorial games for only a limited number of days per year, generally fewer than ten.[67]

We may suggest that in explaining the near absence of amphitheatres in the Greek world, we must consider the archaeology of the initial reception of Roman gladiatorial games and Roman colonists in the Greek world as outlined in this chapter. The initial negative reaction in Greek circles to Julius Caesar's colony at Corinth is no better illustrated than in an epigram by the Augustan poet Krinagoras of Mytilene: "O pitiable, what dwellers

you have found for yourself, and in what others' place! Woe for the misery of great Hellas! O Corinth, I would have you lie more prostrate than [...], more deserted than the sands of Libya, rather than be surrendered whole to such shop-soiled slaves, and vex the bones of the ancient Bacchaids."[68] In the early imperial period the Athenians and other Greeks were not eager to adopt a building type that had become an architectural symbol of Roman power because of its colonial associations, first in the cities of Italy and then in Roman colonies in Greece such as Corinth.

As an epilogue, we may consider why in the second century AD the Corinthians, who already had an amphitheatre, decided to convert their theatre for gladiatorial games (see Figure 187 in the Appendix).[69] The answer is somewhat ironic in that it constitutes a sort of reverse competition. By the second century the pattern of converting the orchestras of Greek theatres began to exert an influence on Corinth. By that time, most important Greek cities had already converted their theatres, following the lead of Athens. Corinth was not to be left behind. Instead of exclusively holding these games in a marginalized spot in an agricultural area at the edge of the city, the Corinthians decided to hold gladiatorial games in the more prestigious civic center, as other Greek cities were now doing. In second century AD Corinth, gladiatorial combat was no longer associated only with one particular group in the city, that is, the Roman colonists. As Athens had become more Roman, so Corinth, which had been reborn under Julius Caesar as a Roman city, had become more Greek.

CONCLUSION

This book has shown that the significance of the amphitheatre in the Roman world is to be found in its origins in the city of Rome and in the Roman military ethos of the middle and late Republic. It argues that the beginnings of the amphitheatre lie, not in Campania, but at Rome itself in the *Forum Romanum* and that this was a function of gladiatorial contests being regular events in Rome, as early as the middle republican period. The canonical oval form of the amphitheatre was dictated by the oblong shape of the Roman Forum, where wooden seating was erected for gladiatorial shows on a semiregular basis. The prestigious location of these temporary wooden arenas in the Forum made them the model for the earliest stone amphitheatres in the towns of Italy, where the oval shape and functional appearance were proudly reproduced in the era of the Social and Civil Wars, a time of cultural change around the issue of Italian unification under Rome.

The earliest permanent amphitheatres appear in the first century BC in cities that had particularly close ties to Rome, primarily military colonies and old Latin colonies, and seem to have been closely associated with the program of military colonization initiated there by the Roman dictator Sulla (in 80 BC) and with the Social War (90-88 BC). Since the late second century BC, the training of Roman soldiers seems to have included gladiatorial methods, and soldiers certainly enjoyed gladiatorial contests as a regular form of entertainment while on campaign. The arenas built by veteran colonists, such as those at Pompeii, provided a permanent venue in which they could view gladiatorial combat, as well as afforded them a way of putting a Roman architectural stamp on non-Roman, Italic communities. The association of the arena and the army is further demonstrated by the existence of early amphitheatres in such far-flung locations as Corinth in Greece and Antioch in Syria, places which were provincial capitals and where Julius Caesar's troops were settled or stationed during the 40s BC.

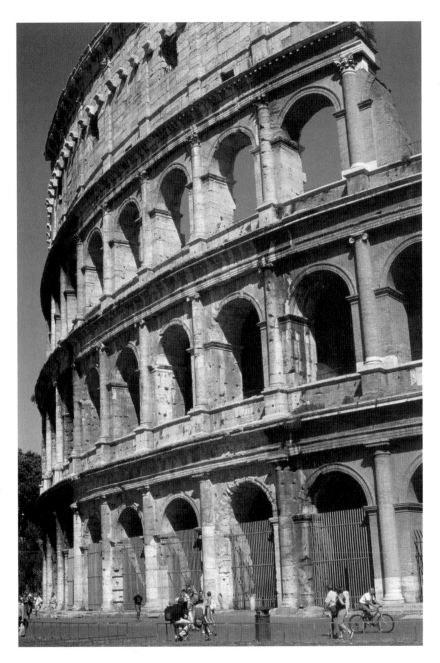

Plate 1. Colosseum, façade, AD 80 (Saskia).

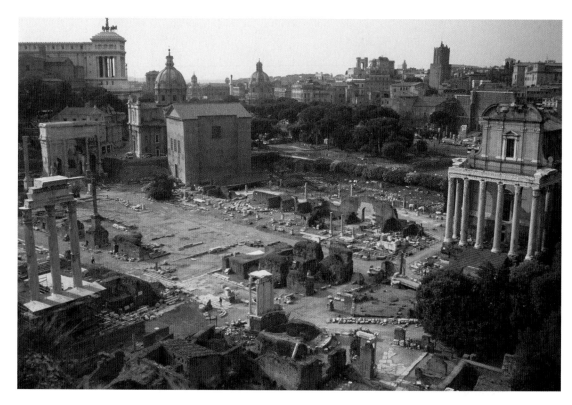

Plate 2. Aerial view of the *Forum Romanum*, where gladiatorial combats were held from the 3rd–1st centuries BC (Saskia).

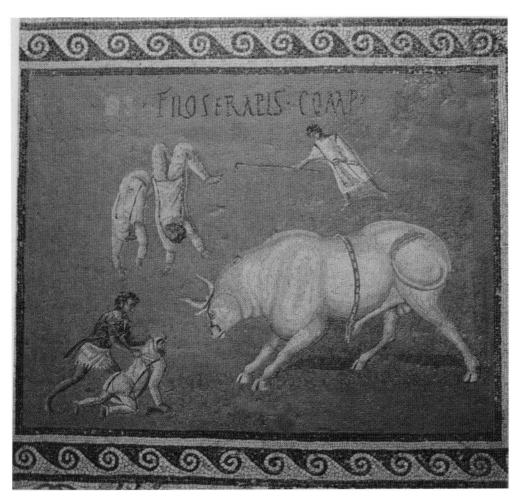

Plate 3. Scene of *damnatio ad bestias* on a mosaic in a Roman villa at Silin, Libya, showing barbarian prisoners being flipped and mauled by a bull, with an arena attendant thrusting them toward the animal. Signed by the artist: *Filoserapis comp(osuit)* (O. Al Mahjub, "I mosaici della villa Romana di Silin," R. Farioli Campanati ed., *III Colloquio Internazionale sul Mosaico Antico: Ravenna, 6–10 Settembre 1980* [Ravenna, Girasole 1983]).

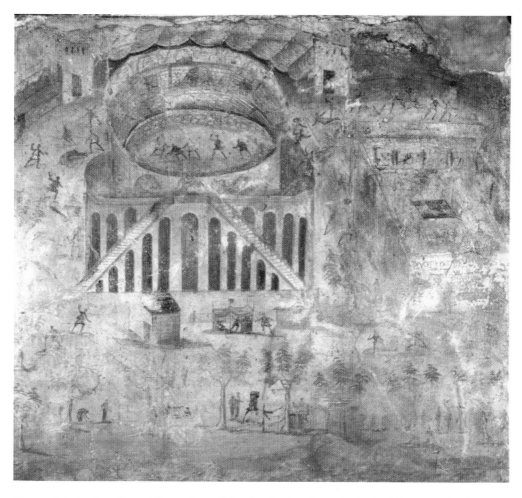

Plate 4. Painting from House I iii 23 at Pompeii showing the riot of AD 59 in the amphitheatre, with Palestra Grande (*Campus*) at right (R. Seaford, *Pompeii* [New York, Summerfield Press, distributed by Thames & Hudson, 1978]). (Figure 18 in the text.)

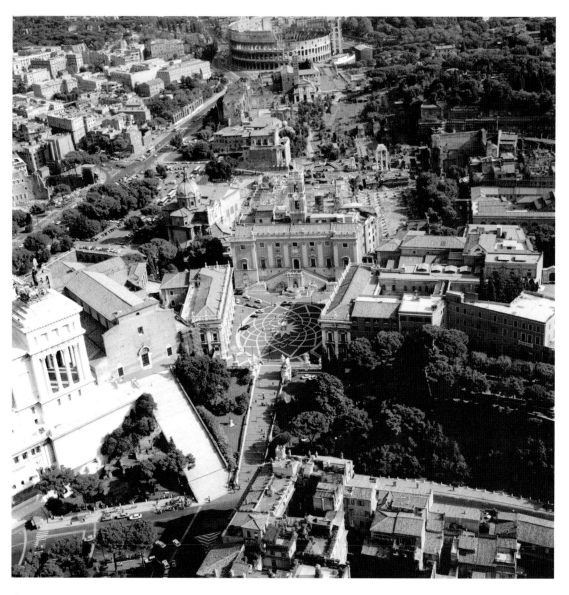

Plate 5. Aerial view of the Campidoglio with *Forum Romanum* and Colosseum in the background (Stato Maggiore Aeronautica, Ufficio Storico). (Courtesy of the Center for Audiovisual Production, Stato Maggiore Aeronautica, Rome.)

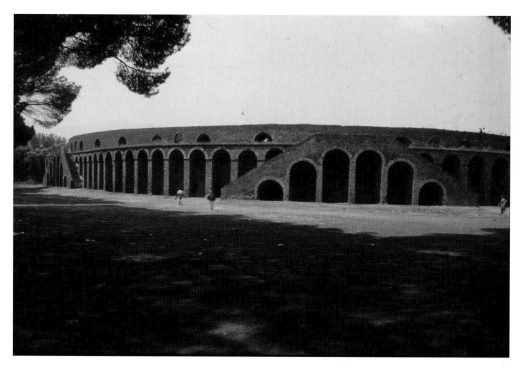

Plate 6. Amphitheatre at Pompeii, façade, ca. 70 BC (photo, author).

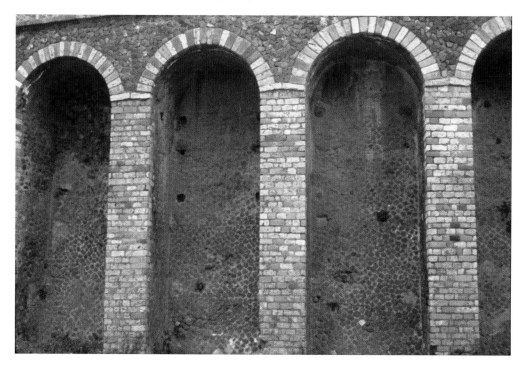

Plate 7. Amphitheatre at Pompeii ca. 70 BC, detail of façade (photo, author).

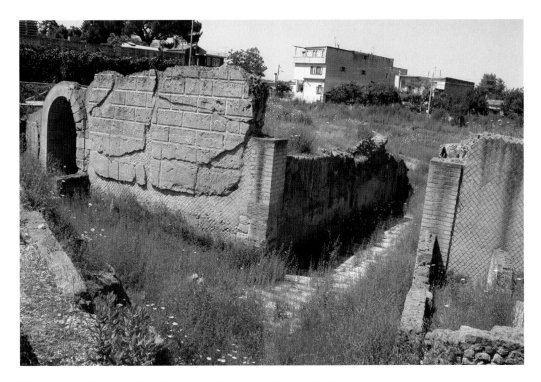

Plate 8. Amphitheatre at Nola, façade, ca. mid-1st c. BC (photo, author).

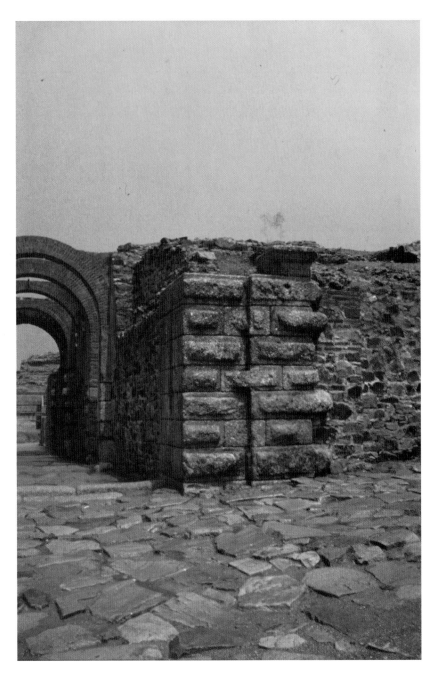

Plate 9. Amphitheatre at Augusta Emerita (Mérida), façade, Augustan (photo, M. Wilson Jones).

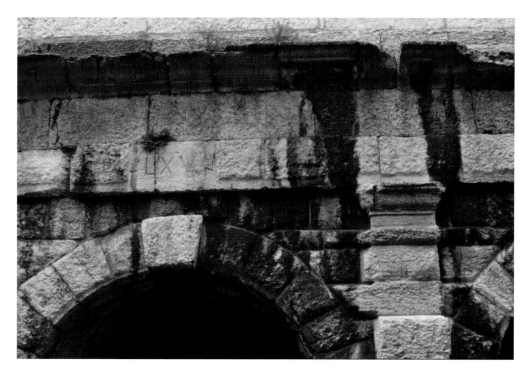

Plate 10. Amphitheatre at Verona, detail of façade, Julio-Claudian (photo, author).

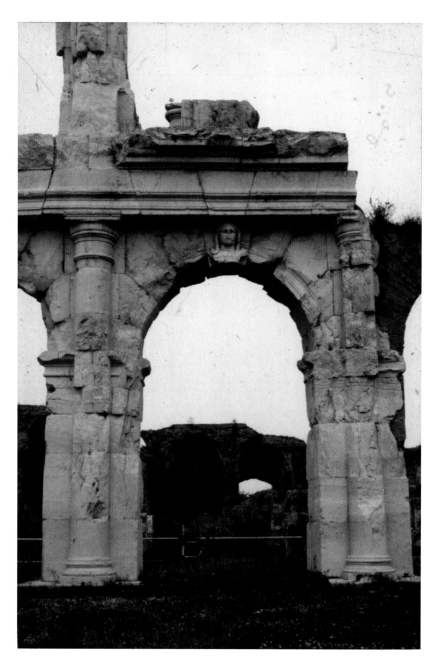

Plate 11. Imperial amphitheatre at Capua, façade, Hadrianic (photo, author).

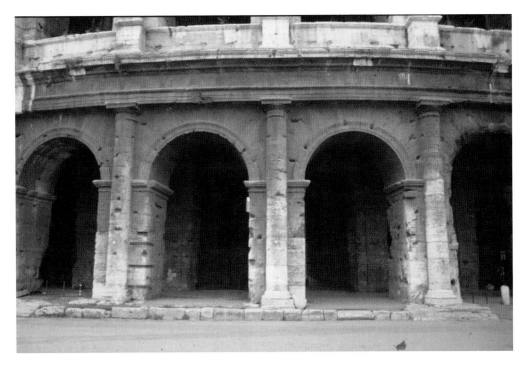

Plate 12. Colosseum, first story of façade, AD 80 (photo, author).

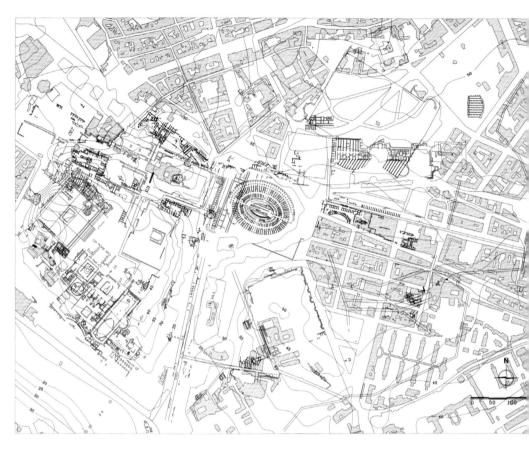

Plate 13. Plan at central Rome showing *Domus Aurea* structures in red, 1st c. AD. Note porticus surrounding the *Stagnum Neronis*, upon which the Colosseum was later built (C. Panella *et al.*, *Meta Sudans I un' area sacra in Palatio e la valle del Colosseo primo e dopo Nerone* [Rome, 1996]). (Figure 94 in this text.)

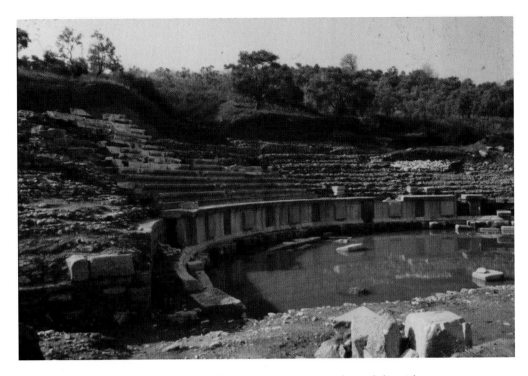

Plate 14. Theatre at Magnesia on the Meander, with orchestra converted into gladiatorial arena, 2nd c. AD (photo, author).

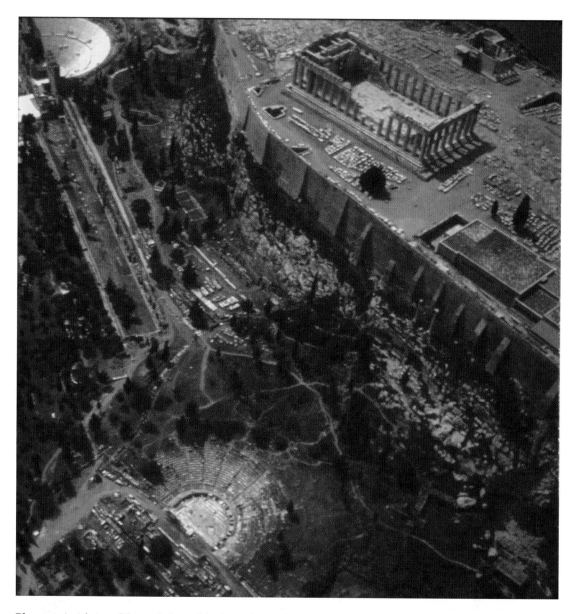

Plate 15. Aerial view of the south slope of the Acropolis at Athens, showing Theatre of Dionysus and Parthenon (Loyola University Chicago, c. 1989, R. V. Schoder, SJ, photographer).

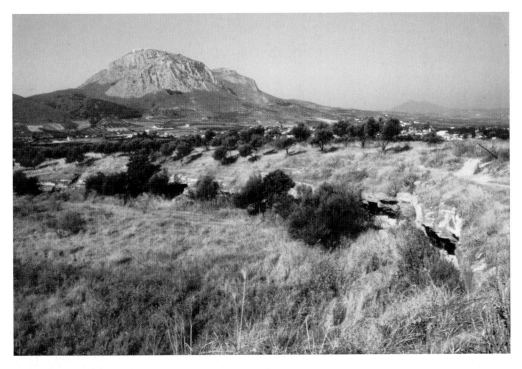

Plate 16. Amphitheatre at Corinth, late 1st c. BC, view with Acrocorinth in the background (photo, author).

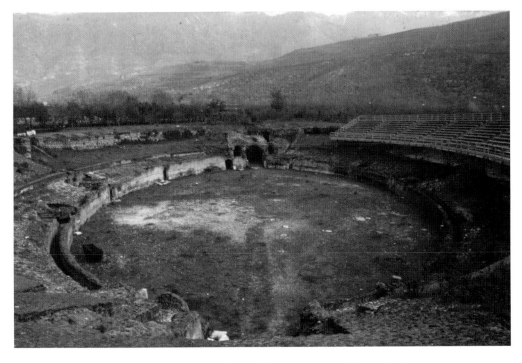

Plate 17. Amphitheatre at Abella 1st c. BC (modern Avella), 1st c. BC *cavea* (photo, author).

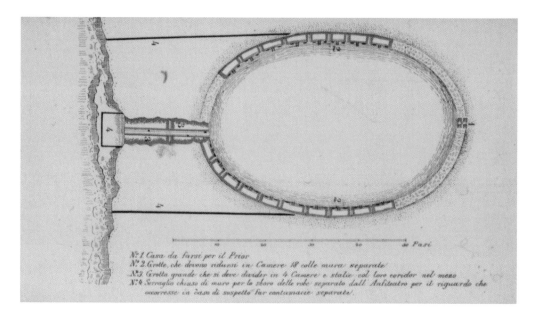

Plate 18. Amphitheatre at Corinth, plan of 1701 by Grimani (S. P. Lampros, "Ueber das korinthische Amphitheater" *Ath. Mitt.* 2 [1877]). (Figure 113 in the text.)

These early amphitheatres had an undecorated, functional appearance with embanked rather than freestanding *caveae*, making them in formal terms little more than 'architecturalized' terrain of concrete and earth. Their 'styleless' design has been shown here to have derived from the wooden prototype in the *Forum Romanum*. The amphitheatre lost its functional appearance in Augustan times when it began to be monumentalized in cut stone, with substructures and imposing façades, decorated with architectural orders, becoming a quintessentially Roman building type. The Augustan age witnessed a proliferation of such amphitheatre buildings throughout Italy. These are the first amphitheatres that exhibit a truly civic architectural character, as opposed to a military one (as seen in republican amphitheatres). The prototype for these Augustan amphitheatres was the Amphitheatre of Statilius Taurus, Rome's first permanent amphitheatre built in 30 BC. Evidence suggests that this building was built up on level ground and that its façade was decorated with a rusticated Tuscan order in a fornix motif. The Amphitheatre of Statilius Taurus is the missing architectural link between early amphitheatres, such as that at Pompeii with their unadorned façades, and the great amphitheatres of the imperial period, such as the Colosseum. From the Augustan period on, one may discern two strands in amphitheatre architecture: a new civilian one exemplified by the Amphitheatre of Taurus and by the Julio-Claudian arena at Verona, and a continuation of the old military one first seen at Pompeii and later during the high imperial period in the many amphitheatres built along Rome's northern frontiers.

The Colosseum was the first amphitheatre to have used Greek architectural orders (Ionic, Corinthian) for its façade. In this respect the Colosseum's façade would have struck viewers as being similar to that of theatres (namely, that of Marcellus), except for the substitution of now traditional Tuscan elements (the native Italic architectural order *par excellence*) for Doric in the lower story. As a parallel to the new use of Greek architectural orders, a new type of event was held in the arena on a grand scale on the occasion of the Colosseum's inauguration: dramas whose subject matter was drawn from violent and/or titillating Greek myths (but in which the actors were actually killed). These 'fabulous' executions together with the 'noble' architectural orders of the Colosseum's façade reflect the Roman concern that the amphitheatre be recognizably distinct from the Greek theatre by borrowing from and at the same time (from a Roman point of view) improving on it. These new executions surpassed the Greek stage both by leaving little to the spectator's imagination and by conveying a chastening reminder of civic values.

The elevated iconography of the Colosseum was closely connected (both visually and ideologically) with the palace complex over which it was built:

Nero's Golden House, or *Domus Aurea*. As a quasi-public park, the *Domus Aurea* was a place where the Roman people could freely enjoy Greek-style artistic amenities (such as statues and performances) that previously had been enjoyed only by the elite class in private contexts or by the public, seated in the theatre. In the Colosseum, on the other hand, comparable amenities were offered, but in a quintessentially Roman manner. Inside the building, the people's movements were tightly controlled, and Greek works of art and Greek plays were metaphorically pressed into the service of the conquering Roman state. Greek statues were implicitly labeled as 'war booty' (in that the Colosseum and its decorations were paid for *ex manubiis*, "from the proceeds of war"), and Greek plays were transformed into public executions. The Colosseum, with its highly particularized architectural iconography, canonized the architectural form of the Roman amphitheatre and was subsequently imitated widely for amphitheatres in large and important cities throughout the Empire (for example, at Capua, Arles, Italica in Spain, and at El Djem in Africa). In an overall sense, after the Colosseum was built, the amphitheatre essentially ceased to evolve as a building type. The period between c. 70 BC (Pompeii) and AD 80 (the Colosseum) saw the most important developments.

During the imperial period, the amphitheatre (as a distinctive Roman architectural type) became widespread in Italy and the Roman West but not in the Greek East. Romanization was complex in the eastern part of the Empire, and differing attitudes toward Roman rule are reflected in the architectural choices made to accommodate the gladiatorial events that were an important part of the imperial cult festival. The amphitheatre's colonial and military associations may help to explain its conspicuous absence in Greek cities (except in colonies settled by Roman citizens and army veterans, such as Corinth). Greeks preferred to hold gladiatorial shows in their own native theatres. The adaptation of the theatre's orchestra in a city such as Athens was a way of accommodating Roman spectacles without actually adopting Roman architectural forms, thus keeping Greek cultural identity relatively intact.

Finally, this study of the origin and development of the amphitheatre as a building type suggests that we should take seriously the ancient Roman explanation for the importance of the amphitheatre in their culture, that it provided "no stronger discipline against pain and death for the eye."[1] By showing that the amphitheatre originated in the very heart of the Roman world (the *Forum Romanum*), and in the military ethos of the Republic, I hope to have explained why this building type and its games became so important and ubiquitous in Roman society. More than any other artifact of their culture, the amphitheatre gave Romans a tangible sense of exactly who they were.

AMPHITHEATRES OF REPUBLICAN DATE

Architectural Characteristics of Republican Amphitheatres

The great imperial amphitheatres, such as those at Verona and Capua, are built up on level ground by means of vaulted substructures and are adorned with monumental columnar facades.[1] Republican amphitheatres, on the other hand, are relatively simple structures. They are excavated out of the existing terrain and generally make use of extensive vaulting only at *summa cavea* level. The façades of republican amphitheatres (such as those at Pompeii, Paestum, Abella [Plate 17], and Cumae) are plain in appearance and function as concrete retaining walls for the *cavea*, which is formed of the excavated earth. A parallel for this type of early amphitheatre construction may be found in the theatres embanked against the sides of hills in the late second century BC in Campanian cities, such as at Capua and Cales.[2] In the case of republican amphitheatres, sometimes one side of the *cavea* is completely embanked against a hillside, and the other side is partially built up on vaults, for example, at Abella, Cales, and Ferentium. Some amphitheatres (Sutrium, Carmo, and Corinth) are cut out of the living rock and completed by a wooden superstructure. Republican amphitheatres sometimes have annular walkways at the top, such as those at Pompeii and Puteoli. Most are not well enough preserved, however, to determine if this was a regular feature. Spectator access was provided by minimal vaulting, sometimes via staircases on either side of the tunnels at the major axis (Abella, Paestum) or by means of external staircases leading to the *summa* and *media cavea* (Pompeii). At least one (Pompeii) has a large annular gallery behind the *ima cavea* for spectator circulation. Others (Nola, Abella, Sutrium, Paestum) have a small annular service corridor behind the podium, containing "refuges" for arena personnel.

The *caveae* of republican amphitheatres are relatively small – between c. 67 and 135 m in length, as compared to the Colosseum's 188 m. Pompeii, Puteoli, and Nola, are the largest, all having *caveae* close to 130 m in length. Republican amphitheatres have no basement structures, as do imperial

189

amphitheatres, but only *carceres* (starting gates) at the arena level, as at Pompeii and Nola, or refuges in the podium. Only a few amphitheatres are well enough preserved for us to establish the size of their arenas: Pompeii (67 m), Telesia (ca. 68 m), Puteoli (69 m), Nola (ca. 68 m), Cales (ca. 70 m), Cumae (probably c. 65 m), Carmo (ca. 60 m), Paestum (57 m), Sutrium (50 m).

The functional appearance and simple construction technique of republican amphitheatres have their closest parallels in the architecture of military amphitheatres of the imperial period with their embanked *caveae* and plain façades, reinforced by unadorned concrete piers, for example, at Caerleon in Wales (Figure 51), Aquincum in Pannonia Inferior, and Carnuntum in Pannonia Superior (Figures 76 and 77).

In terms of construction materials, republican amphitheatres are made out of earth and concrete and are sometimes supplemented with wood. The concrete matrices used in their construction are particularly coarse (Cumae, Nola, Abella, Puteoli, and Nola) or (at least in one case) made of ashlar tufa blocks haphazardly mortared together (Paestum). The kind of wall facing most commonly used in republican amphitheatres located in Italy is "quasi-reticulate" (Pompeii, Puteoli, Telesia, Ferentium), or reticulate (Abella, Nola, Abellinum). "Quasi-reticulate" wall facing is characteristic of buildings in Rome and environs dating to the late second/early first century BC (and at Pompeii appears with the Sullan colony in 80 BC); regularized reticulate comes into use in c. 55 BC and later,[3] allowing us to posit a first century BC date for those republican amphitheatres that lack good archaeological or external dating criteria. Although only the amphitheatre at Pompeii is closely dated, the combination of simple architectural form, small building size, construction material in coarse concrete, and "quasi-reticulate," or reticulate (with no brick), wall facing of the other amphitheatres (as well as the fact that many were rebuilt in imperial times in brick-faced concrete, as at Cales, Nola, Abellinum, and Paestum) indicates that they date to late Republican times. In addition, several amphitheatres were refurbished in the Augustan period in reticulate (Cumae, Nola, Puteoli), demonstrating a republican date for the original building.

Amphitheatres of the republican period appear to have been laid out on the ground as ovals in a simple, ad hoc sort of way, as a series of arcs of circles, using four *foci*, two on each axis, from which were drawn two pairs of arcs, one pair of opposite arcs being smaller than the other pair.[4] The theoretical principles that were used to design the nearly perfect oval shape of many imperial arenas (Verona, the Colosseum) were evidently not applied in the pre-imperial period. These principles, which made use of the circumferential rhythm of the façade interaxials as the starting module, were apparently developed only in conjunction with the arrival of freestanding amphitheatres with applied architectural orders in Augustan times.[5] That of Statilius Taurus, as it was built on level ground, could have been the first such one.

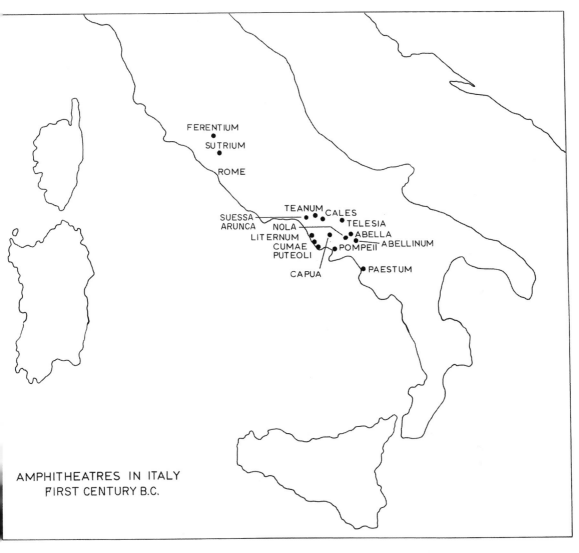

FERENTIUM

SUTRIUM

ROME

SUESSA
ARUNCA

TEANUM CALES

NOLA TELESIA

LITERNUM ABELLA

CUMAE ABELLINUM

PUTEOLI POMPEII

CAPUA PAESTUM

AMPHITHEATRES IN ITALY
FIRST CENTURY B.C.

114a. Location of known amphitheatres in Italy, late republican period.

Although most republican amphitheatres are located at the edge of town (as would usually be the case later with amphitheatres of the imperial period), some republican amphitheatres are located quite close to the center of the city (at Capua, Puteoli, and at Paestum,[6] where the amphitheatre is actually adjacent to the forum); this probably stems generally from the time-honored practice of showing gladiatorial games in Italic *fora* and specifically to the tradition of holding such games in the Forum in Rome. The undecorated, functional appearance of these buildings is also likely to be a reflection of the shape of the wooden prototype in the *Forum Romanum*. Finally, of the eight amphitheatres for which we can establish the size of the oval arena, six of them (Pompeii, Puteoli, Telesia, Cales, Nola and probably Cumae)

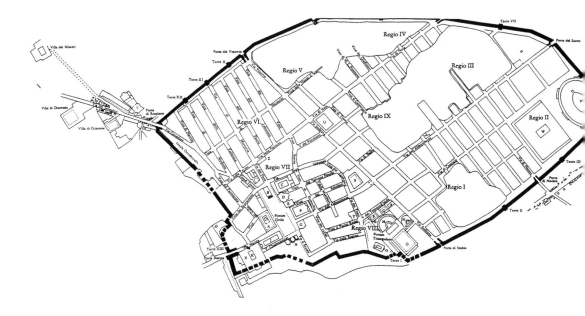

114b. Pompeii: plan of the city (H. Eschebach, *Pompeji*, Leipzig, 1978, p. 287).

have arenas quite similar in dimension, between ca. 65 and 70 m in length. This coincidence is likely to reflect the size of the arenas associated with their common prototype, the *spectacula* in the *Forum Romanum*, which I have reconstructed (Figures 21–30) using an arena of 67 × 35 m, the same size as that at Pompeii.

At Pompeii the quasi-reticulate blocchetti and tufa quoins are arranged in a 'decorative' manner (in different color schemes: see Plate 4). This would suggest that the facades of some republican amphitheatres were not stuccoed. But the case of Nola (see Plate 8 and Cat. 13) suggests that some were stuccoed and painted in "First Style." Finally, the amphitheatre at Pompeii reveals that stone wedges of seating were often added piecemeal over a lengthy period of time. Throughout the republican period, then (at least at Pompeii), spectators either used wooden seating (which has left no trace) or simply sat on the earthen embankment forming the *cavea*.

Republican Amphitheatres in Italy

1. POMPEII (Campania)

Description

The amphitheatre is located at the northeast corner of the city, just inside the fortification walls (Figure 114b). Earth was excavated to form the arena, *ima* and *media cavea*, and was then piled up outside to support the seating of the *summa cavea*. The façade of the building functions as a retaining wall for

this fill. The façade wall (Figure 115, Color Plates 6 & 7) is articulated by a continuous blind arcade and was reinforced by a series of double-ramped staircases. The staircases lead up to a broad walkway (representing the upper level of the excavated portion of the *cavea*), which is the main access route to the seating of the auditorium.

The *cavea* (Figures 116 and 117) is divided into *cunei* by radial steps and into four seating sections by annular *baltei*. The public could enter the *ima cavea* by means of an annular corridor and then by means of stairs (marked d, e, f, g on plan, Figure 117). This annular corridor was accessible by means of two vaulted corridors (marked H and I) that led into the building from the outside. The *ima cavea* is clearly separated from the rest of the *cavea* by a curving parapet wall 0.80 m high (Figure 118). The seats of the *ima cavea* are 0.88 m wide (larger by 0.30 m than those of the rest of the *cavea*), indicating that they were for *bisellia*, or portable wooden seats, used by the more important people in the town. The *media* and *summa cavea* were accessible from the broad walkway at the top of the extant building. Above the *summa cavea* was a superstructure that held tiers of wooden seating (the "*summa cavea in ligneis*"). A series of vaulted openings in this structure (*vomitoria*) lead from the walkway into the auditorium. At the top of the *cavea* are remains of sockets that held the masts for the *velaria* (awnings), as depicted in the famous fresco of the riot of AD 59 from House I iii 23 at Pompeii (Figure 18, Plate 4).

The arena, which lacks basement structures, is bounded by a podium 2 m. high (and lacking "refuges"). The podium was stuccoed and on it were painted scenes of gladiatorial combat (Figure 119). A broad vaulted gallery (marked A on plan, Figure 117), 4.26 m wide, leads into the building from the north

115. Pompeii: façade (photo, author).

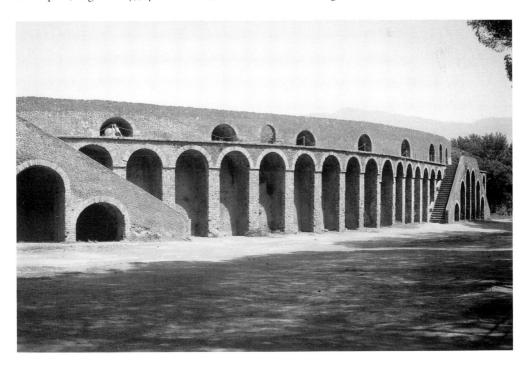

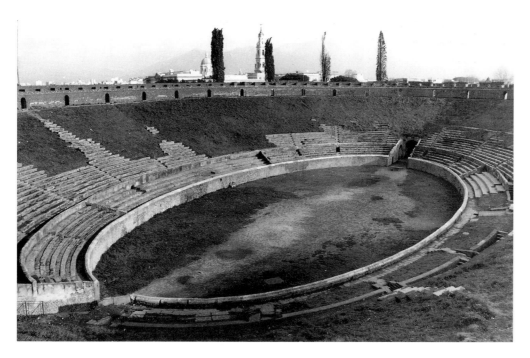

116. Pompeii: *cavea* (photo, author).

at its major axis and slopes down into the arena. A second gallery (B on plan, Figure 117) leads into the arena from the southwest. These galleries (the so-called *"porta triumphalis"* and *"porta libitinensis,"* respectively) were used for the entry and exit of arena combatants and personnel during shows. There are a pair of *carceres* (marked C on plan, Figure 117) at each of the major axes, positioned so that their doorways face onto the corridors (A and B), not directly onto the arena (as in the amphitheatre at Nola). A third and smaller gallery (marked C on plan, Figure 117) exists at the west side of the building at the minor axis; a staircase leads from it up to the seat of honor, indicating that it was used as a service corridor for arena personnel.

The seats of the *cavea* were constructed in several phases. Originally, any seats would have been entirely in wood. Inscriptions reveal that the stone seats were added piecemeal by different magistrates, beginning in the Augustan period (*CIL* X 853–7); at the time of Vesuvius' eruption, not all of the seats had been completed. The seating capacity is estimated to be about 22,000.

Materials
The amphitheatre is made of earth and concrete (a coarse matrix of tufa chunks and mortar). The surfaces between the arcades of the façade and the podium are faced in "quasi-reticulate" masonry of broken lava, with tufa and limestone quoins (Figures 120a and 120b). The superstructure was faced in a similar but more irregular technique (Figure 121). The seats were of tufa.

Remains
Well preserved.

Dimensions
Overall: 134.80 × 102.5 m. Arena length, 66.80 × 34.5 m. *Cavea* width, 34 m.

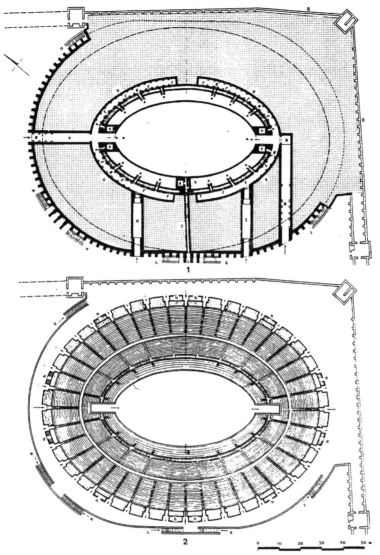

Amphithéâtre de *POMPEI* — 1. Niveau inférieur : a) entrées axiales, b) escalier menant à la loge, c) *carceres,* d) *spoliarium* ou *sacellum?,* c) excavations du *podium*, f) escaliers menant à la première précinction, g) piliers et arcs de consolidation. A. galerie axiale nord: B. galarie axiale sud: C. galerie latérale: H. et I. galeries d'accès aux *cryplae:* J à O. escaliers extérieurs: R. rempart. — 2. Plan de la *cavca :* J à O. escaliers d'accès à la terrasse de distribution, h) escaliers d'accès aux loges.

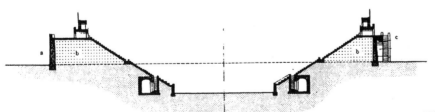

117. Pompeii: plans (top) and section (bottom) (Golvin 1988) pl. 23 and pl. 22 no. 3.

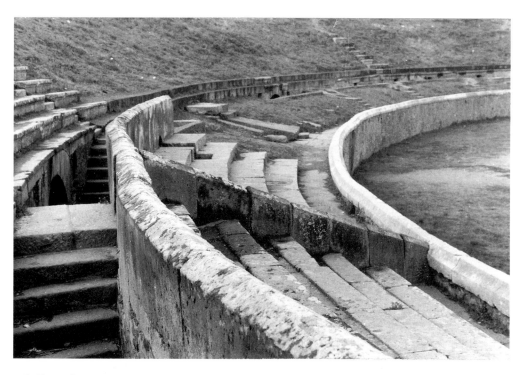

118. Pompeii: *ima cavea* (photo, author).

119. Pompeii: painted decoration on podium (F. Mazois, *Les Ruines de Pompeii* IV, Paris 1838).

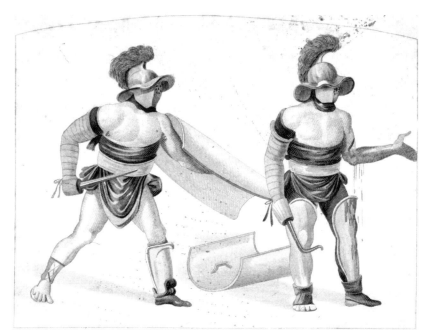

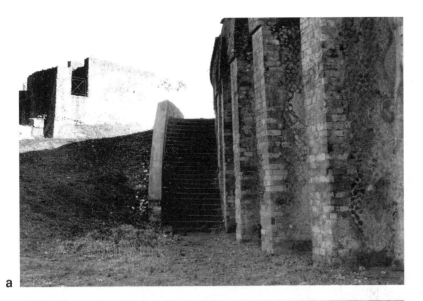

120. Pompeii: (a) façade and (b) details of masonry (photo, author).

Date

C. 75–70 BC (*CIL* X 852). It has been suggested that the superstructure was rebuilt in the imperial period (perhaps after the earthquake of AD 62), because it has an *opus incertum* facing, which is different in appearance from that used in the rest of the structure and which is characteristic of the post-earthquake period of Pompeii's history.

Civic Status of Pompeii

Sullan colony (*CIL* X 852 = *ILLRP* 645 = *ILS* 5627; Cic. *Sull.* 60–2).

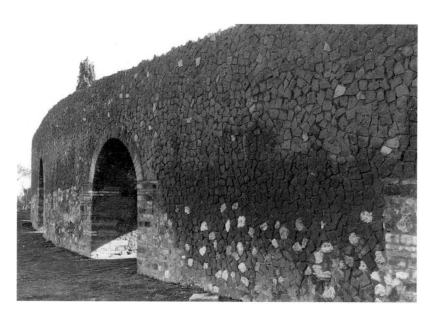

121. Pompeii: *summa cavea* (partial modern restoration) (photo, author).

Bibliography

J. Overbeck & A. Mau, *Pompeji in seinen Gebäuden, Alterthümern und Kunstwerken*, 4th ed. (Leipzig, 1884) 176ff; A. Mau, *Pompeii: Its Life and Art*, trans. F. W. Kelsey (New York, 1902) 212–26; M. Della Corte, *Pompei, I Nuovi scavi e l'anfiteatro* (Pompei, 1930) 84–87; M. Girosi, "L'Anfiteatro di Pompei" *Memorie dell'Accademia di Archeologia, Lettere e Belle Arti di Napoli* 5 (1936) 29ff.; G. Spano, "Alcune osservazioni nascenti da una descrizione dell'anfiteatro di Pompei" *Annali dell' Istituto dell' Università di Magistero di Salerno* I (1953); A. De Vos & M. De Vos, *Pompei, Ercolano, Stabia* (Rome, 1982) 150–4; L. Richardson, jr., *Pompeii: An Architectural History* (Baltimore, MD, 1988) 134–8; J.-P. Adam, "L'amphithéâtre de Pompei: un siècle et demi avant le Colisée, déjà les combats sanglants de l'arène" in *A l'ombre du Vesuve. Collections du musée nationale d'Archéologie de Naples* (Paris, 1995) 204–7; Golvin 1988, 33–7; P. Zanker, *Pompeji. Stadtbilder als Spiegel von Gesellschaftsform* (Mainz, 1987) 19–23; P. Zanker, *Pompeii. Public and Private Life* trans. D.L. Schneider (Cambridge, MA, 1998) 68–72; D. L. Bomgardner, *The Story of the Roman Amphitheatre* (London and New York, 2000) 39–54; A. Gabucci, ed., *Il Colosseo* (Milan, 2000) 30; F. Pesando, "Gladiatori a Pompei" in A. La Regina, ed., *Sangue e arena* (Milan, 2001) 175–97.

2. CAPUA (Campania)

Description

The republican amphitheatre is unpublished, and no (published) measured plan of its remains exists, to my knowledge. The building was located in the north-western sector of ancient Capua, outside the city walls. Its remains are located just southwest of the great imperial amphitheatre (Figures 122 and 123), and it has the same general north–south alignment with respect to

the ancient city's grid as does the imperial building. The arena, *ima* and *media cavea* were dug out of the earth, and the *summa cavea* was built up on vaults, traces of whose foundation walls survive. It has been suggested that this amphitheatre was the gladiatorial school (*ludus*) from which Spartacus' slave revolt broke out. This is highly unlikely, as the amphitheatre is only around 400 m from the forum and civic center of Capua (Figure 122). It is not clear if it went out of use when the great imperial amphitheatre was built. At Puteoli (Cat. 8), at least, which also has both a republican and an imperial amphitheatre, the former remained intact and continued to function into late Antiquity (see Ostrow, 1979: glass flasks, fig. 31 [his text]).

122. Capua: plan of the city (W. Johannowsky, *Capua Antica* [Naples, 1989]).

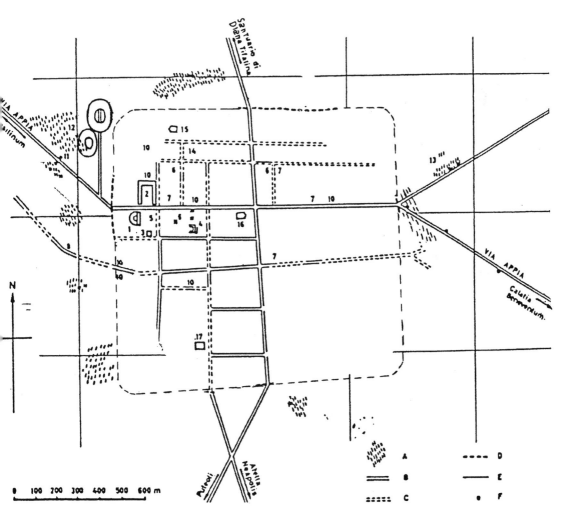

123. Capua: imperial amphitheatre, with remains of republican amphitheatre in foreground (photo, author).

Materials

Earth and coarse concrete, made of roughly hewn chunks of local limestone, 0.10–0.20 m in length, were laid horizontally into thick (c. 0.10 m) mortar beds (Figure 124). The excavator W. Johannowsky calls this technique "*opus incertum*." It should be noted, however, that this does not resemble the *opus incertum* that one associates with Rome and Latium (the so-called *Porticus Aemilia*, Praeneste, and Terracina).

124. Capua: detail of masonry (photo, author).

125. Capua: *summa cavea* substructures, eastern sector (photo, author).

Remains

Three parts of the building are visible: (1) four radially aligned walls apparently of the *media* or *summa cavea* substructures in the eastern sector of the building close to the minor axis (Figure 125), (2) five radially aligned walls presumably substructures of the *media* or *summa cavea* in the north sector of building close to the major axis (Figure 126), (3) the broad gallery (c. 4.5 m wide) that led down into the arena from the north at the major axis (Figure 127). This is the same type of tunnel that exists in the amphitheatre at Pompeii (marked A on

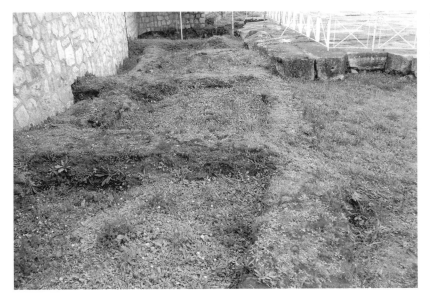

126. Capua: *summa cavea* substructures, northern sector (photo, author).

plan, Figure 117) that was used for the entry and exit of gladiators during shows. This gallery at Capua was stuccoed; in places where the stucco has not survived, one can see that the underlying wall consists of rough concrete without facing.

Dimensions
The configuration of the visible foundation walls of the *summa cavea* indicates that the building was smaller than the amphitheatre at Pompeii, probably no longer than 100 m overall on the major axis.

Date
First century BC. The amphitheatre must predate the great imperial amphitheatre, which was initially constructed in the Augustan period by the *Colonia Iulia Felix Augusta Capua* (*CIL* X 3832 = *ILS* 6309) and subsequently rebuilt in the reign of Hadrian. In its small size and simple form, it resembles the amphitheatre at Pompeii.

Civic Status of Capua
Municipium sine suffragio since 338 BC (Livy 7.29f); the *Lib. colon.* (232) says that Capua was assigned "*e lege Sullana*," but this is doubted (see Brunt, 1971, 306–7 [see bibliography in this section]); veteran settlement 59 BC (Caes. *BCiv.* 1.14; *Lib. colon.* 231); triumviral veteran settlement (Dio Cass. 49.14.5); Augustan colony (*CIL* X 3832 = *ILS* 6309)

Bibliography
Beloch, *Campanien*, 300–7; P. A. Brunt, *Italian Manpower 225 B.C.–A.D. 14* (Oxford, 1971) 306, 313ff, 326ff; De Caro & Greco 1981, 215–18; W. Johannowsky, "Contributo dell' archeologia alla storia sociale: La Campania" *Dial. di Arch.* 5 (1971) 460–71; W. Johannowsky, "La situazione in Campania" in P. Zanker, ed., *Hellenismus in Mittelitalien. Kolloquium in Göttingen vom 5. bis 9. Juni 1974* (Göttingen, 1976) 272ff; Frederiksen, *Campania* 191ff, 285–318; Keppie 1983, 58, n. 51, 143; Golvin 1988, 25; P. Sommella, *Italia antica* (Rome, 1988) 133–4; H. Solin, "Republican Capua" in H. Solin & M. Kajava, eds., *Roman Eastern Policy and Other Studies in Roman History.* Commentationes Humanarum Litterarum 91 (1990) 151–62; W. Johannowsky, *Capua Antica* (Naples, 1991) 66–7 with plan p. 10.

3. LITERNUM (Campania)

Description
The amphitheatre has never been published. According to Johannowsky, it was located in the south sector of the ancient city, just outside the city walls. The arena was dug out of the earth, and the upper part of the *cavea* was embanked against the side of a hill on one side, and on the other side it was partially built up on vaults. It is oriented east–west.

Part of the building was excavated under the supervision of P. Gargiullo in the 1990's, and there exists a notice of this by S. De Caro (see bibliography). The *ima cavea* and arena were explored in the southeastern sector. Some remains of

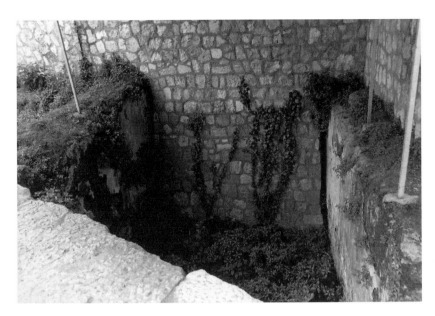

127. Capua: entrance gallery at major axis, northern sector (modern wall in background) (photo, author).

seats were found, terraced into earth. The façade wall had been refaced in the imperial period. De Caro dates the first phase of the amphitheatre to the early 1st c. BC but does not explain on what criteria (presumably from the contents of the fill/foundation material, as he makes no reference to republican wall facing).

Materials
Earth and concrete. A few of the radial walls were apparently visible in the 1970s and were said by Jowannowsky to be of concrete faced with *opus incertum*. (One may surmise that the facing was similar to that of the republican amphitheatre at Capua [Figure 124].)

Remains
Nothing but the general shape of the *cavea* was visible in 1996. There is a (not terribly revealing) photograph of a newly excavated part of its *cavea*, however, in Gialanella (2000, p. 166 [see bibliography in this section]). The results of the excavation will be published, I was told, in a forthcoming issue of *BdA*.

Dimensions
Not clear

Date
Probably first century BC. The building is small, and its facing is said to be "*opus incertum*." Most of the extant buildings at Liternum date to the republican period. Moreover, the city wall is in republican reticulate, with imperial additions.

Civic Status of Liternum
Maritime colony 194 BC (Livy 32.29.3; 34.45.1).

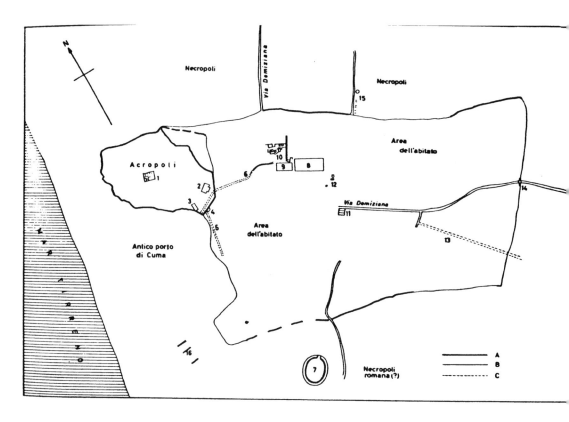

128. Cumae (Cuma): plan of the city (De Caro & Greco 1981).

Bibliography

Beloch, *Campanien*, 377–9; W. Johannowsky, "Contributo dell' archeologia alla storia sociale: La Campania" *Dial. di Arch.* 5 (1971) 469–70; W. Johannowsky, "La situazione in Campania" in P. Zanker, ed., *Hellenismus in Mittelitalien. Kolloquium in Göttingen vom 5. bis 9. Juni 1974* (Göttingen, 1976) 273ff; De Caro & Greco 1981, 91; Frederiksen, *Campania* 264; Golvin 1988, 25; R. Adinolfi, "Liternum" *Bollettino Flegreo. Rivista di storia, arte, e scienze* 1993, 11–23. C. Gialanella, ed., *Nova antiqua phlegraea: nuovi tesori archeologici dai Campi Flegrei* (Naples, 2000). *Atti* 1996, 420–21; 1997, 822–24.

4. CUMAE (Campania)

Description

Located to the south of the Roman city of Cumae, just outside the walls (Figures 128–130). The amphitheatre is still being used as a vineyard and farm and is adjacent to the Villa Vergiliana. The arena was dug out of the ground, and part of the *cavea* was built against the side of a hill. At the top of the *cavea* were a series of arched openings 2.4 m. wide, with piers 1.4 × 1.0 m in section (Figures 131a and 132). The northeast part of the monument, which is built against

the hill, consists of a retaining wall for the fill and is articulated by blind arches. The façade of the amphitheatre was quite plain in appearance (Figure 132). Its arched openings at *summa cavea* level probably functioned as access points for spectators. It is not clear how spectators ascended to the *summa cavea*; there may have been staircases or ramps leading up to it in sectors of the amphitheatre that are still buried. Recent excavations (P. Caputo) suggest that a second annular wall, outside the wall with the arches (Figure 131b), was connected with an enlargement of the *summa cavea* in the imperial period. Just outside the northern sector of the amphitheatre and with its entrance facing the monument are the remains of a small Roman temple, located inside the Palazzino Vergiliano (an annex of the Villa Vergiliana).

Materials

Earth and concrete whose matrix consists of large chunks of tufa (c. 0.15 × 0.08 m), known locally as "pietra di monte," from nearby Monte Grillo set into thick mortar beds (Figure 133). The wall facing is called "*opus incertum*" by Johannowsky, but does not resemble 'canonical' *opus incertum* of the sort found in Rome and its environs.

Remains

Parts of the arcaded façade wall is visible. (It is preserved in the east and southwest sectors of the building.) When I visited in 2002, part of the amphitheatre's façade, entryway at the major axis, and arena (in the southern sector) had been uncovered in the excavations under the direction of Dr. P. Caputo. The parts visible to me were faced in standard early imperial reticulate.

Dimensions

The major axis of the building is ca. 90 m long, making it relatively small.

129. Cumae: *cavea* (American Academy in Rome, Fototeca Unione 3438).

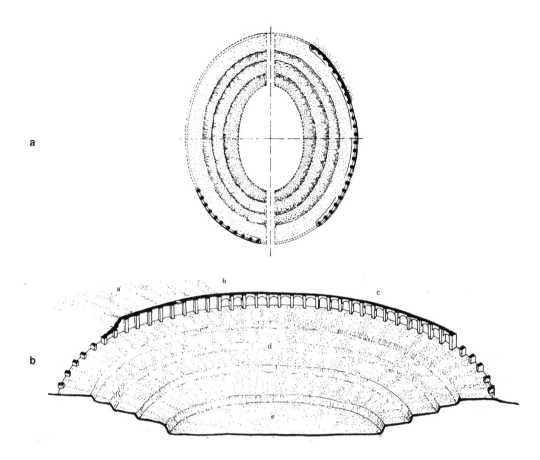

130. Cumae: (a) plan and (b) perspectival drawing (Golvin 1988 pl. 7.1 and 22.1).

Date

Probably first century BC. The building is small and similar in its simplicity to the amphitheatre at Pompeii. P. Caputo dates the initial construction of the amphitheatre to the late second/early first century BC on the basis of black glaze pottery discovered in the concrete foundations (a somewhat problematic method of dating; see Chapter Three, n. 57). He connects the enlargements of the *summa cavea* in the early first century AD and again in the early second century AD with (1) Cuma's economic prosperity in the reign of Augustus and its loyalty to him during the civil wars and (2) the opening of the nearby *Via Domitiana* (AD 95).

Civic Status of Cumae

Municipium sine suffragio after 338 BC (Livy 8.14.11) and probably *municipium optimo iure* after 180 BC (Livy 40.42.13). After the Second Punic War, it was under the authority of resident Roman magistrates called *praefecti Capuam Cumas* (*RE* 3, Kyme 3, cols. 247–248); Livy (40.42.13) informs us that in 180 BC the people of Cumae asked the *praefectura* for permission to substitute Latin for Oscan as their official language. It is uncertain whether Cumae had colonial status in the early imperial period (see Keppie 1983, 148–50).

Bibliography

P. A. Paoli, *Antiquitatum Puteolis, Cumis, Baiis existentium reliquiae* (Naples, 1769) foglio 29, tav. XLVIII; E. Gabrici, "Cuma" *Mon. Ant.* 22 (1913) pl. II; Beloch, *Campanien*, 151f, pl. IV; W. Johannowsky, "Contributo dell' archeologia alla storia sociale: La Campania" *Dial. di Arch.* 5 (1971) 469–70; A. G. McKay, *Ancient Campania, vol. 1: Cumae and the Phlegrean fields* (Hamilton, Ontario, 1972) 153 ff; M. Frederiksen in *JRS* 65 (1975) 191–3 (review of W. Simshäuser, *Iuridici und Munizipalgerichtsbarkeit in Italien* [Munich, Beck, 1973]); W. Johannowsky, "La situazione in Campania" in P. Zanker, ed., *Hellenismus in*

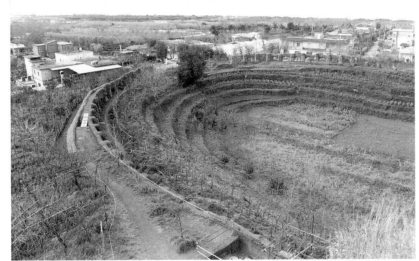

131. Cumae: (a) arcade and (b) wall behind at *summa cavea* level (before recent excavations) (photos, author).

a

b

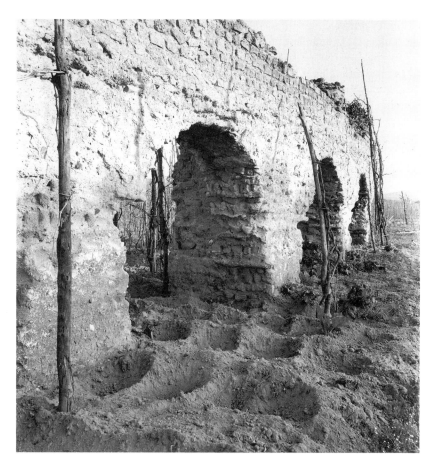

132. Cumae: façade (photo, author).

Mittelitalien. Kolloquium in Göttingen vom 5. bis 9. Juni 1974 (Göttingen, 1976) 272 ff; F. Castagnoli, "Topografia dei Campi Flegrei" in *I Campi Flegrei nell' archeologia e nella storia. Atti dei Convegni Lincei 33* (Rome, 1977) 44ff; F. Sartori, "I *praefecti Capuam Cumas*" in *I Campi Flegrei nell' archeologia e nella storia. Atti dei Convegni Lincei 33* (Rome, 1977) 149–71; Salmon 1982, 175–6; H. Jouffroy, *La construction publique en Italie et dans l'Afrique romaine* (Strasbourg, 1986) 58; Golvin 1988, 25; P. Amalfitano, ed., *I Campi Flegrei. Un itinerario archeologico* (Venice, 1990) 306–8; P. Caputo, "Indagini archeologiche all' anfiteatro" *BdA 22* (1993) 130–2; P. Caputo et al., *Cuma e il suo parco archeologico* (Rome, 1996) 168–9.

5. ABELLA (Campania)

Description
Excavated in the 1970s, the amphitheatre at Abella (Figure 134) is fairly well preserved (Plate 17) but has never been published, and no published plan of it exists, to my knowledge. It is located just inside the ancient city wall, at the southeast corner of the city. The arena and *ima cavea* were dug out of the earth.

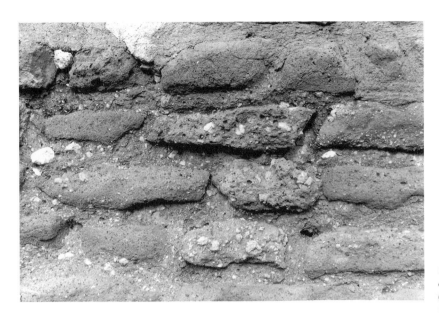

133. Cumae:
detail of masonry
(photo, author).

The southeastern sector of the auditorium is embanked against the *fossa* of the
city wall; the northwestern sector of the auditorium is built up on vaults. The
southeastern part of the building lacks a façade, since it is built up against the
city walls (as at Pompeii). The façade of the northwestern sector of the build-
ing consisted of a series of blind arcades (Figure 135). Spectators entered via
staircases leading to tunnels, located at either side of the main vaulted galleries
at the major axis (Figures 136 and 137, compare Figure 164, Paestum, which
is exactly the same). Just as at Pompeii, two great vaulted galleries descended
into the arena along the major axis for combatants, and a pair of *carceres* existed

134. Abella
(Avella): *cavea*
(photo, author).

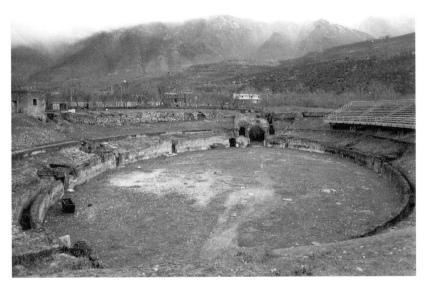

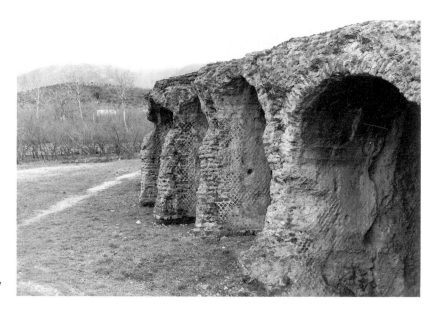

135. Abella: façade of blind, barrel vaulted chambers (photo, author).

at each end, one on either side of the large vaulted gallery (Figure 137). These *carceres*, however, face directly onto the arena and were not connected to the gallery (as they are at Pompeii). A small annular service corridor with "refuges" runs behind the podium (Figure 138), and a small staircase existed at each minor axis which connected the service corridor with the area of the *tribunalia* (seats of honor). The amphitheatre seems still to have been in use in the Antonine period (*CIL* X 1211).

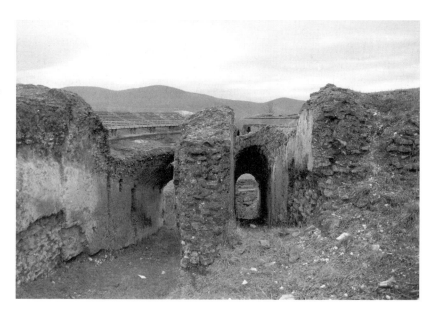

136. Abella: entrance tunnel, for combatants (left) and a smaller one for spectators (right) northwest sector (photo, author).

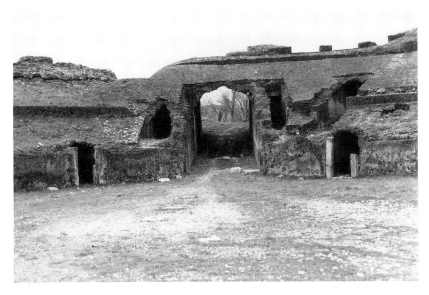

137. Abella: podium, northwest sector; spectator entry ways on either side of main tunnel and *carceres*/"refuges" at podium level. (photo, author).

Materials
Earth and concrete faced with *opus reticulatum* of tufa, with blocchetti of 0.06 × 0.06 m and tufa quoins (Figure 139).

Remains
The building is generally well preserved. The upper part of the *summa cavea* has not survived.

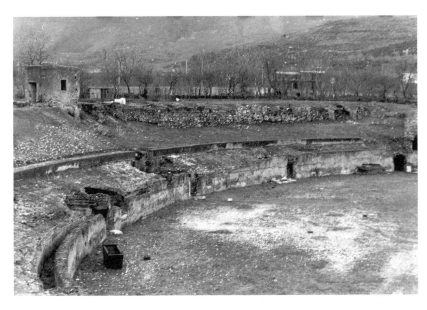

138. Abella: *cavea* with service corridor behind podium and "refuges" (photo, author).

139. Abella: detail of masonry (photo, author).

Dimensions
Overall c. 79 × 53 m.

Date
Probably first century BC. It is small in size and is similar in most respects to the amphitheatres at Pompeii, Paestum, and Sutrium. Its *terminus post quem* is the destruction of Abella during the Social War (87 BC). The lack of brick also suggests that it is pre-imperial, but the regular reticulate technique suggests that it dates to the later first century BC. Little is known of the architectural layout of ancient Abella apart from the amphitheatre and some tombs (Onorato, 1970, pl. 30 [see bibliography in this section]), which are thought to date to the first century BC. There is no evidence, as far as this author is aware, of major imperial-period buildings in this city.

Civic Status of Abella
Abella remained loyal to Rome during the Social War and was destroyed by the Samnites in 87 BC (Granus Licinianus 35, p. 20, line 8 [ed. Flemisch]). Probable Sullan or Caesarian veteran settlement (republican inscriptions mention *duumviri*: *CIL* X 1218 = *ILLRP* 519; *CIL* X 1213 = *ILLRP* 520; cf. Sall. *Hist.* 3.97 Maurenbrecher); colonial status certainly by the Augustan period (*CIL* X 1210; *CIL* X 1211).

Bibliography
Th. Mommsen, "Die italische Bürgercolonien von Sulla bis Vespasian" *Hermes* 18 (1883) 161–213, esp. 164; Beloch, *Campanien*, 411ff; E. T. Salmon, *Roman Colonization under the Republic* (Ithaca, NY, 1970) 131ff; G. O. Onorato, *La ricerca archeologica in Irpinia* (Avellino, 1960) 41 and tav. 29; W. Johannowsky,

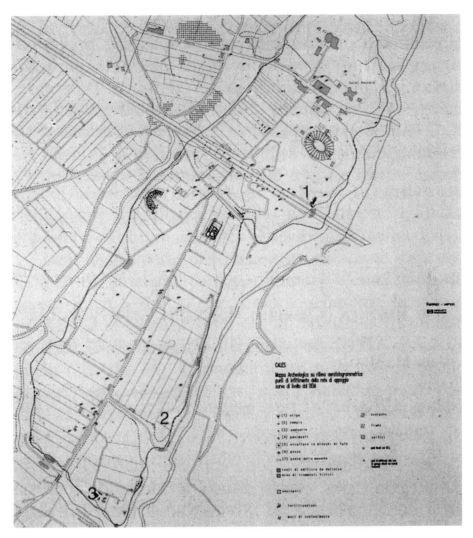

"La situazione in Campania" in P. Zanker, ed., *Hellenismus in Mittelitalien. Kolloquium in Göttingen vom 5. bis 9. Juni 1974* (Göttingen, 1976) 272, n. 33; H. Jouffroy, *La construction publique en Italie et dans l'Afrique romaine* (Strasbourg) 58; Golvin 1988, 37; P. Luciano, "Avella tra mito e storia" *Didattica e territorio. Corsi di formazione per docenti in servizio, Nola 30 marzo-8 giugno 1988* (Nola, 1990) 87–98, esp. 91–2. *Atti 1977*, 346.

140. Cales: plan of the city and environs (Luciano 1990).

6. CALES (Campania)

Description

This amphitheatre is situated in the northeast part of ancient Cales (Figure 140), just outside the ancient city wall. The building is almost completely overgrown, and is being used in conjunction with an adjacent farm (Figures 141a and 141b).

141. Cales: *cavea*, views looking (a) southeast and (b) north (photos, author).

The arena and lower part of the *cavea* were dug out of the rock, a soft tufa. The *summa cavea* was supported by vaulted substructures on its east side, and the west side is embanked against a hillside. An eighteenth-century traveler's report indicates that the *cavea* was divided into three tiers. The major axis of the building is oriented north–south and is perpendicular to the *cardo maximus* of the city. Just as at Abella, two wide galleries (entrance tunnels for arena combatants) existed at the major axes, and there were vaulted chambers 2 m high, one on either side of the entrance tunnels, facing the *cavea* (Figure 142), presumably, for spectator access. In the imperial period the amphitheatre was enlarged and a new façade was added in brick (Figure 143a and 143b); the façade was decorated with applied half-columns, a practice that became

fashionable in amphitheatre architecture beginning in the Augustan age. The brickwork is comparable to Julio-Claudian brickwork in Rome, suggesting that the renovation probably took place in the first century AD.

Materials
Earth and coarse concrete with large tufa chunks (Figure 144). Radial walls faced with somewhat irregular reticulate blocchetti (0.7 × 0.7 m) of tufa (Figure 145), less regularly laid than those at Abella but more carefully cut and arranged than those at Pompeii.

Remains
Some radial walls and entrance tunnel for combatants, along with similar tunnels at either side, probably for spectator access in the northern sector; imperial rebuilding in brick in the northwest sector.

Dimensions
Arena length c. 70 m. Overall length difficult to determine.

Date
First century BC. The building is small and similar in form to the amphitheatres at Abella and at Pompeii. It was rebuilt in the early imperial period. Most of the buildings at Cales date to the late republican period. (The republican baths use the same type of irregular [or "quasi"] reticulate masonry as does the amphitheatre.)

Civic Status of Cales
Latin colony late-fourth century BC (Livy 8.16.13–14; Vell. Pat. 1.14.3); possible veteran settlement 59 BC (Cic. *Leg. agr.* 2.96); probable veteran settlement in the triumviral period (*ILS* 2321 records veteran presence; see Keppie 1983, 85).

142. Cales: entrance gallery and tunnel presumably for spectator access (visible at left) at major axis of the building southeastern sector (photos, author).

a b

143. Cales: imperial-period facade faced in brick (photos, author), (a) front view of applied half column and (b) half column, view from the side, with radial wall that supported a vault.

Bibliography

W. Johannowsky, "Relazione preliminare sugli scavi di Cales" *Bollettino d'Arte* 46 (1961) 258–68, esp. 266 n. 14; id., "Contributo dell' archeologia alla storia sociale: La Campania" *Dial. di Arch.* 5 (1971) 469–70; Frederiksen, *Campania* 213f; De Caro & Greco 1981, 242. Keppie 1983, 55 n. 39, 85; H. Jouffroy, *La construction publique en Italie et dans l'Afrique romaine* (Strasbourg, 1986) 58; Golvin 1988, 38; P. Sommella, *Italia antica* (Rome, 1988) 41–2; S. Raffaele Femiano, *Linee di storia, topografia ed urbanistica della antica Cales* (Calvi, 1992) 31–9; C. Passaro, "Scavi nell' area di parcheggio Cales nord dell' Autosole" *BdA* 22 (1993) 49–51 with plan fig. 39.

7. TEANUM (Campania)

Description

The amphitheatre is located in the southern part of Teanum, along the circuit of the city wall, just south of the theatre (Figure 146). The building is not well preserved, is overgrown, has never been excavated, and is (to my knowledge) unpublished. The contours of the *cavea* were difficult for me to discern. The area was in part being used as an apiary (Figure 147). Part of the *cavea* was

144. Cales: detail of concrete, entrance tunnel (photo, author).

embanked against a hillside, and the other part was built up on vaults. Just as at Cales, the amphitheatre was rebuilt in brick in the imperial period.

Materials
Earth and concrete with somewhat irregular tufa facing in reticulate (*blocchetti* c. 0.08 × 0.10 m) with tufa quoins (Figure 148 [detail of Figure 149a]).

Remains
One wall that may be associated with the amphitheatre can be seen in what was presumably the lower sector of the building (Figure 149a and 149b; compare

145. Cales: detail of masonry (photo, author).

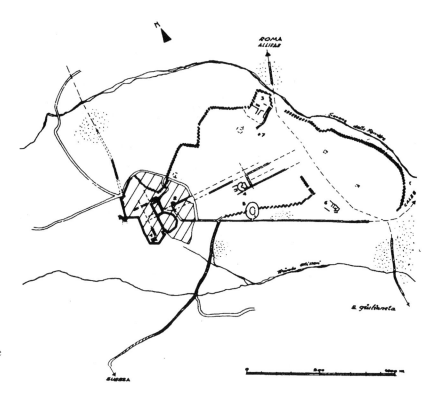

146. Teanum:
plan of the city
and environs (De
Caro & Greco
1981, p. 236).

Figures 115, 135, 170, 172). Apparent brick remains of the imperial period in
the upper sector.

Dimensions
Unsure. Golvin indicates ca. 79 × 53 m.

Date
First century BC. It has irregular reticulate wall facing, and it was probably
rebuilt in the imperial period. Teanum has a temple in reticulate that is thought
to be Sullan: (Johannowsky 1963, fig. 46, [see bibliography in this section]).

Civic Status of Teanum
Sometimes said to be a Sullan colony, but there is no convincing evidence;
all we hear is that Sulla's troops were stationed near Teanum during the Civil
War (App. *BCiv.* 1.85). Possible veteran settlement 59 BC (Cic. *Leg. agr.* 2.96),
probable triumviral colony (dedication to Augustus by *Colonia Classica Firma
Teanum: CIL* X 4781, 4799; cf. Pliny *HN* 3.63) and Augustan veteran settlement
(*Lib. colon.* 238: *Teanum Sidicinum: colonia deducta a Caesare Augusto*).

147. Teanum: probable area of *cavea* (photo, author).

Bibliography

E. Pais, *Storia della colonizzazione di Roma antica* (Rome, 1923) 263–5; K. J. Beloch, *Römische Geschichte bis zum Beginn der punischen Kriege* (Berlin-Leipzig, 1926) 514; A. Degrassi, "Problemi chronologici delle colonie di Luceria, Aquileia, Teanum Sidicinum" *Rivista di Filologia* 66 N.S. 16 (1938) 129–43, esp. 140ff; A. De Monaco, *Teano osco e romano* (Teano, 1960) 41ff; W. Johannowsky, "Relazione preliminare degli scavi di Teano" *Bollettino d' Arte*

148. Teanum: detail of masonry (photo, author).

48 (1963) 131–65; id., "Contributo dell' archeologia alla storia sociale: La Campania" *Dial. di Arch.* 5 (1971) 469–70; id., "La situazione in Campania" in P. Zanker, ed., *Hellenismus in Mittelitalien. Kolloquium in Göttingen vom 5. bis 9. Juni 1974* (Göttingen, 1976) 272, n. 33; id., in *EEA* 7, 638–40, fig. 757; id., in *Princeton Encyclopedia of Classical Sites* 888; De Caro & Greco 1981, 236–7 on Teanum (location of amphitheatre shown, p. 236); Keppie 1983, 139–41; H. Jouffroy, *La construction publique en Italie et dans l'Afrique romaine* (Strasbourg, 1986) 58; Golvin 1988, 38; P. Sommella, *Italia antica* (Rome, 1988) 52–3.

149. Teanum: wall in lower sector (photos, author), (a) one of the radial or façade walls and (b) detail of "a".

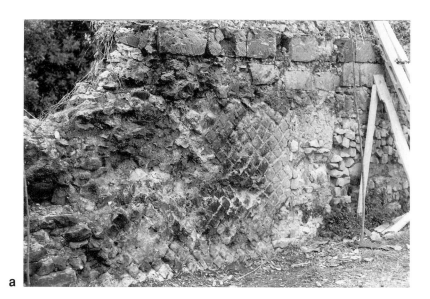

a

b

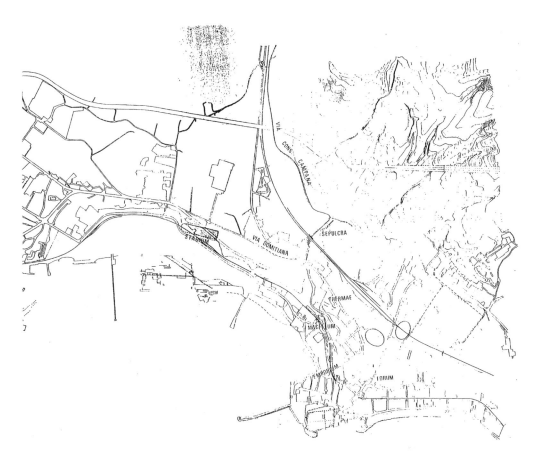

8. PUTEOLI (Campania)

Description

The republican amphitheatre was located 100 m. to the east of the great imperial amphitheatre and perpendicular to it (Fig. 150). The building was only a few hundred meters from the forum area of ancient Puteoli. The arena was dug out of the ground and the whole northeast part of the *cavea* was built up against a hillside, but the *summa cavea* in the other sectors of the building were built up on vaults (Figures 151 a and b), only a few of whose walls are visible. Above the *summa cavea* was a vaulted annular walkway with an arched opening every 7.5 m., a dimension corresponding to the width of each *cuneus* (Figure 152). Part of the great barrel-vaulted entrance tunnel that led down into the arena is still visible in the southwest sector of the building. Just to its right is what is apparently an entry way for spectators, as at Abella. Some of the vaults at *summa cavea* level show evidence of having been re-faced in the early imperial period (Figures 153 a and b). Golvin estimates the seating capacity at 20,000, approximately the same as that at Pompeii. A glass vessel of late Antique date indicates that the republican amphitheatre and the famous imperial amphitheatre (Fig. 31) were both in use similtaneously.

150. Puteoli (Pozzuoli): plan of the city (*I Campi Flegrei nell' archeologia e nella storia* (Rome [1977] fig. 7).

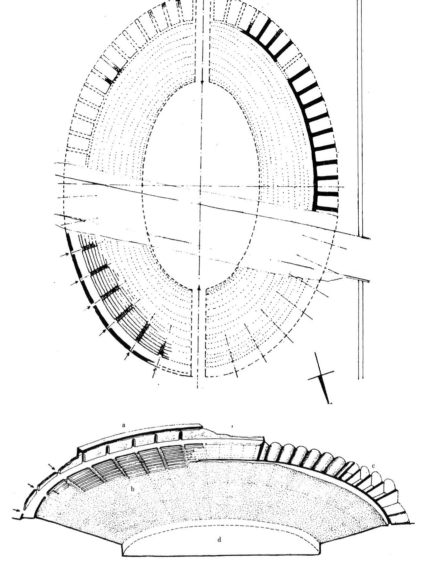

151. Puteoli: (a) plan and (b) perspectival reconstruction (P. Sommella, "Forma e urbanistica di Pozzuoli romana," *Puteoli: studi di storia antica*, II [Naples, 1978]; Golvin 1988 pl. 7.2 and 22.2).

Materials

Earth and coarse concrete (Figure 154), as at Capua and Cumae; radial walls have "quasi-reticulate" facing in tufa and remnants of a heavy layer of plaster (Figure 46). The vaults at *summa cavea* level are faced in "quasi-reticulate." Re-facing in regular reticulate seems to have taken place in a later period (Figures 153 a and b), perhaps in the Augustan age, when there was much building activity in Puteoli following its colonization by Augustus.

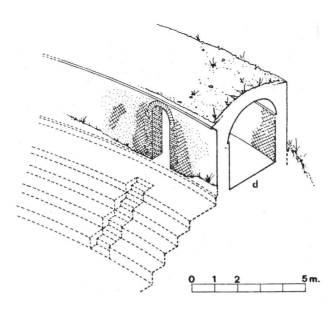

152. Puteoli: reconstruction of *summa cavea* (P. Sommella, "Forma e urbanistica di Pozzuoli romana," *Puteoli: studi di storia antica*, II [Napoli, 1978] fig. 111).

Remains

Remains are visible at *summa cavea* level: radial walls in the western and southern sectors; part of the annular corridor in the northern and eastern sectors; and part of the great barrel-vaulted gallery (entrance tunnel) leading into the building from the south. The ruins were exposed when the Circum Flegrea train line was built right through the amphitheatre in the early 20th c.

Dimensions

Overall length 130 × 95 m (close to the size of the amphitheatre at Pompeii). Arena length ca. 69 × 35 m.

Date

First century BC. In its small size, simple form, and quasi-reticulate facing technique, it is quite close to the amphitheatre at Pompeii.

Civic Status of Puteoli

Maritime colony 194 BC (Livy 32.29.3–4; 34.45.1f; cf. Vell. Pat. 1.15.3); the Granii, a prominent family of Puteoli, were closely connected with Marius (Plut. *Vit. Mar.* 35, 37, 40); after a *stasis* Sulla prescribed a code of laws (*lex*) for the city's governance (Plut. *Vit. Sull.* 37.3; Cic. *leg. agr.* 2.86) probably because of the conflicting interests of merchants, sailors, and farmers. The city is referred to as *colonia Iulia Augusta Puteoli* on a wax tablet from Pompeii: C. Giordano, "Nuove tavolette cerate pompeiane" *Rend. Acc. Nap.* 45 (1970) 211–31, no. 6; see the discussion in Keppie 1983, 147–8.

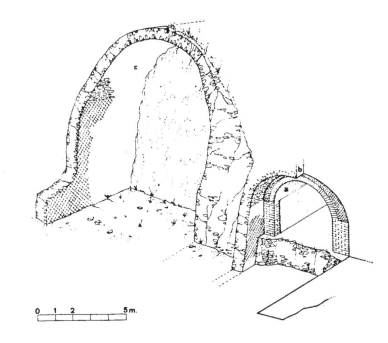

153. Puteoli: *summa cavea*, drawing of the southern sector, remains of entrance tunnel for combatants on major axis (large vault at left) and barrel-vaulted access way, apparently for spectators (on right); with evidence of later (Augustan?) rebuilding (P. Sommella, "Forma e urbanistica di Pozzuoli romana," *Puteoli: studi di storia antica*, II, [Napoli, 1978 fig. 112] photo, author).

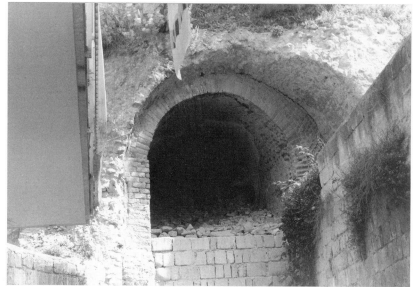

Bibliography

C. Dubois, *Pouzzoles antiques* (Paris, 1907); see no. 9 on foldout map; V. Spinazzola, "Pozzuoli, rovine di un secondo anfiteatro" *Not. Scav.* 12 (1915) 409ff; A. Maiuri, *I Campi Flegrei* (Naples, 1934) 32–4; Beloch, *Campanien*, 90–1; C. Giordano, "Nuove tavolette cerate pompeiane" *Rend. Acc. Nap.* 45

(1970) 218ff; F. Castagnoli, "Topografia dei Campi Flegrei" *I Campi Flegrei nell' archeologia e nella storia. Atti dei Convegni Lincei 33* (Rome, 1977) 51ff; D. Pulice, "Sviluppo costituzionale della *colonia Puteoli* in età repubblicana" *Puteoli. Studi di storia antica* 1(1977) 27–49; S. E. Ostrow, *Problems in the Topography of Roman Puteoli* (Diss. University of Michigan, 1977) 78, 113–15, 118–19; P. Sommella, "Forma e urbanistica di Pozzuoli romana" *Puteoli, Studi di storia antica* 2 (Naples, 1978) esp. 54–7; Frederiksen, *Campania* 264, 323–37; S. E. Ostrow, "The topography of Puteoli and Baiae on the eight glass flasks" *Puteoli. Studi di Storia Antica* 3 (1979) 77–137; R. Adinolfi, "Notizie su uno scarico di materiale di età romana nell' area dell' anfiteatro minore di Pozzuoli, 1964–66" *Puteoli. Studi di storia antica* 4–5 (1980–1) 235–43; L. Caruso et al., "Ricerche sul piu antico anfiteatro puteolano" *Puteoli. Studi di storia antica* 4–5 (1980–1) 163ff; De Caro & Greco 1981, 43–4, 39–43; Keppie 1983, 147–50; Golvin 1988, 38; G. Race, "Puteoli nella crisi dell Repubblica romana" in A. Alosco, ed., *La storia di Pozzuoli dalle origini all' età contemporanea* (Pozzuoli, 1994) 21–40.

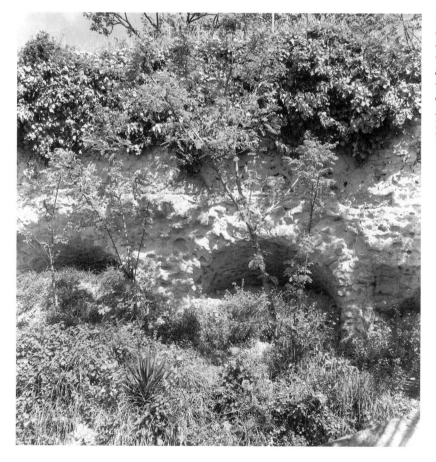

154. Puteoli: detail of concrete, vaulting at *summa cavea* level, western sector (American Academy in Rome, Fototeca Unione 2628).

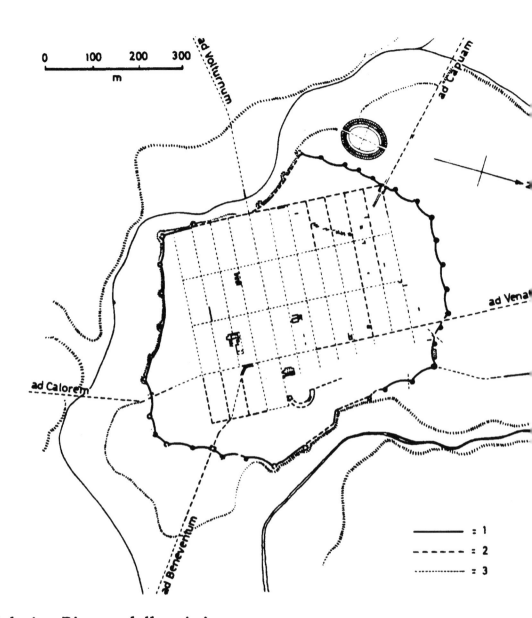

Telesia. Pianta della città.

155. Telesia:
plan of the city
(De Caro &
Greco 1981
p. 199).

9. TELESIA (Campania)

Description

The amphitheatre was located in the western sector of the city, just outside the
city walls (Figure 155). It is part of a farm and is being used as an orchard (Fig-
ure 157). The arena and *ima cavea* were dug out of the earth, while the *media*

and *summa caveae* were supported on radial vaults (Figure 156). Only the vaults of the *summa cavea* are visible (Figure 158). The façade appears to have consisted of a blind arcade (with arches 2.5 m wide) in the manner of the amphitheatre at Abella (Figure 135). The podium was evidently over 3 m high. Golvin estimates the seating capacity at 9,000.

156. Telesia: (top) plan and (bottom) section (Golvin 1988 pl. 24.3 and 24.4).

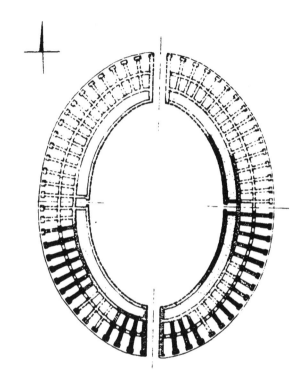

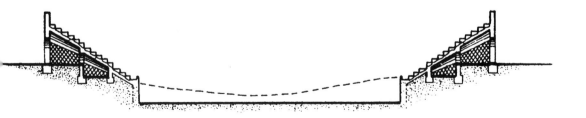

157. Telesia; *cavea* (photo, author).

Materials
Earth and concrete faced with opus *quasi reticulatum* in white limestone (Figure 159).

Remains
Some of the vaults of the *summa cavea* and parts of the podium are still visible.

158. Telesia: vaults at *summa cavea* level (photo, author).

159. Telesia: detail of masonry, podium wall (photo, author).

Dimensions

Overall length around 99 × 77 m. Arena length is 68 × 46 m. Width of the *cavea* 15.60 m.

Date

First century BC. The building's small size and the fact that it is constructed in exactly the same "quasi-reticulate" technique and white limestone as the city walls, which are datable to the Sullan era (*CIL* IX 2235 = *ILLRP* 675) suggest that the amphitheatre at Telesia was planned when the city was rebuilt after the Social and Civil Wars, that is, around the second quarter of the first century BC.

Civic Status of Telesia

Possible Sullan colony (*duumviri* in the republican period: *CIL* IX 2235 = *ILLRP* 675; *CIL* IX 2240 = *ILLRP* 676; also uniformity of construction of city walls and major monuments in "quasi-reticulate," identical to that at Pompeii); colonial status certainly by Augustan times (*CIL* IX 2219); see the discussion in *CIL* IX, p. 205. Probable viritane assignation (assignment of extra-urban plots of land to veterans) in triumviral period (Brunt 329, n. 7).

Bibliography

Th. Mommsen, "Die italische Bürgercolonien von Sulla bis Vespasian" *Hermes* 18 (1883) 161–213, esp. 167–8; E. M. Blake, *Ancient Roman Construction in Italy from the Prehistoric Period to Augustus. A Chronological Study Based in Part upon*

the Material Accumulated by Esther Boise Van Deman (Washington, 1947) 238 f;
L. Quilici, "Telesia" *Quaderni dell' Istituto di Topographia Antica della Università
di Roma, Vol. 2, Studi di Urbanistica Antica* 2 (1966) 85–106; P. A. Brunt, *Italian
Manpower 225 B.C. – A.D. 14* (Oxford, 1971); De Caro & Greco 1981, 199;
Salmon 1982, 132; H. Jouffroy, *La construction publique en Italie et dans l'Afrique
romaine* (Strasbourg, 1986) 58; Golvin 1988, 38–9; P. Sommella, *Italia antica*
(Rome, 1988) 131–2.

10. PAESTUM (Lucania)

Description
The amphitheatre was located (unusually) in the very center of the ancient city,
adjacent to the *comitium* and forum (Figure 160). The building is unpublished,

160. Paestum:
plan of the forum
area (*Dial. di
Arch.* 6 [1988]).

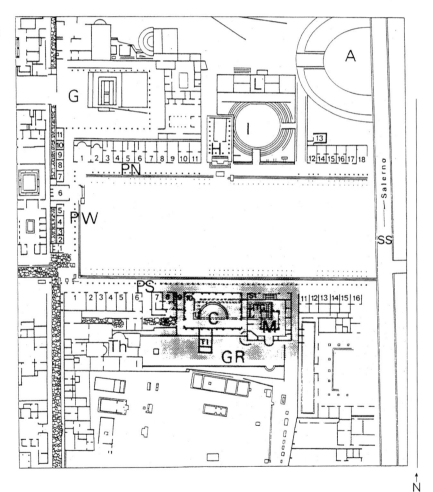

161. Paestum: façade (photo, author).

and only the western half of it has been excavated (the eastern half lies under the street and courtyard of the Museo Archeologico). The arena and lower part of the *cavea* were dug down into the earth, and the upper part of the *cavea* consisted of an earthen embankment, faced with a plain façade of ashlar limestone blocks, with dimensions varying between 0.50 and 1.50 m (Figure 161). These blocks

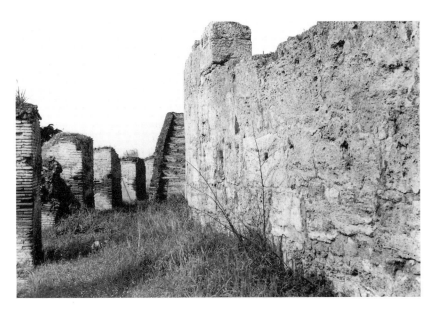

162. Paestum: enlargement in brick (photo, author).

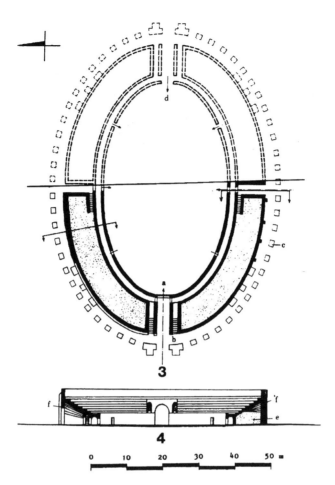

163. Paestum: plan and section (Golvin 1988).

were taken from the archaic city wall of Paestum and mortared together rather haphazardly. The building was enlarged in the imperial period by means of a peripheral gallery and arcade in brick-faced concrete (Figure 162). The new arcaded façade was very different from the republican one, which was simply a blind wall.

The *cavea* was no more than 10 m high and was divided into four *cunei* (Figures 163 and 164). Staircases (two at each major and minor axis) led from ground level outside the building up to the top of the structure, from where spectators could proceed to their seats. The podium was 2.80 m high. Behind it is an annular service corridor 1.4 m wide, on top of which was a platform that could accommodate *bisellia* (Figure 165). This annular corridor (which was for arena personnel, not spectator circulation) gave access onto the arena by means of six rectangular openings ("refuges"). Two large barrel-vaulted corridors led

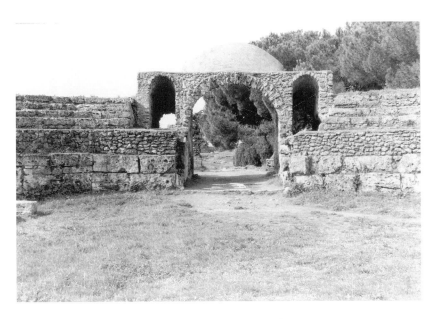

164. Paestum: entrance gallery and podium, looking west (partial modern restoration) (photo, author).

from the outside down to the arena level at the major axis. Golvin estimates the seating capacity at 4,500.

Materials
Earth, concrete, and limestone. The façade is made of reused limestone ashlar blocks, rubble, and mortar (Figure 166). The *cavea* is constructed in coarse concrete simply covered by a layer of stucco.

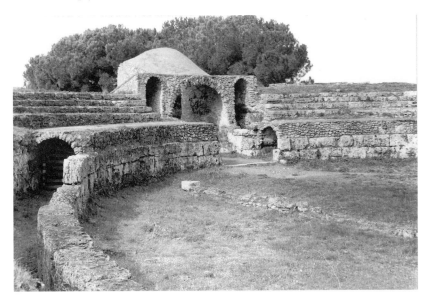

165. Paestum: service corridor behind podium (photo, author).

166. Paestum: detail of masonry, façade (photo, author).

Remains

The podium, the annular corridor behind it, and four tiers of seating survive. The vault of the western entrance gallery was reconstructed in the 1960s. Enlargement in brick is evident in the southwest sector of the building.

Dimensions

Overall length, 77.3 × 54.8 m. Arena length, 56.90 × 34.40 m. *Cavea*, 10.20 m wide.

Date

Probably first century BC. The building is very small, simple in form, and located close to the forum area. It was enlarged in the imperial period.

Civic Status of Paestum

Latin colony 273 BC (Livy *Per.* 14; Vell. Pat. 1.14.7). Possible Sullan or Caesarian colony (*duumviri* are attested in *CIL* X 480 = *ILLRP* 636). Colonial status probably by the early Augustan period (*CIL* X p. 53). See the discussion in Keppie (1983, 154–55).

Bibliography

Th. Mommsen, "Die italische Bürgercolonien von Sulla bis Vespasian" *Hermes* 18 (1883) 161–213, esp. 166–7; M. Mello, *Paestum romana* (Rome, Istituto Italiano per la Storia Antica, 1974) 148 ff; Keppie 1983, 153ff; Golvin 1988, 39–40; E. Greco, "Archeologia della colonia latina di Paestum" *Dial. di Arch.* 6 (1988) 79–86; P. Sommella, *Italia antica* (Rome, 1988) 95, fig. 26; J. G. Pedley,

Paestum: Greeks and Romans in Southern Italy (London, 1990) 14, 121; F. Zevi, ed., *Paestum* (Naples, 1990) 291 (color photograph of amphitheatre).

11. SUESSA AURUNCA (Campania)

Description
The amphitheatre was located in the southwestern part of the city, in the lower town (Figure 167) in the area known as "Vigna del Vescovo." The building is unexcavated and unpublished.

Materials
Earth and concrete.

Remains
"Dell'edificio (forse delle fine del I sec. ac) posto nella zona detta «Vigna del Viscovo» oggi sono visibili gli avanzi di un muro elissoidale di sostegno in *opus incertum*" (Villucci, 1980, 15 [see bibliography in this section]). Remains searched for, but not found, by the present author.

Dimensions
Unclear.

Date
First century bc. Most of the extant buildings at Suessa Aurunca date to the late republican period (the city wall, for example, is faced in "quasi-reticulate"),

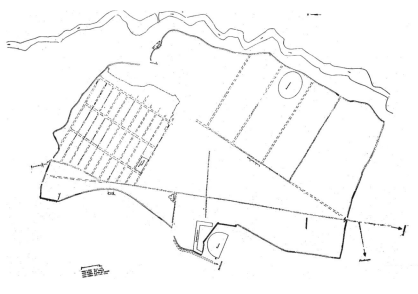

167. Suessa Aurunca: plan of the city (*Studia Suessana* II [Sessa Aurunca, 1980] pl. 1).

and the amphitheatre (which was small) is also likely to be of late republican date.

Civic Status of Suessa Aurunca

Latin colony 313 BC (Livy 9.28.7–8). Suessa sided with Sulla in the Civil War (App. *BCiv.* 1.85). Statue dedication to Sulla (*CIL* X 4751 = *ILLRP* 351; App. *BCiv.* 1.85). A man called A. Opinius C.f. Sulla is cited in a local inscription (Villucci 1980, 40 [see bibliography in this section]). An inscription refers to the town as *Colonia Iulia Felix Classica Suessa* (*CIL* X 4832), suggesting that it was a triumviral veteran colony, perhaps populated by veterans of a *legio Classica*.

Bibliography

A. Valletrisco, "Note sulla topografia di Suessa Aurunca" *Rend. Acc. Nap.* 52 (1977) 59–73, esp. 70–1, fig. 1; id., "Note aggiuntive sulla topografia di Suessa Aurunca" *Studia Suessana* II (Sessa Aurunca, 1980) 39–44 with fig. 1; A. M. Villucci, *I monumenti di Suessa Aurunca* (Gruppo Archeologico di Suessa Aurunca 1980) 15; De Caro & Greco 1981, 234; Keppie 1983, 143; Frederiksen, *Campania* 207, 214; P. Sommella, *Italia antica* (Rome, 1988) 44–5, fig. 9; P. Arthur, *Romans in Northern Campania, Settlement and Land-use Around the Massico and Garigliano Basin.* Archaeological Monographs of the British School at Rome, no. 1 (1991) 55–6.

12. ABELLINUM (Campania)

The amphitheatre was located in the southern sector of ancient Abellinum (modern Altripalda), just outside the city walls. It was documented during a rescue excavation in 1976 when a gas station was to be built on the spot (Figure 168). The choice of the site was determined by a natural depression in the terrain. The amphitheatre was divided by parapet walls into three tiers (Figures 168 and 169). The arena and *ima cavea* were embanked in earth, and the *media* and *summa cavea* seem to have been supported on vaults (Figure 170). Only a few parts of the building have been exposed. The *summa cavea* had radial vaults supporting small staircases that divided the different *cunei*. There may have been an annular circulation corridor at the *summa cavea* level. The amphitheatre was enlarged in the imperial period, as evidenced by remains in brick (Figure 171). The modern Via Appia runs through the area of the ruins of the building.

Materials

Coarse concrete faced with *opus reticulatum* with tufa blocchetti and tufa quoins (Figure 172). Stairs in cut tufa blocks; *baltei* in white limestone.

Remains

Earth and concrete. Some radial walls, parts of the façade, and stairs in the northern sector of the building; piers that supported vaults in the area dividing

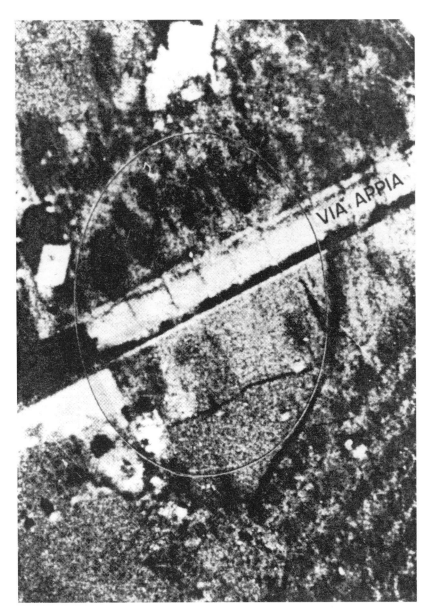

VIA APPIA

168. Abellinum: aerial photograph of amphitheatre contours (G. C. Pescatori, "Evidenze archaeologiche in Irpinia" *La Romanisation du Samnium* [Napoli 1991]).

the *media* and *summa cavea*. Remains in brick in the eastern sector of the building.

Date
Probably later first century BC. The amphitheatre was enlarged in the imperial period, and its reticulate wall facing, which is comparable to that at the amphitheatre at Abella but is less regular, seems to be late republican.

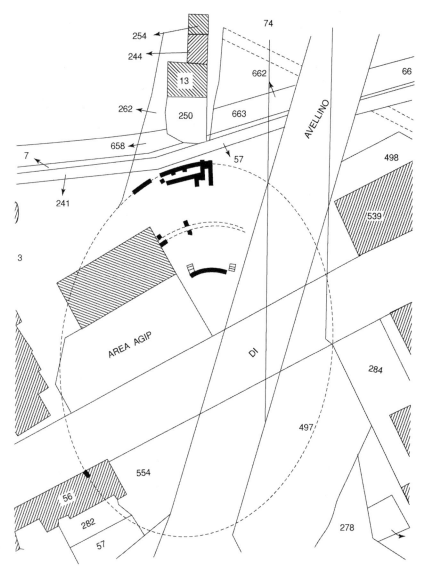

169. Abellinum:
plan (courtesy of
the
Soprintendenza
Archeologica
delle Province di
Salerno-Avellino-
Benevento).

Civic Status of Abellinum

Probable Sullan colony. C. Quinctius Valgus, who built the amphitheatre at
Pompeii, was *duumvir* at Abellinum, where he built the *forum, porticus, curia,*
and a cistern (*ILLRP* 598); Augustan colony (*CIL* X 1117 refers to the city as
Colonia Veneria Livia Augusta Alexandriana Abellinatium; the title *Veneria* may be
a vestige of the city's status as a colony under Sulla – cf. Pompeii's title *Colonia
Veneria Cornelia Pompeianorum*). See the discussion in *CIL* X p. 127.

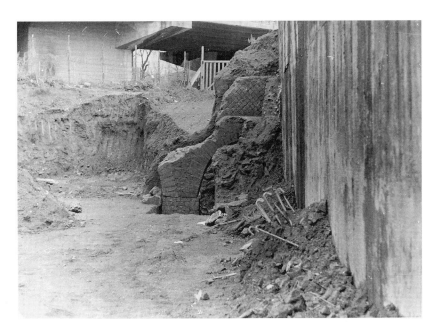

170. Abellinum: vaulting at *summa cavea* level (photo, courtesy of the Soprintendenza Archeologica delle Province di Salerno-Avellino-Benevento).

Bibliography

The amphitheatre is basically unpublished; for historical background, see Th. Mommsen, "Die italische Bürgercolonien von Sulla bis Vespasian" *Hermes* 18 (1883) 161–213, esp. 164; Salmon 1982, 132; G. Colucci Pescatori, "L'alta Valle del Sabato e la colonia romana di Abellinum" in *L'Irpinia nella società meridionale* (Avellino, 1987) 139–58; id., "Anfiteatro" *Abellinum. Una colonia romana. Mostra*

171. Abellinum: enlargement in brick (photo, courtesy of the Soprintendenza Archeologica delle Province di Salerno-Avellino-Benevento).

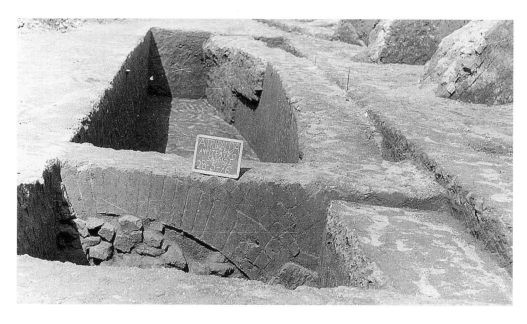

172. Abellinum: detail of masonry (photo, courtesy of the Soprintendenza Archeologica delle Province di Salerno-Avellino-Benevento).

documentaria (Avellino, 1986); id., "Evidenze archeologiche in Irpinia" in *La Romanisation du Samnium aux IIe et Ier siècles av. J.C.* (Naples, 1991) 85–122, esp. 89–98.

13. NOLA (Campania)

Description

The amphitheatre, which is still unpublished, was located in the northwestern sector of the ancient city, just inside the late republican city wall. Much of the building is now covered by a market (the "Mercato Nuovo," which is defunct), but part of the building was excavated throughout the 1990's, first by Valeria Sampaolo and later by Giuseppe Vecchio (Figures 173–175; Plate 8). The excavations have revealed roughly one half of the building in the western sector and what is currently one of the best preserved/excavated of all amphitheatres of republican date, next to Pompeii and Abella. The amphitheatre was quite large and is estimated to have accommodated 20,000 spectators. It had three tiers of seating. The *ima cavea* and the arena were dug out of the earth. The *media* and *summa cavea* were supported on vaults. The podium featured "refuges" used by arena personnel (Figure 176a). Just as at Pompeii, access to the cavea for spectators seems to have been provided by large vaulted galleries via the façade that led into an annular walkway behind the *ima cavea* giving access to the auditorium (Figure 176b). Also exactly as at Pompeii, each main entranceway for the combatants (at the major axis) had a pair of *carceres*, connected from the building to the inside of the tunnel itself. These *carceres* were spatially

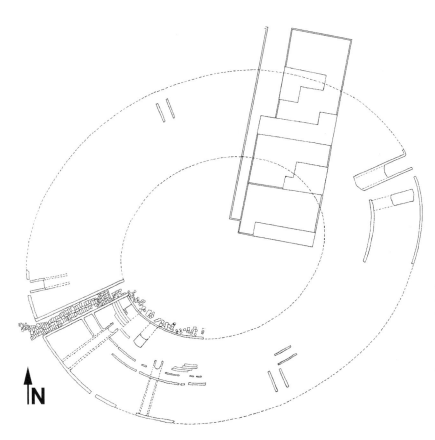

173. Nola: plan (after most recent excavations and clearing) (courtesy of the Soprintendenza per i Beni Archeologici delle province di Napoli e Caserta).

contiguous with the "refuges" that issued onto the arena on either side of the tunnel.

The amphitheatre had three main phases. According to the excavators, the first dates to ca. the mid 1st c. BC (thus, a generation or so after the Sullan colonization), using an early reticulate masonry (comparable to that used in the Theatre of Pompey, ca. 55 BC). In the early imperial period, the podium was faced with white marble slabs (Figure 177a), and the height of the *cavea* was increased by the addition of further seating. These restorations are in good reticulate, which suggests an early imperial or mid 1st c. AD in date. Further repairs to the amphitheatre (in brick), perhaps after an earthquake, were made sometime in the 2nd or 3rd c. AD.

Remarkably, the facade is quite well preserved and turns out to have been faced with stucco molded in faux masonry style and painted (effectively in the so-called Pompeian First Style), the "blocks" being represented in ochre against a blue background, colors invisible to me when I examined the façade (Figure 177b; Plate 8). (The fact that the façade of the amphitheatre at Pompeii was decorated in elaborate motifs with the use of stone blocchetti in

174. Nola: façade with entrance tunnel for arena combatants at major axis; imperial additions at right in foreground (photo, author).

different colors in a "decorative" pattern [Plate 7] would suggest that some republican amphitheatres were not stuccoed and painted). But the evidence of Nola indicates that others were stuccoed and painted (assuming, of course, that the painted stucco was not an 'updating' after amphitheatres with cut stone façades began regularly to be built in the early imperial period).

The façade of this amphitheatre is an important discovery and adds to our view of the aesthetic treatment of amphitheatres in the republican period. It is also, like Pompeii, an amphitheatre in an important city that can be linked

175. Nola: remains of *cavea* after most recent excavation and clearing (courtesy of the Soprintendenza per i Beni Archeologici delle province di Napoli e Caserta).

directly with veteran colonists from Rome. In most architectural respects the amphitheatre at Nola is notably similar to that at Pompeii. Moreover, the amphitheatre was constructed in an area where there had been pre-existing buildings that were demolished (by the colonists, as evidently was also the case with the amphitheatre at Pompeii). The foundations of the amphitheatre (according to the excavator) contained ceramic and other material from the *necropoleis* of the Classical and Hellenistic period at Nola, as well as other structures,

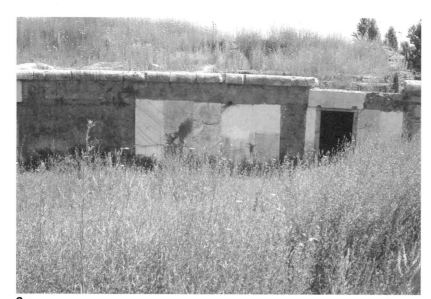

a

176. Nola: (a) podium, with marble revetment (an imperial addition) and "refuge." (b) façade with entrance tunnel for spectators at left (photos, author).

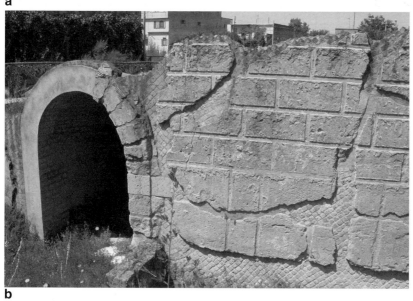

b

indicating that the colonists destroyed (and pillaged?) buildings, including tombs, at the edge of town to build their amphitheatre.

The cavea of the amphitheatre was decorated (in its imperial phase) with stele-like limestone panels ("pilastrini") each with relief decoration (six such panels have been recovered). The decoration includes scenes of gladiators, trophies with bound captives, an Amazonomachy, and a laurel wreath and turreted crown representing a city wall with a gate (presumably that of Nola). The reliefs, which may have stood on top of the balustrade of the *balteus*, or walkway, separating the *ima* from the *media cavea*, are as yet unpublished and are on display in the Archaeological Museum at Nola.

All of the above information was kindly shared with me by the excavator and Director of the Archaeological Museum at Nola, Giuseppe Vecchio.

Materials
Earth and coarse concrete with large chunks of tufa, radial walls faced with somewhat irregular *opus reticulatum* in tufa (0.10 × 0.11 cm.), with tufa quoins. Early imperial restorations in tufa reticulate of 0.08 × 0.9 cm. Later repairs in brick. Podium faced in white marble (apparently Carrara).

Remains
Some radial and annular walls in the eastern sector of the building. Western sector of the building well preserved and excavated.

Dimensions
Overall, 138 × 108 m.

Date
Mid-first century BC with early and high imperial refurbishments. Dating is based on excavated material, wall facing technique, and the striking architectural similarity of Nola's amphitheatre to the amphitheatre at Pompeii.

Civic status of Nola
Sullan colony. Nola was taken by the Samnites in 90 BC (Livy 9.28; App., *BCiv.* 1.42; 1.50). Sulla sacked it in 88 and again in 80 (App., *BCiv.* 1.50; Cic., *de Div.* 1.72; Livy, *Per.* 73.89; Pliny, *HN* 22.12; Plut., *Sull.* 8; *ILLRP* 116; also *Lib. colon.* 236). In 73 BC the city was sacked by Spartacus and his army (Eutr. 2.8.5). Augustan colony (inscription refers to it as *Colonia Felix Augusta Nola*: *CIL* X 1244). An imperial inscription mentions *duumviri* chosen from amongst veterans: *CIL* X 1273=*ILS* 6344. See Keppie 1983, 102, 152.

Bibliography
Th. Mommsen, "Die italische Bürgercolonien von Sulla bis Vespasian" *Hermes* 18 (1883) 185; E. Gabba, "Ricerche sull' esercito professionale romano da Mario ad Augusto" *Athenaeum* 29 (1951) 171–272, esp. 235; C. Giordano, *Spettacoli anfiteatrali in Nola e l'origine della città di Comiziano alla luce di documenti pompeiani* (Pompei, 1961); Beloch, *Campanien*, 391 f.; P.A. Brunt, *Italian Manpower 225 BC–AD 14* (Oxford, 1971) 285, 287f., 306–7; E. La Rocca, *Introduzione allo studio*

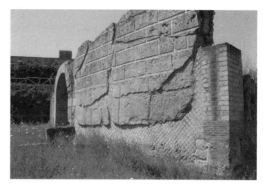

b

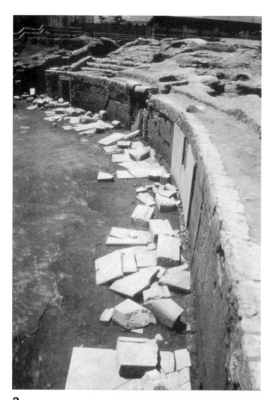

a

177. (a) Nola: podium during excavation with fallen marble slabs (courtesy of the soprintendenza per i Beni Archeologici delle province di Napoli e Casterta) (b) detail of façade, showing reticulate wall facing, covered with stucco in "faux" masonry style (photos, author).

di Nola antica (Naples, 1971) 63–70, 74–75; De Caro & Greco 1981, 207; Salmon 1982, 131f.; Keppie 1983, 102, 152; Golvin 1988, 252 with n. 11; P. Sommella, *Italia antica* (Rome, 1988) 128; V. Sampaolo, "Località Masseria d'Angerio. Anfiteatro" *BdA* 11–12 (1991) 165–166; S. De Caro in *Atti* 1993, 686. Best (though short) discussion in *Atti* 1998, 657–59 (De Caro).

14. AECLANUM (Campania)

The existence of an amphitheatre at Aeclanum is not certain. The evidence for it is that in his commentary in *CIL* I² (p. 54), Th. Mommsen writes that an inscription from Aeclanum (*CIL* IX 1138 = *ILLRP* 522) was "*in amphitheatro, ut dicebatur, reperta,*" ("found, as they say, in the amphitheatre"). The inscription reads as follows: *C. Obellius C.f. C. / Marius C.f. / IIII vir(i) i(ure) d(icundo) d(e) s(enatus) s(ententia) / crepidinem / de sua pequ(nia) / f(aciendum) c(uraverunt).* It is possible that the *crepido* (an architectural term meaning "base," "foundation," or "edge"; see *TLL s.v. crepido* cols. 1167–1168) mentioned here was the retaining wall for the earth excavated to form the *cavea* of an amphitheatre. There are no obvious remains of an amphitheatre at Aeclanum, but as has been pointed out by G. O. Onorato, there are many buildings at the site which have never been either explored or identified.

Civic Status of Aeclanum

Probable Sullan settlement. C. Quinctius Valgus, who built the amphitheatre at Pompeii, was *patronus municipii* at Aeclanum (*ILLRP* 523), where he built the city's fortification walls and towers after they had been destroyed by Sulla's troops (App., *BCiv.* 1.51). There is also evidence that *"maeniana"* were set up in the forum at Aeclanum, probably in imitation of the wooden amphitheatres in the *Forum Romanum* at Rome (*CIL* IX 1148 = *ILS* 5360; *ILLRP* 599).

Bibliography

G. O. Onorato, *La Ricerca archeologica in Irpinia* (Avellino, 1960) 12–15; Golvin 1988, 254; G. Colucci Pescatori, "Evidenze archeologiche in Irpinia" in *La Romanisation du Samnium aux IIe et Ier siècles av. J.-C.* (Naples, 1991) 98–104, with fig. 9 = *ILLRP* 523; P. Sommella, *Italia antica* (Rome, 1988) 128–9.

15. SUTRIUM (Etruria)

Description

We are unsure of the amphitheatre's location in the city plan. It was entirely cut out of the bedrock of soft tufa (Figure 178). The *cavea* is divided into two tiers of seating (Figure 179). The podium is 3.2. m high and bears remnants of stucco. A thin channel ran around the edge of the arena by means of which water was drained. Just as at the amphitheatres at Paestum and Abella, there was a service corridor behind the podium – in this case a crude, rock-cut service corridor 1.2 m wide and 2.25 m high, which gave onto the arena by means of rectangular openings 0.90 m wide (Figure 180). The arena is less elongated and rounder than those of most amphitheatres; this may have to do with the shape of the rock formation out of which the amphitheatre was quarried.

The arena was served by means of two galleries, situated at the extremities of the major axis. On either side of these are two curved walkways that issue into staircases for spectators leading up into the *media cavea*. At the minor axes are platforms 5.70 m long (*tribunalia*, or seats of the chief magistrates) with stairs on either side that descended into the service corridor. Just as at the amphitheatre at Pompeii, the *ima cavea* comprises five steps which are somewhat larger (0.40 m high and 0.60 m deep) than those of the *cavea* above (0.40 m high and 0.45 m deep). At the top of the *summa cavea* was a peripheral gallery of which the wall was decorated with niches and engaged Tuscan columns, cut out of the rock. There is evidence of a superstructure in wood above the *summa cavea*. Golvin estimates the seating capacity at 8,500.

Materials

Tufa and wood.

Remains

Well preserved.

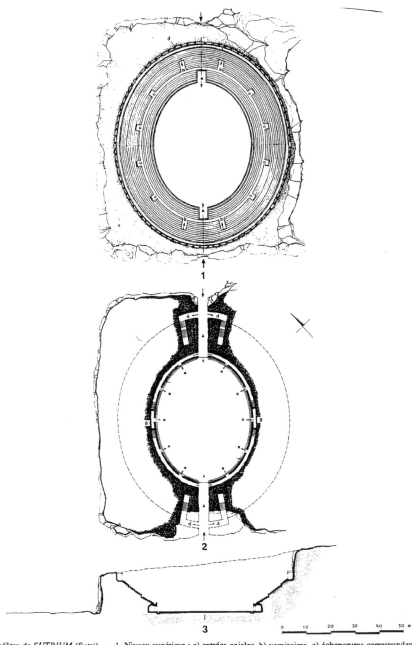

Amphithéâtre de *SUTRIUM* (Sutri). — 1. Niveau supérieur : a) entrées axiales. b) vomitoires. c) échancrures correspondant à des vomitoires inachevés. d) galerie supérieure. e) falaise de tuf. f) escarpement rocheux surplombant l'amphithéâtre. — 2. Niveau inférieur : A. galeries axiales. B. corridor de service. d) accès aux vomitoires. e) portes de service. — 3. Coupe transversale : B. corridor de service. f) euripe. d) galerie supérieure. C. masse de rocher enlevée.

178. Sutrium, amphitheatre: plans (1 and 2) and section (3) (Golvin 1988).

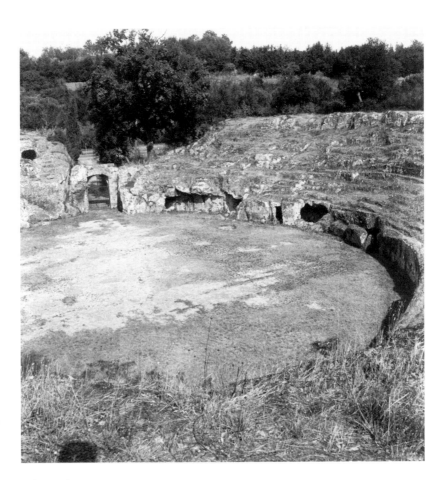

179. Sutrium: *cavea* (Fototeca, American Academy in Rome).

Dimensions
Overall length around ca. 85 × 75 m, arena 50 × 40 m.

Date
Probably first century BC. The building is small, and its form is in most respects similar to that of the amphitheatres at Pompeii, Abella, Paestum.

Civic Status of Sutrium
Latin colony late fourth century BC (Livy 6.9.4; Vell. Pat. 1.14.2). Triumviral or Augustan colony: inscription refers to the city as *Colonia Coniuncta Iulia Sutrina* (*CIL* XI 3254). Statue dedication to Sulla (*CIL* XI 7547 = *ILLRP* 354).

Bibliography
L. Canina, *L'antica Etruria marittima* (Rome, 1846) 76, pl. XXI; P. C. Sestieri, "L'Anfiteatro di Sutri" *Palladio* 3 (1939) 241–7; M. Torelli, *Guida Archeologica Laterza 3: Etruria* (Rome-Bari, 1980) 47–8; Keppie 1983, 169–70; C. Morselli, *Sutrium* (Rome, 1982) 45–54; Golvin 1988, 40–1; S. Meschini,

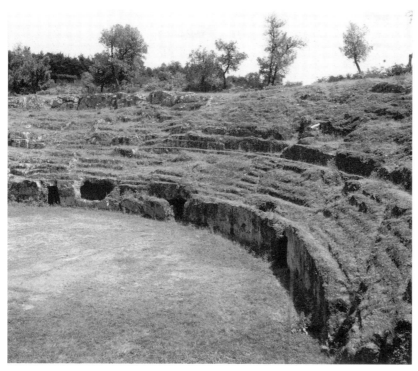

180. Sutrium: podium and service corridor (American Academy in Rome, Fototeca Unione 3131).

"Sutri: L'anfiteatro e il territorio" *Archeologia nella Tuscia* (Rome, 1982) 128–32; G. A. Mansuelli, *L'ultima Etruria. Aspetti della romanizzazione del paese etrusco* (Bologna, 1988) 28, 30, 186.

16. FERENTIUM (Etruria)

Description
The site of Ferentium is 30 km north of Sutrium, just off the Via Cassia. The amphitheatre at Ferentium was located in the northern part of the city, inside the city walls (Figure 181). It was very small and is completely covered by vegetation, but its contours are visible in the ground (Figure 182). The east side of the building was cut out of the terrain (Figure 183), while on the west it was built in concrete (Figure 184). There may have been some rebuilding in brick in the imperial period (Figure 185).

Materials
C. F. Giuliani (see bibliography in this section) mentions that in the western sector of the building there were vestiges of concrete radial walls faced in an *"opus quasi reticulatum."*

Remains
Completely overgrown. Possible brick additions visible in the eastern sector.

Dimensions

Overall length around 68 × 40 m.

Date

First century BC. The building is small, and the wall facing (not visible to me) is described as being "quasi-reticulate," presumably similar to that of either Pompeii, Telesia, or Teanum.

Civic Status of Ferentium

Municipium after Social War (*ILLRP* 588).

181. Ferentium: plan of the city (P. Sommella et al., *Italia antica* [Rome, 1988] fig. 15).

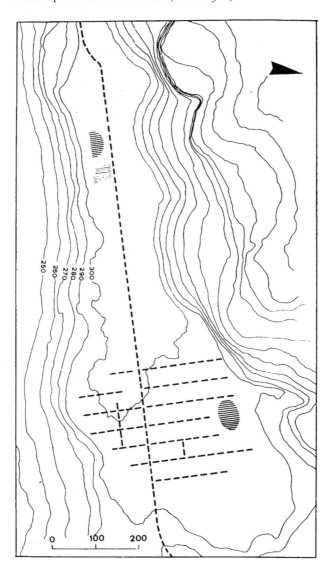

182. Ferentium: area of the amphitheatre; depression in ground coincides with *cavea* (photo, author).

Bibliography
C. F. Giuliani, "Bolsena e Ferento" *Quaderni dell' Istituto di Topografia Antica della Università di Roma*, vol. 2, *Studi di Urbanistica Antica* (1966) 61–78, esp. 66ff, figs. 10 and 11; M. Torelli, *Guida Archeologica Laterza* 3: *Etruria* (Rome-Bari, 1982) 221 (plan of the site); Golvin 1988, 41; P. Sommella, *Italia antica* (Rome, 1988) 68, fig. 15.

183. Ferentium: *cavea*, eastern sector (photo, author).

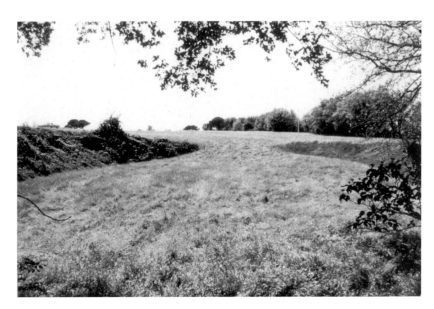

184. Ferentium: *cavea*, western sector (photo, author).

Republican Amphitheatres Outside of Italy

17. CARMO (Spain, Baetica)

Description

Like the amphitheatre at Sutrium, the amphitheatre at Carmo (modern Carmona) was rock-cut and was situated in a natural depression (Figure 186). In the northeast sector, where there was a gap in the rock, it was necessary to construct part of the structure in cut tufa blocks and mortar, as was done in the amphitheatre at Paestum. There are two rock-cut corridors leading down to the arena, one on each side of the building's major axis. The oval arena was irregular in shape. The *carceres* were situated at the ends of the major axis, one on either side of the principal entrance galleries; they issued directly onto the arena, and those on the east side opened both directly onto the arena and onto the corridor. The lowest tier of seating consisted of six steps of 0.4 m in height, cut into the rock. At the minor axis there are the remains of a platform (*tribunalium*) 4 m in width. One ascended to the lower *cavea* by means of small staircases situated at the end of a corridor cut in behind the *carceres*, at least in the eastern sector. A parapet wall separated the *ima cavea* from the steps above, as at Pompeii. Unlike the *ima cavea*, which was entirely cut out of the living rock, the *media* and *summa cavea* were supported by a wooden structure, for which a multitude of rectangular sockets were apparently cut out of the rock.

Materials

Tufa and wood.

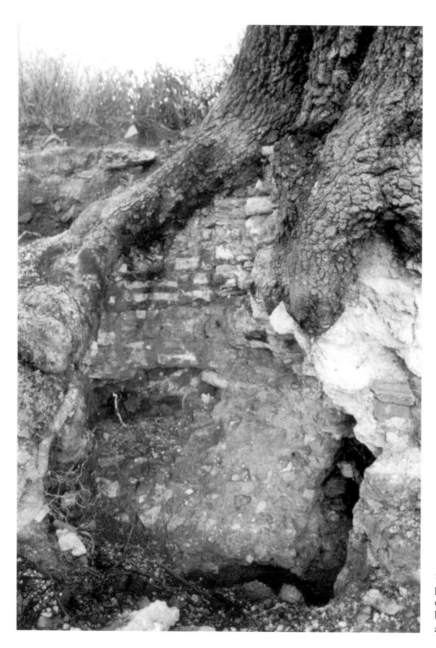

185. Ferentium: possible enlargement in brick (photo, author).

Remains

Six rock-cut steps and rock-cut passageways (*carceres*) at the major axis survive; remains of *cavea* substructures of stone and mortar in the northeast sector of the building.

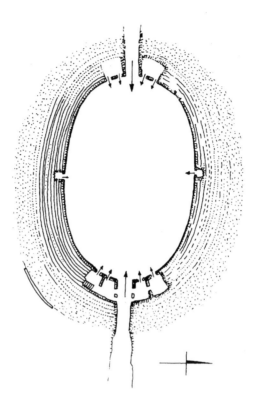

186. Carmo
(Carmona): plan
(Golvin 1988 pl.
7.5).

Dimensions
Overall length around 90 m. Arena around 58 × 39 m.

Date
First century BC. The excavators date the building to the time of Caesar (Fernandez-Chicarro, 1973). In its simplicity, small size, and rock-cut construction the building is similar to the amphitheatre at Sutrium.

Civic status of Carmo
Probably a municipium since the second century BC (Caes., *BCiv.* 2.19.4). The *B.Alex.* 57 records presence of Caesar's troops.

Bibliography
R. Thouvenot, *Essai sur la province romaine de Bétique* (*BEFAR* 149) (Paris, 1940) 196, 457; C. Fernandez-Chicarro, "Informe sobre las excavaciones del anfiteatro romano de Carmona" XIII *Congreso Nacional de Arqueología* (Huelva, 1973) 855–60; Golvin 1988, 41–2; S. J. Keay, *Roman Spain* (Berkeley and Los Angeles, 1988) 127–8; R. Corzo Sánchez, "Notas sobre el anfiteatro de Carmona y otros anfiteatros de la Betica," J. M. Álvarez–Martinez and J. J. Enríquez–Navascués, eds., *El anfiteatro en la Hispania Romana* (Mérida, 1994) 239ff.

18. CORINTH (Achaea)

Description

The amphitheatre at Corinth was built in an area about 1 km east of the Classi-
cal civic center but still inside the Classical city walls (Figure 187). It is located
exactly at the northeastern corner of the centuriated grid plan of the Roman
colony (Figure 188 [amphitheatre not shown on plan]). The building is not well
preserved and has never been excavated. The exact plan is still uncertain, but it
is clear that the structure was oval and rock-cut (Figures 189 and 190, Plate 16).
Several tiers of seating are still visible (Figures 191 and 192). The amphithe-
atre's crater-like *cavea* was quarried out of the surrounding soft bedrock; the
irregular contour of the arena that can be seen today is the result of consider-
able erosion of this stone. Bits of concrete survive in the earth above the *media
cavea*, but not enough to suggest that the amphitheatre had a superstructure of
stone or concrete. They are probably remains of the foundation of a wooden
superstructure (*summa cavea*).

A nineteenth-century plan of the amphitheatre shows a *cavea* divided into
twelve wedges (Figure 193). It also shows a rock-cut passage leading out from
the arena to the north. This feature, which is still visible (Figure 194), was
presumably the so-called "*porta libitinensis*" because it faces away from the civic
center. The southern sector of the building is completely buried, but it is likely
to have had a corresponding rock-cut passage that functioned as the so-called
"*porta triumphalis*." A plan executed in 1701 (Figure 113, Plate 18) shows a series
of rectangular chambers intended to be built into the remains of the amphithe-
atre in order to safeguard valuables during the wars between the Venetians and
the Turks; these chambers were never actually built.

Materials

Bedrock (a mixture of limestone and clay, called marl) and wood.

Remains

Not well preserved. The part of the rock-cut auditorium that is visible is ev-
idently the partially collapsed *media cavea*. The *ima cavea*, podium, and arena
floor are still buried. Remains of a *balteus* (low wall that divided the *ima* from the
media cavea) can still be discerned in the southern sector of the building at mod-
ern ground level; one can also make out the remains of staircases that divided
the *media cavea* vertically into different wedges of seating (see photographs in
Welch, 1999). The *summa cavea*, which was probably made of wood, is not
preserved.

Dimensions

As surveyed by D. G. Romano, 78 × 52 m. (see bibliography in this section)
These dimensions reflect the size of the crater-like *cavea* as preserved, which
is the result of weathering. The dimensions of the line of the podium that
encircled the arena were somewhat smaller in antiquity. The line of the outer
façade is no longer discernible.

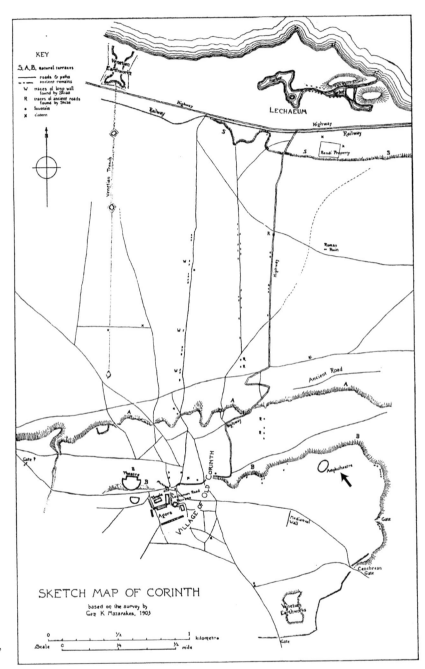

187. Corinth:
plan of the city
(H. N. Fowler &
R. Stillwell,
*Corinth I:
Introduction:
Topography and
Architecture*
[Cambridge, MA,
1932] fig. 46).

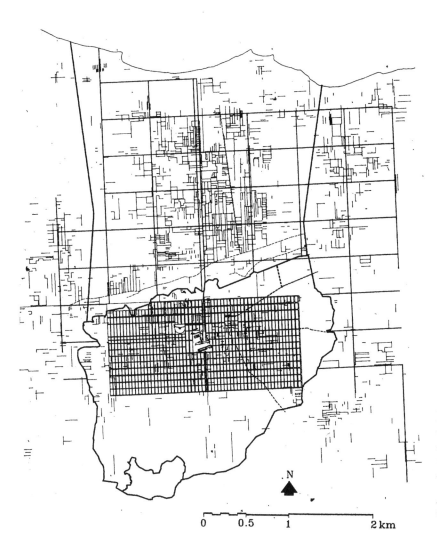

188. Plan of Corinth with Roman colonial grid (D. G. Romano, "Post 145 *B.C.* land use in Corinth and early planning of the Roman colony" in *The Corinthia in the Roman Period* [*JRA* Suppl. 8 Ann Arbor, 1994] Color fig. 7).

0 0.5 1 2 km

Date

Late republican, probably built by Caesar's colonists. The building is small, functional looking, and has its closest parallels in the rock-cut amphitheatres at Sutrium and Carmo.

Civic Status of Corinth

Colony of Julius Caesar (Strabo 8.6.23; 17.3.15; Plut. *Vit. Caes.* 57). Veteran settlement under Augustus (*Res Gestae* 28).

Bibliography

W. Leake, *Travels in the Morea*, III (London, 1830) 244–5; A. Blouet et al., *Expédition scientifique de Morée ordonné par le gouvernement français* III (Paris,

189.
Amphitheatre at
Corinth: aerial
view (at center,
near bottom).
(Hellenic Air
Force photograph
No. 20681, April
1963; courtesy of
the Corinth
Excavations,
American School
of Classical Stud-
ies at Athens).

1838) 36–7, pl. 77, fig. III; E. Curtius, *Peloponnesus* II. (Gotha, 1850) II 527;
W. Vischer, *Erinnerungen und Eindrücke aus Griechenland* (Basel, 1875) 264–5;
S. P. Lampros, "Über das korinthische Amphitheater" *MDAI(A)* 2 (1877) 282–
8 with plan Taf. XIX; E. Dodwell, *A Classical and Topographical Tour through
Greece* II (London, 1850) 191; F. J. de Waele, *Theater en Amphitheater Te Oud
Korinthe* (Utrecht, 1928) 25–31; H. N. Fowler & R. Stillwell, *Corinth* I, part 1:
Introduction, Topography, Architecture (Cambridge, MA, 1932) 89–91, figs. 54–
56 with plan p. 79; Robert 1940, 33, 117, no. 61; P. A. Brunt, *Italian Man-
power 225 B.C.–A.D. 14* (Oxford, 1971) 256, 598; Keppie 1983, 58, n. 51; Golvin
1988, 138; D. G. Romano, "Post 145 B.C. land use in Corinth and planning
of the Roman colony" in T. E. Gregory, ed., *The Corinthia in the Roman Period*,
(Ann Arbor, 1994) 9–30; M. E. H. Walbank, "The foundation and planning of

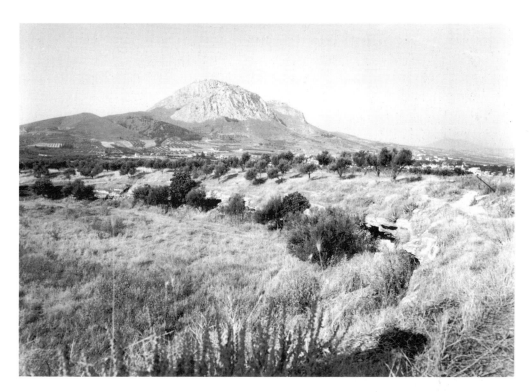

early Roman Corinth" *JRA* 10 (1997) 95–130; K. Welch, "Negotiating Roman spectacle architecture in the Greek world: Athens and Corinth" in B. Bergmann and C. Kondoleon, eds., *The Art of Ancient Spectacle* (New Haven, 1999) 125–45.

190. Amphitheatre at Corinth: view looking south, with Acrocorinth in the distance (photo: courtesy of the Corinth Excavations, American School of Classical Studies at Athens).

19. ANTIOCH (Syria)

Description

The amphitheatre is known from a 19th-century map of Antioch. The building is recorded as being situated in a natural depression, the contour of which is still visible.

Remains

The sloping *cavea* is discernible in the terrain (Figures 195 and 196). These are presumably the remains of an imperial rebuilding.

Date

First century BC. Malalas (9.216–17) mentions that Caesar built a μονομαχίον ("place of single combat") as well as a basilica, public bath, and a theatre at Antioch. The presence of the amphitheatre may be explained by the fact that Antioch was the site of a substantial garrison and an important area of army

191.
Amphitheatre at
Corinth:
northeast sector.
Remains of
seating (photo:
courtesy of the
Corinth
Excavations,
American School
of Classical
Studies at
Athens).

recruitment in the Near East during the late republican and early imperial periods. Roman troops were stationed there as early as 51 and 43 BC (Cic. *Att.* 5.18.1; *Fam.* 12.15.7) and are also attested in the imperial period (Tac. *Hist.* 2.80; Dio Cass. 68.24–5). The city was, of course, also the provincial capital of Syria and the seat of the proconsul and procurator of the province, who had military personnel on staff (*Inscriptions grecques et latine de la Syrie* III.1. 837).

Bibliography

G. Downey, *Ancient Antioch* (Princeton, 1963) 76; J. C. Mann, *Legionary Recruitment and Veteran Settlement during the Principate* (London, 1983) 49, 144–6;

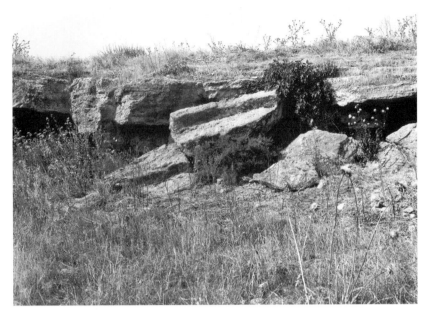

192.
Amphitheatre at
Corinth:
northeast sector,
with collapsed
seating and
hollow beneath
media cavea
(photo: courtesy
of the Corinth
Excavations,
American School
of Classical
Studies at
Athens).

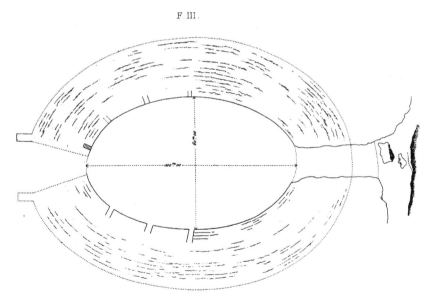

F. III.

193.
Amphitheatre at
Corinth: plan of
the 1830s (Abel
Blouet et al.,
*Expédition
scientifique de
Morée, ordonnée
par le
gouvernement
français* [Paris
1831–8]).

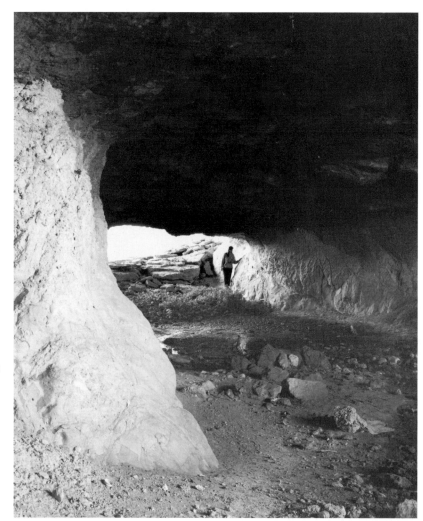

194.
Amphitheatre at
Corinth: interior
of so-called *"porta
libitinensis,"*
looking north,
with author for
scale (photo:
courtesy of the
Corinth
Excavations,
American School
of Classical
Studies at
Athens).

195. Antioch:
area of
amphitheatre
(photo, W. V.
Harris).

196. Antioch: area of amphitheatre, with remains of radial walls (photo, W. V. Harris).

E. Jeffreys, M. Jeffreys, & R. Scott, eds. and trans., *The Chronicle of John Malalas* (Melbourne, 1986); Golvin 1988, 42; B. Isaac, *The Limits of Empire: The Roman Army in the East* (Oxford, 1990) 270ff; N. Pollard, *Soldiers, Cities, and Civilians in Roman Syria* (Ann Arbor, 2000) 277–9.

NOTES

Introduction

1 A notable exception is L. Robert's *Les Gladiateurs dans l'Orient grec* (Paris, 1940), which dealt with the reception of Roman arena games in the Greek East. Robert's consideration of the epigraphical evidence demonstrated (to the surprise of some) that gladiatorial spectacles had been just as popular (during the high imperial period) in the culturally Greek, eastern half of the Roman Empire as they had been in the Roman West.

2 A similar conclusion is reached in A. Cameron, *Circus Factions: Blues and Greens at Rome and Byzantium* (Oxford, 1976) 157–92.

3 The author died while the work was still in note form; the notes were assembled, edited, and published posthumously by members of the French School in Rome.

4 K. M. Coleman, "Fatal Charades: Roman Executions Staged as Mythological Enactments" *JRS* 80 (1990) 44–73; "Launching into History: Aquatic Displays in the early Empire" *JRS* 83 (1993) 48–74. See also the impressive exhibition catalogue A. La Regina, ed., *Sangue e arena* (Milan, 2001); and A. Gabucci, ed., *Il Colosseo* (Rome, 1999).

5 Futrell 1997, 169–210; also H. S. Versnel, *Inconsistencies in Greek and Roman Religion* VI: *Tradition and Reversal in Myth and Ritual* (Leiden and New York, 1993) 210–17; and originally A. Piganiol, *Recherches sur lex jeux romains: notes d'archéologie et d'histoire religieuse* (Strasbourg, 1923) 133ff.

6 For example, Livy 22.57.2–6, where the practice of human sacrifice is called un-Roman. See further K. Welch, "Recent work on amphitheatres and arena spectacles" *JRA* 14 (2001) 492–8.

7 On the cultural specificity of Roman violence, see generally W. V. Harris, *War and Imperialism in Republican Rome 327–70 BC* (Oxford, 1979) esp. 53; and K. Hopkins, *Conquerors and Slaves* (Cambridge and New York, 1978) 102–4.

8 See review by K. Welch. *Journal of Social History* 27 (1993) 430–3.

9 An approach similar to Barton's is taken by P. Plass, *The Game of Death in Ancient Rome: Arena Sport and Political Suicide* (Madison, WI, 1995).

10 See M. Wistrand, *Entertainment and violence in ancient Rome: The attitudes of Roman writers of the first century AD* (Göteborg, 1992) esp. 15–29; R. A. Bauman, *Crime and Punishment in Ancient Rome* (London, 1996) 78–81;

D. G. Kyle, *Spectacles of Death in Ancient Rome* (London, 1998) 2–7; P. Cagniart, "The Philosopher and the Gladiator" *Classical World* 93 (2000) 607–18. Seneca (*Ep.* 7.2–5) is sometimes cited in support of the idea that educated Romans thought that arena activities were cruel. But in the letter Seneca objects to arena events involving unevenly matched opponents, in this case, defenseless criminals being slaughtered during the *spectacula meridiana*, or midday games. The author's concern is not for the men who are killed, but for the effect that this kind of spectacle has on the viewer. One wonders, moreover, why Seneca stayed for the midday events. He may have been expecting something better (i.e., more suspenseful).

11 Tacitus (*Ann.* 1.76) refers to the blood shed by gladiators as worthless: *vilis sanguis*.

12 On the ordinariness of violence in ancient Rome, see T. P. Wiseman, *Catullus and His World: A Reappraisal* (Cambridge and New York, 1985): "A World Not Ours" (pp. 1–10).

13 See K. Welch, "Roman Amphitheatres Revived" *JRA* 4 (1991) 272–80.

14 See particularly D. L. Bomgardner, *The Story of the Roman Amphitheatre* (London, 2000), which consists of a series of case studies; for a review, see K. Welch, "Recent work on amphitheatre architecture and arena spectacles" *JRA* 14 (2001) 492–8. See also K. M. Coleman, "Entertaining Rome" in J. Coulston & H. Dodge, eds., *Ancient Rome: The Archaeology of the Eternal City* (Oxford, 2000) 205–52; Futrell 1997; H. Dodge, "Amusing the Masses: Buildings for Entertainment and Leisure in the Roman World" in D. S. Potter & D. J. Mattingly, eds., *Life, Death, and Entertainment in the Roman Empire* (Ann Arbor, 1999) 205–55, esp. 224–36; A. Hönle & A. Henze, *Römische Amphitheater und Stadien: Gladiatorenkämpfe und Circusspiele* (Zürich, 1981); and R. Graefe's *Vela erunt: die Zeltdächer der römischen Theater und ähnlicher Anlagen* (Mainz am Rhein, 1979), a book that tackles the subject of the workings of the awnings in Roman amphitheatres from an engineering point of view. A brief article has appeared, the incongruous thesis of which is that the amphitheatre building was not a marker of Romanization or a claim to membership in a Roman community: A. T. Fear, "Status symbol or leisure pursuit? Amphitheatres in the Roman world" *Latomus* 59 (2000) 82–7. That the amphitheatre had a symbolic Roman significance has always been a logical assumption, however; and this is borne out amply by the arguments in this and other books, such as Futrell 1997 and Bomgardner (op. cit.).

15 Hopkins 1983, 12, 16; Friedländer II, 1ff.

16 See, for example, Cic. *Off.* 2.57. The issue of the sponsorship of games as a path to advancement for aspiring aediles is discussed by L. R. Taylor, *Party Politics in the Age of Caesar* (Berkeley, 1949) 30–1; see also E. Gruen, *Culture and National Identity in Republican Rome* (Ithaca, NY, 1992) 188ff. with bibliography, n. 23.

17 Hopkins 1983, 17; Friedländer II, 2.

18 Livy 39.46.1–3. *P. Licinii funeris causa visceratio data, et gladiatores centum viginti pugnaverunt, et ludi funebres per triduum facti, post ludos epulum. In quo cum toto foro strata triclinia essent, tempestas cum magnis procellis coorta coegit plerosque tabernacula statuere in foro.* See also Val. Max. 7.5.1 on a public spectacle and feast given by Q. Aelius Tubero in the late second century BC, mentioned only because of its excessive frugality, which was frowned upon.

19 Hopkins 1983, 18–19; Friedländer II, 3–4.

20 Cic. *Sest.* 125. *equidem existimo nullum tempus esse frequentioris populi quam illud gladiatorium neque contionis ullius neque vero ullorum comitiorum . . .*

21 Cic. *Sest.* 125. . . . *haec igitur innumerabilis hominum multitudo, haec populi Romani tanta significatio sine ulla varietate universi . . .* Other such texts for the republican period: Cic. *Att.* 1.16.11; 2.19.3; 14.2; 16.2; 16.5; *Fam.* 8.2.1; *Phil.* 1.36–7; *Sest.* 117–18.

22 See Suet. *Aug.* 44; and E. Rawson, "*Discrimina Ordinum:* the *lex Julia Theatralis*" *PBSR* 55 (1987), 83–114. See also J. C. Edmondson, "Dynamic arenas: Gladiatorial presentations in the city of Rome and the construction of Roman society during the early Empire" in W. J. Slater, ed., *Roman Theater and Society. E. Togo Salmon Papers* I (Ann Arbor, 1996) 69–112.

23 T. J. Moore, "Seats and Social Status in the Plautine Theatre" *CJ* 90 (1995) 113–23. From 196 BC senators were given special seats (Livy 34.44.4–5; 34.54.4; Val. Max. 2.4.3; 4.5.1) and equestrians from 67 BC on (Cic. *Mur.* 40; Plut. *Vit. Cic.* 13.2; Dio Cass. 36.42.1). For freedom of expression at public spectacles during the Republic, see, for example, Plut. *Vit. Sull.* 35; Cic. *Att.* 2.19.3; App. *BCiv.* 5.16; by contrast, Suet. *Aug.* 53.1 (Augustus sternly rebukes the Roman people by edict after a performance in the theatre when they vociferously applauded the princeps after an actor uttered the phrase "*O dominum aequum et bonum*" [O just and good master]).

24 Suet. *Iul.* 10; Cic. *Off.* 2.57. See also H. Mouritsen, *Plebs and Politics in the Late Roman Republic* (Cambridge, 2001) 125, n. 102 on the *lex Tullia de ambitu.*

25 Th. Mommsen, "*Senatus consultum de sumptibus ludorum gladiatorum minuendis*" *Gesammelte Schriften* viii, 508–9.

26 Dio Cass. 54.2.2–4.

27 Suet. *Aug* 45.3.

28 Suet. *Tib.* 75.3; 47; see also Sen. *Prov.* 4.4 (the gladiator Triumphus laments his lack of opportunity to perform during the reign of Tiberius).

29 Suet. *Tib.* 34.1; Dio Cass. 58.1.1.

30 Tac. *Ann.* 13.31.

31 Hopkins writes that after the institution of peace under Augustus "the mass of Roman citizens living in the capital were divorced from the direct experience of war . . . in memory of their warrior traditions the Romans set up artificial battlefields [amphitheatres] in their cities and towns. They re-created battlefield conditions for public amusement." Hopkins 1983, 2; see also Friedländer II, 60.

32 See D. Bomgardner, "Amphitheatres on the fringe" *JRA* 4 (1991) 282–94.

33 Hopkins 1983, p. 7.

34 Such a survey already exists. Golvin 1988; see also the useful short discussion of amphitheatre architecture by P. Gros, *L'architecture romaine du début du IIIe siècle av. J.-C. à la fin du Haut-Empire I. Les monuments publics* (Paris, 1996) 317–45.

35 An exception to this rule is the work of British archaeologists on amphitheatres in Rome's northern territories; see Bomgardner (supra n. 32).

36 For example, Caesar gave gladiatorial games in every region all over the city of Rome (Suet. *Iul.* 39.1: *regionatim urbe tota*), and Augustus gave gladiatorial games in the *Forum Romanum,* the Amphitheatre of Statilius Taurus, the *Circus Maximus* and the *Saepta* (Suet. *Aug.* 43.1).

One. Arena Games during the Republic

1 F. Weege, "Oskische Grabmalerei" *JDI* 24 (1909) 134–5; Ville 1981, 35–42.
Ville (pp. 1–56) contains the most detailed summary of the evidence for the
origins of gladiatorial combat. A useful summary of the evidence is to be found
in A. Futrell, *Blood in the Arena* (Austin, 1997) 9–19 (upon which my own
summary is largely based); see also D. Kyle, *Spectacles of Death in Ancient Rome*
(London, 1998) 44ff.; A. Gabucci, ed., *Il Colosseo* (Milan, 1999, English edn.
2000) 21–2, for the *opinio communis*.

2 Originally W. Henzen, *Explicatio musivi in villa Burghesiana asservati* (Rome,
1845) 74–75 (cited by Ville 1981 1, n. 2); see also M. Pallottino, *The Etruscans*
(trans. J. Cremona, Bloomington & London, 1975) 101, 180; E. Richard-
son, *The Etruscans* (Chicago, 1964) 229; F. Poulsen, *Etruscan Tomb Paintings.
Their Subjects and Significance* (trans. I. Anderson, Oxford, 1922) 14; L. Malten,
"Leichenspiel und Totenkult" *MDAI(R)* 38–9 (1923–4) 300ff.; K. Schneider,
"Gladiatores" *RE* Supp. 3 (1918), cols. 760–84; Ville 1981, 35–42; and esp. J. P.
Thuillier, *Les jeux athlétiques dans la civilisation étrusque* (Rome, 1985) 338–40,
who does not believe that gladiatorial games originated in Etruria but outlines
the opinions of those who do. A strange attempt has been made to attribute the
origins of gladiatorial combat to the Greeks: J. Mouratidis, "On the Origin of
the Gladiatorial Games" *Nikephoros* 9 (1996) 111–34.

3 Livy 9.40.17. . . . *Campani ab superbia et odio Samnitium gladiatores, quod
spectaculum inter epulas erat, eo ornatu armarunt Samnitiumque nomine
compellarunt.*

4 Strabo 5.4.13: Καμπανοῖς δὲ συνέβη διὰ τὴν τῆς χώρας εὐδαιμονίαν ἐπ' ἴσον
ἀγαθῶν ἀπολαῦσαι καὶ κακῶν. ἐπὶ τοσοῦτον γὰρ ἐξετρύφησαν ὥσϑ' ἐπὶ δεῖπνον
ἐκάλουν πρὸς ζεύγη μονομάχων, ὁρίζοντες ἀριθμὸν κατὰ τὴν τῶν δείπνων
ἀξίαν.

5 Sil. *Pun.* 11.51–4. *Quin etiam exhilarare viris convivia caede / mos olim, et miscere
epulis spectacula dira / certantum ferro, saepe et super ipsa cadentum / pocula respersis
non parco sanguine mensis.*

6 On Campanian banquets, see C. P. Jones, "Dinner Theater," in W. J. Slater,
ed., *Dining in a Classical Context* (Ann Arbor, 1991) 185–98.

7 P. C. Sestieri, "Tombe dipinte di Paestum" *Rivista dell' Istituto nazionale
d'archeologia e storia dell' arte* 5–6 (1956–7) 65ff.; C. Nicolet, "Les *equites campani*
et leurs représentations figurées" *MEFRA* 74 (1962) 463ff.; G. Gori, "Elementi
greci, etruschi, e lucani nelle pitture tombali a soggetto sportivo di Paestum"
Stadion 16 (1990) 73–89, esp. 78–9 with figs. 4–6; A. Pontrandolfo & A. Rou-
veret, *Le tombe dipinte di Paestum* (Modena, 1992) 55–8; E. T. Salmon, *Samnium
and the Samnites* (Cambridge, 1967) 60–1, and id., *The Making of Roman Italy*
(Ithaca, NY, 1982) 12; M. Frederiksen, *Campania* (Rome, 1984) 323f, 339, n. 33;
Ville 1981, 8, 20–35; J.-P. Thuillier, "Les origines de la gladiature: Une mise au
point sur l'hypothèse étrusque," in C. Domergue, C. Landes, & J.-M. Pailler,
eds., *Spectacula* I: *gladiateurs et amphithéâtres* (Paris and Lattes, 1990) 140. See
also F. Zevi, ed., *Paestum* (Paris and Lattes, 1990) 248–9 (for detailed pho-
tographs in color).

8 See M. Cipriani, "Prime presenze italiche organizzate alle porte di Poseidonia,"
in M. Cipriani, F. Longo, and M. Viscione, eds., *I Greci in occidente. Poseidonia
e i Lucani* (Naples, 1996) 119–58 with color plates.

9 Quoted in Ath. 4.153f. τὰς τῶν μονομάχων θέας οὐ μόνον ἐν πανηγύρεσι καὶ θεάτροις ἐποιοῦντο Ῥωμαῖοι, παρὰ Τυρρηνῶν παραλαβόντες τὸ ἔθος, ἀλλὰ κἂν ταῖς ἑστιάσεσιν.

10 *hic [Tarquinius Priscus] . . . prior Romanis duo paria gladiatorum edidit quae comparavit per annos XXVII.* A less likely translation for *comparavit* would have Tarquinius Priscus obtaining the gladiators over the course of twenty-seven years. The fragment is probably from Suetonius, *De Regibus.* A. Reifferscheid, *C. Suetoni Tranquilli praeter Caesarum: libros reliquiae* (Leipzig, 1860) 320; Ville 1981, 8, n. 32.

11 Livy 1.35; 1.38. Futrell 1997, 19–20. Contra Wiedemann, who interprets the ascription of gladiatorial combat to Etruria as having to do with Roman ambivalence toward the games: T. Wiedemann, *Emperors and Gladiators* (London and New York, 1992) 33.

12 Isid. *Etym.* 10.159. *lanista, gladiator, id est carnifex, Tusca lingua appellatus, a laniando scilicet corpora* (*Lanista*, gladiator, that is to say executioner, so called in the Etruscan language, doubtless from the term for "tearing apart" bodies). See Ville 1981, 3; and A. Ernout & A. Meillet, *Dictionnaire étymologique de la langue latine*, 3rd ed. (Paris, 1951) *s.v. lanista.*

13 Tert. *Ad Nat.* 1.10.47.

14 F. De Ruyt, *Charun: démon étrusque de la mort* (Institut historique belge, Rome, 1934) 191–2. Kyle (supra n. 1), 155–7, is skeptical of this association.

15 See, for example, F. Poulsen, *Etruscan Tomb Paintings* (Oxford, 1922) 12–14; L. B. van der Meer, "*Ludi scaenici et gladiatorum munus*: A Terracotta Arula in Florence" *BaBesch* 57 (1982) 87–99.

16 See Thuillier (supra n. 7) 137–41; M. Pallottino 1975, 180; L. Bonfante, "Daily life and afterlife," L. Bonfante, ed., *Etruscan Life and Afterlife: A Handbook of Etruscan Studies* (Detroit, 1986) 260; D. Rebuffat-Emmanuel, "Le jeu de Phersu à Tarquinia: nouvelle interprétation" *CRAI* (1983) 421–38; M. Torelli, "Delitto religioso. Qualche indizio sulla situazione in Etruria," in id. et al., *Le délit religieux dans la citéantique* (Rome, 1981) 5–6; Ville 1981, 4–6; Futrell 1997, 15–16; J.-R. Janot, "Phersu, Phersuna, Personna. À propos du masque étrusque," in *Spectacles sportifs et scéniques dans le monde étrusco-italique* (Rome, 1991) 281–320.

17 Although beast fighters and victims of the *damnatio ad bestias* are sometimes shown being attacked by animals, they are never depicted with sacks over their heads, to my knowledge. For depictions of arena events in Roman art, see especially A. Hönle & A. Henze, *Römische Amphitheater und Stadien: Gladiatoren Kämpfe und Circusspiele* (Zürich, 1981); also E. Köhne, C. Ewigleben, & R. Jackson, eds., *Gladiators and Caesars: The Power of Spectacle in Ancient Rome* (Berkeley, 2000); Gabucci (supra n. 1); A. La Regina, et al., ed., *Sangue e arena* (Milan, 2001); K. M. D. Dunbabin, *The Mosaics of North Africa: Studies in Iconography and Patronage* (Oxford and New York, 1978); S. Brown, "Death as Decoration: Scenes from the Arena on Roman Domestic Mosaics," in A. Richlin, ed., *Pornography and Representation in Greece and Rome* (Oxford, 1992) 180–211; G. Lafaye, "Gladiator" and "Venatio," DS II (1896) 1563–99, V (1919) 680–709; *EAA* III *s.v.* gladiatore (pp. 937–47); A. M. Reggiani, "La 'venatio': origine e prime raffigurazioni" in M. L. Conforto et al., *Anfiteatro flavio. Immagine testimonianze spettacoli* (Rome, 1988) 147–55.

18 Ville 1981, 35ff. Etruscan influence on chariot racing is more plausible: R. C. Bronson, "Chariot racing in Etruria," in *Studi in onore di Luisa Banti* (Rome, 1965) 89–106.

19 Livy *Per.* 16; Val. Max. 2.4.7 – discussed in the following. It is difficult to reconcile Ville's proposal that gladiatorial combat was borrowed by the Etruscans from Campania with the fact that Etruscan presence in Campania was sharply curtailed after the battle of Cumae in 474 BC; as pointed out by Futrell 1997, 12–14, and by M. Bonghi Jovino, "The Etruscan expansion into Campania," in M. Torelli ed., *The Etruscans* (Milan, 2000) 157–67, esp. 167.

20 Ath. 4.153f. Καμπανῶν δέ τινες παρὰ τὰ συμπόσια μονομαχοῦσι. Νικόλαος δ' ὁ Δαμασκηνός, εἷς τῶν ἀπὸ τοῦ περιπάτου φιλοσόφων, ἐν τῇ δεκάτῃ πρὸς ταῖς ἑκατὸν τῶν ἱστοριῶν Ῥωμαίους ἱστορεῖ παρὰ τὸ δεῖπνον συμβάλλειν μονομαχίας, γράφων οὕτως· τὰς τῶν μονομάχων θέας οὐ μόνον ἐν πανηγύρεσι καὶ θεάτροις ἐποιοῦντο Ῥωμαῖοι, παρὰ Τυρρηνῶν παραλαβόντες τὸ ἔθος, ἀλλὰ κἂν ταῖς ἑστιάσεσιν.

21 Ath. 4.154a–b. Ποσειδώνιος δ' ἐν τρίτῃ καὶ εἰκοστῇ τῶν ἱστοριῶν· Κελτοί, φησίν, ἐνίοτε παρὰ τὸ δεῖπνον μονομαχοῦσιν. ἐν γὰρ τοῖς ὅπλοις ἀγερθέντες σκιαμαχοῦσι καὶ πρὸς ἀλλήλους ἀκροχειρίζονται, ποτὲ δὲ καὶ μέχρι τραύματος προΐασιν καὶ ἐκ τούτου ἐρεθισθέντες, ἐὰν μὴ ἐπισχῶσιν οἱ παρόντες, καὶ ἕως ἀναιρέσεως ἔρχονται.

22 Ath. 4.154d. Ἕρμιππος δ' ἐν ἀ περὶ νομοθετῶν τῶν μονομαχούντων εὑρετὰς ἀποφαίνει Μαντινεῖς Δημώνακτος ἑνὸς τῶν πολιτῶν συμβουλεύσαντος.

23 Wiedemann 1992, 31ff.

24 Friedländer II 50–4; K. Hopkins 1983, 4–5; Futrell 1997, 33.

25 It is not clear that gladiatorial combats in the city of Rome were ever entirely separated from funerary associations until the imperial period. However, the funerary connection had relaxed by the early to mid-first century BC when Caesar, for example, chose to celebrate gladiatorial games in honor of his father during his aedileship (in 65 BC), even though his father had died twenty-one years earlier (Dio Cass. 37.8.1; Plut., *Vit. Caes.* 5.5; Suet. *Iul.* 10.2; Ville 1981, 78–9).

26 Livy *Per.* 16. *Decimus Iunius Brutus munus gladiatorium in honorem defuncti patris primus edidit.* He was consul in 266 BC and celebrated a triumph over Sassina in Umbria: *MRR* I 201. See the discussion on this individual in Futrell 1997, 20–1.

27 *Munus* is a word meaning not only gladiatorial show but also duty or offering. Val. Max. 2.4.7: *Nam gladiatorium munus primum Romae datum est in foro boario Ap. Claudio, Q. Fulvio consulibus: dederunt M. et D. filii Bruti Perae, funebri memoria patris cineres honorando.*

28 Auson. *Griphus* 36–7. *tris primas Thraecum pugnas tribus ordine bellis / Iuniadae patrio inferias misere sepulcro.*

29 Servius, *Ad Aen.* 3.67.10–14. *Apud veteres etiam homines interficiebantur, sed mortuo Iunio Bruto cum multae gentes ad eius funus captivos misissent, nepos illius eos qui missi erant inter se composuit, et sic pugnaverunt; et quod muneri missi erant, inde munus appelatum.* Other evidence for the killing of captives and the staging of gladiatorial combat in front of Roman tombs: Tert., *De spect.* 12.2.3; Servius, *Ad Aen.* 10.519.

30 See G. Ville, "La guerre et le *munus*," J.-P. Brisson, ed., *Problèmes de la guerre à Rome* (Paris, 1969) 185–95, esp. 187f.

31 Livy 23.30.15: *Et M. Aemilio Lepido, qui bis consul augurque fuerat, filii tres, Lucius, Marcus, Quintus, ludos funebres per triduum et gladiatorum paria duo et viginti in foro dederunt.* MRR I 225, 234–5.

32 Livy 28.21.1. *Scipio Carthaginem ad vota solvenda deis munusque gladiatorium, quod mortis causa patris patruique paraverat, edendum rediit.*

33 Livy 31.50.4; 39.46.2–3; 41.28.11.

34 Ville 1981, 43.

35 Livy 41.28.11. *Munera gladiatorum eo anno aliquot, parva alia, data; unum ante cetera insigne fuit T. Flaminini, quod mortis causa patris sui cum visceratione epuloque et ludis scaenicis quadriduum dedit. Magni tum muneris ea summa fuit quod per triduum quattuor et septuaginta homines pugnarint.* See also the casual mention of a gladiatorial combat (of unspecified sponsorship) in Rome sometime in the 190s (Plut. *Vit. Cat. Mai.* 17.2); note that there is no record of this event in the text of Livy, which is preserved for the first decade of the second century BC.

36 Polyb. 31.28.5–7: ἔστι δ᾽ οὐκ ἐλάττων ἡ σύμπασα τριάκοντα ταλάντων, ἐάν τις μεγαλομερῶς ποιῇ.

37 See P. Roussel & J. Hatzfeld, "Fouilles de Délos exécutées aux frais de M. le duc de Loubat; décrets, dédicaces et inscriptions (1905–8)" *BCH* 34 (1910) 355–423, esp. 404–5.

38 M. Bulard, *La religion domestique dans la colonie italiennne de Délos d'après les peintures murales et les autels historiés* (Paris, 1926) 124–30, 149–50, 158–9. Also *Délos* IX pl. I, 3; p. 72; and L. Robert, *Les gladiateurs dans l'Orient grec* (Paris, 1940) 264.

39 An inscription from the Agora of the Italians (*IDélos* 1756, located on a pilaster of the façade of the vestibule to the baths) records that the *magistri* of a series of *collegia* sponsored games and restored certain bath features: *(l)udosque impe(nsa sua) / (fe)cerunt ornato(sque) / dederunt de (s)ua / (p)ecunia (e)t art(e) / tectaque tradiderun(t).* The *ludi* here have been interpreted as gladiatorial games, perhaps given in the context of *ludi funebres*. See Roussel & Hatzfeld (supra n. 37) and N. K. Rauh, "Was the Agora of the Italians an *Établissement de Sport*?" *BCH* 116 (1992) 293–333, esp. 313–15; Rauh points to a similarity in plan between the Agora of the Italians and the *Ludus Magnus* in Rome (Chapter Two and Fig. 32, this work).

40 Robert 1940, no. 62.

41 Perhaps the mint official of 135–4 BC: *MRR* II 453.

42 Pliny *HN* 35.52. *libertus eius, cum daret Anti munus gladiatorium, publicas porticus occupavit pictura, ut constat, gladiatorum ministrorumque omnium veris imaginibus redditis. hic multis iam saeculis summus animus in pictura, pingi autem gladiatoria munera atque in publico exponi coepta a C. Terentio Lucano. Is avo suo, a quo adoptatus fuerat, triginta paria in foro per triduum dedit tabulamque pictam in nemore Dianae posuit.*

43 L. Venditelli, "Diana Aventina, Aedes" *LTUR* II 11–13.

44 Ter. *Hec.* preface 2.39–43. *primo actu placeo. quom interea rumor venit / datum iri gladiatores, populus convolat / tumultuantur, clamant pugnant de loco. ego interea meum non potui tutari locum.* This passage suggests that at this time gladiatorial combat and *ludi scaenici* could take place in the same venue; whether this was in the *Forum Romanum* or in a theatre in another location is not clear: see E. J. Jory, "Gladiators in the Theatre" *CQ* 36 (1986) 537–9; N. Horsfall, "The Ides of March: Some New Problems" *Greece and Rome* 21 (1974) 195–6.

45 Hor. *Ars P.* 32; commentary by Porphyrius, ad loc. *Aemilii Lepidi ludus gladia-toriusfuit, quod nunc Polycleti balineum est.* D. Palombi, "Ludus Aemilius" *LTUR* III 195; Rauh (supra n. 39) 329–30, and T. P. Wiseman, "Rome and the Resplendent Aemilii," in H. D. Jocelyn & H. Hurt, eds., *Tria Lustra: Essays Presented to John Pinsent* (Liverpool, 1993) 181–92. Cf. Cicero's mention (*Cat.* 2.5.9) of a gladiatorial school in Rome later, in 63 BC.

46 Livy 41.20.10: *Spectaculorum quoque omnis generis magnificentia superiores reges vicit, reliquorum sui moris et copia Graecorum artificum; gladiatorum munus, Romanae consuetudinis.*

47 Polyb. 30.25.1.

48 See J. C. Edmondson, "The cultural politics of public spectacle in Rome and the Greek East, 167–166 BCE," in B. Bergmann & C. Kondoleon, eds., *The Art of Ancient Spectacle* (New Haven, 1999) 77–95.

49 F. W. Walbank, *A Historical Commentary on Polybius III* (Oxford, 1979) 284–5, 448–51.

50 Hopkins 1983, 7.

51 Enn. *Ann.* (frag. 470 Warmington). Other examples: Polyb. 18.37.7; Plaut. *Asin.* 15, *Capt.* 67–8, *Cas.* 87–8; *Rud.* 82; Livy 30.42.17; 37.45.8; Cic. *Off.* 1.35. That military prowess and Romanness were inextricable concepts had become a trope by the later second century BC (Sall. *Iug.* 85: Marius' speech in the popular assembly) and a matter of poetic expression by the time of Augustus (Hor. *Carm. saec.* 41–9 and Virg. *Aen.* 6.847–53). On Rome's military self-image, see W. V. Harris, *War and Imperialism in Republican Rome, 327–70 BC* (Oxford, 1979), esp. 41–53, and M. McDonnell, *Roman Manliness. Virtus and the Roman Republic* (Cambridge and New York, 2006).

52 Sall. *Cat.* 7.3–6. *Sed civitas incredibile memoratu est adepta libertate quantum brevi creverit; tanta cupido gloriae incesserat. Iam primum iuventus, simul ac belli patiens erat, in castris per laborem usum militiae discebat magisque in decoris armis et militaribus equis quam in scortis atque conviviis lubidinem habebant. Igitur talibus viris non labor insolitus, non locus ullus asper aut arduus erat, non armatus hostis formidulosus; virtus omnia domuerat. Sed gloriae maxumum certamen inter ipsos erat; se quisque hostem ferire, murum ascendere, conspici dum tale facinus faceret, properabat.* Translation W. V. Harris, 1979, 17.

53 Tacitus says as much (*Ann.* 13.31) as does Cicero (*Sest.* 119). See J. C. Edmondson, "Dynamic Arenas: Gladiatorial Presentations in the City of Rome and the Construction of Roman Society during the Early Empire," in William J. Slater, ed., *Roman Theater and Society. E. Togo Salmon Papers I* (Ann Arbor, 1996) 69–112, esp. 75f.

54 In the middle of his description of the topography of the Aetna region in Sicily, Strabo, in 6.2.6–7, remarks: "Recently in my own time, a certain Selourus, called 'Son of Aetna,' was sent up to Rome because he had put himself at the head of an army and for a long time had overrun the regions around Aetna with frequent raids. I saw him torn to pieces by wild beasts as part of an appointed gladiatorial combat in the Forum; for he was placed on a lofty scaffold, as though on Aetna, and the scaffold was made to break up and collapse, and he himself was carried down with it into cages of wild beasts – fragile cages which had been prepared beneath the scaffold for that purpose. As for the fertility of the Aetna region . . ." (νεωστὶ δ᾽ ἐφ᾽ ἡμῶν εἰς τὴν Ῥώμην ἀνεπέμφθη Σέλουρός τις, Αἴτνης υἱὸς λεγόμενος, στρατιᾶς ἀφηγησάμενος καὶ λεηλασίαις πυκναῖς καταδεδραμηκὼς

τὰ κύκλῳ τῆς Αἴτνης πολὺν χρόνον, ὃν ἐν τῇ ἀγορᾷ μονομάχων ἀγῶνος συνεστῶτος εἴδομεν διασπασθέντα ὑπὸ θηρίων· ἐπὶ πήγματος γάρ τινος ὑψηλοῦ τεθεὶς ὡς ἂν ἐπὶ τῆς Αἴτνης, διαλυθέντος αἰφνιδίως καὶ συμπεσόντος, κατηνέχθη καὶ αὐτὸς εἰς γαλεάγρας θηρίων εὐδιαλύτους, ἐπίτηδες παρεσκευασμένας ὑπὸ τῷ πήγματι. Τὴν δὲ τῆς χώρας ἀρετὴν θρυλουμένην . . .)

55 On Martial, see K. M. Coleman, "The *liber spectaculorum*," in F. Grewing, ed., *Toto notus in orbe. Perspektiven der Martial-Interpretation* (Stuttgart, 1998) 15–36. On Suetonius' writings on games, see A. Wallace-Hadrill, *Suetonius: The Scholar and his Caesars* (London, 1983) 46–7.

56 Ville 1981, 129–73; Wiedemann 1992, 55ff.

57 J. H. Humphrey, *Roman Circuses: Arenas for Chariot Racing* (London, 1986) 71.

58 Pliny *HN* 8.53. *Leonum simul plurium pugnam Romae princeps dedit Q. Scaevola P.f. in curuli aedilitate, centum autem iubatorum primus omnium L. Sulla, qui postea dictator fuit, in praetura; post eum Pompeius Magnus in circo DC, in iis iubatorum CCCXV, Caesar dictator CCCC.*

59 Ville, 1981, 53ff., argues that it began with the importation of African elephants into Italy, perhaps after the First Punic War and certainly by the end of the Second Punic War; see the discussion in Futrell 1997, 26ff.

60 Seneca *de Brev. Vit.* 13.3. *primus Curius Dentatus in triumpho duxit elephantos. MRR* I 195 for Dentatus' triumph.

61 Eutropius 2.14.5. *[Curius] Primus Romam elephantos quattuor duxit.* Cf. Pliny *HN* 8.16.

62 Pliny *HN* 8.16–17. "There were 142 of them, or by some accounts 140, and they had been brought over on rafts . . . Verrius records that they fought in the Circus and were killed with javelins, because it was not known what use to make of them . . . Lucius Piso says that they were merely led into the Circus, and in order to increase the contempt felt for them were driven all around it by attendants carrying spears with a button on the point. The authorities who do not think that they were killed do not explain what was done with them afterwards." (*CXLII fuere aut, ut quidam, CXL travecti ratibus quas doliorum consertis ordinibus inposuerat. Verrius eos pugnasse in circo interfectosque iaculis tradit, paenuria consilii, quoniam neque ali placuisset neque donari regibus; L. Piso inductos dumtaxat in circum atque, ut contemptus eorum incresceret, ab operariis hastas praepilatas habentibus per circum totum actos. Nec quid deinde iis factum sit auctores explicant qui non putant interfectos.*). See *MRR* I 213–14.

63 Livy 39.22.2: *Athletarum quoque certamen tum primo Romanis spectaculo fuit et venatio data leonum et pantherarum et prope huius saeculi copia ac varietate ludicrum celebratum est.* See A. M. Reggiani 1988, 147–55.

64 Pliny *HN* 8.64. *Senatus consultum fuit vetus ne liceret Africanas in Italiam advehere. Contra hoc tulit ad populum Cn. Aufidius tribunus plebis, permisitque circensium gratia inportare.*

65 Livy 44.18.8. *Et iam magnificentia crescente notatum est ludis circensibus P. Corneli Scipionis Nasicae et P. Lentuli aedilium curulium sexaginta tres Africanas et quadraginta ursos et elephantos lusisse.*

66 See, for example, J. A. Crook, *Law and Life of Rome* (Ithaca, NY, 1967) 273–4, who says that the earliest certain evidence for casting to beasts is in the time of Augustus and cites Strabo 6.2.6 (passage about Selourus, the "Son of Aetna," quoted earlier in n. 54) as evidence; F. Millar, in "Condemnation to

Hard Labour in the Roman Empire from the Julio-Claudians to Constantine" *PBSR* 52 (1984) 134, alleges that the earliest example is in 65 BC during Caesar's aedilician games, as described by Pliny *HN* 33.53.

67 Val. Max. 2.7.14. *et L. Paullus, Perse rege superato, eiusdem generis et culpae homines elephantis proterendos substravit ... Aspero enim et absciso castigationis genere militaris disciplina indiget ...* Cf. Livy *Per.* 51.

68 Val. Max. 2.7.13. *Exterarum gentium transfugasque in edendis populo spectaculis feris bestiis obiecit.*

69 Livy *Per.* 51. *Scipio exemplo patris sui Aemilii Pauli, qui Macedoniam vicerat, ludos fecit transfugasque ac fugitivos bestiis obiecit.*

70 Diod. Sic. 36.10.2–3. "... when later, after an exchange of envoys, they surrendered, [Aquillius] released them from immediate punishment and took them to Rome to do combat with wild beasts. There, as some report, they brought their lives to a most glorious end; for they avoided combat with the beasts and cut one another down at the public altars, Satyrus himself slaying the last man. Then he, as the final survivor, died heroically by his own hand." (μετὰ δὲ ταῦτα διαπρεσβευόντων καὶ παραδόντων ἑαυτοὺς τῆς μὲν παραυτίκα τιμωρίας ἀπέλυσεν, ἀπαγαγὼν δὲ εἰς τὴν Ῥώμην θηριομάχας αὐτοὺς ἐποίησε. Τοὺς δὲ φασί τινες ἐπιφανεστάτην ποιήσασθαι τοῦ βίου καταστροφήν· τῆς μὲν γὰρ πρὸς τὰ θηρία μάχης ἀποστῆναι, ἀλλήλους δὲ ἐπὶ τῶν δημοσίων βωμῶν κατασφάξαι, καὶ τὸν τελευταῖον αὐτὸν τὸν Σάτυρον ἀνελόντα· τοῦτον δὴ ἐπὶ πᾶσιν αὐτοχειρίᾳ ἡρωικῶς καταστρέψαι.) See K. R. Bradley, *Slavery and Rebellion in the Roman World, 140 B.C.–70 B.C.* (Bloomington, IN & London, 1989) 66–82, esp. 81.

71 On *naumachiae*, see K. M. Coleman, "Launching into History: Aquatic Displays in the early Empire" *JRS* 83 (1993) 48–74. The best known *naumachia* is that of Claudius on the Fucine Lake: Tac. *Ann.* 12.56; Suet. *Claud.* 21.6.

72 Suet. *Iul.* 39.4.

73 Dio Cass. 48.19.1.

74 Livy 29.22.1–2: "While they were on their way to Syracuse Scipio prepared tangible evidence, not words, in his defense. He ordered the entire army to convene there, and the fleet to be cleared for action, as if on that day he must fight on land and sea with the Carthaginians. On the day of the arrival [of the praetor and his staff from Rome] they were hospitably entertained, and the next day he showed them his land and naval forces, not merely drawn up in line, but the soldiers in maneuvers and the fleet likewise maneuvering in mimicry of a naval battle in the harbor." (*Venientibus iis Syracusas Scipio res, non verba ad purgandum sese paravit. Exercitum omnem eo convenire, classem expediri iussit ... Quo die venerunt hospitio comiter acceptis, postero die terrestrem navalemque exercitum, non instructos modo, sed hos decurrentes, classem in portu simulacrum et ipsam edentem navalis pugnae ostendit ...*). See the discussion in K. Welch, "Roman amphitheatres revived" *JRA* 4 (1991) 277–9.

75 *CIL* IV 9983a. *Cumis gl(adiatorum) p(aria) XX / [et eorum] suppos[ticii] pu]gn(abunt) k(alendis) Oct(obribus), III, pr(idie) n[on(as) oct(obres)]: / cruciani (pro cruciarii) ven(atio) et vel(a) er(unt).*

76 Livy 22.33.2. See H. Parker, "Crucially Funny or Tranio on the Couch: The *servus callidus* and Jokes about Torture" *TAPA* 119 (1989) 233–46.

77 Val. Max. 2.7.12. "The elder Africanus was the mildest of men. Yet for the confirmation of military discipline he thought it proper to borrow some harshness

from a cruelty quite alien to himself. When he had conquered Carthage and brought into his power all those who had deserted from our armies to the Carthaginians, he punished the Roman deserters more severely than the Latins, crucifying the former as runaways from their country and beheading the latter as faithless allies. " (*Nihil mitius Superiore Africano. Is tamen ad firmandam disciplinam militarem aliquid ab alienissima sibi crudelitate amaritudinis mutuandum existimavit: si quidem devicta Carthagine, cum omnes qui ex nostris exercitibus ad Poenos transierant, in suam potestatem redegisset, gravius in Romanos quam in Latinos transfugas animadvertit: hos enim tamquam patriae fugitivos crucibus adfixit, illos tamquam perfidos socios securi percussit.*)

78 Plut. *Vit. Crass.* 12ff.; App. *BCiv.* 1.120. On crucifixion, see generally, E. Cantarella, *I supplizi capitali in Grecia e a Roma* (Milan, 2nd ed., 1991) 186–9; R. A. Baumann, *Crime and Punishment in Ancient Rome* (London, 1996) 151–2.

79 Euseb. *Hist. eccl.* 4.15.15–48; see K. E. Welch, "Greek stadia and Roman spectacles: Asia, Athens, and the tomb of Herodes Atticus" *JRA* 11 (1998a) 117–45, esp. 129–30; also Cantarella (supra n. 78) 223ff.; Baumann (supra n. 78) 18, 67–8, 141–52.

80 Cic. *Fam.* 10.32.3.

81 Hopkins 1983, 29, writes that the popularity of gladiatorial games was "a by-product of war." He discusses discipline and decimation on pp. 1–2. See also Wiedemann 1992, 45ff., and Kyle supra n. 1, 47ff.

82 On military amphitheatres, see Golvin 1988, 154–6. Gladiatorial oath – Sen., *Ep.* 37. "The words of this most noble oath are the same as those of that most dishonorable one: 'to be burnt (i.e., branded), to be chained up, and to be killed by an iron weapon.' A binding condition is imposed on those who hire their hands out to the arena and consume food and drink which they are to pay back in blood, that they should suffer such things even if they do not wish to." (*eadem honestissimi huius et illius turpissimi auctoramenti verba sunt: uri, vinciri ferroque necari. Ab illis qui manus harenae locant et edunt ac bibunt quae per sanguinem reddant cavetur ut ista vel inviti patiantur.*) The army recruit had to take an oath to follow his general wherever he might go and not to either desert or disobey on pain of death: see G. R. Watson, *The Roman Soldier* (Ithaca, NY, 1969) 44; 49–50; J. Harmand, *L'Armée et le soldat à Rome de 107 à 50 avant notre ère* (Paris, 1967) 299–302.

83 See, for example, Polyb. 10.20; Livy 26.51.3–7.

84 Polyb. 6.38; Tac. *Ann.* 14.44.

85 Appian *Hisp.* 7.36 ... προσέταξε τοῖς ὑπηρέταις διαστῆσαι τὸ πλῆθος. οἱ μὲν δὴ διίστανον, οἱ δὲ βουλευταὶ τοὺς αἰτίους παρῆγον ἐς τὸ μέσον. Ἀναβοησάντων δὲ αὐτῶν, καὶ τοὺς συστρατιώτας βοηθῆσαι σφίσι παρακαλούντων, τοὺς ἐπιφθεγγομένους εὐθὺς ἔκτεινον οἱ χιλίαρχοι. καὶ τὸ μὲν πλῆθος ἐπειδὴ τὴν ἐκκλησίαν φρουρουμένην εἶδεν, ἐφ' ἡσυχίας ἦν σκυθρωποῦ· ὁ δὲ Σκιπίων τοὺς ἐς τὸ μέσον παραχθέντας αἰκισάμενος, καὶ μᾶλλον αὐτῶν τοὺς ἐκβοήσαντας, ἐκέλευσε τοὺς αὐχένας ἁπάντων ἐς τοὔδαφος παττάλοις προσδεθέντας ἀποτμηθῆναι, καὶ τοῖς ἄλλοις ἀμνηστίαν ἐκήρυξε διδόναι. Ὧδε μὲν τὸ στρατόπεδον καθίστατο τῷ Σκιπίωνι.

86 Tac. *Ann.* 1.44.

87 Tac. *Ann.* 1.44: *et gaudebat caedibus miles, tamquam semet absolveret.*

88 *ILS* 5134 (a graffito, which is the only evidence for such acclamations; it is not known if they were regularly used).

89 Tac. *Hist.* 3.83. *aderat pugnantibus spectator populus, utque in ludicro certamine, hos, rursus illos clamore et plausu fovebat.*

Two. Origins of Amphitheatre Architecture

1 Livy *Per.* 16.

2 Val. Max. 2.4.7; Ausonius, *Griphus* 36–7. It has been suggested that this was an appropriate place to hold a gladiatorial contest because of its proximity to the numerous shrines of Hercules around the northwest sector of the *Circus Maximus*: N. K. Rauh 1992, 293–333, esp. 324 with n. 125.

3 The Tomba delle Bighe at Tarquinia shows spectators seated on what appear to be wooden stands; they are watching a boxing match above a podium (Figure 6). But little can be said about the shape of this space, since the seating is shown two dimensionally in the painting.

4 A. Piganiol, *Recherches sur les jeux romains. Notes d'archéologie et d'histoire religieuse* (Paris, 1923) 20ff.

5 Tert. *De spect.* 12. *Nam olim, quoniam animas defunctorum humano sanguine propitiari creditum erat, captivos vel mali status servos mercati in exequiis immolabant. . . . Itaque quos paraverant, armis quibus tunc et qualiter poterant eruditos, tantum ut occidi discerent, mox edicto die inferiarum apud tumulos erogabant.*

6 Servius, *ad Aen.* 10.519. *sane mos erat in sepulchris virorum fortium captivos necari: quod postquam crudele visum est, placuit gladiatores ante sepulchra dimicare.*

7 Livy 23.30.15 (see Chapter One).

8 Suet. *Tib.* 7.1. At the same time Tiberius also put on a gladiatorial show in honor of his grandfather in the newly constructed Amphitheatre of Statilius Taurus of 30 BC (see Chapter Four).

9 Dio Cass. (55.8.5) records that Agrippa's funeral games of 7 BC had to be held in the *Saepta* (the voting enclosure in the *Campus Martius*), because the Forum had been severely damaged by fire. See Coarelli 1985, 225ff.

10 Prop. 4.8.75–6. *tu neque Pompeia spatiabere cultus in umbra, / nec cum lascivum sternet harena Forum.* Cf. Ov. *Ars. Am.* 1.165–70.

11 Vitruvius 5.1.1–2. *Graeci in quadrato amplissimis et duplicibus porticibus fora constituunt . . . Italiae vero urbibus non eadem est ratione faciendum, ideo quod a maioribus consuetudo tradita est gladiatoria munera in foro dari. Igitur circum spectacula spatiosiora intercolumnia distribuantur circaque in porticibus argentariae tabernae maenianaque superioribus coaxationibus conlocentur; quae et ad usum et ad vectigalia publica recta erunt disposita. Magnitudines autem ad copiam hominum oportet fieri, ne parvum spatium sit ad usum aut ne propter inopiam populi vastum forum videatur. Latitudo autem ita finiatur uti, longitudo in tres partes cum divisa fuerit, ex his duae partes ei dentur; ita enim erit oblonga eius formatio et ad spectaculorum rationem utilis dispositio.* Cf. Vitruvius 10, *praef.* 3. See P. Gros, ed., *Vitruvio, De Architectura* Vol. I (Turin, 1997) 529ff., 602–14; *Vitruvius. Ten Books on Architecture* with trans. and commentary by I. Rowland and T. N. Howe (Cambridge, and New York, 1999) 239, fig. 77.

12 The dimensions of the *fora* of Rome's colonies do not conform exactly to Vitruvius' specifications, but they often come close. For example, the *fora* of Cosa and Paestum (both Latin colonies of 273 BC) are rectangles of 140 × 60 m (Cosa) and 150 × 57 m (Paestum) making the proportions roughly 2.3 : 1 and 2.5 : 1, respectively. See A. Futrell 1997, 36 and J. Russell, "The Origin and Development of Republican Forums" *Phoenix* 22 (1968) 304–36.

13 The latter comment is presumably a reference to the money that could be charged to the spectators who watched the games from these balconies. Access to space from which to view the gladiatorial games in the *Forum Romanum* was not free (see following).

14 For example Suet. *Calig.* 18.3 and *CIL* VI 2059, line 29.

15 *MRR* I 374–5.

16 Pseudo-Asconius *Ad Cic., div. in Caecil.* 16.50. *Maenius . . . unius columnae superquam tectum proiecerit ex provolantibus tabulatis unde ipse et posteri eius spectare munus gladiatorium possent.*

17 Porphyrius *ad Hor., Serm.* 1.3.21. *Hic fertur domo sua, quam ad forum spectantem habuerat, divendita unam columnam inde sibi excepisse, unde gladiatores spectaret, quae ex eo Maeni columna nominabatur.*

18 See Pliny, *HN* 34.20–21; *RE* 14 Maenius 9: cols. 249–51; *MRR* I 138, 155. See Coarelli 1985, 39–53, esp. 44; M. Torelli, "Columna maenia" *LTUR* I, 301–2; T. Hölscher, "Die Anfänge römischer Repräsentationskunst" *MDAI(R)* 85 (1978) 315–57, esp. 318ff.

19 Festus, *Breviarum rerum gestarum populi Romani* 22. *Maeniana appellata sunt a Maenio censore qui primus in foro ultra columnas tigna proiecit quo ampliarentur superiora spectacula.*

20 Isid. *Etym.* 15.3.11. *Maenius collega Crassi in foro proiecit materias, ut essent loca in quibus spectantes insisterent, quae ex nomine eius maeniana appellata sunt. MRR* I 155.

21 Nonius *De compendiosa doctrina,* p. 91: *L. Maeniana ab inventore eorum Maenio dicta sunt; unde et columna Maenia.*

22 *RE* 14 Maenius 4: col. 248. The arguments are summarized by Coarelli 1985, 42–53.

23 Ch. Hülsen, "Das Comitium und seine Denkmäler in der republikanischen Zeit" *MDAI(R)* 8 (1893) 79–94, esp. 84–5, followed by Coarelli 1985. K. Lehmann-Hartleben, "Maenianum and Basilica" *AJPhil.* 59 (1938) 280–96, is alone in arguing that a Maenian column erected by C. Maenius, cos. 338 BC, never existed, and that the *Columna Maenia* mentioned in so many ancient sources was merely one of the columns of the *Basilica Porcia.*

24 A. Boëthius, "*Maeniana.* A study of the *Forum Romanum* of the fourth century B.C." *Eranos* 43 (1945) 89–110; followed by E. Welin, *Studien zur Topographie des Forum Romanum (Acta Instituti Romani Regni Sueciae* ser. 8, Vol. 6, Lund, 1953) 142.

25 Pliny, *HN* 35.113. "'A picture by Serapio [a scene painter],' says Varro, covered the whole of the *maeniana* at the place beneath the Old Shops'" (*Maeniana, inquit Varro, omnia operiebat Serapionis tabula sub Veteribus.*). For *maeniana* in the *Tabernae Novae,* see Cic., *Ac.* 2. 70, and further, Coarelli 1985, 202ff. On the basilicas, see E. M. Steinby, "Basilica Porcia" *LTUR* I 187; H. Bauer, "Basilica Fulvia" *LTUR* I 173–5; I. Iacopi, "Basilica Sempronia" *LTUR* I 187–8.

26 F. E. Brown, E. Richardson, L. Richardson jr., *Cosa* III. *The Buildings of the Forum (MAAR* 37, University Park, PA, 1993) 121ff., 207ff.

27 *ILLRP* 599. That this practice continued into the imperial period is also indicated by another inscription from Aeclanum in Italy, of early imperial date, which records: *[Fla]ccus, C. Arrius N. f. Kan [ma]eniana circ(a) forum d(e) s(ua) p(ecunia) f(ecit)* "constructed *maeniana* around the forum at his own

expense" (*CIL* IX 1148 = *ILS* 5360). We also hear of a man who, during the reign of Antoninus Pius, left the city of Salutium money for a "gladiatorial show and a wooden enclosure" (*munus gladiatorium et saepta lignea*: *ILS* 5065), and in the city of Atina there is the record of an aedile who apparently gave a "*venatio in saepto foro*" (*AE* 1981.219).

28 Livy 23.30.15.

29 As late as 210 BC, when a major fire swept the *Forum Romanum*, there were private houses lining the north side of the Forum square (Livy 26.27.3). For what these may have looked like, see K. E. Welch, "A new view of the origins of the Roman basilica: the *Atrium Regium*, the *Graecostasis*, and Roman diplomacy" *JRA* 17 (2003) 5–34, Fig. 11. A little later when Ti. Sempronius Gracchus built the *Basilica Sempronia* in 170 BC, this involved the purchase and demolition of the house of Scipio Africanus, one of several private houses lining the south side of the Forum (Livy 44.16.10). See A. Carandini, "Domus aristocratiche sopra le mura e il pomerio del Palatino" in M. Cristofani, ed., *La grande Roma dei Tarquini* (Rome, 1990) 97–9 with figs.; A. Wallace-Hadrill, "Elites and trade in the Roman town" in J. Rich and A. Wallace-Hadrill, eds., *City and Country in the Ancient World* (New York & London, 1991) 241–72, esp. 262–4. Also F. E. Brown et al. (supra n. 26) 57ff., fig. 19.

30 The *tabernae* of houses from the Osco-Samnite period at Pompeii sometimes have in the upper part of their façades wooden galleries "*pergulae*" opening toward the street, which could be a reflection of the *maeniana* associated with elite houses in Rome: see A. Mau, "Sul significato della parola *pergula* nell' architettura antica" *MDAI (R)* 2 (1887) 214–20; Platner-Ashby 505; Lehmann-Hartleben (supra n. 23) 295; and cf. Suet. *Aug.* 45.1 (Augustus' watching circus games from a freedman's house that overlooked the *Circus Maximus*). While the houses around the Forum were private (Livy 26.27.1–4), the *tabernae* themselves came to be publicly owned. For discussion and bibliography on the *tabernae* and basilicas around the Forum, see Welch, "New View," 5–34 passim and especially 12, n. 2; 18, n. 52–4.

31 Coarelli 1985, 126–31; L. Du Jardin, "I pozzi della valle del Foro Romano" *Rend. Pont.* 7 (1930) 129–91; G. Lugli, *Roma antica, centro monumentale* (Rome, 1946) 81–2; E. B. Van Deman, "The Sullan Forum" *JRS* 12 (1922) 1–31, esp. 23ff. No plan of the pozzetti in the *Forum Romanum* has been published to my knowledge.

32 On the republican structure under the Temple of Divus Iulius, see Coarelli 1985, 190–9; E. M. Steinby, "Il lato orientale del Foro Romano" *Arctos* 21 (1987) 139–84; E. Tortorici, *Argiletum: commercio speculazione edilizia e lotta politica dall'analisi topografica di un quartiere di Roma di età repubblicana* (Rome, 1991) 64–6.

33 Coarelli 1985, 125–31, 157–8.

34 Cic. *Iam.* 96; Varro *Rust.* 1.2.9.

35 Plut. *Vit. C. Gracch.* 5.3.

36 Varro *Rust.* 1.2.9; Coarelli 1985, 131 (reading *septem* as *saepta*). See the useful summary of the discussion, upon which I have relied, in J. R. Patterson, "The City of Rome: from Republic to Empire" *JRS* 82 (1992) 186–215, esp. 191–2; also N. Purcell, "Forum Romanum (the Republican period)" *LTUR* II 325–36, esp. 326–8.

37 See F. E. Brown et al. (supra n. 26) 58, fig. 19; F. E. Brown, *Cosa: The Making of a Roman Town* (Ann Arbor, 1980) 24, 27, 31ff., fig. 36.

38 See generally F. Millar, *The Crowd in Rome in the Late Republic* (Ann Arbor, 1998), esp. 147ff.; and Purcell (supra n. 36). But see H. Mouritsen, *Plebs and Politics in the Late Roman Republic* (Cambridge and New York, 2001) 43ff., arguing that in its capacity as the setting for *contiones*, the Forum was always in the republican period primarily the preserve of the Roman elite.

39 Cic. *Sest.* 124–6. *Id autem spectaculi genus erat, quod omni frequentia atque omni genere hominum celebratur, quo multitudo maxime delectatur. In hunc consessum P. Sestius tribunus pl., cum ageret nihil aliud in eo magistratu nisi meam causam, venit et se populo dedit . . . Venit, ut scitis, a columna Maenia. Tantus est ex omnibus spectaculis usque a Capitolio, tantus ex fori cancellis plausus excitatus, ut numquam maior consensio aut apertior populi Romani universi fuisse ulla in causa diceretur . . . At vero ille praetor . . . is cum cotidie gladiatores spectaret, numquam est conspectus, cum veniret. Emergebat subito, cum sub tabulas subrepserat . . . Itaque illa via latebrosior, qua spectatum ille veniebat, Appia iam vocabatur.*

 The path that Appius Claudius took was not the regular and approved means for a prominent politician to reach his seat. Members of the political elite were expected to enter the seating openly and receive the acclaim of the crowd, as did P. Sestius. We may surmise that Appius was afraid of being hissed at by the public and so passed to his seat via one of the passages in the substructures under the seating, normally designated for Romans of lesser status.

40 G. Carettoni, "Le gallerie ipogee del Foro Romano e i ludi gladiatori forensi" *Bull. Com. Arch.* 76 (1956–8) 23–44. See also Coarelli 1985, 222ff.

41 Coarelli 1985, 222ff.; C. F. Giuliani and P. Verduchi, *L'area centrale del Foro Romano* (Florence, 1987) 53–66.

42 See Golvin 1988, 77, 319–20, 323–30.

43 Suet. *Iul.* 37. Ville 1981, 70; and Golvin 1988, 48–9, both believe that the cynegetic theatre was built in the Forum, whereas Coarelli suggests the *Campus Martius*: F. Coarelli, "Gli anfiteatri a Roma prima del Colosseo" in A. La Regina ed., *Sangue e arena*, (Milan, 2001) 43–8, esp. 43. See also A. Gabucci, ed., 1999, 23–5. Dio Cass. (43.19–24) gives a lengthy account of the triumph of 46 BC. Coarelli 1985, 222–5, points out that the orientation of the central gallery of the *hypogea* aligns with the main axis of the *Basilica Julia*, which was dedicated in 46 BC, providing some corroboration for the dating of the *hypogea* to the same year. C. F. Giuliani and P. Verduchi (supra n. 41) argue – unconvincingly – that the *hypogea* date to the time of Sulla, and this idea has met with some acceptance: for example, N. Purcell (supra n. 36) 325–36, esp. 331). T. P. Wiseman ("The central area of the Roman Forum" *JRA* 3 [1990] 245–7) writes that the mention, in Cicero, *Sest.* 126 (57 BC; passage quoted in n. 39), of Ap. Claudius attending a gladiatorial game in the *Forum Romanum* and reaching his seat via a "hidden way" and of his appearing suddenly "from under the floorboards" refers to the underground (basement) galleries (*hypogea*), which, therefore, had to have been in existence before Caesar's games in the Forum of 46 BC. But on analogy with amphitheatres of the imperial period, it is probable that these *hypogea* were basement structures reserved only for the likes of arena personnel, and not used by spectators at all (let alone Roman noblemen). Moreover, the *hypogea* presumably did not actually lead to the seating; they led to the arena (performance) floor, which was separated from the seating by a high podium. *Contra* Wiseman, I think that the "hidden way" mentioned by Cicero more likely refers to a passage above ground level in the wooden substructures of the seating in the *Forum Romanum*.

44 Dio Cass. 43.22–3. θέατρόν τι κυνηγετικὸν ἰκριώσας, ὃ καὶ ἀμφιθέατρον, ἐκ τοὑπέριξ πανταχόθεν ἕδρας ἄνευ σκηνῆς ἔχειν προσερρήθη. καὶ ἐπὶ τούτῳ καὶ ἐπὶ τῇθυγατρὶ καὶ θηρίων σφαγὰς καὶ ἀνδρῶν ὁπλομαχίας ἐποίησεν... τοὺς δ᾽ ἄνδρας συνέβαλλε μὲν καὶ ἕνα ἑνὶ ἐν τῇ ἀδορᾷ, ὥσπερ εἴθιστο, συνέβαλλε δὲ καὶ ἐν τῷ ἱπποδρόμῳ πλείους, καὶ ἱππέας ἱππεῦσι καὶ πεζοὺς πεζοῖς, ἄλλους τε ἀναμὶξ ἀλλήλοις ἴσους. Also during Caesar's great triumph of 46 BC: *Athletae stadio ad tempus exstructo regione Marti campi certaverunt per triduum*, "Athletes competed for three days in a temporary stadium built for the purpose in the region of the *Campus Martius*" (Suet. *Iul.* 39.3; cf. *Aug.* 43.1).

45 Pliny *HN* 19.23; cf. Dio Cass. 43.24.2. Q. Catulus (cos. 78 BC) had done this earlier (Val. Max. 2.4.6): "As wealth increased, elegance followed religion in the games. At its prompting Q. Catulus was the first to cover the sitting spectators with a shady awning in emulation of Campanian luxury" (*Religionem ludorum crescentibus opibus secuta lautitia est. Eius instinctu Q. Catulus Campanam imitatus luxuriam primus spectantium consessum velorum umbraculis texit*). This remark presumably refers to Campanian theatres in stone of the second century BC, such as the second-century BC ones at Pompeii, Cales, Teanum, and Capua (which at *summa cavea* level had sockets that carried masts for *vela*). See W. Johannowsky "La situazione in Campania" in P. Zanker, ed., *Hellenismus in Mittelitalien. Kolloquium in Göttingen vom 5. bis 9. Juni 1974* (Göttingen, 1976) 271–2); and P. Gros, *Architecture et société à Rome et en Italie centro-mériodionale aux deux derniers siècles de la République*, Collection Latomus, vol. 156 (Brussels, 1978) 43. The theater at Capua is known only from an inscription of 108 BC that records its construction and refers to it as a *theatrum terra exaggerandum* (*ILLRP* 708), suggesting that it was terraced and could have been vaulted at *summa cavea* level with an earthen embankment as support. See G. A. Mansuelli, *Roma e il mondo romano dalla media repubblica al primo impero (II sec. a.C.–I sec. d. C.)* (Turin, 1981) 33ff.

46 *Contra* F. Millar 1998, who states (p. 147): "To convert the Forum for a gladiatorial *munus*, all that was needed was to line it with barriers, *cancelli* (for theatrical *ludi*, in contrast, an actual temporary wooden theatre might be constructed)."

47 Golvin 1988, 18–21; Golvin and Landes 1990, 40–54, 58ff.; K. Welch, "The Roman arena in late-republican Italy: A new interpretation" *JRA* 7 (1994) 59–80.

48 Golvin 1988, 300, 304.

49 J. H. Humphrey, *Roman Circuses: Arenas for Chariot Racing* (London 1986) 71; and Ville 1981, 51–6, 123–6. Key passages attesting to *venationes* in the *Circus Maximus*: Livy 41.27.6 (174 BC); Suet. *Claud.* 21.3; cf. Pliny *HN* 8.21, which mentions a water channel that functioned as a barrier that ran around the *Circus Maximus*; it was eventually filled in by Nero.

50 Strabo 6.2.6 (quoted in Chapter One, n. 54); see N. Biffi, *L'Italia di Strabone. Testo, traduzione e commentario dei libri V e VI della Geografia* (Rome, 1988) 184–5.

51 Augustus, *RG* 22.

52 See T. Wiedemann, *Emperors and Gladiators* (London and New York, 1992) 119–20.

53 Dio Cass. 43.23.3 (quoted in n. 44). Cf. Dio Cass. 55.8.5, where funeral games in honor of Agrippa in the *Saepta* featured both one-to-one gladiatorial combat as well as group engagements. The combats were held here because the *Forum Romanum* had burned in 14 BC and was under reconstruction; also probably

because of the popular connotations of the *Saepta*, which Agrippa himself had rebuilt [Dio Cass. 53.23.1–4]; and because of its proximity to Agrippa's bath complex.

54 See *Pompei. Pitture e Mosaici* I (Rome, 1990) 80–1. The riot was disruptive enough to have been mentioned by Tacitus (*Ann.* 14.17) and to have resulted in an imperial ban on gladiatorial shows at Pompeii for ten years.

55 Golvin 1988, 112–14; also P. Leveau, "Le problème de la date de l'amphithéâtre de Caesarea de Mauretanie: sa construction et son agrandissement," in C. Domergue, C. Landes, & J.-M. Pailler, eds., *Spectacula I: gladiateurs et amphithéâtres* (Paris & Lattes, 1990) 47–54, with good illustrations.

56 There are two other amphitheatres with straight sides and two curved ends (both, however, have arenas about half the length of Cherchel's): the early imperial amphitheatre at Luceria (Golvin 1988, 76–7) and the one at Bet She'an in Israel (as yet unpublished, to my knowledge).

57 Juba II had grown up in Italy, had become a Roman citizen, had fought with Octavian on campaign, and as a young man was given the kingdom of Mauretania by Augustus: *RE* 9 Juba II, cols. 2384–95. On the association of the amphitheatre building and Rome, see Chapter Three.

58 *RE* I Aemilius 81 (cols. 564–5). See Coarelli 1985, 233–57; also N. Purcell, "Forum Romanum (the Imperial period)" *LTUR* II 336–42; H. Bauer, "Basilica Paul(l)i" *LTUR* I 183–7; C. F. Giuliani & P. Verduchi, "Basilica Iulia" *LTUR* I 177–9; T. P. Wiseman 1992, 181–92.

59 On these edifices, see Coarelli 1985, 135–40.

60 From 194 BC on, senators were legally guaranteed the right to front row seats (Livy 34.54.5). The so-called *lex Roscia Theatralis* (67 BC) reserved the first fourteen rows for equestrians (Plut., *Cic.* 13). On the hierarchical nature of Roman seating arrangements, see J. Kolendo, "La répartition des places aux spectacles et la stratification sociale dans l'empire romain: à propos des inscriptions sur les gradins des amphithéâtres et théâtres" *Ktema* 6 (1981) 301–15.

61 See Coarelli 1985, 11–27; *Il foro romano: periodo archaico* (Rome, 1983) 119–226; "Comitium" *LTUR* I 309–14; also L. Richardson, jr., "Cosa and Rome, Comitium and Curia" *Archaeology* 10 (1957) 49–55.

62 As mentioned by M. Wilson Jones, "Designing amphitheatres" *MDAI(R)* 100 (1993) 392.

63 Of the nine republican amphitheatres where we can gauge the size of the oval arena, five are quite close in size to the one at Pompeii: Puteoli, Telesia, Cales, Nola and probably Cumae. See Appendix.

64 Plut. *Vit. C. Gracch.* 12.3. τῶν ἀρχόντων οἱ πλεῖστοι θεωρητήρια κύκλῳ κατασκευάσαντες ἐξεμίσθουν.

65 Plutarch had access to good Republican sources for his lives of the Gracchi: a major source was C. Fannius (mentioned in *Vit. T. Gracch.* 4.5), a contemporary of T. Gracchus, who had served with him in the Third Punic War. Another possible source is L. Calpurnius Piso Frugi, cos. 133 BC and censor 120 BC, who wrote *Annales* from the origin of Rome down to his own time (see H. Peter, *Historicorum Romanorum Reliquiae* I [Leipzig, 1883] cxcvii).

66 Dio Cass. *Epit.* 73.19.1.

67 Vitruvius 5.1.1–2 (quoted Chapter Two, fn. 11).

68 On the *Ludus Magnus*, see A. M. Colini & L. Cozza, *Ludus Magnus* (Rome, 1962); C. Pavolini, "Ludus Magnus" *LTUR* III, 196–7. Another analogy is the early imperial amphitheatre at Carsulae in Umbria, which is an oval

structure set into a rectangular enclosure. (The latter is actually the *porticus post scaenam* [porticus behind the stage building] of the neighboring theatre.) See P. Bruschetti, *Carsulae* (Rome, 1995) 46f, figs. 7, 21; Golvin 1988, 112, pl. XXVI, 2.

69 See C. F. Giuliani, "Lacus Curtius" *LTUR* III 166–7, figs. 112–15.

70 See F. Coarelli, *Il foro romano: periodo archaico* (Rome, 1983) 157–60; and C. F. Giuliani and P. Verduchi (supra n. 41) 60. Caesar also removed an altar in the Forum because of his plans to hold a gladiatorial game there (Pliny *HN* 15.78), perhaps in the context of the great games associated with his triumph of 46 BC (see earlier).

71 Other such examples of the covering over of sacred space in Roman times include the *Curia* of Pompey, which had been a *templum* but – after Caesar's murder there – was closed and eventually became a latrine: F. Coarelli, "Curia Pompei, Pompeiana (Suet.)" *LTUR* I 334–5. A striking case of a temple that was covered is the Julio-Claudian *Augusteum* that was discovered under the Arch of Constantine: see C. Panella, *Meta Sudans* I (Rome, 1996) 27–93. Finally, the construction of the Theatre of Marcellus involved the displacement of two temples (that of Pietas and of Diana): F. Coarelli, *Il Campo Marzio: dalle origini alla fine della repubblica* (Rome, 1997) 375–6, 448, 485. For an earlier period see also I. E. M. Edlund-Berry, "Ritual destruction of cities and sanctuaries: The 'Un-founding' of the Archaic Monumental Building at Poggio Civitate (Murlo)" in R. D. De Puma & J. Penny Small, eds., *Murlo and the Etruscans: Art and Society in Ancient Etruria* (Madison, WI, 1994), 16–28.

72 Cic. *Tusc.* 2.41.

73 A passage from Cicero's *Philippicae* (9.7.16) relates that in 43 BC the Senate awarded a bronze (standing) statue to Servius Sulpicius and decreed that it should be placed on the *Rostra*, and that around the statue there be reserved a space of five feet on all sides for his children and descendants to view gladiatorial shows. The *Rostra* to which Cicero refers was probably the *Rostra Caesaris* whose concrete core (which is 3.5 m high as preserved) was incorporated into the later *Rostra Augusti* at the western end of the *Forum Romanum*: see Coarelli 1985, 237–57. This passage raises the question of how high the wooden seating in the Forum could have been. In my reconstructions the *cavea* is 10 m high and stops short of the eastern edge (front) of the *Rostra*. The height of the *cavea* in my reconstruction is difficult to reconcile with this passage in Cicero (since the descendents of Maenius were supposed to have a view of the spectacles from the *Rostra*). In this case, the seating may have been built around the *Rostra*, so that the new Rostra, which had just been built in 44 BC, and the statue of Sulpicius could be admired by everyone seated in the Forum. On certain grand occasions such as this, the seating around the oval arena could have spread even up the slopes of the Capitol, as Pliny (*HN* 19.23) said it did during Caesar's triumphal games in 46 BC. Such a seating arrangement would have put the seats of the Sulpicii fairly close to the bottom of the *cavea* and thereby in a choice viewing area. Another possibility is that in this instance the *cavea* was high along the long sides of the Forum (reaching the second stories of the basilicas) but lower at the short sides (in the area of the *Rostra*). It should be stressed that it is the arena dimension that is important to my argument, not the proportions of the seating around it. As I imagine it, the arena remained consistently oval from year to year, whereas different versions of the wooden *cavea* were constructed

more or less elaborately, depending upon the wishes and means of the different magistrates who sponsored gladiatorial shows there.

74 Rome's population is estimated to have been 200,000 at the beginning of the second century BC; 500,000 in 130 BC; and close to 1 million by the time of Augustus; see N. Morley, *Metropolis and Hinterland: the City of Rome and the Italian Economy, 200 BC - AD 200* (Cambridge, 1996) 33–9. It should be noted that all such figures are notoriously inexact; hence, they cannot always be relied upon with confidence; see E. Lo Cascio, "The Size of the Roman Population: Beloch and the Meaning of the Augustan Census Figures" *JRS* 84 (1994) 23–40.

75 Cic. *Mur.* 72-73; *Att.* 2.1.5. See the useful discussion of these texts in A. Futrell 1997, 162ff.; and also H. Mouritsen, *Plebs and Politics in the Late Roman Republic* (Cambridge and New York, 2001) 111, n. 62.

76 This is indicated by the aforementioned passage in Plutarch (*Vit. C. Gracch.* 12.3) in which Gracchus arranged to pull down the banks of seats around the Forum, which the magistrates of 123 BC were offering for hire, so that the plebs could see the show without paying.

77 Isid. *Etym.* 15.3.11 (quoted Chapter Two, fn. 20) indicates that people stood on the *maeniana*. That positions on the *maeniana* were less expensive is suggested by later monumental amphitheatres such as the Colosseum, where the space at the very top of the *cavea* was occupied by poorer (or less important) spectators: Cal. Sic., *Ecl.* 7.26-7; *CIL* VI 2059.

78 Another reason, of course, was probably that the building of temporary *spectacula* in the Forum by different magistrates was connected with public aristocratic competition and self-display, which came to be discouraged under Augustus.

79 Val. Max. 2.4.2; Tac. *Ann.* 14.20; Vell. Pat. 1.15.3; App. *BCiv.*1.28. See, generally, E. Gruen, *Culture and National Identity in Republican Rome* (Ithaca, NY, 1992) 183–222, esp. 205–10.

80 See Purcell (supra n. 36). As mentioned previously, Tiberius gave a gladiatorial show in it in memory of his grandfather but chose the more prestigious Forum location for games in honor of his father (Suet. *Tib.* 7.1).

81 See, for example, Pliny *Pan.* 33.1

82 On the traditional morality of gladiatorial games versus the corrupting nature of Greek entertainment, see Tac. *Ann.* 14.20 (senatorial discussion).

83 Golvin's idea that the relatively modest scale and importance of the gladiatorial games during the republican period (compared to imperial times) explains the temporary character of the structure in the Forum would seem to be unsatisfactory (Golvin 1988, 20-1).

84 I thank Dr. Daniel Schodek, of the Graduate School of Design at Harvard University, and especially Philip Stinson for their help in trying to reconstruct this process. (The entire construction scenario discussed here is largely the work of Stinson.) See also J.-P. Adam, *La construction romaine, matériaux et techniques* (Paris, 1984) 91–109, fig. 231.1 (mortise and tenon joint), and 213–33. On the construction process with wood see further R. Taylor, *Roman Builders: A Study in Architectual Process* (Cambridge and New York, 2003), Ch. 5 and bibliography.

85 Compare the "circus" (actually an oval structure designed for horse and chariot races) designed by Andrea Palladio in 1576 in Vicenza: L. Puppi, *Andrea Palladio* II (Milan, 1973) 418, no. 128.

86 Hart V. and P. Hicks eds, *Sebastiano Serlio on Architecture* Vol. I, Books I–V of S. Serlio, "*Tutte l'opere d'archittura*," trans. from the Italian with an introduction and commentary by the editors. (New Haven and London, Yale University Press, 1996) 82; also B. Hewitt, ed., *The Renaissance Stage. Documents of Serlio, Sabbattini and Furttenbach* (Coral Gables, FL, 1958) 22–4.

87 See P. Chonéet et al., *Jacques Callot 1592-1635* (Paris, 1992) 189–91, nos. 82–7; A. R. Blumenthal, *Theater Art of the Medici* (Hanover, NH, 1980) 97-101; H. D. Russell et al., *Jacques Callot. Prints and Related Drawings* (Washington, DC, 1975) 84, pls. 49–51; A. M. Nagler, *Theatre Festivals of the Medici 1539-1637* (New Haven and London, 1964) 126–30.

88 See G. Lugli, "L'origine dei teatri stabili in Roma antica secondo i recenti studi" *Dioniso* 9 (1942) 55–64; E. Gruen (supra n. 79) 205–10; R. C. Beacham, *The Roman Theatre and its Audience* (Cambridge, MA, 1992) 56–85; K. E. Welch, "L'origine del teatro romano antico: l'adattamento della tipologia greca al contesto romano" *Annali di Architettura. Rivista del Centro Internazionale di Studi di Architettura Andrea Palladio* 9 (1997) 7–16; S. M. Goldberg, "Plautus on the Palatine" *JRS* 88 (1998) 1–20.

89 Vit. 5.5.7–8; cf. 1.1.9. The *scaenae frons* of the theater at Aphrodisias, which dates to the early Augustan period (before 27 BC) and was built on Roman models of the first century BC, has broken pediments and extensive statuary decoration; see N. de Chaisemartin and D. Theodorescu, "Recherches préliminaires sur la *frons scaenae* du théâtre" *Aphrodisias Papers* 2, R. R. R. Smith and K. T. Erim, eds. (Ann Arbor, 1991) 29–66, with foldout drawing of elevation. It gives a good sense of the architectural innovations that had occurred in theater architecture during the late republican period in Rome.

90 Livy 40.51.3. *theatrum et proscaenium ad Apollinis* [sic]. ("in the area of the Temple of Apollo").

91 Livy 41.27.6. *scaenam aedilibus praetoribusque praebendam.* *MRR* I 404. On the public *ludi* (which involved stage plays and chariot racing), see F. Bernstein, *Ludi publici. Untersuchungen zur Entstehung und Entwicklung der öffentlichen Spiele im republikanischen Rom* (Stuttgart, 1998); also T. P. Wiseman, *Remus* (Cambridge, 1995) 133–8. For an enormous stage, already in the mid-2nd c BC, see Polyb. 30.22.2.

92 Livy *Per.* 48; Val. Max. 2.4.1–2; Tac., *Ann.* 14.20; cf. App. *BCiv.* 1.28; Vell. Pat. 1.15.3; Oros. 4.21.4. See M. Sordi, "La decadenza della repubblica e il teatro del 154 a. C." *Invigliata Lucernis. Rivista dell' Istituto di Latino, Università di Bari*; 10 (1988) 327–41; Goldberg, 1998 (supra n.88); and K. Coleman, "Entertaining Rome," in J. Coulston & H. Dodge, eds., *Ancient Rome: The Archaeology of the Eternal City* (Oxford, 2000) 210-58, esp. 219-21.

93 Pliny *HN* 36.7–8. After the theater was dismantled, Crassus took six of its columns, of Hymettian marble, and set them up in his house on the Palatine, an action that aroused aristocratic suspicion and jealousy and also earned him the nickname "Palatine Venus."

94 Val. Max. 2.4.6. Pliny *HN* 35.23. *habuit et scaena ludis Claudii Pulchri magnam admirationem picturae, cum ad tegularum similtudinem corvi decepti imagine advolarent.* ("Also the stage erected for the shows given by Claudius Pulcher won great admiration for its painting, as crows were seen trying to alight on the roof tiles represented on the scenery, quite taken in by its realism.")

95 Val. Max. 2.4.6. *MRR* II.1; II. 151f; II.164, n. 1.

96 Pliny, *HN* 36.102–3.

97 P. Gros, "Theatrum Pompei" *LTUR* V, 35–8, with bibliography.

98 Tac., *Ann.* 14.21. *Sed et consultum parsimoniae, quod perpetua sedes theatro locata sit potius, quam immenso sumptu singulos per annos consurgeret ac destrueretur.*

99 Pliny *HN* 36.117: *theatra iuxta duo fecit amplissima ligno, cardinum singulorum versatili suspensa libramento, in quibus utrisque antemeridiano ludorum spectaculo edito inter sese aversis, ne invicem obstreperent scaenae, repente circumactis – ut constat, post primos dies etiam sedentibus aliquis – cornibus in se coeuntibus faciebat amphitheatrum gladiatorumque proelia edebat.* A casual reference in Cicero indicates that Curio's theater was still standing in 50 BC (Cic. *Fam.* 8.2.1). Golvin 1988, 30–2, pl. IV, provides a convincing reconstruction of this theater. See J.-C. Golvin and P. Leveau, "L'amphithéâtre e le théâtre – amphithéâtre de Cherchel. Monuments à spectacle e histoire urbaine à Caesarea de Maurétaine" *MEFRA* 91(1979) 817–843; also D. L. Bomgardner, *The Story of the Roman Amphitheatre* (London and New York, 2000) 36–7. Some have wanted to see in this virtuoso construction the origin of the term "amphitheatre" (since the word *amphitheatrum* is used by Pliny to describe it). *Amphitheatrum* (a Latin transcription of the Greek ἀμφιφέατρον) means "theater on both sides" or, more literally "a place for looking from both sides." See F. Coarelli, "Gli anfiteatri a Roma prima del Colosseo" in A. La Regina ed., *Sangue e Arena* (Milan, 2001), 43–8, esp. 43–4; A. Gabucci, ed., 2000, 27.

100 M. Aemilius Scaurus was curule aedile in 58 BC. He had conducted a military campaign in Nabataean Arabia in 62–60 BC: *MRR* II 195; *RE* 1 588–90, s.v. "Aemilius" 141 (Klebs). See N. Pollard, "Theatrum Scauri" *LTUR* V, 38–9. On his procurement of exotica from the East for display in Rome, see K. M. Coleman, "Ptolemy Philadelphus and the Roman Amphitheater" in W. J. Slater ed., *Roman Theater and Society: E. Togo Papers* I (Ann Arbor, 1996) 49–68, esp. 61–2. Pliny *HN* 36.114-15. *In aedilitate hic sua fecit opus maximum omnium quae umquam fuere humana manu facta, non temporaria mora, verum etiam aeternitatis destinatione. Theatrum hoc fuit; scaena ei triplex in altitudinem CCCLX columnarum in ea civitate quae sex Hymettias non tulerat sine probro civis amplissimi. Ima pars scaenae e marmore fuit, media e vitro, inaudito etiam postea genere luxuriae, summa e tabulis inauratis; columnae, ut diximus, imae duodequadragenum pedum. Signa aerea inter columnas, ut indicavimus, fuerunt \overline{III} numero; cavea ipsa cepit hominum \overline{LXXX} cum Pompeiani theatri totiens multiplicata urbe tantoque maiore populo sufficiat large \overline{XXXX} sedere. Relicus apparatus tantus Attalica veste, tabulis pictis, cetero choragio fuit ut, in Tusculanam villam reportatis quae superfluebant cotidiani usus deliciis, incensa villa ab iratis servis concremaretur HS |\overline{CCC}|.* See also Pliny *HN* 34.36; 36.5, 50, 189; and M. Medri, "Fonte letterarie e fonti archeolologiche: un confronto possible sul M. Emilio Scauro il Giovane, la sua 'domus magnifica' e il theatrum 'opus maximum omnium'" *MEFRA* 109 (1997) 83–110.

101 Pliny *HN* 36.5.

102 Tac. *Ann.* 4.62-3. *Nam coepto apud Fidenam amphitheatro Atilius quidam libertini generis, quo spectaculum gladiatorum celebraret, neque fundamenta per solidum subdidit, neque firmis nexibus ligneam compagem superstruxit, ut qui non abundantia pecuniae nec municipali ambitione, sed in sordidam mercedem id negotium quaesivisset. Adfluxere avidi talium, imperitante Tiberio procul voluptatibus habiti, virile ac muliebre secus, omnis aetas, ob propinquitatem loci effusius; unde gravior pestis fuit, conferta mole, dein convulsa, dum ruit intus aut in exteriora effunditur inmensamque vim mortalium, spectaculo intentos aut qui circum adstabant, praeceps*

trahit atque operit.... Quinquaginta hominum milia eo casu debilitata vel obtrita sunt; cautumque in posterum senatus consulto, ne quis gladiatorium munus ederet, cui minor quadringentorum milium res, neve amphitheatrum inponeretur nisi solo firmitatis spectatae. Cf. Suet. *Tib.* 40.

103 Tac. *Hist.* 2.21. *In eo certamine pulcherrimum amphitheatri opus, situm extra muros, conflagravit, sive ab obpugnatoribus incensum, dum faces et glandis et missilem ignem in obsessos iaculantur, sive ab obsessis, dum retorta ingerunt. Municipale vulgus, pronum ad suspiciones, fraude inlata ignis alimenta credidit a quibusdam ex vicinis coloniis invidia et aemulatione, quod nulla in Italia moles tam capax foret.*

104 S. Aurigemma, "Gli anfiteatri di Placentia, di Bononia, e Forum Cornelii" *Historia. Studi storici per l'antichità classica* 6 (1932) 558–87, esp. 570–86; A. M. Capoferro Cencetti, "Gli anfiteatri romani dell' Aemilia" *Studi sulla città antica. L'Emilia Romagna* (Rome, Studia Archaeologica 1983) 245–82, esp. 259–64; A. M. Capoferro Cencetti, "Gli anfiteatri romani dell' Emilia-Romagna" in *Spettacolo in Aquileia e nella Cisalpina romana* (Udine, 1994) 301–4, with figs. 10–13.

105 The amphitheatre is as yet unpublished, but is briefly discussed in V. Gaffney, H. Patterson, P. Roberts, "Forum Novum-Vescovio: Studying urbanism in the Tiber valley" *JRA* 14 (2001) 58–79, esp. 72–5 (Gaffney).

106 See S. Settis, A. La Regina, G. Agosti, V. Farinella, *La Colonna Traiana* (Turin, 1988) 439, fig. 181.

107 See E. Rodríguez-Almeida, "Marziale in Marmo" *MÉFRA* 106 (1994) 197-217, esp. 215-17.

108 This artifact is one of a class of monuments known as "occupation" or "career" reliefs, which became common for middle-class tombs in the late republican period and continued to be made into the early-second century AD, e.g., the reliefs of the Haterii, now in the Vatican Museums: F. Castagnoli, "Gli edifici rappresentati in un rilievo del sepolcro degli Haterii" *Bull. Com. Arch.* 69 (1941) 59–69. The relief with the wooden amphitheatre is mentioned by F. Coarelli, "Gli anfiteatri a Roma prima del Colosseo," in A. La Regina et al., eds., *Sangue e Arena* (2001), 43–8, esp. 46–7. He suggests that it might depict Caesar's cynegetic theater of 46 BC. (If it does actually depict a famous monument, in my opinion, a more likely candidate is the Amphitheatre of Statilius Taurus of 30 BC, which seems to have had a wooden interior and a stone façade: see Chapter 4.) For a fuller (if rather confusing) discussion of the relief (interpreted as large-scale scaffolding, perhaps associated with the building projects of the Flavians in the vicinity of the Colosseum), see Rodríguez-Almeida (supra n. 107).

109 Golvin 1988, 98–101.

110 Robert 1940, no. 92.

111 Samnite shields 310 BC (Livy 9.40. 15–17); shield captured from Cimbri by Marius in 101 BC and hung on the *tabernae* below the *Basilica Sempronia* (Cic., *de oratore* 2.266). Battle paintings on the *Curia's* façade first attested in 264 BC (Pliny, *HN* 35.22), also the year of the first gladiatorial show at Rome and of the beginning of the First Punic War, perhaps not a coincidence. See also Herodian 7.8; SHA, *M. Thrax* 12.10.

Three. Stone Amphitheatres in the Republican Period

1 As alleged, for example, by A. Boethius and J. B. Ward-Perkins, *Etruscan and Roman Architecture* (Harmondsworth and New York, 1970) 170–1; P. Gros,

Architecture et société à Rome et en Italie centro-méridionale aux deux derniers siècles de la République (Collection Latomus vol. 156, Brussels, 1978) 43–4; F. Rakob, "Hellenismus in Mittelitalien. Bautypen und Bautechnik" in P. Zanker, ed., *Hellenismus in Mittelitalien* (Göttingen, 1976) 370; Golvin 1988, 24, 42–4; Golvin and Landes 1990, 39ff.; J.-P. Adam, "L'amphithéâtre de Pompei: un siècle et demi avant le Colisée, déjà les combats sanglants de l'arène," in *Pompei: à l'ombre du Vésuve. Collections du musée national d'archéologie de Naples* (Paris, 1995) 204–7, esp. 204; A. Gabucci, ed., *Il Colosseo* (Milan, 1999) 22; D. L. Bomgardner (Introduction n. 14) 39. I argued against this view in "The Roman arena in late-Republican Italy: A new interpretation" *JRA* 7 (1994) 59–80, of which this chapter is a revised version. My argument has been received positively by some: Gros (Introduction n. 34) 318–23; J. C. Anderson, jr., *Roman Architecture and Society* (Baltimore and London, 1997) 279–80, n. 81 (p. 393).

2 For example, at Teanum and Cales, which date to the second century BC; see W. Johannowsky, "Contributo dell'archeologia alla storia sociale: La Campania" *Dial. di Arch.* 4–5 (1970-1) 469ff.; "La situazione in Campania" in P. Zanker, ed., *Hellenismus in Mittelitalien* (Göttingen, 1976) 271–2.

3 M. Girosi, "L'anfiteatro di Pompei" *Memorie dell' Academia di Archeologia, Lettere e Belle Arti di Napoli* 5 (1936) 27–57; Golvin 1988, 33–7; L. Richardson, jr., *Pompeii: An Architectural History* (Baltimore 1988) 134–8; P. Zanker, *Pompeii. Public and Private Life*, trans. D. L. Schneider (Cambridge, MA, 1998) 68–72. Also A. Mau, *Pompeii: Its Life and Art*, trans. F. W. Kelsey, 2nd ed. (New York, 1902) 212–26; J. Overbeck and A. Mau, *Pompeji in seinen Gebäuden, Alterthümern und Kunstwerken* (4th ed., Leipzig, 1884) 176ff. Amphitheatres were usually located just at the edge of a city, either inside the walls in towns like Pompeii, Nuceria, Augustodunum, and Augusta Praetoria (see plans in S. De Caro & Greco 1981, 136; and T. Lorenz, *Römische Städte* [Darmstadt, 1987] 122, 150); or outside the walls in cities such as Luca, Luna, Silcester, Capua, Telesia, Teanum (see plans in Lorenz pp. 107, 109, 166; and in S. De Caro & A. Greco pp. 199, 210, 236). Sometimes the amphitheatre was built into the city wall circuit and functioned as a gateway, for example, at Augusta Treverorum/Trier (see plan in Lorenz, p. 173), Alba Fucens (J. Mertens, *Alba Fucens I, rapports et études* [Brussels, 1969] fig. 32).

4 On the chronological significance of quasi-reticulate wall facing, see n. 52 and Appendix. Vendor: *CIL* IV 1096. *permissu aedilium Cn. Aninius Fortunatus occup(at).* ("By permission of the aediles, Cn. Aninius Fortunatus occupies [this spot].")

5 On such *portae*, see Golvin 1988, 177, 323.

6 *CIL* X 853–7.

7 F. Mazois, *Les Ruines de Pompeii* IV (Paris 1838), pl. xlviii.

8 The number of colonists is variously estimated from 2,000 to 6,000 ex soldiers, as well as their families: F. Zevi, "Personaggi della Pompei sillana" *PBSR* 63 (1995) 1–24, esp. 21; see, generally, E. Lo Cascio, "Pompei dalla città sannitica alla colonia sillana: le vicende istituzionale," in M. Cébeillac-Gervasoni, ed., *Les élites municipales de l'Italie péninsulaire des Gracques à Néron. Actes de la table ronde de Clermont-Ferrand (28-30 Novembre 1991)* (Rome, 1996) 111–23.

9 *CIL* X 852 = *ILLRP* 645 = *ILS* 5627. *C. Quinctius C.f. Valgus / M. Porcius M.f. Duovir(i) / Quinq(uennales) coloniai honoris / caussa spectacula de sua/ peq(unia) fac(ienda) coer(averunt) et coloneis / locum in perpetuom deder(unt).* Two copies of the inscription were found, one near the west and the other at the east entrance

to the amphitheatre. Another inscription from Pompeii, dating to the first century AD, records that one A. Claudius Flaccus in his first duumvirate gave shows "in the forum," including a pompa, bull fighting, boxing, and pantomime. In his second duumvirate he gave shows also "*in spectaculis*" (presumably in the amphitheatre), including athletes, gladiators and a venatio: *CIL* X 1074d = *ILS* 5053. Both the amphitheatre and the forum at Pompeii were evidently being used for shows down to the early imperial period.

10 Vitruvius (5.1.1) still uses "*spectacula.*" The earliest uses of *amphitheatrum* occur in the Augustan age: both in Vitruvius (1.7.1), in an inscription from Luceria of 2 BC (*AE* 1938, 110), and at *RG* 22 (see R. Etienne, "La naissance de l'amphithéâtre: le mot et la chose" *Rev. Et. Lat.* 43 [1965] 213–20). See also Chapter 2, n. 90 and Chapter 4, n. 16.

11 *CIL* X 844. See Zanker, *Pompeii* (supra n. 3) 65–8.

12 See P. A. Brunt, *Italian Manpower 225 B.C. - A.D. 14* (Oxford, 1971) 91–9; P. Castrén, *Ordo populusque pompeianus. Polity and society in Roman Pompeii* (Rome, 1975) 90–1. It should be said, however, that it is by no means clear that in the republican period municipal censuses always happened in the same year that a census was held in Rome; nor is it certain that the colonists at Pompeii, who arrived in 80 BC, would have waited until 70 BC to carry out a census. They could have had one in 75 BC. In any event, one can state with confidence that the amphitheatre was begun sometime within the first decade of the colonization.

13 See E. J. Jonkers, *Social and Economic Commentary on Cicero's De Lege Agraria Orationes Tres* (Leiden, 1963) 36–8; P. B. Harvey, "Socer Valgus, Valgii, and C. Quinctius Valgus," E. N. Borza and R. W. Carrubba, eds., *Classics and the Classical Tradition. Essays Presented to R. E. Dengler on the Occasion of his Eightieth Birthday* (1973) 79–94; also T. P. Wiseman, *New Men in the Roman Senate 139 B.C. - A.D. 14* (Oxford, 1971) 46, n. 3; H. Mouritsen, *Elections, magistrates and municipal élite: studies in Pompeian epigraphy* (Rome, 1988) 72; Castrén (supra n. 12) 52ff. Valgus was active in building at Aeclanum where he was *quinquennalis, patronus municipii*, and where he rebuilt the walls, forum, curia etc., presumably after the town was destroyed by Sulla (*ILLRP* 523; cf. 599; see G. Colucci Pescatori, "Evidenze archeologiche in Irpinia" in *La romanisation du Samnium aux IIe et Ie siècles av. J.-C.* [Naples, 1991] 85–122, esp. 98–104, fig. 19: city wall at Aeclanum, with facing identical in technique to that of the façade of the amphitheatre at Pompeii).

14 P. Zanker, *Pompeji. Stadtbilder als Spiegel von Gesellschaft und Herrschaftsform* (Mainz, 1987) 19–23, suggests that an amphitheatre would have been an appropriate choice of building to have been erected by army veterans who particularly would have appreciated gladiatorial combat. F. Zevi has another view, which seems less probable. He argues that the amphitheatre was set up by Porcius and Valgus in their capacity as *quinquennales* in part to commemorate the first census of the colony, confirming the end of old Osco-Samnite Pompeii and the birth of a new urban community, composed of both the old inhabitants and the new colonists. Although this is plausible, he is less convincing when he argues that the term "colonists" referred to both the Sullan colonists and the native inhabitants and that the amphitheatre was erected in a conciliatory spirit (because the building housed games in the ancient tradition of gladiatorial games in Campania): F. Zevi, "Pompei dalla città sannitica alla colonia

sillana: per un' interpretazione dei dati archeologici," in *Les élites municipales de l'Italie péninsulaire des Gracques à Néron. Actes de la table ronde de Clermont-Ferrand (28-30 novembre 1991)* (Naples-Rome, 1996) 125–38, esp. 131–2.

15 *CIL* II 5439, 70–1 = *ILS* 6087.

16 A similar payment system seems to have been in operation at the Julian colony at Cnossus on Crete (38 BC): *Dedit in hoc muner(e, denarii) D sunt* [sic], *quos e lege / coloniae pro ludis dare debuit* (*CIL* III 12,042 = *IC* I 51). "He gave for this gladiatorial show 500 *denarii*, from the money which, according to the law of the colony, ought to be given for games." 500 denarii = 2000 sesterces. See the (sometimes inconsistent) discussion of gladiatorial games in their municipal context in Ville 1981, 175–88. It should be noted that the text of the *lex Coloniae Genetivae* (from the town of Urso in Spain) is written in an imperial (probably a Flavian-period) script; it is therefore a later copy of the original Caesarian charter. Some have therefore wanted to see the word *munus* (gladiatorial show) used in the law either as a later interpolation or, if the word is original, as a general reference to any sort of spectacle, as opposed specifically to a gladiatorial show: M. H. Crawford, *Roman Statutes I* (London, 1996) 393–454, esp. 395. This seems unlikely to Ville 1981, 175–80 and to the present author, because in the charter the word *munus* is paired with the word *ludi scaenici* (stage plays), and it is therefore difficult to see what type of entertainment other than gladiatorial it could be referring to (surely not chariot races, which in towns of middling importance such as Urso were not regular events).

17 As alleged, for example, by Wiedemann 1992, 6-8.

18 In addition, there is evidence that gladiatorial combat took place as part of one of the *ludi publici* in the late Republic. Of the *Quinquatrus* festival at Rome (March 19–23), which was dedicated to Minerva, Ovid says (*Fasti* 3.811–14): *Sanguine prima vacat, nec fas concurrere ferro: / causa, quod est illa nata Minerva die. / altera tresque super strata celebrantur harena: / ensibus exsertis bellica laeta dea est* ("The first day is bloodless, and it is unlawful to combat with the sword, because Minerva was born on that day. The second day and the three besides are celebrated by the spreading of the sand: the warlike goddess delights in drawn swords"). In the *Tristia* (4.10.11–14) Ovid explains that he was born on "that day among the five sacred to Minerva which is the first to be stained by the blood of combat" (Ovid's birthday was March 20, 43 BC). See W. W. Fowler, *The Roman Festivals of the Period of the Republic* (London and New York, 1899) 57ff., 250ff., H. H. Scullard, *Festivals and Ceremonies of the Roman Republic* (London, 1981) 92–4; and Ville 1981, 119–20.

19 For example, the fragmentary *lex Tarentina* (which dates to just after the Social War) contains several phrases identical to the *lex Ursonensis*: see E. G. Hardy, *Six Roman Laws* (Oxford, 1911) 102–4, 138 n. 2; E. G. Hardy, *Three Spanish Charters and Other Documents* (Oxford, 1912) 7–22, 31–2.

20 *CIL* X 829 = *ILLRP* 648 (found in Stabian Baths). *C. Iulius C.f., P. Aninius C.f. IIv(iri) i(ure) d(icundo) / laconicum et destrictarium / faciund(um) et porticus et palestr(am) / reficiunda locarunt ex d(ecreto) d(ecurionum). ex/ ea pecunia quod eos e lege /in ludos aut in monumento consumere oportuit faciun(da) / coerarunt eidemque probaru(nt).* "C. Uulius, son of Gaius, and P. Aninius, son of Gaius, as *duumviri*, by decree of law, contracted for the construction of a *laconicum* (sweat room) and *districtarium* (scraping room) and for the reconstruction of the porticus and

palestra, from the money which by law is designated to be spent on games or a monument, and they inspected and likewise approved it."

21 *CIL* IV 7991.

22 There is also an Augustan inscription from Pompeii that records gladiatorial games offered by a *duumvir*. *CIL* X 1074d = *ILS* 5053. See Ville 1981, 177–9.

23 See F. Ritschl, "Die Tesserae gladiatoriae der Römer" in *Opuscula Philologica* IV (Leipzig, 1878) 572–656 (esp. 641 ff); and F. Buecheler, "Die staatliche Anerkennung des Gladiatorenspiels" *Rh. Mus.* 38 (1883) 476–9; M. Rostovtzeff, *Tesserarum urbis Romae et suburbi plumbearum sylloge* (St. Petersburg, 1903) 63–86; G. Lafaye *s.v. Tessera, DS* V, 132ff.

24 *MRR* I 555.

25 Ennodius, *Panegyricus dictus regi Theoderico* 19. "We learn that Rutilius and Manlius with commanding foresight gave gladiatorial combat to the people, so that after a long-standing peace was acquired, the plebs might understand, while in the theatral caveas, what happens in battle," (*Rutilium et Manlium comperimus gladiatorium conflictum magistrante populis providentia contulisse, ut inter theatrales caveas plebs diuturna pace possessa quid in acie gereretur, agnosceret.*) (Harris 1979.)

26 Polybius 32.13.6–8. See W. V. Harris, *War and Imperialism in Republican Rome, 327-70 BC* (Oxford, 1979) 9f.

27 Buecheler (supra n. 23). This view has been disputed by E. Baltrusch, who argues that this citation in Ennodius is anachronistic, and that gladiatorial games could not have been officially (that is, not privately) sponsored as early as the time of Marius: "Die Verstaatlichung der Gladiatorenspiele" *Hermes* 116 (1988) 324–37. Baltrusch thinks that the statement of Ennodius cannot be an accurate reflection of events in the late second century BC, since Rome had been at war with the Germans since 113 BC and with Jugurtha since 111 BC. The plebs, therefore, cannot have been lulled by an atmosphere of peace. The battles with the Germans were intermittent, and neither they nor the Jugurthine war were fought in Italy. So one suspects that the mention of "long-standing peace" (in regard to the plebs in the city of Rome) is rhetorical and need not be taken literally.

28 Vit. 5.1.1. see Chapter Two fn. 11 for full citation. See n. 9 earlier for evidence that the forum at Pompeii was used for spectacles in the first century AD.

29 The situation was serious enough that in 105 BC an edict was passed forbidding men under thirty-five years of age from leaving Italy: see esp. E. Gabba, *Esercito e società nella tarda repubblica romana* (Florence, 1973) 30ff. On the military shortage see Brunt (supra n. 12) 75ff.; questioned by J. W. Rich, "The supposed Roman manpower shortage of the later second century B.C." *Historia* 32 (1983) 287–331; but see M. McDonnell, "The Speech of Numidicus at Gellius, *NA* 1.6" *AJPhil.* 108 (1987) 81–94, and M. Crawford, *The Roman Republic* 2nd ed. (Cambridge, 1993) 227, citing App. *BCiv.* I, 45. For full bibliography, see G. Horsmann, *Untersuchungen zur militärischen Ausbildung im republikanischen und kaiserzeitlichen Rom* (Boppard am Rhein, 1991) 43, n. 190.

30 Val. Max. 2.3.2. *Armorum tractandorum meditatio a P. Rutilio consule, Cn. Mallii collega, militibus est tradita: is enim nullius ante se imperatoris exemplum secutus, ex ludo C. Aurelii Scauri doctoribus gladiatorum arcessitis, vitandi atque inferendi ictus subtiliorem rationem legionibus ingeneravit.* See G. Ville 1969, 185–95, esp. 192.

31 Frontin. *Str.* 4.2.2. "With C. Marius having chosen his army from these two groups, the army which had served under Rutilius and the one which had been under Metellus and thereafter under himself, he chose the army of Rutilius even though it was smaller, because he thought it was better trained." (*C. Marius, cum facultatem eligendi exercitus haberet ex duobus, qui sub Rutilio et qui sub Metello ac postea sub se ipso meruerant, Rutilianum quamquam minorem, quia certioris disciplinae arbitrabatur, praeoptavit.*)

32 Plut. *Vit. Sull.* 4.1.

33 See *TLL s.v. ludus*, cols. 1792–3.

34 Cic. *Cael.* 5.2. *nobis quidem olim annus erat unus … ut exercitatione ludoque campestri tunicati uteremur, eademque erat, si statim mereri stipendia coeperamus, castrensis ratio ac militaris.* See also Suet. *Iul.* 26.3 (gladiatorial recruits trained by equestrians and senators); Livy 7.33.2 (military training in which those of the same age contend with each other in both strength and swiftness referred to as *ludus militaris*); Appian *BCiv.* 3.48 (Octavian watches soldiers acting out a battle, as part of their military exercises); cf. Stat. *Achill.* 2.138ff (military training of Achilles involving *simulacra pugnae*).

35 Cic. *Orat.* 2.20.84. *Sed videant, quid velint: ad ludendumne, an ad pugnandum arma sint sumpturi; aliud enim pugna et acies, aliud ludus campusque noster desiderat; attamen ars ipsa ludicra armorum et gladiatori et militi prodest aliquid.* See also Manilius *Astron.* 4.427–9; Vegetius (*Epitoma rei militaris* 1.11): "Familiarity with the *palus* is indeed most valuable not only for soldiers but also for gladiators. Never has the arena or the campus proven that a man is undefeated in armed combat, except he who has been carefully trained and instructed at the stakes." (*Palorum enim usus non solum militibus sed etiam gladiatoribus plurimum prodest. nec umquam aut harena aut campus invictum armis virum probavit, nisi qui diligenter exercitatus docebatur ad palum*); see *Vegetius: Epitome of Military Science*, trans. with notes and introduction by N. P. Milner, 2nd rev. ed. (Liverpool, 1996) 12–13. The *palus*, or wooden stake, may have been introduced to the army with the gladiatorial trainers in 105 BC. See G. Ville 1969: 185–95, esp. 193f; R. W. Davies, "Roman Military Training Grounds," in E. Birley et al., eds., *Roman Frontier Studies 1969* (Cardiff, 1974) 20–6; R. W. Davies, "Fronto, Hadrian, and the Roman army" *Latomus* 27 (1968) 75–95, esp. 84ff.; M. J. V. Bell, "Tactical reform in the Roman Republican army" *Historia* 14 (1965) 404–22, esp. 417; and G. R. Watson 1969, 55ff. Without explanation, J. Harmand (1967, 15 notes 35, 318, and 536) states that gladiatorial practices, if really introduced to the army in 105 BC, probably did not persist. I see no reason to doubt the historicity of Valerius Maximus 2.3.2; nor does Rich (supra n. 29).

36 The evidence for betting is the *lex Cornelia de Aleatoribus* (probably Sullan in date) that made void debts incurred (using borrowed money) while betting, except in the case of a contest that was *pro virtute*, which is defined as a contest involving throwing spears and javelins, running, jumping, wrestling, or fighting (*Dig.* 9.5). By analogy, betting was also practiced at gladiatorial shows: Ovid *Ars Amat.* 1.168.

37 It is possible that gladiatorial trainers were sometimes used in the Roman army even in the imperial period, as the following passage suggests. In the context of praising the emperor Trajan for supervising his soldiers' military training, Pliny the Younger (*Pan.* 13.5) comments: "Now that interest in arms is displayed in spectacle instead of in personal skill, and has become an amusement

instead of a discipline, when exercises are no longer directed by a veteran crowned by the mural or civic crown, but by some petty Greek trainer, it is good to find one single man to delight in the traditions and valor of our fathers…" (*Postquam vero studium armorum a manibus ad oculos, ad voluptatem a labore translatum est, postquam exercitationibus nostris non veteranorum aliquis cui decus muralis aut civica, sed Graeculus magister adsistit, quam magnum est unum ex omnibus patrio more patria virtute laetari…*) The "*Graeculus magister*" here might refer to a gladiatorial trainer.

38 Cic. *Tusc.*, 2.41. *Oculis quidem nulla poterat esse fortior contra dolorem et mortem disciplina.* Cf. Pliny *Pan.* 33.

39 Sen. *Ep.* 70.22–3. *Plus enim a se quisque exiget, si viderit hanc rem etiam a contemptissimis posse contemni… iam ego istam virtutem habere tam multa exempla in ludo bestiario quam in ducibus belli civilis ostendam. Cum adveheretur nuper inter custodias quidam ad matutinum spectaculum missus, tamquam somno premente nutaret, caput usque eo demisit, donec radiis insereret, et tam diu se in sedili suo tenuit, donec cervicem circumactu rotae frangeret.*

40 Pliny *Pan.* 33.1. *Visum est spectaculum inde non enerve nec fluxum, nec quod animos virorum molliret et frangeret, sed quod ad pulchra vulnera contemptumque mortis accenderet, cum in servorum etiam noxiorumque corporibus amor laudis et cupido victoriae cerneretur.* Cf. Fronto *Princ. Hist.* 8–9.

41 *SHA* Max. 8. *Unde autem mos tractus sit, ut proficiscentes ad bellum imperatores munus gladiatorium et venatus darent, breviter dicendum est. multi dicunt apud veteres hanc devotionem contra hostes factam, ut civium sanguine litato specie pugnarum se Nemesis (id est vis quaedam Fortunae) satiaret. Alii hoc litteris tradunt, quod veri similius credo, ituros ad bellum Romanos debuisse pugnas videre et vulnera et ferrum et nudos inter se coeuntes, ne in bello armatos hostes timerent aut vulnera et sanguinem perhorrescerent.* Septimius Severus also gave a gladiatorial game before departing for the war with the Parthians (*SHA* Sev. 14.11–12).

42 It is a mistake to see such remarks either as an attempt to justify gladiatorial combat or as mere rhetorical posturing. Gladiatorial games needed no justification. The disparaging comments about arena games that one does find in the pagan sources (Sen. *Ep.* 7.2–5 is the *locus classicus*; cf. *Ep.* 14.5–6) do not concern gladiatorial combat but have to do with watching defenseless, unarmed criminals being slaughtered with no competition or real display of skill and artistry involved: cf. Cic. *Tusc.* 2.17; A. Grilli, *Marco Tullio Cicerone, Tusculane, Libro II* (Brescia, 1987) 306–7. Elsewhere Seneca refers to gladiatorial games as fortifying and relaxing, e.g., Sen. *Dial.* 11.17.1: see M. Wistrand, "Violence and entertainment in Seneca the Younger" *Eranos* 88 (1990) 31–46, and *id.*, *Entertainment and Violence in Ancient Rome: The Attitudes of Roman Writers of the First Century AD* (Göteborg, 1992) 16-20. Rhetoric can indeed inform belief, and because it was a truism that gladiatorial combat strengthened moral fiber and promoted military discipline, there is no reason why it could not have had this collective effect.

43 As argued by P. Le Roux, "L'amphithéâtre et le soldat sous l'Empire romain," in C. Domergue, C. Landes, & J.-M. Pailler, eds., *Spectacula I: gladiateurs et amphithéâtres* (Paris and Lattes, 1990) 203–15.

44 An inscription from the lower Rhine commemorates a soldier who is designated "bear keeper": *Ursarius Leg(ionis) XXX U(lpiae) V(ictrici) S(everianae) A(lexandrinae)* (*CIL* XIII 8639); and a gladiatorial beaker found at Colchester

describes a *retiarius* as *Valentinus Legionis XXX* (*CIL* VII 1335.3). Soldiers escorted prisoners of war to Rome for use in gladiatorial games, and they served as captors and trainers of wild animals for the games: see *CIL* VIII 21567 *CIL* XIII 8174 = *ILS* 3265: this and further evidence compiled by Le Roux (supra n. 43), esp. 210f.

45 Davies (supra n. 35) 20–6, esp. 21f.

46 See Veg. *Mil.* 1.11 (quoted in n. 35) and the discussion in Golvin 1988, 154–6; also P. Le Roux (supra n. 43) 203–16, esp. 206–7, 212. That the legionary amphitheatre could sometimes be used for weapons training is suggested by a papyrus recording a duty roster for the *legio III Cyrenaica* that assigns men to various tasks, including to the "*harena*": R. O. Fink, *Roman Military Records on Papyrus* (Cleveland, 1971) 106f.

47 Golvin 1988, 154; and D. L. Bomgardner, "Amphitheatres on the fringe" *JRA* 4 (1991) 282–94, esp. 291–2.

48 Suet. *Iul.* 31.1 (cf. Plut, *Caes.* 32.4). *Formam, qua ludum gladiatorium erat aedificaturus, consideravit.*

49 Polyb. 6.27–32.

50 The evidence for pre-imperial legionary camps is largely literary and contains no references to amphitheatres. See M. J. Jones, *Roman Fort-Defences to AD 117, with Special Reference to Britain*, BAR 21 (1975): Chapter 2: "Roman military defenses before AD 43" pp. 8–25. Pre-imperial legionary amphitheatres may have been made of wood and would therefore have left little archaeological trace. Here it is worth noting that many legionary amphitheatres, when carefully excavated, are found to have had wooden predecessors (the amphitheatre at Silchester is a good example: see M. Fulford, *The Silchester Amphitheatre. Excavations of 1979–85* [London, 1989] 13–36).

51 Vitruvius (writing in the later first century BC) 2.8.1. *Structurarum genera sunt haec: reticulatum quo nunc omnes utuntur, et antiquum quod incertum dicitur.* ("These are the types of walls: *reticulatum*, which all people utilize these days, and the walls from the older style, called *incertum.*")

52 *Opus incertum* is seen from the early second century BC; "quasi reticulate" (a modern term) masonry is known from the late-second century BC, and 'true' *reticulatum* is not used until the mid-first century BC. (Adam, 1984) 142–7; and F. Coarelli, "Public building in Rome between the Second Punic War and Sulla" *PBSR* 45 (1977) 1–23. C. F. Giuliani, *L' Edilizia nell'antichità* (Rome, 1990) 19ff.; J. Packer, "Roman Building Techniques," in M. Grant & R. Kitzinger, eds., *Civilization of the Ancient Mediterranean: Greece and Rome I* (New York, 1988) 299–321, esp. 302–3.

53 Gabucci, 1999, 27; Golvin 1988, 24–5; P. Gros 1978 (supra n. 1) 43.

54 Johannowsky (supra n. 2), 272ff., and 1970–1 (supra n. 2), 469ff.

55 Another example is the second-century AD tomb known as "La Conocchia" at Capua: Adam 1984, 140, fig. 299.

56 Although I was able to examine firsthand the remains of the amphitheatre at Cumae and the republican amphitheatre at Capua, the amphitheatre at Liternum was completely covered when I visited the site. A photograph of a recently excavated part of its *cavea* is now published, however, in C. Gialanella, ed., *Nova antiqua phlegraea: nuovi tesori archeologici dai campi flegrei* (Naples, 2000) 166. The results of the excavation will apparently be published in a forthcoming volume of *BdA*. See Cat. 4. No wall facing of the republican period was evidently recovered, as far as I know.

57 In the 1990s, the amphitheatre at Cumae was the object of excavation by P. Caputo: "Bacoli (Napoli). Cuma: Indagini archeologiche all' anfiteatro" *BdA* 22 (1993) 130–2. The full results of Dr. Caputo's excavations will, I understand, appear in a forthcoming issue of the *BdA*. Caputo dates the initial construction of the monument to the late second or early first century BC on the basis of pottery: "Per quanto attiene alla chronologia del monumento, frammenti ceramici, dei quali uno a vernice nera, rinvenuto dallo scrivente nella malta cementizia di fondazione in uno dei costoloni della *summa cavea*, confermano la datazione generalmente proposta per l'anfiteatro tra fine II – inizi I sec. a.C., poco più precocemente, dunque, che in altri centri campani" (p. 130). His dating is based on a pottery of black glaze type (a ware common in the second century BC, but not in the first) discovered in the concrete foundation material of the amphitheatre. This dating is perhaps problematic, in my opinion, because the foundation material of a building can include broken artifacts dating back several generations or more before the building in question began to be constructed. What is important is the latest datable material in a foundation trench, which provides the "time after which" (*terminus post quem*) the building was constructed. In 2001, I contacted Dr. Caputo, wishing to know if more datable material had been found. He kindly informed me that his ideas about the dating of the amphitheatre had not changed since the 1993 article, cited previously. In 2002, I personally examined the lower part of the amphitheatre close to the podium wall, which had been revealed by the recent excavations. It is faced with *opus reticulatum* (and therefore appears to me to be a rebuilding of the early imperial period). I found no *opus incertum* facing, of the sort one would expect to see in a building of the second century BC, anywhere in the newly excavated sectors of the amphitheatre.

58 Golvin 1988, 42. The same view is held by Adam (supra n. 1) 204–7, esp. 204.

59 Municipia were towns in which the local ruling class had the Roman citizenship, while the other inhabitants of the town (*cives sine suffragio*) had the burdens of Roman citizenship (military service and taxes) but none of its prestige and benefits (voting in legislative and electoral assemblies in Rome; the protection of Roman law, particularly the right to appeal the judgment of Roman magistrates). Municipia were supervised, to a degree, by magistrates from Rome. Latin colonies, on the other hand, were independent civic entities in which no one had the Roman citizenship (although originally many of the colonists had been Romans who gave up the Roman citizenship in order to become citizens of the colony). Though internally independent, the inhabitants of the Latin colonies were required to do military service on Rome's behalf. After the Social War of 90-88 BC all free Italians, regardless of in what type of community they lived, had the Roman citizenship. Veteran colonists (of which there were very few before the age of Sulla) were all Roman citizens. On Latin and maritime colonies, see generally *La colonizzazione romana tra la guerra latina e la guerra annibalica. Dial. di Arch.* 3rd series 6.2 (1988). Golvin (1988, pp. 21, 42) attributes the Syrian and Spanish examples of republican amphitheatres to the occurrence of gladiatorial combats in these regions as early as the late third and second centuries BC. (The evidence for these early gladiatorial events is discussed in Chapter One.) But Scipio Africanus's gladiatorial show at New Carthage in 206 BC was an isolated incident that was staged within a Roman army context (Livy 28.21; Val. Max. 9.11.1). Similarly,

Antiochos Epiphanes' show at Antioch in 167 (Polyb. 30.25.6; Livy 45.32.8–11) was unusual: having lived in Rome 188–176 BC after the Peace of Apamea, this king had peculiarly Roman tastes, as discussed in Chapters One and Six. In fact, an amphitheatre was built in Antioch both because it was a provincial capital and because large numbers of Caesar's soldiers were stationed there. The amphitheater at Corinth is located at the edge of the colony grid and was probably planned at the time of the Roman colonization in 44 BC (see Chapter Six). (Note that in his list of pre-imperial amphitheatres, Golvin [1988, p. 42] includes a putative amphitheatre at Ucubi [modern Espejo in Spain], but there is apparently no evidence that an amphitheatre at Ucubi ever existed [I thank Xavier Dupré Raventós, of the Spanish School in Rome, for this information.])

60 For example, in 60 BC the tribune L. Flavius had envisaged that land could be obtained in the *ager Campanus*, from estates in the possession of *Sullani homines* (Cic. *Att.* 1.19.4), and in 43 BC, D. Brutus imagined that allotments for veterans supporting the senate could be obtained *ex agris Sullanis et agro campano* (Cic. *Fam.* 11.20.3). See Keppie 1983, 55, n. 39.

61 Brunt (supra n. 12) 308. On the evidence for Sullan colonies, see Th. Mommsen, "Die italischen Bürgercolonien von Sulla bis Vespasian" *Hermes* 18 (1883) 163–8; E. Gabba, "Ricerche sull'esercito professionale romano da Mario ad Augusto" *Athenaeum* 29 (1951) 171–272, esp. 270–1; Brunt 300ff.; E. T. Salmon, *Roman Colonization under the Republic* (Ithaca, NY, 1970) 129ff., R. Seager, "Sulla," in *The Cambridge Ancient History, Vol. IX: The Last Age of the Roman Republic, 146-43 B.C.* (Cambridge, 1994). 165–207, esp. 203–5. The evidence for the colonial status of some of the places named is ambiguous, and these authorities differ on particulars.

62 Cic. *Fam.* 13.4.1. *Sullani temporis acerbitas.*

63 Not long after the colony was founded (it is not clear exactly when, however) indigenous Pompeian names are again attested among the magistrates and candidates for election: Mouritsen (supra n. 13) 87–8. Cf. Castrén, (supra n. 12) 49–92, esp. 54–8, arguing that native Pompeians were absent from the town government for twenty years after the founding of the colony. It is not clear if and for how long the political rights of the local Pompeians were curtailed after the deduction of the colony.

64 Cic. *Sull.* 60. *Pompeianorum colonorumque dissensio delata ad patronos est, cum iam inveterasset ac multos annos esset agitata.* Cicero continues (n. 62) "For though he himself [Faustus Sulla] established the colony, and though the needs of the state caused the interests of the colonists to disagree with the fortunes of the people of Pompeii, he is so popular with both parties and so acceptable to them that he is thought not to have dispossessed one class but to have established the prosperity of both." (. . . *cum ab hoc illa colonia deducta sit, et cum commoda colonorum a fortunis Pompeianorum rei publicae fortuna diiunxerit, ita carus utrisque est atque iucundus ut non alteros demovisse sed utrosque constituisse videatur.*) On these passages, see T. P. Wiseman, "Cicero, *pro Sulla* 60-61" *LCM* 2 (1977) 21–2. In subsequent campaigns of colonization, there seems to have been a concerted attempt by Rome to avoid such conflict. In a letter from Cicero to Q. Valerius Orca (*Fam.* 13.4.3; 45 BC), concerning the carrying out of Caesar's allotments of land to veterans, Cicero remarks: "You will do me the greatest possible favor . . . if it is your pleasure to leave the people of Volaterra in every respect untouched and their rights undiminished." (*Gratissimum igitur mihi feceris . . . si Volaterranos omnibus rebus integros incolumesque esse volueris.*) Caesar tried to avoid making

his veterans and their neighbors "everlasting enemies," as they had been in the Sullan veteran settlement (App. *B Civ.* 2.94; Suet. *Iul.* 38.1).

65 See E. T. Salmon, *The Making of Roman Italy* (Ithaca, NY, 1982) 128ff., T. Frank, ed., *An Economic Survey of Ancient Rome* I (Baltimore, 1933) 217–21.

66 Brunt (supra n. 12) 300–42; P. A. Brunt, "The Army and the Land in the Roman Revolution" *JRS* 52 (1962) 69–86; Salmon (supra n. 65) 128–48; Keppie 1983, passim; W. V. Harris, *Rome in Etruria and Umbria* (Oxford, 1971) 259ff., Mommsen (supra n. 61) 163–8; E. De Ruggiero, *Dizionario epigrafico di antichità romane* (Rome, L. Pasqualucci, 1895) and F. Kornemann (*RE* 4, cols. 519ff.).

67 Golvin 1988, 169; E. Cecconi, G. Cencini, and G. Romanini *L'anfiteatro di Arezzo. Rilievi, notizie storiche ed ipotesi di ricostruzione come esperienza didattica* (Arezzo, 1988). On Tusculum's amphitheatre, Golvin 1988, 209 with n. 455, 217. For building activity at Tusculum associated with Sulla, see Xavier Dupré Raventós et al., *Excavaciones Arqueológicas en Tusculum. Informe de las campañas de 2000 y 2001* (2002) 55–63, 218–219, and *CIL* XIV 2626.

68 Cic. *Cat.* 2.20. *Tertium genus est aetate iam adfectum, sed tamen exercitatione robustum; quo ex genere iste est Manlius cui nunc Catilina succedit. Hi sunt homines ex iis coloniis quas Sulla constituit; quas ego universas civium esse optimorum et fortissimorum virorum sentio, sed tamen hi sunt coloni qui se in insperatis ac repentinis pecuniis sumptuosius insolentiusque iactarunt. Hi dum aedificant tamquam beati, dum praediis lectis, familiis magnis, conviviis apparatis delectantur, in tantum aes alienum inciderunt ut, si salvi esse velint, Sulla sit iis ab inferis excitandus.*

69 This point was first made explicitly by P. Zanker 1987 (supra n. 14) 22–3. An apparent connection between veteran colonization and the beginning of stone amphitheatres was also mentioned earlier by H. Kähler, "Anfiteatro" *EAA* I (Rome, 1958) 374–90, esp. 374. Note also that the veteran colonists altered Pompeii's theatre. It was originally a Hellenistic-style theatre with a horseshoe-shaped cavea and open *paradoi*. The colonists evidently vaulted the *paradoi*, thus physically connecting the cavea with the *scaenae frons*, making the theatre more Roman in appearance. See C. Curtois, *Le bâtiment de scène des théâtres d'Italie et de Sicilie* (Louvain la-Neure, 1989) 70–75; A. Maiuri, "Pompei: Saggi nella cavea del' Teatro Grande" *Not. Scav.* (ser. 8) 5 (1951) 126–34; M. Bieber, *History of the Greek and Roman Theater*, 2nd ed. (Princeton, 1961) 170–4; K. Mitens, "Theatre architecture in central Italy: reception and resistance" in P. Guldager Bilde, I. Nielsen, and M. Nielsen, eds., *Aspects of Hellenism in Italy. Acta Hyperborea* 5 (Copenhagen 1993) 91–106, esp. 97. This alteration allowed the *duumviri* to have special boxes (*tribunalia*), one over each vaulted *parados*, which became the visual focal point of the theatre's *cavea*. The view of the stage from this vantage point was oblique and quite skewed, but having a good view was evidently less important to these Roman colonists than being conspicuous to the audience at large.

70 On "self-Romanization" before the Social War, see H. Lauter, "Bemerkungen zur späthellenistischen Baukunst in Mittelitalien" *JdI* 94 (1979) 390–459, esp. 416-36; also Zanker (supra n. 3) 53–60. After the Social and Civil Wars, Sulla augmented the Roman senate from 300 to 600 members, including in it equestrians and men from newly enfranchised territories such as Campania, as well as some of his centurions (Sall. *Cat.* 37.6; Dion. Hal. *Ant. Rom.* 5.77.4–5; Livy *Per.* 89; App. *bc* 1.100); see Wiseman (supra n. 13), 6ff., and Salmon (supra n. 65), 128ff.

71 See M. Frederiksen, *Campania* (London, 1984) 308ff.

72 Val. Max. 2.3.2. See *MRR* I 548, 554, 557.

73 Livy *Per.* 95; Orosius 5.24.1; Plut. *Vit. Crass.* 8.1. The nomenclature of Cn. Cornelius Lentulus Vatia suggests that he may have been a patrician Cornelius adopted by a plebeian Servilius; his adoptive father may have been C. Servilius Vatia; see D. R. Shackleton Bailey, "The Roman nobility in the Second Civil War" *CQ* 10 (1960) 258ff.

74 App. *BCiv.* 1.14; Cic. *Att.* 7.14; 8.2.1. See Wiseman (supra n. 13) 78–79, n. 1; also I. Shatzman, *Senatorial Wealth and Roman Politics* (Brussels, 1975) 91–92 n. 43; and K. Bradley, *Slavery and Rebellion in the Roman World 140 B.C.-70 B.C.* (London, 1989) 84; A. W. Lintott, *Violence in Republican Rome* (Oxford, 1968) 83–5. Of the ten senators who are known to have owned gladiators for a considerable time in the city of Rome, at least seven were of old noble families; Varro *Ling.* 9.7; Plut. *Vit. Cat. Min.* 27.1; Cic. *Att.* 2.1.1.

75 Festus 22. *Qui primus in foro ultra columnas tigna proiecit…quo ampliarentur superiora spectacula.* The same term is used by Vitruvius (5.1.1) in his discussion of Italic fora in general: Chapter Two fn. 11.

76 *CIL* X 852. This is also the word used by Vitruvius (in the same passage 5.1.1–2) when describing games in a forum.

77 For plan and reconstruction of the so-called *ekklesiasterion* at Metapontum, see D. Mertens, "Metapont. Ein neuer Plan des Stadtzentrums" *Arch. Anz.* 1985, Heft 4, Abb. 4. There also exists a roughly oval platform of Classical date at Corinth (ca. 18 × 16.5 m) surrounded partly by seating and located near the Classical stadium (and apparently used along with it for athletic contact sports such as boxing, wrestling, and pankration). This has been suggested as a specific antecedent for the Roman amphitheatre building (an idea that seems very unlikely to me): see Bomgardner 2000, 37–39;

78 See F. Fasolo and G. Gullini, *Il santuario della Fortuna Primigenia a Palestrina* (Rome, 1953). Latium has excellent supplies of lime and volcanic sand (the essential ingredients of *opus caementicium*). Concrete from Latium is strong, lightweight, and waterproof; there is nothing inherently superior about Campanian "pozzolana." (I thank J. Delaine for this information.)

79 Pliny *HN* 19.23.

80 On *ascensus* see A. Johnson, *Roman Forts of the 1st and 2nd Centuries A.D. in Britain and the German provinces* (London and New York, 1983) 65–6. Hyginus (*de mun. cast.* 58) recommends that camps should be provided with double *ascensus* in large numbers to enable soldiers to reach their posts on the rampart with minimum delay.

81 Golvin 1988, 128–9.

82 Bomgardner (supra n. 47) 290–2; Jones (supra n. 50) 8–25; R. MacMullen, "Roman Imperial Building in the Provinces" *Harv. Stud.* 64 (1959) 207–35, esp. 214–17; Watson (supra n. 35) 143–6.

83 Valgus built the fortification walls at Abellinum, where he was *quinquennalis* (*ILLRP* 598), and at Aeclanum, where he was *patronus municipii* (*ILLRP* 523).

84 Zanker 1998 (supra n. 3) 114–16; L. Richardson, jr. 1988, 211–15; E. La Rocca et al., *Guida Archaeologica di Pompei* (Rome, 1976) 255–9; A. Maiuri, "Pompei: Scavo della 'Grande Palestra' nel quartiere dell' Anfiteatro" *Not. Scav.* (ser. 6) 15 (1939) 165–238. *Atti* 1993, 695–97; *Atti* 1992, 695–97.

85 M. Jaczynowska, *Les associations de la jeunesse romaine sous le haut-empire* (Warsaw, 1978) 74–82, nos. 35–110.

86 Dio Cass. 52.26. The *collegia iuventutis* were organizations of young men who underwent training in paramilitary discipline and tactics; they displayed these maneuvers publicly every year at the *Iuvenalia*. The exercises of the *iuvenes* are referred to as *exercitationes campestres equorum et armorum* ("camp exercises on horseback and in arms": Suet. *Aug.* 83.1). See M. Kleijwegt, *Ancient Youth: The Ambiguity of Youth and the Absence of Adolescence in Greco-Roman Society* (Amsterdam, 1991) 101ff. J. Delorme, *Gymnasion* (Paris, 1960) 436ff.

87 Republican precedents for the *iuvenalia* existed, as is clear from the previously mentioned passages in *Cael.*11 and *Orat.* 2.20.84, where Cicero mentions that he himself underwent this training in the *Campus Martius* in Rome. For further evidence that the *iuventus* existed during the Republic, see Jaczynowska (supra n. 85) 17ff.

88 Livy 34.9.3.

89 *[C]aecilius L(ucii) f(ilius) Gal(eria tribu) / [Ma]cer, aedil(is) II vir / [cam]pum de sua pec(unia) / [faciund]um coeravit / [idemqu]e probavit.* M. J. Pena, *Epigrafía Ampuritana (1953–1980): Quaderns de Treball* 4 (1981) 12–14; *AE* 1981, 563. M. Almagro, "El anfiteatro y la palestra de Ampurias" *Ampurias* 17–18 (1955–6) 1–26; E. Sanmartí-Greco et al., "El anfiteatro de Emporiae," *El Anfiteatro en la Hispania romana* (Mérida, 1994) 119–37; Golvin 1988, 121. Excavations seem to indicate that the amphitheatre and *campus* were constructed in the Julio-Claudian period. The inscription is republican in date, however, and suggests that the *campus* (and presumably the adjacent amphitheatre) were planned (and existed in some form, though perhaps not as monumental stone structures) when the colony was first deducted.

90 H. Devijver & F. van Wonterghem, "Neue Belege zum 'Campus' der römischen Städte in Italien und im Westen" *ZPE* 60 (1985) 147–58, esp. 147–50. H. Solin, "Epigrafia repubblicana Bilancio, novità prospettive," in *XI Congresso Internazionale di Epigrafia Greca e Latina* (Rome, 1999) 391, no. 62 (late republican); G. Fabre, M. Mager, and I. Rodà, *Inscriptions romaines de catalogne*, V no. 35 (Paris, 2002) (Augustan).

91 R. W. Davies, *Service in the Roman Army* (New York, 1989) 93–139; R. W. Davies, "Roman military training grounds," in E. Birley, ed., *Roman Frontier Studies 1969* (Cardiff, 1974) 20–6. See also T. P. Wiseman, "Campus Martius" *LTUR* I 220–4.

92 *ILLRP* 116. *C. Catius M.f. IIIIvir campum publice / aequandum curavit, maceriem / et scholas et solarium, semitam / de s(ua) p(ecunia) f(aciunda) c(uravit) / Genio coloniae et colonorum / honoris causa / quod perpetuo feliciter utantur.* Cf. *ILLRP* 518, 528, 577, 619 (other instances of the dedication of *campi* in republican Italy). *ILLRP* 528, which is from Aletrium, records that one L. Betilenus Varrus dedicated a number of public buildings, among which was a *campus ubei* [sic] *ludunt* "campus where they exercise." See the discussion in F. Zevi, "Alatri," in P. Zanker, ed., *Hellenismus in Mittelitalien* (Göttingen, 1976) 84–96, esp. 84ff.

93 I thank S. Nappo for this information. On the houses see S. Nappo's article "The urban transformation at Pompeii in the late third and early second centuries B.C.," in R. Laurence and A. Wallace Hadrill, ed., *Domestic space in the Roman World: Pompeii and Beyond* (*JRA* Suppl. 22) (Portsmouth, RI, 1997) 91–120.

94 *CIL* XI 3938; see Golvin 1988, 168, n. 84; F. Coarelli, "Lucus Feroniae" *Studi Classici e Orientali* 24 (1975) 164–6; R. Bartoccini, "L'anfiteatro di Lucus Feroniae e il suo fondatore" *Rend. Pont. Acc.* 33 (1960) 173–4, figs. 1 (transcription

of *CIL* XI 3938), 4 (plan of amphitheatre), and 7 (dedicatory inscription of amphitheatre). For *iuvenes*' sponsorship of *munera*, see *CIL* XIV 2121 (Lanuvium); an inscription from Ostia records that an individual who was *duumvir* and "*curator lusus iuvenalis*" ("curator of the games of the *iuvenes*") was the first in this city to exhibit female gladiators; see M. Cébeillac-Gervasoni and F. Zevi, "Des femmes-gladiateurs dans une inscription d'Ostie" *MEFRA* 88 (1976) 612–20. That *iuvenes* sat together as a group in amphitheatres is suggested by *CIL* XIII 3708, an inscription on several seats of the amphitheatre at Augusta Treverorum (Trier) that records "*locus iuven(um)*."

95 M. Jaczynowska, *Les associations de la jeunesse romaine sous le Haut-Empire* (Warsaw, 1978) 53ff.

96 *ILS* 6635 ("*pinnirapus*" is a colloquial term for *retiarius*: Juv. 3.158); cf. Juv. 3.155–8.

97 Kleijwegt (supra n. 86) 109–10. *Iuvenes* also played at being actors, particularly in the Atellan farce; see W. J. Slater, "Pantomime riots" *Cl. Ant.* 13 (1994) 120–44; and H. Leppin, *Histrionen. Untersuchungen zur sozialen Stellung von Bühnenkünstlern im Westen des römischen Reiches zur Zeit der Republik und des Principats* (Bonn, 1992) 143.

98 *CIL* XII 533. The inscription dates to the second century AD. J. Carabia, "*Felicissimus* ou la perfection: l'épitaphe d'un jeun médecin d'Aix-en-Provence" *Trames* (Limoges, 1985) 123. It has been hypothesized that the riot of AD 59 in the amphitheatre at Pompeii involved rival factions of *iuvenes*: see M. Della Corte, *Iuventus* (Naples, 1924) 36–41.

99 Dio Cass. 67.14.3.

100 B. Levick, "The *senatus consultum* from Larinum" *JRS* 73 (1983) 97–115.

101 For example, Juv. 2.147 and 8.199–206. "And here too you have seen scandal in our city: a Gracchus fighting, not indeed as a murmillo, nor with round shield and curved blade: such accoutrements he rejects and detests; nor does a helmet shroud his face. See what he wields – trident! And when with poised right hand he has cast the trailing net in vain, he lifts his bare face to the benches and flies, for all to recognize, from one end of the arena to the other." (*et illic / dedecus urbis habes, nec murmillonis in armis / nec clipeo Gracchum pugnantem aut falce supina; / damnat enim talis habitus, sed damnat et odit; / nec galea faciem abscondit; movet ecce tridentem. / postquam vibrata pendentia retia dextra / nequiquam effudit, nudum ad spectacula voltum / erigit et tota fugit agnoscendus harena.*) In AD 15, Tiberius made an exception and allowed the request of some of the *equites* that they be allowed to fight in the gladiatorial games given by his son Drusus (Dio Cass. 57.14.3; also 43.23.5 [similar situation under J. Caesar]; cf. Suet. *Tib.* 35.2). On Nero "forcing" senators and knights to fight in the arena, see Suet. *Nero* 12.

102 *SHA* Comm. 8.5; 11.10–12; 13.3–4; 15.3–8; Dio Cass. 73.17.2–3; 74.2.2–3; Herodian 1.15–16. Caligula fought with gladiators in private and performed publicly as a Thracian gladiator (Suet. *Calig.* 32.2; 54.1). And Hadrian knew how to use gladiatorial weapons (*SHA* Hadrian 14.10: *gladiatoria arma tractavit*).

103 Similar explanations are offered by: Wiedemann 1992, 108–11; Kyle, 1998, 87; S. Brown, "Explaining the arena: Did the Romans 'need' gladiators?" *JRA* 8 (1995) 376–84, esp. 380–2.

104 The *Dig.* 3.1.1.6 says that as long as one performs *virtutis causa* ("for the purpose of virtus [military courage]") and does not accept pay, one could avoid dishonor. See Slater (supra n. 97); J. Edmonson 1996, 69–112, esp. 107–8; W. D. Lebek,

"Standeswürde und Berufsverbot unter Tiberius: Das Senatus Consultum der Tabula Larinas" *ZPE* 81 (1990) 37–96, esp. 50–8.

105 C. A. Barton, *The Sorrows of the Ancient Romans: The Gladiator and the Monster* (Princeton, 1993) 25ff. Ville 1981, 227. E. Gunderson links the phenomenon with the decreased possibilities for aristocratic public display in the early imperial period: "The Ideology of the Arena" *Cl. Ant.* 15 (1996) 113–51, esp. 140.

106 See n. 36.

107 Suetonius (*Iul.* 39.1) says that "in the gladiatorial contest in the Forum, Furius Leptinus, from a praetorian family, and Q. Calpenus, a former senator and an actor, fought to the finish" (*Munere in foro depugnavit Furius Leptinus stirpe praetoria et Q. Calpenus senator quondam actorque causarum.*). Of Caesar's games of 46 BC we hear from Dio. Cass. 43.23.4–5: "In all the contests the captives and those condemned to death took part; yet some even of the knights and, not to mention others, the son of one who had been praetor fought in single combat. Indeed, a senator named Fulvius Sepinus desired to contend with full armor but was prevented . . . " (Sepinus is prevented from wearing gladiatorial armor, not necessarily from fighting). (ἐμάχοντο δὲ ἐν πᾶσι τοῖς ἀγῶσιν οἵ τε αἰχμάλωτοι καὶ οἱ θάνατον ὠφληκότε καί τινες καὶ τῶν ἱππέων, οὐχ ὅτι τῶν ἄλλων ἀλλὰ καὶ ἐστρατηγηκότος τινὸς ἀνδρὸς υἱός, ἐμονομάχησαν. καὶ βουλευτὴς δέ τις Φόλουιος Σεπῖνος ἠθέλησε μὲν ὁπλομαχῆσαι, ἐκωλύθη δέ . . .)

108 A Gracchan law, the *lex Acilia*, stipulates that no one who has contracted himself and fought as a gladiator for pay may sit on an equestrian extortion jury: A. C. Johnson, P. R. Coleman-Norton, and F. C. Bourne, *Ancient Roman Statutes: A Translation with Introduction, Commentary, Glossary, and Index* (Austin, TX, 1961) Doc. 45.6, 8. Note that the injunction is only against those who accept payment for this fighting. Cf. Cicero's mention (*Sest.* 9) of one of the Catilinarians, C. Marcellus, who went to Capua to train as a gladiator, and *Orat.* 3.86, recording a reference in Lucilius (mid-second century BC) to one Q. Velocius, who as a boy fought as a Samnite gladiator. See Wiedemann 1992, 109; Kyle 1998, 89–90.

109 See Appendix for details.

Four. The Amphitheatre between Republic and Empire: Monumentalization of the Building Type

1 Augusta Emerita: Golvin 1988, 109–10; J. R. Mélida, "El anfiteatro romano de Mérida" *Memorias de la Junta Superior de Excavaciones y Antigüedades* (Madrid, 1919) 1–36: The dedicatory inscription reveals that the amphitheatre was dedicated by Augustus in 8 BC (pp. 31–6); M. Bendala Galán and R. Durán Cabello, "El anfiteatro de Augusta Emerita: rasgos arquitectónicos y problemática urbanística y cronologia" *El anfiteatro en la Hispania romana* (Mérida, 1994) 247–64: arguing that the amphitheatre dates largely to the mid-first century AD. Also X. Dupré Raventós, ed., *Mérida. Colonia Augusta Emerita* (Rome, 2004) 58–61. Luca: C. F. Giuliani, "Lucca, il teatro e l'anfiteatro" *Atti. Centro ricerche e documentazione sull' antichità classica* (1973–4) 287–95; G. Ciampoltrini, "Lucca. Ricerche nell' area dell' anfiteatro" *BdA* 16–18 (1992) 51–5; *id.*, 'Municipali ambitione': La tradizione locale negli edifici

per spettacolo di Lucca romana" *Prospettiva* 67 (1992) 39–48; Golvin 1988, 160. Lupiae: M. Bernardini, *Lupiae* (Lecce, 1959) pl. IX (plan); L. Martines, *L'anfiteatro di Lecce* (Galatina, 1957); M. Pani "Economia e società in età romana," in G. Musca, ed., *Storia della Puglia I* (Bari, 1979) 99–120, esp. 110f, and *id.*, "Politica e amministrazione in età romana" 83–98; C. M. Amici, "Iter progettuale e problemi architettonici dell' anfiteatro di Lecce" in F. D. Andria, ed., *Metodologie di catalogazione dei beni archeologici*. 1.2 (Lecce, 1997) 181–98, figs. 169, 170; Golvin 1988, 158–9.

2 See Kolendo (1981) 301–15; also E. Rawson, "*Discrimina Ordinum*: The *Lex Julia Theatralis*" *PBSR* 55 (1987) 83–114.

3 An exception is the Augustan amphitheatre at Luceria (Lucera in Puglia), whose entrances on the major axis of the façade are flanked by Ionic half columns: see Golvin 1988, 76–7. On Tuscan, see Vitruvius 4.7 (his prescriptions for building Tuscan temples discuss only ground plans and conform to the norms of an early period, before the middle Republic when the proportions of Tuscan temples began to change under Greek influence), with the commentary by P. Gros in *Vitruve, De L'architecture livre IV* (Paris, 1992) 178–94; P. Gros, ed., *Vitruvio, De Architectura* (Turin, 1997) 494ff., esp. n. 232; also *Vitruvius. Ten Books on Architecture* with trans. and commentary by I. Rowland and T. N. Howe (Cambridge and New York, 1999) 234, fig. 73; *EEA sv.* "Ordini Architettonici"; A. Lezine, "Chapiteaux toscan trouvés en Tunisie" *Karthago* 6 (1955) 11–29; P. Broise, "Éléments d'un ordre Toscan provincial en Haute-Savoie" *Gallia* 27 (1969) 15–22; and J. Onians, *Bearers of Meaning. The Classical Orders in Antiquity, the Middle Ages, and the Renaissance* (Princeton, 1988) 28ff. Note that these Augustan amphitheatres all had free-standing façades on two levels but only the amphitheatre at Mérida is preserved at the second level (both levels are decorated with Tuscan pilasters). That the amphitheatres at Aosta, Lecce, and Lucca, just as at Mérida, were also decorated with Tuscan elements both at the first and second level is indicated by their followers, the great amphitheatres of the Julio-Claudian period at Verona (fig. 64) and Pula, which have Tuscan pilasters on both levels of their façades. It was not until the Flavian period that amphitheatres begin to use Greek orders for façade decoration, following the Colosseum (e.g. at Arles) – see Chapter Five and the chart in Golvin 1988, 382–83.

4 Golvin 1988, 157–8; S. Maggi, *Anfiteatri della Cisalpina Romana (Regio IX; Regio XI)* (Florence, 1987) 37–41, pl. 18–25; C. Promis, *Le antichità di Aosta* (Turin, 1862) 168–74.

5 Dio Cass. 53.25ff.

6 On these buildings, see A. Boëthius, *Etruscan and Early Roman Architecture* (New York, 1978) 32–63; S. De Angeli, "Iuppiter Optimus Maximus Capitolinus, Aedes" *LTUR* III 148–53. Vitruvius (4.7) does not discuss the elevation of Tuscan, either because he was relying on Greek sources, or because Tuscan was not considered a canonical order (in the Greek sense). See also n. 61. Vitruvius also missed or ignored the Augustan reformulation of the Corinthian order.

7 A. Kirsopp Lake, "The Archaeological Evidence for the 'Tuscan Temple'" *MAAR* 12 (1935) 89-149.

8 See F. Coarelli, *Guida Archeologica di Roma* (Rome, 1989) 284–6; A. Mura Sommella, "Tabularium" *LTUR* V, 17–20; H. Bauer, "Basilica Paul(l)i" *LTUR* I, 183–7, fig. 103; F. Coarelli, "Hercules Olivarius" *LTUR* III, 19–20. On

Augustan Corinthian, see M. Wilson Jones, *Principles of Roman Architecture*, New Haven and London, 2000, 139-56; P. Zanker, *The Power of Images in the Age of Augustus*, trans. A. Shapiro (Ann Arbor, 1988) 65–71, 101–18; M. Wilson Jones, "Designing the Roman Corinthian order" *JRA* 2 (1989) 35-69; E. La Rocca, "Der Apollo-Sosianus-Tempel," and S. Sande and J. Zahle, "Der Tempel der Dioskuren auf dem Forum Romanum," both in *Kaiser Augustus und die verlorene Republik* (Mainz, 1988) 121–36, 213–24. D. E. Strong and J. Ward Perkins, "The Temple of Castor in the Forum Romanum," *PBSR* 30 (1962) 1–30; D. E. Strong, "Some Observations on early Roman Corinthian" *JRS* 53 (1963) 73–84.

9 Tuscan is used for the first story of most of the great imperial amphitheatres: Verona, Pula, the Colosseum, Pozzuoli, Arles, Nîmes, Italica, Capua; see Golvin 1988, 381-6.

10 Dion. Hal. 1.30.4.

11 See, generally, A. Wardman, *Religion and Statecraft among the Romans* (Baltimore, 1982) 63–79; and, generally, Zanker (supra n. 8) 102–35.

12 Vit. 1.4.9.

13 M. Torelli, *Elogia Tarquiniensia* (Florence, 1975) passim. See Harris (1971), 14ff.; M. Torelli, "Alle radici della nostalgia augustea," in M. Pani, ed., *Continuità e trasformazione tra Repubblica e Principato: Instituzioni, politica, società. Atti dell' incontro di studi, Bari 27-28 gennaio 1989* (Bari, 1991) 47–67.

14 See Ath. 4.153f; A. Reifferscheid 1860, 320; Ville 1981, 8, n. 32.

15 Onians (supra n. 3) 44 does not discuss the use of Tuscan in amphitheatres, but he connects the invention of the composite capital at this time with the patriotic, Augustan cultural milieu.

16 See A. Wallace Hadrill, "Roman arches and Greek honours: The language of power at Rome" *PCPS* 216, n.s. 36 (1990) 143–81. The earliest uses of *amphitheatrum* occur in the Augustan age: in Vitruvius (1.7.1); in an inscription from Luceria of 2 BC or a little later, dedicating the building to Augustus (*AE* 1938, 110; G. Gifuni, *Lucera Augustea* [Urbino, 1939] 5, 13, 16ff. figs. 1, 7); and in the Augustus' *RG* 22 (see R. Etienne, "La naissance de l'amphithéâtre: le mot et la chose" *Rev. Ét. Lat.* 43 [1965] 213–20). It is not out of the question that it was Rome's Greek population who first began using this word; this idea finds some support in the fact that Dio Cass. (42.22–3) states that Caesar's cynegetic theatre of 46 BC was called ἀμφιθέατρον. This structure is discussed in Chapter Two. Others have connected the origin of this term with the double-theatre of Scribonius Curio of 55 BC (see Chapter Two, n. 99), though there is no evidence that Curio's structure was called an "amphitheatre."

17 *RE* 2nd ser. 3, cols. 2199–2203 (T. Statilius Taurus 34). Suet. *Aug.* 29; Tac. *Ann.* 3.72; Dio Cass. 51.23.1: "While Caesar was still in his fourth consulship, Statilius Taurus both constructed at his own expense and dedicated with a gladiatorial combat a hunting theatre of stone in the *Campus Martius*." (τοῦ δὲ δὴ Καίσαρος τὸ τέταρτον ἔτι ὑπατεύοντος ὁ Ταῦρος ὁ Στατίλιος θέατρόν τι ἐν τῷ Ἀρείῳ πεδίῳ κυνηγετικὸν λίθινον καὶ ἐξεποίησε τοῖς ἑαυτοῦ τέλεσι καὶ καθιέρωσεν ὁπλομαχίᾳ...). A. Viscogliosi, "Amphitheatrum Statilii Tauri" *LTUR* I 36-7; Golvin 1988, 52-3; F. Coarelli, *Il Campo Marzio* (Rome, 1997) 376, 399, 403 n. 40, 519; *id.*, *Roma* (Laterza, Rome, 1995) 312.

18 Golvin 1988, 53: "Il apparait que le premier amphithéâtre permanent de Rome n'était probablement pas très important ou prestigieux." P. Gros, *L'architecture*

romaine du début du IIIe siècle av. J.-C. à la fin du Haut-Empire I. Les monuments publics (Paris, 1996) and id. 323: "L'amphithéâtre de Statilius Taurus...restait en toute hypothèse trop modeste pour susciter une lignée importante..." D. Favro, *The Urban Image of Augustan Rome* (Cambridge and New York, 1996) 164.

19 See P. Ciancio Rossetto, "Theatrum Marcelli" *LTUR* V, 31–5. The order used in the first story of the façade is sometimes referred to as "Romanized Doric" because it is not a 'pure' rendition of Greek Doric. It is Doric in its triglyph and metope frieze and its lack of column bases. But the columns are not fluted and the upper part of the shaft has an astragal (necking ring) and cyma molding in place of a capital.

20 For example, Zanker (supra n. 8) 148.

21 Suet. *Aug.* 29.4–5: *Sed et ceteros principes viros saepe hortatus est, ut pro facultate quisque monumentis vel novis vel refectis et excultis urbem adornarent. Multaque a multis tunc exstructa sunt, sicut a Marcio Philippo aedes Herculis Musarum, a L. Cornificio aedes Dianae, ab Asinio Pollione atrium Libertatis, a Munatio Planco aedes Saturni, a Cornelio Balbo theatrum, a Statilio Tauro amphitheatrum, a M. vero Agrippa complura et egregia.*

22 Tac. *Ann.* 3.72. *Erat etiam tum in more publica munificentia; nec Augustus arcuerat Taurum, Philippum, Balbum hostilis exuvias aut exundantis opes ornatum ad urbis et posterum gloriam conferre.*

23 Dio Cass. 59.10.5. "He held these contests at first in the *Saepta*, after excavating the whole site and filling it with water, to enable him to bring in a single ship, but later he transferred them to another place, where he demolished a great many large buildings and erected wooden stands; for he despised the amphitheatre of Taurus." (ἐποίησε δὲ τοὺς ἀγῶνας τούτους τὰ μὲν πρῶτα ἐν τοῖς Σέπτοις, πᾶν τὸ χωρίον ἐκεῖνο ἐξορύξας καὶ ὕδατος πληρώσας, ἵνα μίαν ναῦν ἐσαγάγῃ, ἔπειτα δὲ καὶ ἑτέρωθι, πλεῖστά τε καὶ μέγιστα οἰκοδομήματα καθελὼν καὶ ἰκρία πηξάμενος· τὸ γὰρ τοῦ Ταύρου θέατρον ὑπερεφρόνησε.) Cf. Suetonius's mention (*Calig.* 21) of an amphitheatre beside the *Saepta* (*iuxta Saepta*) begun by Caligula but abandoned by Claudius. See D. Palombi, "Amphitheatrum Caligulae" *LTUR* I 35 and F. Coarelli, "Gli anfiteatri a Roma prima del Colosseo" in A. La Regina ed., *Sangue e arena* (Milan, 2001) 43–8, esp. 44–5.

24 Suet. *Calig.* 18.1. *Munera gladiatoria partim in amphitheatro Tauri partim in Saeptis aliquot edidit.*

25 See Golvin 1988, 171–3, 169–71; F. Coarelli and L. Franzoni, *L'arena di Verona* (Verona, Ente autonomo Arena di Verona, 1972) passim; Gros (supra n. 18) 326, figs 382, 383; G. Tosi, "Gli edifici per spettacolo di Verona" *Spettacolo in Aquileia e nella Cisalpina romana* (Udine, 1994) 241–57, esp. 252ff.

26 Suet. *Tib.* 7.1. *Munus gladiatorium in memoriam patris et alterum in avi Drusi dedit, diversis temporibus ac locis, primum in Foro, secundum in amphitheatro.* As discussed in Chapter Two, the *Forum Romanum* continued to be used for gladiatorial shows until the fires of 14 and 9 BC (see Golvin 1988, 57–8).

27 Augustus *RG* 22. *Venationes bestiarum Africanarum meo nomine aut filiorum meorum et nepotum in circo aut in foro aut in amphitheatris populo dedi sexiens et viciens, quibus confecta sunt bestiarum circiter tria millia et quingentae.*

28 Dio Cass. 51.23.1 (quoted in n. 17).

29 See F. W. Shipley, "Chronology of the Building Operations in Rome from the Death of Caesar to the Death of Augustus" *MAAR* 9 (1931) 24ff.

30 Dio Cass. 62.18.2.Τοιούτῳ μὲν δὴ πάθει τότε ἡ πόλις ἐχρήσατο οἵῳ οὔτε πρότερόν ποτε οὔθ᾽ ὕστερον, πλὴν τοῦ Γαλατικοῦ. τό τε γὰρ Παλάτιον τὸ ὄρος σύμπαν καὶ τὸ θέατρον τοῦ Ταύρου τῆς τε λοιπῆς πόλεως τὰ δύο που μέρη ἐκαύθη, καὶ ἄνθρωποι ἀναρίθμητοι διεφθάρησαν. Note that the Amphitheatre of Nero did not replace the Amphitheatre of Taurus, as is alleged in Platner-Ashby *s.v. amphitheatrum Tauri*. Nero's amphitheatre was built in AD 57 (Tac. *Ann.* 13.31), seven years before the destruction of Taurus' building.

31 On Dio's use of sources, see M. Reinhold, *From Republic to Principate: An Historical Commentary of Cassius Dio's Roman History*, volume 6: Books 49–52 (Atlanta, 1988) 6–9; F. Millar, *A Study of Cassius Dio* (Oxford, 1964) 34–8, 85–91. (Neither addresses the passage in question.)

32 Golvin 1988, 98–101. On the relief, see Chapter 2, n. 108.

33 E. Brizio, *Pitture e sepolcri scoperti sull'Esquilino dalla Campagnia fondiaria italiana nell' anno 1875* (Rome, 1876) 49ff.; M. L. Caldelli & C. Ricci, *Monumentum familiae Statiliorum: un riesame* (Rome, 1999) 84, no. 009; 90, no. 068; 113, no. 313.

34 *CIL* VI 6226–8. Note that the titles *custos* (guard), *ostiarius* (attendant), and *vicarius* (doorkeeper) are also used as ranks and titles in the Roman army: see J. F. Gilliam, *Roman Army Papers* (Amsterdam, 1986) 163, 168, notes 20, 34, 323, 374, and 420.

35 *CIL* VI 6354, 6363–5.

36 See S. D. Martin, *The Roman Jurists and the Organization of Private Building in the Late Republic and Early Empire* (Brussels, 1989) 64–5; J. H. D'Arms, *Commerce and Social Standing in Ancient Rome* (Cambridge, MA, 1981) 155–6, n. 20; and Anderson, jr. 1997, 78–9. On the extensive property holdings of the Statilii Tauri, see E. Champlin, "*Aeternumque tenet per saecula nomen*: Property, Place-Names and Prosopography," in W. Eck, ed., *Prosopographie und Sozialgeschichte* (Cologne, 1993) 51–9, esp. 57.

37 Vell. Pat. 2.127. *Raro eminentes viri non magnis adiutoribus ad gubernandam fortunam suam usi sunt, ut duo Scipiones duobus Laeliis, quos per omnia aequaverunt sibi, ut divus Augustus M. Agrippa et proxime ab eo Statilio Tauro, quibus novitas familiae haut obstitit quominus ad multiplicis consulatus triumphosque et complura eveherentur sacerdotia.* See also Dio Cass. 53.23.1–4.

38 Zanker (supra n. 8) 104–14, 135–43; K. Galinsky, *Augustan Culture. An Interpretive Introduction* (Princeton, 1996) 197–224; J.-M. Roddaz, *Marcus Agrippa* (Rome, 1984) 249–98.

39 Nine inscriptions attesting to soldiers of Taurus have been found in the tomb of the Statilii. For example, *Felix German[us] armiger Tauri f /hic situs est.* See *CIL* VI 6229–37. See R. Syme, *The Augustan Aristocracy* (Oxford, 1986) 35; Martin (supra n. 36) 64–5.

40 *CIL* II 3556; *ILS* 893.

41 Dio Cass. 54.19.6; Tac., *Ann.* 6.11. See *PIR* 7.2, 615.

42 Val. Max. 2.3.2; and see Chapter Three.

43 Q. Naevius Macro, prefect of the praetorian guard under Tiberius, built the amphitheatre at Alba Fucens; a *primus pilus* (chief centurion) of *legio VIII Hispanensis* built one at Falerii Novi during the reign of Augustus (see F. Castagnoli, "La 'carta archeologica d' Italia' e gli studi di topografia antica" *Quaderni dell' Istituto di Topografia Antica della Università di Roma*, 6, *Ricognizione archeologica e documentazione cartografica* (1974) 17; *CIL* XI 3112 and 3139; J. Mertens, 1969, 88; and F. de Visscher, "L'amphithéâtre d' Alba Fucens et son fondateur Q.

Naevius Macro, prefect de prétoire de Tibère" *Rend. Linc.* ser. VIII, XII [1957] 39–49); and Marcus Agrippa built one in Berytus: Josephus *BJ* 2.491–2. Most amphitheatres seem to have been built with private funds; inscriptions suggest that the cost of these buildings averaged around several hundred thousand sesterces (roughly the annual income of an individual of the equestrian order): see P. I. Wilkins, "Amphitheatres and private munificence in Roman Africa: A new text from Thuburnica" *ZPE* 75 (1988) 215–21.

44 On manubial temple building in the *Campus Martius*, see E. M. Orlin, *Temples, Religion and Politics in the Roman Republic* (Leiden, 1997) 117–39; M. Aberson, *Temple votifs et butin de guerre dans la Rome republicaine* (Rome, 1994) passim; A. Ziolkowski, *The temples of mid-republican Rome and their historical and topographical context* (Rome, 1992) passim; L. Pietilä-Castren, *Magnificentia publica: the victory monuments of the Roman generals in the era of the punic wars* (Helsinki, 1987) passim.

45 Strabo 5.3.8: πλησίον δ'ἐστὶ τοῦ πεδίου τούτου καὶ ἄλλο πεδίον καὶ στοαὶ κύκλῳ παμπληθεῖς καὶ ἄλση καὶ θέατρα τρία καὶ ἀμφιθέατρον καὶ ναοὶ πολυτελεῖς καὶ συνεχεῖς ἀλλήλοις, ὡς πάρεργον ἂν δόξειεν ἀποφαίνειν τὴν ἄλλην πόλιν.

46 T. P. Wiseman, "Strabo on the Campus Martius: 5.3.8, C235" *LCM* 4.7 (1979) 129–33, esp. 130.

47 G. B. Piranesi, *Campus Martius antiquae urbis* (Rome, 1762) pl. XXVIII, n. 61. R. Lanciani, *Forma Urbis Romae* (reprint Quasar, Rome, 1990) pl. XXI and XXVIII. G. Lugli, *I Monumenti antichi di Roma e suburbio* III (Roma, G. Bardi, 1938) 85–7. As explained to me by J. Wilton-Ely, author of *Piranesi as Architect and Designer* (New Haven, 1993), Piranesi's habit when drawing a Roman ruin was to 'think away' the medieval and later structures around or encasing it and to exaggerate its scale in order to lend the scene monumentality, but he took little license with the actual appearance of a ruin. (The details, cracks, and surface damage are usually fairly accurate when the monument survives with which to compare Piranesi's rendering of it.) Therefore, in this case we may assume that Piranesi's rendering of the ruin he saw in the Monte de' Cenci is accurate in its overall architectural rendering.

48 Piranesi's exact words are: *Rudera substructionum theatri Balbi cuius ruinis congestus est tumulus exurgens in regione Regulae. Visuntur in quadam caupona infra aedes Cinciorum ad Ripam Tiberis* (supra n. 47).

49 A. Nibby, *Roma nell' anno MDCCCXXXVIII* II (Rome, 1839) 588: "Uno de' cunei sostenenti i gradini del teatro nella bottega allora di osteria, oggi di conceria di pelli sotto la chiesa di S. Tommaso a Cenci nella Via S. Bartolomeo de' Vaccinari, dirimpetto alla sega de' marmi nel Tevere."

50 A sixteenth-century property deed mentions an arched vault beneath the church of San Tommaso a' Cenci: *arcus volti subtus ecclesiam Sancti Thomae*; see R. Lanciani, *Ruins and Excavations of Ancient Rome* (Rome, 1897) 494, n. 1; id., *Storia degli scavi di Roma*, (vol. 1 of 4) (Rome, 1902) 169–70. Also during the sixteenth century (in the papacy of Pius IV), two statues of the Dioscuri were found near San Tommaso and placed on the Campidoglio. The base of one of them is inscribed as follows: *S.P.Q.R. / simulacra Castorum / ruderibus in Theatro Pompei / egestis reperta restituit / et in Capitolio posuit*; see R. Lanciani, *Storia degli Scavi di Roma* I (1000–1530) 226; II (1531–49) 85. This indicates that the Monte de' Cenci was (erroneously) considered in this period to be where the Theatre of Pompey had been located, which is another indication that some kind of theatre-like ruin, including the "*cuneus*" that Piranesi rendered, actually

existed in this area. On the Monte de' Cenci see C. Pietrangeli, *Guide rionali di Roma. Rione VII* (Rome, 1973) 58ff.; and M. Bevilaqua, *Il Monte dei Cenci. Una famiglia romana e il suo insediamento urbano tra medioevo ed età barocca* (Rome, 1988) 3–10.

51 Since Lanciani, in *Forma Urbis Romae* (supra n. 47), cites Piranesi's etching rather than a report from an excavation in the area of the radial walls, it is not clear that he ever actually saw the walls. (They may have been unrecognizable by his time because of the recent excavations for the clearing of the Via Arenula in the 1880s.) Lanciani may have placed the walls where he did (in the southwest corner of the Palazzo Cenci), because he thought that this is where they should be if they had comprised part of the substructures and façade of the Theatre of Balbus, which in Lanciani's time was thought to be located here. See G. Marchetti Longi, "Theatrum et Crypta Balbi" *Rend. Pont.* 16 (1940) 237–42. In 1994, I gained access to the underground floors of the building, which coincide with the part of the Monte de' Cenci where Lanciani depicted the radial walls, but there was no sign of them, even in the ground plans of the rooms which were quadilateral, not trapezoidal, as far as I could tell.

52 G. Gatti, "Dove erano situati il Teatro di Balbo e il Circo Flaminio?" *Capitolium* 35 (1960) 3–12.

53 Gatti (supra n. 52) 11; G. Marchetti Longhi, "Nuovi aspetti della topografia dell' antico Campo Marzio di Roma: Circo Flaminio o Teatro di Balbi" *MEFRA* 82 (1970) 117–58, esp. 141–4, 155–6.

54 See G. Marchetti Longhi (supra n. 53) 130, n. 1; T. P. Wiseman, "The Circus Flaminius" *PBSR* 29 (1974) 3–26, esp. 11; F. Coarelli, "Il Pantheon, l'apoteosi di Augusto e l'apoteosi di Romolo" *Analecta Romana Instituti Danici* X (Suppl. X, 1983) 41–6, fig. on p. 43, where the Amphitheatre of Taurus appears at the Monte de' Cenci, although Coarelli does not actually discuss the probable location of this building in the text. See now, however, Coarelli 2002 (supra n. 23) esp. 44; also Coarelli (supra n. 17) 399; and Gros 1996 (supra n. 18) 323. Viscogliosi (supra n. 17) 36–7 alleges that the recent identification of some Roman remains beneath the church of S. Tommaso ai Cenci (located in the eastern sector of the Monte de' Cenci) as the Temple of the Dioscuri *in Circo Flaminio* (dating to the early first century BC) precludes the possibility of the amphitheatre of Taurus having been located in this area. In this he follows M. Conticello de' Spagnolis, *Il Tempio dei Dioscuri nel Circo Flaminio* (Rome, 1984) 45, 62ff., who argues, on the basis of the fragment of the Marble Plan from the Via Anicia, that the walls recorded by Piranesi were actually those of shops located to the west of the temple ("*complesso* A"; see Conticello de' Spagnolis fig. 23). The argument is not persuasive for a number of reasons. First, the walls recorded in Piranesi's etching are radial, not parallel; they represent the substructure of a *cuneus* (wedge of seating). Second, as pointed out by Coarelli, *Campo Marzio* (supra n. 17) the topographical position of the temple of the Dioscuri as shown on the Via Anicia fragment does not correspond with that of the present-day San Tommaso ai Cenci but should be further east, in the area of the "Scuola Catalana," where one sees in old plans of the area clear traces of surviving remains perfectly corresponding to the structure indicated on the Via Anicia fragment: *Campo Marzio* (supra n. 17) 507–8; P. L. Tucci, "Nuove ricerche sulla topografia dell' area del Circo Flaminio" *Studi Romani* 41 (1993)

229–42, esp. 231ff.; *id.*, "Il tempio dei Castori *in Circo Flaminio*: la lastra di Via Anicia," in L. Nista, ed., *Castores. L'immagine dei Dioscuri a Roma* (Rome, 1994) 123–8, fig. 3; C. Parisi Presicce, "I Dioscuri capitolini e l'iconografia dei gemelli divini in età romana" also in Nista, ed *Castores*. In short, there is no topographical reason that the Monte de' Cenci should not have been occupied by the Amphitheatre of Statilius Taurus. It is an artificial hill, created by the ruin of something monumetal, otherwise unaccounted for.

55 The topographical issue resolves itself into whether the Amphitheatre of Taurus was located either to the east of the Via Arenula in the Monte de' Cenci area or to the west of the Via Arenula in the area of the present Ministero di Grazia e Giudizia. Excavations in the latter area along the Via delle Zoccollette, however, have revealed no trace of any sort of large public building but only the foundations of *insulae* and shops (see P. Virgili, "Scavi in Via delle Zoco-lette e adiacenze" in *Archeologia Laziale* VIII [1987] 102–8; and L. Quilici, "Il Campo Marzio occidentale," in *Città e architettura nella Roma imperiale, Analecta Instituti Danici* Suppl. X [Odense, 1983] 59–85, Fig. 4).

56 Dio Cass. 51.23.1 (quoted in n. 17).

57 Dio Cass. 51.21.5–9.

58 On the route of the Roman triumph, see F. Coarelli, "La Porta Trionfale e la Via dei Trionfi" *Dial. di Arch.* 2 (1968) 55–103; E. Makin, "The Triumphal Route, with Particular Reference to the Flavian Triumph" *JRS* 11 (1921) 25–36; and Pietilä-Castrén (supra n. 44) 154–6. For the mustering of the triumph in the *Circus Flaminius*: Plut. *Vit. Aem.* 32.1 and *Vit. Luc.* 37; Livy 39.5.17. People may have been seated inside the Amphitheatre of Taurus and from that vantage point watched the procession pass through the amphitheatre as it left the *Circus Flaminius*, on analogy with the fact that the people watched the triumph from the *Circus Maximus* (Josephus *BJ* 7.4; Plut. *Vit Aem.* 32.1), from scaffolding erected in the *Forum Romanum* and perhaps also later from the seats of the Theatre of Marcellus as it passed through the vaulted *parodoi* of that building: on this possible aspect of the Theatre of Marcellus, see D. Favro, "Rome. The Street Triumphant: The Urban Impact of Roman Triumphal Parades," in Z. Çelik, D. Favro, and R. Ingersoll, eds., *Streets: Critical Perspectives on Public Space* (Berkeley, 1994) 151–64, esp. 157.

59 On the (overgrown and unexcavated) amphitheatre at Caesarea Maritima, see D. W. Roller, *The Building Program of Herod the Great* (Berkeley, 1998) 70ff., 140–1; Golvin 1988, 256, n. 51; A. Reifenberg, "Caesaerea: A study in the decline of a town" *IEJ* 1 (1950–1) 24–6; Roller, 1982, 90–103, esp. 100–2; Z. Weiss, "The Jews and the Games in Roman Caesarea," in A. Raban and K. G. Holum, eds., *Caesarea Maritima. A Retrospective after Two Millennia* (Leiden, 1996) 443–52. On another entertainment building at Caesarea (combining features of a circus, stadium, and amphitheatre) dubiously attributed to Herod, see Y. Porath, "Herod's 'amphitheatre' at Caesarea: A multipurpose entertainment building," in *The Roman and Byzantine Near East: Some Recent Archaeological Research* (Ann Arbor, 1995) 15–27.

60 In the preface to *De Architectura*, Vitruvius hails his patron as "Caesar Imperator," suggesting that the work dates to before 27 BC when Octavian was given the title "Augustus." See P. Gros, *Vitruvio* (supra n. 3) xxvii–xxxii, 103, n. 301, n. 302; discussed in more detail by Anderson jr., 1997, 39–44, esp. 43–4.

61 Vitruvius only mentions the word *amphitheatrum* once (1.7.1): "temples to Hercules should be situated at the circus in communities that have no gymnasia or amphitheatres" (...*Herculi in quibus civitatibus non sunt gymnasia neque amphitheatra ad circum*...). P. Fleury, *Vitruve, De l'architecture, Livre I* (Paris, Les Belles Lettres, 1990) 190–1, suggests that the reason that the word amphitheatre exists in Vitruvius only at 1.7.1 is that the author regularly followed published architectural treatises whenever discussing individual building types, and that the amphitheatre was a sufficiently new type that there was no definitive treatise for him to follow at the time he was writing. In this passage, Vitruvius was probably relying upon a Greek architectural treatise, which would explain the association of Hercules with "gymnasia," where young men exercised and underwent military training in the Greek world. The inclusion of the word "amphitheatres" would then be Vitruvius' own addition to make the statement more relevant to his Roman audience. I thank J. Anderson, jr. for this information. On Vitruvius' reliance on Greek treatises, see P. Gros, "Vitruve: l'architecture et sa theorie" *ANRW* II.30.1 (1982) 659–95, esp. 673–5. Hercules' associations with athleticism and victory made this deity a logical choice for identification with the amphitheatre. On the association between amphitheatres and Hercules, see Golvin 1988, 81, no. 21, n. 42, and 337–40; and Hor. *Epist.* 1.1.4-6, which speaks of retired gladiators hanging their weapons *Herculis ad postem*.

62 Pula: Golvin 1988, 159, 171–3; Carnuntum and Aquincum: Golvin 1988, 135–8; J. Kolendo, "Deux amphithéâtres dans une seule ville: le cas d'*Aquincum* et de *Carnuntum*" *Archeologia Warz.* 30 (1979) 39–55.

Five. The Colosseum: Canonization of the Amphitheatre Building Type

1 Golvin 1988, 169–73.

2 See P. Gros, *Aurea templa: recherches sur l'architecture religieuse de Rome à l'époque d'Auguste* (Rome, 1976) Ch. VI, 197–232; M. Wilson Jones 1989, 35–69; M. Wilson Jones, *Principles of Roman Architecture* (New Haven, and London, 2000) 135–56. P. Zanker 1988, 104ff; P. Ciancio Rossetto, "Theatrum Marcelli" *LTUR* V 31–5; P. Ciancio Rossetto & G. Pisani Sartorio, eds., *Teatri greci e romani alle origini del linguaggio rappresentato* vol. 2 (Rome, 1994) 595–8.

3 Golvin 1988, 273.

4 Golvin 1988, 180–4, 204–5; M. T. Boatwright, "Hadrian and Italian Cities" *Chiron* 19 (1989) 235–71, esp. 258–9.

5 Tac. *Ann.* 13.31. "In the second consulship of Nero and of L. Piso (AD 57) little occurred that deserves remembrance unless the chronicler is pleased to fill his rolls with panegyrics of the foundations and beams on which Caesar reared his vast amphitheatre in the *Campus Martius*." (*Nerone iterum L. Pisone consulibus pauca memoria digna evenere, nisi cui libeat laudandis fundamentis et trabibus, quis molem amphitheatri apud campum Martis Caesar extruxerat.*) According to Suet. *Nero* 12 (it was built in less than a year). See D. Palombi, "Amphitheatrum Neronis" *LTUR* I, 36. Also Platner-Ashby 11, alleging that the Amphitheatre of Nero was built on the site of the Amphitheatre of Statilius Taurus (an impossibility since the latter burned down in AD 64, according to Cass. Dio 62.18). A passage in the Neronian poet Calpurnius Siculus

(*Ecl.* 7.23–34; quoted below in text and in n. 25) probably describes the Amphitheatre of Nero and suggests (because the poet says one could see it from the Tarpeian Rock) that the Amphitheatre was built within viewing distance of the Capitol, somewhere in the southeastern *Campus Martius*. It has been suggested that it was built on the location (near the *Saepta*) of the amphitheatre started by Caligula and abandoned by Claudius (*Calig.* 21): K. M. Coleman, "Entertaining Rome," in J. Coulston and H. Dodge, eds., *Ancient Rome: The Archaeology of the Eternal City* (Oxford, 2000) 210–58; F. Coarelli, "Gli anfiteatri a Roma prima del Colosseo," in A. La Regina ed., *Sangue e arena* (Milan, 2001) 43–8, esp. 45–6; Palombi (*art. cit.*). For the location of the Tarpeian Rock, see T. P. Wiseman, "Saxum Tarpeium" *LTUR* IV 237–8. On the date of Calpurnius Siculus, see G. B. Townend, "Calpurnius Siculus and the *Munus Neronis*" *JRS* 70 (1980) 166–74; and R. Mayer, "Calpurnius Siculus: Technique and Date" *JRS* 70 (1980) 175–6, both arguing against a proposed Severan date for the poet (E. Champlin, "The life and times of Calpurnius Siculus" *JRS* 68 [1978] 95–110; see also B. Baldwin, "Better Late than Early: Reflections on the Date of Calpurnius Siculus" *Illinois Classical Studies* 20 [1995]157–67). Note: the very fact that a description of an elaborate wooden amphitheatre in the capital is included in the works of Calpurnius Siculus is itself strong evidence for a first- (as opposed to second-) century date for this poet. Such virtuoso wooden arenas were a hallmark of early imperial Rome and did not exist in the capital during the high imperial period (which did not need them since it already had the Colosseum).

6 The passage in Calpurnius Siculus (supra n. 5; and quoted later, with n. 25) describes the *cavea* of an amphitheatre (probably that of Nero) equipped with *vela* and having a podium decorated with a series of elephant tusks (from which were suspended golden nets) and ivory rollers that impeded the animals from climbing over the net into the audience. Pliny the Elder (*HN* 19.24; 16.200) mentions that the Amphitheatre of Nero had *vela* of sky blue, spangled with stars, and that it was constructed of timbers from the largest tree ever exhibited in the city of Rome.

7 Suet. *Tit.* 7.3; Dio Cass. 66.25; Mart. *Spect.* passim. The name Colosseum, first attested in the eighth century AD, is either derived from the colossal size of the building or more probably from the fact that the Colossus of Nero stood beside it (see n. 45). The bibliography on the Colosseum is immense. See P. Colagrossi, *L'Anfiteatro Flavio nei suoi venti secoli di storia* (Florence, 1913). More recently: K. Hopkins and M. Beard, *The Colosseum* (London, 2005); A. La Regina et al., eds. 2002; A. Gabucci, ed. 1999; also R. Rea, "Amphitheatrum Flavium" *LTUR* I 30–5; R. Rea, *Anfiteatro Flavio, Roma* (Rome, 1996); G. Croci, *Studi e ricerche sul Colosseo* (Rome, 1990); R. H. Darwall-Smith, *Emperors and Architecture. A Study of Flavian Rome* (Brussels, 1996) 76–90; M. L. Conforto et al., *Anfiteatro Flavio: Immagine, Testimonianze, Spettacoli* (Rome, 1988); Golvin 1988, 173–80.

8 See F. Coarelli, "Ludus gladiatorius" in A. La Regina ed., *Sangue e Arena* (Milan, 2001) 147–51; C. Pavolini, "Ludus Magnus" and "Ludus Matutinus" *LTUR* III, 196–8; K. E. Welch, "Summum Choragium" *LTUR* IV 386–7; E. Rodríguez Almeida, "Armamentaria" *LTUR* I, 126.

9 On the Colosseum complex and its effect on the urban center, see J. C. Anderson, jr., 1997, 218–19, n. 50 (p. 384), fig. 4.10 (p. 220).

10 Hopkins 1983, 2.

11 Suet. *Vesp*. 9.1. *Item amphitheatrum urbe media, ut destinasse compererat Augustum.* Why the amphitheatre was never built during the course of Augustus' long reign is curious. Coleman suggests that a lack of funds for this kind of huge project may be the reason: (supra n. 5) esp. 228, n. 118. A better explanation is that Augustus wanted to avoid the impropriety of doing what Nero later did (see following), namely, acquiring up a large tract of property owned by others (warehouses, mansions) and demolishing what was there to create space for buildings of his own (see Augustus, *RG* 21).

12 B. Levick, *Vespasian* (London and New York, 1999), esp. 65–78.

13 R. Rea, "Recenti osservazioni sulla struttura dell' Anfiteatro Flavio," in M. L. Conforto et al., *Anfiteatro Flavio: Immagine, testimonianze, spettacoli* (Rome, 1988) 9–22; G. Cozzo, *Il Colosseo: L'Anfiteatro Flavio nella tecnica edilizia, nella storia delle strutture, nel concetto esecutivo dei lavori* (Rome, 1971) passim. For the design aspects, see M. Wilson Jones, "Designing Amphitheatres" *MDAI(R)* 100 (1993) 391–442, esp. 418–20.

14 On the basement and foundations of the Colosseum, see C. Mocchegiani Carpano, "L'arena e i sotterranei dell' Anfiteatro Flavio," in R. Luciani, ed., *Roma sotteranea* (Rome, 1985) 108–11; G. Schingo & L. Rendina, "Anfiteatro Flavio: saggio nelle fondazioni" *Bull. Com. Arch.* 92 (1987–8) 323–5; Gabucci, ed. 148–59; H.-J. Beste, "I sotterranei del Colosseo: impianto, trasformazioni e funzionamento," in A. La Regina, ed., 1999, (supra n. 5) 277–99; id., "Relazione sulle indagini in corso nei sotterani: i cosidetti ipogei" *MDAI(R)* 105 (1998) 106–18; id., "Neue Forschungsergebnisse zu einem Aufzugssystem im Untergeschloss des Kolosseums" *MDAI(R)* 106 (1999) 249–76.

15 Adam, 1984 205–210.

16 On which see R. Graefe, *Vela erunt: die Zeltdächer der römischen Theater und ähnlicher Anlagen* (Mainz, 1979), esp. 56–61; also Coleman (supra n. 5) 233–4; N. Goldman, "Reconstructing the Roman Colosseum Awning" *Archaeology* 35.2 (1982) 57–65.

17 R. Rea, "Le antiche raffigurazione dell' Anfiteatro" in M. L. Conforto et al., *Anfiteatro Flavio: immagine, testimonianze, spettacoli* (Rome, 1988) 23–46, n. 7. Rea has convincingly argued (on the basis of epigraphical [*CIL* VI 2059, recording reserved seating for the *Fratres Arvales* in the *media cavea, summa cavea,* and *summa cavea in lignels*] and numismatic evidence [coins minted in AD 80 show the Colosseum as being fully built]) that the Flavian amphitheatre was completed to attic level at the time of its dedication in AD 80. On the inscription, see also Gabucci, ed. (Gabucci, Introduction n. 4) 126; Bomgardner 1984, 18–20.

18 The same is true of the eighteenth-century wooden model that one can see in the Colosseum today: for pictures, see C. Conti, "Il modello ligneo dell' anfiteatro flavio di Carlo Lucangeli: osservazioni nel corso del restauro," in La Regina (Milan, 2001) 117–125. (The statues are not discussed, but there are excellent close-up photographs of the model, showing the statues.) There is no trace of the statues today, which is not surprising since they would have been the first elements to have been removed when the Colosseum began to be mined for metal and building material in Late Antiquity. The lack of any obvious remains suggests that the statues were made of bronze than of marble. That the statues were indeed present on the Colosseum's façade is indicated by the

fact that they are depicted not only on coins of the reign of Titus and Domitian but also, much later, on coins of Alexander Severus in AD 223 (Rea [supra n. 17] 26, fig. 4). In May 1999, when part of the façade of the Colosseum was being cleaned and consolidated, I was given permission to search for evidence for the statue bases (traces of setting lines, dowel holes). I examined bays 51–53 at the second and third stories and found that the floor level behind the parapet walls (where we would expect the statue bases to have been positioned) was mostly covered over with modern concrete. Where it was not, I found no evidence of setting lines or dowel holes. We might not expect to find such traces, however. Although the statues themselves would certainly have been doweled onto their bases, there is no reason, given the weight of the bases and the statues' position behind the parapet walls, that the bases needed to be doweled onto the floor below.

19 See Rea (supra n. 17) 25, fig. 3; and F. Castagnoli, "Gli edifici rappresentati in un rilievo del sepolcro degli Haterii" *Bull. Com. Arch.* 69 (1941) 59–69. The Colosseum is represented (incorrectly) as having Ionic columns on the façade in the first two stories and Corinthian columns on the third. The building is also shown lacking its attic story. Such liberties are common in the representation of buildings in Roman relief sculpture, especially grave monuments. A. Claridge, *Rome: An Archaeological Guide* (Oxford, 1998) 142, suggests that the building depicts the Stadium of Domitian (instead of the Colosseum). The Stadium of Domitian may have had an arch with quadriga on its long façade at the entrance to the imperial box, based on a depiction of the building on some rare Severan gold coins (aurei), which evidently commemorated a reconstruction. The existence for such an arch at the curved end of the Stadium of Domitian (as we see it restored in the Museo della Civiltà Romana) is less clear.

20 See A. Stewart, *Greek Sculpture: An Exploration* (New Haven, 1990) 190, 220 figs. 566, 784, 520.

21 It is less likely that a series of identical eagles occupied the *fornices* of the façade's third story, as depicted on the relief from the Tomb of the Haterii (Fig. 90). Note that the interior of the Colosseum also featured painted sculpted decoration in both marble and stucco, for example, panthers on the balustrades of the *cavea* and elaborate painted decoration on the barrel-vaulted corridors. It was the first amphitheatre we know of to have such embellishment. Its followers, such as the amphitheatre at Capua, used a similar kind of decoration: see M. L. Conforto et al., *Anfiteatro Flavio: immagine, testimonianze, spettacoli* (Rome, 1988); Gabucci 1999 138–47; and Bomgardner 2000 62–3, 95–104.

22 This innovation has not generally been recognized; for example, J. B. Ward-Perkins (*Roman Imperial Architecture* [New Haven, 1994] 70): "The Colosseum was not a building of any great originality"; so too Darwall-Smith (supra n. 7) 80: "...it is important to understand that its design was not very revolutionary, and it differed from other theatres and amphitheatres only in size..." But see P. Zanker, *Der Kaiser baut fürs Volk* (Opladen, 1997) 31–3, where the placement of the statues in the façade is compared to the placement of statues in the *scaenae frons* (stage building) of a Roman theatre and interpreted as one of the ways that the emperor made elite cultural amenities available to the Roman people and as visual reminders of the originally religious nature of public *ludi*. See also Coleman (supra n. 5) 231. It is not certain if statues ever adorned the façades

of other amphitheatres (though this is taken for granted by Bomgardner 2000 62, 104). Statuary (in marble and including close replicas of stock Greek types, notably the Pasquino) also seems to have been displayed in the upper *fornices* of the façade of the Stadium of Domitian in Rome (which drew on the Colosseum's iconography in a variety of ways): see A. M. Colini, *Stadium Domitiani* (Rome, 1943) 94–5; and P. Virgili, "Stadium Domitiani" *LTUR* IV (1999) 341–4, esp. 342. The fornices in this case are considerably smaller and shorter than those of the Colosseum, and the probable remains of the statues show that they stood less than 3 m in height, as opposed to 5 m for the Colosseum.

23 The keystones of the vaults of the Theatre of Marcellus' façade, however, were decorated with theatre masks sculpted in relief: P. Ciancio Rossetto, "Le maschere del Teatro di Marcello" *Studi Romani* 22 (1974) 74–76, and *Bull. Com. Arch.* 88 (1982–3) 7–49; id., "Le maschere del Teatro di Marcello, Teatro Argentina" *Bollettino dei Musei Comunali di Roma* 5 (1991) 121–7; "Le maschere del teatro di Marcello a Roma" in C. Landes, ed., *Spectacula 2. Le théâtre antique et ses spectacles. Actes du colloque tenu à Lattes les 27-30 avril 1989* (Lattes, 1992) 187–95.

24 The traditional, hierarchical 'stacking' in Greek architectural orders (Doric – Ionic – Corinthian), known in earlier sanctuary architecture (Praeneste) and the *scaenarum frontes* (stage buildings) of Roman theatres, had now been artfully adjusted for a less 'privileged' building type. (There are no known examples in pre-Roman architecture of such vertical 'stacking' of architectural orders in a single building; the closest parallel is the Stoa of Attalus in Athens [2nd c. BC] that has Doric and Ionic on its façade, and palm capitals in its interior.)

25 Calpurnius Siculus *Ecl.* 7.23–34. *vidimus in caelum trabibus spectacula textis surgere, Tarpeium prope despectantia culmen; / emensique gradus, et clivos lene iacentes. / venimus ad sedes, ubi pulla sordida veste / inter femineas spectabat turba cathedras. / nam quaecumque patent sub aperto libera caelo, / aut eques aut nivei loca densavere tribuni. / qualiter haec patulum concedit vallis in orbem / . . . / sic ibi planitiem curvae sinus ambit harenae / et geminis medium se molibus alligat ovum . . . 69–73: a! trepidi quotiens sola discedentis harenae / vidimus inverti, ruptaque voragine terrae / emersisse feras! et in iisdem saepe cavernis / aurea cum subito creverunt arbuta nimbo.* The more important Romans, seated in the *ima cavea*, presumably had their own provisions for shade.

26 Statius *Silv.* 1.6, *Kalendae Decembres*. See C. E. Newsvlands, "The Emperor's *Saturnalia*: Statius, *Silvae* 1.6," in A. J. Boyle & W. J. Dominick, eds., *Flavian Rome. Culture, Image, Text* (Leiden and Boston, 2003) 499–522 with bibliography. *Et Phoebus pater et severa Pallas / et Musae procul ite feriatae: / Iani vos revocabimus kalendis. / Saturnus mihi compede exsoluta / et multo gravidus mero December / et ridens Iocus et Sales protervi / adsint, dum refero diem beatum / laeti Caesaris ebriamque aparchen. / . . . / Ecce autem caveas subit per omnis / insignis specie, decora cultu / plebes altera, non minor sedente. / hi panaria candidasque mappas / subvectant epulasque lautiores, / illi marcida vina largiuntur; / Idaeos totidem putes ministros. / orbem, qua melior severiorque est, / et gentes alis insemel togatas, / et, cum tot populos, beate, pascas, / hunc Annona diem superba nescit. / i nunc saecula compara, Vetustas, / antiqui Iovis aureumque tempus: / non sic libera vina tunc fluebant / nec tardum seges occupabat annum. / una vescitur omnis ordo mensa, / parvi, femina, plebs, eques, senatus: / libertas reverentiam remisit. / et tu quin etiam quis hoc vocare, / quis promittere possit hoc deorum? / nobiscum socias dapes*

inisti. / iam se, quisquis is est, inops beatus, / convivam ducis esse gloriatur. / hos inter fremitus novosque luxus / spectandi levis effugit voluptas: / stat sexus rudis, insciusque ferri; / ut pugnas capit improbus viriles! / credas ad Tanain ferumque Phasim / Thermodontiacas calere turmas. / hic audax subit ordo pumilorum, / quos natura brevis statim peracta / nodosum semel in globum ligavit. / edunt vulnera conseruntque dextras / et mortem sibi (qua manu!) minantur. / ridet Mars pater et cruenta Virtus / casuraeque vagis grues rapinis / mirantur pugiles ferociores.

 vixdum caerula nox subibat orbem, / descendit media nitens harena / densas flammeus orbis inter umbras / vincens Gnosiacae facem coronae. / conlucet polus ignibus nihilque / obscurae patitur licere nocti. / fugit pigra Quies inersque Somnus / haec cernens alias abit in urbes. / quis spectacula, quis iocos licentes, / quis convivia, quis dapes inemptas, / largi flumina quis canat Lyaei? / iam iam deficio tuoque Baccho. Cf. Suet. *Dom.* 4.

27 These executions have been studied in detail by K. M. Coleman: "Fatal Charades: Roman Executions staged as Mythological Enactments" *JRS* 80 (1990) 44–73. Evidence for Greek mythological executions before the Flavian period is scanty. The earliest known theatrical execution took place in the *Forum Romanum* in 35 BC, when a Sicilian brigand was displayed on an artificial mountain representing Aetna; the scaffolding collapsed, and he was devoured by wild beasts issuing from underneath (Strabo 6.2.6; quoted in Chapter One, n. 54). We hear nothing about such mythological executions from Tacitus or Suetonius in their accounts of the Augustan and Julio-Claudian periods. In the reign of Nero, Lucilius (*Anth. Pal.* 11.184) describes a criminal burned alive in the guise of Hercules, and Clement of Rome (I *Cor.* 6.2) alludes to the execution of Christian women in the guise of Dirce and of the Danaids. These executions may have taken place in the context of Nero's persecution of Christians after the great fire of AD 64. On these passages, see Coleman (*art. cit.*) 60f, 65f. The story of an actor playing Icarus who fell down in front of Nero and spattered him with blood (Suet. *Nero* 12.1–2) is probably a reference to a pantomime performance gone awry; the incident occurred in the context of a performance of Greek dancers who were given Roman citizenship upon completion of the show. It is presumably mentioned only because of the (portentious) anecdote of the emperor's being spattered with blood.

28 Mart. *Spect.* 10 (8). *Daedale, Lucano cum sic lacereris ab urso, / quam cuperes pinnas nunc habuisse tuas!*

29 Mart. *Spect.* 25 (21b). *Orphea quod subito tellus emisit hiatu / ursam invasuram, venit ab Eurydice.*

30 Mart. *Spect.* 6 (5). *Iunctam Pasiphaen Dictaeo credite tauro:/ vidimus, accepit fabula prisca fidem./ nec se miretur, Caesar, longaeva vetustas:/ quidquid fama canit, praestat harena tibi.* See Gabucci, 1999, for color photograph of a terracotta figurine depicting a condemned slave woman, astride a bull with hands behind her back, being mauled by a feline.

31 Apul. *Met.* 10.29–34. "That was the woman with whom I was supposed to celebrate the solemnities of marriage in public . . . I awaited the day of the show in a state of terrible suspense and great torment, frequently wishing to kill myself rather than be polluted by the infection of that depraved woman or shamed by the disgrace of a public spectacle . . . And now the day appointed for the show had come. I was led to the precinct of the *cavea* escorted by crowds in an enthusiastic parade . . . And now a soldier came hurrying across the middle of

the space in answer to the audience's demands, to fetch the woman from the public prison, the one who I told you had been condemned to the beasts for her manifold crimes and engaged to make an illustrious match with me. And now a bed, evidently meant to serve as our honeymoon couch, was being elaborately made up, shining with Indian tortoise-shell, piled high with a feathered mattress, and spread with a flowery silk coverlet. But as for me, besides my shame at indulging in sexual intercourse in public, besides the contagion of this damnable polluted woman, I was greatly tormented by the fear of death; for I thought to myself that, when we were in fact fastened together in Venus' embrace, any wild animal that might be let in to slaughter the woman could not possibly turn out to be so intelligently clever or so skillfully educated or so temperately moderate as to mangle the woman lying attached to my loins while sparing me on the grounds that I was unconvicted and innocent."

Talis mulieris publicitus matrimonium confarreaturus ingentique angore oppido suspensus expectabam diem muneris, saepius quidem mortem mihi et volens consciscere priusquam scelerosae mulieris contagio macularer vel infamia publici spectaculi depudescerem... Dies ecce muneri destinatus aderat. Ad consaeptum caveae prosequente populo pompatico favore deducor... Ecce quidam miles per mediam plateam dirigit cursum, petiturus iam populo postulante illam de publico carcere mulierem, quam dixi propter multiforme scelus bestiis esse damnatam meisque praeclaris nuptiis destinatam, et iam torus genialis scilicet noster futurus accuratissime disternebatur lectus Indica testudine perlucidus, plumea congerie tumidus, veste serica floridus. At ego praeter pudorem obeundi publice concubitus, praeter contagium scelestae pollutaeque feminae, metu etiam mortis maxime cruciabar, sic ipse mecum reputans, quod in amplexu Venerio scilicet nobis cohaerentibus, quaecumque ad exitium mulieris bestia fuisset immissa, non adeo vel prudentia sollers vel artificio docta vel abstinentia frugi posset provenire, ut adiacentem lateri meo laceraret mulierem, mihi vero quasi indemnato et innoxio parceret.

32 See J. Perlzweig, *The Athenian Agora VII: Lamps of the Roman Period* (Princeton, 1961) 123, no. 833 (described as "woman with horse"); Hönle and Henze, 1981, 57–8.

33 Suet. *Nero* 12.2.

34 Suet. *Calig.* 57; Juv. 8.187.

35 Mart. *Spect.* 9 (7). *Qualiter in Scythia religatus rupe Prometheus / adsiduam nimio pectore pavit avem, / nuda Caledonio sic viscera praebuit urso / non falsa pendens in cruce Laureolus. / vivebant laceri membris stillantibus artus / inque omni nusquam corpore corpus erat. / denique supplicium [dignum tulit: ille parentis]/ vel domini iugulum foderat ense nocens, / templa vel arcano demens spoliaverat auro, / subdiderat saevas vel tibi, Roma, faces. / vicerat antiquae sceleratus crimina famae, / in quo, quae fuerat fabula, poena fuit.*

36 M. Griffin, *Nero. The End of a Dynasty* (New Haven, 1984), esp. 160–163.

37 Suet. *Nero* 12.1. "At the gladiatorial show, which he gave in a wooden amphitheatre in the *Campus Martius*, which had been built in less than a year, no one was allowed to be killed during these combats, not even criminals." *Munere, quod in amphitheatro ligneo regione Martii campi intra anni spatium fabricato dedit, neminem occidit, ne noxiorum quidem.* This was in contrast with Nero's father Claudius and the latter's brother Drusus the Younger, who had been taken to task for allowing too much killing and openly enjoying it: Suet. *Claud.* 14, 34.2; Tac. *Ann.* 1.76.

38 For the negative reaction to the *Neronia* among conservatives, see Tac. *Ann.*
 14.20 (senatorial discussion): "As for the shows, let them continue in the old
 Roman way, whenever it falls to the praetors to celebrate them, and provided no
 citizen is obliged to compete. Traditional morals, already deteriorating, have
 been utterly ruined by this imported laxity. It makes everything potentially cor-
 rupting and corruptible flow into the capital – foreign influences demoralize
 our young men into shirkers, gymnasts, and perverts." *Spectaculorum quidem
 antiquitas servaretur, quotiens praetor sederet, nulla cuiquam civium necessitate cer-
 tandi. Ceterum abolitos paulatim patrios mores funditus everti per accitam lasciviam,
 ut quod usquam corrumpi et corrumpere queat, in urbe visatur, degeneretque studiis
 externis iuventus, gymnasia et otia et turpis amores exercendo.*

39 Pliny *HN* 37.19; Suet. *Nero* 22.2.

40 Mart. *Spect.* 2. *Hic ubi sidereus propius videt astra colossus / et crescunt media pegmata
 celsa via, / invidiosa feri radiabant atria regis / unaque iam tota stabat in urbe domus./
 hic ubi conspicui venerabilis Amphitheatri/ erigitur moles, stagna Neronis erant./
 hic ubi miramur velocia munera thermas,/ abstulerat miseris tecta superbus ager./
 Claudia diffusas ubi porticus explicat umbras,/ ultima pars aulae deficientis erat./
 reddita Roma sibi est et sunt te praeside, Caesar,/ deliciae populi, quae fuerant/
 domini.*

41 Tac. *Ann.* 15.42. *Ceterum Nero usus est patriae ruinis extruxitque domum, in qua
 haud perinde gemmae et aurum miraculo essent, solita pridem et luxu vulgata, quam
 arva et stagna et in modum solitudinum hinc silvae, inde aperta spatia et prospectus . . .*

42 Suet. *Nero* 31. . . . *domum a Palatio Esquilias usque fecit, quam primo transitoriam,
 mox incendio absumptam restitutamque auream nominavit. De cuius spatio atque
 cultu suffecerit haec retulisse. Vestibulum eius fuit, in quo colossus CXX pedum staret
 ipsius effigie; tanta laxitas, ut porticus triplices miliarias haberet; item stagnum maris
 instar, circumsaeptum aedificiis ad urbium speciem; rura insuper arvis atque vinetis
 et pascuis silvisque varia, cum multitudine omnis generis pecudum ac ferarum. In
 ceteris partibus cuncta auro lita, distincta gemmis unionumque conchis erant; cena-
 tiones laqueatae tabulis eburneis versatilibus, ut flores, fistulatis, ut unguenta desuper
 spargerentur; praecipua cenationum rotunda, quae perpetuo diebus ac noctibus vice
 mundi circumageretur; balineae marinis et albulis fluentes aquis. Eius modi domum
 cum absolutam dedicaret, hactenus comprobavit, ut se diceret quasi hominem tandem
 habitare coepisse.*

43 Pliny *HN* 33.54 (*et quota pars ea fuit aureae domus ambientis urbem*; the com-
 parison here is with the Theatre of Pompey); 36.111 (*bis vidimus urbem totam
 cingi domibus principum Gai et Neronis, huius quidem, ne quid deesset, aurea*); Suet.,
 Nero 39.2. "Rome is quickly becoming one house; off with you Quirites, go
 to Veii if [Nero] does not occupy Veii as well'" (*Roma domus fiet; Veios migrate,
 Quirites, / si non et Veios occupat ista domus.*). Suet., *Vesp.* 9, adds the detail that
 work on the Temple of Divine Claudius on the Caelian hill was interrupted by
 Nero so that he could incorporate the area for his private use.

44 The bibliography on the *Domus Aurea* is vast. The most important references
 may be found in A. Cassatella, "Domus Aurea" and "Domus Aurea: complesso
 del Palatino"; C. Panella, "Domus Aurea: Area dello Stagnum"; A. Cassatella
 and S. Panella, "Domus Aurea: Vestibulum"; L. Fabbrini, "Domus Aurea: Il
 Palazzo sull' Esquilino"; E. Papi, "Domus Aurea: Porticus Triplices Miliariae":
 LTUR II (Roma, 1995) 49–64, for recent work on and excavation of the Es-
 quiline. Especially important treatments are W. L. MacDonald, *Architecture of*

the Roman Empire I (New Haven, 1965; rev. ed. 1982) 20–46; and A. Boethius, *The Golden House of Nero* (Ann Arbor, 1960) 94–128. L. Richardson jr., 1992, 119–121, is a useful short summary.

45 The colossal statue of Nero was rededicated to the sun god in AD 75 by Vespasian after Nero's fall, and under Hadrian it was moved to a location next to the Colosseum. The base of the colossal statue (from which the name Colosseum was probably derived in the Middle Ages) stood next to the Colosseum until it was destroyed under Mussolini in 1933 during construction of the Via dei Fori Imperiali. On the iconography and meaning of the Colossus, see M. Bergmann, *Der Koloss Neros, die Domus Aurea und der Mentalitätswandel im Rom der frühen Kaiserzeit* (Mainz, 1994); also R. R. R. Smith, "Nero and the Sun-god: Divine accessories and political symbols in Roman imperial images" *JRA* 13 (2000) 532–42; S. Carey, "*In memoriam (perpetuam) Neronis 'Damnatio Memoriae'* and Nero's Colossus" *Apollo* vol. 152 (2000) 20–31.

46 As argued by N. Purcell, "Town in Country and Country in Town" in E. MacDougall ed., *Ancient Roman Villa Gardens* (Washington DC, 1987) 187–203, especially 198–203.

47 Mart. *Spect.* 2 (quoted in n. 40).

48 See M. P. O. Morford, "The distortion of the *Domus Aurea* tradition" *Eranos* 66 (1968) 158–79.

49 Mart. *Ep.* 10.19; see E. Rodríguez-Almeida, "Qualche osservazione sulle Esquiliae patrizie e il Lacus Orphei," in *L'Urbs. Espace Urbain et histoire* (Rome, 1987) 415–28.

50 Suet. *Nero* 38.

51 A. M. Colini and L. Cozza, *Ludus Magnus* (Rome, 1962) 51–3, fig. 71. See also, C. Panella, "La valle del Colosseo prima del Colosseo e la *Meta Sudans*," in A. La Regina (supra n. 5) 49–67, esp. 54

52 The first scholar to suggest this was Griffin (supra n. 36) 139–41. See also E. Champlin, "God and man in the golden house," in M. Cima and E. La Rocca, eds., *Horti romani; atti del convegno internazionale, Roma, 4–6 maggio 1995* (Rome, 1998) 333–44, proposing that the whole complex was open to the public; and E. M. Moorman, "'Vivere come un uomo.' L'uso dello spazio nella *Domus Aurea*" (in the same volume) 345–61, suggesting that the Palatine wing of the complex was used for official, public functions, and that on the Esquiline for private ones; see also P. J. E. Davies, *Death and the Roman Emperor: Roman Imperial Funerary Monuments from Augustus to Marcus Aurelius* (Cambridge, U.K. and New York, 2000) 145ff., and now E. Champlin, *Nero* (Cambridge, MA, 2004) 200–209. Note that these are still minority opinions.

53 M. Medri, "Suet., *Nero* 31.1: Elementi e proposte per la ricostruzione del progetto della Domus Aurea," in C. Panella, ed., *Meta Sudans* I (Rome, 1996) 165–88; also Panella, "La valle del Colosseo nell'antichità" *BdA* 1–2 (1990) 35–88, esp. 62–74, figs. 27, 28, 32; and id. (supra n. 51), esp. 60. I thank D. Favro for the idea that the grounds of the *Domus Aurea* could have been closed off by guards at key points of ingress and egress.

54 Pliny *HN* 37.18ff (quoted in n. 56).

55 Tac. *Ann.* 15.39; 15.44.

56 Pliny, *HN* 37.18–20. . . . *et crescit in dies eius luxuria . . . anus consularis, ob amorem adroso margine eius, ut tamen iniuria illa pretium augeret; neque est hodie myrrhini alterius praestantior indicatura. idem in reliquis generis eius quantum voraverit, licet aestimare ex multitudine, quae tanta fuit ut auferente liberis eius Nerone exposita*

occuparent theatrum peculiare trans Tiberim in hortis, quod a populo impleri canente se, dum Pompeiano proludit, etiam Neroni satis erat. vidi tunc adnumerari unius scyphi fracti membra, quae in dolorem, credo, saeculi invidiamque Fortunae tamquam Alexandri Magni corpus in conditorio servari, ut ostentarentur, placebat.

57 Vit. 6.5.2.

58 Tac. *Ann.* 15.37. *Ipse quo fidem adquireret nihil usquam perinde laetum sibi, publicis locis struere convivia totaque urbe quasi domo uti. Et celeberrimae luxu famaque epulae fuere, quas a Tigellino paratas . . . Igitur in stagno Agrippae fabricatus est ratem, cui superpositum convivium navium aliarum tractu moveretur. Naves auro et ebore distinctae, remigesque exoleti per aetates et scientiam libidinum componebantur. Volucris et feras diversis e terris et animalia maris Oceano abusque petiverat. Crepidinibus stagni lupanaria adstabant inlustribus feminis completa, et contra scorta visebantur nudis corporibus. Iam gestus motusque obsceni.*

59 Such barging parties had been staged before Nero's time, but only by and for the Roman elite in private contexts, for example, at Lake Nemi in the Alban hills, where two great Roman ships of Caligula were found, each over 80 m long, four stories high, and equipped with plumbing, central heating, baths, gardens, and the very latest in *opus sectile* and other decoration; see G. Ucelli, *Le navi di Nemi* (Rome, 1950) passim; G. Ghini, *Museo delle navi romane, Santuario di Diana Nemi* (Rome, 1992). These were presumably modeled on the festival ships built by the Hellenistic kings (Ath. 5.204d–6c [Nile ship of Ptolemy IV]). In staging such festivals in the *Campus Martius* and then apparently in the *Domus Aurea* itself, therefore, Nero seems to have been making available to the public a type of Greek-style, elite recreation that before had only been staged far from the public eye. On the use of Nero's *stagnum* for *naumachiae*, see Mart. *Spect.* 34 (30; 28), quoted in n. 66.

60 This is a practice that had precedents in Caesarian and Augustan times, but only outside the center of town, for example, in *Transtiberim* or in the *Campus Martius*: see Zanker (1988) 137–9. See Plut. *Pomp.* 44.3; Val. Max. 9.15.1; Plut. *Vit. Caes.* 55.2; Cic. *Phil.* 2.116, Suet. *Caes.* 26.2; 38–9; 83.2; Dio Cass. 43.21.3; 43.42.1; 54.29.4; Pliny *HN* 14.66, 14.97; Pliny *HN* 35.26–8; G. V. Gentili, *Epigraphica* 10 (1948) 136–41 (texts delineating the public banquets and other amenities offered the people by Pompey, Caesar, Agrippa, and Augustus). On the possible connections between Neronian and Augustan political ideologies, see recently, M. Bergmann, *Die Strahlen der Herrscher: theomorphes Herrscherbild und politische Symbolik im Hellenismus und in der römischen Kaiserzeit* (Mainz, 1998) 133–230.

61 Tac. *Ann.* 15.40 and Suet. *Nero* 55. *Contra* J. Elsner, who argues that there was nothing about the *Domus Aurea* to occasion outrage in Nero's time; it was only after the fall of Nero that the *Domus Aurea* became a symbol of tyranny: J. Elsner, "Constructing decadence: The representation of Nero as Imperial builder" in J. Elsner & J. Masters, eds., *Reflections of Nero* (London, 1994) 112–27.

62 Pliny *HN* 34.49–83.

63 Pliny *HN* 34.84. *Atque ex omnibus, quae rettuli, clarissima quaeque in urbe iam sunt dicata a Vespasiano principe in templo Pacis aliisque eius operibus, violentia Neronis in urbem convecta et in sellariis domus aureae disposita.*

64 See Tac. *Hist.* 1.20, *Ann.* 15.42–52; and Griffin (supra n. 36) 166–82. On Nero's removal of Greek statuary from Greek sites, see Paus. 5.25.8; 5.26.2–4; 9.27.3; 10.7.1. In Pliny's famous passage [*HN* 34.49–83] outlining famous Greek

sculptures, it is impossible to know if he is talking about originals or "copies" (i.e., replicas). The distinction between the two categories is a largely modern one. See E. Bartman, "Sculptural Collecting and Display in the Private Realm" in E. Gazda ed., *Roman Art in the Private Sphere: New Perspectives on the Architecture and Décor of the Domus* (Ann Arbor, 1991) 75, n. 28.

65 And, therefore, resembling in its statuary decoration a republican manubial temple. On the *Templum Pacis*, see F. Coarelli, "Pax, Templum" *LTUR* IV 67–70, fig. 24; and J. C. Anderson, jr., *Historical Topography of the Imperial Fora*. Collection Latomus vol. 182 (Brussels, 1984) 101–18.

66 Mart. *Spect.* 34 (30; 28). *quidquid et in Circo spectatur et Amphitheatro, / id dives, Caesar, praestitit unda tibi / Fucinus et diri taceantur stagna Neronis: / hanc norint unam saecula naumachiam.* It is worth suggesting here that the graphic and violent imagery used by Lucan in his description of a naval battle between the forces of Caesar and Pompey (*Pharsalia* III 567–762) was inspired by the poet's own visual experience as a spectator during bloody mock naval battles in Nero's *stagna*. On *naumachiae* in general see K. M. Coleman, 1993, 48–74; and id. (supra n. 5) 234–5, 240–1. Mock sea battles were generally held in real lakes or artificial ones called *naumachiae*, not in amphitheatres, and the evidence that they were ever held in the Colosseum is questionable. If Titus actually did succeed in staging a *naumachia* inside the Colosseum, this would have been an isolated occurrence. (There is no evidence, aside from the Martial passage, that the Colosseum was ever used for mock sea battles.) It is worth noting that Martial does not say that the *naumachia* which took place as part of the Colosseum's 100-day inauguration festival actually occurred inside the amphitheatre itself. It is more probable that it took place in the *Naumachia Augusti* in *Transtiberim*: A. M. Liberati, "Naumachia Augusti" *LTUR* III 337. The arenas of amphitheatres are much too small to have accommodated naval battles on a respectable scale with real ships, but they are a fine size to have housed small-scale aquatic events such as the piquant water ballets described in Martial (*Spect.* 30 [26]), which could have taken place in shallow water. On possible *naumachiae* in the Colosseum, see R. Rea et al., "Sotteranei del Colosseo. Ricerca preliminare al progetto di ricostruzione del piano dell' arena" *RM* 107 (2000) 311–39, esp. 332–7 (H.-J. Beste). For a skeptical view on *naumachiae* in amphitheatres, see K. Welch, "Roman amphitheatres revived" *JRA* 4 (1991) 277–9.

67 These bollards used to be associated with the workings of the *vela* or awnings spread over the top of the *cavea* to create shade for the spectators. They are now more plausibly seen as having solely to do with crowd control, whereas the *vela* are thought to have been operated by means of a pulley system manipulated at *summa cavea* level. See Coleman (supra n. 5) 231–4 for discussion.

68 See E. Rawson 1987, 83–114; J. Kolendo 1981, 301–15; Bomgardner 2000, 9ff.

69 K. E. Welch, "L'origine del teatro romano antico: l'adattamento della tipologia greca al contesto romano" *Annali di architettura. Rivista del Centro Internazionale di Studi di Architettura Andrea Palladio* 9 (1997) 7–16, esp. 13.

70 G. Alföldy, "Eine Bauinschrift aus dem Colosseum" *ZPE* 109 (1995) 195–226. See also Gabucci 1999, 165; Coleman (supra n. 5) 229–31. Alföldy's reconstruction has not been universally accepted.

71 Alföldy (supra n. 70) 216–22. Compare the contemporary and more standardly worded (i.e., verbose) inscription from the Arch of Titus in the *Circus Maximus* (*CIL* VI 944): *senatus populusq(ue) Romanus / imp(eratori) Tito Caesari divi*

*Vespasiani f(ilio) Vespasian[o] Augusto / pontif(ici) max(imo), trib(unicia) pot(estate)
X, imp(eratori) XVII, [c]o(n)s(uli) VIII, patri patriae, principi suo, / quod praeceptis
patr[is?] consiliisq(ue) et auspiciis gentem / Iudaeorum domuit et urbem Hierosolymam
omnibus ante / se ducibus regibus gentibus aut frustra petitam aut / omnino intemp-
tatam delevit.* "The senate and the people of Rome to the emperor Titus Caesar
Vespasian Augustus, son of the deified Vespasian, pontifex maximus, holder of
the tribunician power for the seventeenth time, consul for the eighth time, pa-
ter patriae, princeps, because in accordance with his native precepts, projects
and auspices he tamed the nation of Jewry, and the city of Jerusalem – which
all generals, kings, and nations before had either assaulted in vain or avoided
altogether – he utterly destroyed." See also P. Zanker, "Das Trajansforum in
Rom" *Arch. Anz.* 85 (1970) 499–544, esp. 520–1; F. W. Shipley 1931, 11ff.
Alföldy (pp. 208–10, 212–13, Abb. 3–5) argues that the Colosseum inscription
was originally configured with Vespasian (who died in AD 79) as the dedicator
of the building but was later reconfigured (by the insertion of a "T") with his
son Titus as the dedicator.

72 The shields are perhaps also reminiscences of the shield portraits that deco-
rated the façade of the *Basilica Aemilia* when it was redecorated by M. Aemilius
Lepidus, probably in the year of his consulship, 78 BC: see Coarelli 1985, 203,
fig. 31; E. M. Steinby, "Basilica Aemilia" *LTUR* I 167–8. (L. Papirius Cur-
sor had hung the Forum with captured Samnite shields much earlier, in 308
BC [Livy 9. 40.15–17]; the Cimbrian shield of Marius [captured by him in
101 BC] hung below the *tabernae novae* in front of the *Basilica Sempronia* [Cic.,
Orat. 2.266]). Such shields would have formed an impressive and inspiring
backdrop in the Forum during gladiatorial spectacles during the republican age
(see Chapter Two).

73 See W. L. MacDonald and J. Pinto, *Hadrian's Villa and its Legacy* (New Haven,
1995).

74 See L. Sasso D' Elia, "Domus Augustana, Augustiana" *LTUR* II 40–45; also
Anderson jr., 1997, 303–4.

75 Golvin 1988, 180–3, 204–5, 200–2, 209–12; Bomgardner 2000, 72–106, 146–
51. The amphiteatre at El Djem is third century in date and has a Corinthian
order on all three stories of its façade (as did the Severan *Amphitheatrum Cas-
trense* in Rome: *LTUR* I, 35–36). The others (which date from the Flavian to
Hadrianic periods) are so close to the Colosseum, in their interior decoration,
their basement structures, and in their use of Tuscan on the ground floor, that
it is virtually certain that they also used Tuscan, Ionic, and Corinthian orders
on their façades in imitation of the Colosseum. As for the motif of shields
in the Colosseum's attic and the triumphal arch at ground level, there are no
certain examples in the decoration of other amphitheatres. These may have
been considered especially appropriate for the Colosseum in Rome because
of its associations with the Flavian military triumph over Jerusalem (and, of
course, because of the manubial nature of the monument and the traditional
association of the amphitheatre building with the Roman army).

76 Rome's addition to athletics was the spiked boxing glove; Rome 'improved
upon' Greek chariot racing by requiring charioteers to strap the horses' reins
around their waists, thereby increasing the danger to them.

77 Mart. *Spect.* 1. *Barbara pyramidum sileat miracula Memphis, / Assyrius iactet nec
Babylona labor; / nec Triviae templo molles laudentur Iones, / dissimulet Delon cornibus
ara frequens; / aere nec vacuo pendentia Mausolea / laudibus inmodicis Cares in astra*

ferant. / omnis Caesareo cedit labor Amphitheatro; / unum pro cunctis Fama loquetur opus.

Six. The Reception of the Amphitheatre in the Greek World in the Early Imperial Period

1 Polyb. 30.25–6; 21.17. See Edmondson, 1999, 77–95.

2 The evidence was discussed in Chapter One. See Robert 1940, no. 62. Roussel and Hatzfeld 1910, 404–5, 416–17.

3 Plut. *Vit. Luc.* 23. Cic. *Att.* 6.3.9. This is the sum total of the evidence. For a second-century inscription in honor of one Polemaios, a self-declared *philorhomaios*, who may have put on a gladiatorial contest in his native Kolophon, see L. Robert and J. Robert, *Claros I. Décrets hellénistiques* (Paris, 1989) 35ff; and F. Canali De Rossi, "*Claros I, Décrets hellénistique*s par L. et J. Robert" *Athenaeum* 79 (1991) 646ff: the inscription dates to the second century BC and states that, among other benefactions, Polemaios gave διδασκαλία μονο…(col. 5, line 2). Canali de Rossi restores the inscription as follows: διδασκαλία μονο(μαχῶν), "gladiatorial training grounds." Aside from this instance at Kolophon and Antiochos Epiphanes' games at Antioch, there is no other evidence for Greeks putting on gladiatorial shows before the imperial period: see J.-L. Ferrary, *Philhellénisme et impérialisme: Aspects idéologiques de la conquête romaine du monde hellénistique, de la seconde guerre de Macédoine à la guerre contre Mithridate* (Rome, 1988) 560–565.

4 Robert 1940, passim; also *Hellenica* III, 112–50; V, 77–99; VII, 126–51; VIII, 39–72.

5 Livy 41.20. … *gladiatorum munus, Romanae consuetudinis, primo maiore cum terrore hominum, insuetorum ad tale spectaculum, quam voluptate dedit; deinde saepius dando et modo volneribus tenus, modo sine missione, etiam familiare oculis gratumque id spectaculum fecit, et armorum studium plerisque iuvenum accendit.*

6 E. R. Fiechter, *Das Dionysos-Theater in Athen*, I (Stuttgart, 1935) 60–1; W. Dörpfeld & E. Reisch, *Das griechische Theater* (Athens, 1896 [repr. 1966]) 82–94, esp. 91–3. The name κόνιστρα was used for the orchestra (Suda *s.v. skene*); this is also the word used for a wrestling ground in a gymnasium (e.g., Ael. *NA* 11.10).

7 Fiechter (supra n. 6) vol. III (1936) 78–83, esp. 82; J. Travlos, *Pictorial Dictionary of Ancient Athens* (London, 1971) 538; Golvin 1988, 237–8, n. 23.

8 See Dörpfeld and Reisch (supra n. 6) 91–3; and L. Polacco, *Il teatro di Dioniso Eleutereo ad Atene* (Rome, 1990) 179–82.

9 The inscription (*IG* II² 3182), as far as it can be certainly restored, reads as follows: [Διονύσῳ 'Ελ]ευθεριεῖ καὶ [Νέρωνι] Κλαυδίῳ Καίσαρι Σε[βαστῷ…ἐκ τῶν] ἰδίων ἀνέθηκεν στρατηγοῦντος ἐπὶ τοὺς ὁπλείτας τὸ ζ κ[.

The name of the hoplite general here is probably to be restored as Ti. Claudius Novius, who was hoplite general for the seventh time shortly before AD 61/62 and was high priest of Nero during his eighth hoplite generalship in AD 61/62 (*IG* II² 1990). The theatre was dedicated before AD 61/62; the *terminus post quem* for the dedication is AD 54 (the year of Nero's accession). It is likely that the project was begun sometime after Nero's accession and finished around AD 60. For the chronology, see J. H. Oliver, *The Athenian Expounders of the Sacred and Ancestral Law* (Baltimore, 1950) 81–3;

D. J. Geagan, *The Athenian Constitution after Sulla* (Princeton, 1967) 18–32, esp. 25–6.

10 The Greeks also held Roman spectacles in their much more capacious stadia: see K. E. Welch, "Greek stadia and Roman spectacles: Asia, Athens, and the Tomb of Herodes Atticus" *JRA* 11 (1998a) 117–45, and id., "The Stadium at Aphrodisias" *AJArch* 102 (1998b) 547–69.

11 Aphrodisias, Ephesos, Aspendos, Hierapolis, Side, Termessos, and so forth. See Golvin 1988, 237–46; J. Reynolds, "Epigraphic evidence for the construction of the theatre: First century BC to mid-third century AD" in R. R. R. Smith and K. T. Erim, eds., *Aphrodisias Papers 2: The Theatre, a Sculptor's Workshop, Philosophers and Coin-types* (Ann Arbor, *JRA* Suppl. 2, 1991) 19.

12 See Bieber, 1961, 63–71, 213–15, fig. 254 (state plan), with fig. 721 (Fiechter's reconstruction of the stage). The architectural details of the Roman stage are much disputed; see A. W. Pickard-Cambridge, *The Theatre of Dionysus in Athens* (Oxford, 1946) 250–8, for a summary of the different opinions.

13 Bieber, 1961, 108–28.

14 On Novius, see D. J. Geagan, "Tiberius Claudius Novius, the Hoplite Generalship and the *Epimeleteia* of the Free City of Athens" *AJPhil.* 100 (1979) 279–87; S. Follet, *Athènes au IIe et IIIe siècle* (Paris, 1976) 160ff; C. P. Jones, "Three foreigners in Attica" *Phoenix* 32 (1978) 227–8; M. C. Hoff, "The so-called Agoranomion and the imperial cult in Julio-Claudian Athens" *Arch. Anz.* 109 (1994), 93–117, esp. 113ff, 110 ff; P. Graindor, *Athènes de Tibère a Trajan* (Cairo, 1931) 141–6.

15 During the first half of the first century BC the hoplite general began to appear in the headings of decrees and in dedications with his name in the genitive case. The name was not included for the purpose of eponymity, but because of an interest in the dedication per se. See Geagan (supra n. 9) 20, 24–6, 30; Oliver (supra n. 9) 81–3; T. Sarikakis, *The Hoplite General in Athens* (Princeton, 1951) 19ff; and Hoff (supra n. 14) 110, notes 68–69.

16 *IG* II² 3535.

17 *IG* II² 3535.

18 *IG* II² 4174.

19 *IG* II² 3270. A consolidated cult of the "Theoi Sebastoi" seems to have been introduced under Claudius; see Hoff (supra n. 14) 109, n. 58.

20 The definitive work on this inscription (*IG* II² 3277), with commentary and a history of its decipherment, is K. K. Carroll, *The Parthenon Inscription* (Durham, NC, 1982). See also A. Spawforth, "Symbol of unity? The Persian-Wars tradition in the Roman Empire," in S. Hornblower, ed., *Greek Historiography* (Oxford, 1994) 234–7.

21 The restored text, after Carroll (supra n. 20) reads as follows: Ἡ ἐξ Ἀρείου Πάγου Βουλὴ καὶ ἡ Βουλὴ τῶν Χ καὶ ὁ δῆμος ὁ Ἀθηναίων Αὐτοκράτορα μέγιστον Νέρωνα Καίσαρα Κλαύδιον Σεβαστὸν Γερμανικὸν Θεοῦ υἱὸν στρατηγοῦντος ἐπὶ τοὺς ὁπλίτας τὸ ὄγδοον τοῦ καὶ ἐπιμελητοῦ καὶ νομοθέτου Τι Κλαυδίου Νουίου τοῦ Φιλίνου ἐπὶ ἱερείας Παυλλείνης τῆς Καπίτωνος θυγατρός.

22 *IG* II² 1990.

23 The office of *epimeletes* was concerned with the building and dedication of monuments in Athens: Carroll (supra n. 20) 45–53.

24 Oliver (supra n. 9) 94–5.

25 *IG* II² 3535.

26 *IG* V¹ 509. See Spawforth (supra n. 20).

27 Philost. *VA* 4.22. οἱ Ἀθηναῖοι ξυνιόντες ἐς θέατρον τὸ ὑπὸ τῇ ἀκροπόλει προσεῖχον σφαγαῖς ἀνθρώπων, καὶ ἐσπουδάζετο ταῦτα ἐκεῖ μᾶλλον ἢ ἐν Κορίνθῳ νῦν, χρημάτων τε μεγάλων ἐωνημένοι ἤγοντο μοιχοὶ καὶ πόρνοι καὶ τοιχωρύχοι καὶ βαλαντιοτόμοι καὶ ἀνδραποδισταὶ καὶ τὰ τοιαῦτα ἔθνη, οἱ δ᾽ ὥπλιζον αὐτοὺς καὶ ἐκέλευον ξυμπίπτειν. ἐλάβετο δὲ καὶ τούτων ὁ Ἀπολλώνιος, καὶ καλούντων αὐτὸν ἐς ἐκκλησίαν Ἀθηναίων οὐκ ἂν ἔφη παρελθεῖν ἐς χωρίον ἀκάθαρτον καὶ λύθρου μεστόν. ἔλεγε δὲ ταῦτα ἐν ἐπιστολῇ. καὶ θαυμάζειν ἔλεγεν ὅπως ἡ θεὸς οὐ καὶ τὴν ἀκρόπολιν ἤδη ἐκλείπει τοιοῦτον αἷμα ὑμῶν ἐκχεόντων αὐτῇ.

28 Lucian, *Demon.* 57. Ἀθηναίων δὲ σκεπτομένων κατὰ ζῆλον τὸν πρὸς Κορινθίους καταστήσασθαι θέαν μονομάχων, προελθὼν εἰς αὐτούς, Μὴ πρότερον ταῦτα, ὦ Ἀθηναῖοι, ψηφίσησθε, ἂν μὴ τοῦ Ἐλέου τὸν βωμὸν καθέλητε." See C. P. Jones, *Culture and Society in Lucian* (London, 1986) 90–8; R. E. Wycherley, "The Altar of Eleos" *CQ* 4 (1954) 143–50.

29 Dio Chrys. *Or.* 31.121. νῦν δὲ οὐθέν ἐστιν ἐφ᾽ ὅτῳ τῶν ἐκεῖ γιγνομένων οὐκ ἂν αἰσχυνθείη τις. οἷον εὐθὺς τὰ περὶ τοὺς μονομάχους οὕτω σφόδρα ἐζηλώκασι Κορινθίους, μᾶλλον δ᾽ ὑπερβεβλήκασι τῇ κακοδαιμονίᾳ κἀκείνους καὶ τοὺς ἄλλους ἅπαντας, ὥστε οἱ Κορίνθιοι μὲν ἔξω τῆς πόλεως θεωροῦσιν ἐν χαράδρᾳ τινί, πλῆθος μὲν δυναμένῳ δέξασθαι τόπῳ, ῥυπαρῷ δὲ ἄλλως καὶ ὅπου μηδεὶς ἂν μηδὲ θάψειε μηδένα τῶν ἐλευθέρων, Ἀθηναῖοι δὲ ἐν τῷ θεάτρῳ θεῶνται τὴν καλὴν ταύτην θέαν ὑπ᾽ αὐτὴν τὴν ἀκρίπολιν, οὗ τὸν Διόνυσον ἐπὶ τὴν ὀρχήστραν τιθέασιν ὥστε πολλάκις ἐν αὐτοῖς τινα σφάττεσθαι τοῖς θρόνοις, οὗ τὸν ἱεροφάντην καὶ τοὺς ἄλλους ἱερεῖς ἀνάγκη καθίζειν.

30 C. P. Jones, *The Roman World of Dio Chrysostom* (Cambridge, MA, 1978) 26–35. On Greek polemic against Roman spectacles, see Robert 1940, 248–53.

31 Dio Cass. 54.7.2–3.

32 The affair is described by different authors as *res novae, stasis,* and *seditio*. Orosius (6.22.2) comments that the doors of the Temple of Janus, closed in 2 BC, were opened again twelve years later on account of the events in Athens. These and other sources recording unrest at Athens are collected in G. W. Bowersock, *Augustus and the Greek World* (Oxford, 1965) 101–11 = Chapter VIII: "Opposition among the Greeks," and Bowersock, "The mechanics of subversion in the Roman provinces" in *Fondation Hardt 33: Opposition et résistances à l'empire d'Auguste à Trajan* (Geneva, 1986) 291–320.

33 *Syll.*³ 783, 29–30.

34 See A. Spawforth, "Corinth, Argos, and the Imperial Cult, Pseudo-Julian, *Letters* 198" *Hesperia* 63 (1994) 211–32; also P. Graindor, 1927, 41; V. Ehrenberg, "Legatus Augusti et Tiberii?" in G. E. Mylonas & D. Raymond, eds., *Studies Presented to David Moore Robinson*, vol. 2 (St. Louis, MO, 1953) 943–4.

35 Tac. *Ann.* 1.76; 2.55.

36 Dio Cass. 57.18.5.

37 In addition to Athens, there is evidence for opposition on Rhodes in AD 44 (Dio Cass. 60.24.4), at Cyzicus in AD 25 (Tac. *Ann.* 4.36; Suet. *Tib.* 37.3; Dio Cass. 57.24.6–7, compare 54.7.6), and in Lycia in AD 43 (Dio Cass. 60.17.3; Suet. *Claud.* 25.3). Opposition to Rome may perhaps be inferred from Tiberius' legislation instructing all cities in the Greek East that had claims to *asylum* to present formal justification of those claims (Tac. *Ann.* 3.60–3; Suet. *Tib.* 37.3) and by the support gained in the Greek world by the three false Neros (men who claimed to be Nero), the first in AD 69, the second in AD 80, and the third in AD 88 (Tac. *Hist.* 1.2, 2.8; Dio Cass. 66.19.3; Suet. *Nero* 57.2).

38 Julian *Ep.* 198, 409A (Budé ed.).

39 The text is discussed and analyzed by Spawforth (supra n. 34).

40 Inscriptions on Roman temples in the West normally appear on the frieze. When they appear on the architrave, this is usually a later addition (as, for example, in the Severan inscription on the architrave of the Pantheon; the original dedicatory inscription of Hadrian appears on the frieze). There are examples in Hellenistic times of inscriptions on the entablatures of shrines, such as the distyle *heroön* of Mithridates VI at Delos, and other small temple-like structures, such as the *andra* at Labraunda. See P. Bruneau and J. Ducat, *Guide de Délos* (Paris, 1983) 222–3, fig. 77; A. C. Gunter, *Labraunda*, vol. 2, part 5, *Marble Sculpture* (Stockholm, 1995) 25, fig. 6. But such inscriptions on temples only became common in Greece during the high Imperial period: for example, Temple H (of Commodus) at Corinth. See C. K. Williams II, "The refounding of Corinth: Some religious attitudes" in S. Macready and F. H. Thompson, eds., *Roman Architecture in the Greek World* (London, 1987) 26–37, fig. 5.

41 It is difficult for this author, at least, to see the Parthenon inscription (text in n. 21) as anything but a straightforward dedication of that building to Nero, in anticipation of a visit by him to Athens (that the visit would not occur could not have been foreseen at the time). On Nero's visit to Greece and why he did not stop at Athens, see S. E. Alcock, "Nero at play? The emperor's Grecian Odyssey" in J. Elsner and J. Masters, eds., *Reflections of Nero* (London, 1994) 98–111. Some scholars, most recently J. Hurwit, have seen the inscription instead as an honorific decree in support of Nero's eastern campaigns against Armenia (implicitly equating the Parthians with the Persians, Athens' ancient foe): J. M. Hurwit, *The Athenian Acropolis: History, Mythology, and Archaeology from the Neolithic Era to the Present* (Cambridge, U.K. and New York, 1999) 280–1; also Spawforth (supra n. 20). But there is nothing in the text of the inscription remotely concerning Nero's eastern campaign against the Parthians, which in AD 61/62 had anyway only just begun. Regardless of the precise interpretation of the Parthenon inscription, it should be said that the architectural innovations in Neronian Athens associated with Novius should to be added to those of other pivotal periods of the architecture of Roman Athens (namely, the Augustan and Hadrianic eras), which have been outlined in two important survey articles: T. L. Shear, Jr., "Athens: From City-State to Provincial Town" *Hesperia* 50 (1981) 356–77; and H. A. Thompson, "The impact of Roman architects and architecture on Athens, 170 B.C. – A.D. 170," in S. Macready and F. H. Thompson, eds., *Roman Architecture in the Greek World* (London, 1987) 1–17.

42 On this building, see H. N. Fowler and R. Stillwell, *Corinth* I, part 1: *Introduction, Topography, Architecture* (Cambridge, MA, 1932) 89–91, figs. 54–56 with plan, p. 79; Golvin 1988, 138; S. P. Lampros, "Über das korinthische Amphitheater" *MDAI(A)* 2 (1877) 282–8 with plan Taf. XIX; Robert 1940, 33, 117, no. 61; F. J. de Waele, *Theater en amphitheater te oud Korinthe* (Utrecht, 1928) 25–31. See also Friedländer IV, 230; E. Dodwell, *A Classical and Topographical Tour through Greece*, II (London, 1819) 191; W. Leake, *Travels in the Morea*, vol. 3 (London, 1830 [repr. 1968]) 244–5; A. Blouet et al., *Expédition scientifique de Morée ordonné par le gouvernement français*, III (Paris, 1838) 36–7, pl. 77, fig. III; E. Curtius, *Peloponnesus*, vol. II (Gotha, 1850) 527; W. Vischer, *Erinnerungen und Eindrücke aus Griechenland* (Basel, 1875) 264–5.

43 Golvin 1988, 138, mentions excavations, but there is no record of such in the literature.

44 Fowler and Stillwell (supra n. 42) 90. No remains of a superstructure were noted by any of the early travelers.

45 There is also a sketch plan of the building in de Waele (supra n. 42).

46 On these *portae*, see Golvin 1988, 323.

47 An inscription relates that the *venatores* of Corinth (θηραίτορες ἄνδρες) erected a bronze statue of their *doctor* Trophimos "near the entrances of the beasts" (ἐγγὺς θηρείων ἱστάμενοι στομάτων): Robert 1940, 33, 117, no. 61. The στομάτα might refer to a pair of starting gates for gladiators (*carceres*) located one at either side of the "*porta triumphalis*," as one finds in many amphitheatres (as at Pompeii). The word στόμα exists in no other gladiatorial inscription, as far as the author is aware.

48 Fowler and Stillwell (supra n. 42) 90; de Waele 1928 (supra n. 42) 26; Vischer 1875 (supra n. 42) 264–5.

49 The stone is too soft to have made *cavea* substructures possible, since the superstructure would have collapsed. I thank geologist Christopher Hayward, with whom I examined the amphitheatre, for this information.

50 Lampros (supra n. 42) 286–8 with text of Grimani's letter, now located in the Archivio dei Frari, Venice (doc. 120, file 8: Dispacci dei Provveditori): "But it will be convenient to close it with a wall above it for greater security of persons, their effects, and their health. Being at some distance from the sea it would not be accessible to the people and goods that could arrive from Lepanto to Salona, once those places have fallen under our dominion. According to the agreement, one could either change the site of the hospital or make two, yet we have so far believed our object to be one of economy, to take advantage of what we have, and to change it later on in the form in the enclosed plan, in which are indicated in different colors that which is already built and that which needs to be added with due caution at the entrance and with the house of the Warden in a position overlooking the whole area, in which a detachment of soldiers, when valuable goods should come, would ensure that the valuables would be contained and guarded in the grottoes."

"Ma converrà serrarlo con Muro di sopra a maggior sicurezza delle persone, degli effetti e della salute. Distante dal Mare non sarà cosi opportuno per le Genti e robbe che capitassero da Lepanto a Salona, ricaduti che siano quei Luochi sotto il Dominio della Porta. Tuttavia, secondo il negotio, potrà o mutarsi il sito del Lazzaretto, or farne due, havendo per hora creduto bene coll' ogetto alla minor spesa et al presente bisogno valermi d'esso e ridurlo poi al prossimo giungere de Muratori Rumeliotti nella forma delineata nell' unito disegno, in cui si scorge dalla diversità de colori ciò che vi sia d'eretto, e che pur deve aggiungervisi colla dovuto cautela all' ingresso, e colla casa per il Priore in sito soldati, quando pervenissero merci di valore, assicurarebbe i Capitali ben rinchiusi e custoditi nelle Grotte."

51 As pointed out by Lampros (supra n. 42), 287–8; and de Waele (supra n. 42), 30.

52 Golvin 1988, 138, interpreting Grimani's plan incorrectly, writes that the amphitheatre had two phases: the first was a rock-cut amphitheatre comprising the *ima* and *media cavea*, and a later phase consisted of a *summa cavea* supported on masonry compartments. But the "ensemble de petits 'caissons' maçonnnés"

that Golvin adduces are in fact the planned, but never executed, storage rooms of Grimani's facility.

53 Paus. 2.2.4; 2.3.6; 2.4.5. On Pausanias' selection of monuments to record (with preference often given to older Greek ones), see (with bibliography) S. E. Alcock, J. F. Cherry, and J. Elsner, eds., *Pausanias. Travel and Memory in Roman Greece* (Oxford, 2001) esp. 185ff.

54 Lampros (supra n. 42) 282–3; Friedländer IV, 230; de Waele 1928 (supra n. 42), 26–7; Fowler and Stillwell (supra n. 42), 90–1; Golvin 1988, 138, n. 394; Leake (supra n. 42), 244–5. O. Broneer, *Corinth* X: *The Odeum* (Cambridge, MA, 1932) 147, n. 1, suggests an early-third century AD date for the amphitheatre, corresponding to the probable date of the conversion of the odeion for gladiatorial games.

55 This assumption about the amphitheatre seems to be based partly on the fact that a mid-fourth century AD geography (*Liber iunioris philosophi in quo continentur totius orbis descriptio* 28) mentions that Corinth "has an excellent amphitheatre" (*habet et opus praecipuum amphitheatrum*): text quoted in de Waele (supra n. 42), 26, n. 51. The fact that Apuleius (*Met.* 10.18) mentions a three-day *munus* at Corinth also seems to have informed the frequent suggestion of an Antonine date for the amphitheatre.

56 See Wiedemann 1992, 128–64 = Ch. 4: "Opposition and Abolition."

57 Golvin 1988, 40–2. Like the amphitheatre at Corinth, the amphitheatre at Carmo was rock-cut and had a wooden superstructure (Appendix: Cat. 17).

58 D. G. Romano, "Post 146 B.C. land use in Corinth and planning of the Roman colony of 44 B.C.," in T. E. Gregory, ed., *The Corinthia in the Roman Period* (Ann Arbor, 1994) 9–30.

59 M. E. H. Walbank ("The foundation and planning of early Roman Corinth" *JRA* 10 [1997] 95–130, esp. 124–5) claims that in the first century A.D. the depression where the amphitheatre was located was a natural geological feature (hence, Dio Chrysostom's characterization of it as a "ravine" or "torrent"), which was only later monumentalized as a genuine amphitheatre. Any permanent structure for gladiatorial games, she alleges, must date to after the time of Dio's Rhodian oration (that is, after the 70s AD). It is not clear, however, whether the depression was a natural feature or whether it was quarried in its entirety out of the surrounding bedrock. Moreover, there is no evidence, textual or archaeological, that the amphitheatre was rebuilt later than the first century AD. Dio's characterization should not be taken literally. It is as much a rhetorical dismissal of the amphitheatre's importance as an institution as it is a caricature of its functional appearance. Such a functional, undecorated appearance is, however, perfectly consistent with late-republican amphitheatre architecture (see Chapter Three and Appendix).

60 Strabo 8.6.23; 17.3.15; Plut. *Vit. Caes.* 57. A probable link between veteran settlement/Roman colonization and the spread of gladiatorial games in the Greek world is noted by B. Levick, *Roman Colonies in Southern Asia Minor* (Oxford, 1967) 192. See also F. Vittinghoff, *Römische Kolonisation und Burgerrechtspolitik unter Caesar und Augustus* (Wiesbaden, 1952) 86–7. My argument is simply that detachments of colonists from Rome would have been particularly keen on building an amphitheatre. Walbank (supra n. 59) seems to think that it hangs on veteran settlement at Corinth, for which there is "slight and ambiguous evidence" (p. 124, n. 107). Although my argument does not depend

specifically on a veteran presence at Corinth, the literary testimony that veterans were settled there is not at all ambiguous (Plut. *Vit. Caes.* 57): "in the effort to surround himself with men's goodwill as the fairest and at the same time securest protection, he [Julius Caesar] again courted the people with banquets and distribution of grain, and his soldiers with the newly planted colonies, the most conspicuous of which were Carthage and Corinth." See P. A. Brunt, *Italian Manpower. 225 B.C. – A.D. 14* (Oxford, 1971) 256, 598; Keppie 1983, 58. In the Augustan period, also, some veterans were settled in Achaia (presumably at Corinth and its surrounding territory), as we read in Augustus, *RG*, 28.

61 For Knossos, see Vittinghoff (supra n. 60) 131; foldout plan in S. Hood and D. Smyth, *Archaeological Survey of the Knossos Area* (2nd ed., London, 1981) 22–3, see map no. 110. For Gortyn: M. Ricciardi, "L'anfiteatro ed il grande teatro romano di Gortina" *ASA* 64–65 (1986–7) 327–51. A badly preserved building at Patras (veteran colony of Augustus) may be an amphitheatre, but my own examination of its remains leads me to believe that it was a stadium (it has straight sides); on this structure, see I. A. Papapostolou, "Monuments des combats de gladiateurs à Patras" *BCH* 113 (1989) 351–401. I. A. Papapostolou, "Themata Topographias kai Poleodomias ton Patron kata te Romaiokratia" in A. D. Rizakis, ed., *Achaia und Elis in der Antike* (Athens and Paris, 1991) 305–20; A. D. Rizakis, "La Colonie romaine de Patras en Achaie: Le témoignage épigraphique" in S. Walker and A. Cameron eds., *The Greek Renaissance in the Roman Empire* (London, 1989) 185.

62 Syrian Antioch: see Cat. 19 in Appendix. Roman presence in Pergamon: Cassius Dio 51.20–1. Amphitheatre at Pergamon: W. Radt, *Pergamon. Geschichte und Bauten, Funde und Erforschung einer antiken Metropole* (Cologne, 1988) 292–5; Golvin, 1988, 203. Cyzicus: Golvin, 1988, 202–3. Pisidian Antioch (a wooden amphitheatre; see Chapter Two): *AE* 1926 no. 78; Vittinghoff (supra n. 60); Levick (supra n. 60) 42–6 (on the colony).

63 An illustration of this shift in power is provided by the earliest coinage of the colony, which reveals that the *duumviri* (chief magistrates) were all citizens of Rome and seen to have included men of servile origin. They have Latin *praenomina* and *nomina* with variable Latin or Greek cognomina: see M. Amandry, *Le monnayage des duovirs Corinthiens* (Paris, 1988) 26–43.

64 Spawforth (supra n. 34) argues that in AD 54, to mark the accession of Nero, a cult of the emperors was instituted at Corinth by the member cities of the Achaean League, with its focus on the annual imperial cult festival. This event would also have provided additional incentive for the Athenian conversion of the orchestra of the Theatre of Dionysos for Roman spectacles.

65 A city's stadium could be outfitted for particularly large wild beast shows. See Welch (supra n. 10).

66 On the use of traditional symbols and customs as a way of enhancing distinctive status (Greek in this case) and the notion of an allegiance to the past in an effort to "stay Greek," see G. Woolf, "Becoming Roman, staying Greek: Culture, identity and the civilizing process in the Roman East" *PCPS* 40 (1994) 116–43, esp. 126–8; S. E. Alcock, "Greece: A landscape of resistance?" in D. J. Mattingly, ed., *Dialogues in Roman imperialism, JRA* Supp. No. 23 (Portsmouth, RI, 1997) 103–15, esp. 111ff and S. E. Alcock, *Archaeologies of the Greek Past: Landscape, Movements, and Memories* (Cambridge and New York, 2002) esp. 36–38. Also, F. Yegül, *Baths and Bathing in Classical Antiquity* (Cambridge, MA, 1992) 250–313.

67 See Ville 1981, 389–95; Wiedemann 1992, 11–12, 47, 56; P. Sabbatini Tumolesi, *Gladiatorum paria: Annunci di spettacoli gladiatorii a Pompeii* (Rome, 1980) 133–8.

68 Translated by A. S. F. Gow and D. L. Page, *The Greek Anthology: The Garland of Philip and Some Contemporary Epigrams* I (London, 1968) no. 37, 220–1. The description of the colonists as "shop-soiled slaves" expressed Greek disdain for Corinth's new colonists, many of whom were indeed ex-slaves (freedmen); see Spawforth (supra n. 34) 227–8.

69 See R. Stillwell, *Corinth* II: *the Theatre* (Princeton, 1952), esp. 84–98; M. Sturgeon, *Sculpture: The Assemblage from the Theater Corinth* IX 3 (Princeton, 2004).

Conclusion

1 Cic. *Tusc.*, 2.41. *Oculis quidem nulla poterat esse fortior contra dolorem et mortem disciplina.*

Appendix: Amphitheatres of Republican Date

1 See P. Gros, *L'architecture romaine du début du IIIe siècles av. J.-C. à la fin du Haut-Empire I. Les monuments publics* (Paris, 1996) 323–41.

2 P. Gros, *Architecture et société à Rome et en Italie centro-méridionale aux derniers siècles de la République, Collection Latomus*, vol. 156 (Brussels, 1978) 43.

3 F. Coarelli, "Public building in Rome between the Second Punic War and Sulla" *PBSR* 45 (1977) 1–23.

4 M. Wilson Jones, "Designing Amphitheatres" *MDAI(R)* 100 (1993) 391–442, fig. 2a.

5 The earliest definite example is the amphitheatre at Verona, which is Julio-Claudian in date, but Augustan amphitheatres, such as that at Augusta Praetoria (on which see Chapter Four), are likely to have been the first to be designed using the new method (Wilson Jones, supra n. 4). The free-standing Amphitheatre of Taurus may very well have been the first amphitheatre to have been planned this way, in my view.

6 There is a late-republican elliptical enclosure (perhaps originally an amphitheatre or livestock pen, but much altered in subsequent centuries) directly adjacent to the forum at the Roman city of Egnatia in Puglia. See E. Greco, *Magna Grecia* (Rome, 1980) 237; A. Donvito, *Egnazia: dalle origini alla riscoperta archeologica* (Brindisi, 1988) 137, fig. 96; G. Andreassi, "La città nel tempo" *in Mare d'Egnazia* (Fasano, 1982) 15–22. A comparable structure also exists at Mignano Montelungo in the region of Caserta: *Atti* 1996, 406 with 404, fig. 1.

BIBLIOGRAPHY

M. Aberson, *Temples votifs et butin de guerre dans la Rome republicaine* (Rome, Institut suisse de Rome, 1994).

J.-P. Adam, *La construction romaine: matériaux et techniques* (Paris, Picard, 1984).

J.-P. Adam, "L'amphithéâtre de Pompei un siècle et demi avant le Colisée, déjà les combats sanglants de l'arène" in *Pompei: A l'ombre du Vesuve. Collections du musée nationale d'archéologie de Naples* (Paris, Paris-Musées, Picard, 1995) 204–7.

S. E. Alcock, *Archaeologies of the Greek Past: Landscape, Monuments, and Memories* (New York, Cambridge University Press, 2002).

S. E. Alcock, "Nero at play? The emperor's Grecian Odyssey," in J. Elsner & J. Masters, eds., *Reflections of Nero: Culture, History, & Representation* (London, Duckworth, 1994) 98–111.

S. E. Alcock, "Greece: A landscape of resistance?" in D. J. Mattingly, ed., *Dialogues in Roman imperialism: power, discourse, and discrepant experience in the Roman Empire*, *JRA* Supp. No. 23 (Portsmouth, RI, 1997) 103–15.

S. E. Alcock, J. F. Cherry, J. Elsner, eds., *Pausanias: Travel and Memory in Roman Greece* (Oxford, Oxford University Press, 2001).

G. Alföldy, "Eine Bauinschrift aus dem Colosseum" *ZPE* 109 (1995) 195–226.

M. Almagro, "El anfiteatro y la palestra de Ampurias," *Ampurias* 17–18 (Barcelona, Imprenta Rubiralta, 1955–1956) 1–26.

J. M. Álvarez Martínez, & J. J. Enríquez Navascués, eds., *El anfiteatro en la Hispania romana. Coloquio Internacional Mérida, 26–28 de Noviembre 1992* (Mérida, Junta de Extremadura, Consejieria de Cultura y Patrimonio, 1994).

M. Amandry, *Le monnayage des duovirs Corinthiens* (Paris, De Boccard, 1988).

C. M. Amici, "Iter progettuale e problemi architettonici dell' anfiteatro di Lecce," in F. D. D'Andria, *Metodologie di catalogazione dei beni archeologici* (Lecce, Martano; Bari: Edipuglia, 1997) 181–98.

J. C. Anderson, jr., *Historical Topography of the Imperial Fora.* Collection Latomus. vol. 182 (Brussels, 1984).

J. C. Anderson, jr., *Roman Architecture and Society* (Baltimore and London, Johns Hopkins University Press, 1997).

G. Andreassi, "La città nel tempo" in *Mare d'Egnazia dalla preistoria ad oggi: ricerche e problemi: Museo nazionale di Egnazia* (Fasano, Schena, 1982) 15–22.

P. Arthur, *Romans in Northern Campania, Settlement and Land-use Around the Massico and Garigliano Basin* (Archaeological Monographs of the British School at Rome, vol. 1, London, British School at Rome, 1991).

R. Auguet, *Cruauté et civilisation: les jeux romains* (Paris, Flammarion, 1970).

S. Aurigemma, "Gli anfiteatri di Placentia, di Bononia, e Forum Cornelii" *Historia: Studi storici per l'antichità classica* 6, 558–87.

B. Baldwin, "Better Late than Early: Reflections on the Date of Calpurnius Siculus" *Illinois Classical Studies* 20, 157–67.

E. Baltrusch, "Die Verstaatlichung der Gladiatorenspiele" *Hermes* 116 (1988) 324–37.

R. Bartoccini, "L'anfiteatro di Lucus Feroniae e il suo fondatore" *Rendiconti della Pontificia Accademia romana di archeologia* 33 (1960–1) 173–84.

E. Bartman, "Sculptural Collecting and Display in the Private Realm" in E. Gazda, ed., *Roman Art in the Private Sphere: New Perspectives on the Architecture and Décor of the Domus, Villa, and Insula* (Ann Arbor, University of Michigan Press, 1991) 71–88.

C. A. Barton, *The Sorrows of the Ancient Romans: The Gladiator and the Monster* (Princeton, Princeton University Press, 1993).

R. A. Bauman, *Crime and Punishment in Ancient Rome* (London, Routledge, 1996).

R. C. Beacham, *The Roman Theatre and Its Audience* (Cambridge, MA, Harvard University Press, 1991).

M. J. V. Bell, "Tactical reform in the Roman Republican army" *Historia* 14 (Wiesbaden, F. Steiner, 1965) 404–22.

J. Beloch, *Campanien, Geschichte und Topographie des antiken Neapel und seiner Umbegung* (Breslau, Morgenstern, 1990).

M. Bendala Galán & R. Durán Cabello, "El anfiteatro de Augusta Emerita: rasgos arquitectónicos y problemática urbanística y cronologia" in J. M. Alvárez Martínez and J. J. Enríquez Navascués, eds., *El anfiteatro en la Hispania Romana* (Mérida, Junta de Extremadura, Consejeria de Cultura y Patrimonio, 1994) 247–64.

M. Bergmann, *Der Koloss Neros, die Domus Aurea und der Mentalitätswandel im Rom der frühen Kaiserzeit* (Mainz, P. von Zabern, 1994).

M. Bergmann, *Die Strahlen der Herrscher: theomorphes Herrscherbild und politische Symbolik im Hellenismus und in der römischen Kaiserzeit* (Mainz, P. von Zabern, 1998).

B. Bergmann & C. Kondoleon, eds., *The Art of Ancient Spectacle* (New Haven, Yale University Press, 1999).

M. Bernardini, *Lupiae* (Lecce, Centro di studi salentini, 1959).

F. Bernstein, *Ludi publici. Untersuchungen zur Entstehung und Entwicklung der öffentlichen Spiele im republikanischen Rom* (Stuttgart, F. Steiner, 1998).

H.-J. Beste, "Relazione sulle indagini in corso nei sotteranei, i cosidetti ipogei" *MDAI(R)* 105 (1998) 106–18.

H.-J. Beste, "Neue Forschungsergebnisse zu einem Aufzugssystem im Untergeschloss des Kolosseums" *MDAI(R)* 106 (1999) 249–76.

H.-J. Beste, "I sotterranei del Colosseo: impianto, trasformazione e funzionamento," A La Regina, ed., *Sangue e Arena* (Milan, Electa, 2001) 277–99.

M. Bevilacqua, *Il monte dei Cenci: una famiglia romana e il suo insediamento urbano tra Medioevo ed età barocca* (Rome, Gangemi, 1988).

M. Bieber, *The History of the Greek and Roman Theater* (Princeton, Princeton University Press, 2nd ed. 1961).

N. Biffi, *L'Italia di Strabone. Testo, traduzione e commento dei libri V e VI della Geografia* (Genova, Università di Genova, 1988).

E. M. Blake, *Ancient Roman Construction in Italy from the Prehistoric Period to Augustus. A Chronological Study based in part upon the Material Accumulated by Esther Boise Van Deman* (Washington, Carnegie Institution of Washington, 1947).

A. Blouet et al., *Expédition scientifique de Morée ordonné par le gouvernement français* III (Paris, Firmin Didot, 1838).

A. R. Blumenthal, *Theater Art of the Medici* (Hanover, NH, Dartmouth College Museum and Galleries, 1980).

M.T. Boatwright, "Hadrian and Italian cities" *Chiron* 19 (1989) 235–71.

A. Boëthius, "*Maeniana*. A study of the Forum Romanum of the fourth century B.C." *Eranos* 43 (1945) 89–110.

A. Boëthius, *The Golden House of Nero* (Ann Arbor, University of Michigan Press, 1960) 94–128.

A. Boëthius & J. B. Ward-Perkins, *Etruscan and Roman Architecture* (Harmondsworth and New York, Penguin Books, 1970).

D. L. Bomgardner, "Amphitheatres on the fringe" *JRA* 4 (1991) 282–94.

D. L. Bomgardner, *The Story of the Roman Amphitheatre* (London and New York, Routledge, 2000).

L. Bonfante, ed., *Etruscan Life and Afterlife: A Handbook of Etruscan Studies* (Detroit, MI, Wayne State University Press, 1986).

M. Bonghi Jovino, "The Etruscans expansion into Campania," in M. Torelli ed., *The Etruscans* (Milan, Bonpiani, 2000) 157–8.

A. Bonnet Correa, "Arquitectura de las plazas de toros en Madrid" in M. Kramer ed., *Las Ventas: 50 años de corridas* (Madrid, Excelentísima Diputación Provincial de Madrid, 1981) 20–40.

G. W. Bowersock, *Augustus and the Greek World* (Oxford, Clarendon Press, 1965).

G. W. Bowersock, "The mechanics of subversion in the Roman provinces" in Fondation Hardt, tome 33: *Opposition et résistances à l'Empire d'Auguste à Trajan* (Geneva, 1986) 291–320.

K. R. Bradley, *Slavery and Rebellion in the Roman World, 140 B.C.–70 B.C.* (Bloomington, Indiana University Press and London, B.T. Batsford, 1989).

E. Brizio, *Pitture e sepolcri scoperti sull'Esquilino dalla Campagnia fondiaria italiana nell' anno 1875* (Rome, Tipografia Elzeviriana, 1876).

P. Broise, "Éléments d'un ordre Toscan provincial en Haute-Savoie" *Gallia* 27 (1969) 15–22.

O. Broneer, *Corinth* X: *The Odeum* (Cambridge, MA, Harvard University Press, 1932).

R. C. Bronson, "Chariot racing in Etruria" in *Studi in onore di Luisa Banti* (Rome, Roma "L'Erma" di Bretschneider, 1965) 89–106.

T. R. S. Broughton, *The Magistrates of the Roman Republic* I–II (New York, American Philological Association, 1951–2).

F. E. Brown, *Cosa: The Making of a Roman Town* (Ann Arbor, University of Michigan Press, 1980).

F. E. Brown, E. Richardson, & L. Richardson jr., *Cosa* III. *The Buildings of the Forum* (*MAAR* 37, University Park, PA, 1993).

F. E. Brown, E. Richardson, & L. Richardson jr., *Cosa* III. *The Buildings of the Forum: Colony, Municipium, and Village* (*MAAR* 40, University Park, PA, Pennsylvania State University Press, 1993).

S. Brown, "Death as Decoration: Scenes from the Arena on Roman Domestic Mosaics" in A. Richlin, ed., *Pornography and Representation in Greece and Rome* (New York, Oxford University Press, 1992) 180–211.

S. Brown, "Explaining the arena: did the Romans 'need' gladiators?" *JRA* 8 (1995) 376–84.

P. Bruneau & J. Ducat, *Guide de Délos* (Paris, E. de Boccard, 1965).

P. A. Brunt, "The Army and the Land in the Roman Revolution" *JRS* 52 (1962) 69–86.

P. A. Brunt, *Italian Manpower 225 B.C. – A.D. 14* (Oxford, Clarendon Press, 1971).

P. Bruschetti, *Carsulae* (Rome, Istituto Poligrafico e Zecca dello Stato, 1995).

F. Buecheler, "Die staatliche Anerkennung des Gladiatorenspiels" *Zeitschrift Rheinische Museum Für Philologie* 38 (1883) 476–9.

M. Bulard, *La religion domestique dans la colonie italiennne de Délos d'après les peintures murales et les autels historiés* (Paris, E. de Boccard, 1926).

P. Cagniart, "The Philosopher and the Gladiator" *Classical World* 93 (2000) 607–18.

M. L. Caldelli & C. Ricci, *Monumentum familiae Statiliorum: un riesame* (Rome, Quasar, 1999).

A. Cameron, *Circus Factions: Blues and Greens at Rome and Byzantium* (Oxford, Clarendon Press, 1976).

I Campi Flegrei nell' archeologia e nella storia: convegno internazionale, Roma, 4–7 maggio 1976 (Rome, Accademia Nazionale dei Lincei, 1977).

F. Canali De Rossi, "*Claros I, Décrets hellénistiques* par L. et J. Robert" *Athenaeum* 79 n.s. (1991) 646–8.

E. Cantarella, *I supplizi capitali in Grecia e a Roma* (Milan, Rizzoli, 1991).

H. V. Canter, "The Venerable Bede and the Colosseum" *TAPA* 61 (1930) 150–64.

A. M. Capoferro Cencetti, "Gli anfiteatri romani dell' Aemilia" *Studi sulla città antica. L'Emilia Romagna* (Rome, L'Erma di Bretschneider, 1983) 245–82.

A. M. Capoferro Cencetti, "Gli anfiteatri romani dell'Emilia Romagna," in *Spettacolo in Aquileia e nella Cisalpina romana* (Udine, Arti Grafiche Friulane, 1994) 301–46.

P. Caputo, "Bacoli (Naples). Cuma: Indagini archeologiche all' anfiteatro" *BdA* 22 (1993) 130–2.

J. Carabia, "Felicissimus ou la perfection: l'épitaph d'un jeun médecin d'Aix-en-Province" *Etudes Antiques* (*Trames:* Limoges, Université de Limoges, 1985).

A. Carandini, "Domus aristocratiche sopra le mura e il pomerio del Palatino," in M. Cristofani, ed., *La grande Roma dei Tarquini* (Rome, "L'Erma" di Bretschneider, 1990) 97–9.

G. Carettoni, "Le gallerie ipogee del Foro Romano e i ludi gladiatori forensi" *Bull. Com. Arch.* 76 (1956–8) 23–44.

S. Carey, "*In memoriam (perpetuam) Neronis 'Damnatio Memoriae'* and Nero's Colossus" *Apollo* 152 (2000) 20–31.

K. K. Carroll, *The Parthenon Inscription* (Durham, NC, Duke University, 1982).

F. Castagnoli, "Gli edifici rappresentati in un rilievo del sepolcro degli Haterii" *Bull. Com. Arch.* 69 (1941) 59–69.

F. Castagnoli, "La 'carta archeologica d' Italia' e gli studi di topografia antica" *Quaderni dell' Istituto di Topografia Antica 6: Ricognizione archeologica e documentazione cartografica* (Rome, Leo Olschki, 1974) 7–17.

P. Castrén, *Ordo populusque pompeianus. Polity and society in Roman Pompeii* (Rome, Bardi, 1975).

M. Cébeillac-Gervasoni & F. Zevi, "Des femmes-gladiateurs dans une inscription d'Ostie" *MEFRA* 88 (1976) 612–20.

E. Cecconi, G. Cencini, & G. Romanini, *L'anfiteatro di Arezzo. Rilievi, notizie storiche ed ipotesi di ricostruzione come esperienza didattica* (Arezzo, Istituto tecnico statale per geometri "V. Fossombroni," 1988).

E. Champlin, "The Life and Times of Calpurnius Siculus" *JRS* 68 (1978) 95–110.

E. Champlin, "God and man in the golden house" in M. Cima & E. La Rocca, eds., *Horti romani; atti del convegno internazionale, Roma, 4–6 maggio 1995* (Rome, "L'Erma" di Bretschneider, 1998) 333–44.

E. Champlin, "*Aeternumque tenet per saecula nomen:* Property, Place-Names and Prosopography" in W. Eck ed., *Prosopographie und Sozialgeschichte: Studien zur Methodik und Erkenntnismöglichkeit der kaiserzeitlichen Prosopographrie* (Vienna, Böhlau, 1993) 51–9.

E. Champlin, *Nero* (Cambridge, MA, Harvard University Press, 2004).

P. Choné et al., *Jacques Callot 1592–1635* (Paris, Editions de la Réunion des musées nationaux, 1992).

G. Ciampoltrini, "Lucca: Ricerche nell'area dell'anfiteatro" *BdA* 16–18 (1992) 52–5.

G. Ciampoltrini, "*Municipali ambitione:* La tradizione locale negli edifici per spettacolo di Lucca romana" *Prospettiva* 67 (1992) 39–48.

P. Ciancio Rossetto, "Le maschere del teatro di Marcello" *Studi Romani* 22 (1974) 74–6.

P. Ciancio Rossetto, "Le maschere del teatro di Marcello" *Bull. Com. Arch.* 88 (1982–3) 7–49.

P. Ciancio Rossetto, "Les masques du Théâtre de Marcellus" *Histoire et archéologie. Les dossiers*, 82 (Dijon, 1984).

P. Ciancio Rossetto, "Le maschere del teatro di Marcello, teatro Argentina" *Bollettino dei Musei comunali di Roma* 5 (1991) 121–7.

P. Ciancio Rossetto, "Le maschere del teatro di Marcello a Roma" in C. Landes, ed., *Spectacula 2: Le théâtre antique et ses spectacles. Actes du colloque tenu au Musée archéologique Henri Prades de Lattes les 27–30 avril 1989* (Lattes, Editions Imago: Musée archéologique Henri Prades, 1992) 187–95.

P. Ciancio Rossetto & G. Pisani Sartorio, eds. *Teatri greci e romani: alle origini del linguaggio rappresentato: censimento analitito* 3 vols. (Rome, Edizioni SEAT, 1994).

M. Cipriani, "Prime presenze italiche organizzate alle porte di Poseidonia" in M. Cipriani, F. Longo, & M. Viscione, eds., *I Greci in occidente. Poseidonia e i Lucani* (Naples, Electa, 1996) 119–58.

A. Claridge, *Rome: An Archaeological Guide* (Oxford and New York, Oxford University Press, 1998).

F. Coarelli, "La Porta Trionfale e la Via dei Trionfi" *Dial. di Arch.* 2 (1968) 55–103.

F. Coarelli & L. Franzoni, *L'arena di Verona. Venti secoli di storia* (Verona, Ente Autonomo Arena di Verona, 1972).

F. Coarelli, *Guida archeologica di Roma* (Milan, A. Mondadori, orig. publ. 1974, rev. eds., 1989, 1994, etc.).

F. Coarelli, "Lucus Feroniae" *Studi Classici e Orientali* 24 (1975) 164–6.

F. Coarelli, "Public Building in Rome between the Second Punic War and Sulla" *PBSR* 45 (1977) 1–23.

F. Coarelli, *Il Foro romano: periodo archaico* (Rome, Quasar, 1983).

F. Coarelli, "Il Pantheon, l'apoteosi di Augusto e l'apoteosi di Romolo" in *Città e architettura nella Roma imperiale* (Odense, Odense University Press, 1983) 41–6.

F. Coarelli, *Il Foro Romano: periodo repubblicano e augusteo* (Rome, Quasar, 1985).

F. Coarelli, *Il Campo Marzio* (Rome, Quasar, 1997).

F. Coarelli, "Gli anfiteatri a Roma prima del Colosseo," in A. La Regina et al., eds., *Sangue e arena* (Milan, Electa, 2001) 43–8.

P. Colagrossi, *L'Anfiteatro Flavio nei suoi venti secoli di storia* (Florence, Libreria editrice fiorentina, 1913).

K. M. Coleman, "Fatal Charades: Roman Executions Staged as Mythological Enactments" *JRS* 80 (1990) 44–73.

K. M. Coleman, "Launching into History: Aquatic Displays in the Early Empire" *JRS* 83 (1993) 48–74.

K. M. Coleman, "Ptolemy Philadelphus and the Roman Amphitheater" in W. J. Slater, ed., *Roman Theater and Society: E. Togo Salmon Papers* I (Ann Arbor, University of Michigan Press, 1996) 49–68.

K. M. Coleman, "The *liber spectaculorum*" in F. Grewing, ed., *Toto notus in orbe. Perspektiven der Martial-Interpretation* (Stuttgart, F. Steiner, 1998) 15–36.

K. M. Coleman, "Entertaining Rome," in J. Coulston & H. Dodge, eds., *Ancient Rome: The Archaeology of the Eternal City* (Oxford, Oxford University School for Archaeology, 2000) 205–52.

A. M. Colini, *Stadium Domitiani* (Rome, Reale Istituto di Studi Romani, 1943).

A. M. Colini & L. Cozza, *Ludus Magnus* (Rome, Collana della Fondazione Monte dei Paschi di Siena, 1962).

La colonizzazione romana tra la guerra latina e la guerra annibalica. Dial. di Arch. 3rd series, 6.2 (1988).

G. Colucci Pescatori, "Evidenze archeologiche in Irpinia," in *La romanisation du Samnium aux IIe et Ie siècles av. J.-C.* (Naples, Centre Jean Bérard, 1991) 85–122.

M. L. Conforto et al., *Anfiteatro Flavio: immagine, testimonianze, spettacoli* (Rome, Edizioni Quasar, 1988).

C. Conti, "Il modello ligneo dell' anfiteatro flavio di Carlo Lucangeli: osservazioni nel corso del restauro," La Regina, ed., *Sangue e arena* (Milan, Electa, 2001) 117–25.

M. Conticello de' Spagnolis, *Il Tempio dei Dioscuri nel Circo Flaminio* (Rome, De Luca, 1984).

G. Cozzo, *Il Colosseo: L' Anfiteatro Flavio nella tecnica edilizia, nella storia delle strutture, nel concetto esecutivo dei lavori* (Rome, Fratelli Palombi, 1971).

M. H. Crawford, *Roman Statutes* (London, Institute of Classical Studies, 1996).

M. Crawford, *The Roman Republic*, 2nd ed. (Cambridge, MA, Harvard University Press, 1993).

G. Croci, *Studi e ricerche sul Colosseo* (Rome, Università degli studi La Sapienza, 1990).

J. A. Crook, *Law and Life of Rome* (Ithaca, NY, Cornell University Press, 1967).

E. Curtius, *Peloponnesus* vol. II (Gotha, J. Perthes, 1850).

C. Curtois, *Le bâtiment de scène des théâtres d'Italie et de Sicilie: étude chronologique et typologique* (Louvain-la-Neuve, l'Université Catholique de Louvain, 1989).

J. H. D'Arms, *Commerce and Social Standing in Ancient Rome* (Cambridge, MA, Harvard University Press, 1981).

R. H. Darwall-Smith, *Emperors and Architecture. A Study of Flavian Rome* (Collection Latomus vol. 231, Brussels, 1996).

P. J. E. Davies, *Death and the Roman Emperor: Roman Imperial Funerary Monuments from Augustus to Marcus Aurelius* (Cambridge and New York, Cambridge University Press, 2000).

R. W. Davies, "Fronto, Hadrian, and the Roman Army" *Latomus* 27 (1968) 75–95.

R. W. Davies, "Roman Military Training Grounds" in E. Birley, B. Dobson, & M. Jarrett eds., *Roman Frontier Studies 1969* (Cardiff, University of Wales Press, 1974).

R. W. Davies, *Service in the Roman Army* (New York, Columbia University Press, 1989).

J. Delorme, *Gymnasion: étude sur les monuments consacrés a l'education en Grèce des origines à l'Empire romain* (Paris, E. de Boccard, 1960).

S. De Caro & A. Greco, *Guide Archeologiche Laterza* 10: *Campania* (Rome-Bari, Laterza, 1981).

N. de Chaisemartin & D. Theodorescu, "Recherches préliminaires sur la *frons scaenae* du théâtre" in R. R. R. Smith & K. T. Erim eds., *Aphrodisias Papers 2: the theatre, a sculptor's workshop, philosophers, and coin-types* (*JRA* suppl. 2, Ann Arbor, 1991) 29–66.

M. de Duc de Loubat, "Inscriptions (1905–1908)" *BCH* 34 (1910) 404–5, 416–17.

F. de Ruyt, *Charun, démon étrusque de la mort* (Rome, Institute historique belge, 1934).

M. Della Corte, *Iuventus* (Naples, G. Fraioli 1924).

H. Devijver & F. van Wonterghem, "Neue Belege zum 'Campus' der römischen Städte in Italien und im Westen" *ZPE* 60 (1985) 147–58.

F. de Visscher, "L'amphithéâtre d' Alba Fucens et son fondateur Q. Naevius Macro, préfect du prétoire de Tibère" *Rend. Linc.* ser. VIII, XII (1957) 39–49.

F. J. de Waele, *Theater en amphitheater te oud Korinthe* (Utrecht, N. V. Dekker & Van de Vegt, en J. W. Van Leeuwen, 1928).

H. Dodge, "Amusing the Masses: Buildings for Entertainment and Leisure in the Roman world" in D. S. Potter & D. J. Mattingly, eds., *Life, Death, and Entertainment in the Roman Empire* (Ann Arbor, University of Michigan Press, 1999) 205–55.

E. Dodwell, *A Classical and Topographical Tour through Greece* 2 vols. (London, Rodwell and Martin, 1819).

C. Domergue, C. Landes, & J.-M., Pailler, eds., *Spectacula I: gladiateurs et amphithéâtres* (Paris, Editions Imago, Lattes: Musée archéologique Henri Prades, 1990).

A. Donvito, *Egnazia: dalle origini alla riscoperta archeologica* (Brindisi, Schena, 1988).

W. Dörpfeld & E. Reisch, *Das griechische Theater* (Athens, Barth & von Hirst, 1896 [repr. 1966]).

L. Du Jardin, "I pozzi della valle del Foro Romano" *Rend. Pont.* 7 (1930) 129–91.

K. M. D. Dunbabin, *The Mosaics of Roman North Africa: Studies in Iconography and Patronage* (Oxford and New York, Oxford University Press, 1978).

X. Dupré Raventós et al., *Excavaciones Arquelógicas en Tusculum. Informe de las campañas de 2000 y 2001* (Esquela Española de Historia y Archeología en Roma, Rome, 2002).

X. Dupré Raventós, ed., *Mérida, Colonia Augusta Emerita* (Rome, "L'Erma" di Bretschneider, 2004).

F. Dürrbach, ed., *Inscriptions de Délos* (Paris, H. Champion, 1923–37).

W. Eck, ed., *Prosopographie und Sozialgeschichte: Studien zur Methodik und Erkenntnismöglichkeit der kaiserzeitlichen Prosopographie* (Cologne, Böhlau, 1993).

École Françaises de Rome, *Spectacles sportif et scéniques dans le monde étrusco-italique* (Rome, "L' Erma" di Bretschneider, 1983).

I. E. M. Edlund-Berry, "Ritual Destruction of Cities and Sanctuaries: The 'Unfounding' of the Archaic Monumental Building at Poggio Civitate (Murlo)" in R. D. De Puma & J. Penny Small, eds., *Murlo and the Etruscans: Art and Society in Ancient Etruria* (Madison, WI, University of Wisconsin Press, 1994) 16–28.

J. C. Edmondson, "Dynamic Arenas: Gladiatorial presentations in the city of Rome and the Construction of Roman Society during the Early Empire" in W. J. Slater, ed., *Roman Theater and Society. E. Togo Salmon Papers* I (Ann Arbor, University of Michigan Press, 1996) 69–112.

J. C. Edmondson, "The Cultural Politics of Public Spectacle in Rome and the Greek East, 167–166 BCE" in B. Bergmann & C. Kondoleon, eds., *The Art of Ancient Spectacle* (New Haven, CT, Yale University Press, 1999) 77–95.

V. Ehrenberg, "Legatus Augusti et Tiberii?" in G. Mylonas & D. Raymond, eds., *Studies Presented to David Moore Robinson on his Seventieth Birthday*, vol. 2 (St. Louis, MO, Washington University, 1953) 938–44.

J. Elsner, "Constructing decadence: The representation of Nero as Imperial builder" J. Elsner & J. Masters, eds., *Reflections of Nero. Culture, History, and Representation* (London, Duckworth, 1994) 112–27.

A. Ernout & A. Meillet, *Dictionnaire étymologique de la langue latine*, 3rd ed. (Paris, C. Klincksieck, 1951).

R. Etienne, "La naissance de l'amphithéâtre: le mot et la chose" *Rev. Et. Lat.* (1965) 213–20.

G. Fabre, M. Mayer, & I. Rodà, *Inscriptions romaines de Catalogne* (Paris, de Boccard, 2002).

F. Fasolo & G. Gullini, *Il santuario della Fortuna Primigenia a Palestrina* (Rome, Università di Roma, 1953).

D. Favro, "Rome. The street triumphant: The urban impact of Roman triumphal Parades" in Z. Çelik, D. Favro, & R. Ingersoll, eds., *Streets: Critical Perspectives on Public Space* (Berkeley, University of California Press, 1994) 151–64.

D. Favro, *The Urban Image of Augustan Rome* (Cambridge and New York, Cambridge University Press, 1996).

A. T. Fear, "Status symbol or leisure pursuit? Amphitheatres in the Roman world" *Latomus* 59 (2000) 82–7.

J.-L. Ferrary, *Philhellénisme et impérialisme: Aspects idéologiques de la conquête romaine du monde hellénistique, de la seconde guerre de Macédoine à la guerre contre Mithridate* (Rome, École française de Rome, 1988).

E. R. Fiechter, *Das Dionysos-Theater in Athen*, 4 vols. (Stuttgart, W. Kohlhammer, 1935–50).

R. O. Fink, *Roman Military Records on Papyrus* (Cleveland, Press of Case Western Reserve University, 1971).

S. Follet, *Athènes au IIe et au IIIe siècle* (Paris, Les Belles Lettres, 1976).

W. W. Fowler, *The Roman Festivals of the Period of the Republic: An Introduction to the Study of the Religions of the Romans* (London and New York, Macmillan, 1899).

H. N. Fowler & R. Stillwell, *Corinth*, I.1, *Introduction, Topographie, Architecture* (Cambridge, MA, Harvard University Press, 1932).

T. Frank, ed., *An Economic Survey of Ancient Rome* I (Baltimore, MD, The Johns Hopkins Press, 1933).

M. Frederiksen, *Campania* (London, British School at Rome, 1984).

L. Friedländer, *Darstellungen aus der Sittengeschichte Roms in der Zeit von August bis zum Ausgang der Antonine*, 6th ed., 4 vols. (Leipzig, Hirzel, 1919) English translation: London, Routledge, and Kegan, Ltd., 1908.

M. Fulford, *The Silchester Amphitheatre. Excavations of 1979–85* (Britannia Monograph no. 10, London, 1989).

A. Futrell, *Blood in the Arena. The Spectacle of Roman Power* (Austin, TX, University of Texas Press, 1997).

E. Gabba, "Ricerche sull'esercito professionale romano da Mario ad Augusto" *Athenaeum* n.s. 29 (1951) 171–272.

E. Gabba, *Esercito e società nella tarda repubblica romana* (Florence, La nuova Italia, 1973).

A. Gabucci, ed., *Il Colosseo* (Milan, Electa, 1999).

V. Gaffney, H. Patterson, & P. Roberts, "Forum Novum-Vescovio: Studying urbanism in the Tiber valley" *JRA* 14 (2001) 58–79.

K. Galinsky, *Augustan Culture. An Interpretive Introduction* (Princeton, Princeton University Press, 1996).

G. Gatti, "Dove erano situati il Teatro di Balbo e il Circo Flaminio?" *Capitolium* 35 (Rome, 1960) 3–12.

D. J. Geagan, *The Athenian Constitution after Sulla, Hesperia:* Suppl. 12 (Princeton, American School of Classical Studies at Athens, 1967).

D. J. Geagan, "Tiberius Claudius Novius, the Hoplite Generalship and the *Epimeleteia* of the Free City of Athens" *AJPhil.* 100 (1979) 279–287.

G. Ghini, *Museo delle navi romane, e il Santuario di Diana a Nemi* (Rome, Istituto Poligrafico e Zecca dello Stato: Libreria dello Stato, 1992).

C. Gialanella, ed., *Nova antiqua phlegraea: nuovi tesori archeologici dai Campi Flegrei* (Milan, Electa, 2000).

G. Gifuni, *Lucera Augustea* (Urbino, S.T.E.U., 1939).

J. F. Gilliam, *Roman Army Papers* (Amsterdam, J. C. Gieben, 1986).

C. Giordano, "Nuove tavolette cerate pompeiane" *Rend. Acc. Nap.* 45 (1970) 211–31.

M. Girosi, "L'anfiteatro di Pompeii" *Memorie dell' Accademia di Archeologia, Lettere e Belle Arti di Napoli* 5 (Naples, G. Macchiaroli, 1936) 27–57.

C. F. Giuliani, "Lucca: il teatro e l'anfiteatro" *Atti. Centro ricerche e documentazione sull' antichità classica* 5 (1973–4) 287–95.

C. F. Giuliani, *L'Edilizia nell'antichità* (Rome, La Nuova Italia Scientifica, 1990).

C. F. Giuliani & P. Verduchi, *L'area centrale del Foro Romano* (Florence, L. S. Olschki, 1987).

S. M. Goldberg, "Plautus on the Palatine" *JRS* 88 (1998) 1–20.

N. Goldman, "Reconstructing the Roman Colosseum Awning" *Archaeology* 35.2 (1982) 57–65.

J.-C. Golvin, *L'amphithéâtre romain: essai sur la théorisation de sa forme et de ses fonctions* (Paris, de Boccard, 1988).

J.-C. Golvin & C. Landes, *Amphithéâtres & gladiateurs* (Paris, CNRS, 1990).

J.-C. Golvin & M. Reddé, "Naumachies, jeux nautiques et amphithéâtres," in C. Domergue, C. Landes, & J.-M. Pailler, eds., *Spectacula I: gladiateurs et amphithéâtres* (Paris, Imago; Lattes, Musée archéologique Henri Prades, 1990) 165–71.

J. C. Golvin & P. Leveau, "L'amphithéâtre et le théâtre – amphithéâtre de Cherchel. Monuments à spectacle e histoire urbaine à Caeserea de Maurétaine" *MEFRA* 91 (1979) 817–84.

G. Gori, "Elementi greci, etruschi, e lucani nelle pitture tombali a soggetto sportivo di Paestum" *Stadion* 16 (1990) 73–89.

R. Graefe, *Vela erunt: die Zeltdächer der römischen Theater und ähnlicher Anlagen* (Mainz am Rhein, P. von Zabern, 1979).

P. Graindor, *Athènes sous Auguste* (Cairo, Impr. Misr., 1927).

P. Graindor, *Athènes de Tibère à Trajan* (Cairo, Impr. Misr., 1931).

M. Grant, *Gladiators* (New York & London, Delacorte Press, 1967).

E. Greco, *Magna Grecia* (Rome & Bari, Laterza, 1981).

M. Griffin, *Nero: The End of a Dynasty* (New Haven, Yale University Press, 1984).

A. Grilli, *Marco Tullio Cicerone, Tuscolane, Libro II* (Brescia, Paideia, 1987).

P. Gros, *Aurea templa: recherches sur l'architecture religieuse de Rome à l'époque d'Auguste* (Rome, École français de Rome, 1976).

P. Gros, *Architecture et société à Rome et en Italie centro-méridionale aux deux derniers siècles de la République* (Collection Latomus, 156, Brussels, 1978).

P. Gros, "Vitruve: l'architecture et sa theorie" *ANRW* II.30.1 (1982) 659–95.

P. Gros, *Vitruve, De l'architecture, livre IV* (Paris, Les Belles Lettres, 1992).

P. Gros, *L'architecture romaine; du début du IIIe siècle av. J.-C. à la fin du Haut-Empire I. Les monuments publics* (Paris, Picard, 1996).

P. Gros, ed., *Vitruvio, D'Architectura* (Turin, Einaudi, 1997).

E. Gruen, *Culture and National Identity in Republican Rome* (Ithaca, NY, Cornell University Press, 1992).

E. Gunderson, "The Ideology of the Arena" *Cl. Ant.* 15 (1996) 113–51.

A. C. Gunter, *Labraunda* 2.5: *Marble Sculpture* (Stockholm, Swedish Research Institute in Instanbul, 1995).

E. G. Hardy, *Six Roman Laws* (Oxford, Clarendon Press, 1911).

E. G. Hardy, *Three Spanish Charters and Other Documents* (Oxford, Clarendon Press, 1912).

J. Harmand *L'Armée et le soldat à Rome de 107 à 50 avant notre ère* (Paris, Picard, 1967).

W. V. Harris, *Rome in Etruria and Umbria* (Oxford, Clarendon Press, 1971).

W. V. Harris, *War and Imperialism in Republican Rome*, 327–70 BC (Oxford, Clarendon Press, 1979).

W. V. Harris, *Ancient Literacy* (Cambridge, MA, Harvard University Press, 1989).

V. Hart & P. Hicks, eds. *Sebastiano Serlio on Architecture* I, Books I–V of "*Tutte l'opere d'architettura*," by Sebastiano Serlio, trans. from the Italian with an introduction and commentary (New Haven, Yale University Press, 1996).

P. B. Harvey, "Socer Valgus, Valgii, and C. Quinctius Valgus," in *Classics and the Classical Tradition. Essays Presented to R. E. Dengler on the Occasion of his Eightieth Birthday*, ed. E. N. Borza & R. W. Carrubba (University Park, PA, Pennsylvania State University, 1973) 79–94.

B. Hewitt, ed., *The Renaissance Stage. Documents of Serlio, Sabbattini and Furttenbach* (Coral Gables, FL, University of Miami Press, 1958).

M. C. Hoff, "The so-called Agoranomion and the Imperial Cult in Julio-Claudian Athens" *Arch. Anz.* 109 (1994) 93–117.

T. Hölscher, "Die Anfänge römischer Repräsentationskunst" *MDAI(R)* 85 (1978) 315–57.

A. Hönle & A. Henze, *Römische Amphitheater und Stadien: Gladiatorenkämpfe und Circusspiele* (Zürich, Atlantis, 1981).

S. Hood & D. Smyth, *Archaeological Survey of the Knossos Area*, 2nd ed. (London, British School at Athens, 1981).

K. Hopkins, *Conquerors and Slaves* (Cambridge and New York, Cambridge University Press, 1978).

K. Hopkins, *Death and Renewal* (Cambridge and New York, Cambridge University Press, 1983).

K. Hopkins & M. Beard, *The Colosseum* (London, Profile Books, and Cambridge, MA, Harvard University Press, 2005).

N. Horsfall, "The Ides of March: Some new problems" *Greece and Rome* 21 (1974) 191–9.

G. Horsmann, *Untersuchungen zur militärischen Ausbildung im republikanischen und kaiserzeitlichen Rom* (Boppard am Rhein, H. Boldt, 1991).

C. Hülsen, "Das Comitium und seine Denkmäler in der republikanischen Zeit" *MDAI(R)* 8 (1893) 79–94.

J. H. Humphrey, *Roman Circuses: Arenas for Chariot Racing* (London, B. T. Batsford, 1986).

J. M. Hurwit, *The Athenian Acropolis: History, Mythology, and Archaeology from the Neolithic Era to the Present* (Cambridge and New York, Cambridge University Press, 1999).

M. Jaczynowska, *Collegia Juvenum* (Torun, Uniwersytetu Mikolaja Kopernika, 1964).

M. Jaczynowska, *Les associations de la jeunesse romaine sous le haut-empire* (trans. from Polish by L. Woszeyzk Filogiczne 36, Warsaw, 1978).

J. R. Janot, "Phersu, Phersuna, Personna. Àpropos du masque étrusque" in *Spectacles sportifs et scéniques dans le monde étrusco-italique* (Rome, École française de Rome, Rome, 1991) 281–320.

W. Johannowsky, "Contributo dell'archeologia alla storia sociale: La Campania" *Dial. di Arch.* 4–5 (1971) 460–71.

W. Johannowsky, "La situazione in Campania," in P. Zanker, ed., *Hellenismus in Mittelitalien. Kolloquium in Göttingen vom 5. bis 9. Juni 1974* (Göttingen, Vandenhoeck und Ruprecht, 1976) 267–89.

A. Johnson, *Roman Forts of the 1st and 2nd Centuries A.D. in Britain and the German Provinces* (London, A. & C. Black; New York, St. Martins Press, 1983).

A. C. Johnson, P. R. Coleman-Norton, & F. C. Bourne, *Ancient Roman Statutes: A Translation with Introduction, Commentary, Glossary, and Index* (Austin, TX, University of Texas Press, 1961).

C. P. Jones, "Three foreigners in Attica" *Phoenix* 32 (1978) 222–34.

C. P. Jones, *The Roman World of Dio Chrysostom* (Cambridge, MA, Harvard University Press, 1978).

C. P. Jones, *Culture and Society in Lucian* (Cambridge, MA, Harvard University Press, 1986).

C. P. Jones, "Dinner Theatre," in W. J. Slater ed., *Dining in a Classical Context* (Ann Arbor, University of Michigan Press, 1991) 185–98.

M. J. Jones, *Roman Fort Defences to AD 117, with Special Reference to Britain*, BAR 21 (Oxford, 1975).

E. J. Jonkers, *Social and Economic Commentary on Cicero's de Lege Agraria Orationes Tres* (Leiden, E. J. Brill, 1963).

H. Jouffroy, *La construction publique en Italie et dans l'Afrique romaine* (Strasbourg, AECR, 1986).

E. J. Jory, "Gladiators in the Theatre" *CQ* 36 (1986) 537–9.

H. Kähler, "Anfiteatro" *EAA* I (Rome, 1958) 374–90.

L. J. F. Keppie, *Colonisation and Veteran Settlement in Italy 47–14 B.C.* (London, British School at Rome, 1983).

A. K. Kirsopp Lake, "The Archaeological Evidence for the 'Tuscan Temple' " *MAAR* 12 (1935) 89–149.

M. Kleijwegt, *Ancient Youth: The Ambiguity of Youth and the Absence of Adolescence in Greco-Roman Society* (Amsterdam, J. C. Gieben, 1991).

E. Köhne, C. Ewigleben, & R. Jackson, eds., *Gladiators and Caesars: The Power of Spectacle in Ancient Rome* (Berkeley, University of California Press, 2000).

J. Kolendo, "Deux amphithéâtres dans une seule ville: le cas d'Aquincum et de Carnuntum" *Archeologia Warz.* 30 (1979) 39–55.

J. Kolendo, "La répartition des places aux spectacles et la stratification sociale dans l'empire romain à propos des inscriptions sur les gradins des amphithèâtres et thèâtres" *Ktema* 6 (1981) 301–15.

D. G. Kyle, *Spectacles of Death in Ancient Rome* (London and New York, Routledge, 1998).

G. Lafaye, "Gladiator," in *DS* eds., *Le Dictionnaire des antiquités grecques et romaines*, II.2, Paris, Hachette, (1896) 1563–99.

S. P. Lampros, "Über das korinthische Amphitheater" *MDAI(A)* 2 (1877) 282–288.

R. Lanciani, *Forma Urbis Romae* (Rome, 1893, repr. Quasar, 1990).

R. Lanciani, *Ruins and Excavations of Ancient Rome* (New York, Bell Pub. Co., 1897; repr. 1979).

R. Lanciani, *Storia degli scavi di Roma e notizie intorno le collezioni romane di antichità* (Rome, E. Loeschler & Co., 1902).

A. La Regina, ed., *Sangue e arena* (Milan, Electa, 2001).

E. La Rocca, "Der Apollo-Sosianus-Tempel" in *Kaiser Augustus und die verlorene Republik* (Mainz am Rhein, P. von Zabern, 1988) 121–36.

E. La Rocca, A. M. De Vos, and F. Coarelli, *Guida Archeologica di Pompei* (Milan, Mondadori, 1976).

H. Lauter, "Bemerkungen zur späthellenistischen Baukunst in Mittelitalien" *JdI* 94 (1979) 390–459.

W. Leake, *Travels in the Morea*, 3 vols. (Amsterdam, A. M. Hakkert, 1830 [repr. 1968]).

W. D. Lebek, "Standeswürde und Berufsverbot unter Tiberius: Das *Senatus Consultum* der Tabula Larinas" *ZPE* 81 (1990) 37–96.

K. Lehmann-Hartleben, "Maenianum and Basilica" *AJPhil.* 59 (1938) 280–96.

H. Leppin, *Histrionen. Untersuchungen zur sozialen Stellung von Bühnenkünstlern im Westen des Römisches Reiches zur Zeit der Republik und des Principats* (Bonn, R. Habelt, 1992).

P. Le Roux, "L'amphithéâtre et le soldat sous l'Empire romain," in C. Domergue, C. Landes & J.-M. Pailler, eds., *Spectacula I: gladiateurs et amphithéâtres* (Paris, Imago: Lattes, Musée archéologique Henri Prades, 1990) 203–15.

P. Leveau, "Le problème de la date de l'amphithéâtre de Caesarea de Mauretanie: sa construction et son agrandissement," in C. Domergue, C. Landes, & J.-M. Pailler, eds., *Spectacula I: gladiateurs et amphithéâtres* (Lattes, Editions Imago: Musée archéologique Henri Prades, 1990) 47–54.

B. Levick, *Roman Colonies in Southern Asia Minor* (Oxford, Clarendon Press, 1967).

B. Levick, "The *senatus consultum* from Larinum" *JRS* 73 (1983) 97–115.

B. Levick, *Vespasian* (London and New York, Routledge, 1999).

A. Lezine, "Chapiteaux toscan trouvés en Tunisie" *Karthago* 6 (1955) 11–29.

A. W. Lintott, *Violence in Republican Rome* (Oxford, Clarendon Press, 1968).

E. Lo Cascio, "Pompei dalla città sannitica alla colonia sillana: le vicende istituzionale" in M. Cébeillac-Gervasoni ed., *Les élites municipales de l'Italie péninsulaire des Gracques à Néron: actes de la table ronde de Clermont-Ferrand (28–30 novembre 1991)* (Rome, École française de Rome, 1996) 111–23.

E. Lo Cascio, "The Size of the Roman Population: Beloch and the Meaning of the Augustan Census Figures" *JRS* 84 (1994) 23–40.

T. Lorenz, *Römische Städte* (Darmstadt, Wissenschaftliche Buchgesellschaft, 1987).

R. Luciani, ed., *Roma sotteranea* (Rome, F. lli Palombi, 1984).

G. Lugli, *I monumenti antichi di Roma e suburbio* III (Rome, G. Bardi, 1938).

G. Lugli, "L'origine dei teatri stabili in Roma antica secondo i recenti studi" *Dioniso* 9 (1942) 55–64.

G. Lugli, *Roma antica, il centro monumentale* (Rome, G. Bardi, 1946).

G. MacDonald, "Notes on the Roman Forts at Rough Castle and Westerwood with a Postscript" *Proceedings of the Royal Scottish Society* (March 13, 1933) 287–88.

W. L. MacDonald, *Architecture of the Roman Empire* I (New Haven, Yale University Press, 1965, rev. ed., 1982).

W. L. MacDonald & J. Pinto, *Hadrian's Villa and Its Legacy* (New Haven, Yale University Press, 1995).

R. MacMullen, "Roman Imperial Building in the Provinces" *Harv. Stud.* 64 (1959) 207–35.

S. Macready & F. H. Thompson, eds., *Roman Architecture in the Greek World* (London, Society of Antiquaries of London, 1987).

S. Maggi, *Anfiteatri della Cisalpina Romana (Regio IX; Regio XI)* (Florence, La Nuova Italia, 1997).

A. Maiuri, "Pompei: Scavo della 'Grande Palestra' nel quartiere dell' Anfiteatro" *Not. Scav.* ser. 6, vol. 15 (1939) 165–238.

A. Maiuri, "Pompei: Saggi nella cavea del 'Teatro Grande'" *Not. Scav.* ser. 8, vol. 5 (1951) 126–34.

E. Makin, "The Triumphal Route, with Particular Reference to the Flavian Triumph" *JRS* 11 (1921) 25–36.

L. Malten, "Leichenspiel und Totenkult" *MDAI (R)* 38–39 (1923-4) 300–40.

G. A. Mansuelli, *Roma e il mondo romano dalla media repubblica al primo impero (II sec. a.C.-I sec. d. C.)* (Turin, UTET, 1981).

G. Marchetti Longhi, "Nuovi aspetti della topografia dell' antico Campo Marzio di Roma. Circo Flaminio o Teatro di Balbo?" *MEFRA* 82 (1970) 117–58.

G. Marchetti Longhi, "Theatrum et Crypta Balbi" *Rend. Pont.* 16 (1940) 225–307.

S. D. Martin, *The Roman Jurists and the Organization of Private Building in the Late Republic and Early Empire* (Collection Latomus, Brussels, 1989).

L. Martines, *L'anfiteatro di Lecce* (Galatina, Pajano, 1957).

A. Mau "Sul significato della parola *pergula* nell' architettura antica" *MDAI (R)* 2 (1887) 214–20.

A. Mau, *Pompeii, Its Life and Art*, trans. F. W. Kelsey, 2nd ed. (New York and London, Macmillan, 1902).

R. Mayer, "Calpurnius Siculus: Technique and Date" *JRS* 70 (1980) 175–6.

F. Mazois, *Les Ruines de Pompeii* (Paris, F. Didot, 1824–38).

M. McDonnell, "The Speech of Numidicus at Gellius, *NA* 1.6" *AJPhil.* 108. (1987) 81–94.

M. McDonnell, *Roman Manliness. Virtus and the Roman Republic* (Cambridge and New York, Cambridge University Press, 2006).

M. Medri, "Fonte letterarie e fonti archeologiche: un confronto possibile sul M. Emilio Scauro il Giovane, la sua domus 'magnifica' e il theatrum "opus maximum omnium,'" *MEFRA* 109 (1997) 83–110.

M. Medri, "Suet., *Nero* 31.1: Elementi e proposte per la ricostruzione del progetto della Domus Aurea," in C. Panella ed., *Meta Sudans* I (Rome, Istituto Poligrafico e Zecca dello Stato, 1996) 165–88.

J. R. Mélida, "El anfiteatro romano de Mérida" *Memorias de la Junta Superior de Excavaciones y Antigüedades* (Madrid, 1919) 1–36.

M. Melo, *Paestum romana: ricerche storiche* (Rome, Istituto italiano per la storia antica, 1974).

D. Mertens, "Metapont. Ein neuer Plan des Stadtzentrums" *Arch. Anz.* (1985) 645–651.

J. Mertens, *Alba Fucens I. Rapports et études* (Brussels, Istitut historique belge de Rome, 1969).

F. Millar, *A Study of Cassius Dio* (Oxford, Clarendon Press, 1964).

F. Millar, "Condemnation to Hard Labor in the Roman Empire from the Julio-Claudians to Constantine" *PBSR* 52 (1984) 124–47.

F. Millar, *The Crowd in Rome in the Late Republic* (Ann Arbor, University of Michigan Press, 1998).

K. Mitens, "Theatre architecture in central Italy: reception and resistance" in P. Guldager Bilde, I. Nielsen, & M. Nielsen, eds., *Aspects of Hellenism in Italy: towards a cultural unity?* (Copenhagen, Museum Tusculanum Press, 1993) 91–106.

C. Mocchegiani Carpano, "L'arena e i sotterranei dell' Anfiteatro Flavio," in R. Luciani, ed., *Roma sotterranea* (Rome, Fratelli Palombi, 1984) 108–11.

Th. Mommsen, "Die italischen Bürgercolonien von Sulla bis Vespasian" *Hermes* 18 (1883) 161–213.

Th. Mommsen, "*Senatus consultum de sumptibus ludorum gladiatoriorum minuendis*" *Gesammelte Schriften* 8 (Berlin, Weidmannsche Buchhundlung, 1913) 499–531.

T. J. Moore, "Seats and Social Status in the Plautine Theatre" *CJ* 90 (1995) 113–23.

E. M. Moorman, "'Vivere come un uomo.' L'uso dello spazio nella *Domus Aurea*" in M. Cima & E. La Rocca, eds., *Horti romani; atti del Convegno internazionale, Roma, 4–6 maggio 1995* (Rome, L'Erma di Bretschneider, 1998) 345–61.

N. Moreley, *Metropolis and Hinterland. The City of Rome and the Italian Economy, 200 B.C.-A.D. 200* (Cambridge and New York, Cambridge University Press, 1996) 33–9.

M. P. O. Morford, "The distortion of the Domus Aurea tradition" *Eranos* 66 (1968) 158–79.

J. Mouratidis, "On the Origin of the Gladiatorial Games" *Nikephoros* 9 (1996) 111–34.

H. Mouritsen, *Elections, magistrates and municipal élite: studies in Pompeian epigraphy* (Rome, L'Erma di Bretschneider, 1988).

H. Mouritsen, *Plebs and Politics in the Late Roman Republic* (Cambridge and New York, Cambridge University Press, 2001).

G. Musca, ed., *Storia della Puglia* I: Antichità e Medioevo (Bari, M. Adda, 1987).

A. M. Nagler, *Theatre Festivals of the Medici 1539–1637* (New Haven and London, Yale University Press, 1964).

S. Nappo, "The urban transformation at Pompeii in the late third and early second centuries B.C." in R. Laurence & A. Wallace Hadrill, eds., *Domestic space in the Roman World: Pompeii and Beyond*. *JRA* Suppl. 22 (Pourtsmouth, RI, 1997) 91–120.

C. E. Newlands, "The Emperor's *Saturnalia*: Statius' 1.6," in A. J. Boyle & W. J. Dominick, eds., *Flavian Rome, Culture, Image, Text* (Leiden and Boston, Brill, 2003) 499–522.

A. Nibby, *Roma nell'anno MDCCCXXXVIII* [1838] (Rome, Tipografia delle Belle Arti, 1839).

C. Nicolet, "Les *equites campani*, et leurs représentations figurées" *MEFRA* 74 (1962) 463–517.

J. H. Oliver, *The Athenian Expounders of the Sacred and Ancestral Law* (Baltimore, MD, Johns Hopkins Press, 1950).

J. Onians, *Bearers of Meaning: The Classical Orders in Antiquity, the Middle Ages and the Renaissance* (Princeton, Princeton University Press, 1988).

E. M. Orlin, *Temples, Religion and Politics in the Roman Republic* (Leiden, Brill, 1997).

S. E. Ostrow, "The topography of Puteoli and Baiae on the eight glass flasks" *Puteoli. Studi di storia antica* 4–5 (1980–1) 235–43.

J. Overbeck & A. Mau, *Pompeji in seinen Gebäuden, Alterthümern und Kunstwerken*, 4th ed. (Leipzig, W. Engelmann, 1884).

J. Packer, "Roman Building Techniques," in M. Grant & R. Kitzinger, eds., *Civilization of the Ancient Mediterranean: Greece and Rome* (New York, Scribner's, 1988) 299–321.

M. Pallottino, *The Etruscans*, trans. J. Cremona, Bloomington & London, Indiana University Press, 1975.

C. Panella, "La valle del Colosseo nell'antichità" *BdA* 1–2 (1990) 35–88.

C. Panella, ed., *Meta Sudans* I (Rome, Istituto Poligrafico e Zecca dello Statto, Libreria dello Stato, 1996).

M. Pani, "Economia e società in età romana," in G. Musca, ed., *Storia della Puglia* I (Bari, M. Adda, 1979) 99–120.

M. Pani, "Politica e amministrazione in età romana," in G. Musca, ed., *Storia della Puglia* I (Bari, Sede regionale Puglia, 1979) 83–98.

I. A. Papapostolou, "Monuments des combats de gladiateurs à Patras" *BCH* 113 (1989) 351–401.

I. A. Papapostolou, "Themata Topographias kai Poleodomias ton Patron kata te Romaiokratia," in A. D. Rizakis, ed., *Achaia und Elis in der Antike* (Athens, Centre de Recherches de l'Antiquité Grecque et Romaine; Paris: E. De Boccard, 1991) 305–20.

C. Parisi Presicce, "I Dioscuri capitolini e l'iconografia dei gemelli divini in età romana," in L. Nista, ed., *Castores. L'immagine dei Dioscuri a Roma* (Rome, De Luca, 1994) 150–91.

H. Parker, "Crucially Funny or Tranio on the Couch: The *Servus Callidus* and Jokes about Torture" *TAPA* 119 (1989) 233–46.

J. R. Patterson, "The City of Rome from Republic to Empire" *JRS* 82 (1992) 186–215.

M. J. Pena, *Epigrafía Ampuritana (1953–1980)*, (Quaderns de Treball 4, Barcelona, 1981).

J. Perlzweig, *The Athenian Agora VII: Lamps of the Roman Period, First to Seventh Century after Christ* (Princeton, American School of Classical Studies at Athens, 1961).

A. W. Pickard-Cambridge, *The Theatre of Dionysus in Athens* (Oxford, Clarendon Press, 1946).

L. Pietilä-Castrén, *Magnificentia publica: The victory monuments of the Roman generals in the era of the Punic wars* (Helsinki, Societas Scientiarum Fennica, 1987).

C. Pietrangeli, *Guide rionali di Roma* (Rome, 1967).

A. Piganiol, *Recherches sur les jeux romains: notes d'archéologie et d'histoire religieuse* (Strasbourg, Librarie Istra, 1923).

G. B. Piranesi, *Campus Martius antiquae urbis* (Rome, apud auctorem, 1762).

P. Plass, *The Game of Death in Ancient Rome: Arena Sport and Political Suicide* (Madison, WI, University of Wisconsin Press, 1995).

L. Polacco, *Il teatro di Dioniso Eleutereo ad Atene* (Rome, L'Erma di Bretschneider, 1990).

Pompei. Pitture e Mosaici I (Rome, Istituto della Enciclopedia italiana, 1990).

A. Pontrandolfo & A. Rouveret, *Le tombe dipinte di Paestum* (Modena, F. C. Panini, 1992).

Y. Porath, "Herod's 'amphitheatre' at Caesarea: A multipurpose entertainment building," in *The Roman and Byzantine Near East: Some Recent Archaeological Research* (*JRA* Suppl. 14, Ann Arbor, 1995) 15–27.

F. Poulsen, *Etruscan Tomb Paintings: Their Subjects and Significance* (trans. I. Anderson, Oxford, Clarendon Press, 1922).

C. Promis, *Le antichità di Aosta, Augusta Praetoria Salassorum, misurate disegnate, illustrate* (Turin, Stamperia Reale, 1862).

K. Puppi, *Andrea Palladio* II (Milan, Electa, 1973).

N. Purcell, "Town in Country and Country in Town," in E. MacDougal, ed., *Ancient Roman Villa Gardens* (Washington DC, Dumbarton Oaks, 1987) 187–203.

L. Quilici, "Il Campo Marzio occidentale," in *Città e architettura nella Roma imperiale. Analecta Romana Instituti Danici* Suppl. 10 (Rome, 1983) 59–85.

W. Radt, *Pergamon. Geschichte und Bauten, Funde und Erforschung einer antiken Metropole* (Cologne, DuMont, 1988).

F. Rakob, "Hellenismus in Mittelitalien. Bautypen und Bautechnik," in P. Zanker, ed., *Hellenismus in Mittelitalien* (Göttingen, Vandenhoeck und Ruprecht, 1976) 366–86.

N. K. Rauh, "Was the Agora of the Italians an *Établissement de Sport*?" *BCH* 116 (1992) 293–333.

E. Rawson, "*Discrimina Ordinum*: The *Lex Julia Theatralis*" *PBSR* 55 (1987) 83–114.

R. Rea, *Anfiteatro Flavio* (Rome, Istituto Poligrafico e Zecca dello Stato, 1996).

R. Rea, "Le antiche raffigurazione dell' Anfiteatro," in M. L. Conforto et al., *Anfiteatro Flavio: Immagine, testimonianze, spettacoli* (Rome, Quasar, 1988) 23–46.

R. Rea, "Recenti osservazioni sulla struttura dell' Anfiteatro Flavio," in M. L. Conforto et al., *Anfiteatro Flavio: immagine, testimonianze, spettacoli* (Rome, Quasar, 1988) 9–22.

R. Rea et al., "Sotteranei del Colosseo. Ricerca preliminare al progetto di ricostruzione del piano dell' arena" *MDAI(R)* 107 (2000) 311–39.

D. Rebuffat-Emmanuel, "Le jeu du Phersu à Tarquinia: nouvelle interprétation" *CRAI* (1983) 421–38.

A. M. Reggiani, "La 'venatio': origine e prime raffigurazioni," in M. L. Conforto et al., *Anfiteatro Flavio: immagine, testimonianze, spettacoli* (Rome, Quasar, 1988) 147–55.

A. Reifenberg, "Caesaerea: A Study in the Decline of a Town" *IEJ* 1 (1950–1) 20–32.

A. Reifferscheid, *C. Suetoni Tranquilli praeter Caesarum: libros reliquiae* (Leipzig, Teubner, 1860).

M. Reinhold, *From Republic to Principate: An Historical Commentary of Cassius Dio's Roman History. Volume 6: Books 49–52 (36–29 B.C.)* (Oxford, Oxford University Press, 1988).

J. M. Reynolds, "Epigraphic evidence for the construction of the theatre: 1st c. B.C. to mid 3rd c. A.D.," in R. R. R. Smith & K. T. Erim, eds., *Aphrodisias Papers 2: The theatre, a sculptor's workshop, philosophers, and coin-types* (*JRA* Suppl. 2, Ann Arbor, 1991).

M. Ricciardi, "L'anfiteatro ed il grande teatro romano di Gortina" *ASAA* 64–65 (1986–87) 327–51.

J. W. Rich, "The supposed Roman manpower shortage of the later second century B.C." *Historia* 32 (1983) 287–331.

E. Richardson, *The Etruscans* (Chicago, IL, University of Chicago Press, 1964).

L. Richardson, jr., "Cosa and Rome: Comitium and Curia" *Archaeology* 10 (1957) 49–55.

L. Richardson, jr., *Pompeii: An Architectural History* (Baltimore, MD, Johns Hopkins University Press, 1988).

L. Richardson, jr., *A New Topographical Dictionary of Ancient Rome* (Baltimore and London, Johns Hopkins University Press, 1992).

F. Ritschl, "Die Tesserae gladiatoriae der Römer," in *Opuscula Philologica* IV (Leipzig, B. G. Teubner, 1878) 572–656.

A. D. Rizakis, "La Colonie romaine de Patras en Achaie: le témoignage epigraphique" in S. Walker & A. Cameron, eds., *The Greek Renaissance in the Roman Empire* (London, Institute of Classical Studies, 1989) 180–6.

L. Robert, *Les gladiateurs dans l'Orient grec* (Paris, Champion, 1940).

L. Robert & J. Robert, *Claros I: Décrets hellénistiques I* (Paris, Editions Recherche sur les civilisations, 1989).

J.-M. Roddaz, *Marcus Agrippa* (Rome, École française de Rome, 1984).

E. Rodríguez-Almeida, "Qualche osservazione sulle Esquiliae patrizie e il Lacus Orphe", in *L'Urbs. Espace urbain et histoire (Ier siècle av. J. C. – IIIe J. C.)* (Rome, École français de Rome, 1987) 415–28.

E. Rodríguez-Almeida, "Marziale in Marmo" *MEFRA* 106 (1994) 197–217.

D. W. Roller, "The Wilfrid Laurier University Survey of Northeastern Caesarea" *Levant* 14 (1982) 90–103.

D. W. Roller, *The Building Program of Herod the Great* (Berkeley and Los Angeles, University of California Press, 1998).

D. G. Romano, "Post 146 B.C., land use in Corinth and planning of the Roman colony of 44 B.C.," in T. E. Gregory, ed., *The Corinthia in the Roman Period* (*JRA* Suppl. 8, Ann Arbor, 1993) 9–30.

M. Rostovtzeff, *Tesserarum urbis romae et suburbi plumbearum sylloge* (St. Petersburg, Commissionnaires de l'Académie impériale des sciences, 1903).

P. Roussel & J. Hatzfeld, "Fouilles de Délos executées aux frais de M. le duc de Loubat, décrets, dédicaces et inscriptions (1905–08)" *BCH* 34 (1910) 355–423.

J. Russell, "The Origin and Development of the Republican Forums" *Phoenix* 22 (1968) 304–36.

H. D. Russell et al., *Jacques Callot. Prints and Related Drawings* (Washington DC, National Gallery of Art, 1975).

P. Sabbatini Tumolesi, *Gladiatorum paria: Annunci di spettacoli gladiatorii a Pompei* (Rome, Edizioni di Storia e Letteratura, 1980).

E. T. Salmon, *Samnium and the Samnites* (Cambridge, Cambridge University Press, 1967).

E. T. Salmon, *Roman Colonization under the Republic* (London, Thames & Hudson, 1970).

E. T. Salmon, *The Making of Roman Italy* (Ithaca, NY, Cornell University Press, 1982).

S. Sande & J. Zahle, "Der Tempel der Dioskuren auf dem Forum Romanum," in *Kaiser Augustus und die verlorene Republik* (Mainz, P. von Zabern, 1988) 213–24.

E. Sanmarti-Greco et al., "El anfiteatro de Emporiae" in *El anfiteatro en la Hispania Romana* (Mérida, Junta de Extremadura, 1994) 119–37.

T. C. Sarikakis, *The Hoplite General in Athens* (Princeton, dissertation, 1951).

G. Schingo & L. Rendina, "Anfiteatro Flavio: saggio nelle fondazioni" *Bull. Com. Arch.* 92 (1986–7) 325–8.

K. Schneider, "Gladiatores" *RE*, Suppl. 3 (1918), cols. 760–84.

A. Scobie, "Spectator Security and Comfort at Gladiatorial Games" *Nikephoros* 1 (1988) 191–243.

H. H. Scullard, *Festivals and Ceremonies of the Roman Republic* (London, Thames and Hudson, 1981).

R. Seager, "Sulla," in J. A. Crooke, A. Lintott, & E. Rawson, eds., *The Cambridge Ancient History 2nd ed. Vol. IX: The Last Age of the Roman Republic, 146–43 B.C.* (Cambridge, Cambridge University Press, 1994) 165–207.

P. C. Sestieri, "Tombe dipinte di Paestum" *Rivista dell' Istituto nazionale d'archeologia e storia dell' arte* n.s. 5–6 (1956–7) 65–110.

S. Settis, A. La Regina, G. Agosti, V. Farinella, *La Colonna Traiana* (Turin, Einaudi, 1988).

D. R. Shackleton Bailey, "The Roman Nobility in the Second Civil War" *CQ* 10 (1960) 253–67.

I. Shatzman, *Senatorial Wealth and Roman Politics* (Collection Latomus, Brussels, 1975).

T. L. Shear, Jr., "Athens: From City-state to Provincial Town" *Hesperia* 50 (1981) 356–77.

F. W. Shipley, "Chronology of the Building Operations in Rome from the Death of Caesar to the Death of Augustus" *MAAR* 9 (1931) 7–60.

W. J. Slater, "Pantomime riots" *Cl. Ant.* 13 (1994) 120–44.

R. R. R. Smith, "Nero and the Sun-god: Divine accessories and political symbols in Roman imperial images" *JRA* 13 (2000) 532–42.

H. Solin, "Epigrafia repubblicana. Bilancio, novità, prospettive," in *XI Congresso Internazionale di Epigrafia Greca e Latina* (Rome, Quazar, 1999).

H. Solin, "Republican Capua" H. Solin & M. Kajava, eds., *Roman Eastern Policy and Other Studies in Roman History. Commentationes Humanarum Litterarum* 91 (Helsinki, 1990) 151–62.

P. Sommella et al., *Italia antica: l'urbanistica romana* (Rome, Jouvence, 1988).

M. Sordi, "La decadenza della repubblica e il teatro del 154 A.C." *Invigliata Lucernis.* 10 (1988) 327–41.

A. Spawforth, "Corinth, Argos, and the Imperial cult: Pseudo-Julian, *Letters* 198" *Hesperia* 63 (1994) 211–32.

A. Spawforth, "Symbol of unity? The Persian-Wars tradition in the Roman Empire," in S. Hornblower, ed., *Greek Historiography* (Oxford, Clarendon Press, 1994) 233–47.

Spectacles sportifs et scéniques dans le monde étrusco-italique (Rome, École française de Rome, 1993).

E. M. Steinby, "Il lato orientale del Foro Romano" *Arctos* 21 (1987) 139–84.

E. M. Steinby, ed., *Lexicon Topographicum Urbis Romae* I–VI (Rome, Quasar, 1993–2000).

A. Stewart, *Greek Sculpture: An Exploration* (New Haven, Yale University Press, 1990).

R. Stillwell, *Corinth II: The Theatre* (Princeton, American School of Classical Studies at Athens, 1952).

D. E. Strong, "Some Observations on early Roman Corinthian" *JRS* 53 (1963) 73–84.

D. E. Strong & J. B. Ward Perkins, "The Temple of Castor in the Forum Romanum" *PBSR* 30 (1962) 1–30.

M. C. Sturgeon, *Sculpture: the Assemblage from the Theatre* (Corinth IX.3, Princeton, American School of Classical Studies at Athens, 2004).

R. Syme, *The Augustan Aristocracy* (Oxford, Clarendon Press, 1986).

L. Ross Taylor, *Party Politics in the Age of Caesar* (Berkeley, University of California Press, 1949).

R. Taylor, *Roman Builders: A Study in Architectural Process* (Cambridge and New York, Cambridge University Press, 2003).

H. A. Thompson, "The Impact of Roman Architects and Architecture on Athens, 170 B.C.–A.D. 170," in S. Macready and F. H. Thompson, eds., *Roman Architecture in the Greek World* (London, Society of Antiquaries of London, 1987) 1–17.

J. P. Thuillier, *Les jeux athlétiques dans la civilisation étrusque* (Rome, École française de Rome, 1985).

J. P. Thuiller, "Les origines de la gladiature: une mise au point sur l'hypothèse étrusque" in C. Domergue, C. Landes, & J.-M. Pailler, eds., *Spectacula I: gladiateurs et amphithéâtres* (Lattes, Musée archéologique Henri Prades, 1990) 137–41.

M. Torelli, *Elogia Tarquiniensia* (Florence, Sansoni, 1975).

M. Torelli, *Guide Archeologiche Laterza 3: Etruria* (Rome and Bari, Laterza, 1980).

M. Torelli, "Delitto religioso. Qualche indizio sulla situazione in Etruria," in *Le délit religieux dans la cité antique* (Rome, École française de Rome, 1981) 1–7.

M. Torelli, "Alle radici della nostalgia augustea" in M. Pani, ed., *Continuità e trasformazioni tra Repubblica, e Principato. Instituzioni, politica, società. Atti dell' incontro di studi, Bari 27–28 gennaio 1989* (Bari, Edipuglia 8) 47–67.

M. Torelli, ed., *The Etruscans* (Milan, Bompiani, 2000).

E. Tortorici, *Argiletum: commercio, speculazione, edilizia e lotta politica dall'analisi topografica di un quartiere di Roma di età repubblicana* (Rome, L'Erma di Bretschneider, 1991).

G. Tosi, "Gli edifici per spettacolo di Verona" *Spettacolo in Aquileia e nella Cisalpina romana* (Udine, Arti Grafiche Friulane, 1994) 241–57.

G. B. Townend, "Calpurnius Siculus and the *Munus Neronis*" *JRS* 70 (1980) 166–74.

J. Travlos, *Pictorial Dictionary of Ancient Athens* (London, Thames and Hudson, 1971).

P. L. Tucci, "Nuove ricerche sulla topografia dell' area del Circo Flaminio" *Studi Romani* 41, 1993, 229–42.

P. L. Tucci, "Il tempio dei Castori *in Circo Flaminio*: la lastra di Via Anicia," in L. Nista, ed., *Castores. L'immagine dei Dioscuri a Roma* (Rome, De Luca, 1994) 123–8.

G. Ucelli, *Le navi di Nemi* (Rome, Fratelli Palombi, 1942).

E. B. Van Deman, "The Sullan Forum" *JRS* 12 (1922) 1–31.

L. B. van der Meer, "*Ludi scaenici et gladiatorum munus*: A Terracotta Arula in Florence" *BaBesch* 57 (1982) 87–97.

Vegetius: Epitome of Military Science, trans. with notes and introduction by N. P. Milner (Liverpool, Liverpool University Press, 1996).

H. S. Versnel, *Inconsistencies in Greek and Roman Religion* II: *Transition and Reversal in Myth and Ritual* (Leiden, E. J. Brill, 1990–93).

P. Veyne, *Le pain et le cirque: sociologie historique d'un pluralisme politique* (Paris, Seuil, 1976).

G. Ville, "La guerre et le *munus*," in J.-P. Brisson, ed., *Problèmes de la guerre à Rome* (Paris, Mouton, 1969) 185–95.

G. Ville, *La gladiature en Occident des origines à la mort de Domitien* (Rome, École française de Rome, 1981).

P. Virgili, "Scavi in Via delle Zoccolette e adiacenze" *Archeologia Laziale* 8 (1987) 102–8.

W. Vischer, *Erinnerungen und Eindrücke aus Griechenland* (Basel, Schweighauser, 1875).

F. Vittinghoff, *Römische Kolonisation und Bürgerrechtspolitik unter Caesar und Augustus* (Wiesbaden, Akademie der Wissenschaften und der Literatur, 1952).

Vitruvius. Ten Books on Architecture with trans. and commentary by I. Rowland and T. N. Howe (Cambridge and New York, Cambridge University Press, 1999).

F. W. Walbank, *A Historical Commentary on Polybius III* (Oxford, Clarendon Press, 1979).

M. E. H. Walbank, "The foundation and planning of early Roman Corinth" *JRA* 10 (1997) 95–130.

A. Wallace-Hadrill, *Suetonius: The Scholar and His Caesars* (London, Duckworth, 1983).

A. Wallace-Hadrill, "Roman Arches and Greek Honours: The Language of Power at Rome" *PCPS* 216 (1990) 143–81.

A. Wallace-Hadrill, "Elites and Trade in the Roman Town" in J. Rich & A. Wallace-Hadrill, eds., *City and Country in the Ancient World* (London and New York, Routledge, 1991) 241–72.

A. Wardman, *Religion and Statecraft among the Romans* (Baltimore, MD, Johns Hopkins Press, 1982).

J. B. Ward-Perkins, *Roman Imperial Architecture* (New Haven, Yale University Press, 1994).

G. R. Watson, *The Roman Soldier* (Ithaca, NY, Cornell University Press, 1969).

F. Weege, "Oskische Grabmalerei" *JDI* 24 (1909) 99–162.

Z. Weiss, "The Jews and the games in Roman Caesarea," in A. Raban & K. G. Holum, eds., *Caesarea Maritima. A Retrospective after Two Millennia* (Leiden, Brill, 1996) 443–52.

K. E. Welch, "Roman amphitheatres revived" *JRA* 4 (1991) 272–81.

K. E. Welch, "The Roman arena in late republican Italy: A new interpretation" *JRA* 7 (1994) 59–80.

K. E. Welch, "L'origine del teatro romano antico: l'adattamento della tipologia greca al contesto romano" *Annali di Architettura. Rivista del Centro Internazionale di Studi di Architettura Andrea Palladio* 9 (Milan, Electa, 1997) 7–16.

K. E. Welch, "Greek stadia and Roman spectacles: Asia, Athens, and the tomb of Herodes Atticus" *JRA* 11 (1998a) 117–45.

K. E. Welch, "The Stadium at Aphrodisias" *AJArch.* 102 (1998b) 547–69.

K. E. Welch, "Recent work on amphitheatre architecture and arena spectacles" *JRA* 14 (2001) 492–8.

K. E. Welch, "A new view of the origins of the Roman basilica: the *Atrium Reqium*, the *Graecostasis* and Roman diplomacy" *JRA* 17 (2003) 5–34.

E. Welin, *Studien zur Topographie des Forum Romanum* (*Acta Instituti Romani Regni Sueciae*, ser. 8, vol. 6, 1953).

R. E. M. Wheeler, "The Roman Amphitheatre at Caerleon, Monmouthshire," *Archaeologia*, 78 (1928).

T. Wiedemann, *Emperors and Gladiators* (London and New York, Routledge, 1992).

P. I. Wilkins, "Amphitheatres and private munificence in Roman Africa: A new text from Thuburnica" *ZPE* 75 (1988) 215–21.

C. K. Williams, II, "The Refounding of Corinth: Some Roman Religious Attitudes" in S. Macready & F. H. Thompson, eds., *Roman Architecture in the Greek World* (London, Society of Antiquaries of London, 1987) 26–37.

M. Wilson Jones, "Designing the Roman Corinthian order" *JRS* 2 (1989) 35–69.

M. Wilson Jones, "Designing Amphitheatres" *MDAI (R)* 100 (1993) 391–442.

M. Wilson Jones, *Principles of Roman Architecture* (New Haven and London, Yale University Press, 2000).

J. Wilton-Ely, *Piranesi as Architect and Designer* (New Haven, Yale University Press, 1998).

T. P. Wiseman, *New Men in the Roman Senate 139 B.C. – A.D. 14* (Oxford, Oxford University Press, 1971).

T. P. Wiseman, "The central area of the Roman Forum" *JRA* 3 (1990) 245–7.

T. P. Wiseman, "The Circus Flaminius" *PBSR* 42 (1974) 3–26.

T. P. Wiseman, "Cicero, *pro Sulla* 60–61" *LCM* 2 (1977) 21–22.

T. P. Wiseman, "Strabo on the Campus Martius: 5.3.8, C235" *LCM* 4 (1979) 129–33.

T. P. Wiseman, *Catullus and His World: A Reappraisal* (Cambridge and New York, Cambridge University Press, 1985).

T. P. Wiseman, "The central area of the Roman Forum" *JRA* 3 (1990) 245–7.

T. P. Wiseman, "Rome and the Resplendent Aemilii," in H. D. Jocelyn & H. Hurt, eds., *Tria Lustra: Essays Presented to John Pinsent* (Liverpool Classical Papers 3, Liverpool, 1993) 181–92.

T. P. Wiseman, *Remus*: a Roman Myth (Cambridge and New York, Cambridge University Press, 1995).

M. Wistrand, "Violence and entertainment in Seneca the Younger" *Eranos* 88 (1990) 31–46.

M. Wistrand, *Entertainment and violence in Ancient Rome: The attitudes of Roman writers of the first century* AD (Göteborg, *Studia Graeca et Latina Gothoburgensia* 56, 1992).

G. Woolf, "Becoming Roman, staying Greek: Culture, identity and the civilizing process in the Roman East" *PCPS* 40 (1994) 116–43.

R. E. Wycherley, "The altar of Eleos" *CQ* 4 (1954) 143–50.

F. Yegül, *Baths and Bathing in Classical Antiquity* (Cambridge, MA, MIT Press, 1992).

P. Zanker, "Das Trajansforum in Rom als Monument Kaiserlicher Selbstdarstellung" *Arch. Anz.* 85 (1970) 499–544.

P. Zanker, *Pompeji. Stadtbilder als Spiegel von Gesellschaft und Herrschaftsform* (Mainz, P. von Zabern, 1987).

P. Zanker, *The Power of Images in the Age of Augustus*, trans. A. Shapiro (Ann Arbor, University of Michigan Press, 1988).

P. Zanker, *Der Kaiser baut fürs Volk* (Opladen, Westdeutscher, 1997).

P. Zanker, *Pompeii. Public and Private Life*, trans. D. L. Schneider (Cambridge, MA, Harvard University Press, 1998).

F. Zevi, "Alatri," in P. Zanker, ed., *Hellenismus in Mittelitalien: Kolloquium in Göttingen vom 5. bis 9. Juni 1974* (Göttingen, Vandenhoeck und Ruprecht, 1976) 84–7.

F. Zevi, ed., *Paestum* (Naples, Banco di Napoli, 1990).

F. Zevi, "Personaggi della Pompei sillana" *PBSR* 63 (1995) 1–24.

F. Zevi, "Pompei dalla città sannitica alla colonia sillana: per un' interpretazione dei dati archeologici" in M. Cébellac-Gerrasoni, ed., *Les Élites municipales de l'Italie péninsulaire des Gracques à Néron: actes de la table ronde de Clermont-Ferrand (28–30 Novembre 1991)* (Rome, École française de Rome, 1996) 125–38.

A. Ziolkowski, *The temples of mid-republican Rome and their historical and topographical context* (Rome, L'Erma di Bretschneider, 1992).

INDEX